Anne-Marie Sankovitch, *in memoriam*

During my first trip to Dogon country I carried with me photographs of various card and papier-mâché masks that I had made in my work as a theater designer. On showing these to the smith with whom I was apprenticed, he peered at the photos and appeared to recognize something familiar in what he saw. "Ahhh!" he said looking at a black and white cow mask, "*imina na*" (ox mask), and similarly of a rabbit mask, "*imina jon*" (hare mask). One image of a masked female sitting in a tent caused confusion at first, until I explained that her home was portable. "Ah yes . . . *imina pulloyana*" (Fulani woman mask) he said at once with conviction. . . .

On a later field trip to the Dogon region I took with me an assortment of plastic character masks that I'd carefully selected from a local novelty store. After some thought, my final choice consisted of a lurid rendition of "Bugs Bunny," a devil mask, and "Eh-Oh," a character from the children's show "Teletubbies" (complete with a triangular superstructure above his head). Perhaps, I thought, one of these would also strike a familiar chord and might even be danced at the next Dogon funerary rite. But no. Instead, my purchases provoked only hilarity from my Dogon friends: "These are not real masks . . . these are just games for children," they retorted, and the objects in question were quickly cast off to a gang of young boys who put them on and promptly rampaged through the village with glee.

So if these weren't "real" masks, then what kind of reality I thought did Dogon masks in fact present?

PR

Res 49/50 Spring/Autumn 2006

Anthropology and aesthetics

Contents

LECTURES, DOCUMENTS, AND DISCUSSIONS

Res 49/50 Spring/Autumn 2006

Anthropology and aesthetics

EDITOR
Francesco Pellizzi

ASSOCIATE EDITORS
Remo Guidieri
Joseph Koerner
Joseph Rykwert

EXECUTIVE EDITORIAL COUNCIL
William Fash
Thomas Lentz
Francesco Pellizzi

ASSISTANT EDITOR
Natasha Kurchanova

CONTRIBUTING EDITORS

Suzanne Preston Blier
Sarah Brett-Smith
Thomas Cummins
Finbarr Barry Flood
David Freedberg
Dario Gamboni
Ivan Gaskell

Oleg Grabar
Jeffrey Hamburger
Jonathan Hay
Michael Meister
Erika Naginski
Jeffrey Quilter
Victor Stoichita

Z. S. Strother
Karl Taube
Marvin Trachtenberg
Gary Urton
Irene Winter
Gerhard Wolf
Christopher Wood

EDITORIAL ADVISORS

Alain Babadzan
Akeel Bilgrami
Edmund Carpenter
Clemency Coggins
Whitney Davis
Kurt Forster
John Hay
Robert Hullot-Kentor

Adrienne Kaeppler
C. C. Lamberg-Karlovsky
Pamela Lee
Stephen Melville
Alina Payne
Marshall Sahlins
Carlo Severi
David Shapiro

David Stuart
S. J. Tambiah
Robert Farris Thompson
Emily Umberger
Gianni Vattimo
Peter Warshall
Rubie Watson

PROJECT COORDINATOR (Peabody Museum) Susan McNally
DESIGNER Richard Bartlett
COVER DESIGN From a 1981 sketch by Dan Flavin
LAYOUT Glenna Collett

EDITORIAL OFFICE
12 East 74th Street, New York, NY 10021, fax: (212) 861-7874,
e-mail for Editor: pellizzi@fas.harvard.edu
e-mail for Assistant Editor: respell@earthlink.net

PUBLISHED BY
The Peabody Museum of Archaeology and Ethnology and the Harvard University Art Museums

PRODUCED BY
The Peabody Museum of Archaeology and Ethnology, Harvard University
11 Divinity Avenue, Cambridge, Massachusetts 02138

Manufactured in the United States of America
Printing by Puritan Press

ISSN 0277-1322 ISBN 0-87365-767-5

Editorial

RES at fifty: Revisiting the field

FRANCESCO PELLIZZI

Understand—it ALWAYS makes sense. Sense can't be avoided.
—*Richard Foreman*, Reverberation Machines[1]

This double-volume of *RES*, 49/50, marks the journal's first quarter-century and a new alliance: The Harvard Art Museums joins the Peabody Museum of Archaeology and Ethnology as co-publishers of the journal. This collaboration fulfills on an institutional level a transdisciplinary vocation present from *RES*'s inception and increasingly manifest in the ensuing years.[2]

In our opening editorial (*RES* 1, spring 1981), Remo Guidieri and I briefly discussed two goals: to rejuvenate and reinvigorate the study of artifacts in societies traditionally constituting the field of anthropology, and

to offer students of cultures for which vast written documents existed the opportunity to reexamine their cult and aesthetic objects in light of those anthropological findings.[3] Thus, in the study of what used to be called "tribal art," *RES* has promoted a move away from reductive forms of semiology toward a reevaluation of the specificity of the archaic *silent* artifact, while in the fields of literate civilizations it has welcomed different modes of inquiry that transcend (without negating or excluding) both formalist and socio-historical analysis. At the start, while stressing *RES*'s perduring anthropological underpinnings, we asked:

> What . . . impels us today to deal with creations that are not ours? . . . In the past century, the study of archaic objects has had a glorious history, yet . . . these forms have not been truly integrated, but merely set in place alongside our own. They will remain opaque as long as the ultimate justification for their inclusion continues to be nothing more than a vague appeal to a universal aesthetics (ibid., p. 4).

It seemed clear to us, even then, that Western art's aesthetic appropriation of objects of ethnographic (and Colonial) provenance, beyond reflecting its supposed break with our representational tradition, also implied that "art has now become [in itself] a problematic category." And yet, if I finally decided to append the word "aesthetics" to my original and rather cryptic Latin

1. Richard Foreman, *Reverberation Machines: The Later Plays and Essays* (Barrytown, c.1985), p. 190. My warmest thanks to Gini Alhadeff, Robert Hullot-Kentor, Natasha Kurchanova, and David Shapiro for their most helpful readings of this editorial.

2. It is fit to recall here the support *RES* has received from subsequent directors of the Peabody Museum—Stephen Williams, Karl Lamberg-Karlovsky, David Pillbeam, Rubie Watson, and, last but not least, William Fash—and from the staff of its publications office. Early on, the director of the Laboratoire d'Anthropologie Sociale of the University of Paris X, Nanterre, the late Eric de Dampierre, provided sympathetic encouragement. Later and for a period of six years, *RES* was co-published by the Getty Research Center (through the good offices of Kurt Forster, its director at the time), and for the past ten years the journal has received substantial and crucial support from the Fanny and Leo Koerner Charitable Trust, and has also been supported by Pinewood Foundation. I know that all the scholars, artists, writers, and readers who make up the communal body of *RES* are very grateful, as I am to them and to the "family" of authors, artists, associate editors, contributing editors, and editorial advisors, without whose invaluable and sustained input the journal could not have become what it is and might not even have survived. Last, but certainly not least, I also wish to recall the extraordinarily generous, imaginative, and unfailingly kind support that *RES*—and I personally— have received, throughout the years, from associate editor Joseph Rykwert, a constant source of critical insight and editorial inspiration (he also guest-edited the special issue *RES* 34, autumn 1998: *Architecture*); and from Joseph Koerner, another associate editor, who started publishing in the journal when still a graduate student and later guest-edited *RES* 31, spring 1997: *The abject* and *RES* 36, autumn 1999: *Factura*.

3. The idea for a "Bulletin of the Anthropology of Art," which soon expanded into *RES*'s unique multidisciplinary form, originated from numerous discussions between Remo Guidieri and myself, over a period of about two years (1976–1978) in Paris, New York City, and San Cristobal de las Casas (Chiapas), as we worked on an account and interpretation of documents relating to the production of cult objects in certain funerary rituals on the Island of Malakula, New Hebrides (now Vanuatu). This work led to the writing of an extensive essay that was published in the second issue of the journal and constituted, in many ways, the first application of its programmatic and theoretical underpinnings. R. Guidieri and F. Pellizzi, "Shadows: Fourteeen tableaux on the cult of the dead in Malekula, Eastern Melanesia," *RES* 2 (autumn 1981):5–69. Remo Guidieri, *RES*'s co-founder, has remained active as an author and associate editor of the journal.

title for the journal, it was because of a sense—more intuitive perhaps than thoroughly reasoned—that something primary and pervasive, a power within form going well beyond any formalist analysis, accompanied all conscious *aesthesis* and creation. The Lebanese critic Jalal Toufic, in discussing the persistence of the particular and the unique in what are now called "global" settings, may have offered a glimpse of how a borderline general aesthetic could still be viable:

> What can resist, and resists the expansion of globalization is not the local of every country, but the universal of artistic works, which present each a universe that is not part of the expanding universe in which humans materially live but *borders* it.[4]

Such an approach, always somewhat *à coté* of established boundaries, reflects an ever more marked contemporary awareness of what is characteristic and problematic about borders: the fact that they often resurface just as they are being negated, and that they tend to dissolve as their lasting relevance is affirmed.

Anthropology (including large sectors of archaeology), originated by and large with the Western study of societies that had not for the most part recorded their history in writing. As a consequence, we and the present representatives of those societies—when they have survived their encounter with us and other accidents of the ages—must now contend with records that were and are the objects of multiple registers of translation-transformation: those resulting from cultural and technological transfers between cultures; those from the oral to the written medium; and, as a consequence, those from archaic (and, on occasion, "archaist") modes, contents, and forms to a proliferation of new and diverse modern (and modernist) ones. All translation being at one and the same time notoriously treacherous and the source of much that is vital (and even salvific), anthropology could be said to be the discipline of systematic (or systemic) misapprehension—weaving new interactive narratives out of inescapably hybrid threads.[5]

A crucial component of this search is given by the experience of fieldwork in which a collectivity *mirrors* the intruding outsiders and is in turn mirrored by them. All such reflections—like those in the amusement park scene at the end of Orson Welles's *The Lady from Shanghai*—are eminently distorting ones. And yet, from their accretion, pictures can emerge in which something essential, or at least in some way significant, is touched, expressed, and, eventually, re-presented. I have long suspected that it is this fundamental aspect and component of anthropology, particularly in relation to the study of exogenous objects, which has been of special interest to modern Western artists. As an editor, I was struck by the fact that an academic journal of "Anthropology and Aesthetics" should have proved so immediately appealing to contemporary artists. I realized that this was not so much because *RES* was a *new* art magazine as because it was, principally, an *anthropological* art journal, though open to contemporary art. It was as if many of the artists among those who shaped the aesthetics of the last decades had longed, on the one hand, to escape from the parochialism of the art world and, on the other, to connect with some lost world of scholarship or even science, exotic as much for the remote objects it studied as for the secluded academic enclosures where the processing and re-presentation of those objects are cooked up and served. Anthropology offered a double attraction—the wilderness and the ivory tower, intimations of physical danger and philological rigor. And all of it suffused with ever more pressing ecological longings and concerns. This is not a new scenario, of course, but while the earlier modernists had sought to appropriate and incorporate the "primitive" within their own imagination and expression (just as Freud had done in his speculations on the unconscious, or even Darwin, seeking the simpler original forms of biological complexity, and Marx, uncovering the material constraints and mechanisms underlying and fueling cultural superstructures), artists of the last fifty years have often shown an almost opposite tendency to view *themselves* as belonging to that other world, the world of *fieldwork* and anthropology.

The field of operation—and hence the work—has really moved out of the atelier. There is a gap, in fact almost a reversal, between Breton's and Picasso's hoarding of primitive objects, or Gauguin's and Nolde's tropical immersions (from the end of the nineteenth and the first decades of the twentieth centuries), and the

4. Jalal Toufic, *(Vampires): An Uneasy Essay on the Undead on Film*, rev. ed. (Sausalito, 2003), p. 98, emphasis mine.

5. Some of these questions were discussed at the fifteenth anniversary conference of *RES* (also the inaugural event of the Italian Academy for Advanced Studies in America at Columbia University) under the title of *Tradition—Translation—Treason,* on November 16–17, 1995. The proceedings of this conference were later published as the special issue of *RES* 32, autumn 1997.

artistic *estrangements* of the past fifty years: from the "crippled symmetries" Morton Feldman sought in Turkish "nomadic" rugs (*RES* 2, autumn 1982); Walter De Maria's, Robert Smithson's, and James Turrel's interventions in the Western American deserts; Michael Heizer's reverse archaeology in Nevada; Alighiero e Boetti's reliance on Afghan weavers; Francesco Clemente's understated yet constant dialogue with Hindu and Buddhist iconographies (as in the covers for *RES* 22, autumn 1992); and Jean-Michel Basquiat's with those of the American ghetto (to cite only a few examples).

Even such a late and inveterate hypermodernist as Dan Flavin—the inventor of fluorescent-light sculpture—was absolutely entranced by the folksy crafts *and* technology of thin, perfectly transparent old glass wares. It was he who spontaneously offered to provide the basic graphic design for *RES*—minimalist in essence, yet incorporating the images of objects from the four corners of the world. It has remained the journal's visual signature ever since. It was to *RES* that Flavin's great friend Donald Judd turned when he decided to publish his Yale lecture on Adolf Loos and proportion (*RES* 7/8, spring/autumn 1984). Thus, from the start and throughout the history of the journal, contributions from ethnographers, art historians, and artists from different fields have appeared side by side, and occasionally intermingled, as perhaps nowhere else before, showing—if only by implication—that difference, in controlled settings, can have *resonance*.[6]

6. Among the numerous other artists and musicians who have been close to the "anthropology" of *RES* are John Cage, LaMonte Young, Iannis Xenakis, Mel Bochner, Enzo Cucchi, Saint-Clair Cemin, Ray Smith, Cheri Samba, Claudio Parmiggiani, Robert Rauschenberg, Philip Taaffe, Cy Twombly, Brice Marden, and others. In my personal writing, these juxtapositions culminated in a collaboration between art and anthropology in which I had the good fortune to take part, wherein a "field experience" was constructed in an artistic setting: This was the "art procession" with which the artist Francis Alys (who has lived in Mexico for many years) celebrated the temporary relocation of New York's Museum of Modern Art's galleries and collections from Manhattan to Queens. As an anthropologist-consultant and critic, I had a part in the planning of the event while it was being developed, and as a participant-observer of its actual performance. In this work, the urban social and geographical fabric of the modern city was made to resonate (literally, too, thanks to a traditional Latin brass band that led the way) to the physical, outdoor presence of the effigies of "treasures" (or their officially certified copies) normally kept in highly guarded museum recesses: The ritual of the procession—in this case also a sort of parade—functioned at one and the same time as an ironic distancing and a quasi-devotional connection between

Anthropologists are trained to take field notes and even to keep field diaries. The first are supposed to provide the empirical (read: scientific) base for our subsequent writings, while the second, quite often, remain private and even secret, often jealously hidden for decades, if not forever, while artists' papers and correspondence are prized—at least in modern times—and have frequently been made available.[7] For my part, I was by and large too overwhelmed by the rhythm of field encounters and events to keep a diary. I regret the omission now, but at least I trained some of my Maya friends to do so for me (I was already acting more as an editor than as an author). Curiously, though, once I turned to writing about contemporary Western art, I often did so in the form of a field diary, as the record of a certain *time* and *place*. I felt instinctively that *for me* any legitimate critical discourse on art could only take the form of a description of my own particular, and often awkward, stumbling across the marginality of the setting—in short, of a kind of field experience.

Few would dispute that the old dialectic of sameness versus otherness on which the whole field of anthropology was founded, and to which key aspects of artistic modernism were also attuned, is ripe for some rethinking. Yet, as art breaks its old bounds and spills out over the most trivial and mundane recesses of late- and post-industrial life, the paradox may be that in so doing it also rejoins key features of archaic object-making: the aesthetic fetish, *pars pro toto,* is as ubiquitous as the amulet and potentially as charged. But the fetish, Michael Taussig showed us in an important study long ago, is the product of a cultural short-circuiting based on inequality, which marginalizes the object, as well as the body, as seats of power.[8] Many artists seem to be

"believers" and "non-believers" (or agnostics) of the "religion of art" (see Francesco Pellizzi, "MoMA's Progress: Francis Alys," in Francis Alys, *The Modern Procession* [New York, 2004], pp. 21–30).

7. This is not, of course, invariably the case: Barnett Newman's widow, Annalee, discouraged the diffusion of his writings (whether published or unpublished), thinking that they might promote a misrepresentation of her husband as an "intellectual" rather than an "artist." However, she generously provided *RES* with images from his *The 14 Stations* for an article by Arthur Danto ("Art and the text," *RES* 5 [spring 1983]:5–13).

8. Michael Taussig, *The Devil and Commodity Fetishism in South America* (Chapel Hill, 1980). The history and theory of the notion of the "fetish," announced in our already mentioned first editorial, was systematically and imaginatively developed by William Pietz in a series of memorable articles: "The problem of the fetish, I," *RES* 9

well aware of this neo-fetishistic condition of the art object today, within our own society: It is important to remember that it affects as much the products of our own arts as those of alien object-making of any sort.

We seem to have moved beyond the (so-called) post-modern *Angst* of anthropologists looking into non-Western eyes in search of their own reflection. Now that most, if not all, ex-"primitive" societies have adopted ersatz versions of their own Western image as banners for survival (a fundamentalist pseudo-Primitivism of sorts), the notion and experience of fieldwork seems to be shifting again (if not dissolving) into some sort of *performative* mode: Rather than work-in-the-field we now appear to have fluid *fields* of work, areas that configure themselves as more or less structured domains of interaction defined only by the moment and place in which they are experienced and observed. It is as if the very foundation of science (social or any other)—the notion of *repetition*—was now in question.

Far from devaluing the fieldwork event, however, such emphasis on its *once-only* nature gives it a heightened significance as the realm (or field) of all encounter. It is in this sense, in my experience, that anthropological fieldwork may rejoin the "anthropic" *factura* of the artist performing in his/her *field*. So, we may have finally proceeded well beyond Primitivism, both in art and anthropology, at least in part because, while still ostensibly obsessed with the social and the symbolic, we have already actually interiorized the view that *community* is an intrinsically contingent notion, whose reality fades in and out of focus as we move through the innumerable *fields,* or dimensions, of our individual experience. This may be seen as a departure from science, but in fact science may soon be trying to catch up with art, and with the art of anthropology: The heirs of quantum theorists may one day tell us that all reality is contingent on different sorts of field encounters (a few already do).

The invention of, and movement toward, the *Other*—be it by conquest, conversion, or investigation—has for centuries characterized modernity. But again, instead of breaking with the past, modern*ism* has incorporated the alien, making the archaic in some way relevant and contemporary: It was an outward gaze that both reenacted and countered that of the Renaissance toward classical antiquity. It was a heightening of our awareness *as* moderns that paradoxically found one outlet in the general adoption of "archaism" as a sort of undeclared cosmopolitan language. Today, "primitivism" itself has become a problematic and *passé* notion, yet we should not forget that the roots of our cult of marginality are still steeped in these essentially modernist contradictions.[9]

As has been shown (by Nicholas Thomas, for instance), it is possible to speak of a sort of "modernism-of-the-other," a way in which archaic forms—those that principally originated with non-literate and non-urban societies—can resist globalizing modernity, at least for a time, and become the source of a *reflection* (a double or even multiple reflection) that stands modernity on its head. Michael Taussig, once more, has dealt with questions of masking and un-masking, mimesis and de-facement, in stalking the fields within which the anthropological performance can take place as a theatrical event, as the stage for an initiation—which, of course, invariably implies an element of deception:

> Now the strange thing about this silly, if not desperate place between the real and the really made-up is that it appears to be where most of us spend most of our time as epistemically correct, socially created, and occasionally creative beings . . . and if . . . modernity has ushered in a veritable rebirth, a recharging and retooling the mimetic faculty, then it seems . . . that we are forthwith invited if not forced into the inner sanctum of mimetic mysteries where, in imitating, we will find distance from the imitated and hence gain some release from the suffocating hold of "constructionism" no less than the dreadfully passive view of nature it upholds.[10]

(spring 1985):5–17; "The problem of the fetish, II: The origin of the fetish," *RES* 13 (spring 1987):23–45; "The problem of the fetish, IIIa: Bosman's Guinea and the Enlightenment theory of fetishism," *RES* 16 (autumn 1988):105–123. These were followed by the related "Death of the deodand: Accursed objects and the money value of human life," *RES* 31 (spring 1997: *The Abject*):97–108, and "The future of treason: Political boundaries in the information age," *RES* 32 (autumn 1997: *Tradition—Translation—Treason*):105–123. From a different perspective, fundamental questions regarding the interpretation of African cult objects have been covered by Sarah Brett-Smith and Suzanne P. Blier, who have been critically present on the pages of the journal since its beginning.

9. Somebody has noted (the critic David Schiff, I believe) how there is a borderline quality to the modernist "mainstream": As we move further and further away from it, it acquires an ever more "peripheral, exotic and intriguing" aura. I never tire of remembering Morton Feldman's utterance in front of a colorful and swirling *Moroccan Village* painting by Frank Stella: "That too is 'folk art!'"

10. Michael Taussig, *Mimesis and Alterity: A particular history of the senses* (New York, 1993), pp. xvii–xix.

Here too, boundaries are transcended and inverted, while the secret of the object—both the art-object and the body-object—as fetish is reaffirmed within the playful and terrifying gesture that reveals it.

The fieldwork metaphor is still one drawn from agriculture, as if we were all peasants in disguise, tilling away in the hope of furthering some natural growth (gods and weather permitting). But at least since Marcel Duchamp the image of play has actually dominated the art *field*. Today, as before, only artists can tell us what *fieldwork* may still mean to them (if anything) and I suspect that there might be as many answers as there are artists—and *RES*, while remaining an anthropological journal, also belongs with the art museums: Its history attests to a certain communality of intent, or at least a kinship in sensibility. Anthropologists are familiar—as Aby Warburg tried to be—with elaborate rituals combining performance, installation, poetry, painting, carving, etc., into elaborate aesthetic (that is *formal*) constructs, not infrequently involving children, both as participants and essential audience. This is in fact serious, sometimes even tragic play (often having to do with initiation, i.e., with a *beginning*, difficult as all beginnings): But aren't children often deadly serious at their games?

In any event, this circus-like dimension is one more way in which the archaic rejoins the forms of expressive awareness of our post-industrial arts. And if there can be suspension of belief in child-play, such an immersion is akin to an act of faith—and perhaps to the attitude that presides over the making and use of *magical objects*, to the (hidden) *arbitrariness* of their *sacrificial* assemblage. It was not, once more, a "primitive" influence that affected Picasso on his way toward cubism: There was nothing primitive for him about African and other ethnographic artifacts in the Musée de l'Homme, since he well knew that every one of them was actually steeped in a long and sophisticated formal tradition, or, as David Shapiro (citing the lesson of *RES*) poetically put it to me, "that primitive cultures were better regarded as 'refining' cultures, and their history, so erased, seemingly was the history of refinement." This was, rather, the encounter of *two* forms of archaism and modernity, the Western and the hyper-Western (or exotic), both post- (or late-) Colonial. So, in the *RES* forum, the *field*—and *fieldwork*—of these and other contradictions that we (for the most part unwittingly) encounter as scholars and artists must also be explored: We may wonder (for instance) what has changed since the time when modernism swung between the centrality of "function" and the marginality of play, between DADA and abstraction.[11]

As art history expanded into domains once governed by the discipline of anthropology, it could not help but be affected by new forms of metaphilological and exotic contamination within its own traditional and well-documented preserves: Its painstaking reconstructions of formal and iconographic sequences—invaluable as they were (and still are)—began to be viewed as inadequate for a deeper comprehension of the Western artifact record. Aby Warburg felt it so, as he sought to escape from the folly, and lure, of the Pagan mysteries and

11. Some of these considerations were first sketched on the occasion of the conference "Fieldworks: Dialogues between Art and Anthropology," held at the Tate Modern Gallery in London, September 26–28, 2003: I wish to thank Arndt Schneider and the Educational Department of the Tate Modern for inviting me to take part in its proceedings. In *RES*, we have dealt with some of the issues of the relation between art history and anthropology—as pertinent to the pre-Columbian field—in the special volume called *West by nonwest*, *RES* 42, autumn 2002, guest-edited by Esther Pazstory, which was in good part the result of a conference she organized at New York's Metropolitan Museum of Art, November 10–12, 2000. In her guest editorial for this same issue, Esther Pazstory wrote of the "twists and turns . . . of scholarly plots" as "detours" necessary to reach some measure of self-knowledge in facing the alien. One could relate her notion to the way Duchamp spoke of some of his works as "delays" (for instance: "a delay in glass"): The common element is the relinquishing of any illusion of *directness*—scientific, conceptual, artistic, or otherwise—in the perception and translation of inner or outer realities, and, especially, of those "utopias and dystopias" and "imaginary" or "unconscious needs" (*West by nonwest*, p. 6) through which we have invested the old and new worlds of Asia, Africa, Oceania, and the Americas. (In regard to the latter, Jeffrey Quilter, long a contributing editor of RES, guest-edited the special issue *RES* 33, spring 1998: *Pre-Columbian states of being*.) Some of these questions were also taken on in three other special issues of the journal: *RES* 35, spring 1999: *Intercultural China*, guest-edited by Jonathan Hay, *RES* 39, spring 2001: *African works*, guest-edited by Zoë Strother, and *RES* 48, autumn 2005: *Permanent/Impermanent*, also guest-edited by her, in collaboration with Barry Flood. All three of them are stalwart and imaginative contributing editors of RES, just as is Marvin Trachtenberg, who guest-edited *RES* 40, autumn 2001: *Desedimenting time*, a special issue to which the much missed Anne-Marie Sankovitch contributed a seminal essay: To her memory is dedicated the present volume of the journal. In part to a reexamination of the role of (Hegelian) dialectics in today's practice and criticism of art was dedicated *RES* 46, autumn 2004: *Polemical objects*. Guest-edited by Philip Armstrong, Stephen Melville, and Erika Naginski, the last two deeply trusted contributing editors of the journal, as is, last but certainly not least, Oleg Grabar, who understood and supported our efforts from the very start and has more recently guest-edited the special issue *RES* 43, spring 2003: *Islamic arts*.

slumbering water nymphs of antiquity's so-called "renaissance" (at the dawn of modernity) by seeking refuge, solace, and justification through a quasi-ethnographic immersion into, and transcultural interpretation of the spectacular, yet esoteric, dances of the New World Pueblo natives. From this adventure and consequent derangement, he reemerged as the *artifex* of a vast and most ambitious project for the mapping of our Western collective memory of images (*Mnemosyne*—Ezra Pound, H.D., and Frances Yates were almost contemporaries). It was perhaps an attempt to recreate the *imagination* of our world through an infinite *combinatoire* of visual associative paths. As he himself relates, Warburg felt the impulse not to take the "comical" antics of the katchina impersonators seriously, but perhaps at the (temporary) cost of his own sanity he also realized that "to laugh at the comical element in ethnology is wrong, because it instantly shuts off insight into the tragic element." The fact is that the native can laugh, but not the outsider-interpreter: In a commentary to his translation of Warburg's "Images From the Region of the Pueblo Indians of North America," Michael Steinberg aptly observed:

> Warburg thus founds the practice of cultural iconology in a way that was immediately diminished by his successors. His iconology de-idolizes the image, makes it move, travels from the surface into the depths where dwell the demons, personal, cultural, social, and political.[12]

And it was with demons that one of the exemplary (but perhaps equally irreproducible) lessons of Meyer Schapiro also dealt: He injected into the most rigorous of formal and historical analyses a singularly fruitful search for covert significance—a sort of meta-art-history, one might call it—in which Marxian echoes, more imaginative than any social history of that or any day, gave contextual life (almost in a sort of prelude to *Rezeption Theorie*) to the painstaking examination of forms not just within but *against,* as it were, the boundaries of their time-settings. In his study of the tympanum sculpture in the portal of the church of Sainte Marie at Souillac, for instance, Schapiro discovered the principle of "discoordination" as "a grouping or division such that corresponding sets of elements include parts, relations, or properties that

negate that correspondence."[13] An anthropologist would (or should) immediately perk up at such a description, recognizing some of the distinctive traits of the "symbolic" form of representational thought prevalent in archaic and "oral" cultures. Yet Shapiro's aim, in this as in other instances, is anthropological at an even higher pitch, because in unraveling what Thomas Crow termed "a rhetoric of discrepancy" (ibid.), he was able to dialectically transcend the limitations of disciplinary discourses about norm and exception, prescription and preference, and, in a vision of the totality of the work's significance, of its "form and content." Very close attention to form, combined with a keen sensibility to what that form might convey that is not immediately *visible,* make for a rather unique approach to interpretation and to comparison.

These art historical and critical endeavors (and many more besides) ran parallel to the way in which theoretical and hermeneutic discourses on art-for-art's-sake problematically shadowed Western criticism, eventually reaching out to the domain of archaic crafts and cult objects. Today, beyond the already venerable debate concerning the relations between primitivism and modernism (including post-avatars of both), the rapid emergence of a globalized modernity in the most diverse non-Western settings is conferring new perspectives to the study of *all* artifacts. Indeed, those who can entertain the utopia of a post-industrial society—quite different from the old, more or less enlightened dream of a return to nature—can now also envisage a world of informational creators in which, as in certain avant-garde manifestos, *everybody is an artist* (just as everybody is a critic and entitled to his or her own taste); in which universal desirability and commoditization will finally bite their own tails and dissolve into all-pervasive insignificance.

Of course, it would also mean that no one will any longer be an *artist:* In societies for which tools are (or were) still consciously invested with *ambivalent* (or ambiguous) powers (including our own, until recently), the "artist" is/was a magician—i.e., the possessor of a knowledge capable of affecting the lives (and deaths) of others. We are delegating that role to scientists, increasingly, and that process may be irreversible. Yet

12. Michael Steinberg, "Aby Warburg's Kreuzinlingen Lecture: A reading," in A. M. Warburg, *Images from the Region of the Pueblo Indians of North America* (Ithaca, 1995), p. 79.

13. Meyer Schapiro, "The Sculptures of Souillac" (1939) in *Romanesque Art: Selected Papers* (New York, 1993), pp. 102–130; p. 104; quoted in Thomas Crow's illuminating *The Intelligence of Art* (Chapel Hill, 1999), p. 15.

art, and artists, past and present, may still hold a few secrets worth unraveling, which remain out of the reach of experimental science, even though this very activity—be it anthropological, art historical, or other—is bound to contribute to art's progressive secularization, and thus perhaps to its ultimate demise (though in a conversation with a biologist, David Rosand, the distinguished specialist of the Venetian Renaissance and a self-declared "non-believer," recently called himself a "theologian"). The nature of these half-hidden contents, in a paradox well fitting the hybrid and ambivalent character of art, is bound to be both universal and contextual, ephemeral and everlasting.

Neurobiologists (notably, Semi Zeki), are pointing to the ability, and even tendency, of our perception to sustain *ambiguity* as a "very stable system," allowing for quite different, and even opposite, interpretations (Jasper Johns and other artists have long been cognizant of this phenomenon). It is as if that propensity of symbolic thought to elaborate intrinsically ambivalent, hybrid, and even self-contradictory constructs had its natural grounding, as it were, in the neurological plasticity of our brains, to whose well-being it may actually be essential as a primary instrument of our imagination. Other researchers (Elizabeth Livingstone, for one) have experimentally determined the irrelevance (or redundancy) of color to our perception of outline and depth—the latter being the basic parameters we use in the inner representation of our perceived environment by which we derive ways to move and survive in it. Others still (such as Vittorio Gallese and his team in Parma) have now discovered—or at least hypothesized on the basis of controlled experiments—the presence and action of "mirror neurons" in our brains that might account for a host of mimetic and empathic aptitudes not only in our transpersonal (and trans-animal) relations, but also in our emotive and proto-intellective response to perceived interactions between inanimate *things*.

Of course, we know that redundancy can actually be a tool for disambiguation, which would speak in favor of seeing the elaborately repetitive rituals of archaic societies as steps toward the covert (and even, at times, esoteric) unraveling of symbolic knots. In this perspective, redundancy can be taken to stand for quite the opposite of irrelevance, and perhaps even as an intimation of what art, cross-culturally, might be all about: not a "superstructure" for sure, but an *essential* vehicle for individual and communal epiphanies. And color—whose use in representation is likely to have

begun with the funerary and hypogeal depiction of life itself—may have always been, since the beginning of *time* (the notion of which is exclusively human), "a matter of life and death," as Bruce Nauman was reported (by Marina Abramovic) to have stated about art itself.[14]

Much might be said against comparisons: Artists, for instance, are inclined to consider their works individually, even when part of a series. Biological beings are unique, in themselves and in their manifestations, and so are artifacts. Every one of them stands not only next to, but also *against* all others, sometimes to the point of covertly or overtly negating their existence. Yet, comparison can also be viewed as a form of primal thinking—akin to the "will to think" of certain philosophers of Vedic ritual and sacrifice, or to that conflation of the heterogeneous-generating new sense that is also called symbolic thinking.[15] Comparison across disciplinary boundaries is an uncertain, tricky affair (to say the least), but it may also be singularly fruitful on condition that those boundaries be acknowledged and taken into full account just as they are transcended. The "dark energy" (or "energy of vacuum," as some physicists call it), which increases the distance between significant entities, must be countered by a strong synthetic impulse, and this may be provided by controlled analogical thought. Such an effect, however, is not likely to take place in the single scholarly contributions to this journal, but rather, when and where it can, in the spirit of its transdisciplinary readers. *RES* is above all a *place*, a forum, in which the distinctive *differences* between discourses are meant to generate possible insight into the very gulfs that separate them.

14. Some of these considerations were inspired by the conference "Art and the New Biology of Mind," held on March 24, 2006, in the Italian Academy for Advanced Studies in America at Columbia University, and jointly organized by its director, David Freedberg, and Eric Kandel (with the support of the Louise T. Blouin Foundation), which brought together some of the most innovative neurobiologists and artists of today. I am grateful to the Academy for the invitation to assist in the proceedings of this conference.
15. Charles Malamoud, *La Danza delle Pietre* (Milan, 2005), p. 70 and pp. 71–72, n. 11.

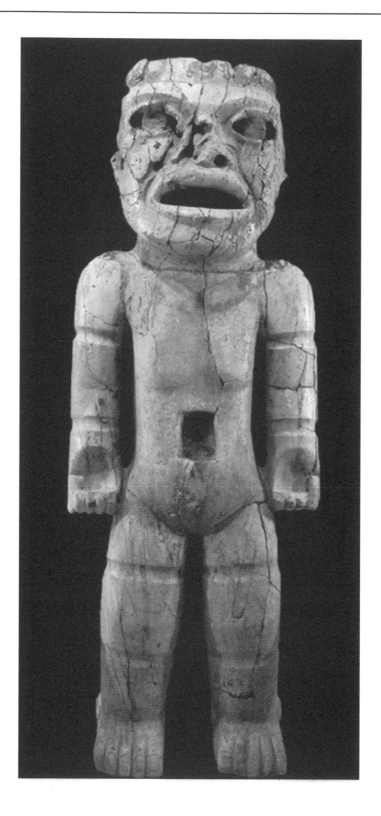

Figure 4. The Xalla sculpture after restoration. Photo by Leonardo López Luján.

The destruction of images in Teotihuacan

Anthropomorphic sculpture, elite cults, and the end of a civilization

LEONARDO LÓPEZ LUJÁN, LAURA FILLOY NADAL, BARBARA W. FASH, WILLIAM L. FASH, and PILAR HERNÁNDEZ

Images can serve as vehicles of all powers and of all forms of resistance.
— Serge Gruzinski, La guerre des images

The decline of a metropolis

The end of Teotihuacan was "fiery and cataclysmic," in the words of René Millon (1988:149) in his classic study on the last years of this archetypal city.[1] The metropolis perished in flames and never again managed to rise from its ashes. However, it was not a fateful urban blaze that spread wildly and randomly, consuming everything in its path. Quite the contrary, the catastrophe was unequivocally the consequence of a premeditated, highly selective group action. Today we know that the targets focused on the city's palaces, temples, and administrative buildings. At Teotihuacan, the remains of destruction are the expression of a tremendous collective effort in which the architectural monuments that served as seats of the state's political, religious, and economic power were destroyed, dismantled, and torched with uncommon fury. One by one, the pyramids succumbed to blazes lit on their summits as well as in front and on the sides of their stairways, the sculptures of their facades were pulled down and scattered with violence, and the cult images were reduced to fragments.

The archaeological evidence seems conclusive. Between 1974 and 1979, Millon (1988:149–156) and his team examined the city anew in pursuit of material testimony of the catastrophe. On the Street of the Dead, they recorded 147 buildings with clear traces of incineration and another 31 that also seemed to have been burned. In fact, the only constructions lacking any burn marks were those severely altered by the passage of time or by the hand of the archaeologist. In the rest of the city, roughly 53 percent of the temples examined were victims of fire, compared to only 14 percent in apartment compounds.[2] Every time new excavations are undertaken in the monumental zone, these surface data are confirmed and reinforced. Further testimony from those apocalyptic days has been reported by archaeologists working at the Ciudadela (Jarquín and Martínez 1982a, 1982b, 1982c; Cabrera and Sugiyama 1982:168; Sugiyama 1998:152 and 161; Jarquín 2002), the Street of the Dead Complex (Armillas 1944: 122–123; Matos 1980:87; Morelos 1993:64–66), the Sun Pyramid (Batres 1906a:14–15; Batres, 1906b:12), the Puma Mural Temple (Martha Sempowski quoted by Millon 1988:151), the Quetzalpapalotl Palace (Acosta 1964:24–25; Ignacio Bernal quoted by Coe 1968b: 72–73), and the Moon Plaza (Bernal quoted by Coe 1968b:72–73; Saburo Sugiyama, personal communication, October 2003).[3]

The research presented here focuses specifically on that dramatic moment of final destruction. Our reflections are based on abundant new archaeological evidence recovered in the Central Plaza of Xalla, Teotihuacan, and particularly on the discovery of an exceptional sculpture carved from white marble. Given the historical and aesthetic importance of this image, we first consider its formal and technological characteristics in detail. Next, we undertake a systematic analysis of

We would like to thank the support given by INAH, UNAM, Harvard University, and Dumbarton Oaks, as well as by our friends Luis Barba, Warren Barbour, Rubén Cabrera, Fernando Carrizosa, Maricarmen Castro, George L. Cowgill, Lourdes Cué, Eduardo Matos, Tenoch Medina, René Millon, Debra Nagao, Johannes Neurath, Guilhem Olivier, Agustin Ortíz, Francesco Pellizzi, Joanne Pillsbury, Roberto Ramírez, Ricardo Sánchez, Ana María Soler, Saburo Sugiyama, Karl Taube, Javier Urcid, Javier Vázquez, and all the members of the Xalla Project.

1. Although the evidence is not entirely conclusive, it seems that in the last years at Teotihuacan, society experienced a demographic reduction, a widening gap in status differentiation, secularization of political roles, weakened connections of the religious state, and a preponderance of military power (Millon 1988:142–145; Cowgill 1992:110–114; Cowgill 1997:156; Moragas 2005).

2. Beginning with the buildings on the Street of the Dead, Millon and his team analyzed the vestiges of 68 temples and 965 apartment compounds in the rest of the city.

3. Sugiyama discovered evidence of burning in the compound located directly to the west of the Moon Pyramid.

the corpus of human sculpture from Teotihuacan, discussing its significance and assessing the archaeological contexts in which large-scale male figures tend to appear. Based on this discussion, we analyze the crucial problem of the destruction of temples and images at the end of the sixth century to better understand the iconoclastic conduct observed at the collapse of the metropolis.

The marble statue from Xalla

The evidence discussed in this paper took place within the framework of the recently concluded Xalla Project (2000–2003), the result of collaboration between the INAH (National Institute of Anthropology and History), the UNAM (National Autonomous University of Mexico), and Harvard University (López Luján and Manzanilla 2001; López Luján et al. 2002; Manzanilla and López Luján 2001; Manzanilla et al., 2005). This project was coordinated by Linda Manzanilla (UNAM), Leonardo López Luján (INAH), and William L. Fash (Harvard University). The setting of our explorations, Xalla, which means "sandy area" in Nahuatl, is a monumental complex located 230 m to the north of the Sun Pyramid (fig. 1).[4] It has unusually large dimensions within the urban context, for it is ten times larger than the average apartment compound; its outer perimeter wall surrounds a surface of 3.5 hectares in which thirty-two buildings were constructed around eight plazas.

Besides its colossal proportions, Xalla displays other characteristics that might indicate to us that it was one of the seats of Teotihuacan government: location in the oldest sector of the city between the Sun Pyramid and the Moon Pyramid; early ceramics on the surface from the Tzacualli and Miccaotli phases; exceptional communication with the Street of the Dead by means of a raised road; privacy, produced by wide avenues isolating it from the nearby buildings and by a thick limiting wall; the existence of several mounds more than 4 m in height; the presence of mural painting and sumptuary objects, detected by surface reconnaissance and excavations; and complex configuration of interior spaces, which may be correlated with the highly diverse spaces appropriate for a palace (López Luján and Manzanilla 2001; Manzanilla et al., 2005).

Between 1999 and 2002, we conducted two surface survey seasons and four excavation seasons in an effort to corroborate the hypothetical identification of Xalla as

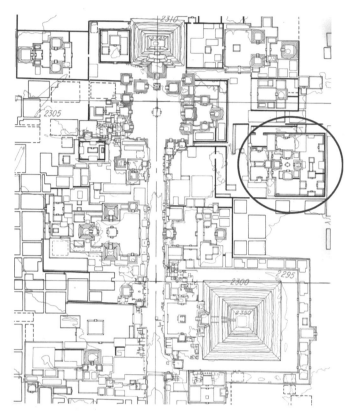

Figure 1. Location of the Xalla Compound in the heart of Teotihuacan. Based on Millon 1973, vol. 1, part 2, map 1. Courtesy of René Millon.

one of the seats of Teotihuacan government. Given its gigantic dimensions, we focused a good part of our efforts on studying the Central Plaza (fig. 2). All indications seemed to support the idea that this served as the complex's main ritual theater, because all internal circulation routes met there and the religious buildings of greatest dimensions were concentrated there. This space departs completely from the Teotihuacan norm: unlike the typical three-temple plazas, the Central Plaza of Xalla has five large religious constructions that occupy the cardinal points and the center, echoing the form of the renowned Mesoamerican quincunx. In fact, the number five and the quincunx seem to serve as a leitmotif in the context of the Xalla Central Plaza. For example, an offering (AA18) found to the west of the central temple (E9) formed a true cosmogram,[5] for it

4. It is located in quadrant N4E1 of Millon's grid (1973:1:31).

5. Quadrant N346–347, E359.

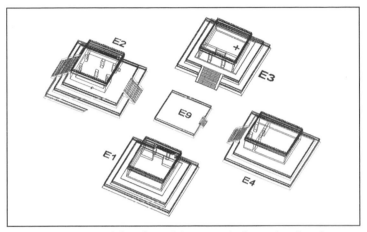

Figure 2. Drawing of the plan of the Central Plaza of Xalla. The cross in Structure E3 marks the place where the marble sculpture was found. Drawing by Tenoch Medina.

contained three seashells and a small green obsidian blade at each cardinal point of the deposit in addition to a greenstone bead placed in the center. Furthermore, it is likely that the sanctum sanctorum of the third construction phase of E9 had five irregular greenstone stelae in its interior, as indicated by the oval marks found on the stucco floor of the precinct.[6]

The Central Plaza of Xalla has a long history of remodeling that apparently began in the Miccaotli phase (A.D. 150–225) and concluded in the Xolalpan phase (A.D. 350–550). The central temple (E9) is a spacious building with roof decorations that rose from a platform measuring 14 m per side. This platform has *talud-tablero* profiles and a stairway on the west side. In its interior, we uncovered four substructures whose respective dates are still unclear. On the other hand, each one of the four temples located respectively at the north (E1), east (E2), south (E3), and west (E4) end of the plaza had at least four construction stages. Based on a preliminary analysis of ceramics found within the oldest substructure of E4, Barbara Fash reached the conclusion that it dates to the Miccaotli phase. On the firmer basis of radiocarbon analysis of burned pole laths and beams, it is possible to date the penultimate stage to the Early Tlamimilolpa phase, while the last one would date to the Early Xolalpan phase.

During the fourth excavation season, archaeologists Edgar Rosales and Paul Morales, accompanied by an enthusiastic crew of workers, explored the summit of Structure E3, a mound measuring a little more than 4 m in height that closes off the south side of the plaza. After an extensive excavation, the vestiges of the shrine that had been erected on a two-tiered *talud-tablero* platform were uncovered. This shrine is a spacious room with a portico and an entrance from the plaza.[7] The portico and the room were divided by a wall running east-west; both were interconnected by an opening from the central access. The room measures 10.8 m from east to west and more than 9.4 m from north to south (no remains of the southern wall have been preserved). To create such a large opening, Teotihuacan architects supported the roof on six pilasters from which four still remain.[8] The vestiges of a quadrangular stuccoed base, 20 cm in height, were located at the head of the room, in other words, in the zone corresponding to the sancta sanctorum;[9] although broken, this base shows a cavity where an image was possibly placed. It is important to point out that this large space seems to have been the setting for ritual activities that involved the ongoing handling of organic compounds, as revealed by chemical analysis of the stucco floors conducted by

6. Associated with one of these holes, we recovered a big fragment of an irregular greenstone stela that is similar to those found in the West Plaza Compound by Morelos (1993:F4).

7. Only part of the floor in quadrant N325 of the portico has survived.

8. The two pillars flanking the entrance are located in quadrants N324/E363–364 and N324/E368, while the two central pillars are located in quadrants N320–321/E363 and N320–321/E368. The pillars added to the south wall no longer exist, but they surely must have been found on squares E363 and E368, respectively.

9. Quadrant N317, E367.

archaeologist Laura Bernal (2005:193–206). High values for phosphates, fatty acids, and protein residues were recorded throughout the room, particularly around the pilasters and the rectangular base, which may be the consequence of plant and animal offerings, burning incense, auto-sacrifice, and other sacrificial acts involving blood.

On October 9, 2002, the first fragment of one of the most spectacular specimens of Teotihuacan anthropomorphic sculpture appeared in the shrine just below the surface. Following this discovery, the fragments of the left thigh appeared, then those of the torso, the head, left foot, right leg, left arm, and, finally, the right arm (fig. 3). It took us almost two months to uncover and register more than 160 fragments into which the image had been mutilated.

Following its meticulous restoration we are in a better position to describe the sculpture's principal features. It is a freestanding full-bodied human figure. Despite the fact that it lacks genitals, it clearly represents an adult male (fig. 4). It measures 128 cm in height, 46 cm in width, and 20 cm in depth, and weighs approximately 140 kg. The body of the sculpture is markedly disproportional compared to a real human body, because it is equivalent to a proportion of 3.7 heads. The representation strictly conforms to a model of bilateral symmetry; the individual stands erect, with head facing forward, arms extended downward and held close to the body, legs straight, and feet firmly planted on the ground.

The facial features are realistic and follow the traditional Teotihuacan style (Pasztory 1992:292–295). The impersonal features are framed by a curved line in the shape of a "U": a flat, straight band forms the forehead. A slightly curved, raised area marks the brow; the cavities of the eyes are elliptical, and in their interior, there are disk-shaped reliefs simulating the iris. The nose has a wide base with drilling in the cavities; its half-open mouth lacks teeth and is limited to fleshy lips. The cheeks and chin are fine protuberances, and two rectangular plaques stand for the ears. The upper part of the head has two grooves: one that runs

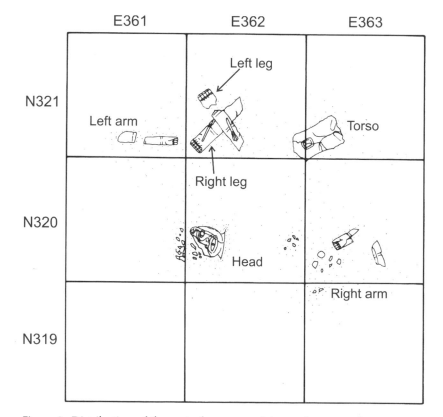

Figure 3. Distribution of the main fragments of the sculpture on the summit of Structure E3 in the Central Plaza. Drawing by Fernando Carrizosa.

along the sagittal plane, and the other that follows the transversal plane.

A short, thick neck conveys the weight of the head on the torso, which takes the shape of a slender rectangle. In it, delicate relief masterfully outlines the clavicles, nipples, abdomen, shoulder blades, and the gluteus, while a long depression indicates the spinal cord and a rectangular cavity of the abdomen.[10] Two muscular arms with strange grooves at the level of the biceps and wrist are flushed against the torso. The hands display hollowed-out palms facing frontward, framed by semi-flexed fingers. The gracefulness of the torso contrasts with the robust quality of the hips and of the lower extremities. These also display horizontal grooves, both above and below the knees. The ankles are only indicated by pairs of disk-shaped malleoli and the toes appear as rough rectangular shapes, oddly enough with two rows of toenails.[11] The soles of the feet are completely flat.

The figure is naked and its sole attire consists of a diadem decorated with three rings. These rings are defined in the catalogue prepared by James C. Langley (1986:282) as "171. Roundel," which he ascribes with the same value as the *chalchihuitl* in Mexica iconography, a symbol for water, and, by extension, preciosity. Of crucial importance for our interpretation are the bas-reliefs of the lower extremities, each of which represent slanted spears: one of them penetrates the instep of the right foot, while the other enters the left thigh. In both cases, only part of the spear's shaft is visible and the entirety of the end with its stabilizing plumes. These iconographic elements appear defined in Langley's catalogue as "56. Dartbutt" (ibid.:245).[12]

Furthermore, after the figure was cleaned, remains of polychrome color were revealed—hematite red on the ridges of the head, the iris of the eyes, and the cavity on the abdomen and smoky black on the sclera, the inside of the mouth, and on the face—forming two curved lines beginning at the eyes and ending at the base of the cheeks (fig. 5).[13] Also during cleaning, a tiny jadeite bead was discovered inside a cylindrical cavity drilled in the back of the mouth (Sánchez and Robles 2005).[14]

Thanks to the detailed petrographic study and X-ray diffraction conducted by Ricardo Sánchez and Jasinto Robles (ibid.) in the INAH laboratories, we know that this sculpture was carved from whitish fine-grained calcite marble, a rock exceptionally rare in archaeological contexts at Teotihuacan. In this regard, it is interesting to point out that remains of marble have not been found in any of the four zones of lapidary workshops excavated to date in the ancient city.[15] Furthermore, to date, only four marble artifacts have been reported at the site, two of which are from the Temple of Quetzalcoatl.[16]

Whitish calcite marble, the product of the metamorphosis of limestone,[17] does not occur naturally in the Valley of Teotihuacan or its immediate vicinity.[18]

10. This cavity measures 8 cm in height, 6 cm in width, and 3 cm in depth.

11. Curiously, each toe has two nails: one on the tip and the other higher up at the level of the articulation of the phalanges. In this regard, we might propose that each toe once had only the nail at the tip. But given the evident instability of the piece (the sole of each foot measures 20 by 14 cm), the people of Teotihuacan must have decided to tenon the feet into the platform of the sancta sanctorum (see below), so that the toenails would have remained hidden beneath the floor plaster. This would have led, *a posteriori*, to the carving of new nails (more roughly rendered) a few centimeters above and in a visible area. This idea is confirmed by the presence of remains of plaster and sand on the tips of the toenails, in the back part of the heel, on the sides of the feet, and on the soles. All of this also shows that the sculpture was set up in a vertical position.

12. In Atetelco and Tepantitla, the stabilizing feathers are painted black, indicating that they could come from an owl (García-Des Lauriers 2000:94–95). Sometimes, decorative plumes are represented together with the stabilizing feathers.

13. We thank Javier Vázquez (ENCRyM, INAH) for the identification of both pigments.

14. The bead is globular and measures 0.7 cm in diameter; its perforation is biconical and measures 1.8 cm in outer diameter and 2.4 cm in depth.

15. See the information on the so-called "lapidary craftsmen barrio" or Tecopac in N3E5 (Turner 1987, 1992:91–93); the compound to the west of the Moon Pyramid in 6G:N5W1 (ibid.:103); Tlajinga 33 in 33:S3W1 (Widmer 1987, 1991), and the Architectural Compound A of La Ventilla in N1 W2 (Gómez 2000:558–580). As for the highly diverse materials used by sculptors and lapidary artisans at Teotihuacan, see also Ordóñez (1922), Sotomayor (1968), Cabrera Cortés (1995:165–189), and Sánchez (1995).

16. According to Sotomayor (1968:46–47), during unspecified excavations carried out by INAH, a marble vessel was recovered (made of thick-grained calcite) and a fragment of contact marble. However, in the fill of the Temple of Quetzalcoatl, two white marble beads were found, representing 0.11 percent of the collection of the lapidary materials found at the building (Cabrera Cortés 1995:174; Sánchez 1995:341–342). Also, we cannot exclude the possibility that marble artifacts might have been erroneously identified as travertine.

17. Marble is unfoliated metamorphic rock. Its texture is fine-grained and it may be composed either of calcite or dolomite. Calcite marble contains between 95 and 100 percent calcium carbonate (Rich 1988:223–225).

18. As is widely known, the Valley of Teotihuacan and the neighboring regions are areas of high volcanic activity that lack outcrops of metamorphic rock (Mooser 1968:31–32; Sotomayor 1968:41–45).

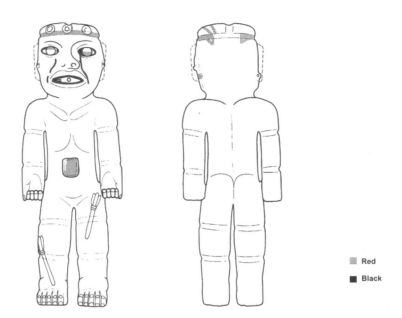

Figure 5. Remains of paint detected on the Xalla sculpture. Drawing by Fernando Carrizosa.

III Red

■ Black

The closest deposits are in Apasco, State of Mexico (Sotomayor 1968:48); in the municipalities of Zimapán and Nicolás Flores, Hidalgo (Sánchez 1995:341–342; Consejo de Recursos Minerales 1993:41–44); in the municipalities of San Martín Atéxcatl, Acajete, and Tepeaca, Puebla (Sánchez 1995:341–342; Cabral 1988; Torres 1989); in the municipalities of Pilcaya and Ixcateopan, Guerrero (Consejo de Recursos Minerales 1993:29–37); and in the central part of the State of Veracruz, to the northwest of Xalapa and northeast of Perote (Sánchez and Robles 2005). After carefully examining the sculpture, it was clear that a bed with well-preserved compact marble with sacaroid fine-grained texture had been selected. The whitish and cream color of the calcite predominates, although in some parts it has grayish hues, as well as numerous impurities in the form of reddish brown streaks and bands, caused by montmorillonite-type clays visible in the planes of the fracture (ibid.).

Beginning with the shape and dimensions of this piece, we can infer that a quadrangular block weighing some 280 kg,[19] or else a pre-form of close to 220 kg (fig. 6),[20] had been transported to Teotihuacan from the deposit. The prized load would have traveled from 80 to 200 km before arriving at the specialized workshop, where it was endowed with human form.[21] Given the softness[22] and the dense crystalline structure of the marble, the process of carving and polishing must have been relatively easy, producing subtle details and glossy surfaces.[23] Based on studies of Teotihuacan lapidary work, it must have been made following a technical sequence of fracturing, sawing, grooving, drilling, polishing, and burnishing.[24] However, only the use of

19. This calculation was made based on the minimum dimensions of a hypothetical quadrangular block (128 by 46 by 20 cm) and the specific gravity of calcite (2.40–2.75 gr/cm³). Obviously these calculations only provide an approximate value. As we mentioned, the sculpture weighs about 140 kg, which represents half the hypothetical weight of the original block.

20. This hypothetical pre-form would adapt to the silhouette of a cross and would lighten the load by some 60 kg.

21. This effort would be insignificant if we compare it to the transport of the celebrated Goddess of Water, a 24-ton monolith that would have been carried to Teotihuacan from a quarry located some 25 km south of the city. Depending on the formula utilized, between 363 and 816 individuals would have been needed for its transport (Heizer and Williams 1963:96–97).

22. Marble has a low hardness of 3 on the Mohs scale.

23. The block was cut so that the planes of the fracture were oriented longitudinally, thus reducing the risk of fracturing the piece during the process of carving. Because the original block had some imperfections, the sculptor decided to hide them, leaving them on the back side of the image. There one can see, for example, a small piece missing in the left gluteus and another larger piece missing on the heel of the same side. The nails of the large toe of the left foot were carefully carved next to a crack, suggesting that it was there from the beginning.

24. For the fracturing of the original block, generally all types of percussion tools were used, as well as wooden wedges. Sawing was

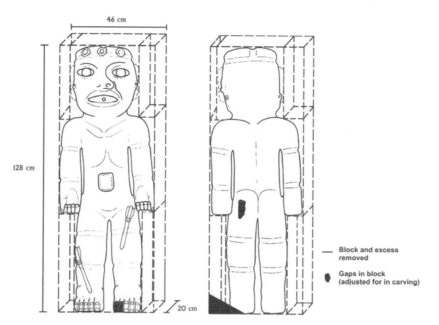

Figure 6. Dimensions and hypothetical shape of the original marble block. Drawing by Fernando Carrizosa.

rigid saws is perceptible in this sculpture in the delineation of anatomical details and the separation of the arms from the torso. Flat chisels were used to mark the rings on the diadem,[25] pointed drills to create orifices,[26] tubular drills to delimit curved shapes,[27] and polishing tools to smooth the surface.[28]

carried out with the help of obsidian, quartz, and flint tools. They might also have used hard wood blades in combination with sand abrasives or cord instruments. Grooving and incising served to delineate elements of the design, such as the facial features, arms, and legs. Conical, biconical, or tubular drilling was carried out with conical chalcedony tools or with hollow tubular drills made of bone or reed. The cylindrical core resulting from the boring was possibly removed with a string or cord. Finally, the polishing and burnishing was done with all sorts of fine abrasives, in addition to skins, leathers, reeds, gourds, wood, and hard stones such as opal and chalcedony (Turner 1987:469, 1992:95–102; Cabrera Cortés 1995:190–200; Gómez 2000:567–578).

25. The rings were not polished. Instead they were left as rough surfaces produced by the flat chisel.

26. Two wide orifices were perforated in the nasal cavities and another in the center of the mouth. Narrow orifices were also made at the middle and lower section of the ears.

27. The two lateral sides of the eye cavities were drilled, the two lateral sides of the mouth, and the four corners of the cavity of the abdomen. In these latter holes, the use of a tubular drill measuring 2.1 cm in outer diameter is clearly evident.

28. With the exception of the cavities between the arms and torso, which have rough surfaces, the entire sculpture was well-polished and burnished.

The corpus of male sculptures from Teotihuacan

In characterizing sculpture, studies of Teotihuacan visual arts appear inextricably linked with monumental public and private architecture (Seler 1960:424–437; Beyer 1922; Gamio 1922a:LXII–LXXIII; Gamio 1922b; Marquina 1922:122–124; Nicholson 1971:97–102; Sarro 1991, Allain 2000). In fact, a large number of the sculptures created by this civilization served the primordial function of highlighting and qualifying the most important buildings in the urban center. Carved from volcanic stone, they emerge from walls, stairways, and entrances, or in the middle of first-order patios and plazas. They are markedly flat frontal representations from which little or no information is obtained when one walks around them. Symmetry dominates them, and, above all, a sense of geometry rigorously adapted to the blocks from which they were hewn.

The Xalla sculpture pertains to a rare group of stone images that were designed to be placed not outside but rather in the dark interiors of shrines or buried inside of temples. They are freestanding realistic representations with well-modeled volumes and curved, finely polished surfaces.[29] This corpus barely exceeds a dozen complete

29. There are some greenstone sculptures very similar to those in our corpus, from the Late Preclassic period in Oaxaca and possibly from Guerrero. The most well-known specimen measures 49 cm in

Table 1. COMPARATIVE TABLE OF THE CORPUS OF MALE SCULPTURE FROM TEOTIHUACAN

Corpus	Stone color	Height cm	Canon	Preservation	Inlays	Attire	Nipples	Male genitals	Mouth	Abdomen cavity	Palms	Malleoli
Xalla	white	128	3.7	mutilated	no	diadem	yes	no	naturalistic	yes	frontward	yes
Casa Sacerdotes	green	71	?	mutilated	yes	no	yes	yes	?	yes	?	no
Ciudadela 1	green	75	3.6	mutilated	yes	diadem	no	no	naturalistic	no	?	yes
Ciudadela 2	green	47.5	3.3	complete	yes	diadem/ loincloth	no	no	naturalistic	no	frontward	no
Ciudadela 3	white	45	3.5	complete	yes	no	no	no	Olmecoid	no	frontward	no
Moon Pyramid 1	green	30.6	3.4	complete	yes	head- dress	yes	no	Olmecoid	no	backward	no
Moon Pyramid 2	green	25.5	3	complete	yes	no	no	no	Olmecoid	no	frontward	yes
Mexico City 1	green	54	?	mutilated	no	no	yes	yes	Olmecoid	no	?	no
Mexico City 2	green	39.5	2	complete	yes	no	no	no	naturalistic	no	backward	no
Mexico City 3	white	25.4	3.2	complete	yes	no	yes	no	naturalistic	yes	toward body	yes
New York	green	40	?	mutilated	no	no	no	no	naturalistic	no	toward body	no
Paris	green	76	4.2	mutilated	no	no	yes	yes	Olmecoid	no	?	no
Hamburg 1	green	42	2.8	complete	no	no	no	no	naturalistic	no	frontward	yes
Hamburg 2	green	34	2.7	complete	no	no	no	no	naturalistic	no	toward body	no

or semi-complete specimens (table 1).[30] Six of them come from controlled excavations, so that we are quite familiar with their archaeological context. The first to appear was discovered by Leopoldo Batres in 1905 during his explorations of the so-called "Casa de los Sacerdotes."[31] Many years later, in the context of the Proyecto Teotihuacan 80–82, Rubén Cabrera and his team unearthed a specimen of large dimensions in

height, and it was found in an offertory box under Structure 35 at San José Mogote (Marcus and Flannery 2001:127–128); this context dates to the Monte Albán II phase (100 B.C.–A.D. 200). Three others are lacking a context: one forms part of the Leff Collection and measures 23 cm (Easby 1967:18); another was found in a private collection in the United States and measures 38 cm (Javier Urcid, personal communication, May 2002); the third is from Harvard University and measures 45 cm (Peabody Museum, cat. 22-18-20/C9551). This last example has a vaguely simian figure holding a spear-thrower and a pair of darts engraved on its torso. Finally, we cite a similar, although more schematic, image in the so-called Guerrero-Teotihuacanoid style. It is made from serpentine, it measures 47.8 cm, and it is in the collection of the Fundación Cultural Televisa (Reyero 1978:piece 23).

30. We should emphasize that our corpus is not in any way exhaustive. For example, we did not include two complete sculptures from the collections of the Museum für Völkerkunde of Vienna, because we were unaware of its dimensions and raw material (Becker-Donner 1965:pls. 10 and 12). In addition, we have not taken into account several fragments found in the House of the Priests (Batres 1906a:17, figs. 10 and 11), the West Plaza Compound (Morelos 1982:311 and F.1.2.; elemento 5, associated with a niche inserted in the wall of room 14), and the Ciudadela (Jarquín and Martínez 1982c:115; northeast room of Group E of Compound 1D; sector N1E1, sección 14, unidad 52, cuadro 71, capa II/III, elemento 192). In the Ceramoteca of the Archaeological Zone of Teotihuacan, there is a leg, perhaps made of marble, measuring 11.1 cm in height, which is formally identical to the legs of the Xalla sculpture (Néstor Paredes, personal communication, November 2002; inv. 10-336611).

31. See "Casa Sacerdotes" in table 1 (Museo Nacional de Antropología, inv. 10-81806). This piece was published, among others, by Batres (1906a:13–18), Seler (1960:434, fig. 26), Marquìna (1922:124), and Berrin and Pasztory (1993:177).

Structure 1Q of the Ciudadela[32] and two other smaller ones in Group 1D of this same quadrangle.[33] And most recently in 1999, Saburo Sugiyama found two spectacular images in Burial 2 of the Moon Pyramid.[34]

The provenience of the remaining pieces is unknown. Three of them are in Mexico City and they form part of the rich collections of the Museo Nacional de Antropología.[35] The others have been sold or donated by private collectors to museums abroad: one is located in the Metropolitan Museum of Art in New York,[36] another is in the Musée du Louvre in Paris,[37] and the remaining two are in the Hamburgisches Museum für Völkerkunde.[38]

A review of this corpus makes it clear that stones with whitish and greenish tonalities were always chosen.[39] Depending on their height, the sculptures may be divided[40] into those measuring between 24 and 35 cm,

those between 40 and 50 cm, and those exceeding 60 cm (fig. 7).[41] Despite these variations, they almost always conform to an anatomical canon by which the proportion of the body varies between 2.7 to 3.7 heads. Half of the corpus has shell, obsidian, slate, and pyrite inlay. Distinctive traits include nudity and masculine features, whether or not genitals are depicted (not unlike the much earlier Preclassic white and greenstone figurines). Occasionally, the face resembles Teotihuacan masks either with a naturalistic or Olmecoid mouth. Another constant feature is the unnatural position of the arms, rigidly close to the side of the body with palms facing frontward, backward, or toward the body.

Deprived of any accoutrements, it is difficult to determine who these fourteen sculptures represent. The possibility that they could have been dressed with perishable materials and that their attire disappeared with the passage of time cannot be discarded.[42] However, in the case of the image from Xalla, it strikes us as illogical that darts, in other words, its principal iconographic attributes, would have been hidden beneath any sort of clothing. Furthermore, it should be considered that female sculptures from Teotihuacan always have the headdresses, *huipiles*,[43] and skirts carved from the same stone.[44] It is for this reason that we are more inclined to propose that nudity is an intentional trait of our corpus. We should recall, for example, that in different times and places in Mesoamerica, the naked body alluded to the war captive on the verge of being sacrificed.[45]

32. See "Ciudadela 1" in table 1 (Museo de sitio de Teotihuacan, inv. 10-333079). It has been described by Cabrera (1982:33–37), Jarquín and Martínez (1982a:122–123, 126; 1982b:34–36), and Berrin and Pasztory (1993:178).

33. See "Ciudadela 2" (Ceramoteca de la Zona Arqueológica de Teotihuacan, inv. 10-2113191) and "Ciudadela 3" (Museo de sitio de Teotihuacan, inv. 10-336690) in table 1. The former, made known by Jarquín and Martínez (1982c:115), was discovered in room 2 of Group B of Compound 1D (sector N1E1, sección 35, unidad 14, cuadro 73, capa II/III, elemento 195). The latter, published by Jarquin and Martínez (ibid.) and by Berrin and Pasztory (1993:179), comes from room 4 of Group D of Compound 1D (sector N1E1, sección 14, unidad 73, cuadro 4, capa II, elemento 186).

34. See "Moon 1" (Ceramoteca de la Zona Arqueológica de Teotihuacan, inv. 10-614783) and "Moon 2" (Ceramoteca de la Zona Arqueológica de Teotihuacan, inv. 10-614784) in table 1 (Sugiyama 2004). Burial 2 was located in the north facade of phase 3 of the Moon Pyramid. It was interred during the construction of phase 4 (ca. A.D. 319).

35. See "Mexico 1" (Museo Nacional de Antropología, inv. 10-9465), "Mexico 2" (Museo Nacional de Antropología, inv. 10-229755), and "Mexico 3" (Museo Nacional de Antropología, inv. 10-2562) in table 1. This last piece formed part of the collection of Miguel Covarrubias (Solís and Velasco 2002:404–405).

36. See "New York" in table 1 (The Metropolitan Museum of Art, inv. 1979.206.585, former collection Nelson A. Rockefeller, 1979). It was published by Berrin and Pasztory (1993:180).

37. See "Paris" in table 1 (Pavillon des Sessions, Musée du Louvre, inv. 70.1998.2.1., former collection Eugène Pepin). It has been analyzed by Pasztory (2000) and Querré (2000).

38. See "Hamburg 1" (Hamburgisches Museum für Völkerkunde, inv. B3627, former collection Hackmack, 1889) and "Hamburg 2" (Hamburgisches Museum für Völkerkunde, inv. B264, former collection C. W. Lüders, 1880) in table 1. Both were published by Berrin and Pasztory (1993:180 and 278).

39. Thanks to diverse petrographic studies, we know that Teotihuacanos used stones such as serpentinite, metadiorite, dacite, marble, and tuff in their creations.

40. According to Allain (2000:20–21), the three-dimensional sculptures may be divided into figurines (less than 25 cm), statuettes (25–80 cm), and statues (more than 80 cm). These latter are extremely rare at Teotihuacan.

41. Equivalents in miniature are types 5 and 6 of greenstone human figurines defined by Cabrera Cortés (1995:271, 274, 280). All of them come from Burial 14 of the Temple of Quetzalcoatl. According to the author, they could have been used as amulets in the burials.

42. Pasztory (1992:307) is among those who have proposed that these figures wore clothing made of fabric and feather ornaments.

43. Closed-sewn sleeveless tunic.

44. These are large-scale representations (heights of 45 to 46.5 cm) that were carved in greenstone. The most well-known examples are exhibited in the Museo de la Pintura Mural Teotihuacana (inv. 10-213190; see Cabrera 1982:33–34 and photo 12; Morelos 1982:311 and F.1.2.; Berrin and Pasztory 1993:179) and in the Museum für Völkerkunde in Vienna (inv. 6270, former collection Bilimek, 1878; see ibid.:180).

45. In the iconography of the Preclassic to the Epiclassic, there are abundant examples of captives partially or completely stripped of their garments and jewelry. Among the most celebrated images are examples from San José Mogote, Monte Albán, Yaxchilán, Bonampak, Toniná, Dzibanché, and Cacaxtla (Marcus 1976; Foncerrada 1993; Marcus and Flannery 2001; Baudez 2004). In the case of the Postclassic, we could mention the god Mixcoatl, prototype of the sacrificial victim represented without clothing (Olivier 2001:40–41).

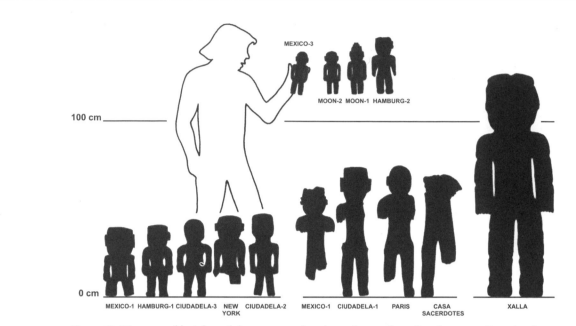

Figure 7. Diagram of heights of the corpus of male sculpture from Teotihuacan. Drawing by Fernando Carrizosa.

The marble captive from Xalla

After discovering the image, we immediately considered its four possible identities: god, divine ancestor, legendary figure from Teotihuacan history, or foreigner captured in battle.[46] From the start, the high status of the individual in question was evident, from the rich diadem on his head. However, the projectiles carved penetrating the sculpture's foot and thigh were iconographic elements that provided the key to recognizing his true identity. Based on exhaustive studies by Guilhern Olivier (2004), we know that the projectiles of spear-throwers (*atlatl*) and bows (*tlahuitolli*) are referred to indistinguishably by the terms *acatl, tlacochtli, mitl,* and *tlaxichtli* in documents in Nahuatl. Not only that, but also the spear and arrow tend to share the same polysemic character. Both serve throughout Mesoamerica as symbols of a declaration of war, military conflict, conquest, sacrificed warrior, punishment, imparting justice, fertilization, and rebirth.

In the specific case of Teotihuacan iconography, the dart[47] and its thrower are the weapons most commonly represented (Garcia-Des Lauriers 2000:88–96, 138–142; see also Caso 1966:272). The point of the dart[48] appears as a calendrical sign (Caso 1966:275),[49] and as decorative elements in tassel headdresses (C. Millon 1973:296). Often darts are found on bundles and beside shields constituting military emblems (Langley 1986:306). They are also frequently seen held by the Rain God and by high-status warriors, as well as by bellicose carnivorous mammals and birds of prey (Garcia-Des Lauriers 2000). On the other hand, Teotihuacan art does not offer examples of the active use of the dart- and spear-thrower, because it does not appear in explicit scenes of either battle or sacrifice (Millon 1981:213; C. Millon 1988:217; Pasztory 1990:183–188; Cowgill 1992:113). Therefore, the image from Xalla would be the sole case of its kind reported to date.

Following the discovery, we speculated that the darts carved on the sculpture could be onomastic or personal

46. Jarquín and Martínez (1982a:126) have suggested that the image they discovered in Structure 1Q of the Ciudadela was of "a deity that represented the ruling class." However, Pasztory (1992:307; 2000:370) proposes several designations for this type of sculpture, such as "prized central idols in temples," "idealized ancestors of various social groups," "ancient images venerated as relics," or "a combination of mythical ancestors and nature spirits."

47. This element is defined in Langley's catalogue (1986:306) as "55. Dart."

48. This element appears defined in Langley's catalogue (1986:247) as "57. Dartpoint."

49. According to Caso, this glyph is equivalent to the sign *tecpatl* or flint from the Mexica calendar.

name glyphs, above all because we recalled that some figures bear the particles "leg" or "dart-that-penetrates" in their name. Then we thought of *Ehmibäthä* or "mask-of-thigh (skin)," ruler of the Otomi domain of Xilotepec (Códice de Huichapan 1992:fol. 40; cf. fols. 51 and 63); Iztlacoliuhqui, deity with a dart thrown by the Sun God and entering his forehead or his headdress (Olivier 2003:117–123); and the head pierced with an arrow painted on the rise of the north walkway of the Red Temple at Cacaxtla (Piña Chan 1998:fig. III.2.c).[50] In addition, there are onomastic glyphs with "shot foot" found in codices borne by the figure of Xomimitl ("Arrow-Foot") (Codex Mendoza 1992:fol. 2r; Códice Azcatitlan 1995: XIII)[51] as well as that of Tizoc ("The Bled One") (Códice Ramírez 1944:pl. XIII)[52] both protagonists in Mexica history.

Although this hypothesis was exciting in the heat of the moment of the discovery, we had to consider that Central Mexican name glyphs tended to be drawn next to the head or in front of the figure. They could also be sculpted on the back of the neck or the back of the image. Furthermore, the existence not of one, but of two darts in different positions made us seek alternative explanations: We proposed that the sculpture was made in memory of a celebrated individual wounded at an important moment in his life, as in the case of Motecuhzoma Xocoyotzin in the ill-fated encounter with his own people (Códice Azcatitlan 1995:XXIV).[53] However, as far as we know, the art of Teotihuacan differed from Mexica and Maya art in that it did not glorify the individuality of rulers.

By delving deeper into our inquiries, we sought another explanation. It struck us as more likely that we were dealing with the figure of a victim of *tlacacaliztli* ("being-shot-to-death-with-arrows"; Molina 1944, v. *tlacacalli*)—in other words, with one of the numerous men, generally of high military rank, who were captured in battle, stripped of their clothing, and sacrificed with darts or arrows (Seler 1963:1:129–133; Taube 1988; Vié-Wohrer 1999:1:30, 35, 77–78, 93, 99, 107; Neurath, forthcoming).[54] As is widely known, prisoners of war were tied up to a tree, a post, or a scaffold for this purpose (Taube 1988:331, 337, 346–348; Vié-Wohrer 1999:1:93). In Nahuatl, the scaffold was known as *cuauhtzatzaztli,* which may be translated as "stick framework" (Molina 1944, v. *cuauhtzatzapictli,* "wooden gate"). Generally, it was a structure placed on the floor, a stone base, or a platform. It was composed of two vertical beams joined by one, two, three, five, six, or seven transversal sticks bound with rope.

The *Relación de las Cosas de Yucatán* (Landa 1941: 117–118) contains one of the most vivid descriptions of this ceremony:

> [W]hen the day arrived, they all came together in the court of the temple, and if the victim was to be sacrificed with arrows, they stripped him naked, and anointed his body with a blue color, and put a headdress on his head. When they had reached the victim, all armed with bows and arrows, danced a solemn dance with him around the stake and while dancing they put him up on it and bound him to it, all of them keeping on dancing and gazing at him. The foul priest in vestments went up and wounded the victim with an arrow in the parts of shame, whether it was a man or woman, and drew blood and came down and anointed the faces of the idol with it. And making a certain sign to the dancers, they began one after another to shoot, as they passed rapidly before him, still dancing, at his heart, which

50. An imperfect drawing was published by Piña Chan. According to Urcid (personal communication, November 2002), it is an onomastic glyph composed of the signs "knotted band-painted face-crossed arrow-plant with flowers or fruit."

51. In the Codex Mendoza, Xomimitl appears as one of the ten founding chiefs of the city of Tenochtitlan. In the Códice Azcatitlan, Xomimitl participated in the coronation of Acamapichtli in the year 1376. Durán (1984:2:218) mentions that a person named Xomímitl was one of the "caudillos" who left Aztlan.

52. However, it should be recalled that Tizoc normally is indicated by either a bleeding or dotted leg (Codex Mendoza 1992:fol. 12r) or by a leg pierced by a sharp instrument (Códice Telleriano-Remensis 1995:fol. 38v).

53. In this plate, a figure may be seen falling from the top of a pyramid with a leg shot by an arrow. According to Graulich's commentary on this same document (Códice Azcatitlan 1995:138), it is Motecuhzoma Xocoyotzin, shown at the moment when his subjects threw all sorts of projectiles at him as he tried to placate them; he was struck on the temple by a stone and in the leg by an arrow (Durán 1984:2:551; Díaz del Castillo 1982:279).

54. This sacrifice was staged in different *veintenas.* The Códice Zouche-Nuttall (1992:fols. 83–84) show the gloss *tlacaxipectli* over the scaffold of Lord 6 House. On the other hand, the Códice Tudela (1980:fol. 21v) indicates that in Ochpaniztli—a *veintena* linked symmetrically and symbolically with Tlacaxipehualiztli—"they put an arrow through the throat" of a Chicomecoatl impersonator, whose body was then decapitated. Durán (1984:1:140) agrees by stating that the sacrifice was held in Ochpaniztli in honor of Chicomecoatl: on that occasion, a group of shooters armed with bows and arrows and dressed as Tlacahuepan, Huitzilopochtli, Titlacahuan, Ixcozauhqui, the Sun, and the Four Dawns cast their projectiles at the war captives bound to wood. In contrast, the *Anales de Cuauhtitlan* (1975:13) and Motolinia (Benavente 1971:65) comment that in Cuauhtitlan, shooting with arrows was done in Izcalli. In that *veintena,* according to the Franciscan, they decapitated two women, flayed them, then ordered six war captives to shoot them with arrows.

had been marked beforehand with a white mark. And in this way they made his whole chest one point like a hedgehog of arrows.

The terrible ceremony of *tlacacaliztli,* which could have originated in Pre-Ceramic societies,[55] achieved widespread distribution on the continent, according to accounts of Caddo Indians on the Prairies, the Mound Builders of the southeastern United States, and Mesoamerican peoples (Neurath, forthcoming). According to Eduard Seler (1963:1:131–132), the Mesoamerican version of this ceremony was linked to Xipe Totec, god of war and fertility. In his opinion, the rite evoked both the sexual act as well as the earth penetrated by the planting stick and fertilized by grains of corn. Seler stated that drops of blood shed by the victim on the ground fulfilled the symbolic function of strengthening the earth for the new period of vegetation.[56] It is worth pointing out that since that time, other researchers have seconded this proposal (Taube 1988:341; Graulich 1999:116–117). For example, Doesburg (in Códice Porfirio Díaz and Códice Fernández Leal 2001:171, note 273) indicates that this ritual "was connected with the military god of fertility Xipe Totec: the sacrifice of prisoners during his fiesta ensured rain and good harvests. The ritual illustrates the role of warriors in the natural cycle." In a more recent study of a greater spatial and temporal scope, Johannes Neurath (forthcoming) also concluded that this ceremony was rich in political, cosmological, sexual, and fertility content. From his keen perspective, the enemies immolated with darts or arrows personified the forces of darkness annihilated at dawn by the solar king and his astral warriors.[57]

In Mesoamerican pictographs, *tlacacaliztli* is abundantly illustrated. It invariably appears in the framework of military victories and promotions of dignitaries, which tend to be protected by the image of Xipe Totec (Taube 1988:340–350, Doesburg in Códice Porfirio Diaz and Códice Fernández Leal 2001:171–175, 178–179). Mexica annals, for example, record one of these ceremonies in the year 1 Rabbit (A.D.1506) to celebrate the conquest of Zozollan by the troops of Motecuhzoma Xocoyotzin (Códice Telleriano-Remensis 1995:fol. 41v and commentary on pp. 228–229; Códice Vaticano A 1996:fol. 86v).[58] In the Otomi Códice de Huamantla (1984:frag. 5–2, 16), the tlacacalizti was also a direct consequence of a conquest,[59] just as in the *Historia tolteca-chichimeca* (1976:15, fols. 28r, ms. 46–50; 24–25, fols. 32v–33r, ms. 46–50), where *tlahuahuanaliztli* (better known as "gladiatorial sacrifice") is simultaneously carried out.[60] Something similar occurs in the Mixtec codices Zouche-Nuttall (1992:fols. 83–84 and commentary on pp. 241–244) and Becker I (1961:fol. 10):[61] in the year 12 Rabbit (A.D. 1102), lords 10 Dog and 6 House perish, personifying Xipe Totec himself, the former in

55. Taube (1988:351) supposes a pre-state origin, while Vié-Wohrer (1999:1:107) goes even further by suggesting its roots in times prior to the neolithic revolution. The *tlacacaliztli* has symbolic connections with ancient hunting activities. According to Durán (1984:2:147), the people of Chalco "did not have any other means of sacrificing, because, as their god was the god of hunting, they always sacrificed with arrows."

56. The *Leyenda de los Soles* (1975:124) tells how Mixcoatl cast four arrows at Chimalma, when she was naked and unarmed; then he fertilizes her and procreates Quetzalcoatl with her. According to the *Anales de Cuauhtitlan* (1975:13), the first *tlacacaliztli* took place in the year 9 Reed, when the Ixcuiname (the four forms of Tlazolteotl, closely associated with Xipe Totec) arrive at Tollan and shoot two of their Huastec husbands that they had brought along as captives from Cuextlan. They do so with the express purpose of fertilizing the earth (Seler 1963:1:130 and 133; cf. Graulich 1999:116–117).

57. In the *Leyenda de los Soles* (1975:123), the Sun turns over arrows of *tzihuactli* to Mixcoatl and his four brothers, so that they kill the four hundred *mimixcoah* of the night.

58. Both documents show the same scene, although the Códice Vaticano A lacks an explicative gloss. The Códice Telleriano-Remensis on the other hand, specifies that the sacrifice was intended to "placate the gods because well it had been two hundred years, when they always suffered from famine in the year of 1 Rabbit." However, the *Historia de los mexicanos por sus pinturas* (1973:63; see also Barlow 1990:116–117), confirms the execution of this sacrifice in 1506 (in other words, the 184th year since the foundation of Tenochtitlan) not in conjunction with the famine, but rather with the conquest of Zozollan. This passage concludes by adding that "each year they held this fiesta."

59. According to Carmen Aguilera (in Códice de Huamantla 1984:43), it was held in Atlancatepec under the eyes of the goddess Acxacapo, the Otomi version of Cihuacoatl.

60. On the day 7 Flower of the year 7 Rabbit, the Tepilhuan Chichimecs conquered the towns of the Xochimilca, Ayapanca, Teciuhqueme, Texallo, Tlilhua, Cuilocatl, and Auzolcatl. The defeated *tlatoque* were led to the main pyramid of Cholula. There, Quauhtzitzimitl was shot with arrows, while the rest of the dignitaries died in gladiatorial sacrifice. Later, it says in the year 8 House, the Tepilhuan Chichimecs conquered Tepetlcotocan, Petlazolmetepec, Tzouac Xillotepec, Quauhtli ychan, Ocellotl ychan, and Tlatlauhqui tepexioztoc. As a result, Lords Totozintli and Xicalan were sacrificed with arrows.

61. On the day 12 Monkey of the year 11 House (A.D. 1101), 8 Deer-Jaguar Claw began his campaign of revenge for the death of his elder half-brother 12 Movement. He conquered the city of the Sacred Bundle of Sticks on the Hill of White Flowers, and he took captives. One of them, Lord 10 Dog-Burning Tobacco Eagle is immolated on the day 6 Serpent, while Lord 6 House-Bound Flints was sacrificed eight days later on 1 Reed.

gladiatorial confrontation and the latter shot to death with darts from a spear-thrower. This event marked the beginning of the autocratic government of 8 Deer at Tilantongo over a good part of the Mixteca region.

We have the parallel scenes from the Cuicatec codices Fernández Leal (2001:fols. 5–7, 10–12) and Porfirio Díaz (2001:fols. 9–13, 16–18). In the first sequence, the celebration of the day 2 Eagle in the year 1 Grass is represented, resulting from the triumph of Tepeucila over Papalotícpac. There, the victorious Lord Serpent sacrifices a prisoner as part of his military promotion. Later, in another sequence on the day 5 Serpent of the year 3 Deer, Lord Ballcourt orchestrates his own sacrifice.[62] Repeatedly, the illustrations in question show the sacrificial victims and the main participants in these ceremonies with attributes of Xipe Totec.

Other iconographic representations of *tlacacaliztli* from the Postclassic period are found in the spear-thrower from the Museo Nazionale Preistorico Etnografico Luigi Pigorini in Rome (Alcina et al. 1992:247–248) and in the atrium cross of Topiltepec, Tepozcolula, State of Oaxaca (Caso 1956). In this latter monument, which reused a pre-Hispanic relief, it can be seen how a warrior casts darts with his thrower at the body of a captive tied to a scaffold; both have the garments of Xipe Totec. Vestiges of sacrifice by shooting arrows and flaying can be found in the terrifying scenes of hell painted in the shrine of Santa Maria Xoxoteco, Hidalgo (Artigas 1984:83–100).

There are older scenes of *tlacacaliztli* and of prisoners tied to scaffolds, dating back to the Classic period. We can recall, among others, the incised graffito in Temple

2 at Tikal (Trik and Kampen 1983:1, 9, figs. 38a, 103b),[63] the Maya cylindrical vessel in the Art Institute of Chicago with a captive tied up prior to his immolation (Taube 1988:342, fig. 12.11), and the celebrated Scaffold Vessel in Dumbarton Oaks in Washington, D.C.,[64] where the sacrificial ceremony takes the life of a deer-man (Coe 1975:26–27). Several stelae from Piedras Negras present an imposing image of kings who just took power, showing them seated majestically on scaffoldings to preside over the sacrificial rites held for their accession. Taube (1988:341–346, 350) writes about these stelae: "Blood sacrifice appears to have been the major ritual link between the ruler and his prisoner. Just as the Maya lord pierced such sensitive parts of his body as his tongue and phallus, the body of the tortured prisoner was repeatedly pierced by spears. In terms of the state ceremonies of the Maya elite, it is as if the torture and killing of the victim served as a ritual amplification of the lord's bloodletting act." Something very similar is captured in a relief from the Building of the Columns at El Tajín. There, Lord 13 Rabbit receives offerings seated on a scaffold, while on the other scaffold death presides over a line of prisoners who are being undressed and their hair is being tied up by their captors (Taube 1988:340–341; Koontz 1994:108–129)

In addition to this long list of representations of sacrifices, we want to mention an extremely interesting offertory deposit at Teotihuacan. It was discovered by Millon in 1959 at the base of the Sun Pyramid. It consisted of a typical human-shaped, obsidian eccentric carefully deposited in a vertical position. Around it and pointing toward it was an arrangement of more than thirty tiny projectile points also fashioned of obsidian (Millon et al. 1965:24–25 and figs. 37–41). According to Taube (personal communication, May 1999), Teotihuacan eccentrics could have represented captives with their arms tied behind their backs.

To return to the image of the naked, wounded personage from Xalla in light of what is discussed here, we propose that the two darts piercing the figure's legs indicate that he is a victim of *tlacacaliztli*. As pointed out by George L. Cowgill (personal communication, March 2004), neither of the two darts penetrates zones with vital organs. This fact is not unusual in pictographic scenes of *tlacacaliztli*, where the victims appear with arrows or darts both in the torso as well as in the extremities. This detail makes sense if we recall that the

62. Codices Porfirio Díaz and Fernández Leal make clear the ritual sequence of the two ceremonies. Both were staged in the patio of the main temple, where the post of the flyers was raised and the scaffold was assembled. The prisoner was then tied to the scaffold and his hair was covered with white feathers to show that he was to be sacrificed. He also had to wear a white helmet with a red cord characteristic of Xipe Totec. Then, in the patio, a heavy stone was placed in which the Sacred Staff of the Eagle's Feather was inserted. After the staff was honored, the sacrifice by shooting with arrows would begin. At the end, the vanquished lord was militarily promoted to the degree of *tequihua* and received as signs of his new status a loincloth, a red mantle, and a special coiffure (*temilotl* or *quetzalilpiloni*). Finally, the descent down the flyer's pole followed (Doesburg in Códice Porfirio Díaz and Códice Fernández Leal 2001:171–175, 178–179).

63. This incised graffito belongs to a context dated to the Late Classic period. It is located in Structure 5D-2-1st (Temple 2). It represents a victim tied to a scaffold and shot with arrows. As noted by Javier Urcid and by us, the ritual of El Volador also might be represented in this graffito.

64. In it, one of the participants in the ceremony carries a staff similar to the one used by the Mexica *xipeme*.

objective of this ceremony was not to immediately kill the victim, but rather to wound him, so that his fertilizing blood would drip slowly onto the ground. In fact, in the work of Fray Diego Durán (1984:1:140), it is explicitly stated that the projectiles were not what caused the captives' death: "As soon as those unfortunate men were shot with arrows they tossed them down and they cut their chests and wrenched out the heart. . . ." In the same vein, Motolinia (Benavente 1971:65) comments that "they shot them with many arrows, and as they were shot and half-dead, they allowed them to be cast down from that height, and from the strong impact of the fall their bones were crushed and broken, and then they killed them a third time by sacrificing them and removing their hearts, and dragging them and taking them away from there, the fourth [act of] cruelty was slitting their throats and cutting off their heads. . . ."[65]

Employing this line of reasoning, we propose that the uncomfortable position of the arms and hands of the Xalla sculpture, as well as the presence of grooves on its four extremities indicate that this figure was originally bound, perhaps to a post or a scaffold in the shrine of Structure E3 (fig. 8).[66] As is widely known, at Teotihuacan, the practice of binding captives before sacrifice was very common. This is evident from the position of the bodies of dozens of cadavers that served to consecrate the Temple of Quetzalcoatl (Cabrera et al. 1991) and the Moon Pyramid (Sugiyama and Cabrera 1999, 2000). In fact, in some cases, vestiges of ropes and gags were associated with the wrists and mouth of these victims. Along similar lines, Millon (1981:241, note 12) emphasizes the existence of Teotihuacan

Figure 8. Hypothetical reconstruction of the way the Xalla sculpture could have been exhibited in Structure E3. Drawing by Fernando Carrizosa.

representations of individuals (possibly captives) with arms closely bound to the torso (fig. 9).[67]

Equally revealing are the red eyes and vertical black lines crossing the face of the Xalla sculpture—standard attributes of Xipe Totec in the Postclassic period.[68] In fact, that particular iconography of the god of war and fertility was already present in the Classic period in Mesoamerica,[69] for example in Oaxaca (Caso and

65. Something similar occurred with *tlahuahuanaliztli* or "gladiatorial sacrifice," a ritual related directly to *tlacacaliztli*. There, once the captive was wounded with the *macuahuitl* on the *temalacatl,* he was untied and taken down from his stone to be led to the *cuauhxicalli,* where his heart was extracted (Durán 1984:1:98 and 2:275; Seler 1963:1:131).

66. It is clear that the body of the figure from Xalla is not in the same position as the victims of *tlacacaliztli* in the pictographs. One possible explanation could have to do with the artistic license of the Teotihuacan sculptor: Technically the carving of a body with arms and legs open and extended would require a block at least two times larger in addition to the fact that the work would be extremely fragile because of the relative thinness of the extremities. Another possible explanation is related to a hypothetical "Teotihuacan usage" of tying victims of *tlacacaliztli* with their arms close to the body and the legs closed. A similar practice was employed among the Maya and other Mesoamerican societies. In fact, in images published by Taube (1988:figs. 12.3, 12.4, 12.10, 12.11, 12.13), the figures that are tied to scaffolds do not have their arms or legs in an open position.

67. Almost all of them are figurines and ceramic fragments (Séjourné 1966:fig. 161).

68. It should be pointed out that these lines tend to be black or red and can be either single, double, triple, composed of dots, or in the shape of a rope. They usually cross the centers of outer ends of the eyes of Xipe Totec. In our sculpture, the line is very blurry, since it is "smoky black." It is single, crossing the eye at the level of the tear duct: Javier Urcid has pointed out to us that the line could also allude to the tears of the victim, because weeping is represented in codices, particularly in images of *tlacacaliztli.*

69. Nicholson (1976:164–169) has discussed the temporal depth of images of Xipe Totec. Coe (1968a:ll1–114) and Joralemon (1971:79–81) connect the so-called God VI of the Olmecs with Xipe Totec. This deity in the Preclassic period also has vertical lines crossing its face.

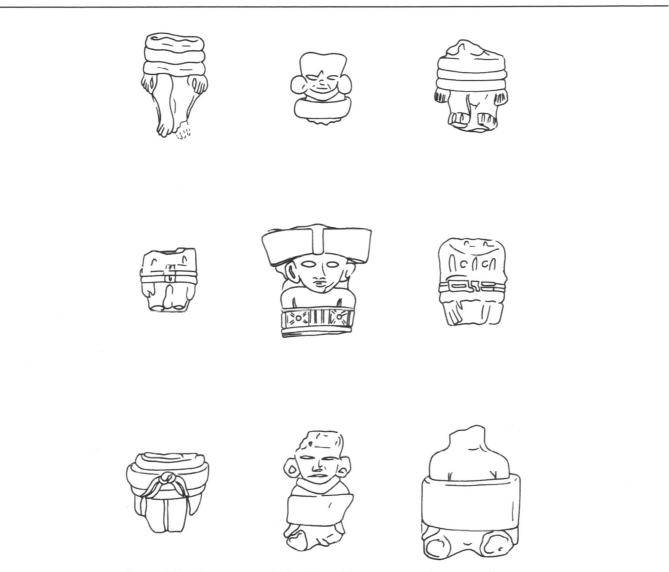

Figure 9. Teotihuacan ceramic figurines with arms next to the torso and bound. Drawing by Fernando Carrizosa.

Bernal 1952:247–262),[70] in the Maya area (Taube 1992:105–112), and at Teotihuacan itself.[71] With respect to this site, we recall the mural from the northwest apartment of Zacuala that represents the face of a dead individual with vertical lines on his cheeks (Séjourné 1959:22, fig. 6; Fuente 1995:339, fig. 21.9).

In conclusion, if our proposal is correct, the south temple of the Central Plaza of Xalla would have exhibited in its interior the image of a high-ranking prisoner who was sacrificed as part of the festivities of a major military victory and perhaps also as part of a

70. There are images of Xipe Totec from phases I and II at Monte Albán until at least the beginning of phase IIIB.

71. Numerous authors have identified the so-called "god with mask"—which appears in figurines, on vessels, and in reliefs—as a Teotihuacan version of Xipe Totec (Seler 1960: 462–463, fig. 53, pl. XXV-2; Beyer 1922:169, pls. 81c–d; Gamio 1922b, pls. 86d, 96a–f;

Linné 1942, fig: 181; Armillas 1945:52–55; Séjourné 1959:62, 97–99, fig. 675; Caso 1966:269–270, figs. 33–34; Kubler 1967:7, fig. 32). These are images that show a circular mask with three holes for the eyes and mouth, a diagonal band that runs from the shoulder to the opposite hip, sometimes a plaque with rosettes behind the head, and the St. Andrew's cross. Von Winning (1987:1: 147–149, figs. 1–3) and Scott (1993:13–19) have questioned this identification.

ceremony of social promotion.[72] In this way, the sculpture in question would have ideologically backed the preponderant power of the inhabitants of this complex, possibly a Teotihuacan palace. As is known, this sort of iconographic program is fairly common in Mesoamerican contexts (for example, Chichén Itzá, Monte Albán, Dzibanché; see Morris et al. 1931; Marcus 1976; Baudez 2004). To cite one example, at Copán we find that Structure 10L-16, erected by Yax Pasaj Chaan Yopaat,[73] exhibits three large sculptural panels along the stairway leading up to the temple (Agurcia and B. Fash 2005). The central panel is occupied by the sculpture of the founder of the dynasty dressed as a solar warrior, and the upper one contains the image of a bound prisoner within the jaws of a serpent mountain deity. According to Barbara Fash and Karl Taube, K'inich Yax K'uk' Mo' in his guise as apothesized solar warrior sought captives for sacrifice to the ancestral deity of the cave and earth, represented here by motifs for mountain and pu (cat tail). Yet another example of bound captives is found flanking the stairway at the East Court of Palenque's Palace.

We can tentatively suggest that the other sculptures of the Teotihuacan anthropomorphic corpus depict war captives as well. However, they could also be the images of lords who, after being elected as rulers, were naked for the ceremony of ritual death, purification, self-sacrifice, and onthological change. The ritual was transformative, allowing the rulers to be metaphorically reborn as divine solar deities, then crowned and enthroned (López Luján 2006). We see this action taking place in El Tajin with the ruler 13 Rabbit, the king's enthronement ritual depicted in the newly discovered San Bartolo murals, and among the Aztec rulers.

Iconoclasm at Teotihuacan

During the preceding analysis, we examined the contexts in which some images from our corpus had been found. In the first place, we said that all of them were located in highly exclusive religious buildings, always close to the Street of the Dead. In the specific case of the sculpture found in the Casa de los Sacerdotes, to the southwest of the Sun Pyramid, Batres presumed to have discovered "the revelation of how that extremely

sumptuous city was destroyed" (Batres 1906a:13–18). In particular, he says: "In that entire labyrinth of patios and rooms, and even in the architectural parts of the construction, traces of the terrible fire that consumed them can be seen, as another Troy." Among the rubble, the polemic archaeologist from the era of Porfirio Díaz recovered burned roof ornaments, charred beams, and skeletons of men, women, and children. There, at the foot of the shrine, on its west side, he exhumed remains of masks and cult effigies, including the famous serpentine torso that we analyzed above, violently shattered into pieces.

We have very similar testimony from the West Plaza Compound and the Temple of the Puma Mural.[74] However, much more enlightening are the contexts from the Ciudadela, particularly that of Structure 1Q, the temple located directly behind the Temple of Quetzalcoatl (Cabrera 1982:33–37; Jarquín and Martínez 1982a:122–123, 126; Jarquín and Martínez 1982b:34–36; Berrin and Pasztory 1993:178.)[75] There, evidence of destruction was everywhere to be found. According to Jarquín and Martínez, it dated to the very demise of the city, in the Metepec phase. The beautiful sculpture that we have described was broken into numerous fragments, all of them mixed with charcoal and ash, and in direct contact with the burned floor from the last construction stage of the building. However, the most interesting aspect of the discovery is that these bits were dispersed over an area of 800 m² around the temple (where surely the image was once venerated): one fragment to the north, three to the south, five to the east, and one to the west, in addition to a fragment of the quadrangular base on which the image would have rested.

The explorations at Xalla amply corroborate what was reported by earlier researchers. The destruction seems to have been concentrated in the Central Plaza,[76] where

72. Marcus and Flannery (2001:127–128) discovered a sculpture very similar to ours in an offering in Structure 35 at San José Mogote. In an interesting discussion, they interpreted it as the image of a noble who had been sacrificed.

73. Sixteenth ruler at Copán.

74. In the West Plaza Compound, there is the same type of evidence of violent destruction. Two sculptures, one male and the other female, appeared broken, positioned next to the remains of a small altar in room 14 (Morelos 1982:311, L.1. y F.1.2., elemento 5). In the case of the Puma Mural Temple, Martha Sempowski (quoted by R. Millon 1988:151) documents a layer of ash on the plaza floor, as well as a sculpture made of green travertine that was broken into pieces and intentionally dispersed.

75. Of the fifteen temples framing the Ciudadela, Structure 1Q occupies a place of preeminence, because it is the only one located on the central east-west axis.

76. Between 2000 and 2002, we did not detect any evidence of incineration during the excavations conducted in plazas 2 and 5 of Xalla, located to the north and to the south of the Central Plaza, respectively.

we recorded many obsidian artifacts deformed by the heat, floors with evidence of fire, fallen walls, flat roofs with the ceiling hardened by the fire, charred beams, and roof ornaments torn out of their cornices. One highly special case is Structure E2, whose exceptional facades displayed mythological felines that emerged from portals with starfish, "equilateral sawteeth," and feathers (López Luján et al. 2002). Once this structure was freed from the rubble, to our surprise we found that the heavy blocks out of which the felines had been carved were mixed up, scattered about, and many of them found at a great distance from their original position (fig. 10).

As we mentioned, the marble sculpture under discussion was destroyed on the summit of Structure E3 (fig. 3).[77] Its fragments were found several meters from the base that possibly supported it, dispersed without preserving any anatomical relationship. They were found directly on the floor of the shrine, mixed with ash, and bits of the roof and the west wall, indicating that the destruction of the image and the temple were simultaneous.[78] The marble displays several types of damage, the most significant of which was caused by the fire.[79] On one side, there is a physical expansion of the mass of the stone and the resulting splitting, and on the other, chemical transformations that converted the calcite in some areas into limestone. The analysis of

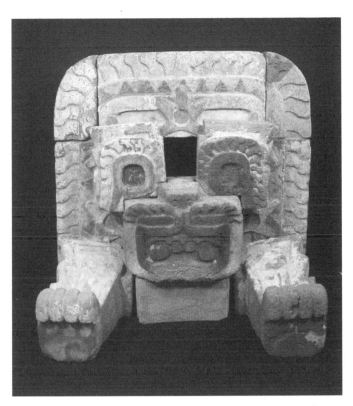

Figure 10. One of the two mythological felines discovered in front of Structure E2, Central Plaza of Xalla. Photo by Leonardo López Luján.

areas where the piece had been fractured showed the traces of diverse tools,[80] including a chisel 2 cm in width. The impact was focused on the base of the neck and the extremities in order to split up the image into six large body segments (fig. 11).[81] Then the ears were broken into pieces and heavy blows were delivered at the level of the nose and the right cheek. Finally, the segments were systematically reduced to more than 160 pieces of extremely diverse dimensions (fig. 12).[82]

77. The sculpture was found between the west wall and one of the central pilasters. The area of dispersion was recorded as "activity area 50" (P1, E3-C1, N320.25-321.47/E361.7 363.38, z=2307.349-2307.034 masl). Four fills were excavated (R1-R4) of sandy-muddy earth of dark-grayish brown color (10YR 4/2) with the inclusion of granules, round smooth pebbles, small round pebbles, and irregular angular rocks. A moderate presence of carbonates was recorded, as well as a pH of 7–8. As related material, ceramics, lithics, stucco plaster, mural painting, and fragments of limestone were recovered.

78. The floor of the shrine displays several intrusions of post-Teotihuacan looting, both in the opening entrance (N323-324/E365-367) and in the central part; in addition, its southern side was broken in an irregular way. Most of the fragments were found in R1-R4 (N320-321/E361-363), directly on the shrine floor. In that great post-Teotihuacan looting pit (N316-321/E362-367), only two fragments of small dimensions were found (N317-320/E362-363).

79. Marble is a material sensitive to chemical reactions, the effects of sun, carbonic acid absorbed by the rain, moisture, and freezing—agents that provoke changes in coloring, corrosion, chemical dissolution, or structural disintegration. It is estimated that Carrara marble tends to live twenty years when it is left exposed to the elements (Rich 1988:242–244). Among the features of deterioration recorded in our sculpture, there is abrasion, dissolution, disgregation, displacement, cracks, fissures, and deformations, in addition to the presence of roots, soil, charcoal, ash, concretions, saline layers, and iron salts.

80. Much of the breakage from blows or other impact followed the cracks and fracture planes of the stone itself.

81. The arms and neck were separated from the torso by strong blows aimed at the shoulders. The hands were severed from the hip with chisel blows to the front and back of the image. Finally, the legs were cut with a chisel at the level of the base of the gluteus.

82. The most seriously damaged body segments were the head with thirty-one large fragments, and the right arm with twenty-two, followed by the left arm with twelve, the torso with three, and the left leg with three. The right leg was not destroyed. Unfortunately, 8 percent of the fragments could not be found during our exploration.

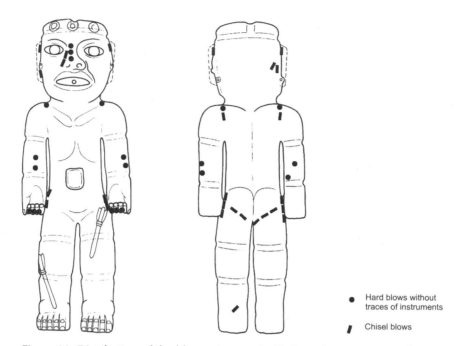

Figure 11. Distribution of the blows given to the Xalla sculpture. Drawing by Fernando Carrizosa.

Fortunately, we now have the first archaeomagnetic data from the burned floors of Structure E3, which places the disaster around A.D. 550.[83] These results are confirmed by the discovery of a "mountain type" incense burner decorated with images of rain gods, a piece that was trapped between the floor and ceiling of Structure E2 at the moment of destruction. According to observations made on-site by Warren Barbour, the piece dates to the last epoch of Teotihuacan.[84]

The contexts at Xalla help us better understand the Teotihuacan iconography of power and the actions of those who annihilated that power for all time. Obviously, the archaeological evidence of destruction is not conclusive when it comes to the identity of those responsible for the catastrophe. Much has been speculated on this weighty matter. Ignacio Bernal (quoted by Coe 1968b:72–73), for example, speaks of a revolution; R. Millon (1988:156–158) is also inclined to point to the city's inhabitants; Cowgill (1997:156–157)

prefers the idea that they were neighboring societies, perhaps allied to the Teotihuacan "dissidents"—an idea that coincides with that of Eduardo Matos (1990:88–90) and that of our own team. However, whatever the case, it is clear that it was carried out by a group of people highly familiar with Teotihuacan culture. This is why the old hypothesis that attributed these actions to nomads from the north (for example, Jiménez Moreno 1982:1063–1069), a hypothesis inspired by the fall of the Roman empire, may be definitively dismissed.

The evidence of iconoclasm that we have seen presents us with far more than isolated cases of vandalistic aggression, if this aggression is understood as an irrational act lacking specific significance. At Teotihuacan it is clear that the desecration of images and locations in which they were venerated formed part of a strategy full of meaning (Jarquín and Martínez 1982a:126; Millon 1988:156; Pasztory 2000). The devastation this Mesoamerican metropolis experienced may be added to the long list of iconoclastic movements in world history, including the renowned "Quarrel of the Images" that occurred in Byzantium in the eighth and ninth centuries; Protestant iconoclasm during the Reformation; the profanation of symbols of the *Ancien Régime* during the French Revolution; the Nazi

83. Samples of E3 were taken and analyzed by Ana María Soler at the Instituto de Geofísica, UNAM (personal communication, December 2001).

84. According to this researcher (personal communication, September 2003), the piece dates to the Metepec phase.

Legend for figure:
● Hard blows without traces of instruments
▮ Chisel blows

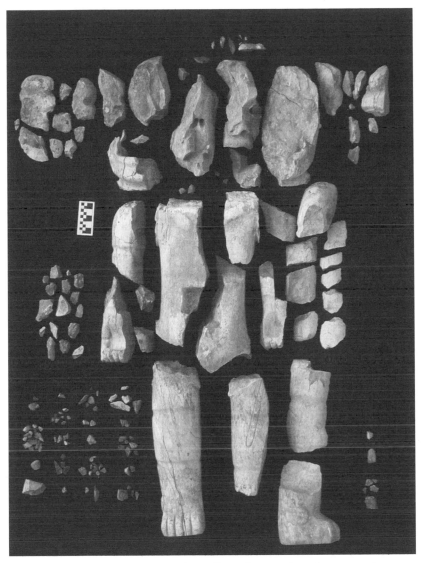

Figure 12. Fragments composing the Xalla sculpture. Photo by Leonardo López Luján.

persecution of *Entartete Kunst*; the fall of the Berlin Wall in 1989; and the taking of Baghdad in March 2003 (Freedberg 1991:378–428; Gamboni 1997:27–90). In the case of Mexico, we should not overlook the hotly debated mutilation of Olmec sculptural monuments (Stirling 1940:334; Coe 1967:25; Grove 1981:67; Porter 1990), the so-called burning of idols that took place after the Conquest (Gruzinski 1990:55–147), the violent demolition of monasteries during the Reform period (Tovar y Teresa 1991), or, more recently, the iconophobic festivals promoted by Governor Tomás Garrido Canabal in the State of Tabasco (Hernández 2003).

By comparing these historical events, we discovered that iconoclasm is a multiform, irreducible phenomenon, encompassing conduct dissimilar in motives, purposes, promoters, actions, targets, and yielding equally diverse results.[85] Unfortunately, the lack

85. As Gamboni (1997:22–24) indicates to us, the heterogeneity of acts of iconoclasm has meant that individuals who study it have created a large number of typologies, each one based on distinct taxonomic criteria. He tells us: "It will be possible to observe distinctions and nuances in each case: aggressive motives can be explicit or implicit and of a more 'ideological' or more 'private'

of historical records on the societies that we study prevents us from knowing many of the details indispensable for undertaking a satisfactory reconstruction of the events. Archaeology is only able to reveal the consequences of iconoclastic acts, which include the suppression or replacement of symbols and inscriptions on monuments; the transformation, deformation, or decapitation of effigies; their confinement, definitive burial, or total elimination. Based on the analysis undertaken here, we can conclude that at Teotihuacan, the images used to express, impose, and legitimate power were the ones that were profaned with the express purpose of insulting, rejecting, or desecrating them.[86]

However, let us read between the lines and attempt to go a bit further. By Postclassic times, the conquest of enemy societies—neighboring and distant—was depicted in two correlative ways. On the one hand, it was represented by the triumphant warrior seizing the rival by the hair on the crown of the head (for example, the Stone of Tizoc), the zone where the *tonalli* resided—the source of vigor and bravery without which the warrior could die. According to Nahua belief in the sixteenth century, it was dangerous to cut the hair on the crown of the head, for this action could lead to the release of the *tonalli,* and the lack of the *tonalli* brought about serious illness and led to death (López Austin 1980:1:225, 231, 239, 241–243). On the other hand, the well-known glyph of a temple in flames was drawn to symbolize destruction, as was the case with the damaged residence of the divinities that protected the subjugated community (for example, Codex Mendoza 1992). In this respect, Olivier (forthcoming, chapter 1) points out: "When Sahagún's indigenous informants describe the beginning of a battle, it would seem that they had this glyph in mind: 'War cries were raised;

there was fighting. They shot arrows of fire at the temples' (*quitlemina in teucalli*)" (see Sahagún 1979: bk.VIII:fol. 53).[87]

The iconography of the Postclassic period shows us that the attacker aimed part of the aggression at locations where the divine power of the enemy was concentrated, demoralizing him and causing profound terror in him. Surely, such practices had their roots in ancient times and were shared by societies during the Classic period. In this regard, archaeology tells us that those who destroyed the ancient city of Teotihuacan not only politically annihilated the people who ruled the metropolis, but also ritually terminated every one of the sources of supernatural power of a community composed of tens of thousands of individuals. Although it is true that the violent destruction of images might speak to us of wild irrational fury, the systematic dispersion of its fragments can only be understood as a logical act aimed at preventing the reemergence of a power intolerable from every perspective through magical means. Something similar may be said of the destruction of virtually all the city temples, which never again were to rise from the rubble. In our opinion, the people of Teotihuacan would never have damaged their own patron gods in this way. Therefore, we are convinced that the instigators of the cataclysm must be sought in the political entities formerly subject to Teotihuacan, or else the city's rivals, or conceivably both, as was the case in the fall of Mexico Tenochtitlan.

87. We should also recall the toponyms shown shot with an arrow in Mixtec codices—undoubtedly symbols of conquest.

nature; aims can be equated with the physical result of the attack or go far beyond it; assailants can be individual or collective, make themselves known or remain anonymous, possess or not different kinds of power and authority; their actions can be more or less violent and destructive, direct or indirect, visible or clandestine, legal or illegal; the targets can be private or public property, deemed attractive or 'offensive,' acknowledged as art or not, appear as 'autonomous' or associated with certain groups or values; the context, finally, can be variously accessible and be permanently dedicated to the display of art or not."

86. With reason, Gombrich (2003:153) indicates that "their own power [of certain sculptural monuments], the finality for which they were commissioned and erected, may also be their perdition . . . this destiny was imposed on these statues not for what they were, but rather for what they meant or represented. . . ."

BIBLIOGRAPHY

Acosta, Jorge R.
 1964 *El Palacio del Quetzalpapálotl.* INAH, Mexico City.

Agurcia, Ricardo, and Barbara W. Fash
 2005 "The Evolution of Structure 10L-16, the Heart of the Copan Acropolis," in *Copan: The History of an Ancient Maya Kingdom,* eds. E. Wyllys Andrews and W. L. Fash, pp. 201–237. School of American Research Press, Santa Fe.

Alcina Franch, José, Miguel León-Portilla, and Eduardo Matos Moctezuma
 1992 *Azteca-Mexica. Las culturas del México antiguo.* Sociedad Estatal Quinto Centenario/Lunwerg Editores, Madrid.

Allain, Ariane
 2000 "Inventaire de la sculpture en ronde-bosse à Teotihuacán." Memoire de DEA, Université de Paris I-Panthéon-Sorbonne, Paris.

Anales de Cuauhtitlan
 1975 In *Códice Chimalpopoca,* translated from Nahuatl by P. F. Velázquez, pp. 3–68. UNAM, Mexico City.

Armillas, Pedro
 1944 "Exploraciones recientes en Teotihuacan, México." *Cuadernos Americanos* XVI (4):121–136.
 1945 "Los dioses de Teotihuacan." *Anales del Instituto de Etnología Americana* VI:35–61.

Artigas H., Juan B.
 1984 *La piel de la arquitectura. Murales de Santa María Xoxoteco.* UNAM, Mexico City.

Barlow, Robert H.
 1990 "Las conquistas de Moctezuma Xocoyotzin," in *Los mexicas y la triple alianza,* ed. J. Monjarás-Ruiz, E. Limón, and M. C. Paillés H., pp. 115–127. INAH/UDLA, Mexico City.

Batres, Leopoldo
 1906a *Teotihuacan. Memoria que presenta Leopoldo Batres, Inspector y Conservador de los Monumentos Arqueológicos de la República Mexicana al XV Congreso Internacional de Americanistas.* Imprenta de Fidencio S. Soria, Mexico City.
 1906b *Teotihuacán ó la ciudad sagrada de los tolteca.* Imprenta de Hull, México.

Baudez, Claude-François
 2004 "Los cautivos mayas y su destino," in *Los cautivos de Dzibanché,* ed. E. Nalda, pp. 57–77 and 142–143. INAH, Mexico City.

Becker-Donner, Etta
 1965 *Die Mexikanischen Sammlungen.* Museum für Völkerkunde, Vienna.

Benavente, Fray Toribio de (Motolinía)
 1971 *Memoriales o libro de las cosas de la Nueva España y de los naturales de ella,* ed. E. O'Gorman. UNAM, Mexico City.

Bernal Gutiérrez, Laura
 2005 "Análisis funcional del posible palacio de Xalla, Teotihuacan: un enfoque arqueométrico." Licentiate thesis in archaeology, ENAH, Mexico City.

Berrin, Kathleen, and Esther Pasztory (ed.)
 1993 *Teotihuacan. Art from the City of the Gods.* Thames and Hudson/The Fine Arts Museums of San Francisco, San Francisco.

Beyer, Hermann
 1922 "Estudio interpretativo de algunas grandes esculturas," in *La población de Valle de Teotihuacán,* dir. M. Gamio, vol. 1, pp. 160–174. Dirección de Antropología, Secretaría de Educación Pública, Mexico City.

Cabral Ureño, J. C.
 1988 "Informe de la visita de reconocimiento al yacimiento de mármol ubicado en la fracción B del Rancho San Antonio, Municipio de San Martín Atexcatl, Puebla." Manuscript, Archivo Técnico del Consejo de Recursos Minerales, Mexico City.

Cabrera Castro, Rubén
 1982 "El Proyecto Arqueológico Teotihuacan," in *Teotihuacan 80–82. Primeros resultados,* coord. R. Cabrera, I. Rodríguez, and N. Morelos, pp. 7–40. INAH, Mexico City.

Cabrera Castro, Rubén, and Saburo Sugiyama
 1982 "La reexploración y restauración del Templo Viejo de Quetzalcóatl," in *Memoria del Proyecto Arqueológico Teotihuacan 80–82,* coord. R. Cabrera, I. Rodríguez, and N. Morelos, pp. 163–183. INAH, Mexico City.

Cabrera Castro, Rubén, Saburo Sugiyama, and George L. Cowgill
 1991 "The Templo de Quetzalcóatl Project at Teotihuacan. A Preliminary Report." *Ancient Mesoamerica* 2 (1):77–92.

Cabrera Cortés, Mercedes Oralia
1995 "La lapidaria del Proyecto Templo de Quetzalcóatl
 1988–1989." Licentiate thesis in archaeology, ENAH,
 Mexico City.

Caso, Alfonso
1956 "La cruz de Topiltepec, Tepozcolula, Oaxaca," in
 Estudios antropológicos publicados en homenaje al
 doctor Manuel Gamio, pp. 171–182. SMA, Mexico
 City.
1966 "Dioses y signos teotihuacanos," in Teotihuacan,
 Onceava Mesa Redonda, pp. 249–279. SMA, Mexico
 City.

Caso, Alfonso, and Ignacio Bernal
1952 Urnas de Oaxaca. INAH, Mexico City.

Codex Mendoza
1992 The Codex Mendoza, ed. F. F. Berdan and P. R.
 Anawalt, 4 vols. University of California Press,
 Berkeley.

Códice Azcatitlan
1995 Códice Azcatitlan, ed. D. Michelet, R. H. Barlow, M.
 Graulich, and L. López Luján, 2 vols. Bibliothèque
 nationale de France/Société des Américanistes, Paris.

Códice Becker I
1961 In Codices Becker I/II, ed. K. A. Nowotny.
 Akademische Druck- und Verlagsanstalt, Graz.

Códice Fernández Leal
2001 In Códices cuicatecos Porfirio Díaz y Fernández Leal,
 ed. S. van Doesburg, 2 vols. Miguel Ángel Porrúa,
 Mexico City.

Códice de Huamantla
1984 Códice de Huamantla, ed. C. Aguilera. Gobierno del
 Estado de Tlaxcala, Tlaxcala.

Códice de Huichapan
1992 Códice de Huichapan, ed. A. Caso.
 Telecomunicaciones de México, Mexico City.

Códice Porfirio Díaz
2001 In Códices cuicatecos Porfirio Díaz y Fernández Leal,
 ed. S. van Doesburg, 2 vols. Miguel Ángel Porrúa,
 Mexico City.

Códice Ramírez
1944 Manuscrito del siglo XVI intitulado: Relación del
 origen de los indios que habitan esta Nueva España,
 según sus historias, ed. Manuel Orozco y Berra,
 Editorial Leyenda, Mexico City.

Códice Telleriano-Remensis
1995 Codex Telleriano-Remensis: Ritual, Divination, and
 History in a Pictorial Aztec Manuscript, ed. E.
 Quiñones Keber. University of Texas Press, Austin.

Códice Tudela
1980 Códice Tudela, ed. J. Tudela de la Orden. Ediciones
 Cultura Hispánica/Instituto de Cooperación
 Iberoamericana, Madrid.

Códice Vaticano A
1996 Códice Vaticano A, ed. F. Anders and M. Jansen.
 Akademische Druck- und Verlagsanstalt/FCE, Mexico
 City.

Códice Zouche-Nuttall
1992 Códice Zouche-Nuttall, ed. F. Anders, M. Jansen, and
 G. A. Pérez Jiménez. Sociedad Estatal Quinto
 Centenario/Akademische Druck-und Verlagsanstalt/
 FCE, Mexico City.

Coe, Michael D.
1967 "Solving a Monumental Mystery." Discovery 3
 (1):21–26.
1968a America's First Civilization. American Heritage
 Publishing/The Smithsonian Institution, New York.
1968b "San Lorenzo and the Olmec Civilization," in
 Dumbarton Oaks Conference on the Olmec, ed. E. P.
 Benson, pp. 41–78. Dumbarton Oaks, Washington,
 D.C.
1975 Classic Maya Pottery at Dumbarton Oaks. Dumbarton
 Oaks, Washington, D.C.

Consejo de Recursos Minerales
1993 Los mármoles de México. Inventario de rocas
 dimensionables. Secretaría de Energía, Minas e
 Industria Paraestatal, Mexico City.

Cowgill, George L.
1992 "Toward a Political History of Teotihuacan," in
 Ideology and Pre-Columbian Civilizations, ed. A. A.
 Demarest and G. W. Conrad, pp. 87–114. School of
 American Research Press, Santa Fe.
1997 "State and Society at Teotihuacan, Mexico." Annual
 Review of Anthropology 26:129–161.

Díaz del Castillo, Bernal
1982 Historia verdadera de la conquista de la Nueva
 España, ed. C. Sáenz de Santamaría. Instituto de
 Investigaciones Históricas, UNAM, Mexico City.

Durán, Fray Diego
1984 Historia de las indias de Nueva España e islas de la
 tierra firme, 2 vols., ed. A. M. Garibay. K. Porrúa,
 Mexico City.

Easby, Elizabeth K.
1967 *Ancient Art of Latin America from the Collection of Jay C. Leff.* The Brooklyn Museum, New York.

Foncerrada de Molina, Martha
1993 *Cacaxtla. La iconografía de los olmeca-xicalanca.* Instituto de Investigaciones Estéticas, UNAM, Mexico City.

Freedberg, David
1991 *The Power of Images. Studies in the History and Theory of Response.* The University of Chicago Press, Chicago.

Fuente, Beatriz de la
1995 "Zacuala," in *La pintura mural prehispánica en México. I Teotihuacan. Tomo I Catálogo,* coord. B. de la Fuente, pp. 320–342. UNAM, Mexico City.

Gamboni, Dario
1997 *The Destruction of Art. Iconoclasm and Vandalism since the French Revolution.* Reaktion Books, London.

Gamio, Manuel
1922a "Introducción, síntesis y conclusiones," in *La población del Valle de Teotihuacán,* dir. M. Gamio, vol. 1, pp. V–CII. Dirección de Antropología, Secretaría de Educación Pública, Mexico City.
1922b "Las pequeñas esculturas," in *La población del Valle de Teotihuacán,* dir. M. Gamio, vol. 1, pp. 179–186. Dirección de Antropología, Secretaría de Educación Pública, Mexico City.

García-Des Lauriers, Claudia
2000 "Trappings of Sacred War: The Warrior Costume of Teotihuacan." Master's thesis in art history, University of California, Riverside.

Gombrich, E. H.
2003 "Escultura para exteriores," in *Los usos de las imágenes. Estudios sobre la función social del arte y la comunicación social,* pp. 136–161. FCE, Mexico City.

Gómez Chávez, Sergio
2000 "La Ventilla, un barrio de la antigua ciudad de Teotihuacan." Licentiate thesis in archaeology. ENAH, Mexico City.

Graulich, Michel
1999 *Ritos aztecas. Las fiestas de las veintenas.* INI, Mexico City.

Grove, David C.
1981 "Olmec Monuments, Mutilation as a Clue to Meaning," in *The Olmec & Their Neighbors,* ed. E. P. Benson, pp. 49–69. Dumbarton Oaks, Washington, D.C.

Gruzinski, Serge
1990 *La guerre des images: de Christophe Colomb à "Blade Runner" (1492–2019).* Fayard, Paris.

Heizer, Robert F., and Howel Williams
1963 "Geologic Notes on the Ídolo de Coatlinchán," *American Antiquity* 29 (1):95–98.

Hernández, Irma
2003 "'Es hora de destruir y de crear.' Una quema de santos en Villahermosa, Tabasco, durante el periodo garridista," in *Los pinceles de la Historia. La arqueología del régimen, 1910–1955,* pp. 40–41. Museo Nacional de Arte, NBA, Mexico City.

Historia de los mexicanos por sus pinturas
1973 In *Teogonía e historia de los mexicanos. Tres opúsculos del siglo XVI,* ed. Ángel Ma. Garibay K., pp. 21–90. Porrúa, Mexico City.

Historia tolteca-chichimeca
1976 *Historia tolteca-chichimeca,* ed. P. Kirchhoff, L. O. Güemes, and L. Reyes García. INAH, Mexico City.

Jarquín Pacheco, Ana María
2002 "El Conjunto Norte y Lado Este de la Ciudadela: análisis de contextos arqueológicos del periodo Clásico desde la perspectiva de la etnohistoria." Doctoral thesis in Mesoamerican Studies, UNAM, Mexico City.

Jarquín Pacheco, Ana María, and Enrique Martínez Vargas
1982a "Una escultura tardía teotihuacana," in *Teotihuacan 80–82. Primeros resultados,* coord. R. Cabrera, I. Rodríguez, and N. Morelos, pp. 121–127. INAH, Mexico City.
1982b "Exploración en el lado este de la Ciudadela (estructuras: 1G, 1R, 1Q y 1P)," in *Memoria del Proyecto Arqueológico Teotihuacan 80–82,* coord. R. Cabrera, I. Rodríguez, and N. Morelos, pp. 19–47. INAH, Mexico City.
1982c "Las excavaciones en el Conjunto 1D," in *Memoria del Proyecto Arqueológico Teotihuacan 80–82,* coord. R. Cabrera, I. Rodríguez, and N. Morelos, pp. 89–126. INAH, Mexico City.

Jiménez Moreno, Wigberto
　1982　"Síntesis de la historia pretolteca de Mesoamérica,"
　　　　in *Esplendor del México Antiguo,* coord. C. Cook de
　　　　Leonard, pp. 1019–1108. Centro de Investigaciones
　　　　Antropológicas de México/Editorial del Valle de
　　　　México, Mexico City.

Joralemon, Peter David
　1971　*A Study of Olmec Iconography.* Dumbarton Oaks,
　　　　Washington, D.C.

Koontz, Rex Ashley
　1994　"The Iconography of El Tajín, Veracruz, Mexico."
　　　　Doctoral dissertation, University of Texas at Austin,
　　　　Austin.

Kubler, George
　1967　*The Iconography of the Art of Teotihuacán.*
　　　　Dumbarton Oaks, Washington, D.C.

Landa, Fray Diego de
　1941　*Landa's Relación de las cosas de Yucatán,* ed. A. M.
　　　　Tozzer. Peabody Museum of American Archaeology
　　　　and Ethnology, Harvard University, Cambridge.

Langley, James C.
　1986　*Symbolic Notation of Teotihuacan. Elements of
　　　　Writing in a Mesoamerican Culture of the Classic
　　　　Period.* BAR Oxford.

Leyenda de los Soles
　1975　In Códice Chimalpopoca translated from Nahuatl by
　　　　P. F. Velázquez, pp. 119–128. UNAM, Mexico City.

Linné, Sigvald
　1942　*Mexican Highland Cultures. Archaeological
　　　　Researches at Teotihuacan, Calpulalpan and
　　　　Chalchicomula in 1934–35.* The Ethnographical
　　　　Museum of Sweden, Stockholm.

López Austin, Alfredo
　1980　*Cuerpo humano e ideología. Las concepciones de los
　　　　antiguos nahuas,* 2 vols. UNAM, Mexico City.

López Luján, Leonardo
　2006　*La Casa de las Águilas: un ejemplo de la arquitectura
　　　　religiosa de Tenochtitlan.* FCE/INAH, Mexico City.

López Luján, Leonardo, and Linda Manzanilla
　2001　"Excavaciones en un palacio de Teotihuacan: el
　　　　Proyecto Xalla." *Arqueología mexicana* IX
　　　　(50):14–15.

López Luján, Leonardo, Linda Manzanilla, and William L. Fash
　2002　"Mythological Feline," in *Aztecs,* pp. 106 and 405.
　　　　Royal Academy of Arts, London.

Manzanilla, Linda, and Leonardo López Luján
　2001　"Exploraciones en un posible palacio de Teotihuacan:
　　　　el Proyecto Xalla (2000–2001)." *Mexicon* XXIII
　　　　(3):58–61.

Manzanilla, Linda, Leonardo López Luján, and William L. Fash
　2005　"Cómo definir un palacio en Teotihuacan," in
　　　　*Arquitectura y urbanismo en Teotihuacan. Memoria
　　　　de la Tercera Mesa Redonda de Teotihuacan,* ed.
　　　　M. E. Ruiz Gallut, pp. 185–209. UNAM/INAH,
　　　　Mexico City.

Marcus, Joyce
　1976　"The Iconography of Militarism at Monte Albán and
　　　　Neighboring Sites in the Valley of Oaxaca," in
　　　　*Origins of Religious Art and Iconography in
　　　　Preclassic Mesoamerica,* ed. H. B. Nicholson, pp.
　　　　123–139. University of California at Los
　　　　Angeles/Ethnic Arts Council of Los Angeles, Los
　　　　Angeles.

Marcus, Joyce, and Kent V. Flannery
　2001　*La civilización zapoteca. Cómo evolucionó la
　　　　sociedad urbana en el valle de Oaxaca.* FCE, Mexico
　　　　City.

Marquina, Ignacio
　1922　"Primera parte. Arquitectura," in *La población del
　　　　Valle de Teotihuacán,* dir. M. Gamio, vol. 1, pp.
　　　　99–164. Dirección de Antropología, Secretaría de
　　　　Educación Pública, Mexico City.

Matos Moctezuma, Eduardo
　1980　"Teotihuacan: excavaciones en la Calle de los
　　　　Muertos (1964)." *Anales de Antropología* XVII
　　　　(I):69–90.
　1990　*Teotihuacan. La metrópoli de los dioses.* La aventura
　　　　humana, Mexico City.

Millon, Clara
　1973　"Painting, Writing, and Polity in Teotihuacan,
　　　　Mexico." *American Antiquity* 38 (3):294–314.
　1988　"Coyote with Sacrificial Knife," in *Feathered Serpents
　　　　and Flowering Trees. Reconstructing the Murals of
　　　　Teotihuacan,* ed. K. Berrin, pp. 206–217. The Fine
　　　　Arts Museum of San Francisco, San Francisco.

Millon, René
　1973　*Urbanization at Teotihuacan, Mexico,* 2 vols.
　　　　University of Texas Press, Austin.

1981 "Teotihuacan: City, State, and Civilization," in *Supplement to the Handbook of Middle American Indians,* vol. 1, *Archaeology,* ed. J. A. Sabloff, pp. 198–243. University of Texas Press, Austin.

1988 "The Last Years of Teotihuacan Dominance," in *The Collapse of Ancient States and Civilizations,* ed. N. Yoffee and G. L. Cowgill, pp. 102–164. The University of Arizona Press, Tucson.

Millon, René, Bruce Drewitt, and James A. Bennyhoff
1965 *The Pyramid of the Sun at Teotihuacán: 1959 Investigations.* The American Philosophical Society, Philadelphia.

Molina, Fray Alonso de
1944 *Vocabulario en lengua castellana y mexicana.* Ediciones de Cultura Hispánica, Madrid.

Mooser, Federico
1968 "Geología, naturaleza y desarrollo del Valle de Teotihuacan," in *Materiales para la arqueología de Teotihuacan,* ed. J. L. Lorenzo, pp. 29–37. INAH, Mexico City.

Moragas Segura, Natalia
2005 "Sobreviviendo al colapso: teotihuacanos y coyotlatelcos en Teotihuacan." *Revista Española de Antropología Americana* 35:33–50.

Morelos García, Noel
1982 "Exploraciones en el área central de la Calzada de los Muertos al norte del Río San Juan, dentro del llamado Complejo Calle de los Muertos," in *Memoria del Proyecto Arqueológico Teotihuacan 80–82,* coord. R. Cabrera, I. Rodríguez, and N. Morelos, pp. 271–317. INAH, Mexico City.

1993 *Proceso de producción de espacios y estructuras en Teotihuacan. Conjunto Plaza Oeste y Complejo Calle de los Muertos.* INAH, Mexico City.

Morris, Earl H., Jean Charlot, and Ann Axtel Morris
1931 *The Temple of the Warriors at Chichén Itzá, Yucatán,* 2 vols. Carnegie Institution of Washington, Washington, D.C.

Neurath, Johanness
Forthcoming. "La iconografía del Complejo Ceremonial del Sureste y el sacrificio humano pawnee: contribuciones analíticas desde la perspectiva mesoamericanista," in *Por los caminos del maíz: mito, ritual y cosmovisión en la periferia septentrional de Mesoamérica.* CONACULTA/FCE, Mexico City.

Nicholson, H. B.
1971 "Major Sculpture in Pre-Hispanic Central Mexico," in *Handbook of Middle American Indians,* ed. R. Wauchope, vol. 10, pp. 92–134. University of Texas Press, Austin.

1976 "Preclassic Mesoamerican Iconography from the Perspective of the Postclassic: Problems in Interpretational Analysis," in *Origins of Religious Art and Iconography in Preclassic Mesoamerica,* ed. H. B. Nicholson, pp. 141–175. University of California at Los Angeles/Ethnic Arts Council of Los Angeles, Los Angeles.

Olivier, Guilhem
2001 "Images et discours: à propos de quelques représentations de Mixcoatl, divinité des anciens Mexicains," in *L'image au Mexique: usages, appropiations et transgressions,* ed. A. Hémond and P. Ragon, pp. 35–51. L'Harmattan/CEMCA, Paris.

2003 *Mockeries and metamorphoses of an Aztec god. Tezcatlipoca, "lord of the smoking mirror."* University Press of Colorado, Boulder.

2004 "De flechas, dardos y saetas. Mixcóatl y el simbolismo de las flechas en las fuentes nahuas," in *De historiografía lingüística e historia de las lenguas,* I. Guzmán Betancourt, P. Mánez, and A. H. de León-Portilla, pp. 309–324. UNAM/Siglo XXI, Mexico City.

Forthcoming. *De Nubes, venados y antepasados: Mixcóatl, una deidad mesoamericana.* Instituto de Investigaciones Históricas, UNAM, Mexico City.

Ordóñez, Ezequiel
1922 "La labra de la piedra," in *La población del Valle de Teotihuacán,* dir. M. Gamio, vol. 1, pp. 164–168. Dirección de Antropología, Secretaría de Educación Pública, Mexico City.

Pasztory, Esther
1990 "El poder militar como realidad y retórica en Teotihuacan," in *La época clásica: nuevos hallazgos, nuevas ideas,* coord. Cardós de Méndez, pp. 181–204. INAH, Mexico City.

1992 "Abstraction and the Rise of a Utopian State at Teotihuacan," in *Art, Ideology, and the City of Teotihuacan,* ed. J. C. Berlo, pp. 281–320. Dumbarton Oaks, Washington, D.C.

2000 "Sculpture de Teotihuacan," in *Sculptures. Afrique, Asie, Océanie, Amériques, Musée du Louvre, pavilion des Sessions,* pp. 368–370. Réunion des Musées Nationaux/Musée du Quai Branly, Paris.

Piña Chan, Román
1998 *Cacaxtla. Fuentes históricas y pinturas.* FCE, Mexico City.

Porter, James B.
1990 "Las cabezas colosales como altares reesculpidos, 'mutilación,' revolución, reesculpido." *Arqueología, segunda época,* 3:91–97.

Querré, Guirec
2000 "Une statuette anthropomorphe du Mexique." *Techne* 11:84–87.

Reyero, Manuel
1978 *Colección prehispánica.* Fundación Cultural Televisa, Mexico City.

Rich, Jack C.
1988 *The Materials and Methods of Sculpture.* Dover Publications, New York.

Sahagún, Fray Bernardino de
1979 *Códice Florentino. Manuscrito 218–20 de la Colección Palatina de la Biblioteca Medicea Laurenziana,* 3 vols. Secretaría de Gobernación, Archivo General de la Nación, Mexico City.

Sánchez Hernández, Ricardo
1995 "Informe del estudio petrográfico de 34 piezas arqueológicas del Templo de Quetzalcóatl, Teotihuacan, Edo. de México," in M. O. Cabrera Cortés, "La lapidaria del Proyecto Templo de Quetzalcoatl 1988–1989," pp. 337–349, Licentiate thesis in archaeology, ENAH, Mexico City.

Sánchez Hernández, Ricardo, and Jasinto Robles Camacho
2005 "Petrografía, difracción de rayos-X y propuestas de probable procedencia geológica, de la roca componente de una escultura teotihuacana." Manuscript, Subdirección de Laboratorios y Apoyo a la Investigación del INAH, Mexico City.

Sarro, Patricia Joan
1991 "The Role of Architectural Sculpture in Ritual Space at Teotihuacan, Mexico." *Ancient Mesoamerica* 2 (2):249–262.

Scott, Sue
1992 *Teotihuacan Mazapan Figurines and the Xipe Totec Statue: A Postclassic Link with the Valley of Oaxaca.* The University of Alabama, Tuscaloosa.

Séjourné, Laurette
1959 *Un palacio de la Ciudad de los Dioses (Teotihuacán).* INAH, Mexico City.
1966 *El lenguaje de las formas en Teotihuacan.* N.p., Mexico City.

Seler, Eduard
1960 "Die Teotiuacan-Kultur des Hochlands von Mexiko," in *Gesammelte Abhandlungen zur Amerikanischen Sprach- und Altertumskunde,* vol. 5, pp. 405–585. ADV, Graz.
1963 *Comentarios al Códice Borgia,* 2 vols. FCE, Mexico City.

Solís, Felipe, and Roberto Velasco Alonso
2002 "15. Anthropomorphic Figure," in *Aztecs,* pp. 404–405. Royal Academy of Arts, London.

Sotomayor Castañeda, Alfredo
1968 "Estudio petrográfico del área de San Juan Teotihuacan, Edo. de México," in *Materiales para la arqueología de Teotihuacan,* ed. J. L. Lorenzo, pp. 39–49. INAH, Mexico City.

Stirling, Matthew W.
1940 *An Initial Series from Tres Zapotes, Veracruz, Mexico,* National Geographic Society, Washington, D.C. (Contributed Technical Papers, Mexican Archaeology Series, vol.1, no. 1).

Sugiyama, Saburo
1998 "Termination Programs and Prehispanic Looting at the Feathered Serpent Pyramid in Teotihuacan, Mexico," in *The Sowing and the Dawning. Termination, Dedication, and Transformation in the Archaeological and Ethnographic Record of Mesoamerica,* ed. S. B. Mock, pp. 147–164. University of New Mexico Press, Albuquerque.
2004 "Catálogo," in *Viaje al centro de la Pirámide de la Luna: recientes descubrimientos en Teotihuacán,* pp. 43–56. CONACULTA INAH/Arizona State University, Mexico City.

Sugiyama, Saburo, and Rubén Cabrera Castro
1999 "Proyecto Arqueológico de la Pirámide de la Luna. *Arqueología, segunda época,* 21:19–34.
2000 "Proyecto Pirámide de la Luna: algunos resultados de la segunda temporada 1999." *Arqueología, segunda época,* 23:161–172.

Taube, Karl A.
1988 "A Study of Classic Maya Scaffold Sacrifice," in *Maya Iconography,* ed. E. P. Benson and G. G. Griffin, pp. 331–351. Princeton University Press, Princeton.
1992 *The Major Gods of Ancient Yucatan.* Dumbarton Oaks, Washington, D.C.

Torres Durán, V.
 1989 "Informe de la visita de reconocimiento realizada al predio No. 1, ex-hacienda San Martín, Mpio. de Acajete, Edo. de Puebla." Manuscript, Archivo Técnico del Consejo de Recursos Minerales, Mexico City.

Tovar y Teresa, Guillermo
 1991 *La Ciudad de los Palacios: crónica de un patrimonio perdido,* 2 vols. Vuelta/Fundación Cultural Televisa, Mexico City.

Trik, Helen, and Michael E. Kampen
 1983 *The Graffiti of Tikal.* The University Museum, University of Pennsylvania, Philadelphia.

Turner, Margaret Hempenius
 1987 "The Lapidaries of Teotihuacan, Mexico: A Preliminary Study of Fine Stone Working in the Ancient Mesoamerican City," in *Teotihuacan. Nuevos datos, nuevas síntesis, nuevos problemas,* coord. E. McClung de Tapia and E. C. Rattray, pp. 465–471. UNAM, Mexico City.
 1992 "Style in Lapidary Technology: Identifying the Teotihuacan Lapidary Industry," in *Art, Ideology, and the City of Teotihuacan,* ed. J. C. Berlo, pp. 89–112. Dumbarton Oaks, Washington, D.C.

Vié-Wohrer, Anne-Marie
 1999 *Xipe Totec, Notre Seigneur l'Écorché. Étude glyphique d'un dieu aztèque,* 2 vols. CEMCA, Mexico City.

Widmer, Randolph
 1987 "The Evolution of Form and Function in a Teotihuacan Apartment Compound: The Case of Tlajinga 33," in *Teotihuacan. Nuevos datos, nuevas síntesis, nuevos problemas,* coord. E. McClung de Tapia and E. C. Rattray, pp. 317–368. UNAM, Mexico City.
 1991 "Lapidary Craft Specialization at Teotihuacan: Implications for Community Structure at 33:S3W1 and Economic Organization in the City." *Ancient Mesoamerica* 2 (1):131–147.

Winning, Hasso von
 1987 *La iconografía de Teotihuacan. Los dioses y los signos.* 2 vols. UNAM, Mexico City.

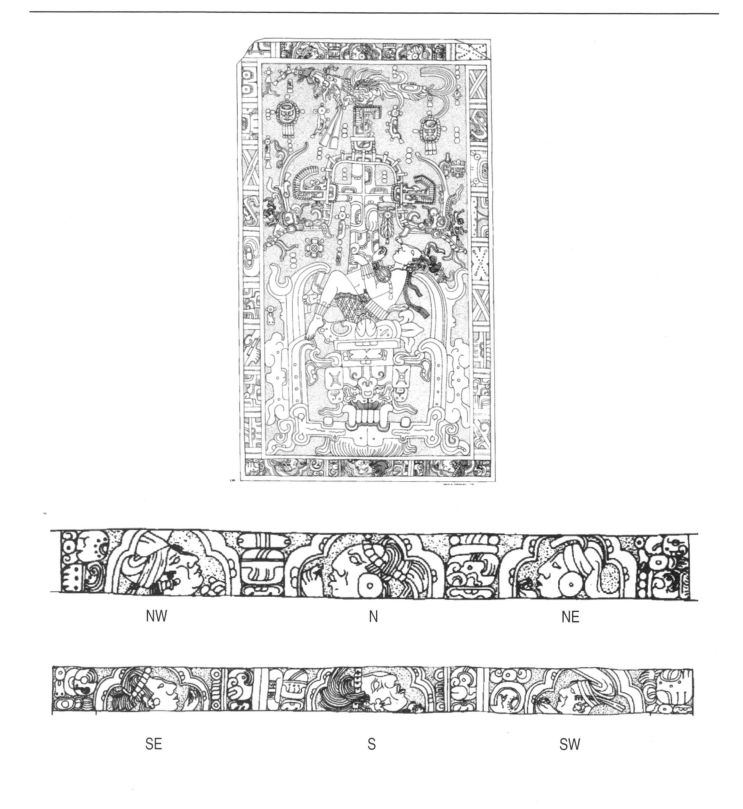

Figure 1. The Palenque sarcophagus lid with detail of the portrait cartouches on the north and south borders. From Robertson 1983, plate 99. Copyright 1970 Merle Greene Robertson. Used with permission by Merle Greene Robertson.

The stars of the Palenque sarcophagus

OSWALDO CHINCHILLA MAZARIEGOS

In his classic essay "Glifos Nominales en el Sarcófago de Palenque," Heinrich Berlin (1959) explored the question of whether the characters represented on the lid, sides, and supports of the Palenque sarcophagus were historical beings or deities. Finding support in Tatiana Proskouriakoff's unpublished work on the Piedras Negras inscriptions, he cautiously suggested that they were historical, and that the associated hieroglyphs might indicate their names. Subsequent research has proved him correct, yet has also shown that the essential problem he confronted—the dichotomy between historical beings and gods—was not crucial for the ancient Maya. The characters represented on the sides of the Palenque sarcophagus are both historical figures and deified ancestors of the deceased king K'inich Janahb' Pakal, who is himself equated with the maize god in his transit to death and rebirth.

Least understood are the characters represented on the border of the sarcophagus lid (fig. 1), which, Berlin demonstrated, are the same that appear on the legs that carry the weight of the monument (fig. 2). Current decipherment of their names and titles, coupled with their presence in other sculptures, reveals their status as nobles of non-royal rank, yet they enjoyed multiple portraits on the sarcophagus. The reasons for this are unclear. Linda Schele and Peter Mathews (1998:111) considered them as "architects and administrators that oversaw the construction and decoration of the temple and tomb," an interpretation that depended on a questionable reading of the ajk'uhuun title (Schele and Mathews 1993:113; Jackson and Stuart 2001; Zender 2004). In this article, I suggest less mundane motivations for their presence on the sarcophagus. On both the lid and legs, they were immortalized as celestial bodies. Whatever their historical role in the Palenque realm, they were elevated to the category of stars. This interpretation makes them significant elements in the cosmic symbolism of the king's burial monument, while

This research was possible thanks to support from the Popol Vuh Museum, Francisco Marroquín University. Stephen Houston, Joel Skidmore, Karl Taube, and an anonymous reviewer offered valuable comments and suggestions to earlier drafts. Special thanks are due to Merle Greene Robertson, Barbara Fash, and Liwy Grazioso for their assistance in obtaining illustration reproductions and permits. The interpretations presented in this paper are the sole responsibility of the author.

bringing up important issues for our understanding of Classic Maya notions of death and afterlife.

Names and portraits

In his original report (1958:108), Alberto Ruz Lhuillier commented that the supports were probably carved after their placement below the sarcophagus. The sculptors had to work in an awkward position, which explains the inferior quality of the carving and the fact that they didn't always follow the black carbon guidelines still observable on them. Their concealed location has also complicated their proper study. The drawings of Hipólito Sánchez Vera and Alberto García Maldonado, published by Ruz Lhuillier (1958:109; 1973:180), remain the only available (fig. 2), while both he and Merle Greene Robertson (1983) published oblique photographs that show the portrait heads but not the hieroglyphic captions. The masonry abutments that surround the sarcophagus largely hide the inscribed sides from view (fig. 3).

Table 1 summarizes the characters' names and the locations where they appear. Berlin's identification of four characters was upheld by Robertson and David Kelley's inspection of the legs (Robertson 1983:64). Schele and Mathews (1998:111) saw only three, suggesting that the central characters on the north and south borders of the sarcophagus lid were the same. Their portraits resemble each other, but the prefixes in their respective name captions, chak and possibly yax, seem enough to distinguish them as separate characters, unless the variation is due to the hasty execution of the border, pointed out by Robertson (ibid.:63). The chak prefix is also distinct on the northwest leg, but the available drawing of the southwest leg is not detailed enough to clarify this issue. Berlin's identification of four characters remains plausible, despite the fact that the name Yax Chan is not attested elsewhere in contemporary Palenque inscriptions, while those of his three companions are.

Noting consistent variations in their appearance—headdresses and jewelry—and their name clauses, Berlin deduced that these were portraits of historical individuals. Current decipherment of their names and especially their titles validates his interpretation. Ajk'uhuun and sajal are among the best-documented titles borne by nobles of secondary rank in the Classic

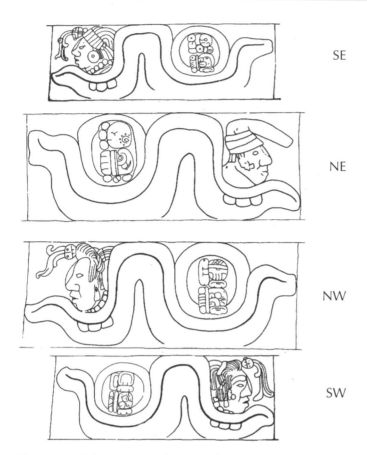

SE

NE

NW

SW

Figure 2. Relief carvings on the sarcophagus legs. Drawings by Hipólito Sánchez Vera and Alberto García Maldonado after Ruz Lhuillier 1958. Reproduction authorized by the Instituto Nacional de Antropología e Historia.

Maya political hierarchy. Both were subordinated to the *ajaw*. The *sajal* title is frequently associated with governors of peripheral centers, but Houston and Stuart (2001:61–64) show that it was also used by noble residents of primary centers. The precise roles of the *ajk'uhuun* are less clear. In a detailed study of the compound, Jackson and Stuart (2001) acknowledge the plausibility of Coe and Kerr's (1997) reading as *aj k'uhul huun*, "he of the holy books/papers/headbands," while proposing the reading ajk'uhuun, "one who keeps, guards" or "one who worships, venerates." Marc Zender (2004) argues for a straightforward translation as "worshipper," and identifies the *ajk'uhuun* as priests, often associated with writing, the instruction of noble children, and the role of palace chaplains. The holders of both titles were important members of Classic Maya nobility, and they are portrayed in a variety of courtly

scenes, on pottery, mural paintings, and sculptures. Some of them commissioned the creation of monuments and inscriptions where they normally acknowledged vassalage to their masters, using the possessed forms of their titles to indicate their status as "the *sajal* of" or "the *ajk'uhuun* of" their kings. Such relationships seem to have been close and personal, sometimes continuing after the king's death (Jackson and Stuart 2001:225).

Other inscriptions provide details on the eminence of these characters and their relationship with Pakal.[1] In his study of Maya priesthood, Zender (2004:292) highlights the presence of *Chak Chan* and "Jewel" *Muut* on a fragmentary panel, stylistically dated to ca. A.D. 650. According to the text, they assisted K'inich Janahb Pakal in an attack against an unknown site. The name of *Chak Chan* also appears on a fragmentary stone *incensario* found in the Palenque Palace (ibid.:309–310).[2] While its dating is uncertain, Zender suggests that both sculptures were shattered during a memorable defeat suffered by Palenque at the hands of Calakmul, probably in A.D. 654. A roughly contemporary monument, the censer stand portrait head found by Roberto López Bravo (2000) in Group IV includes a statement of the accession of *Yuk Mak'abajte* to the rank of *yajawk'ahk* on the date 9.8.17.10.17 (A.D. 610).[3] Zender (2004:210) interprets *yajawk'ahk* as "an office of warrior priests who were also charged with making incense-offerings to the gods, and presumably for maintaining temple fires and elaborate effigy censers." *Yuk Mak'abajte* did not use this title on the sarcophagus, where he is ranked as a *sajal,* a title that he may have obtained sometime during the interval between the carving of both monuments (ibid.).

These readings allow recognition of these characters as noblemen, members of Pakal's court, who played paramount roles in the site's priesthood and deployed their services in military campaigns. Such noblemen were important throughout the history of Palenque, where they seem to rise in importance and visibility during the last stages of the site's history (Bernal Romero 2002; Miller and Martin 2004:210). Yet their high rank

1. Special thanks are due to Joel Skidmore, who pointed out to me the presence of these characters in other inscriptions and kindly provided relevant texts and images.

2. Porter (1994) suggested that this was a fragment of a much later monument, the "Lápida de la Creación," originally the back of a throne at the base of the Palace tower.

3. Ringle and Smith-Stark (1996:24–25) propose an alternative reading for the dates on the Group IV head in which the accession of *Yuk Mak'abajte* would take place on 9.11.10.5.14 (A.D. 662).

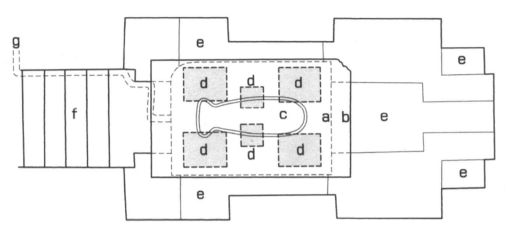

Figure 3. Plan of the Temple of the Inscriptions Burial Chamber showing the location of the sarcophagus legs. (a) Sarcophagus. (b) Lid. (c) Burial cavity. (d) Legs. (e) Abutments. (f) Stairway. (g) Psychoduct. Drawing by the author, based on Ruz Lhuillier 1973.

Table 1

Name	Lid	Supports
Chak Chan Ajk'uhuun	North center	Northwest
Yax(?) Chan Ajk'uhuun	South center	Southwest (?)
"Jewel" Muut Ajk'uhuun	Northeast Southeast	Southeast
Yuk Sajal	Northwest Southwest	Northeast (Name spelled as *Yuk ma-?-k'abate*)[4]

and offices tell only part of the story. Analysis of their associated stellar symbolism is crucial to grasp the full significance of their presence on Pakal's sarcophagus.

Stellar symbolism

On the north and south borders of the sarcophagus lid, the portraits emerge from partly visible quatrefoil openings. The shape is commonly associated with caves, but quatrefoil openings may also house celestial beings, such as the moon god on Quirigua Altar R. On the sarcophagus, they are fully integrated into the skyband that frames the scene. Their apparent dissociation, perhaps suggested by the fact that they occupy the

entire southern border, is contradicted on the north side, where the skyband turns on both corners to encircle the scene. On the southern border, the openings are separated from each other by twin bands, identical to those that separate every other segment of the skyband. Space restrictions may have dictated the absence of separators on the north side, where the portraits seem to occupy a single segment of the skyband, between the *ak'bal* and *k'in* segments on the corners.

By itself, the noble portraits' manifestation as skyband segments betrays their heavenly nature. Skybands are known to substitute for the body of the Cosmic Monster, a representation of heaven itself, or perhaps the Milky Way (Carlson and Landis 1985; Stuart 2003a). The individual segments of skybands contain celestial symbols, usually separated from each other by twin bands. These include major celestial bodies such as the sun and the moon, alternating with other celestial

4. In the text, I use the phonetically transparent spelling yu-ku-ma-k'a-ba-ja-te, *Yuk Mak'abajto*, as attested on the Palenque Group IV head.

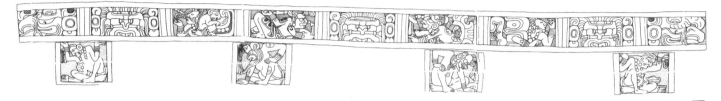

Figure 4. The skyband bench from Group 8N-11, Copán. Drawing courtesy of Barbara Fash, Copán Mosaics Project and Instituto Hondureño de Antropología e Historia.

symbols apparently of a more general nature, such as *ak'bal,* "night," *ek',* "star," or *chan,* "sky." In most skybands, these are symbolic forms, but several examples feature animated, full-bodied beings. On the "skyband bench" of Group 8N-11 at Copán (Webster et al. 1998), each segment contains a full-figure depiction of a celestial deity (fig. 4). The "sun" segment is personified as the sun god, whereas the "moon" segment is a young moon god. The jaguar god with *ak'bal* markings on arms and legs most probably substitutes for the symbolic *ak'bal* sign, suggesting that the latter may represent this particular god in other skybands as well. A young scorpion-tailed god embracing a large *ek'* sign substitutes for the symbolic *ek'* segment.

Further examples of personified segments in skybands include the characters associated with *ek'* signs that populate the frieze of the Monjas building at Chichén Itzá, long ago identified as constellations by Herbert Spinden (1916). Elsewhere, the moon god and the moon rabbit respectively substitute for the lunar segments of skybands on Piedras Negras Stelae 10 and 11 (fig. 5a–b). Yet another example appears in the very same building that shelters Pakal's tomb. The skyband on Pier B of the Temple of the Inscriptions shows a deer poking his head out of the center of an *ek'* sign (fig. 5c), possibly representing the deer constellation (Milbrath 1999:264; Chinchilla Mazariegos 2005). These cases suggest that skyband segments correspond to heavenly bodies that are most often represented by symbolic signs, while sometimes they take animated forms as celestial beings.

Individual segments often repeat more than once in a single skyband, a pattern that fits well with the repetition of the noble portraits on the sarcophagus lid. Instead of symbolic forms of celestial bodies, these segments contain personified, individualized heavenly characters emerging from quatrefoil openings in the sky. Their nature as celestial bodies is made explicit on the sarcophagus legs.

Six legs raise the sarcophagus 45 cm above the floor of the burial chamber (fig. 3). Two of them are plain cubes placed in the medial section, while those near the four corners are rectangular in plan view, with their long sides aligned with the sarcophagus. The relief carvings wrap around their outer sides, measuring 60 x 45 cm and 80 x 45 cm (Ruz Lhuillier 1973:85). The designs run across both surfaces, covering a total of 140 x 45 cm on each leg. The asymmetry is relevant, because it explains the odd shape of the ek' signs represented on the legs (fig. 2). They were described by Ruz Lhuillier (1958:106) as "elementos serpentiformes" and later as "probable serpent stylization, provided with ventral scales and forming a double undulation" (1973:124).[5] A closer look reveals that these are *ek'* signs, carved in such a way that their middle axes coincide with the legs' outer edges. Their proportions were based on the space available on the long side of each leg. Therefore, they simply did not fit in the short sides. The sculptors solved this problem by reducing the ends of the *ek'* signs, a solution that also freed space to carve the details of the faces and headdresses. Interestingly, the asymmetry extends to the circular droplets that frequently adorn the *ek'* volutes, which appear only on one side, underneath the portrait heads. The rings of the *ek'* sign are not entirely absent. They encircle the hieroglyphic captions on the long side of each leg. On the short sides, they are completely substituted or concealed by the portrait heads.

The conflation of the portraits and name captions with *ek'* signs is an unambiguous statement on the nature of these personages. They are celestial bodies—stars, planets, or constellations. Throughout Maya art, *ek'* signs mark a variety of supernatural characters as incarnate celestial bodies. The *ek'* sign is known to associate with a host of heavenly bodies, including planets, constellations, and perhaps individual stars

5. All translations from Spanish texts were made by the author.

a b

c

Figure 5. Personified segments in skybands. (a–b) Moon segments from Piedras Stelae 10 and 11, personified as the moon god and the moon rabbit. Drawings by David Stuart from *Corpus of Maya Hieroglyphic Inscriptions,* vol. 9, part 1, *Piedras Negras.* Reproduced courtesy of the President and Fellows of Harvard College. (c) Deer head in sign, Pier B of the Temple of the Inscriptions, Palenque. From Robertson 1983, figure 21. Copyright 1970 Merle Greene Robertson. Used with permission by Merle Greene Robertson.

(Spinden 1916; Kelley 1976; Lounsbury 1981). Celestial beings marked with *ek'* signs include known gods, animals, and a variety of little-known, often grotesque supernaturals (Chinchilla Mazariegos 2005).

Ek' signs may simply attach to the body of these beings, on their back or on their rear forearm, as if emerging from the armpit—the usual position of the moon sign in lunar gods (figs. 4 and 6a). Beyond this, artists employed a variety of creative solutions. Oversized *ek'* signs may substitute for the entire body of stellar beings (fig. 6b). This solution goes back to the Preclassic period, as shown by one of the earliest known representations of celestial bodies, an unidentified animal emerging from an ek' sign on the upper register of the San Diego cliff carving (fig. 6c). Elsewhere, stellar beings pull arms and legs through the rings of *ek'* signs (figs. 4 and 6d). These solutions are akin to the compositions on the sarcophagus legs, where both the portrait heads and the hieroglyphic captions may be interpreted as emerging from the *ek'* rings.

Human beings are not usually marked with *ek'* signs, although there are celestial characters with essentially human features, such as the human-like personages depicted as constellations on the murals of Bonampak Room 2. Their poor preservation makes it difficult to ascertain whether they had other supernatural attributes. The *ek'* glyph does appear with some frequency in personal names of historical individuals, who were probably named after celestial bodies without necessarily implying that they were regarded as celestial bodies. The figures of the Palenque sarcophagus are essentially different because their personal names do not include the word *ek'.* Instead, their names and faces have become part of *ek'* signs. They have acquired the supernatural quality of stars. As such, they overlook Pakal's transit to death from their places in the skyband—that is, from heaven.[6]

Stars and souls in Mesoamerica

The Palenque sarcophagus is acknowledged as an extraordinary depiction of key elements of Classic Maya religion, "the iconographic statement of a belief system whereby a king dies, but a god is born. It does even more than that; the iconographic content states the Maya belief in three worlds, the world of the living, the world of the dead and the heavens above" (Robertson 1983:56–57; see also Schele and Miller 1986:268–269). What is the role of non-royal noblemen in such major cosmic display? Their presence seems almost anticlimactic, without recognition of their stellar nature. In this light, they become integral elements of the cosmogram as denizens of the superior, celestial plane. Moreover, their presence on the sarcophagus legs is unlikely to be haphazard. From there, they literally sustain the king through eternity.

Why were they accorded such honor? In conformity with the mortuary program of the sarcophagus, it may be assumed that they were dead by the time of Pakal's burial, just like every other character depicted on the monument. While there are few indications on their biography, we know that they were active in the early years of Pakal's reign and perhaps even before his

6. Berlin (1959:4) suggested that these four characters were somehow associated with the cardinal directions. While the associations are not entirely consistent, particularly in the case of *Yuk Mak'abajte Sajal,* a directional pattern may be relevant for their identification as stars. Moreover, it may relate with the apparent color symbolism associated with the names *Chak Chan* and *Yax Chan.*

Figure 6. Stellar beings in Maya art. (a) Deer with *ek'* sign on the back. Vase of the Stars, Museo Popol Vuh, Universidad Francisco Marroquín. Drawing by the author. (b) Stellar being with body substituted by *ek'* sign, incised on a miniature bottle. Drawing by the author, after Muñoz Cosme et al. 1999: 156. (c) Unidentified being emerging from *ek'* sign, San Diego Cliff Carving. After field drawing by Ian Graham, reproduced with permission. (d) Deer pulling leg through *ek'* sign, painted on codex style vase. Drawing by the author, after Robicsek and Hales 1981, Vessel 164.

accession in A.D. 615. *Yuk Mak'abajte* reached the rank of *yajawk'ahk* as early as A.D. 610, that is, seventy-three years before the king's death.[7] During their lifetime, they were prominent members of Pakal's court, in which case, there is also a probability that their master outlived them, judging from his extraordinary longevity (Mathews and Schele 1973). This conjecture is relevant to explain their stellar quality. Likely, these noblemen were regarded as celestial bodies only after their deaths.

J. E. S. Thompson (1960:85) asserted that "the Maya definitely associated the dead with stars and with insects." The belief that human souls become stars after death is still present in the Guatemalan highlands (Barbara Knoke de Arathoon, quoting an informant from Nahualá, personal communication 2005). It has been repeatedly documented in the Lake Atitlán region. According to information gathered by Sol Tax at Panajachel, "there is a clear notion that when a person dies he becomes a star. The better the person, the bigger the star. There is also a notion that when a baby is born, it is one of the stars in the sky come back to earth as the soul of a person" (cited in Thompson 1960:85). Recently, Stanzione (2003:185–186) described the destiny of the *Nawal Winaq*, principal men and women who reached the top of the traditional civil-religious hierarchy at Santiago Atitlán after serving their duties for a lifetime: "These beings at death ascended the greatest mountain of all as they entered the white road of the night sky as stars in the Milky Way, companions of the nighttime sun in his journey through the land of the dead."

Rafael Girard (1966:236) gathered testimonies from Chorti religious leaders, who specified that the spirits of the dead rise to the stars to join the entourage of the sun, formed by forty thousand men, forty thousand women, and forty thousand children. Girard related this belief to the myth of the four hundred boys of the *Popol Vuh*, who rose to heaven as a constellation to become the companions of the sun and the moon. In the Chorti ritual cycle, the feast of the dead is dedicated to the sun god (ibid.:230–232). Before reaching the house of the sun, souls undergo trials and suffering in the underworld, which they overcome with the help of mortuary offerings made by their relatives.

In highland Chiapas, there are persistent beliefs in diverse destinies for human souls, according to the circumstances of their deaths, as reported by Guiteras Holmes (1986:127) among the Tzotzil of San Pedro Chenalhó. Newborn babies and young children are believed to live in a tree that nourishes them with its abundant breasts. The souls of women who die during childbirth, those struck by lightning, the drowned, and the murdered go to *Winajel*, "a place located in the sun that travels with it through heaven and under the earth" (ibid.). Otherwise, souls must go across a river to hell, undergoing a painful transit before reaching *Katibak*,[8] a

7. See note 3. Even if the accession of *Yuk Mak'abajte* took place in A.D. 662, there is ample time between this event and Pakal's death in A.D. 783 to allow speculation about his possible demise before Pakal's death.

8. Various spellings for the names of supernatural places used in the cited literature are respected in this paper.

paradisiacal place where they join their relatives in abundance and happiness. Yet at Chenalhó there is no explicit characterization of *Winajel* souls as celestial bodies, and, in fact, Guiteras Holmes states that stars are insignificant for human life in this community (ibid.:221). In Zinacantán Tzotzil, the word *Winajel* means "heaven," or, perhaps more specifically, a quadrilateral space with three layers, corresponding to the female moon, the stars, and the male sun (Laughlin 1975:370; Vogt 1969:297). A Tzeltal informant from Oxchuc described *Winajel* as the heavenly seat of Jesus Christ: "El *Tatik* Jesucristo . . . tiene su asiento en el Uinagel, que está situado en el Cielo" (Villa Rojas 1990:649).

Pozas Arciniegas (1987: 2:232–240) found analogous beliefs in San Juan Chamula, where the souls of children who die while breastfeeding are constantly nourished by the multiple breasts of a great tree in heaven. The realm of the dead is known as *Olontic,* and *Katimbak* is the jail located in *Olontic,* destined for sorcerers and murderers. However, "those who die murdered go to heaven, where is Chultotic [the sun god]" (ibid.:240; also Gossen 1979:118).

The Tzeltal of Cancuc also believe that souls go to *K'atinbak,* but they describe it as a cold, underground place without sunlight (Pitarch Ramón 1996:53–54). Infant souls go to a nourishing place located somewhere between heaven and earth. Another possible destiny is the underground residence of the lord of the mountain, reserved for the murdered and drowned. Finally, several informants reported that the souls of the murdered, suicides, and those killed in wars rise to heaven where they walk together with the sun and with the souls of the saints that were burned during the Mexican revolution. "It is possible that they are the stars" (ibid.:54).

To summarize, widespread beliefs among the contemporary Maya posit a solar destiny for certain human souls, which in some cases are explicitly associated with the stars. Such a destiny is frequently accorded to the souls of those who suffer violent deaths, and, in some cases, prominent members of the community. Similar notions were widespread in ancient Mesoamerica, as documented in the testimonies gathered by friar Francisco de Bobadilla among the Nicarao in 1528 (León Portilla 1996:160). Babies who died before weaning were eventually reborn in their parents' house. The souls of the ordinary dead were believed to go to *Miktanteot,* under the earth, while those who died in war went up to the place of the gods, "where the sun rises" (Fernández de Oviedo 1959:370–371).

The sixteenth-century Mexica also conceived the existence of several possible destinies for souls. López Austin (1984:378–387) gathered the information on the various possible afterlives mentioned in sixteenth-century central Mexican sources. Among others, Sahagún's informants asserted that the destiny of the souls of rulers and nobles was different from that of commoners. In his Spanish text (1982:611) he wrote: "y creían los antiguos, engañándose, que los señores cuando morían se volvían en dioses, lo cual decían porque fuesen obedecidos o temidos los señores que regían, y que unos se volvían en sol y otros en luna, y otros en otros planetas."[9] The souls of warriors who died in the battlefield, and those that were captured and sacrificed were believed to reside in the house of the sun:

> The brave warriors, the eagle-ocelot warriors, those who died in war, went there to the house of the sun. And they lived there in the east, where the sun arose. And when the sun was about to emerge, when it was still dark, they arrayed themselves, they armed themselves as for war, met the sun as it emerged, brought it forth, came giving cries for it, came gladdening it, came skirmishing (Sahagún 1969:162).

Seler (1996:41–45) argued that these spirits were conceived as stars, since warriors and sacrificial captives appear in the codices with the facial painting characteristic of stellar gods. He highlighted their resemblance with the stellar beings that fought in primeval wars around the time of the birth of the sun—the four hundred *mimixcoa* that were defeated by Mixcoatl, and according to the Codex Chimalpopoca, by his son, Quetzalcoatl (Bierhorst 1992:154). The death of these heavenly warriors provided the sun for the first time with blood and hearts, the necessary sustenance to pursue his journey (Seler 1996:49–52). Earthly warfare was conceived as a reenactment of such primeval conflicts. There are indications that the Classic Maya had a similar myth of primeval heavenly conflict, which later found expression in the story of the four hundred boys of the *Popol Vuh* (Chinchilla Mazariegos 2005).

Like other Mesoamerican peoples, the Classic Maya probably believed in separate destinies for human souls, and there are hints that captive warriors were sometimes elevated to celestial status. At Bonampak, there are

9. The Nahuatl text does not mention the planets: "And thus [the ancients] deluded themselves so that those who were rulers would be obeyed. All were worshipped as gods when they died; some became the sun, some the moon, etc." (Sahagún 1961:192).

Figure 7. Sides 2 and 4 of Toniná Monument 8. Drawings by Peter Mathews from *Corpus of Maya Hieroglyphic Inscriptions,* vol. 6, part 1, Tonina. Reproduced courtesy of the President and Fellows of Harvard College.

captives painted on the upper celestial plane of Room 2, but despite their human appearance, there is no certainty that they were intended to represent dead human beings. More compelling is Toniná Monument 8, which shows three captives encircled by the coils of the Cosmic Monster, whose body is partly serpentine and partly substituted by skyband segments (fig. 7). Two of the captives kneel on the front and back heads of the monster. According to Taube (1988:346), the monument probably sustained a pole used for captive sacrifice, and it is akin to celestial scaffolds where the kings sat during accession rites, thus assuming the role of captive warriors. Not only are the captives on Toniná Monument 8 represented in heaven, but they also appear to have become part of it, judging from the fact that their name tags occupy segments of the skyband. While this may be the result of the sculptor's fancy, it is more likely a deliberate way of indicating their heavenly status. The parallel with the characters on the sarcophagus lid is made even stronger by the fact that one of the captives on Toniná Monument 8 bears the *ajaw* title. These are lordly warriors elevated to heaven, most probably after their defeat and sacrifice. Virginia Miller (1989) also highlights the presence of warriors associated with star symbols at Chichén Itzá, as well as Tula, Hidalgo, and other Mesoamerican sites.

The characters on the sarcophagus do not exhibit obvious warrior attributes, but we do know that they were warriors in life. As described, Chak Chan participated in the attack commemorated in a fragmentary panel, while *Yuk Mak'abajte* held the office of *yajawk'ahk,* a priestly warrior, as interpreted by Zender (2004). We ignore the circumstances of their death, but the possibility that they may have suffered the fate of captive warriors cannot be ruled out. Be that as it may, their associated stellar symbolism may be explained in terms of a belief in the transformation of prominent dead and warriors into stars.

The apotheosis of Pakal

The parallels with contemporary Maya and sixteenth-century Mexica beliefs acquire further significance considering that in Classic Maya art, royal ancestors were often apotheosized as the sun and the moon (Taube 2004a, 2004b:79). In this guise, they frequently occupy locations known as "solar cartouches" or "ancestor cartouches," supernatural openings framed on four corners by skeletal centipede heads, which provide settings for the appearance of the sun god (fig. 8a), and sometimes moon gods as well. Major examples were featured in the mosaic sculptures of the facade wall extending between Structures 1B-3 and 1B-4 at Quirigua (fig. 8b) (Coe and Sharer 1979:18, fig. 6).

The skeletal centipede first identified by Grube and Nahm (1994) is closely associated with the sun god, who sometimes wears a centipede headdress (Taube 2003:410). Citing unpublished work by Erik Boot, Simon

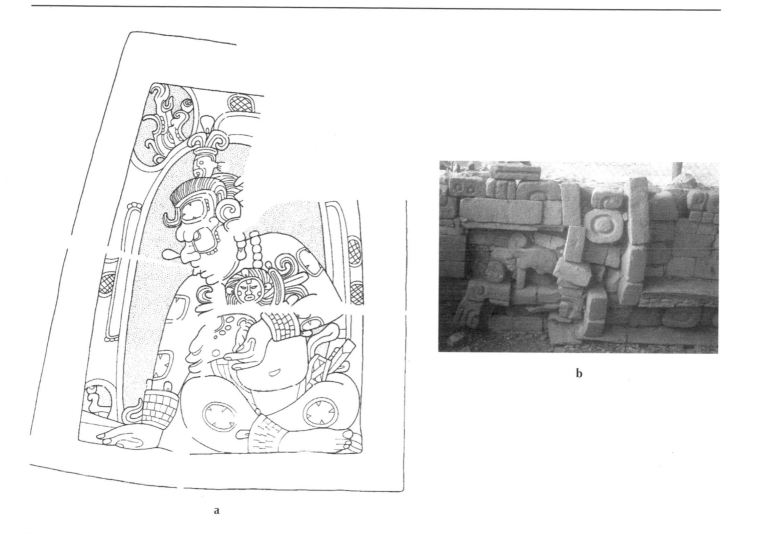

a

b

Figure 8. Solar cartouches. (a) Sun god within solar cartouche. Dos Pilas, carved blocks from Structure N5-21. Drawing by the author. (b) Skeletal centipede from mosaic solar cartouche on façade wall between Quirigua Structures 1B-3 and 1B-4 (note misplaced elements). Photo by the author.

Martin notes the hieroglyphic epithet *wuk chapat tz'ikin,* "seven centipede eagle" associated with *Yax Ehb Xook K'inich Ajaw,* the name of the Tikal dynastic founder. "This would be the name of a particular solar god, very likely a deified form of the Tikal founder" (Martin 2005:6). Some of the greatest Maya kings, including *Nuun Yax Ayiin* at Tikal and the dynastic founder *K'inich Yax K'uk' Mo'* at Copán, were apotheosized as sun gods (fig. 9a) (Taube 2004a:286; 2004b:79).

Male royal ancestors depicted in solar cartouches occupy the position of the sun god himself, his glorious seat and residence. Essentially, they play the role of the sun god, and become identified with him. In the same position, deceased queens are sometimes equated with the moon goddess (fig. 9b) (Taube 2004b:79). The subject is ubiquitous at Palenque. House A of the palace has a badly preserved gallery with thirteen solar cartouches that likely contained the apotheosized images of as many dynastic ancestors (fig. 10a). The building is replete with solar imagery. On the stuccoes of Piers C and D, the headdresses of Kan B'alam II and possibly his father, Pakal, include skybands ending with sun god images (fig. 10b) (Robertson 1985:4–5). Another gallery of solar cartouches once extended along the basement wall of the west court of the palace (fig. 11). The stuccoes are almost completely gone, but the stone frameworks of seven cartouches are still visible (ibid.: 74–76, fig. 357ff.). The best-preserved cartouches

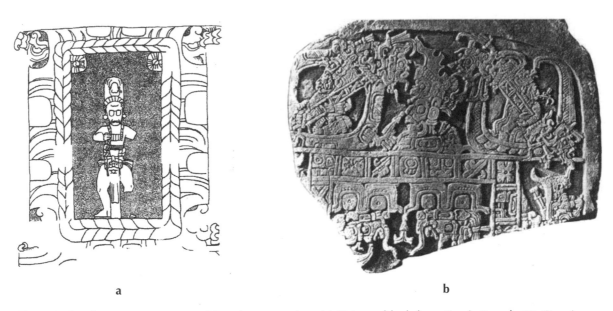

a b

Figure 9. Royal ancestors represented in solar cartouches. (a) Stairway block from Copán Temple 16. Drawing by Karl Taube, reproduced with permission. (b) Solar and lunar ancestors associated with skyband. Heads of the Jaguar god emerge from star signs attached to the skyband. Yaxchilán Stela 4, upper section. From Teobert Maler, *Researches in the Central Portion of the Usumatsintla Valley*, Peabody Museum Memoirs vol. 2, no. 2, 1903. Reprinted courtesy of the Peabody Museum, Harvard University.

suggest that each contained two human profile faces and a central front-facing character with the attributes of the sun god. Taube (2004b:79) notes that the attached quetzal birds probably symbolized the richness and beauty of solar paradise. Instead of centipedes, these cartouches had fret-nosed serpents, creatures that symbolize the floral breath of both the sun god and deified royal ancestors (Taube 2003:432).[10] Most relevant for this inquiry are the stellar beings that flank the southernmost cartouche, a peccary and the god K'awiil, both pulling arms and legs through the rings of large *ek'* signs (fig. 11). Similar figures flanked the other cartouches, judging by the hourglass-shaped armatures placed between them. Thus, stellar gods seemingly stood guard for the solar and ancestral images represented inside the cartouches.

The association of stars with solar cartouches is also patent on Yaxchilan Stelae 1, 4, 6 and 11. The parents of king Bird Jaguar IV occupy solar cartouches above skybands studded with heads of the jaguar god, who is, among other things, a prominent stellar being

(Chinchilla Mazariegos 2005).[11] Most explicit is Stela 4 (fig. 9b), where the heads of the jaguar god emerge from *ek'* signs attached to the skyband. Once again, stars are closely associated with apotheosized ancestors, as if escorting them through heaven. Analyzing the mortuary symbolism of these monuments, Fitzsimmons (2002:114) notes: "The placement of Itzamnaaj Bahlam II and Lady Ik' Skull within the sky, as both sun and moon, indicates that Bird Jaguar IV saw his mother and father—dead at the time of the commission of each of these monuments—as having undergone a transformation into 'heavenly' bodies, residing in a place with other gods of the Classic Maya pantheon."

A revealing case involves the solar apotheosis of the great king *Ukit Kan Le'k,* who ruled Ek' Balam for several decades, probably between A.D. 770 and 814, according to Alfonso Lacadena's scrutiny (2002).[12] The

10. Further examples of solar cartouches associated with fret-nosed serpents appear on the murals of the temple of the jaguars at Chichén Itzá.

11. I use the term "jaguar god" to avoid the connotations implicit in this character's common designation as "jaguar god of the underworld." A related god, named *took'al ajaw,* also appears between the sun and moon cartouches on Yaxchilán stela 4 (Stephen Houston, personal communication, 2005).

12. Karl Taube brought to my attention the Ek' Balam monuments and their relevance for this argument.

a

b

Figure 10. Solar imagery from House A of the Palace, Palenque. (a) Probable ancestor cartouches 3, 10, and 13 from eastern room wall (note avian stellar being that is marking cartouche 3). (b) Details of headdresses from Piers C and D, most likely corresponding to portraits of Pakal and his son, Chan Bahlam. From Robertson 1985, figures 119a, 134a, and 138a. Copyright 1970 Merle Greene Robertson. Used with permission by Merle Greene Robertson.

painted cover of vault 15, apparently associated with the room that contained his burial, portrays the king in the guise of the maize god, with associated glyphs that tell his identity. Another posthumous monument, Column 1, dedicated on the baktun-ending 10.0.0.0.0 (A.D. 830), relates the deceased king with the mythical emergence of the maize god from a turtle, portrayed on the monument. The king's apparent identification with the maize god somehow changed by the time of the erection of Stela 1, on 10.0.10.0.0 (A.D. 840). The upper register of the monument shows him armed as a warrior, seated inside a solar cartouche that rests on a skyband, presiding over the standing portrait of the current king. The associated text declares "this is the image of the sacred kalo'mte' Ukit Kan Le'k" (ibid.), and yet he is now portrayed in the guise of the sun god. As will be shown, the king's transformation into the maize and sun gods, apparently in succession, may find an explanation in the mythical narratives of the origin of the sun.

On the Palenque sarcophagus lid, Pakal is being swallowed by the skeletal centipede (Grube and Nahm 1994:702). The dreary opening is often identified as the maw of the underworld, but that was not the ultimate destiny of the king's soul. Schele and Miller (1986:269) correctly explained this as the metaphorical equivalent of the sun falling down at sunset, only to remerge after his triumph over the lords of death. Their interpretation followed Coe's (1975) argument that deceased Maya kings essentially followed the mythical path of the hero twins of the *Popol Vuh*, undergoing the trials of the underworld. As noted, a similar belief survived among the twentieth-century Chorti (Girard 1966:233–234). Following these mythical sequences, the ultimate destiny of kingly souls was not to remain in the realm of the death lords. Instead, they entered the solar paradise of the exalted dead, to occupy a place with their ancestors. In essence, Pakal will be apotheosized as the sun god. This is the destiny of royal persons, as shown by their

Figure 11. Southern section of the stucco frieze from the West Patio of the Palace, Palenque, cartouches 1 and 2. From Robertson 1985, figure 358. Copyright 1970 Merle Greene Robertson. Used with permission by Merle Greene Robertson.

portraiture within solar cartouches at Palenque and elsewhere.[13]

Royal ancestors within solar cartouches are sometimes associated with "Flower Mountain," a place of abundance and beauty, recently identified in Classic Maya iconography by Karl Taube (2004b). This paradisiacal place was closely associated with the rising sun, the east, and the souls of ancestors. Taube notes its close analogy with the "house of the sun" of Central Mexican mythology. The heavenly solar paradise is implied both by the skyband that encircles the sarcophagus and by the precious objects floating or falling in the blank spaces of the composition. This rain of floral jewels is consistently associated with celestial paradise in Maya art (ibid.:78–79).

Furthermore, the king rests on the "quadripartite monster," currently recognized as a sacrificial bowl (Schele and Mathews 1998:113). In a recent paper, Taube (2005) highlights its resemblance with the Aztec *quauhxicalli*, the receptacle for sacrificial hearts. He interprets such containers as symbolic wombs that give birth to the sun through sacrifice. In this light, Pakal himself rests as a sacrificial victim, whose death will ultimately allow the birth of the sun. Indeed, the

symbolic sacrifice of Pakal parallels the self-immolation of Nanahuatl in a pyre from which he reemerged as the sun in Central Mexican mythology, as well as the self-immolation of the hero twins of the *Popol Vuh* in an oven at Xibalba, an episode that prefigures their rising to heaven as the sun and the moon. Still prevalent in traditional communities throughout Mexico, this episode is also attested ethnographically in the Maya area among the Tzotzil of Venustiano Carranza, Chiapas (Díaz de Salas 1963:260; see also Graulich 1987).

Yet Pakal's portrait on the sarcophagus does not exhibit obvious sun god features. Ruz Lhuillier (1973:225–226) first argued that it incarnates the young maize god, while other authors have noted that his portrait combines the features of the maize god and K'awiil. Taube (1992:48) suggested that this special form of the god "may represent corn as the idealized ancestor." This apparent discrepancy finds an explanation in widespread Mesoamerican myths that recount the ordeal of the maize hero.[14] Of special concern here are the versions where the hero's ultimate destiny is to become the sun (Graulich 1987:310–311; Braakhuis 1990:125–127). Such transformation happens in Totonac myths recorded by Kelly (1966:396) and Münch (1992), where the maize hero attained his solar destiny by throwing himself into a great fire. Likewise, the nahua solar hero Nanahuatl was a provider. According to the Codex Chimalpopoca (Bierhorst 1992:147) he opened Food Mountain to steal maize and other cultigens before his solar transformation through fire.

13. The solar symbolism associated with Classic Maya kingship was also implied by the *k'inich* title used by Pakal and many other Classic Maya kings (Stuart 1996:166). However, it should be noted that deceased kings may also be represented as impersonators of other gods, as noted by Fitzsimmons (2002:74–77). The evidence presented in this paper contradicts Milbrath's (1999:234, plate 10; 2002) proposition that the sarcophagus lid shows Pakal apotheosized as Jupiter, based on her association of God K images with astronomical events involving this planet, including the date of Pakal's death inscribed on the sarcophagus lid. Milbrath (ibid.:83–87) also summarizes evidence on solar symbolism associated with Maya kings.

14. For detailed revisions of this mythic cycle and its numerous variants, see Graulich 1987; Braakhuis 1990; López Austin 1992.

a

b

Figure 12. (a) The Death Vase in the collection of the Ethnographic Museum of Berlin, Germany. Modified from rollout drawing by Stephen D. Houston, with permission. (b) Detail of solar cartouche above the deceased ruler. Drawing by the author, after photograph in Grube et al. 2000:310.

In the Maya area, the subject appears in the Chortí maize hero myth (Girard 1966:275–277) and in the *Popol Vuh* narrative of the hero twins, who share the essential features of maize heroes throughout Mesoamerica (Braakhuis 1990). In both, the heroes meet their solar destiny after defeating the evil lords that had previously killed their father. The version of the Chorti myth published by Girard is unambiguous about the hero's power to generate maize.[15] In the *Popol Vuh*, the twins' identity is subtly revealed by the signal they left to their grandmother—maize stalks or ears of unripe

maize that would dry if they were killed—and by their instructions for the disposal of their bones at Xibalba: "It would be good if they were ground upon the face of a stone like finely ground maize flour" (Christenson 2003:160, 177; Carlsen and Prechtel 1991:31–32).

The twins' resurrection from the ground ashes of their bones recalls the remarkable scene engraved on the Early Classic Death Vase in the collection of the Ethnographic Museum of Berlin (fig. 12). A solar cartouche with a combined image of the sun and the moon hovers above a deceased ruler, shown in the guise of the maize god, with Flower Mountain in the background. The other side of the vase shows the rebirth of the ruler as a tree that rises from his skeleton, once again at Flower Mountain. Taube (2004b:79) interprets these as "the two common Classic Maya themes of rebirth and apotheosis: the resurrection of the maize god

15. Girard summarized a version of this myth that was compiled by Helen Inez Oakley. Fought (1985:136, 144) also refers to the hero as the sun god. Kerry Hull (2003:222–224) provides valuable information on the myth and its versions without making explicit reference to the solar transformation of the hero.

and the ascent of the sun into the sky." The vase makes an explicit statement on two inseparable and yet distinct aspects of royal afterlife: the destiny of the ruler's soul and his bones. The former goes to the house of the sun, while it is from the latter that he reemerges in worldly fashion as a tree. This is consistent with Mesoamerican beliefs that consider human bones as bearers of progeny. As such, they are equated with plant seeds, sometimes referred to as "little skulls" in Santiago Atitlán (Carlsen and Prechtel 1991; Christenson 2003:129, note 277). Schultze-Jena (1954:51–52) noted a correspondence between human bones and fruit seeds at Chichicastenango, while the Chorti equated the maize seeds deposited in the earth with the dead inside their tombs. With remarkable prescience, Girard (1966:128–134) related this concept with the images on the sides of the Palenque sarcophagus, later identified as the king's forebears.[16] Similar notions are found throughout Mesoamerica. López Austin (1984:190) notes that the Nahua term for semen, *omicetl*, literally means "lo óseo que se coagula." In Aztec mythology, humankind was created from the bones of the dead of the previous creation, made fertile by the blood sacrifice of the gods.

The sarcophagus lid merges both aspects of the king's afterlife. Like a seed, he sprouts a robust world tree, while at the same time he enters the skeletal centipede's maw, an opening that prefigures his solar destiny. The juxtaposition of vegetal growth with solar symbolism on both the sarcophagus and the Death Vase is likely related to the act of creation, articulated in multiple passages of the *Popol Vuh* through the paired concepts "to be sown" and "to dawn":

> The creation of all things, including humanity, is therefore likened to the fundamental concepts of sowing a maize field and the dawn of the sun. These are not considered independent actions, but equivalent expressions for the same generative event (Christenson 2001:109; Tedlock 1996:225–226; Carlsen and Prechtel 1991).

In essence, the sarcophagus lid equates Pakal's transit to death with the original sacrifice of the maize god. This was a necessary prelude for his solar apotheosis, the advent of the first dawn. At the same time, this was

the origin of human sustenance. Pakal is shown on the verge of beginning his ordeal in the realm of death, which he will undertake, appropriately, in the guise of the maize god. Only after succeeding in these trials will his triumphant soul be ready to rise to heaven as an equal of the sun.

The transformation of the sovereign into the paramount celestial body may explain the ultimate reasons for the presence of his stellar retinue. Stars escort the sun in heaven, and in like fashion, they escort royal ancestors conceived as the sun's equals. Considering the substantial degree of correspondence between Classic Maya and Central Mexican concepts of solar paradise, it is not far-fetched to take the analogy one step further. Like the Central Mexican sun god, the apotheosized king needs the help of the stars to fulfill his glorious role. They are the ones that will greet him as his brave warriors assist him through his journey and give him sustenance. As immortalized on the sarcophagus, the noble vassals who served Pakal in life are the ones who, turned into stars after death, will sustain and gladden him in heaven.

BIBLIOGRAPHY

Berlin, Heinrich
1959 "Glifos Nominales en el Sarcófago de Palenque—Un Ensayo." *Humanidades: Revista Fascicular de la Facultad de Humanidades de la Universidad de San Carlos de Guatemala* II (10): pp. 1–8.

Bernal Romero, Guillermo
2002 "Análisis epigráfico del tablero de K'an Tok, Palenque, Chiapas," in *La Organización Social entre los Mayas Prehispánicos, Coloniales y Modernos: Memoria de la Tercera Mesa Redonda de Palenque*, ed. Vera Tiesler Blois, Rafael Cobos, and Merle Greene Robertson, pp. 401–423. Instituto Nacional de Antropología e Historia, Mexico.

Bierhorst, John, ed.
1992 *History and Mythology of the Aztecs: The Codex Chimalpopoca*. The University of Arizona Press, Tucson.

Braakhuis, H. Edwin M.
1990 "The Bitter Flour: Birth-Scenes of the Tonsured Maize God," in *Mesoamerican Dualism*, ed. R. van Zantwijk, R. de Ridder, and E. Braakhuis, pp. 125–147. Rijksuniversiteit, Utrecht.

16. This belief may also have found hieroglyphic expression on Tortuguero Monument 6. In the aftermath of a great battle, the expression *witzaj jol* (skulls are piled) is immediately followed by *b'olon hinaj* (nine/many seeds) and the expression *u sak ? ik* (his white ? wind) that refers to the soul in death phrases (blocks H6–H7). Grube et al. (2002:II-21) suggest that skulls are presented as "many seeds" of souls.

Carlsen, Robert S., and Martin Prechtel
1991 "The Flowering of the Dead: An Interpretation of Highland Maya Culture." *Man* 26: 23–42.

Carlson, John, and Linda Landis
1985 "Bands, Bicephalic Dragons, and Other Beasts: The Sky Band in Maya Art and Iconography," in *Fourth Palenque Round Table, 1980,* ed. Merle Greene Robertson and Elizabeth P. Benson, pp. 115–140. Pre-Columbian Art Research Institute, San Francisco.

Chinchilla Mazariegos, Oswaldo
2005 "Cosmos and Warfare on a Classic Maya Vase." *RES: Anthropology and Aesthetics* 47:107–134.

Christenson, Allen J.
2001 *Art and Society in a Highland Maya Community: The Altarpiece of Santiago Atitlán.* University of Texas Press, Austin.
2003 *Popol Vuh: The Sacred Book of the Maya.* O Books, Winchester, U.K.

Coe, Michael D.
1975 "Death and the Ancient Maya," in *Death and the Afterlife in Pre-Columbian America,* ed. Elizabeth P. Benson, pp. 87–104. Dumbarton Oaks, Washington, D.C.

Coe, Michael D., and Justin Kerr
1997 *The Art of the Maya Scribe.* Abrams, N.Y.

Coe, William R., and Robert J. Sharer
1979 "The Quirigua Project, 1975 Season," in *Quirigua Reports,* vol. 1, ed. Robert J. Sharer and Wendy Ashmore, pp. 13–32. University Museum Monograph 37. The University Museum, University of Pennsylvania, Philadelphia.

Díaz de Salas, Marcelo
1963 "Notas sobre la Visión del Mundo entre los Tzotziles de Venustiano Carranza, Chiapas." *La Palabra y el Hombre: Revista de la Universidad Veracruzana* 26:253–267.

Fernández de Oviedo, Gonzalo
1959 *Historia General y Natural de las Indias,* vol. 4, ed. Juan Pérez de Tudela Bueso. Biblioteca de Autores Españoles, vol. 120. Ediciones Atlas, Madrid.

Fitzsimmons, James
2002 "Death and the Maya: Language and Archaeology in Classic Maya Mortuary Ceremonialism" Ph.D. diss., Harvard University. Reprint: University Microfilms International, Ann Arbor, Mich.

Fought, John
1985 "Cyclical Patterns in Chorti (Mayan) Literature," in *Literatures. Supplement to the Handbook of Middle American Indians,* vol. 3, ed. Munro S. Edmonson, series ed. Victoria Reifler Bricker, pp. 133–146. University of Texas Press, Austin.

Girard, Rafael
1966 *Los Mayas: Su Civilización, Su Historia, Sus Vinculaciones Continentales.* D.F.: Libro Mex Editores, Mexico.

Gossen, Gary H.
1979 "Temporal and Spatial Equivalents in Chamula Ritual Symbolism," in *Reader in Comparative Religion,* ed. William A. Lessa and Evon Z. Vogt, pp. 116–129. Harper & Row, New York.

Graulich, Michel
1987 "Los Mitos Mexicanos y Maya-Quichés de la Creación del Sol." *Anales de Antropología* 24:289–325.

Grube, Nikolai, Eva Eggebrecht, and Matthias Seidel, eds.
2000 *Maya: Divine Kings of the Rainforest.* Könemann Verlagsgesellschaft mbH, Cologne.

Grube, Nikolai, Simon Martin, and Marc Zender
2002 "Palenque and its Neighbors," in *Notebook for the XXVIIth Maya Hieroglyphic Forum at Texas,* pt. 2. University of Texas, Austin.

Grube, Nikolai, and Werner Nahm
1994 "A Census of Xibalba: A Complete Inventory of *Way* Characters on Maya Ceramics," in *The Maya Vase Book,* vol. 4, ed. Justin Kerr, pp. 686–715. Kerr Associates, New York.

Guiteras Holmes, Calixta
1986 *Los Peligros del Alma: Visión del Mundo de un Tzotzil.* Fondo de Cultura Económica, Mexico.

Houston, Stephen D., and David Stuart
2001 "Peopling the Maya Court," in *Royal Courts of the Ancient Maya,* vol. 1, Theory, Comparison, and Synthesis, ed. Takeshi Inomata and Stephen D. Houston, pp. 54-83. Westview Press, Boulder, Col.

Hull, Kerry Michael
2003 "Verbal Art and Performance in Ch'orti' and Maya Hieroglyphic Writing." Ph.D. diss., University of Texas, Austin. Reprint: University Microfilms International, Ann Arbor, Mich.

Jackson, Sarah, and David Stuart
 2001 "The Aj K'uhun Title: Deciphering a Classic Maya
 Term of Rank." *Ancient Mesoamerica* 12:217–228.

Kelley, David H.
 1976 *Deciphering the Maya Script.* University of Texas
 Press, Austin.

Kelly, Isabel
 1966 "World view of a Highland-Totonac pueblo," in
 *Summa Antropológica en Homenaje a Roberto
 Weitlaner,* ed. Antonio Pompa y Pompa, pp.
 395–410. Instituto Nacional de Antropología e
 Historia, Mexico.

Lacadena García-Gallo, Alfonso
 2002 "El Corpus Glífico de Ek' Balam, Yucatán, México."
 Report submitted to the Foundation for the
 Advancement of Mesoamerican Studies, Inc.
 <http://www.famsi.org/reports/01057es/index.html>.

Laughlin, Robert
 1975 *The Great Tzotzil Dictionary of San Lorenzo
 Zinacantan.* Smithsonian Institution Press,
 Washington, D.C.

León-Portilla, Miguel
 1996 *El Destino de la Palabra. De la Oralidad y los
 Códices Mesoamericanos a la Escritura Alfabética.* El
 Colegio Nacional/Fondo de Cultura Económica,
 Mexico.

López Austin, Alfredo
 1984 *Cuerpo Humano e Ideología: Las Concepciones de
 los Antiguos Nahuas.* Universidad Nacional
 Autónoma de México, Mexico.
 1992 "Homshuk. Análisis Temático del Relato." *Anales de
 Antropología* 29:261–283.

López Bravo, Roberto
 2000 "La Veneración de los Ancestros." *Arqueología
 Mexicana* 45:38–43.

Lounsbury, Floyd G.
 1981 "Astronomical Knowledge and Its Uses at Bonampak,
 Mexico," in *Archaeoastronomy in the New World,*
 ed. Anthony F. Aveni, pp. 143–168. Cambridge
 University Press, Cambridge, U.K.

Maler, Teobert
 1903 *Researches in the Central Portion of the Usumatsintla
 Valley,* pt. 2, *Memoirs of the Peabody Museum of
 American Archaeology and Ethnology,* vol. II, no. 2.
 Harvard University, Cambridge, Mass.

Martin, Simon
 2005 "Caracol Altar 21 Revisited: More Data on Double
 Bird and Tikal's Wars of the Mid-Sixth Century." *The
 PARI Journal* 6(1):1–9.

Mathews, Peter
 1983 *Corpus of Maya Hieroglyphic Inscriptions,* vol. 6, pt.
 1, *Tonina.* Peabody Museum of Archaeology and
 Ethnology, Harvard University, Cambridge, Mass.

Mathews, Peter, and Linda Schele
 1973 "Lords of Palenque: The Glyphic Evidence," in
 Primera Mesa Redonda de Palenque, pt. 1, ed. Merle
 Greene Robertson, pp. 63–75. Robert Louis
 Stevenson School, San Francisco.

Milbrath, Susan
 1999 *Star Gods of the Ancient Maya: Astronomy in Art,
 Folklore, and Calendars.* University of Texas Press,
 Austin.
 2002 "The Planet of Kings: Jupiter in Maya Cosmology," in
 *Heart of Creation: The Mesoamerican World and the
 Legacy of Linda Schele,* ed. Andrea Stone, pp.
 118–142. The University of Alabama Press,
 Tuscaloosa, Ala.

Miller, Mary, and Simon Martin
 2004 *Courtly Art of the Ancient Maya.* Fine Arts Museum of
 San Francisco/Thames & Hudson, San Francisco.

Miller, Virginia
 1989 "Star Warriors at Chichén Itzá," in *Word and Image
 in Maya Culture: Explorations in Language, Writing,
 and Representation,* ed. William F. Hanks and Don S.
 Rice, pp. 287–305. University of Utah Press, Salt
 Lake City.

Münch Galindo, Guido
 1992 "Acercamiento al Mito y a Sus Creadores." *Anales de
 Antropologia* 29:285–299.

Muñoz Cosme, Gaspar, Cristina Vidal Lorenzo, and Juan
Antonio Valdés Gómez
 1999 *Los Mayas: Ciudades Milenarias de Guatemala.*
 Ayuntamiento de Zaragoza/Generalitat
 Valenciana/Ministerio de Educación y Cultura,
 Zaragoza/Valencia/Madrid.

Pitarch Ramón, Pedro
 1996 *Ch'ulel: Una Etnografia de las Almas Tzeltales.* Fondo
 de Cultura Económica, Mexico.

Porter, James
1994 "The Palace Intaglios: A Composite Stairway Throne at Palenque," in *Seventh Palenque Round Table, 1989,* ed. Merle Greene Robertson and Virginia M. Fields, pp. 11–18. The Pre-Columbian Art Research Institute, San Francisco.

Pozas Arciniegas, Ricardo
1987 *Chamula: Un Pueblo Indio en los Altos de Chiapas,* 2 vols. Instituto Nacional Indigenista, Mexico.

Ringle, William, and Thomas C. Smith-Stark
1996 *A Concordance to the Inscriptions of Palenque, Chiapas, Mexico.* Middle American Research Institute, Publication 62. Tulane University, New Orleans.

Robertson, Merle Greene
1983 *The Sculpture of Palenque,* vol. 1, *The Temple of the Inscriptions.* Princeton University Press, Princeton, N.J.
1985 *The Sculpture of Palenque,* vol. 3, *The Late Buildings of the Palace.* Princeton University Press, Princeton, N.J.

Robicsek, Francis, and Donald M. Hales
1981 *The Maya Book of the Dead. The Ceramic Codex. The Corpus of Codex Style Ceramics of the Late Classic Period.* University of Virginia Art Museum, Charlottesville.

Ruz Lhuillier, Alberto
1952 "Exploraciones en Palenque: 1951." *Anales del Instituto Nacional de Antropología e Historia* 5:47–66.
1958 "Exploraciones Arqueológicas en Palenque: 1953." *Anales del Instituto Nacional de Antropología e Historia* 10:69–116.
1973 *El Templo de las Inscripciones: Palenque.* Colección Científica, Arqueología No. 7. Instituto Nacional de Antropología e Historia, Mexico.

Sahagún, Bernardino de
1961 *Florentine Codex, General History of the Things of New Spain,* bk. 10, *The People,* ed. Arthur J. O. Anderson and Charles E. Dibble. *Monographs of the School of American Research,* no. 14, pt. 11. School of American Research/University of Utah, Santa Fe, N.M.
1969 *Florentine Codex, General History of the Things of New Spain,* bk. 6, *Rhetoric and Moral Philosophy,* ed. Arthur J. O. Anderson and Charles E. Dibble. *Monographs of the School of American Research,* no. 14, pt.7. School of American Research/University of Utah, Santa Fe, N.M.
1978 *Florentine Codex, General History of the Things of New Spain,* bk. 3, *The Origin of the Gods,* ed. Arthur J. O. Anderson and Charles E. Dibble. *Monographs of the School of American Research,* no. 14, pt. 4. School of American Research/University of Utah, Santa Fe, N.M.
1982 *Historia General de las Cosas de Nueva España,* ed. Angel María Garibay. D.F.: Editorial Porrúa S.A., Mexico.

Schele, Linda, and Peter Mathews
1993 "The Dynastic History of Palenque," in *Notebook for the XVIIth Maya Hieroglyphic Workshop, March 13–14, 1993.* University of Texas, Austin.
1998 *The Code of the Kings: The Language of Seven Sacred Maya Temples and Tombs.* Scribner, New York.

Schele, Linda, and Mary Ellen Miller
1986 *The Blood of Kings: Dynasty and Ritual in Maya Art.* Kimbell Art Museum, Fort Worth, Tex.

Schultze-Jena, Leonhard
1954 *La Vida y las Creencias de los Indígenas Quichés de Guatemala.* Biblioteca de Cultura Popular 20 de Octubre. Editorial del Ministerio de Educación Pública, Guatemala.

Seler, Eduard
1904 "Venus Period in the Picture Writings of the Borgian Codex Group," in *Mexican and Central American Antiquities, Calendar Systems, and History,* ed. Charles P. Bowditch, pp. 355–391. *Bureau of American Ethnology Bulletin* 28. Smithsonian Institution, Washington, D.C.
1996 *Collected Works in Mesoamerican Linguistics and Archaeology,* vol. 5, ed. Frank Comparato. Labyrinthos, Culver City, Calif.

Spinden, Herbert
1916 "The Question of the Zodiac in America." *American Anthropologist* 18(1):53–80.

Stanzione, Vincent
2003 *Rituals of Sacrifice: Walking the Face of the Earth on the Sacred Path of the Sun.* University of New Mexico Press, Albuquerque.

Stuart, David
1996 "Kings of Stone: A Consideration of Stelae in Ancient Mayan Ritual and Representation." *RES: Anthropology and Aesthetics* 29:148–171.
2003a "A Cosmological Throne at Palenque." Mesoweb, <www.mesoweb.com/stuart/notes/Throne.pdf>.
2003b *Corpus of Maya Hieroglyphic Inscriptions,* vol. 9, pt. 1, *Piedras Negras.* Peabody Museum of Archaeology and Ethnology, Harvard University, Cambridge, Mass.

Taube, Karl
 1988 "A Study of Classic Maya Scaffold Sacrifice," in *Maya Iconography,* ed. Elizabeth P. Benson and Gillett G. Griffin, pp. 331–351. Princeton University Press, Princeton, N.J.
 1992 *The Major Gods of Ancient Yucatan. Studies in Pre-Columbian Art and Archaeology* 32. Dumbarton Oaks, Washington, D.C.
 2003 "Maws of Heaven and Hell: The Symbolism of the Centipede and the Serpent in Classic Maya Religion," in *Antropología de la Eternidad: La Muerte en la Cultura Maya,* ed. Andrés Ciudad Ruiz, Mario Humberto Ruz, and María Josefa Iglesias Ponce de León, pp. 405–442. Sociedad Española de Estudios Mayas, Madrid.
 2004a "The Stairway Sculptures of Structure 10L-16: Fire and the Evocation and Resurrection of K'inich Yax K'uk' Mo,'" in *Understanding Early Classic Copan,* ed. Ellen Bell, Marcello Canuto, and Robert Sharer, pp. 265–295. The University Museum, University of Pennsylvania, Philadelphia.
 2004b "Flower Mountain: Concepts of Life, Beauty, and Paradise among the Classic Maya," *RES: Anthropology and Aesthetics* 45:69–98.
 2005 "The Womb of the World: The Cuauhxicalli and Other Offering Bowls of Ancient and Contemporary Mesoamerica." Manuscript in possession of the author.

Tedlock, Dennis
 1996 *Popol Vuh. The Maya Book of the Dawn of Life.* Touchstone, New York.

Thompson, J. Eric S.
 1960 *Maya Hieroglyphic Writing: An Introduction.* University of Oklahoma Press, Norman.

Villa Rojas, Alfonso
 1990 *Etnografia Tzeltal de Chiapas: Modalidades de una Cosmovisión Prehispánica.* Gobierno del Estado de Chiapas/Grupo Editorial Miguel Angel Porrúa, Mexico.

Vogt, Evon Z.
 1969 *Zinacantan: A Maya Community in the Highlands of Chiapas.* The Bellkamp Press of Harvard University Press, Cambridge, Mass.

Webster, David, Barbara Fash, Randolph Widmer, and Scott Zeleznik
 1998 "The Skyband Group: Investigation of a Classic Maya Elite Residential Compound at Copán, Honduras." *Journal of Field Archaeology* 25:319–343.

Zender, Marc
 2004 "A Study of Classic Maya Priesthood." Ph.D. diss., University of Calgary. Libraries and Archives of Canada, Ottawa.

A tale of two bodies

On aesthetic condensation in the Mexican colonial graffiti of Actopan, 1629

ALESSANDRA RUSSO

How can you do that if you are the image and resemblance of God and each day you receive his flesh and blood?
—*Maria Magdalena to Juan Durán (ca. 1614) México, Archivo General de la Nación (AGN), Inquisición vol. 491, f. 314*

Death to the viceroy!
—*Memorial de lo sucedido en la ciudad de México desde el día primero de noviembre de 1623 hasta el quince de enero de 1624 Oxford, Bodleian Library, f. 26 v. (Jonathan Israel, note 28)*

Dressed in black, his body slides down the polished wall: arms in the air, a man with glasses falls, head first, in the corner of the room (fig. 1). We can almost hear the noise of the crash, but just as his hat hits the ground, the force of gravity is eternally arrested by an invisible hand that transforms the descent into a drawing. The rapid strokes capture the vertiginous height and speed of the fall. Along the intersecting walls, a profusion of figures, buildings, paths, and scribbles crowd the falling body in a seemingly disorganized jumble of episodes (fig. 2). But as if filmed in slow motion, a pictorial narrative unfolds as each detail emerges.

We are in the Mexican village of Actopan (fig. 3), in the latrine of the Augustinian monastery of San Nicolás de Tolentino, founded in 1546 and generally regarded as one of the key monuments in the history of New Spain.[1] Although the building has been the object of significant studies—especially as the repository of mural paintings valued as masterpieces of colonial art[2]—the graffiti[3] drawn on the walls of the latrine have never received serious attention.[4]

The Instituto de Investigaciones Estéticas (IIE) of the Universidad Nacional Autónoma de México (UNAM) generously supports my research on colonial graffiti. The photos reproduced here were made during a professional photographic session conducted by the Fototeca of the IIE. I am particularly grateful to all who have taken the time to travel with me to Actopan: Primarily, and on several occasions since 1998, to Patrice Giasson, with whom I have progressively discovered the visual multiplicity of the graffiti mural; Darío Barriera, Stefano and Giacomo Dainesi, Maria José Esparza, Eumelia Hernández, Jaime Monje Sierra, Stephanie Migniot, Rosario Nava, Radames Paz, Ernesto Peñaloza, Gabriela Vallejo, and Gerardo Vázquez have accompanied and supported me during many different journeys to the convent. I would also like to thank Elena Isabel Estrada de Gerlero, Serge Gruzinski, and Gerhard Wolf for their intellectual energy and constructive criticism. One of the final drafts of the text was discussed in January 2004 with Carlo Severi, Giovanni Careri, and Denis Vidal in their seminar on Iconographic Traditions at the Ecole des Hautes Etudes en Sciences Sociales in Paris. Thanks are also due to Father Juan Bautista Salinas, prior of the Parroquia de San Nicolás de Tolentino in Actopan, for giving me access to documents preserved in the archives. The library of Berta Maldonado in Mexico City, made known to me through the friendship of Aline Mackissack, set me on the right track. Francesco Pellizzi with patient firmness invited me to submit this work after many rewritings. Finally, without the assistance of Suzanne Downes, the profound, exacting, and stimulating editing of Marlene Chambers, and the final reading of Diana Fane, the Actopan graffiti would not be "visible" in English.

1. Salvador Roquet, *El ex convento de Actopan hoy museo colonial* (México, 1938); Luis Azcuey Mancera, Manuel Toussaint, Justino Fernández, *Catálogo de construcciones religiosas del Estado de Hidalgo*, vol 1. (México: Talleres Gráficos de la Nación, 1940); Luis MacGregor, *Actopan* (México: Instituto Nacional de Antropología e Historia [INAH], 1955); Josefina Lusardi, "El espacio arquitectónico en el conjunto agustino de la iglesia-convento de Actopan" (master's thesis in art history, UNAM-Facultad de Filosofía y Letras, México, 1987).

2. Elena Isabel Estrada de Gerlero, "Los temas escatológicos en la pintura mural novohispana del siglo XVI," in *Traza y baza. Cuadernos hispanos de simbología arte y literatura* (Barcelona: El Abbar, 1978) pp. 71–88; Serge Gruzinski, *L'aigle et la sibylle. Frèsques indiennes du Mexique* (Paris: Imprimerie Nationale, 1994); Berenice Alcántara Rojas, "El infierno en la evangelización de la Nueva España" (licenciatura thesis, UNAM, México, 1999); and Víctor Manuel Ballesteros García, *La pintura mural del convento de Actopan* (Pachuca: Universidad Autónoma del Estado de Hidalgo [UAEH], 1999).

3. I am aware that my use of the word *graffiti* might lead to confusion with the graffiti art of today. However, I intend no comparison and employ this term to point out some formal connections, not common intentions. For an original approach to contemporary graffiti art, see Carlo Bertuccio Michelini, "Graffitismo," *Curare* 20 (México, 2002):10–29.

4. This is the case with thousands of other graffiti drawings in the monasteries of New Spain. See Alessandra Russo, "Lenguaje de figuras y su entendimiento. Preparation de un estudio sobre los graffiti novohispanos de la época colonial," *Anales del Instituto de Investigaciones Estéticas* (México: ILE-UNAM, 1998) and the virtual exhibition: Alessandra Russo, "Activar el monumento. La narración figurativa de los graffiti novohispanos," *Nuevo Mundo Mundos Nuevos* 2 (2002): http://nuevomundo.revues.org/document641 .html.

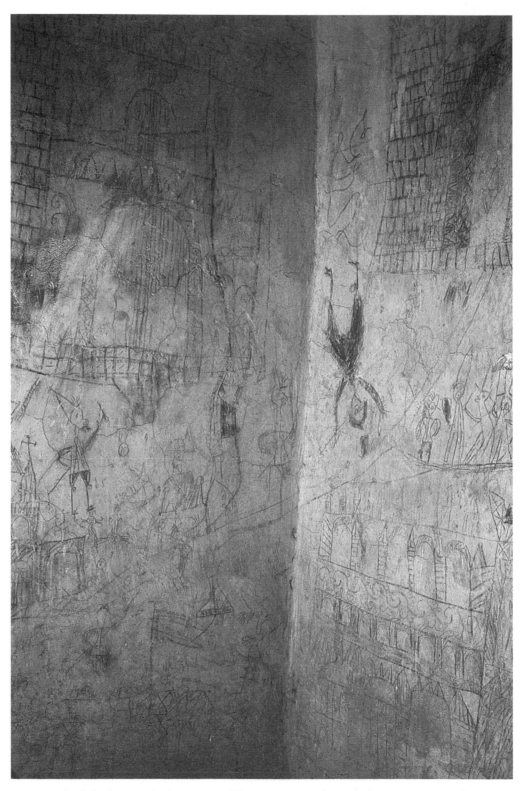

Figure 1. The fall of a man in the corner of the room. Note the path that continues on the intersecting walls. Latrine of the monastery of San Nicolas de Tolentino, Actopan. Reproduced by permission of the Instituto Nacional de Antropología e Historia.

Figure 2. View of a larger part of the latrine graffiti cycle. Latrine of the monastery of San Nicolas de Tolentino, Actopan. Reproduced by permission of the Instituto Nacional de Antropología e Historia.

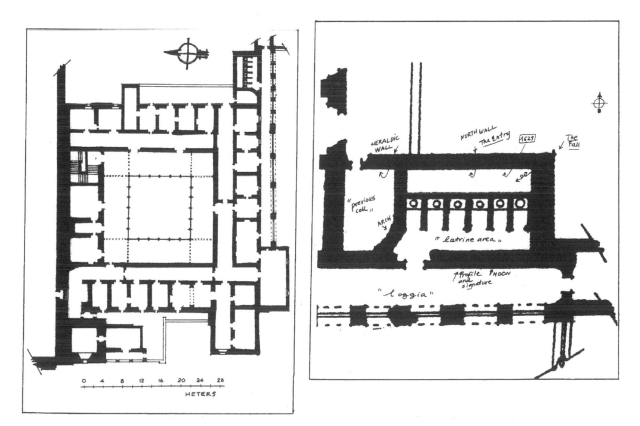

Figure 3. Plan of the upper cloister of the latrine, Actopan monastery. Drawing by the author.

How can we explain the total invisibility of these images in the panorama of Mexican studies? Even more to the point, what possible significance, beyond their purely local historical interest, might these drawings in a Mexican monastery's latrine have for art history and anthropology? Transcending the desire to reveal a new object, my aim in this article is to address these larger questions through a careful study of the graffiti's creative singularity, guided by clues to their authorship, dating, and stories contained within the latrine's walls, as well as visual and documentary evidence found in the archives and in the monastery itself.

Today the latrine area, located in the upper cloister of the monastery (fig. 3), is made up of the toilet and a cell that were previously separate. Because the monastery has undergone a series of complex architectural renovations, it is difficult to date the consolidation of the two rooms. The drawings along the six walls of the toilet and former cell extend at different heights, but they are often linked by continuous lines representing paths (fig. 1). These paths appear to connect the episodes and characters in a narrative structure. This spatial coherence suggests that the drawings were conceived as a cycle according to an initial "blueprint," with some specific key episodes drawn by one hand. This internal evidence suggests that the drawings were conceived as a whole by a single author and that additional characters may have been inserted over the course of time.

Beneath the lime: Concealment and permanence

"With the removal of the lime whitewash from the wall, some ingenuous drawings of other periods have appeared. None is vulgar. They show churches, castles, paths, devils, decorative doodling, and other minor figures. There is a date, 1629."[5] Thus Luis MacGregor, author of one of the monographs on Actopan, briefly describes the monastery's latrine drawings. Their subjects, he tells us, are not vulgar, a feature that sets them apart from the "obscene" genre usually associated with toilet graffiti.[6] Although he recognized this important distinction, the drawings' ingenuousness or lack of artistic sophistication deterred MacGregor from exploring the possible meaning of their unfamiliar

subject matter. He does, however, provide us with the precious information that the graffiti had once been covered by a layer of lime.

Whitewashing—a fate shared by a number of pictorial cycles throughout the world—implies a specific procedure: covering is not the same as erasing, and hiding is not destroying. Paradoxically, concealment conserved the drawings. From a strictly technical point of view, too, the physical "walling" had conservative power: The carbon of the charcoal used to trace the drawings had been fossilized by a chemical reaction to the coating of calcium hydroxide $Ca(OH)_2$. Unfortunately, the dating of the whitewashing and its removal cannot be confirmed, but at some point between the execution of the drawings and their uncovering there was an additional stage—their covering—that suggests a degree of antiquity.

The fact that the drawings have been neither removed nor studied over the years involves an interesting contradiction. Throughout much of their history, the graffiti have been preserved by being hidden, although they have never been fully visible even when in plain view. Now that the drawings have a real material presence, how can we learn to truly *see* them? How can we get these "little bits of soul-fossil" to emerge?[7] The total freedom of working in unexplored territory has a danger, the temptation to give a one-dimensional, definitive interpretation of the cycle. However, that would take away from the complexity of the object and, in a certain sense, betray it. For this reason I prefer to be guided by the drawings and allow the analysis of the whole and hypotheses about the object's construction to develop concurrently. Beginning from an overview of the key areas of the narrative, this approach will make possible a simultaneous reading of several potential storylines.

Three key areas

In an attempt to approach the pictorial structure of the whole—given the impossibility of fully describing and reproducing here all the details of the mural—I have identified three main areas of the graffiti cycle.

5. MacGregor (see note 1), p. 166.
6. Alan Dundes, "Here I Sit—A Study of American Latrinalia," *Kroeber Anthropological Society Papers* 34 (1966):91–105; Monika Bauer, *Toiletten-Graffiti im Lauf der Zeit. Die Entwicklung politischer und geschlechtsspezifischer Unterschiede* (Wien: Graffiti Editions, 2002).

7. Dario Gamboni, Fossiles d'âme: l'usure du temps et ses images," in *L'usure du temps. La restauration des objets du patrimoine* (Vienne: Musée et sites archéologiques de Saint-Romain-en-Gal, 1998). The author of the quotation is Samuel Butler, writing in 1881 of old graffiti encountered in the medieval churches of the Piedmont and Canton Ticino.

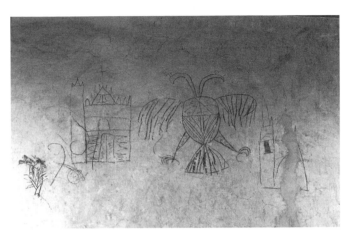

Figure 4. The heraldic wall: the Hapsburgs' two-headed eagle and the Mexica eagle on the *nopal*. Latrine of the monastery of San Nicolas de Tolentino, Actopan. Reproduced by permission of the Instituto Nacional de Antropología e Historia.

1. The heraldic horizon

Upon entering the latrine from either of the two entrances (fig. 3), the visitor is immediately met by an image on the wall of the former cell that appears to be the inaugural icon of the cycle: an enormous two headed eagle (fig 4). The heraldic symbol of the Hapsburgs is drawn between two churches, and at the lower left of this grouping a smaller drawing shows a bird on a prickly plant with a sinuous object in its beak. Without doubt, this image represents the Mexica eagle on a *nopal* (prickly pear cactus) devouring a snake, that is to say, the foundation myth of Mexico-Tenochtitlan that inspired the colonial city's coat of arms.[8] Facing this image, we are transported immediately to a very precise place and time. The wall where the eagle of the Holy Roman Empire and the Mexica eagle appear together, though in a disproportionate relationship, brings us to New Spain, a political entity made possible by the violent integration of the Mexican and Hapsburg empires.

Crossing the threshold to the inner section of the latrine, we pass under an arch marked with a heart crossed by three arrows and accompanied by the letters "SHI," the Christian initials "IHS" (Iesus Hominum Salvator) reversed (fig. 5). The pierced heart evokes the

Figure 5. The arch with the "SHI" inscription and the animals. Latrine of the monastery of San Nicolas de Tolentino, Actopan. Reproduced by permission of the Instituto Nacional de Antropología e Historia.

Augustinian coat of arms and reappears several times elsewhere in the Actopan monastery as well as in the graffiti cycle.[9] Above the heart, two animals with feline characteristics confront each other with threatening claws and open jaws. The same type of wild beast appears again in the latrine area—at nearly the same

8. Doris Heyden, *The Eagle, the Cactus, the Rock: The Roots of Mexico-Tenochtitlan's Foundation Myth and Symbol* (Oxford: BAR, 1989).

9. Apart from its heraldic and Christian meanings, the heart also carried connotations as a symbol of love in sixteenth-century New Spain. See, for example, the drawing in the middle of a letter written by a bigamist who was interrogated in 1571 by the Inquisition (Archivo General de la Nación, *Inquisición*, vol. 300, f. 53), in Solange Alberro, *Inquisición y Sociedad en México. 1571–1700*, 4th repr. (Mexico: Fondo de Cutrlura Económica [FCE], 2000), fig. V, p. 219.

Figure 6. The North Wall. Note the man on horseback, two men wearing shirts, the date of 1629, and the hybrid monster. Latrine of the monastery of San Nicolas de Tolentino, Actopan. Reproduced by permission of the Instituto Nacional de Antropología e Historia.

height as the two eagles—bursting forth from the vestibule of a church. It could represent the clawing lions of the Castilian coat of arms, a figure that appears on numerous coats of arms of New Spain,[10] but it might also refer to the American leopard, the *ocelotl,* often used in Mesoamerican art as a symbol of brave warriors as well as to represent the fleeting victory of battle. Similar to this representation, *ocelotl*-warriors also appear associated with eagles on the painted walls of the Augustinian church of Ixmiquilpan, just a few kilometers from Actopan.

These images take us immediately to the heart of an intricate iconography whose complexity prevents a simple deciphering and obliges us to constantly adjust our viewpoint to accommodate multiple places and periods. The eagles, hearts, and felines offer a mixed heraldic register that seems to refer simultaneously to the pre-Hispanic imperial domain, the Hapsburg Empire, the kingdom of Castile, and the Augustinian

order.[11] Situated in the upper reaches of the wall, these "open" coats of arms—in which heraldic figures circulate without a frame—compose a horizon line for the story we will see developing in the lower registers.

2. The north wall: An entry

On the north wall of the latrine our eyes are drawn to the charismatic figure of a bearded and moustachioed man on horseback, wearing a hat and carrying a sword in his left hand (fig. 6). The large size of the figure in comparison to other images implies its special importance. A man on foot leads the horse, suggesting a parade. The Hapsburgs appreciated the equestrian portrait as the most appropriate artistic genre to symbolize the control of the state by men of power. The sovereign was often painted on horseback after a revolt

10. See the description of the coat of arms of Hernán Cortés: "un águila negra de dos cabezas en campo negro que son las armas de nuestro imperio y en la otra mitad del dicho medio escudo a la parte debajo un león bordado en campo colorado en memoria que vos, el dicho Hernán Cortés, truxistes las cosas del estado arriba dicho." Ignacio de Villar Villani, *Cedulario heráldico de conquistadores de la Nueva España* (México: Secretaria de Educación Pública [SEP], 1933).

11. On the emblematic intertwining of heraldic elements, see Jaime Cuadriello, "Los jeroglíficos de la Nueva España," in J. Cuadriello et al., *Juegos de Ingenio y Agudeza. La Pintura Emblemática de la Nueva España,* exh. cat., Museo Nacional de Arte (MUNAL) (México: Consejo Nacional para la Cultura y las Artes, 1994). John Manning relates the origin of the emblematic genre to serve the display of festivities in *The Emblem* (London: Reaktion Books, 2000), pp. 188 ff.

as an allusion to (and to create the illusion of) his incontestable power.[12]

The mural is crowded with infinite details featuring animals, buildings, floral designs, and what seems to be a fireworks castle ready to go up in flames. Above the figure on horseback, a large church reminds us of the Actopan monastery itself: Its vestibule is left open, and we can catch sight of an altar with a crucifix. Along the path leading from this building, two men hold swords in their hands. They are dressed in the Spanish fashion and wear the gorguera shirts with ruffs outlawed by Philip IV in 1623 but still worn for several years, especially in the overseas territories.[13] Accompanied by a banner bearer and a man carrying a candle, a group of musicians moves forward into the upper part of the wall. Almost on the center of the north wall, we can read a clear date, "year 1629" ("1629 a°s," where a°s must read as a paleographic abbreviation for "años"), surrounded by a rectangular border. Another attempt to write a date appears nearby, but here the final digit has been omitted: "year 162" ("162 a°s").

Thus far, the mood of the graffiti on the north wall is quite festive. We might be looking at a ceremony similar to the triumphal entries staged for important personages such as *vistadores* or viceroys. Based on European models, the pageantry that greeted the arrival of a new official included music, fireworks, and theatrical performances, as well as temporary monuments featuring iconography associated with power: allegories of virtue, portraits of exemplary governors, and emblematic figures—all marked by witty allusions to history.[14] Conflation of the pre-Hispanic past and the viceregal present was a frequent component of New Spanish entries.[15]

As we move toward the right corner of the north wall, the festive atmosphere quickly changes to something else: animals assume monstrous shapes, doors of buildings become shut, and swords are drawn from their scabbards. Two men confront each other in a duel centered on a disembodied face of Christ reminiscent of the veil of Veronica (fig. 7). On the lower level, a man raises his weapon threateningly toward the east wall. These sinister images seem to anticipate the dramatic episode depicted on the east wall while other details strengthen the narrative link between the two walls. The profile of a man with a beard is partially superimposed on the drawing of the church, and the outline of his left shoulder continues on the east wall. A figure on horseback heads down the inclined path uniting the two walls toward the sector of the cycle that we have just studied in detail (fig. 1).

3. The east wall: A fall

As we have seen, the path leading to the religious building on the east wall provides an entry from the north wall (fig. 1). From both sides of the angle where the walls meet, several human figures and a fantastic animal watch the falling body crash to the ground. Dressed completely in black, the unfortunate man in glasses loses his cylindrical hat. Someone watches the fall from the bell tower window.

The iconography of the east wall is particularly cryptic. Does it refer, for example, to a local accident that actually took place in this monastery? Or do we see an emblematic representation of a historical event of much larger importance? For example, in Prague in 1618, Protestant Bohemian delegates literally threw two governors and a Hapsburg secretary out of a window in an episode that marked the beginning of the Thirty Years' War. It is not possible at this stage to confirm whether the fall depicted here represents an accident, a defenestration, or an allegory. However, we can substantiate the close relationship between the two walls: the coming and going of people along the path creates a spatial coherence that suggests a figurative cycle. At the same time, we need to take into account substantial differences in clothing, gestures, profiles, proportions, animals, and especially events described. Although the person on horseback seems to enjoy a grandiose reception on one section of the north wall, we sense in the corner of the same wall a mounting tension (duels, monstrous animals) that reaches a peak after we turn to the east wall where the enigmatic fall seems to provide a paradoxical climax to a narrative.

12. Marie Tanner, *The Last Descendants of Aeneas: The Hapsburg and the Mythic Image of the Emperor* (New Haven and London: Yale University Press, 1993), p. 115. Charles V was painted by Titian in a famous equestrian portrait after the battle of Mühlberg (1547) and Ferdinand of Austria by Rubens after the battle of Nördlingen (1634).

13. Abelardo Carrillo y Gariel, *El traje en la Nueva España* (México: INAH, 1959).

14. Gordon Kipling, *Enter the King: Theatre, Liturgy, and Ritual in the Medieval Civic Triumph* (Oxford: Clarendon Press, 1998). See, for example, Johannes Bochius, "The Ceremonial Entry of Ernst, Archduke of Austria, into Antwerp, June 14, 1594," in *Engravings of Peter van der Borcha after Marten de Vos' Drawings* (New York: Benjamin Blom, 1970).

15. Helga von Kügelgen, "Carlos Sigüenza y Góngora, su *Theatro de virtudes políticas que constituyen a un príncipe* y la estructuración emblemática de unos tableros en el Arco de Triunfo," in Cuadriello et al. (see note 11), pp. 150–160.

Figure 7. The *Veronica duel*. Latrine of the monastery of San Nicolas de Tolentino, Actopan. Reproduced by permission of the Instituto Nacional de Antropología e Historia.

Through the monastery and backwards through the story

By the time visitors encounter the latrine graffiti in the upper section of the cloister, they will already have walked through most of the monastery, past walls almost completely covered by painted murals of the sixteenth century.[16] Let us try to reconstruct their visit. After admiring the building's exterior architecture, they are greeted in the open chapel by murals depicting scenes from the Apocalypse. Proceeding from here directly to the monastery past the closed church door, they walk through the *Sala de Profundis,* whose *Thebaid* mural anticipates the "anatomy" of the graffiti cycle in its use of a spatial framework that links paths, characters, and episodes to construct a narrative (fig. 8). Mounting the staircase to the second floor, visitors pass impressive black-and-white mural paintings of the Church Fathers (fig. 9). Here too, in the monochromatic images of this mural, visitors receive a vague foretaste of the charcoal line drawings they will meet later in the latrine. But the resemblance goes further: Just as these stairway paintings suggest on a grand scale *trompe l'oeil* reproductions of engravings—probably found in books that circulated in the monastery—the graffiti seem to magnify the torturous calligraphy of an enormous manuscript page.

Arriving in the upper cloister, visitors pass more mural paintings in the corridor leading to the cells before they enter the latrine, which is one of the access points to the loggia (fig. 3), offering a marvelous panoramic view of the surrounding landscape. Walking through the latrine, they may become aware of a number of correspondences between images they have seen in the painted murals and those of the graffiti cycle. In the open chapel, for instance, in a painting of "the infernal butcher," they might have noticed the figures hanging by their feet that represent Spanish who abused their authority.[17] Could this moralizing bodily inversion have something to do with that of the man falling head first down the latrine wall?

The coat of arms, animals, and grotesque friezes of the staircase also bear a certain familial resemblance to the graffiti, and a monster with a hybrid zoomorphic body and a forked tongue depicted in the *Thebaid* mural reappears in the latrine (figs. 9 and 6), though with a feathered body and without the goat profile of the

16. See bibliography in note 2.

17. Alcántara Rojas (see note 2), pp. 181 ff.

Figure 8. Mural paintings with the *Thebaid* from the *Sala de Profundis,* lower cloister of the monastery of San Nicolas de Tolentino, Actopan. Reproduced by permission of the Instituto Nacional de Antropología e Historia.

painting. The monogram of Christ that appears in the prior's cell is surrounded by a complex Nahuatl inscription and may also have some connection to the one in the latrine.

Before taking the staircase back to the lower level of the cloister, attentive visitors may notice what is undoubtedly the most interesting clue linking the latrine to other parts of the monastery: Some words have been carved into the red wall of the higher level. They read: "A 7 de agosto, el primer día 1629 en las letrinas de la yglesia aún" ("the 7th of August, the first day of 1629, in the latrine of the church, still"). Although its meaning is somewhat enigmatic (why "the first day of 1629"?), the message clearly announces that at a precise date, something was still [*aún*] happening in the latrine.

All these elements indicate that the person who has drawn the graffiti has circulated through the monastery looking attentively at the paintings and specifically selecting parts of them to enhance his masterpiece. And the person who has drawn the latrine cycle is probably the same person who left a mark on the red wall of the upper cloister. By providing this additional chronological clue, the author stepped outside the physical confines of the latrine murals to create the only written document that could be linked to them until now.

Clues to authorship and some questions of style

Now that we have examined the graffiti's figurative framework and the relationship between the latrine and other key areas of the monastery, we can turn to the question of authorship: who could have drawn the graffiti? Rather than conjuring up an imaginary author, I once again prefer to look for clues within the graffiti itself, beginning with its style. The problem of the graffiti's style is particularly challenging because it is not possible to find just one. We cannot assume, however, that the creation was necessarily collective. Rather, a lack of homogeneity is one of the most salient characteristics of all works produced at the crossroads of different artistic traditions. The phenomenon is in fact typical of other *mestizo* productions in which radically different stylistic traits exist side by side in the same work.[18] As Meyer Schapiro has argued, it is important to analyze a style according to its heterogeneity and not as

18. Serge Gruzinski, *The mestizo mind. The intellectual dynamics of colonization and globalization,* trans. Deke Dusinberre (New York: Routledge, 2002); Alessandra Russo, *El realismo circular. Tierras, espacios y paisajes de la cartografía colonial* (México: IIE-UNAM, 2005).

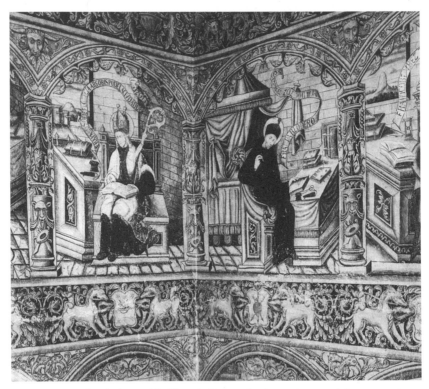

Figure 9. Mural painting with Church Fathers in the staircase of the monastery of San Nicolas de Tolentino, Actopan. Reproduced by permission of the Instituto Nacional de Antropología e Historia.

a standard and monotone language.[19] For this reason, instead of deciphering the stylistic typology of the latrine cycle in a sterile, descriptive way, I have chosen to compare certain formal characteristics of the graffiti with other pictorial documents.

There can be no doubt that the most prominent stylistic properties of the graffiti find a parallel in the *Títulos Primordiales,* documents relatively contemporaneous with the date found in the Actopan graffiti cycle, 1629. Written and drawn by indigenous authors, the *Títulos* were legal documents used to claim the right to territory.[20] Produced primarily during the seventeenth century, they mix Mesoamerican and Western elements in a style that simultaneously eliminates, retains, and transforms pre-Hispanic

features.[21] The resulting plastic vocabulary is undeniably close to that of the latrine graffiti, especially in its depiction of disparate heraldic devices, people dressed *a la española,* church buildings, and animals. The layout of the space is another feature shared by the two artistic traditions: Crossed by paths and dates, the pages of the *Títulos* (at once pictographic and alphabetic) set the scene for the old and new owners of the land in a specific temporal dimension. As legal documents, the drawings sometimes constitute real maps on which village boundaries are indicated (fig. 10). The use of intersecting routes as spatial organizers on the *Map of Actopan and Surrounding Areas* (marked there by the traditional Mesoamerican footprints) recalls their use in both the latrine cycle and the *Thebaid* mural.[22] In the

19. Meyer Schapiro, "Style," in *Anthropology Today,* ed. A. L. Kroeber (Chicago, 1953), pp. 287–312.

20. *Los Títulos Primordiales del centro de México.* Introduction, compilation, and paleography by Paula López Caballero (México: Conaculta, 2003).

21. Serge Gruzinski, *La colonisation de l'imaginaire: Sociétés indigénes et occidentalisation dans le Mexique espagnol, XVIe–XVIIIe siècles* (Paris: Gallimard, 1988).

22. The map was first reproduced by Roquet (see note 1) and recently published by Laura Rodríguez Cano and Alfonso Torres

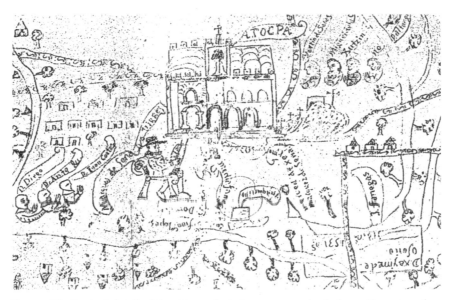

Figure 10. Central detail of the *Mapa de Actopan y sus alredededores.* Seventeenth century, location unknown. Reproduced by permission of the Instituto Nacional de Antropología e Historia.

center of the map, in the tradition of Mesoamerican political cartography, we see the fifteenth viceroy of New Spain, the marquis de Cerralvo, surrounded by indigenous and Spanish attendants. The date "1531 a°s" appears in the lower section of the document, which probably dealt with taxation or territorial claims. It is of special interest that the viceroy who sits in the center of the document actually governed from 1624 to 1635, a period that includes 1629, the very year mentioned in the graffiti.

Is it possible that the graffiti cycle represents a political map of Actopan, like those of the *Títulos Primordiales*? The archives are rife with documents of the 1620s concerning the village's territorial rights.[23] It is feasible to assume that the latrine mural tells the story of a viceregal land grant. In this case, the Indian author would have reproduced on the walls a key event in local history, one that probably took place in 1629—a date that may not necessarily correspond to that of the latrine cycle's creation, just as 1531 doesn't correspond

to the date of creation of the *título* mentioned above. The author's presence inside the monastery could be explained by his participation in the activities of an indigenous confraternity. This hypothesis is supported by several pages in the Actopan *Book of Indian Marriages* of some years later in which we find black ink drawings that show strong stylistic similarities to the graffiti (fig. 11).[24] Based on this hypothesis, the drawings could represent a "wall title," although it would still be necessary to explain the strange location of such a "document" inside the monastery latrine.

However, we are obliged to consider the likelihood of another scenario for the creation of the latrine drawings by their resemblance to charcoal graffiti made far away from Actopan but during the same year of 1629. In a castle tower in Crest, France, prisoners—for the most part Protestants and opponents of the monarchy—covered the walls in figures, dates, and signatures remarkably similar to those found in New Spain.[25] This formal connection requires a fresh start, for it shows that the author of the Actopan cycle could be

Rodríguez, "Mapa de Actopan y sus alrededores," in *Códices del estado de Hidalgo,* ed. Laura Elena Sotelo Santos, Victor Manuel Ballesteros García, and Evaristo Luvaín Torres (Pachuca: UAEH/INAH, 2001), pp. 77–81. The current whereabouts of the map is unknown.

23. México, AGN, *Tierras:* vol. 1723, exp. 1, f. 163; vol. 1792, exp. 1, f. 63; vol. 1881, exp. 1, f. 309.

24. *Libro de Casamiento de Indios del año 1657–1668,* Archivo de la Parroquia de San Nicolás de Tolentino (document without catalogue number).

25. Luc Bucherie, *Murmures de la tour. Les graffiti de la tour de Crest* (Crest: Éditions Créaphis, 1999).

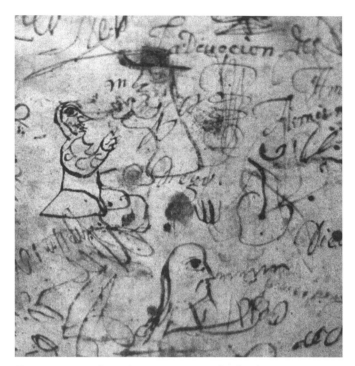

Figure 11. Page from the Actopan's *Book of Indian Marriages,* around 1660. Parish Archives, Actopan. Photograph by the author; reproduction courtesy of Father Juan Bautista Salinas, the Actopan Parish Archives.

either an Indian with artistic roots in the pre-Hispanic tradition, as in the *Títulos,* or a person of European descent in much closer contact with the tradition of Western graffiti practiced for centuries throughout Europe. Exploring the possibility that the author was an Augustinian friar who spent more time in the Actopan latrine than his brothers, perhaps as a penance, led me to the archives of the Inquisition to see whether someone had been detained in the monastery of Actopan during the years in question. And there I found Juan Durán.[26]

Juan Durán

Summoned to Mexico City from the monastery of San Juan Parangaricútiro, the Augustinian friar Juan Durán appeared for the first time before the Tribunal of the Inquisition on June 12, 1617. After several years of preliminary procedures, he had to defend himself from

the accusation of *Sollicitatio ad turpia,* the abuse of his position as confessor to solicit his "daughter or son of confession" to commit carnal sin.[27] The crime of *sollicitation* was widespread in New Spain and can even be regarded as one of the clearest symptoms of spiritual degeneration among both secular and regular clergy, especially in the first half of the seventeenth century.[28] The thick volume that records the inquisitorial proceedings against Juan Durán contains dozens of testimonials by Indian and Spanish women from the most distant villages recounting the missionary's solicitations dating back to 1608. These depositions describe Durán variously as "a young man not very bearded, of average stature, lacking in flesh, and a little bit ruddy,"[29] "white of broken color,"[30] and "*mestizo* in appearance."[31]

On June 12, 1617, at thirty-six years of age, the defendant reported his genealogy and history to the examiners in the "discurso de vida" (speech on life).[32] Born in Puebla in 1581, the son of the *español* Serván Durán and the *criolla* Agustina Sirvendo, at the age of six Juan left home with an uncle to begin several years of travel through Pachuca, Cholula, and Oaxaca. Back in Puebla as a teenager, he studied grammar with the Jesuits and at sixteen moved to Mexico City. Two years later, once again in Puebla, he took the Augustinian habit and the next year began a missionary journey through New Spain that carried him, among other destinations, to Michoacán, Guadalajara, Oaxaca, Valladolid, Cuiseo, Tehuantepec, and finally to San Juan Parangaricútiro, whence he was recalled by the Inquisition.

26. *Proceso contra Juan Durán, fraile de la Orden de San Agustín de Michoacan, por solicitante,* México, AGN, Inquisición, vol. 491, ff. 279–423 (quoted hereafter as Proceso).

27. Adriano Prosperi, *I tribunali della coscienza. Inquisitori, confessori, missionari* (Torino: Einaudi, 1996), pp. 508 ff. The papal bull *Contra sollicitantes* published by Paul III in 1559 conceded to the inquisitor of Granada the power to judge guilty confessors. The bull was extended to New Spain in 1561 (ibid., p. 511). See also Adelina Sarrión Mora, *Sexualidad y confesión. La solicitación ante el Tribunal del Santo Oficio, siglos XVI–XIX* (Madrid: Alianza, 1994).

28. Antonio M. Garcia Molina-Riquelme, *El régimen de penas y penitencias en el tribunal de la Inquisición de México* (México: UNAM, 1999). Jonathan I. Israel mentions about eighty proceedings against the regular and secular clergy for solicitation between 1620 and 1621 (Jonathan I. Israel, *Razas, clases sociales y vida política en el México colonial. 1610–1670* [México: FCE, 1999], p. 150). See also Alberro (note 9), p. 179.

29. *Proceso* (see note 26), f. 290: "Mancebo de poca barba mediana estatura pocas carnes y algo roxo."

30. Ibid., f. 336: "Blanco quebrado de color."

31. Ibid., f. 315 v.: "Que parecía mestizo."

32. Ibid., ff. 356–396 v.

After an exhausting interrogation that proved the charge, Juan Durán was condemned on December 15, 1618, to perpetual exile from the province of Michoacán and to six years' exile from the towns of Mexico City and Puebla.[33] One and a half years later, on Saturday, July 4, 1620, the sentence was ratified, with his exile from Mexico City reduced to the remaining four years of the original decree. On the occasion of the pronunciation and Durán's abjuration, which took place in the monastery of San Agustín in Mexico City two days later, on July 18, 1620, the friar was assigned to the Augustinian monastery of Actopan to serve a two-year penitence. After receiving a "circular discipline,"[34] Durán was transferred to Actopan.[35]

Overleaf, we find that Gabriel de Villanueva, vicar of the monastery of Actopan, wrote to the Inquisition the next year, on July 14, 1621, begging a reduced sentence for Durán, who had been confined there for a year by that time. The vicar writes that the friar "has persisted with much virtue and mortification and penitence in charitable works, serving the poor Indians with his own hands and all the brothers in the most ungrateful offices and setting a great example for all the Spaniards of the village."[36] It is not difficult to imagine that the "most ungrateful offices" mentioned by the vicar included cleaning the monastery, particularly the latrine. The same request was repeated six months later on January 27, 1622, by the friar Gonzalo de Herrera, guard of the Actopan monastery, who asked that Juan Durán be exempted from the remaining four months of his penance.[37]

Although we do not know the outcome of these appeals, one day Durán was set free and began an active life within what had become his monastery. Baptismal records in the Actopan parish archives indicate that Durán began conducting baptisms again in 1623. His signature appears in a *Book of Baptisms and Marriages* three times, twice in 1623, on January 25

and August 3,[38] and again on June 22, 1625.[39] I have found no documents naming Juan Durán for the year 1624 and no clues about his life after 1625, so at the present time I know nothing further of Durán's whereabouts during 1624 and from July 22, 1625, to 1629, the year recorded in the latrine graffiti and on the red wall of the upper cloister.

Let us imagine, however, that Juan Durán was the author of the graffiti. During his missionary work, he must have often come into contact with indigenous images. For instance, one of the women whom he solicited in Michoacán, the Purepecha Salomé Tzipacua, was the wife of a painter, Pedro Tzima.[40] Most probably Durán himself used a mixed glyphic system in the manner of "pictographic catechisms" for teaching Christian doctrine to Indian villagers.[41] Even if he were born *criollo*, he spent a lifetime in close contact with indigenous traditions and languages and managed to master at least Tarascan, Nahuatl, and Otomí.[42] The declarations of the women he solicited, who describe him in constantly changing ways, testify plainly to his protean identity. One in particular, the same Salomé Tzipacua, even brings into question Durán's own description of his ethnic roots by describing him as "of the Tarascan language."[43] However, even if we yield to the temptation to attribute the authorship of the Actopan graffiti cycle to Juan Durán, we still face the problem of decoding the episodes represented there.

Mexico City in 1624: the missing link?

After completing his penance in 1622, Juan Durán performed three baptisms in the church of Actopan, two in 1623 and one in 1625. Why are there none recorded for 1624? Let us recall that on July 18, 1620, before being transferred to the monastery of San Nicolás de

33. Ibid., f. 409 v.

34. "The clergy, of course, were not subjected to the disgrace of public scourging. In their cases, it took the form known as a circular discipline, administered in a convent by all the inmates in turn." Henry Charles Lea, *A History of the Inquisition of Spain* (New York: Macmillan Company, 1907), vol. 3, chapter 3.

35. *Proceso* (see note 26), f. 421 v.

36. Ibid., f. 422: "Ha proseguido con mucha virtud y mortificación y penitencia haciendo obras de caridad y sirbiéndo a los pobres indios con sus propias manos y a todos los frailes en los oficios más vajos con gran ejemplo de todos los españoles del pueblo."

37. México, AGN, *Inquisitión*, vol. 335, exp. 21, f. 153. According to his sentence of July 1620, Juan Durán still had six months of his two-year reclusion actually remaining at the time this request was made in January 1622.

38. *Libro de los bautismos y matrimonios del pueblo de Actopan (1604–1678)*. Archivo de la Parroquia de San Nicolas de Tolentino, Actopart (document without catalogue number, f. 35).

39. Ibid., f. 36 r.

40. *Proceso* (see note 26), f. 302.

41. For the specific relation between image and word in Testerian catechisms, see Alessandra Russo, "Plumes of sacrifice. Transformations in sixteenth century Mexican feather art," *RES* 42 (2002):226–250.

42. When he was thirteen, Durán lived for one year in Oaxaca with his uncle, who had opened a school for children (*Proceso* [see note 26], f. 361 v.). Durán may also have learned rudiments of Mixtec or Zapotec.

43. Ibid., f. 302 v. Does Salomé's use of the idiomatic expression "de lengua tarasca" suggest that she thought Tarascan was Durán's mother tongue? In any case, he spoke Tarascan well enough to be considered a *lengua* (interpreter).

Tolentino in Actopan, Juan was not only sentenced to serve a penance of reclusion for two years but was also prohibited from returning to Mexico City and Puebla for four years, until July of 1624. It is easy to suppose that, even if the requests of the friars of Actopan to reduce his period of reclusion were denied, he may have been granted a reprieve of some months before the end of his exile. Let us imagine that as soon as 1624 arrived, in the first week of January, Juan Durán finally returned, after almost four years, to Mexico City, just in time to witness a fateful moment in the history of New Spain.

It was at that very moment in time—after a year and a half of mounting tension between the viceroy, the marquis de Gelves, and Archbishop Pérez de la Serna— that hostilities between the two authorities reached their peak.[44] After his arrival from Spain in 1622, Gelves had put in place a program to end certain corrupt practices that had become widespread in New Spain: He introduced particularly severe tax reforms, imposing heavy fines on Spaniards and criollos alike. The members of the Audiencia (several of whom the viceroy had indicted) conspired with the archbishop against Gelves, who nonetheless persisted in carrying out his political reforms. The decisive casus belli was the viceroy's indictment of Melchor Pérez de Varaiz, corregidor of Metepec, whom the viceroy accused of illicit procedures and abuse of power over the Indians in his jurisdiction. Gelves not only denied Archbishop Pérez de la Serna's demand to review the charges against the corregidor but also condemned the archbishop to exile. Pérez de la Serna immediately countered by excommunicating the viceroy. In the very first days of 1624, Gelves convened a commission of senior officials that upheld his judgment against the archbishop and forced him to return to Spain. However, during his overland journey to Veracruz, Pérez de la Serna managed to provoke a revolt of unprecedented proportions by issuing a bull, Cessatio a Divinis, ordering the cessation of all religious offices in the churches of New Spain. The archbishop's expulsion and the suspension of liturgical services altered the life of the city so completely that people began asking the clergy whether "Christianity had ended."[45] When the Audiencia tried to revoke the archbishop's sentence on January 12, 1624, the viceroy immediately had the magistrates imprisoned. The news of their detention finally propelled the people into the street on January 15 to attack the palace of the viceroy.

For the first time, every segment of Mexico City's heterogeneous ethnic society—indios, mulatos, españoles, mestizos, and criollos—took up arms against the viceroy's sovereign authority.[46] Swarming everywhere with drawn swords, the mob succeeded in entering the palace and torching it. "Everyone wanted to find the marquis de Gelves in order to have the exquisite pleasure of throwing him into the flames."[47] To save his skin, the viceroy disguised himself as a servant and mingled with the crowd shouting, "Death to the viceroy!" Gelves managed to get out of the palace alive without being hurled from the top of the building.[48] After two days of rioting, the reign of the viceroy had ended.

An interim government took charge until the arrival of the marquis de Cerralvo, fifteenth viceroy of New Spain, in Veracruz on September 14, 1624. A few days after Cerralvo's entry into the capital on October 17, 1624, during a great ceremony in the Plaza Mayor, an effigy of Gelves was burned.[49] However, Gelves himself was reconstituted viceroy briefly on October 31 in order to pass the viceregal mandate to his successor, Cerralvo. Gelves's presence at the ceremony helped to create the illusion of an uninterrupted sovereignty and to conceal the fact that a popular rebellion had led to the overthrow of the viceroyalty.

Unlike Gelves, who suspended all welcoming festivities while still on the boat that had brought him to New Spain,[50] Cerralvo became famous for his passion for entertainment events, among them the unconsummated festivities planned for 1629. Everything was in place for the festivals—musicians, bullfights, floral displays, fireworks, and triumphal arches—when, a few days before the entertainments were to begin, a terrible flood transformed the city into a lagoon that did not recede for more than five years. The town celebrated by Bernardo de Balbuena in Grandeza mexicana (1607) had fallen before the implacable power of nature.[51]

44. For a description of the revolt, see Israel (note 28), pp. 151–163.
45. Ibid., p. 152.

46. Serge Gruzinski, Les quatre parties du monde: Histoire d'une mondialisation (Paris, La Martinière, 2004), pp. 97–101.
47. Artemio de Valle-Arispe, Virreyes y virreinas de la Nueva España (Madrid: Biblioteca Nueva, 1933), chapter "De potencia a potencia," p. 76.
48. Israel (see note 28), pp. 156–165.
49. Ibid., p. 171. Israel's information comes from a document in the Archivo General de las Indias, Patronato Real, 223, r. 8, f. 2v.
50. Ibid., p. 140.
51. Gabriela Vallejo, "Les muses négligées. Deux femmes écrivains en Nouvelle-Espagne au XVIIe siècle." (Master thesis, Ecole des Hautes Etudes en Sciences Sociales, Paris, 1999), see chapter 3: "María de Estrada y Medinilla: Décrire la ville et la fête lors de l'entrée du vice-roi. Mexico, 1640."

Figure 12. Portrait of marquis de Gelves, Chalpultepec Castle. Reproduced by permission of the Instituto Nacional de Antropología e Historia.

Figure 13. Detail of the falling man's face. Latrine of the monastery of San Nicolas de Tolentino, Actopan. Reproduced by permission of the Instituto Nacional de Antropología e Historia.

The viceroy's two bodies

This account of Gelves's downfall and the triumphs accorded to Cerralvo may bring to mind certain images in the Actopan latrine graffiti. The fall of a heavy body in the corner of the east wall could be seen as emblematic of the real fall of the government of New Spain on January 15, 1624. This symbolic link is strengthened by the extraordinary resemblance between the viceregal portrait of Gelves in the collection of the Chapultepec Castle (fig. 12)[52] and the falling man of the graffiti (fig. 13). Similarly, the key episode of the north wall, which features an important personage passing sedately on horseback among his people, seems not only to illustrate the sort of triumphal celebrations enjoyed by the marquis de Cerralvo, but to signal, like the festivals themselves, the unassailable sovereignty of the state. Here, too, we find that the viceroy's portrait in Chapultepec has much in common with the equestrian figure in the graffiti (figs. 14 and 15).

These parallels, along with the fact that we can find on the latrine walls the ghostly echo of Gómez de Trasmonte's famous plan of Mexico City from 1628, point toward a precise political iconography for the Actopan graffiti.[53] It is not difficult to read there the story of Gelves's figurative fall as viceroy during the revolt of January 1624 and the elevation of Cerralvo, whose installation as the new governor (1624–1635) disguised the institutional tremors caused by the uprising. It would be wrong, however, to think that this is a perfectly congruous and complete iconographic reading. Far from expressing a strict linear progression from one historic event to the next, the cyclical character of the graffiti means that its beginning and end always come together.

The difficulties of Cerralvo's viceroyalty were numerous. The political problems of the previous years were not resolved with his appointment, and soon he, too, began to quarrel with the archbishop. Most notably,

52. Inmaculada Rodríguez Moya, *La Mirada del virrey: iconografía del poder en la Nueva España* (Castelló: Universitat Jaume I, 2003).

53. Manuel Toussaint, Federico Gómez de Orozco, and Justino Fernández, *Planos de la Ciudad de México, siglos XVI y XVII. Estudio histórico, urbano y bibiográfico* (1938; repr., México: IIE-UNAM, 1990). Justino Fernández affirms that Trasmonte's *Plan* is the "first European plan of the viceroyal capital" (see p. 187).

Figure 14. Portrait of marquis de Cerralvo, Chapultepec Castle. Reproduced by permission of the Instituto Nacional de Antropología e Historia.

Figure 15. Detail of the horseback man's face. Latrine of the monastery of San Nicolas de Tolentino, Actopan. Reproduced by permission of the Instituto Nacional de Antropología e Historia.

though, the fifteenth viceroy's administration faced one of the most awesome natural disasters in the history of Mexico: the terrible flood of 1629, which claimed thirty thousand victims among Indian inhabitants alone.[54] In the flood's aftermath, much of the population had to be evacuated to nearby villages, and the city returned to normality only toward the end of Cerralvo's tenure five years later. The apocalyptic flood was widely regarded as an example of divine intervention and described in popular literature as a punishment intended to stop Cerralvo's preparations for the 1629 festival.[55] The viceroy himself was apparently convinced in the end that an "unknown divinity" had forestalled the celebrations.[56]

Bearing all this in mind, the graffiti cycle could be viewed as a warning to governors about the interrelation

of the two faces of power symbolized there. Gelves's arrogant and imprudent action led to the fall of his government, just as the reckless ambition of Phaeton precipitated his fall from his father's chariot in emblem 56 of Alciato's *Book of Emblems,* which circulated widely in New Spain from the sixteenth century.[57] Despite Cerralvo's self-confidence, he was riding toward another sort of fall—the submergence of an entire city as a result of still-inadequate drainage, a catastrophe that did nothing to improve the viceroy's popularity at the Council of the Indies, which had already recommended to the king his dismissal for corruption and the abuse of power.[58] The forced end of one mandate, symbolized by a viceroy's dramatic tumble from power, can thus be

54. The year 1629 brought with it another calamity, an epidemic of *cocoliztli* (haemorrhagic fever). See John S. Marr and James B. Kiracofe, "Was the *huey cocoliztli* a haemorrhagic fever?" *Medical History* 44 (2000):341–362.

55. Serge Gruzinski, *Histoire de Mexico* (Paris: Fayard, 1996), pp. 256–259.

56. De Valle-Arispe (see note 47), p. 89.

57. "In Temerarios," emblem n. 56 of the 1621 edition of Andrea Alciato, *Emblematum liber cum commentariis* (Padova: Petrum Paulum Tozzium, 1621), http://www.mun.ca/alciato/desc.html#images. The first edition of the *Emblematum liber* was published in Augsburg in 1531. Mario Praz, *Studies in Seventeenth-Century Imagery* (Roma: Edizioni di storia e letteratura, 1964–1974). The episode of the fall of Phaeton appeared later in a temporary triumphal arch erected in Mexico City in 1761 to honor King Charles III. See Joaquín Velázquez de León, *Arcos de triunfo* (México: UNAM, 1978), p. 100.

58. Israel (see note 28), p. 186.

read as the hopeful and serene beginning of another, depicted in the triumphal entry of the new leader, a lesson that the future viceroy should keep in mind.[59]

Thus, in an unprecedented way, the latrine walls depict "the viceroy's two bodies," which offer a parallel to the two bodies of Christ: one carnal and mortal, and the other political and immortal, symbol of the historical continuity of the government.[60] Just as viceregal authority was overturned for the first time in the history of New Spain by the uprising of 1624, the viceroy's two bodies appear for the first time in the Actopan graffiti. The governor is pictured here both in his "mortal" aspect as a man of flesh and blood subject to the laws of gravity and in his other, "immortal," nature—in equestrian guise—as a fiction of the (vice) kingdom. In this way the viceroy, like the king, is shown to have "a double existence: doubly threatened, doubly mortal, by the death which threatens him and by the other death that threatens the crown."[61]

The friar's two bodies

While I explored a political reading of the graffiti cycle, Juan Durán faded into the background. Had his sentence of exile been commuted so that he was free to return to Mexico City in time to see the revolt of January 15, 1624, with his own eyes? Perhaps, but it is unlikely that we will ever know for sure. Let us end with an additional question: Why would the friar have drawn such a cycle on the walls of the latrine? Is it possible that he found some personal significance in the political events of 1624 that inspired him to create a visual record of the two phases of power?

We have no trace of Juan after 1625, the last year his signature appears in the Actopan *Book of Baptisms and Marriages*. Among the possible reasons for his disappearance from the record is the likelihood that, once reincorporated in the activity of the monastery, he started not only to baptize, but also to hear confessions, falling sooner or later into the same sin that had brought him to Actopan.[62] The enigmatic phrase engraved in the upper cloister, "the 7th of August the first day of 1629, in the latrine of the church still," could thus take on a very clear meaning: In 1629, long after his first trial, Juan Durán may have been once more imprisoned in the monastery for having again fallen prey to his voluptuous impulses, and "the 7th of August" would mark the first day of this new penitence.[63] As before, Juan was probably assigned to carry out the "most painful offices," including cleaning the latrine. The adverb *aún* (still) might therefore be read as "again." Based on this assumption, the graffiti cycle can be seen as more than a pastime or a moralizing and satirical view of the fluctuations of viceregal political power. The drawings could have a much more personal significance: Who better than Juan Durán could bear testimony to the vagaries of fortune? Who more than he had felt the fluctuations of the "two bodies"?

One body: that of Juan, the carnal human body, perpetually soliciting the physical love of women wherever he goes in New Spain, but a body also stripped and scourged by the inquisitors. The other body: that of Fray Juan Durán, the mystical body instructed in the institutional code of a missionary, a body that travels to the most distant villages to convert Indians and that is later held up as an exemplary penitent worthy of resuming an active life in his new monastery, before falling again one day in the body of the other Juan. This

59. When the triumphal arch was painted to celebrate the arrival of the marquis de Villena in 1640, the emblematic portrait of Gelves was associated with the word *infoelix* (unfortunate) and that of Cerralvo with *prudens* (prudent). Vallejo (see note 51).

60. Here I am paraphrasing Ernst Kantorowicz, *The King's Two Bodies. A Study in Mediaeval Political Theology* (Princeton: Princeton University Press, 1957). Thanks to Gerhard Wolf for an enlightening discussion we had in the Warburg Institute Library on the Kantorowicz perspective. See also Louis Marin on the Kantorowicz theory in "Le corps pathétique du Roi. Sur le Journal de Santé du Roi Louis XIV," *Revue des sciences humaines* (Lille: Presses Universitaires de Lille III, 1985), pp. 31–49 (republished in Louis Marin, *Politiques de la représentation* [Paris: Collège International de Philosophie, Editions Kimé, 2005], pp. 95–119, in particular p. 98).

61. Antoni Vicens, "La locura de Hamlet y la del mundo," *Ornicar? digital* n. 209, 2002 (article still printable in 2003 at the address: http://www.wapol.org/ornicar/articles/209vic.htm).

62. In the Archivo General de la Nación, an undated document not included among the volume of original proceedings against the friar states that Juan Durán affirms that "the Holy Office condemned him to two years of reclusion and other penances that he had to accomplish in his monastery of Atocpa [sic], where he had completed [his sentence] with humility and attentive care" ("por culpas que contra él resultaron el santo tribunal le condenó en dos años de reclusion y otras penitencias que las havia de cumplir en su convento de Atocpa [sic], adonde lo ha cumplido con umildad y cuidado atento lo qual pide y suplica a N. S. sea servido de tener por bien que salga de la dicha reclusion que en ello recivirá particular merced" [AGN, *Inquisición*, vol. 335, exp. 93]). The phrase "in his monastery" could suggest that the document concerns another lawsuit brought after Juan's return to an active religious life at Actopan, which had become in the period between 1620 and 1623 "his monastery."

63. On the relapsed *solicitante* Francisco de León Carvajal (Archivo Histórico Nacional, Madrid, lib. 1064), see García-Molina Riquelme, *El régimen de penas y penitencias en el Tribunal de la Inquisición de México* (México: UNAM, 1999), p. 324.

reading of the cycle as a double self-portrait is reinforced upon stepping outside the latrine onto the loggia.

Here, among other graffiti traced in charcoal, are two overlapping drawings. One is a profile accompanied by the signature "Ju°" (fig. 16), which closely resembles Juan's signatures on the final sheets of his inquisitorial proceedings and on the baptismal certificates he signed (fig. 17).[64] The second word of this signature is not easy to decipher, but the first three letters seem to spell *mal* (bad). Below the profile that accompanies the signature, there is another, similar profile inscribed in a crescent moon (fig. 18) near a drawing of the sun. As an emblem of the revolutions of the wheel of Fortuna (fig. 19),[65] the moon image seems to condense the many faces and phases of the graffiti's author, the man whose signature appears above. Who was more capable than Juan Durán of understanding and illustrating the multiple aspects of existence? Like a moon subject to astronomical laws, but not to the pull of terrestrial gravity, his profiles orbit through the graffiti cycle in all their many aspects.[66]

Vertigo, aesthetic condensation, and desire

Tout achever sauf le désir[67]
> —Miss.Tic's graffiti on Paris's La Butte
> aux Cailles, today erased

Deseja-se o que se demora[68]
> —Manoel de Oliveira, O quinto imperio.
> Ontem como hoje, 2004

A man in black slides down the polished wall. His fall, upon which everything else depends, is transformed into the pivot of a story that must be completely (re)constructed in order to become visible.[69] But how

Figure 16. Man's profile and "Ju°" signature in the graffiti's cycle. Loggia of the upper cloister. Latrine of the monastery of San Nicolas de Tolentino, Actopan. Reproduced by permission of the Instituto Nacional de Antropología e Historia.

Figure 17. Juan Durán's signature ("Ju° Duran") in the *Proceso contra Juan Durán, fraile de la Orden de San Agustín de Michoacan, por solicitante.* Photograph courtesy of Archivo General de la Nación, Inquisición, vol. 491, exp. n. 17, f. 420.

64. Juan Durán signs "Jhoan Durán" until f. 393 v. of his inquisition proceedings. Beginning with f. 406, he signs "Ju° Durán." In the lower part of the graffiti mural, there is another man associated with the signature "Don Ju°." At the present stage of research I am not able to exclude the possibility that it was added later. Several other words, certainly more recent from the palaeographic point of view, have been written on the graffiti mural; for example, near one of the churches one can read *calvario* (calvary).

65. Philine Helas, "Fortuna-Occasio. Eine Bildprägung des Quattrocento zwischen ephemeren und ewiger Kunst," *Städel Jahrbuch* (1999):101–124.

66. On astronomical graffiti, see "astronomies" in my virtual exhibition of graffiti: Russo. "Activar el monumento" (see note 4).

67. "Achieve everything but desire." Miss.Tic is a Parisian artist creating art "au pochoir" on the walls of the city. See Miss.Tic, *Re Garde Moi* (Paris: Editions Alternatives, 2003).

68. "One desires what is delayed."

69. "La subversion, si elle a existé quelque part et à un moment, n'est pas d'avoir changé le point de virée de ce qui tourne, c'est

d'avoir substitué un ça tourne un ça tombe," Jacques Lacan, *Encore* (Paris: Seuil, 1972; repr., Paris: Seuil/Points essays: 2002), p. 56. ("The subversion, if it ever existed at any given place and moment, does not consist in having changed the turning point of whatever might be turning, but in having 'it falls' substituted for 'it turns.'")

Figure 18. The crescent moon and the sun. Loggia of the monastery of San Nicolas de Tolentino, Actopan. Reproduced by permission of the Instituto Nacional de Antropología e Historia.

Figure 19. Evert Zoudenbalch, *Fortuna*, 1465–1470. Photograph: Courtesy of Herzog-August-Bibliothek, Wolfenbüttel.

above all to avoid imprisoning the graffiti cycle inside only one explanation, one vision, one purpose. Whether the graffiti was inspired by a territorial, political, or personal conflict, its iconography requires more than one key to unlock it. Only by recognizing the complexity of this object and taking into account its multiple voices can we approach its singularity, which resides precisely in its power to embrace a potentially infinite number of readings. One of the most distinctive features of a great number of postconquest images lies in what can be called the power of "aesthetic condensation."[70] Even if this quality can be regarded as intrinsic to all artistic images, *mestizo* productions push the tendency still further. In this sense, the Actopan graffiti cycle tells "a tale of two (or more) bodies." Far from being, as is often thought, a mere juxtaposition of two artistic traditions—an indigenous corpus and a European one[71]—postconquest artistic work is the site of an internal tension that creates mutual transformations among a multiplicity of procedures, techniques, styles, decisions, and outcomes, to which it is always possible to add another element of complexity without creating a contradiction. Like many other postconquest productions, the graffiti cycle became the locus of a ceaseless aesthetic transformation, which progressively readjusts its aesthetic and narrative coherence. Two examples will help illustrate this phenomenon in other pictorial contexts.

In the *Codex Durán,* a mixed pictographic/pictorial/alphabetic document produced in the heart of Mexico

70. I look forward to developing a more theoretical argument on the dynamics of what I call here "aesthetic condensation." I borrow the expression from Freud's discussion of one of the specific mechanisms of the dream work. My thesis here is greatly indebted to this passage on condensation from "On Dreams": "The process of condensation further explains certain constituents of the content of dreams. . . . What I have in mind are 'collective' and 'composite' figures and the strange 'composite structures.' . . . I may build up a figure by giving it the features of two people; or I may give it the *form* of one person but think of it in the dream as having the *name* of another person. . . . In all these cases the combination of different persons into a single representative in the content of a dream has a meaning; it is intended to indicate 'and' or 'just as,' or to compare the original persons with each other in some particular respect, which may even be specified in the dream itself." (*The Standard Edition of the Complete Psychological Works by Sigmund Freud,* ed. and trans. James Strachey [London: The Hogarth Press and the Institute of Psycho-Analysis, 1953], vol. 5, pp. 650–651. Original German version, *Über den Traum* [1901]).

71. George Kubler, "On the colonial extinction of the motifs of pre-Columbian art," in S. K. Lothrop, ed., *Essays in Pre-Columbian Art and Archaeology* (Cambridge: Harvard University Press, 1961), pp. 14–34.

can we cope with the sense of vertigo produced by the rapid passage of dozens of images on these humid walls, where human traces and slivers of time swirl in confusion? The path taken along these pages is a real work in progress, one in which, at each step, I have tried

Figure 20. Several episodes from the Spanish arrival from Diego Durán, *Codex Durán* (*Historia de las Yndias de la Nueva España e Islas de la tierra firme*), ca. 1570. Photograph: Courtesy of Biblioteca Nacional, Madrid.

Figure 21. Several episodes from the Spanish conquest from *Codex Azcatitlan*, sixteenth century. Photograph: Courtesy of Bibliothèque Nationale, Paris.

around 1578 under the direction of the Dominican Diego Durán (fig. 20),[72] indigenous artists condensed into a single image the separate arrivals of the Spaniards Juan de Grijalba and Hernán Cortés on the Atlantic coast. They thereby created a new iconography of a unique "Arrival" that combines two real historic events that occurred one year apart (in 1518 and 1519)[73] with the emblematic power of "the Entry" (in Judeo-Christian

72. Another remaining path to explore is the possible genealogical relationship between Juan Durán and Diego Durán; the connection could help to explain the graffiti's links with the codex tradition.

73. Russo, *El realismo* (see note 18), pp. 99–103.

tradition, the entry of Christ into Jerusalem). As Diana Magaloni has astutely observed, they even added in the same image precise Mesoamerican references.[74] All these multiple elements are thereby condensed in one image capable of representing several places in time. In the same way, as Federico Navarrete has suggested, a page in the Codex Azcatitlán depicting the fall of a man from the Templo Mayor may integrate references to two different battles that took place during the Spanish conquest, thus producing an emblematic representation of "the Fall" of the Mexican political organization, rather than a strict illustration of a specific event (fig. 21).[75] These two examples raise new questions about the latrine cycle iconography itself: Is it possible to read in the seventeenth-century graffiti mural a reference to the fall of the pagan Mexican government and the Entry of the Christian conquerors? Can we see the graffiti wall as a sort of "good and bad government"[76] of New Spain that includes references even to preconquest rulers?

Leaving these questions aside until further research, let us return now to the dialectic relation between concealment and visibility. The simultaneous walling off and conservation of the Actopan drawings under whitewash finds a parallel in the archives of the Inquisition, where thousands of pages of testimony, transcribed under promise of secrecy, were concealed in heavy volumes that paradoxically ensured their eventual visibility. Only by "opening" these objects and in some sense living with them for a while can we approach them. Although I did not want to reduce the graffiti cycle to a pictorial object to be "read" like any written page, I had to resort to a kind of paleographic procedure to order to "see" the graffiti's aesthetic coherence. Just as one often needs to stare fixedly at an enigmatic line in an ancient document and even imitate it in one's own handwriting before understanding where one word ends and the next begins (fig. 17), I had to plant myself in front of the mural and redraw for a time its dozens of characters, convinced from the start that the graffiti was more than a monumental scribble (fig. 2). Only then did I begin to catch glimpses of its visual syntax.

One last point should be made about the graffiti's very specific location in the latrine, as well as about the reception of the mural by the other inhabitants of the monastery. Still remaining to be taken into account is the symbolic value of the place itself as the locale for the performance of one of the human body's most basic functions.[77] The graffiti's location obliges us to consider the problem of the audience for the drawings, a subject I have not mentioned, and to ask whether, despite its physical visibility, the mural was, after all, a "public" creation? Or might we be standing instead before an extremely intimate work, realized more to elaborate a subjective story than to be presented to a community?

I would like to end with these still-unresolved questions. In this sense, "the writing of this story must retain a whiff of the unaccomplished"[78] in which the desire to know more of an inexhaustible object calls attention to yet another aesthetic effect of this newly visible image.

76. Quentin Skinner, *L'artiste en philosophe politique, Ambrogio Lorenzetti et le Bon Gouvernement,* trans. R. Christin (Paris: Raisons d'Agir, 2003).

77. On the regenerative and fructifying powers of Tlazolteotl, the Mesoamerican divinity able to transform waste into manure, see Patrice Giasson, "Tlazolteotl, diosa del abono: una propuesta," *Estudios de Cultura Náhuatl* 32 (2001):135–157.

78. Arlette Farge, *Le goût de l'archive* (Paris: Le Seuil, 1989), p. 146.

74. Diana Magaloni Kerpel, "Imágenes de la conquista de México en los códices del siglo XVI. Una lectura de su contenido simbólico," *Anales del Instituto de Investigaciones Estéticas* 82 (2003):5–46.

75. Federico Navarrete, "The Hidden Codes of the Codex Azcatitlan," *RES* 45 (2004):144–160. Navarrete states that "the scene could concentrate several meaningful episodes of the conquest related to the temple."

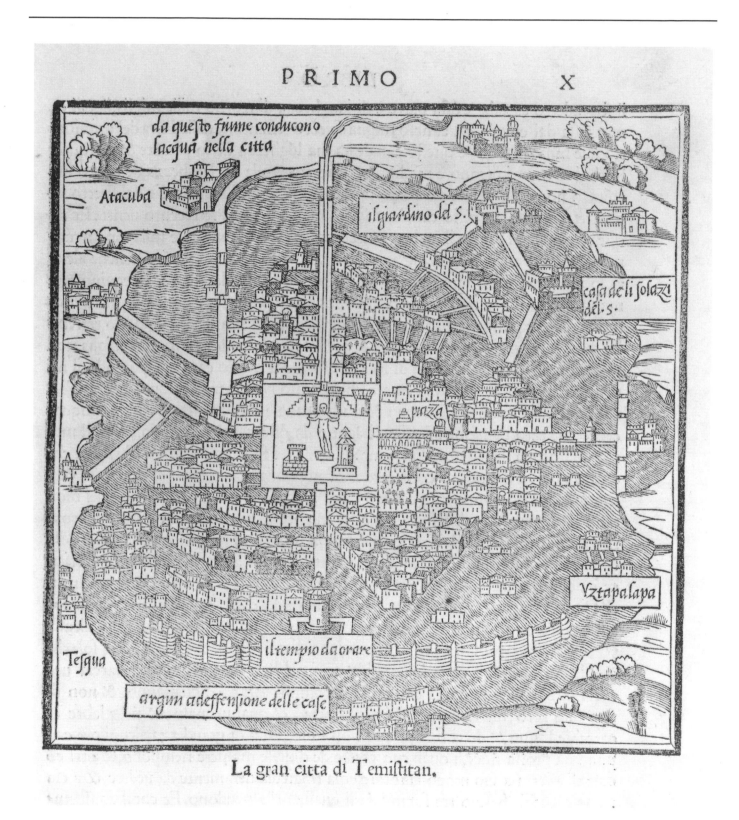

PRIMO X

da questo fiume conducono
lacqua nella citta

Atacuba

il giardino del S.

cafa de li folazi del. s.

piazza

Vztapalapa

Tefgua

il tempio da orare

argini a deffensione delle cafe

La gran citta di Temiftitan.

Figure 5. View of Tenochtitlan from Benedetto Bordone, *Isolario,* 10 recto. Woodcut. Photograph: courtesy of Harvard Map Collection.

Uneasy reflections

Images of Venice and Tenochtitlan in Benedetto Bordone's Isolario

DAVID Y. KIM

Renaissance voyagers often remarked on the similarities between Venice and cities in the New World. The conquistador Alonso de Hoejda, for instance, named the city on the Maracaïbo bay the diminutive "Venezuela" because "it is a village built on pillars, with bridges connecting each other, mak[ing] it look like a little Venice."[1] An *isolario,* or "book of islands," published in 1547, noted a resemblance between Venice and Tenochtitlan, now known as Mexico City. The author of that book, Thomaso Porcacchi da Castiglione, wrote that whereas other cities were founded by men, Tenochtitlan was "another Venice, founded by blessed God . . . by his very holy hand."[2] There was even a miniature version of Venice in this "other Venice." Porcacchi states that one of the islands surrounding Tenochtitlan, once called Cuetavaca, "is now called Venetiola, which is a rather grand and good place."[3] Expressing pride in their New World capital, Spanish humanists even claimed that Tenochtitlan, while resembling Venice, had surpassed the Republic in magnificence. In Francisco Cervantes de Salazar's treatise on New Spain, a foreign visitor touring Tenochtitlan exclaims: "Look at the large number of skiffs there! How many cargo canoes, the best for bringing in merchandise! There is no reason for missing those of Venice."[4]

Venetian cartographers, travelers, humanists, and diplomats also demonstrated a special interest in Tenochtitlan.[5] Gaspare Contarini, the Venetian ambassador to the Spanish court, composed a number of dispatches informing the doge, Antonio Grimani, of Cortés's arrival in Tenochtitlan. His letters concentrate particularly on the wealth of the newly discovered lands, a subject of great interest to the Signoria. On November 24, 1522, he wrote, "Hernando Cortés reconquered the great city of Tenochtitlan . . . [H]e sends back in ships a present for the emperor of pearls, jewels and other precious things from this land, which are worth 10,000 ducats."[6] Contarini adds, perhaps in an ominous tone, that the New World "promises great things for the future."[7] The renowned Venetian humanist Pietro Bembo foresaw the consequences of these recent geographic discoveries in his *Istoria Vinziana.*[8] He described the Portuguese and Spanish discovery of

1. Bruzen de la Martinière, *Grand Dictionnaire géographique, historique et critique* (Paris: Les libraries associés, 1769): "Un village bâti sur pilotis, dans de petites isles, avec des ponts de communication de l'une à l'autre, ce qui la lui fit regarder comme une petite Venize." Cited in Frank Lestringant, *Le Livre des Îles. Atlas et Récits Insulaires de la Genèse à Jules Vernes* (Geneva: Droz, 2002), p. 111. For a general treatment of Venice's relation with the New World see *L'impatto della scoperta dell'America nella cultura veneziana,* ed. Angela Aricò (Rome: Bulzoni Editore, 1990).

2. Thomaso Porcacchi da Castiglione, *L'isole piu famose del mondo, descritte da Thomaso Porcacchi da Castiglione Arentino e intagliate da Girolamo Porro Padovano. Al Sereniss. Principe et Signore Il. S. Don Giovanni d' Austria, General della Santiss. Lega* (Venice: Simon Galignani, 1572), p. 105: "La città, e isola di Temistitan Messico, è nella provincia del Messico nella nuova Spagna, Mondonuovo: & tanto vien commendata per bella, bene ornata, & ricca da tutti gli Scrittori, che non senza maraviglia vediamo un'altra Venetia nel mondo, fondata da Dio benedetto, piamente parlando; con la sua santissima mano: dove l'altre son fondata da gli huomini." Cited in Lestringant (see note 1), p. 111.

3. Porcacchi da Castiglione, (see note 2), p. 106: "Il lago d'acqua dolce è lungo, e stretto, & ha alcuni bei luoghi, come sono Cuetavaca, hora detta Venetiola chè assai grande & buon luogo."

4. Francisco Cervantes de Salazar, *Life in the Imperial and Loyal City of Mexico in New Spain and the Royal and Pontifical University of Mexico as Described in the Dialogues for the Study of the Latin Language Prepared by Francisco Cervantes de Salazar for Use in His Classes and Printed in 1554 by Juan Pablos,* ed. and trans. Minnie Shepard and Carlos Castaneda (Austin: University of Texas Press, Austin, 1953), p. 57.

5. Denis Cosgrove "Mapping New Worlds: Culture and Cartography in Sixteenth-Century Venice," *Imago Mundi* 41(1992):83.

6. Marino Sanuto, *I Diarii di Marino Sanuto, 1496–1533, dall'autografo Marciano ital, cl. VII, codd. 419–477. Publicatti per cura di Rinaldo Fulin, Federico Stefani, Nicolo Barozzo, Guglielmo Berchet, Marco Allegri, auspice la Regia Deputazione Veneta di Storia Patria* (Venice 1879–1902), vol. 33, col. 557: "Fernando Cortese ha recuperato la gran citá di Temistitan, con tutti quelli paesi et provincie che vi ho mandate in nota . . . Manda su in queste nave un presente a l'Imperator, di perle, gioie et alter cose preciose de quell paese." Cited in *Italian Reports on America, 1493–1522, Letters, Dispatches, and Papal Bulls,* ed. G. Symcox, G. Rabitti, trans. P. Diehl (Turnhout: Brepols 2001), p. 87.

7. Ibid., "et prometeno gran cose et intrade per l'advenir."

8. Pietro Bembo, *Della Istoria Viniziana* (Milan: Della Società Tipografica de'Classici Italiani, 1889).

Figure 1. Detail from Battista Agnese, *Atlante Nautico,* 1553. Photograph: Courtesy of Harvard Map Collection.

new lands and trade routes as "a misfortune" to Venice, but nevertheless characterized Tenochtitlan as a "distinguished city, in a lake of salt water."[9]

Venetian interest in Tenochtitlan expressed itself visually in the form of cartographic representations. For example, on Battista Agnese's world map (1536), and later on his map *Atlante Nautico* (1553), Tenochtitlan is the largest depicted city (fig.1).[10] The map

accompanying Pietro Martire d'Anghiera's *Historia de l'Indie Occidentali,* published in Venice in 1534, also illustrates Tenochtitlan. Likewise, Giacomo Gastaldi's *Universale della parte del mondo nuovamente ritrovata* (1556) prominently exhibits the New World capital.[11] Such images of the Americas entered Venetian collections, both private and public. A globe which included the Yucatan peninsula on its world view was once housed in the Palazzo Ducale's Sala del Maggior Consiglio, the meeting place of the highest Venetian

9. Ibid., p. 347: "Alla città, da cotali incomodi percossa, un male non pensato da lontane genti e regioni eziandio le venne." Ibid., p. 359: "Con que'popoli, che di sopra detti abbiamo, Messico, nella contrada Temistiana città egregia, in un laco di salsa acqua."

10. Ibid., p. 83.

11. Ibid.

magistrates.[12] Venetian citizens demonstrating a marked interest in the American city included Alessandro Zorzi, a writer known for his travel accounts of Ethiopia. Zorzi collected a number of documents on the New World, most notably a bird's eye view of Tenochtitlan.[13]

The Venetian fascination with its New World twin was not without reason. The two cities shared a common urban fabric, with buildings built on water, interlaced with canals and bridges. However, a deeper examination reveals that Venice's relationship with her New World counterpart did not merely consist of surface comparisons. While Venetians recognized the similarities with Tenochtitlan and at times attempted to mirror their city after the newly discovered capital, they also wielded a civic rhetoric that simultaneously negated these homologies. A paradox thus ensued: Venice and Tenochtitlan were thought to be like and unlike, similar yet fundamentally different.

Bordone's *Isolario*

Benedetto Bordone's *Isolario,* published in Venice in 1528, best illustrates the oscillating rapport between the two cities (fig. 2).[14] A cartographer, woodcutter, and illuminator of manuscripts, Bordone was active in Venice and the Veneto between the late fifteenth and first quarter of the sixteenth centuries.[15] In addition to being a prolific painter of miniatures, Bordone has also been linked to the design of the famous *Hypnerotomachia Poliphili,* published in 1499 by the humanist printer Aldus Manutius.[16] A hybrid of antiquarian treatise and romance, this lavishly illustrated book presents the dream voyage of a young man Polifilo searching for his beloved in a mystical landscape of gardens and classical ruins.

In a similar vein, the *Isolario* guides its reader through a wondrous voyage. Previous *isolarii,* such as those by Cristoforo Buondelmonti and Bartolomeo dalli Sonetti, were primarily concerned with the Aegean archipelago.[17] In his *Isolario,* Bordone extended the range of distances covered by previous isle manuals, transporting the reader on an itinerary through the Mediterranean, Atlantic, and Indian oceans (fig. 3). Condensing the global archipelago into the format of the book, Bordone's *Isolario* conjures a sensation of virtual travel, which would be impossible given the constraints of geography and notation.[18]

Of all the world's islands depicted in the *Isolario,* the only two island cities included are Venice and Tenochtitlan. For his representation of Venice, Bordone could have drawn from a number of city views, most notably Jacopo de' Barbari's monumental map of *la Serenissima* published in 1500.[19] For his rendering of Tenochtitlan, Bordone modified the famed Nuremberg map, the first image of the New World capital to reach a wide European audience (fig. 4).[20] Published in 1524,

12. *Studi biografici e bibliografici sulla storia della geografia in Italia,* vol. II (Rome: Società Geografica, 1882), p.164.

13. For a brief biography and references on Zorzi, see *Ethiopian Itineraries circa 1400–1524 Including those Collected by Alessandro Zorzi at Venice in the Years 1519–24,* ed. O. G. S. Crawford (Cambridge: University Press, Cambridge, 1958), p. 24.

14. Bendetto Bordone, *Libro di Benedetto Bordone nel quale si ragiona da tutte l'isole del mondo con li lor nomi antichi e moderni, historie e favole, & modi del loro vivere & in qual parte del mare stanno & in qual parallelo e clima giacciono* (Venice: Nicolo d'Aristotile, 1528). Later editions were published in 1534, 1540, and 1547. For a bibliographic note on Bordone's work see the preface by Umberto Eco in Benedetto Bordone, *Isolario* (Torino: Les belles lettres, 2000).

15. See Helena K. Szépe, "The book as companion, the author as friend: Aldine octavos illuminated by Benedetto Bordone," *Word & Image* 11 (1995):77–99.

16. For this attribution, see Lilian Armstrong, "Benedetto Bordone, Miniator, and Cartography in Early Sixteenth-Century Venice," *Imago Mundi* 48 (1996):65–92.

17. Among the literature on Cristoforo Buondelmonti's *Liber insularum archipelagi* (1420) and Bartolomeo dalli Sonetti's *Isolario* (1485) see Patricia Fortini Brown, *Venice and Antiquity: The Venetian sense of the past* (Yale University Press: New Haven, 1996), pp. 160–161 and Lestringant (see note 1). See also Ian R. Manners, "Constructing the Image of a City: The Representation of Constantinople in Christopher Buondelmonti's *Liber Insularum Archipelagi,*" *Annals of the Association of American Geographers* 87, no. 1 (1997):72–102.

18. See Tom Conley, "Virtual Reality and the Isolario," *Annali d'Italianistica* 14 (1996):121–130.

19. See Juergen Schulz, "Jacopo de'Barbari's View of Venice: Map Making, City Views and Moralized Geography before the Year 1500," *The Art Bulletin* 60 (1978):425–474.

20. The attribution of the map is still contested. An indigenous Culhua-Mexican attribution is argued by Barbara Mundy, "Mapping the Aztec Capital: The 1524 Nuremberg Map of Tenochtitlan, Its Sources and Meanings," *Imago Mundi* 50 (1998):11–33. An argument for the map's use of the European *mappa mundi* tradition can be found in Emily Godbey, "The New World Seen as the Old: The 1524 Map of Tenochtitlan," *Itinerario* 19 (1995):53–81. For further bibliography on the Tenochtitlan map, see Jean Michel Massing, "Map of Tenochtitlan and the Gulf of Mexico," in *Circa 1492: Art in the Age of Exploration,* ed. Jay Levenson (Washington: National Gallery of Art; New Haven: Yale University Press, 1992), p. 572. It should be noted that Bordone employs Cortés's letter as a source for his commentary on Tenochtitlan. However, Bordone alters the text, removing sections recounting the interactions between Cortés and Montezuma as well as Cortés's arduous journey toward the capital. Absent of the Spanish conquistador's heroic narrative, Bordone's text becomes a verbal atlas, reciting place names and geographic features of the New World.

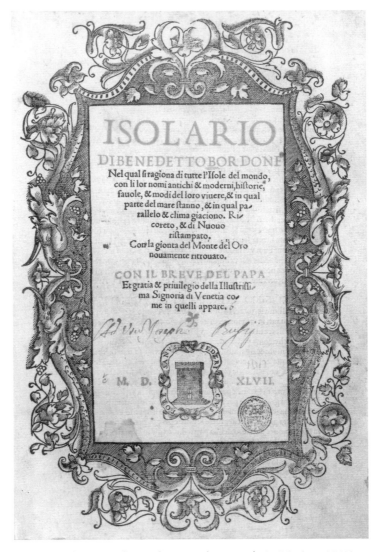

Figure 2. Title page of Benedetto Bordone, *Isolario* (Venice, 1547). Woodcut. Photograph: Courtesy of Harvard Map Collection.

this map accompanied the Latin edition of Hernán Cortés's *Second Letter* narrating his New World conquest.[21] Bordone encountered the map either through this Nuremberg edition or through its Italian translation published in Venice six months later.[22]

It is important to emphasize, however, that Bordone did not simply replicate his cartographic sources for his *Isolario*. Playing one map off the other, the artist's representation establishes a series of visual homologies between Venice and her New World counterpart (figs. 5 and 6).[23] Both cities are set in enclosed lagoons. Though distorted from their appearance in reality, the

21. *Preclara Ferdinadi. Cortesii de Nova maris Oceani Hyspania Narratio,* Nuremberg 1524. For a list of sixteenth- and early seventeenth-century publications of the 1524 Nuremberg map of Tenochtitlan, see Mundy (note 20), p. 32.

22. *La preclara Narratione di Ferdinando Cortese della Nuova Ispagna del Mare Oceano* (Venice: Bernardino de Viano, 1524).

23. Mario Sartor in his *La città e la conquista: mappa e documenti sulla trasformazione urbana e territoriale nell'America centrale del 500* (Reggio Calabria: Casa del libro, 1981) briefly comments on the

Oltra di quefta feguita characara da glifolani cofi nominata, laquale ha papagal
li molto maggiori, che appo noi gli fafiani non fono, liquali hanno tutto il cor
po roffo & l'alli de diuerfi colori depinte, Et è da caniballi poffeduta . per tra-
montana, a quefta non molto fe dilunga l'ifola matinina, che folamente è da fe-
mine habitata, lequali a uno loro certo tempo ne l'anno terminato, con gli ca-
niballi fe congiongono, & poi che al tempo del parto peruenute fono, fe mafco
lo, parturifcono, paffati li tre anni, a l'ifola di caniballi lo mandano , & fe femi-
na, per fe la tengono, & le loro habitationi fono caue fotterranee, nelle quali, fe
alcuno huomo, fuor del tempo che è per loro terminato , con effe cõgiunger fi
uoleffe, fuggono, & dentro di quelle cauerne, con le lor faette fi difendono,

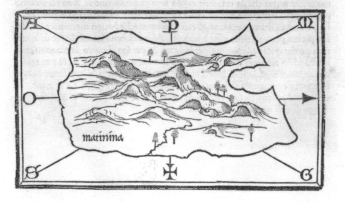

Figure 3. Caribbean islands from Benedetto Bordone, *Isolario,* 18
verso. Woodcut. Photograph: Courtesy of Harvard Map Collection.

surrounding land acts as a frame, offering the viewer similar vistas of the cities. Venice and Tenochtitlan also display the same method of organization. Outlying islands depart from a main urban cluster. In addition, both cities exhibit a dense urban texture. Blocks of houses and other buildings are tightly grouped together, imparting a sense of teeming habitation. The upper and lower ridges of Venice and Tenochtitlan also mimic one another, following the same meandering contours. Dissolving the rigid T-O format of the Nuremberg map, Bordone seems to have employed Venice's urban form to shape his representation of Tenochtitlan. Likewise, the view of Venice seems to borrow the format of enclosure within a lagoon from Tenochtitlan. By means of these cartographic similarities, Bordone enacts a visual and semantic counterpoint between Venice and Tenochtitlan. His text, in fact, emphasizes these analogies. In addition to Tenochtitlan's bridges, canals, and gates, the narrator

similarities between Venice and Tenochtitlan. See p. 92, note 46: "La si confronti con la mappa di Venezia presente nel medismo volume con cui condivide non pochi aspetti formali; ed ancora le due insieme."

Figure 4. Map of Tenochtitlan. Hernán Cortés, *Second Letter to Charles V* (Nuremberg, 1524). Woodcut. Photograph: Courtesy of Harvard Map Collection.

declares that "there are . . . many other things that make this city like Venice."[24]

Discrepancies, however, coexist with the striking similarities in the cities' urban layout. Unlike Venice, Tenochtitlan is provided with a clearly defined center. Dedicated to the Culhua-Mexican gods, this plaza served as the sacred precinct where religious rites, including human sacrifice and heart extraction, occurred.[25] Emphasizing this central precinct is an idol with outstretched arms assuming a cruciform posture. Departing from the template of the Nuremberg map, the

24. Bordone (see note 14), 7v: "Ce ne sono anchora di molti altri per esser la citta come Venetia, posta in acqua, la provincia è tutta circondata da monti grandissimi, & la pianura è de circoito di miglia ducent'ottanta, nella quale sono duoi laghi postri, liquali una grandissima parte ne occupano, percio che questi laghi hanno di circoito dintorno cento miglia, & l'uno è d'acqua dolce, & l'altro è di falsa ripieni, & il piano è da quelli per alchune coline separato, & nel fine questi laghi sono congionto da uno stretto piano, & con barche alla detta citta, & ville si conducono gl'huomini, & il lago salso, cresca & scema, come fa il mare & la città di Temistitan siede nel salso."

25. The Culhua-Mexica erected two temple pyramids on this site, one dedicated to the ancient agricultural and water god Tlaloc, the other to the tribal deity Huitzilopochtli. See Mundy (note 20), pp. 16–20.

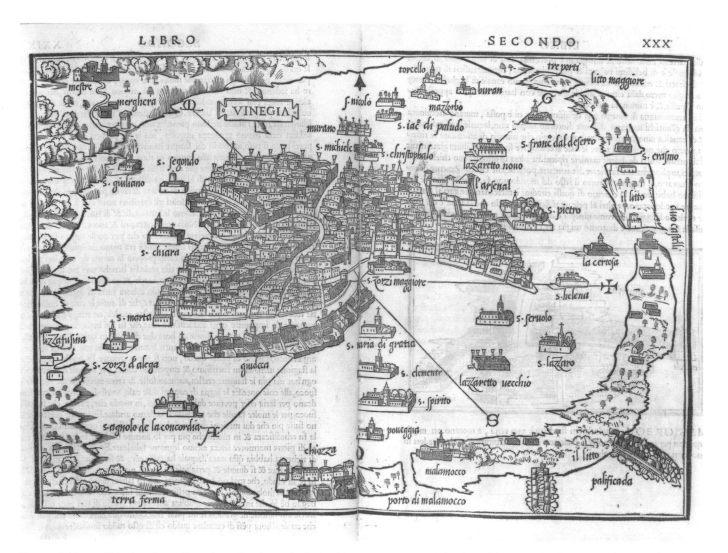

Figure 6. View of Venice, from Benedetto Bordone, *Isolario,* 29 verso, 30 recto. Woodcut. Photograph: Courtesy of Harvard Map Collection.

city's perpendicular avenues mirror the idol's rectilinear shape. As will be explored below, such a visual gesture draws a meaningful equivalence between this pagan idol and the moral character of the New World city.

Venice, by contrast, has no clearly defined center. Instead, islands such as Chioggia and Lido encircle the city. These floating satellites are, in fact, named with churches: Santa Michele, La Certosa, Santa Spirito, and Santa Chiara. Whereas in Tenochtitlan a pagan religious symbol defines the urban center, Venice, without a focal point, is surrounded by island churches forming a holy corona. The notion of conceiving Venice as inviolate and virginal, suggested by Bordone's map, was often

remarked upon by Venetians and foreigners alike. For instance, the sixteenth-century Venetian patrician Marcantonio Sabellico wrote that his city "for a certain novelty of placement and opportune position . . . was by itself the only form in all the universe so miraculously disposed."[26] A century earlier, the Spanish traveler Pero Tafur commented that even "if the whole world came up against the city, the Venetians could sink a ship . . . and

26. Marcantonio Sabellico, *Del Sitio di Venezia* (Venice 1502), ed. Gildo Meneghetti (Venice: Stamperia già Zanetti, 1957), p. 10. Cited in Patricia Fortini Brown, *Art and Life in Renaissance Venice* (New York: Harry N. Abrams, 1997), p. 15.

be safe."[27] The humanist Alvise Cornaro proposed a plan to renovate the Bacino of San Marco in order "to preserve the virginity of my dear patria and the name of the Queen of the sea."[28] In another treatise on the "santo lago," Cornaro referred to Venice's "immaculate virginity," calling his city "holy daughter of God."[29] Bonifazio de'Pitati's triptych *God the Father above Piazza San Marco* (1544) alludes to the myth that Venice was founded on the day of the Annunciation, thereby declaring the city's connection with the Virgin.[30]

Bordone's representation of the two cities thus poses a paradox. Tenochtitlan is depicted as an aggressively pagan city, whereas Venice shows herself, almost defensively, as the Christian Republic. Tenochtitlan's wondrous urban layout, however, finds a counterpart in Venice herself. The two maps thus bring together an unlikely pair of twins, reflecting in the unified scheme of the book contradictory aspects of both likeness and otherness.

Uneasy reflections

The tension between "mimesis and alterity," as one scholar has termed it, was not unique to the Venetians.[31] The Spanish conquistadors, for instance, recognized the "otherness" of the New World in themselves. As the upheavals of the Reformation and Counter-Reformation unfolded, idolatry became an accusation applicable not only to the Indian. Just as the conquistadors toppled Aztec devotional images, so too did Catholics witness the destruction of their own sacred objects in the tumult

of Northern European iconoclasm.[32] Thus, Aztec idolatry and Catholic veneration of images could be seen and, indeed, were accused as being one and the same.

These parallels at times reached improbable extremes. In certain situations, even cannibalism, a ritual synonymous with the New World, became a shared practice. Describing the Aztec consummation of human flesh, the historian Pietro Martire d'Anghiera wrote: "The wylde and myschevous people called Cannibales or caribes whiche were accustomed to eat mannes flesshe . . . molest them excedyngly invadynge theyr countrey, takynge them captive, kylling and eating them."[33] Cannibalism, however, was not an exclusively Indian practice. On several documented occasions, Spanish conquistadors ingested their crewmates to survive shipwrecks and abandonment. In 1527 Álvar Núñez Cabeza de Vaca, attempting to return to Mexico City after enduring a shipwreck in Florida, came across the remains of "five Christians who were in a ranch on the coast, and who came to such extremity that they ate each other, until only one was left, who being alone had no one else to eat."[34] Furthermore, the endorsement for the Spanish to eat human flesh can be found in Juan Focher's *Itinerarium Catholicum* (1574), a treatise discussing the proper interaction between missionaries and Indians.[35] At one point Focher comments: "In effect, God prohibited in Genesis human meat, but there are two occasions in which it is permitted."[36] Focher's first case concerns the consumption of human flesh for medicinal purposes. The second alludes to the scene witnessed by Cabeza de Vaca, a situation of extreme necessity. "In this case," Focher writes, "it is permitted to the Christian to eat the meat of a dead human, whether or not it has been dedicated to the devil."[37] Ruminations on such scenarios demonstrate just a sampling of the vexing circumstances in which New World otherness

27. Pero Tafur, *Travels and Adventures, 1453–39* (New York and London: Broadway Travellers, 1926), pp. 156–172. Cited in Brown (see note 26), p. 10.

28. Document by Alvise Cornaro on the San Marco Basin, Archivo Stato Venezia, "Savi ed Esecutori alle Acque," busta 986, filza 4, cc. 23–25: "Havendo dimostrato il modo, che vi è per conservare la virginità a questa mia cara patria, et il nome di Reina del mare, che il mode è con conservare lo suo porto, e la sua laguna." Cited in Manfredo Tafuri, *Venice and the Renaissance,* trans. Jessica Levine (Cambridge, Massachusetts: The MIT Press, 1989), pp. 159–160.

29. Alvise Cornaro, *Trattato di Acque* (Padova, 1560), 3r–3v: "Eternamente questo lago si conserverà, per esser sempre vigilantissimo Custode dell' immaculate verginità di questa sacrosanta figlioula di Dio." Cited in Vincenzo Fontana, "Modelli per la Laguna di Venezia. Alvise Cornaro e Girolamo Fracastoro," in Renzo Zorzi, ed., *Il paesaggio: Dalla percezione alla descrizione* (Venice: Marsilio, 1999), p. 179.

30. Brown (see note 26), pp. 91–92.

31. Michael Taussig, *Mimesis and Alterity: A Particular History of the Senses* (New York: Routledge, 1993).

32. See Thomas B. F. Cummins "To serve man: Pre-Columbian art, Western discourses of idolatry, and cannibalism," *RES* 42 (2002): 109–130.

33. Pietro Martire d'Anghiera, *The decades of the Newe Worlde or West India* (New York: Readex Microprint, 1955[1555]), folio 3. Cited in ibid., p. 116. Cummins mentions that this 1555 translation of the work would eventually serve as the material that inspired Shakespeare's Caliban.

34. Núñez Cabeza de Vaca, *Naufragios* (1542) (Madrid: Cáfedra, 1998). Cited in Cummins (see note 32), p. 120.

35. Juan Focher, *Itinerarium catholicum profiscentium,* Spanish trans. Antonio Eguiluz (Colección de Libros y Documentos referentes a la Historia de América, vol. XXII, Madrid; Libería General Victoriano Suarez, 1960). Cited in Cummins (see note 32), pp. 119–120.

36. Ibid., pp. 312–313.

37. Ibid.

could be located in the European self. The Spanish struggled to overlook these symmetries between themselves and the Indian. Implementing a policy of evangelization and idol destruction, the conquerors of the New World sought to avoid the disturbing image of resemblance, to separate otherness from likeness.

An ideal city

Bordone's representation of Tenochtitlan not only posits a paradox based on direct statements (Venice is like Tenochtitlan or not like Tenochtitlan): The map of Tenochtitlan also operates in a hypothetical mode, dispensing both prophetic vision and damning exhortation. It shows what Venice should and should not become. On one hand, Tenochtitlan represented in its architectural form the ideal city. Its straight lines and wide causeways corresponded uncannily to the utopian schemes devised by Filarete and Francesco Giorgio di Martini.[38] As the Spanish visitor to Tenochtitlan in Salazar's treatise exclaimed, "How the view of this street exhilarates the mind and refreshes the eyes! How long it is, how wide! How straight, how level it is!"[39] It has even been proposed that Tenochtitlan served as the model for Dürer's scheme of the well-defended ideal city, as represented in his treatise *Etliche underricht zur befestigung der Stett, Schloss und Flecken*.[40]

Venetians, too, acknowledged that Tenochtitlan exhibited features of the ideal city. They thought of transforming the Old World, their world, into the New. Indeed, the humanist Girolamo Fracastoro proposed that Venice become a new "Themestitan."[41] He

recommended that the Republic should develop an urban infrastructure similar to those shown in Bordone's illustration of the New World metropolis. Fracastoro was particularly entranced by Tenochtitlan's network of canals bringing fresh water to the heart of the city. In addition, Alvise Cornaro's previously mentioned renovation of the Bacino of San Marco included a fountain of "fresh flowing water" in the piazza of San Marco.[42] Cornaro's fountain concept derives in part from Tenochtitlan's rectilinear canalization bringing water from a river into the barrio of Mexico.[43] Such projects inspired from the New World urban design were not restricted to the sixteenth century. Later thinkers in the seventeenth century thought of developing a pedestrian bridge linking Venice to Murano, similar to the network linking Tenochtitlan to the surrounding mainland.[44]

Such projects for urban renewal not only fulfilled Venice's need for practical amenities; these schemes also transported the wonder of the New World directly to Venice, thus reinforcing the notion of Venice as *mundus alter,* another world.[45] After stating his proposals for Venice to model herself after Tenochtitlan, Fracastoro declared that if such a plan were implemented, Venice would become "the most beautiful, the most commodious city that one could imagine."[46] Moreover, such a city would "not only be inhabited eternally, . . . it would be called the happiness and elected of God."[47] Envisioning his grand urban projects for Venice, Alvise Cornaro likewise exclaimed,

38. Among the vast literature on Renaissance ideas of utopia, see the insightful essay in Robert Klein, *Form and Meaning: Essays on the Renaissance and Modern Art,* trans. Madeleine Jay and Leon Wieseltier (Princeton: Princeton University Press, 1981).

39. Salazar (see note 4), p. 38.

40. Edwin W. Palm, "Tenochtitlan y la cuidad ideal de Dürer," *Journal de la Société des Américanistes* 40 (1951):59–66. Massing, however, disputes Palm's argument, stating that symmetrical layout of the Greek military camp, as described by Polybius, could have been the source for Dürer's conception of the ideal city. See Massing (note 20), p. 572.

41. Girolamo Fracastoro, *Lettera di Girlamo Fracastoro sulle lagune di Venezia, ora per la prima volta pubblicata ed illustrate* (Venice: Tipografia di Alvisopoli, 1815), pp. 9–10: "E qui una delle due cose si potria fare, ovver allagar tutte le valli predette tra li argini, e così è Themistitna, ovvero non le allagar tutte, ma far canali per quelle, per li quali li rai delli fiumi si potessero condurre, e lasciarne parte da essere cultivata." On the urban layout of Tenochtitlan as a model for Venice, see Cosgrove (note 5), p. 83 and Tafuri (note 28), p. 152.

42. Document by Alvise Cornaro on the San Marco Basin. Archivo Stato Venezia, "Savi ed Esecutori alle Acque," busta 986, filza 4, cc. 23–25: "et oltra tale bello edificio che molto ornerà la Città se potrà condurvi facilmente una fontana di acqua dolce viva, e pura, et in diversi luoghi di essa, oltra la piazza di S. Marco." Cited in Tafuri (see note 28), pp. 159–160.

43. Ibid., p. 153. It should also be pointed out that Cornaro's scheme for a fountain in the heart of Venice has parallels with the central Italian tradition of civic fountains. Among the literature on this theme, see Christer Bruun and Ari Saastamoinen, eds., *Technology, Ideology, Water: From Frontinus to the Renaissance and Beyond* (Rome: Institutum Romanum Finlandiae, 2003).

44. Vincenzo Fontana, "Un Progetto mai realizzato di fine seicento per collegare pedonalmente Venezia a Murano," *Bolletino dei Musei Civico Veneziani* 4 (1978):93–98.

45. The term is Francesco Petrarch's. See his *Familiares* XXIII, 16; *Seniles* IX. Cited in Brown (see note 26) p. 9.

46. "e all'un modo, e all'altro si rimoveria la malizia dell'aere, e si faria la più bella, la più amena città che si potesse immaginare, talc he considerando quello che può essere, e farsi di tempo in tempo, e di età in età, io vedo questa città non solamente abitate eternamente, ma tale che sarà chimata la felice e la eletta d'Iddio." For reference, see note 29.

47. Ibid.

"Oh what a beautiful city I see, how it will be truly famous! Oh how admirably virtuous is thought, which makes us see things before they are made!"[48] In the past, Venetians attributed a variegated identity to their city, conceiving the Republic as a new Jerusalem, Byzantium, or Rome.[49] As Denis Cosgrove has eloquently observed, each of these cities were "*axes mundi* of the Old World around which the *harmonia mundi* turned: now it [Venice] was to be imagined as a future Tenochtitlan, great city of the New World."[50]

A destroyed city

While Bordone's Tenochtitlan served as a model for Venice's future, the map was also a vision of the past. By the time of its publication in 1528, the city as shown in Bordone's map no longer existed. Following the dictum of *policía,* a government policy that legislated the urban layout of New World Cities, Cortés razed the temple precinct, filled the canals with earth and expanded the centralized grid plan that endures to the present day.[51] As Cortés wrote in his *Third Letter* to Charles V, "considering that Temixtitan itself had once been so renowned and of such importance, we decided to settle in it and also to rebuild it, for it was completely destroyed."[52] Describing his progress toward reconstruction, the conquistador boasted that "each day it [Tenochtitlan] grows more noble, so that just as before it was capital and center of all these provinces, so it shall be henceforth."[53] Thoroughly transformed by

August 1521, the Tenochtitlan as shown in Bordone's map was obsolete.

The ultimate cause of the city's destruction was the heathenism of the Aztec Empire. The Spanish Franciscan Fray Juan de Torquemada wrote that Tenochtitlan was "Babylon, a republic of confusion and evil, but now it is another Jerusalem, mother of provinces and kingdoms."[54] Accordingly, Bordone stamps the center of Tenochtitlan with a deity, irrevocably equating the New World metropolis with idol worship. Moreover, the idol's *contrapposto* seems to equate the *place* of the New World with the *time* of classical paganism.[55] Indeed, travelers to the New World often viewed the culture of the New World as another classical civilization. For example, in his description of Tenochtitlan's temple precinct, Cortés remarked "[E]verything has an idol dedicated to it, in the same manner as the pagans in antiquity honored their gods."[56] The Spanish humanist Gonzalo Fernández de Ovideo even compared New World peoples to the ancient Thracians.[57] Bernardino de Sahagún carried the metaphor between the New World and classical antiquity further in his *Historia general de las cosas de Nueva Espana, Códice Florentino* of 1585. In this work, the illustration of the Aztec god Huizlopochtli bears the caption "otro Hercules."[58] Moreover, New World idolatry was understood as comparable to classical paganism before the first great wave of evangelization in Late Antiquity. An illustration from Diego Valadés's *Rhetorica Christiana* of 1579 shows a Franciscan preaching to an attentive Aztec audience dressed in Roman garb.[59] The comparison of the New World with classical antiquity thus served an

48. Cited in Tafuri (see note 28), p. 152.

49. Brown (see note 17).

50. Cosgrove (see note 5), p. 38.

51. Legislation regarding urban layout in the New World was published in 1573 by Phillip II. See *Colección de documentos inéditos, relativos al descrubimiento, conquista y organización de las antiguas posesiones espanolas de América y Oceanía, sacados de los archivos del reino, y muy especialmente del de Indias,* ed. Joaquin Pacheco, Francisco de Cardenas, Luis Torres de Mendoza (Madrid: Ministerio del Ultramar, 1864–1888). For an English translation see Zelia Nuttall, "Royal Ordinances concerning the layout of new towns," *Hispanic American Historical Review* 4 (1921):743–753; 5 (1922):249–254. Cited in Mundy (see note 20), p, 31, note 48. Mundy notes that although Phillip II's urban policy was established in 1573, ordinances concerning the planning of New World cities began even before the conquest of Mexico. On urbanism in the New World, see especially G. Kubler, "Open Grid Town Plans in Europe and America, 1500–1520," in *XXXVIII Internationalen Amerikanistenkongresses, Stuttgart-München, 1968 Verhandlungen,* vol. 4 (München: K. Renner, 1969–1972), pp. 105–122.

52. Hernán Cortes, *Letters from Mexico,* trans. Anthony Pagden (New Haven: Yale University Press, 1986), p. 270.

53. Ibid.

54. Juan de Torquemada, *Monarchía Indiana,* book 3, Mexico 1615, p. 304. Cited in Richard Kagan, *Urban Images of the Hispanic World 1493–1793* (New Haven: Yale University Press), p. 151.

55. See Johannes Fabian, *Time and the Other: How Anthropology Makes its Object* (New York: Columbia University Press, 1983).

56. Cortés (see note 52), p. 107. For a recent examination on this subject, see David A. Lupher, *Romans in a New World: Classical Models in Sixteenth-Century Spain* (Ann Arbor: University of Michigan Press, 2003).

57. Anthony Pagden, *The Fall of Natural Man. The American Indian and the Origins of Comparative Ethnology* (Cambridge: Cambridge University Press, 1982), p. 25. Cited in *Italian Reports on America* (see note 6), p. 21.

58. The image is found on folio 10r of the Florentine Codex. Cummins (see note 32), p. 121.

59. Diego Valadés, *Rhetorica Christiana* (Perugia: Apud Petrumiacobum Petrutium, 1579). Though the Aztecs are wearing *tilmas* (Aztec cloaks), this dress is represented as being akin to Roman style togas. Ibid.

ideological purpose. The Americas promised a second great age of Christian conversion.

Nevertheless, in Bordone's image such a conversion has not yet swept the Aztec capital. Whereas in medieval maps, such as the Ebsdorf *mappa mundi,* an image of the resurrected Christ occupies the center of the world, in Tenochtitlan, an idol referencing pagan sacrifice stands resolutely in the midst of the ideal city.[60] Such idols, Cortés remarks, "are bound with the blood of human hearts which those priests tear out while beating. And also after they are made they offer more hearts and anoint their faces with the blood.[61] Accentuating the drama of this scene, Bordone embellishes Cortés's gory description:

> Those idols most people believe in are the biggest ones, and their size is bigger than any man, and they are made of seeds and legumes that they use to sustain themselves, and they squeeze them and mix them very well, and after mixing them they drop on that flour some blood that they take from the heart of a child, in order to make a sort of pulp, enough to satiate those idols, and after that they put them in their temples, they offer to them many children's hearts, and wet their face with blood. And they have as many gods as the needs of human life.[62]

Thus, the deity represented in the center of Bordone's map does not simply reference idol worship. Rather, combined with the reading of the accompanying text, this image conjures in the reader's imagination the gruesome scene of extracted hearts, sacrificed children, and idols smothered with blood. The contrast with Venice could not be more marked. As though to counter the claims of idol worship and impiety, Venice is shown without figurative images. Embraced by island churches, the city declares herself resolutely as the Christian Republic.

Conclusion

For Venice, Tenochtitlan was a "dialectic mirror," exhibiting images of like and unlike, the ideal and the damned. The New World city dramatized a utopian future for the Republic, yet at the same time characterized a hedonistic and destroyed civilization. Bordone does not offer the reader a resolution to these vexing tensions. Instead, he abruptly ends his *Isolario* with a definitive declaration of faith. The last pages of the book present a letter by the prefect of New Spain addressing "the most holy and Catholic Majesty" Emperor Charles V.[63] After describing the exploits of the conquistador Francisco Pizzaro and the abundance of silver found in these New World possessions, the final sentence of the letter reads: "We do these things in this way, not only to scatter the infidel, but to demolish them and above all to annihilate them."[64] Bordone's images of cities, a shimmering mirror fluctuating between likeness and otherness, shatters into massacre and expropriation.

60. In the Nuremberg map, this idol is represented as headless, bearing the inscription "idol lapideu[m]." Mundy argues that an Aztec artist is representing the headless mother of Huizilopochtli, named Coatlicue. Alternatively, the statue could also refer to the bas-relief of the Coyolxuahquí. Images of both figures stood in the temple precinct. Cortés mentions that idols "very much larger than the body of a big man" stood in the temple precinct, yet these images were made of seed-studded dough, not stone. See Cortés (note 52), p. 107. Above this idol appears the sun rising between two temples, perhaps a reference to the rising sun of the equinox. See Anthony Aveni, *Skywatchers of Ancient Mexico* (Austin: University of Texas Press, Austin, 1980), pp. 245–249. Also, see Alfred P. Maudslay, "A note on the position and extent of the Great Temple enclosure of Tenochtitlan, and the position, structure and orientation of the teocalli of Huitzilopochtli," *Acts of the International Congress of Americanists* (London, 1913), pp. 173–175. References cited in Mundy (see note 20), p. 30. In his translation of the Nuremberg map, Bordone has joined the sun and the headless idol to form a classical statue. Remaining, however, are the rivulets of blood pouring from the idol's hands.

61. Cortés (see note 52), p. 107.

62. Bordone (see note 14), 11r: "Et quelli idoli che piu vi è prestato credenza, sono di maggior forma fatti che non sono gl'altri, & sua grandezza ecciede ogni grandissimo huomo, & sono fatti di semenze & legumi, che nel loro vivere usano, prima le tritano, & dopo insieme benissimo le mescolano, & cosi mescolate, col sangue di fanciulli, che gli cavano del core, & cosi corrente bagnano quella farina, facendola in modo di pasta, & in tanta quantita che possino formar questi loro grandi idii, & àli medesimi idoli poi che compiuti sono & nelle moschee posti, de molti cori di fanciulli gli offeriscono,

& loro visi col sangue de fanciulli bagnano, Et quante sono le bisogna de mortali, tanti idii hanno per savtori." Note that Bordone uses the word *moschee* to refer to Aztec places of worship. That the conquest of the New World paralleled the *reconquista* of Islamic Spain was often commented upon. For architectural manifestations of this correlation, see Valerie Frazer, *The Architecture of Conquest. Building in the Viceroyalty of Peru 1535–1635* (Cambridge: Cambridge University Press, 1990).

63. Bordone (see note 14), 73v: "Copia delle Lettere del Prefetto della India la nova Spagna detta, alla Cesarea Maesta rescritte. Alla Sereniss. & Catho. Maesta Cesarea."

64. Ibid., 54r: "ne gli habbi da mancare re il modo non solo a discacciare li infideli, ma a distruggerli a anullarli al tutto."

Figure 1. Drawing of a *kanaga* mask by Alaye Atô, 1994, showing the typical components of a Dogon mask, including dancing accessories.

What's in a Dogon mask

POLLY RICHARDS

giru-banu-gɔ ninnyia wɔm . . . giru-banu-gɔ ninnyia wɔm lawa (I was afraid of the fearsome aspect . . . I was afraid of the fearsome aspect of masks)

—dama *song*[1]

In the light of the numerous publications concerned with Dogon masks, it is surprising that it still is not entirely clear what in fact masks *are* to Dogon people, other than bundles of fibers and leaves or a block of wood. Throughout *Masques Dogons,* Marcel Griaule referred to *ɲama,* an innate energy or "imperishable force" (Griaule 1938b:46) with which Dogon masks are possessed. However, he failed to fully explore this concept with regard to the range of masks that exist and to clarify how *ɲama* functions to create the "power" attributed to Dogon masks.

A mask for the Dogon people is more than a disguise. "For the Dogon themselves," we were told by Walter Van Beek, "the notion of *èmna*[2] includes the whole person dancing in a costume of which the headpiece is just one part. Masks are not worn; masks dance, perform and shout" (Van Beek 1991b:57). Yet although existing literature has placed an emphasis on the mask as *imina,* it is important to note that no single generic term for mask in fact exists in the Dogon language. There are *imina,* made of fiber and often wood, as performed primarily during post-burial rites, and there are *sanaguroy,*[3] made from leaves that appear prior to the rainy season. In the case of *imina,* the dancer's complete outfit usually consists of a number of fiber skirts and accessories that,

along with the headpiece, determine the particular character being performed (fig. 1). All of these materials are stored for use in successive performances.

Yet although parts of the costume are referred to with the prefix *imina,*[4] it is the dyeing of fibers that defines the costume as a mask. In this sense, *imina* may also be applied to instances where such dyed fibers are worn without a headpiece at all or, furthermore, to dyed fibers tied to a stick marking a prohibited place, in order to prevent non-society members from approaching. In contrast to *imina, sanaguroy* are ephemeral. They are made almost entirely from fresh foliage,[5] knotted into strips of bark, and will last only a few days (fig. 2). In this article, I will explore the ontological status of both *imina* and *sanaguroy* in the context in which they appear. I will aim in the process to further examine the relationship between these two mask categories as perceived by Dogon people.

The energy of *imina*

The *ɲama* or life-force, which is said to inhabit *imina,* is a widespread concept among populations speaking both Mandé and Voltaic languages.[6] The Dogon use of

This paper is adapted from Chapter 5 of my doctoral thesis: "*Imina saɲa:* (masques à la mode): A Study of Dogon Masquerade at the Turn of the Millennium (1994–2000)," awarded in January 2004, by S.O.A.S, University of London, and supervised by John Picton. My research has been made possible through funding from the Arts and Humanities Research Board, University of London Central Research Fund, S.O.A.S. Scholarships Committee, the British Academy, and the Friends of the Horniman Museum. I am also indebted to my friends and colleagues in the field including Sekou Dolo and the Dolo family, Wagaserou Douyon, Etienne and Jeanne Guindo, Nouhoum Guindo, Dagalu Girou, Apomi Saye, and the staff at the Mission Culturelle, Bandiagara, for their invaluable assistance, advice, and support.

1. The title is inspired by John Picton's article "What's in a Mask" from 1989 (see bibliography). The epigraph comes from Kervran, Kassogué, and Tembely 1989:22.

2. Unlike Van Beek, I will use the more frequently applied *tɔrɔ sɔ* phonetic spelling of the word *imina.* Unless otherwise specified, all Dogon references in the text are in *tɔrɔ sɔ.*

3. Griaule wrote of the word *sanaguroy:* "This last term breaks down into *sa:* sa tree ana, male guroy, rustle" (Griaule 1938a:269). By contrast, Denise Paulme noted "*Sanegurey: sa:* sa tree; sa suffix

indicating its name; *gurey,* poetic term for *dyoba* to run" (Paulme 1988 [1940]:151). During my research, one informant in Idiely-Na said that the word for this mask (which he pronounced *sanakuroy*) was derived from *sa* meaning sa tree, *na* meaning big and *kurɔ* meaning "leaf." I was not able to verify this information elsewhere.

4. The *imina* is made up of the following: *imina ku* (a painted wooden or fiber headpiece); *imina guru jamu* (a fiber hood); *imina gonkelu* (a knotted vest worn over the chest); *imina sanu* (a long black fiber underskirt); *imina jibe* (knee-length fiber skirts); *imina dene* (a belt of short fibers); *imina non tongu* (fiber armbands); and *imina kubo tongu* (wristbands) worn with other accessories over *pɔnu* (indigo-dyed trousers).

5. The tree species used for this mask type varied slightly throughout the region. In the *teNe kā*-speaking village of Idiely-Na, there were two main types: *sanaguroy pulɔ* (*sanaguroy* Fulani) in which the wearer was covered with an enormous cloak of *kankaɲa* (*Andira inermis* [dog-almond tree]), *mɛmɛji* (*Ficus lecardii*) leaves, and said to be like the long robe worn by Fulani men; and *sanaguroy bɛdɛ,* made from *sa* (*Lannea microcarpa*), *yoro* (*Parkia biglobosa* [locust bean tree]) and *kogol* (*Bannia*). Both types are made up of the *sanaguroy ku* (a headpiece), *sanaguroy gonkay* (a cape of leaves covering the chest), and *sanaguroy dini pagu* (a thick skirt of green leaves covering the legs).

6. For definitions of *ɲama* in neighboring Bambara, Bobo, and Minianka societies, see Cissé 1964:192–200; Colleyn 1982:5–6, 1988:130–131, 2001:246; Labouret 1934.118–127, Le Moal 1973:198–199; and McNaughton 2001:168.

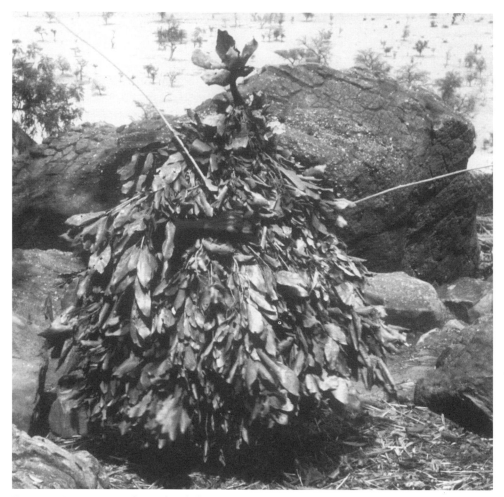

Figure 2. *Sanaguroy pulɔ* mask. Idieli, 1999. Photo by the author.

the word is presumed to have been borrowed from their Bamana neighbors (Calame-Griaule 1965:206).[7] Griaule referred to "the exceptional importance of the idea of *ɲama* among Dogon people" (Griaule 1938b:39) and to the presence of *ɲama* in all living beings, animal or human.[8] Eric Jolly described *ɲama* as "a force or a fluid energy, invisible and ambivalent . . . it circulates with the blood and is concentrated in certain organs or extremities of the body (in particular the liver or the tail)."[9] By contrast, Van Beek proposed that "the crucial concept of *ɲama*, allegedly 'vital force'" was "irrelevant to Dogon religion" (Van Beek 1991a:148), a factor that may illustrate the enormous divergence of belief and practice among a group of people whose "culture" is anything but homogenous.[10]

7. The word *ɲama* is thought to have been borrowed from the identical Bamana term, translating literally as "life, character, spirit" (Calame-Griaule 1965:206). It is also used by Bamana people to describe the "powerful energy that operated between the visible surface of the world to give it structure and make it work" (McNaughton 2001:168). Varying pronunciations are used by different speakers throughout the Dogon region (*ɲama* [tɔrɔ sɔ], *yāwā* [lɔgɔ *ɲama kā*], *yama* [dono sɔ]).

8. For further references to *nyama* among Dogon people, see Calame-Griaule 1965:35; Dieterlen 1940:829–830, 1941, 1947:82–83, 1950:354–356, 1973:213–218; de Ganay 1940:87–98;

Griaule 1940a:127–129, 1940b:79–85; Jolly 1995:506–507; and Kervran, Kassogué, and Tembely 1991:4.

9. ". . . une force ou une énergie fluide, invisible et ambivalente . . . elle circule avec le sang et se concentre dans certains organes ou certaines extrémités du corps (en particulier le foie ou la queue)" (Jolly 1995:506).

10. Like Van Beek, I also found that the concept of *ɲama* did not exist among Dogon people from the village of Tireli.

Among those Dogon villages today where the concept undoubtedly exists, the ɲama, necessary for the health of an individual, can transform itself into a vengeful and aggressive force. It can also be manipulated for either malevolent or beneficial ends (Jolly 1995:506–507).[11] A newborn child will have inherited the ɲama of its mother and father and also (though this may occur later in life)[12] of a deceased ancestor, referred to as his nani. In life he will also accrue the ɲama of various cults to which he pays his respects through blood sacrifice at their relevant altars, including ama, lɛbɛ, nɔmɔ, and (if he participates in the sigi)[13] of the imina-na (great mask); ɲama can therefore be understood from both individual and collective points of view. A particular social configuration of ɲama may entail a specific set of prohibitions concerning food, sexual intercourse, place, and time, which the individual must respect. Adherence to these rules maintains the integrity and stability of the ɲama, whereas the failure of these individuals or groups to maintain them results in puru, a state of rupture or impurity.[14]

A lot of seeming confusions about relationships between ɲama and imina are due to the fact that ɲama is found in many different aspects of the mask and is identified in the materials and processes of mask-making, as well as in the action of entrusting one's mask headpiece or costume to a mask altar. Griaule identified the significance of the color red, which was applied at the last moment to the fiber costumes and, like blood, was perceived as being imbued with ɲama: "[R]ed is one of the most beautiful colors and also the one most fraught with religious meaning. It recalls blood; it also recalls the color of the mythical fibers that Amma gave the world. For all these reasons, it is supposed to contain a powerful ɲama."[15]

Yet, while Griaule stated that the mask costume was endowed with ɲama by association with the color red, colors applied to mask fibers at the present time may be anything other than red. My own informants (making no reference to myth) referred to the more literal aspect of this energy; the degree of ɲama being made visible by the visual clashing that occurs when contrasting colors of imina are placed in juxtaposition to each other. This aspect is even more evident with the vivid imported inks and paints now in use, as one informant told me: "the colors have an effect on your eyes. That shows that the masks have strong ɲama" (N. Guindo 2000a). If the optical effect of dyed and painted masks is a metaphor of a "life" attributed to imina, it is significant that sanaguroy are perceived as being devoid of ɲama (although they would appear to be imbued with something, as shall be discussed below).

Moreover, in addition to the above, ɲama is also associated with the process of dyeing and painting the mask. This was first made evident to me by a smith in Idiely-Na, who in the course of making a mask, lifted freshly dyed fibers out of a pot and exclaimed: "Before it was fibers (jai) . . . Now it is imina . . ."[16] A wooden mask headpiece that has not yet been painted was referred to in Idiely as dege (statue) or lajugɔ nũyũ (mask dead).[17] Yet, at the moment that paint was applied, the sculpted object was said to be transformed into lajugɔ nɛyũyen (mask living) (Dara 1998; fig. 3).

In addition to the colors and effect of colors, ɲama inhabits both the wood and the trees with which mask headpieces are carved. The trees that are shady (in particular the Ceiba pentandra, Bombax Costatum, and Ficus platyphylla) are perceived as being dogi[18] (heavy) with ɲama, and the wood from these trees is viewed as being of extreme danger to both the carver and dancer. Griaule described the extra precautions that were required before the wood was cut from such trees (Griaule 1938b:405 and 407). Blood sacrifice could be undertaken either at the mask altar or on the trunk of the tree in question. Furthermore, the carver could protect himself through the wearing of various amulets, such as a copper bracelet [tumo] or a necklace [ɔmɔlɔ yɔgu], which will have accrued ɲama through direct blood sacrifice, serving a similar protective function. While I was not able to establish whether such sacrifices were still practiced, the wearing of protective amulets [ɔ̃mɔ̃rɔ̃] was still in use at the time of my research.[19]

11. The idea of an energy that is morally neutral is common throughout West Africa.

12. This will be ascertained through divination in response to physical symptoms evident in the individual.

13. Sigi/sigu is the name of a ritual occurring every sixty years in certain villages throughout the region.

14. Elders frequently linked the failure by young people to respect such prohibitions to a demise in the effectiveness of village altars.

15. "[R]ouge est la plus belle des couleurs et aussi la plus chargée de sens religieux. Elle rappelle le sang; elle rappelle aussi la couleur des fibers mythiques qu'Amma a données au monde. Pour toutes ces raisons, elle est censée contenir un nyama puissant" (Griaule 1938b:353).

16. "Avant c'était jai, maintenant c'est lajugɔ" (lajugɔ is teŋe kã for imina) (Dara 1998).

17. These and the subsequent terms are transcribed in tɔgɔ kã (the speech of the tɔgɔ).

18. This is a tɔgɔ kã term.

19. See note 25.

Figure 3. Painting of a *kanaga* mask headpiece. Nombori, 1994. Photo by the author.

In addition to protection from *ɲama*, the need for protection from *dugu*[20] (sorcery) was perceived as being particularly strong at the time of a *dama*[21] post-burial ritual. Besides the precautionary measures described above, an additional action of entrusting one's finished headpiece to a mask altar was still found to be of fundamental importance. Sacrifices would be made on mask altars and other altars extant within the village and at communal altars that served an entire region.[22]

Several methods of protecting one's mask for a *dama* were described to me. In Banani, on the first day of a *dama* performance, in an action referred to as *imina duu deru,* mask east show, the *imina kubaŋa* was said to raise the mask headpiece of the oldest dancer to the east, thus entrusting the headpieces of all masked participants to the *albarga* altar that was situated to the east at Youga-Na. Alternatively, in Touyogou (where there was said to be no mask altar), the three oldest dancers would entrust their masks and those of their fellow performers by making a sacrifice directly onto their headpieces. A similar sacrifice occurred previously in Sangha; Griaule noted that the owner of an *imina* could make the direct sacrifice of a *gannu sunono* (a type of lizard) onto the mask: "introducing into the wood a positive force[23] that will protect the dancer from possible evil spells and will attack the hostile force."[24] However, in Sangha, this action would appear to have been discarded over time. The chief of Sangha-Ogol confirmed that this type of direct sacrifice to the *ɲama* of the mask had been ruled out in the 1970s, as it was proving too dangerous: "Women who had left the region in search of work, were returning and approaching masks without a knowledge of their power and were becoming mad . . . so were tourists . . ." (Dolo 1996).

Another common method described by Griaule (1938b:747) and still evident in many villages was the piercing with a *gɔbɔ*[25] (hook) of the summit of a

20. *dugu* [tɔrɔ sɔ], *dugo* [teɲe kã / dono sɔ], *duge* [tɔmɔ̃ kã] are generic terms for both sorcery and poison (Jolly 1995: Appendix:16). *Dudugu-nɛ* (sorcerers) are men and women who seek to poison the lives of other villagers, fly around at night in search of victims to devour, and form a secret contra-society that reunites regularly in the bush (Jolly 1995:596–605).

21. *dama* [tɔrɔ sɔ], *dãwã* [teɲe kã], *dãɲɪ* [dono sɔ can have two meanings: first, "something forbidden, a prohibition," and second, the name of the rite that marks the end of the period of mourning.

22. In the *tɔmɔ̃ kã* zone, Jolly noted the existence of duu ã, a single mask altar that served the entire region (a commune of twelve villages) (Jolly 1995:94). Similarly, in the *tɔrɔ sɔ* zone my informants in Banani, Koundou, and Tereli still considered the *albarga* altar at Youga-Dogourou (described by Griaule 1938b:768) to be a sure option for those prepared to make the journey. Informants told me how they would take their headpiece to Youga and contribute money for a

chicken to be sacrificed to the *albarga;* afterward, an elder would touch the altar three times with the headpiece. In the event of masks that had been thus protected from being stolen, it was believed that the thief would die within one year.

23. Griaule is not specific about the nature of the "energy" imparted.

24. ". . . à introduire dans le bois une force positive qui protgégera le danseur contre les maléfices possibles et qui attaquera la puissance ennemie" (Griaule 1938b:408).

25. In addition to the *gɔbɔ*, the wearing of *ɔ̃mɔ̃rɔ̃* (amulets) was also evident for the protection of both wooden and fiber mask dancers. These were apparent in several forms: a *tan-sɔgɔ*, a miniature wooden door lock attached to a piece of cord and worn around the neck; a *sɛwi*, a small branded rectangle of leather attached to a twisted cotton belt, worn around the waist; and finally an *inu ɔ̃mɔ̃rɔ̃* (iron *ɔ̃mɔ̃rɔ̃*), a flat branded rectangle in metal, attached to *yɔgu* (a chain), also worn around the neck. Such amulets were said to remain the property of the family after death and would be used by the individual's descendants. In Tereli, long-term protection could also be secured by rubbing a powder made from a grilled newborn kitten (mixed with the bark of unspecified plants) directly onto one's skin. In all cases, the dancer was subject to prohibitions specific to each form of protection, such as not being able to talk to a pregnant or menstruating woman. As with the *gɔbɔ* hook, it was said that the malediction was fixed upon the amulet or powder and the dancer remained unharmed.

wooden headpiece, placed momentarily next to a mask altar during a blood sacrifice, serving to entrust the mask to that altar. However, as Griaule noted, not all dancers would want to undertake such steps: entrusting one's mask to an altar makes an individual "subject to serious servitude which restricts many of the advantages." Being a costly step in terms of sacrifices demanded and prohibitions in force, "many among them . . . prefer to run a risk."[26]

The action *pɛgɛ* (to nail, to fix)[27] is used in a figurative sense to describe the binding or entrusting of the *imina* to an altar in the various ways described above. In Konsogou, one elder described the action of *pɛgɛ* to me, imparting his fear of what would occur if it were not undertaken: "Having prepared it and colored it red, one then has a *gɔbɔ* made by the smith, a pair of chickens are brought that are sacrificed on the *awaga*[28] in order to fix the mask upon it. . . . It is thus that one proceeds. If ever one keeps it without fixing it, it will do harm to the owner that uses it. When it is put down after the *dama*, this object will crack open, the owner will become very hot, in fact it will be difficult for him to take it off. If that happened, would not the people of your family be subjected to shame?" (Ampindo Sagara 2000a: see Appendix I).

My field assistant further explained the neutralizing effect of this action on the energy of *imina*: "There are certain trees such as the *togodo*, when you carve the *walu*[29] with this, if you don't fix it on an altar, in order to neutralize it a little, its force can annihilate the person that wears it, and generally when you wear this mask, you have to face a large rock, or a tree in order to cry '*hun*' to send the harmful *ɲama* to it. Also, if it is not a powerful tree, this action can dry it out. If you omit to do this and face a person [seeing the mask], the person will die" (N. Guindo 2000b).[30]

The action of *pɛgɛ* would appear to be of vital consequence in defining the mask's status (a factor that previous publications have failed to note). An *imina* entrusted in this way is referred to as *imina pɛgati* (*imina*, which has undergone the rite of *pɛgɛ*).[31] As a result of this action, any harm directed at the wearer will stop at the mask and he will not be afflicted. Thus, entrusted to the mask altar, the *imina pɛgati* is no longer considered to be the direct property of the individual and cannot be sold to visiting tourists without prior reparation through animal sacrifice to the mask altar. The *imina pɛgati* may also be referred to as *imina kɔrɛla* (*imina* real), because through the act of *pɛgɛ* it has been bound to the mask altar and thus shares in its *ɲama*. By contrast, the *imina pɛgɛ-la* (*imina* without *pɛgɛ*), which has not been entrusted to the mask altar, may have been worn at dances for visiting tourists and dignitaries, but is referred to as *imina kɔro* (*imina* false) and may easily be sold.

The protection of a mask through *pɛgɛ* is perceived to make it more dangerous to outsiders. Just as the performer of imina is able to be protected by the *ɲama* of his mask and that of the mask altar, he may also harness this energy and direct it at others. One elder at Konsogou-Do described how *imina* would inflict *ɲama* on a member of the community during the rite of *puro*:

> If a man has committed a bad crime against *imina*, the men of the village will mask up and surround the wall enclosing the yard of that man. They will utter the mask cry '*Hun*' three times and will push against the wall. At that moment the *ɲama* of the masks will be transferred onto the criminal. Within three years he will die" (Sagara 2000b).

In this instance, it is said that "the *ɲama* has descended upon him."[32] The effect is perceived as being fatal and irreversible. At a *dama*, outsiders to a village assume all *imina* to be *pɛgati* and therefore maintain a safe distance while watching performances in order to protect themselves from harm.

The process of entrusting masks to the mask altar contradicts the "throwaway value" assigned to masks by previous authors. Germaine Dieterlen noted: "For the Dogon, a mask that is not painted brilliant colors—or not re-painted, if it had been carved and used for a previous *dama*—is nothing but a piece of wood, elegantly sculpted but devoid of life, without any value."[33] Anne

26. ". . . sujet à des servitudes graves qui en restreignent beaucoup des avantages . . . beaucoup d'entre eux . . . préfèrent courir une risque" (Griaule 1938b:752).

27. Griaule (1938b:405) translated *pɛgɛ* as "to plant," referring to an additional rite undertaken at the mask altar to neutralize the harmful effects of the *ɲama* in the wood. Details of this rite were not given, and it is unclear what the relationship is between this rite and the one that is undertaken once the mask is complete.

28. Name for the mask altar in this village.

29. *walu* [tɔrɔ sɔ], *waru* [teŋe kã], *wali* [yanda dom] is a type of buffalo that used to roam wild in the Dogon region and a name of mask type representing this animal. This mask is discussed briefly further in this article.

30. Explanation by Guindo and Sagara in 2000. In retrospect, it is not clear whether this was a general principle concerning masks or a factor specific to the *walu* (buffalo) mask.

31. Also known as *imina brũ* (*imina* entrusted).

32. *yãwã wo kũ sugɛ* [teŋe kã].

33. "Pour les Dogon, un masque non peint de couleurs éclatantes—ou non répeint s'il a été taillé et utilisé pour un dama précédent—n'est rien qu'un morceau de bois élégamment sculpté, mais privé de vie, sans aucune valeur" (Dieterlen 1989:10).

Doquet used this comment as a basis for her subsequent observation that "[t]he masks are therefore not permanent sacred objects. . . . These preliminary dance rituals (placed into contact with the 'mother of masks'; *imina-na,* sacrifices . . .), which are thus the condition of their sacred character, confer to them an effectiveness which is all but momentary, temporary."[34] Similarly, Van Beek assigned masks an ephemeral value: "masks have always been discarded after their use in the *dama* for which they were made" (Van Beek 1991b:70), and Hélène Leloup noted that masks were not "designed to last" (Leloup 1994:539).

In contrast with the existing literature, however, my own research throughout the region revealed that with the exception of *adagay, saku,* and *sanaguroy* masks, which decayed quickly and were generally stored in the vicinity of the mask shelter to rot, fiber and wooden masks were consistently being reused. Mask headpieces observed could be anything up to thirty years old, or sometimes even fifty, usually dating back to the time of the last *dama* in the village concerned. Fiber skirts were replaced with more frequency than wooden headpieces, because of their vulnerability to termites. Moreover, informants were at pains to note that care would be taken to ensure the permanent safekeeping of masks that had been entrusted in the manner described above.[35] Masks that have been worn for a *dama* are never discarded for fear of *dugu* (sorcery) being wrought on its wearer with pieces of the object itself. If driven to sell such a mask to passing tourists, they would do so in secrecy, to avoid shame being brought upon their family. Prior to being sold, the rod held in the mouth and the *gɔbɔ* hook (if present) will be removed to prevent sorcery from befalling the wearer, should the mask fall into the wrong hands. With the additional threat of roving art thieves, masks that have fallen into disuse are no longer kept permanently in the mask shelter (as noted by Griaule 1938b:418)[36] but are instead stored alongside those that are still danced, within the familial domain.[37]

Because of the energy with which *imina* are imbued, these masks are considered a danger to certain people, altars, and crops. As a result, the behavior and movements of the *imina* performers within and around the village are severely restricted. *Imina* may not move along village paths in which key altars are situated, nor may they cross the field belonging to the Hogon [ɔgɔ-nɔ], or fields where crops may be ripening.[38]

Moreover, during a *dama,* each Dogon village is subject to a series of prohibitions, some of which will also be in force during the *sigi* (see note 13). Prohibitions vary from village to village, but among those observed by Griaule in Sangha, many were found to be common to villages elsewhere. A man may not participate in the dyeing or wearing of red fibers if his wife is pregnant for fear of her miscarrying (Griaule 1938b:383).[39] Instead, he will either dance in black fiber skirts (as observed also by Griaule [ibid.]) or (as I observed in Sangha-Bongo in 1996) unmasked, in his own clothes, alongside other masked participants. Sexual behavior is also restricted, men being forbidden to have sexual relations around the time of key *dama* rites.[40] Furthermore, a moratorium is usually declared by elders on disputes among women (Griaule 1938b:384) and households generally, with heavy fines rendered on those who fail to uphold the peace. Finally, in many villages at the time of the *dama,* no fire or lamp can be lit in any courtyard after dark.[41] Those who flout such prohibitions are said to bring

34. "Les masques ne sont donc pas des objets sacrés en permanence. . . . Ces rituels préalables à la danse (mise en contact avec la 'mère des masques'; imina nà, sacrifices . . .), qui sont donc la condition de leur caractère sacré, ne leur confèrent qu'une efficacité momentanée, temporaire" (Doquet 1997:258).

35. Why my findings in this regard contrasted so much with those of my predecessors remains a mystery to me, but this was a point on which my informants were emphatic.

36. Masks may, however, be stored in the mask shelter during the *dama* celebrations and on the days of key dances.

37. While for the most part the male grain store was said to provide a suitable storage place for smaller mask headpieces, longer

headpieces, such as the *sirige,* would be wrapped and stored in the eaves of a man's hut. It was not ascertained what precautions were taken to prevent women from discovering these objects.

38. These routes are also prohibited to menstruating women, deceased persons, newborn children, and *ine pilu* (the category used to refer to smiths, leatherworkers, and dyers).

39. Griaule noted that in Sangha, the day of dyeing the fibers red "en masse," away from the village (as occurred for *dama na*) was referred to as *anam punya* ("men's menses"). It paralleled women's withdrawal to the menstrual hut and was also used jokingly to refer to men who, with spots of red on their tunic, were said to "have their period" (Griaule 1938b:355).

40. In Sangha, for the *dama na,* this prohibition was applied from the moment of dyeing the fibers red to the last day of the rite (Griaule 1938b:383). For the smaller *dama,* sexual relations were said to be prohibited from the moment of the *warsigi* rite to the following day (ibid.). Kervran and Tembely noted that in Pelou dancers were required to abstain from sexual relations from the night before wearing their mask until the following night (Kervran and Tembely 1999:336) Moreover, those men that carried and planted the *dannu*[ds] were required to abstain thus from the day before the *dannu-sibɛ*[ds], until five days after its final removal (ibid.:281).

41. This served a practical purpose of allowing the "night masks" (boys armed with sticks) to roam around the village in relative obscurity.

about a transgression in which the mask and altar or site concerned enter into a state of impurity, referred to as *pourrai*. This state is considered serious, yet temporary, and may usually be reversed though blood sacrifice at the site where the transgression occurred. While the transgression itself may have been witnessed by others, it should be added that often *pourrai* is a state deduced through retrospective judgment. It may not be until someone falls ill, becomes mad, or dies, that a diviner is consulted and the transgression is acknowledged to be at the root of the problem. If possible, it can then be remedied.

In some instances the experience of the dancer would seem to be enhanced by the energy of the mask. One informant said of a *walu* headpiece worn by his father: "He felt it pull him towards the drums, he had to stop wearing it. . . . It was too powerful" (M. Guindo 1994).[42] Another dancer noted: "From the moment that you put on the mask, your body becomes full . . . you start to dance, even if you don't want to dance, because the mask is strong."[43] Yet, in spite of this, such performers appear to remain conscious of the physical impediment of wearing the mask. The previous performer added: "Often you can see through only one eyehole."[44]

References to fire as a metaphor for the innate energy of *imina* occur with surprising regularity when details of past mask events are recounted. This association with fire is at face value because of the flammable nature of fibers and wood. However, fire is also used as a metaphor for the *nama* of *imina* and, in addition, describes the susceptibility of *imina* to *dugu* (sorcery). Griaule cited examples from Sangha and Pelou (Griaule 1938b:234 and 375) in which entire processions of masked dancers were said to have perished, charred. Song-texts also drew a comparison between masks and fire:

> The burning-hot, burning-hot, burning-hot mask is *Amma's* mask . . .
> The mask became powerful, powerful like the sun,
> The mask became powerful, powerful like the fire,
> The mask became powerful, powerful like the *sagaie* (*sic*)[45]
> May *Amma* beat down all the sorcerers.[46]

In the course of my own research, stories and song-texts such as these were frequently recounted. One elder described his first experiences of performing *imina* in which overcoming a fear of fire was a test of his manhood: "The first time my heart was beating very loudly. When I had attached the *imina*, I was really afraid that the *imina* would catch alight. Having carried it the whole day until the early evening, when I undressed I found that it was still there in good condition. From then on, I did not have any fear. I realized that I had entered amongst the heart of men" (Ampindo Sagara 2000a: see Appendix II).

saku versus *sanaguroy*

The *adagay* (or *saku* as it is referred to in parts of the *tɔrɔ sɔ* zone) made solely from the bark of the *sa* tree (*Lannea microcarpa*) is widely perceived as being the oldest of all masks (fig. 4)[47] and, as such, has a prominent role to play in the course of post-burial rites. In his study of Dogon beer, Jolly was the first to explore the status of the *saku* in opposition to *sanaguroy* (Jolly 1995). Taking a structuralist approach as a basis for his analysis, Jolly drew first on the myth cited by Dieterlen (1989:22–23) concerning the origin of *saku* and of the *sanaguroy*, made from the fresh leaves of the same tree. This was not a myth that I myself heard recounted in the field, a fact that may raise questions as to its continued significance.[48] Nonetheless, I will cite it here as a starting point for my analysis of Jolly's findings. The myth concerned *ama* and his eternal rival, *yurugu* (the Pale Fox):

> The Fox, who had always acted in opposition to the Creator God, declared that Amma (*sic*)[49] was dead and he was taking charge. He decided to brew beer from the seeds of the grains he had hidden from Amma. He would drink it and dance on the terrace of his "father" to celebrate his funeral. At the same time the Fox wanted to demonstrate his domination of the Nommo (*sic*)[50] who resided in terrestrial waters and who watched over the spiritual principles of human beings, his "children." To do this he pulled off the

42. Personal communication.

43. "Au moment que tu porte le masque, le corps devient plein . . . tu commence à danser, même si tu n'as pas envie de danser, parce que le masque est fort" (Sirou 1999).

44. "Deux fois tu vois avec un seul oeil" (Sirou 1999).

45. *Adagay.*

46. "Le masque ardent, ardent, ardent, est le masque d'Amma. . . . Le masque est devenu puissant, puissant, puissant comme le soleil,

Le masque est devenu puissant, puissant, puissant comme le feu, Le masque est devenu puissant, puissant, puissant comme la sagaie, Qu'Amma abatte tous les sorciers" (Griaule 1938b:359 and 362).

47. See also Griaule (1938b:565)

48. It is possible that the myth existed but has since been forgotten. Alternatively, the myth may never have existed, but Dieterlen chose to emphasize it. Or, the myth still exists, but I was not there long enough to hear it and/or failed to ask the right questions.

49. Commonly adopted as an alternative for *ama*.

50. Commonly adopted as an alternative for *nɔmɔ*.

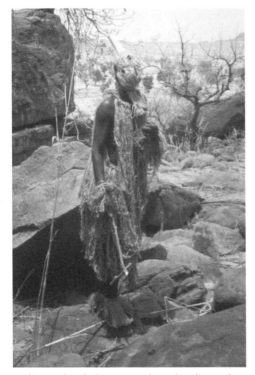

Figure 4. *Saku* mask. Idieli, 1994. Photo by the author.

bark of the *sa* tree, the earthly symbol of sacrifice and resurrection of Nommo, and fabricated a mask with it. The torn bark was red like blood, and this act had the effect of flaying Nommo alive, of repeating on Earth the sacrifice that had occurred in Heaven. The Fox drank a little beer, but his container was immediately struck down. Wearing a mask he danced a bit, but was chased; he fled, abandoning his mask and seeking refuge in a cave. The next day, Nommo caused a *sa* tree that was alive and full of leaves to dance; men, the descendants of Nommo, had also made a mask from it. The Fox remains the first to have initiated funerary rites, and to have created the first of all the masks, the *sa ku*. The rivalry for primacy between the *sa ku* and the masks made of leaves . . . has never ceased (Dieterlen 1989:38–39).

Jolly proposed that this myth was at the root of a relationship of opposition existing between *saku* and *sanaguroy* and affirmed (after Dieterlen) that the appearance of these masks recalled and evoked this mythic event. Jolly also suggested that at the moment of post-burial rites when they intercede, the *saku* masks represent the Fox and embody "the disorders and dangers of the bush in contrast to human society . . . in

opposition to the *sanaŋurɛ* (*sanaguroy*) masks, guarantors of the natural order."[51]

During the post-burial rites, which occur at the height of the dry season, the *saku* are noted for their aggression.[52] Armed with sabers, these masks patrol the interior and exterior of the village, menacing and even wounding passersby. The *saku* further unleash unbridled and fiery temperament through drunken behavior, thus inverting the rules that normally unite beer drinkers (Jolly 1995:583).

By contrast, the *sanaguroy* mask each year announces the return of the rainy season. The *sa* is the first tree to become green again after the dry season, and the *sanaguroy* made with *sa* leaves appear at the approach of the rainy season, protecting the ripening *sa* fruit (used to make *sa* juice) from theft. As "[i]ntemperate and undisciplined beer drinkers, the *ajakay* (*saku*) is the complete opposite of the leaf mask *sanaŋurɛ*, sober drinker of *sa* juice."[53] Where the *saku* wanders in the village drinking to excess, the *sanaguroy* drinks only occasionally and in the bush, consuming the juice of the *sa* fruit.

Jolly's analysis provides a useful starting point for understanding the relationship between *saku* and *sanaguroy* masks. The relationship of opposition, as established by Dieterlen and furthered by Jolly, is to an extent one that I can expand on from my own observations. The *saku*, performed at the peak of the dry season for post-burial rites of the deceased (whose bodies are also now devoid of their moisture), are likened to fire and hung in the sun to dry out. Moreover, *saku*, like all *imina*, are said to spoil if rain should fall upon them. The green-leafed *sanaguroy*, sprayed with water from the mouth of the performer before use, is associated with the moistness of new growth; its performance, which is believed to bring about rain, ensures the vitality of man (living man perceived as being ɔru [moist]) at the onset of the rainy season. *Saku*, like all *imina*, have the right to utter the mask cries and are spoken to in *sigi sɔ*, the secret language of the masks to which they respond. *Sanaguroy*, by contrast, is

51. ". . . les désordres ou les dangers de la brousse par rapport à la société humaine. . . . par opposition aux masques sanaŋure, garants de l'ordre naturel" (Jolly 1995:577).

52. Calame-Griaule (1965:150), Abspoel (1988:56), and Van Beek (1991b:69) also emphasize the aggressive character of this mask.

53. "Buveur de bière intempérant et indiscipliné, le ajakay est le double inversé du masque en feuilles sanaŋure, sobre buveur de jus de saa" (Jolly 1995:587).

addressed in Dogon and makes no sound, apart from the inevitable rustling of its leaves. A more significant fact that all texts fail to mention is that the *saku* and *imina* are charged with *ɲama* (a factor expressed through the metaphors of fire and heat), while the *sanaguroy* are devoid of this innate energy.

However, before one becomes entirely seduced by such structuralist paradigms, it should be noted that this method of analysis lends itself to a simplification of fact, so that, inevitably, there are aspects that do not fit. In many zones, the *sanaguroy* are indeed considered as little more than harmless fun. Yet in villages such as Idiely-Na, where the tradition is more developed, while during the day *sanaguroy* playfully chase children that cajole them, at night, they roam in the bush where they are authorized by elders to beat and inflict serious injury on any stranger that crosses their path. In Idiely as well, prohibitions exist restricting the movements not only of *imina* but also of *sanaguroy*, a factor that would seem to suggest an inherent "energy" of some sort possessed by *sanaguroy*. Here, *sanaguroy* may not enter the household of women or children. Similarly, care must be taken to avoid any part of the *sanaguroy*, such as a fallen leaf, from coming into the courtyard of dwellings, at the risk of causing a bad harvest and bringing misfortune to the family concerned.[54]

In addition, while essentially perceived as "dry things," in reality, the performers of the *saku* masks may also moisten their fibers to soften them before dancing in the heat of the sun. Moreover, as Jolly himself noted, in the last decade or so, among villages in the *teŋe* zone, millet beer is now preferred to the *sa* juice by *sanaguroy* participants (Jolly 1995:589).[55] Thus, with the inevitable adaptation of tradition over time, even the opposition of drinking habits has now been brought into question. Furthermore, while Dieterlen was at pains to stress the competitive and vying relationship of the *saku* to its green twin counterpart (1989:43), this is not a relationship of opposition referred to by Dogon people themselves. The *saku* as possessor of *ɲama* are inherently more dangerous than the *sanaguroy*, who are referred to as the "younger brother" of the *imina* and as such are not taken very seriously. This local attitude may

in itself partly account for the absence of this mask from much of the literature on the subject and, in particular, from *Masques Dogons;* instead, Griaule chose to relegate the *sanaguroy* to *Jeux Dogons,* a book concerned essentially with children's games (Griaule 1938a).

Masks, children, and women

It is important at this point to consider the reality that masks (both *imina* and *sanaguroy*) present to Dogon women of all ages and to uncircumcised boys. The experience of this group, excluded from participating in the activities of masks, contributes to a richer understanding of how and to what extent the "power" of the mask is perceived locally and to the idea of a mask "hierarchy."

A child's early perception of *imina* is largely based on what is told to them by adults. In 2000,[56] as I sat beneath a shelter awaiting the afternoon *dama* celebrations at Amani, a group of young boys, aged around eight or so, were chattering next to me about the fact that they knew that the masks were men. An elder dozing on a rock nearby overheard and asked the question *"imina tiritiri?"* ("Do the masks speak?"). The elder then fiercely objected to the children's discussion: "Masks don't speak, therefore they cannot be men."

Imina is something other than human: the most obvious defining feature being its inability to speak, and this fact may be used by elders to contradict youths that dare to question the identity of masks, before they are deemed mature enough to know. *Imina* may be explained as *yebene,* a spirit that inhabits the bush to the east and has the capacity for transformation. *Imina* may also be referred to as *kɛyi imina bila-bɛ* (the *imina* is an ant transformed), or it may be said *imina kɛyi girɛ nɛ go jɛ* (the mask comes out of an anthill). Although I heard no direct reference to it, this latter explanation may bear some connection to the myth cited by Griaule

54. My Dogon informants did not explain the discrepancy between the danger implied by these prohibitions and the perception in villages elsewhere of the *sanaguroy* as harmless fun.

55. In this zone, juice of the *bii* (made from the crushed fruits of *Sclerocarya birrea*) was used in place of *sa*. Reference is still made to *bii* in songs performed at this event, even though the ritual drink has now changed.

56. My fieldwork totaled nine months during 1994–2000. *Imina* were recorded during this time at *yimu yaana* ceremonies at Idiely-Yere (1994), Neni (1996), Sangha-Ogol (1996), and Konsogou (2000); at *dama* ceremonies taking place at Idiely-Gotanga (1994), Pelou (1994), Sangha-Bongo (1996), Ireli (1999), Amani (2000), Indierou (2000), and Moe-Leye (2000); at official ceremonies held in Dourou (1994), Tereli (1996), Amani (1996 and 2000); and at performances for tourists organized in Sangha-Ogol (1996) and Tereli (1996). In addition during this period, mask headpieces and costumes (including those stored for individual use and those on sale to tourists) were observed and recorded in numerous other villages throughout the region. *Sanaguroy* were recorded in Tereli (1994) and during the *agu* ceremony in Idiely (1999).

(1938b:52–55) in which the first mask was given as a gift by *ama* (God) to his two wives *kɛy* (the ant) and *tu* (the termite). Similarly, during my research in the village of Idiely-Na, masks were also referred to as *laburɔ wiju* (God's [*Ama*] cloth).[57]

Griaule stated that it was only on entering the mask shelter that *imina* were revealed to be men (Griaule 1938b:267). Today, given the proximity of children, in particular young boys, to masked performances (some of which now occur on a daily basis, at the height of the tourist season), realization of the masker's identity occurs much sooner than this. While in early life the child believes in the adult's explanation, later he begins to understand that the *imina* is, indeed, a man. As one informant revealed to me, the performance itself may frequently provide the moment of confirmation: "When I saw it for the first time I thought it was a *jilei*.[58] . . . At the beginning I was very afraid. . . . Seeing them arrive from afar, I covered my face with my hands. . . . Subsequently I realized that they were men. . . . As I grew up I became more and more aware!. . . . Once when the masks were dancing, a dancer of the *kanaga* had agitated the head of the *kanaga* too much . . . when the branches touched the ground it broke. I was a bit older at this point in time, so I recognized that it was a man that was inside" (Ampindo Sagara 2000a: see Appendix III).

Faced with *imina*, the experience of the young girl is similar to that of a boy: *imina* exists to her when she is very young as "wild animals or things from the bush" (Oumou 2000). Access to the mask association is prohibited to all females, with the exception of the *yasiginɛ*, a small number of women selected for the role of "sister of the masks." For a girl, the realization of the masks' identity may be confirmed a little later in life than for a boy. As she reaches maturity around fourteen or fifteen years of age, the young girl's suspicions that men dress as *imina* may be confirmed by adults,[59] often by old women, deemed locally as "having loose tongues."[60]

The *imina* is perceived above all as a dangerous thing, that danger in the first instance being the physical action imparted by the performer in question. A child's

sense of danger regarding *imina* is first instilled by the physically aggressive behavior of the masked performer who chases all non-initiates out of his path and is sanctioned during post-burial rites to beat and inflict physical harm on those who get in his way (fig. 5). The *sanaguroy* may also roam in the village, seeking to grab hold of and envelop victims in its path, to then toss them to the ground (fig. 6). However, while children will flee from *imina* in genuine fright, they will respond to *sanaguroy* with glee, indulging in a game of chase where boys and girls stand on a rock to torment the resting mask with cries, then flee with shrieks of delight as the mask leaps into action[61] (fig. 7). Whereas the *imina* may carry a stick or even a cutlass, the *sanaguroy* is usually armed with a whippy branch and is perceived as being physically less violent and sometimes even benign. Outside of masked performances, the sense of danger with regard to *imina* is reinforced in everyday life, when adults curb the children's bad behavior by such threats as "*imina* kill" and "*imina* swallow children."[62] Likewise, mask association songs, sung in all contexts for mask performance, reaffirm masks as a policing mechanism where the prohibitions set by the mask association need to be respected to avoid punishment.[63]

In the case of women, knowing the identity of a particular *imina* was said to increase the danger of punishment. As one female informant pointed out: "If you recognize one of your age mates you should flee them, or they will come and beat you . . . they are even more likely to beat you if they know you. . . . If you hear their cries you should run, otherwise if they catch you they will beat you hard and even kill you" (Oumou 2000). Women are prohibited from acknowledging a performer's identity in public and, likewise, from pointing at masks, because this action implies recognition. Even today the mask association is an authority that is widely respected. As one female school teacher revealed, the risk of being outcast from one's village, if rules were broken, was simply too great: "There are some women who insult the masks out loud. This is really dangerous. . . . You will be cast out of your

57. This term is in *sigi sɔ* (speech of the *sigi*), the secret language of the mask association.

58. *jilei* [*teŋe kã*]: a type of spirit that lives in trees.

59. This may be compared to how children in our culture gain the gradual understanding of Father Christmas.

60. An accidental perception based on men overhearing female conversation.

61. For example, the children in Idiely-Na tormented the *sanaguroy* with cries of "*sanaguroy giyɛ ma yagaraju yɛrɛ laga*" ("*sanaguroy* I'm scratching my body come and beat me"). Examples of these cries are documented by both Griaule (1938a:271–272) and Jolly (1995:589).

62. These examples were given to me in French, and it has not been possible to ascertain the Dogon translation retrospectively.

63. *lawa purɔnɛ yo giñ ye, pura pura*, a phrase in *dono sɔ*, translating as: "[D]o not violate the prohibitions of the masks, forbidden, forbidden" (Kervran, Kassogué, and Tembely 1989:21).

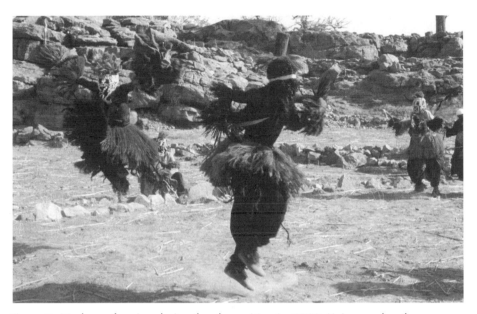

Figure 5. Masks performing during the *dama. Moe-Le,* 2000. Knives and cutlasses are often sported as dancing accessories. Masks are sanctioned to chase and even inflict physical harm on everyone who gets in their way. Photo by the author.

family. The only thing you can eat is the meat of sacrifices.[64] Your family will ignore you" (ibid.).

Men often stress (particularly to the visiting ethnographer) that women do not know the identity of masked performers. The opportunity to question women regarding masks was often denied to me by my assistants on the grounds that women did not know anything in this regard. Yet, in the confines of the home, in the aftermath of a masked dance, women were on occasion overheard happily discussing a particular individual's performance among a small circle of people, including their husband and male friends.

In reality, talk of a mask's "secrecy" serves to create a distance between men, women, and non-initiates, thereby enabling *imina* to serve as an effective policing mechanism aimed at keeping women in order.[65] In the case of *imina,* where the locus of energy is the mask itself (treated to increase its *pama*), secrecy in performance serves to heighten dramatic impact. In this case, what the mask hides is not so significant: "What matters in this case is the visible, tangible material

Figure 6. *Sanaguroy* mask wrestling with a boy. Idieli, 1999. Photo by the author.

64. The meat of sacrifices is left to rot on altars (and not usually eaten).

65. Of course, this is an exercise of male theory about masquerade. The reality is not quite as simple as this.

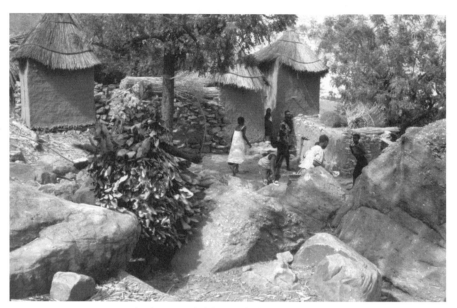

Figure 7. *Sanaguroy* mask chasing children. Idieli, 1999. Photo by the author.

reality of the artifact rather than what it causes to remain hidden: the mask reveals rather than conceals" (Picton 1989:193).[66] Secrecy in this context provides a means of denying the benefit of belief or knowledge to outsiders and preserving it for the initiated. As my field assistant pointed out: "You are made to believe that it is something mysterious . . . things are mysterious . . . but in reality it is to make you respect the customs. . . . In fact there is nothing mysterious about it at all. . . . It is straightforward" (N. Guindo 2000c).

In addition to the physical threat from *imina,* women are also said to be at risk from its *pama.* In whatever form it may appear, the *imina* is said to harm women who touch or approach it; women who do so are said to become inflicted with madness or to have problems bearing children. For this reason, in addition to fleeing *imina* during performances, red fibers attached to a stick are said to serve as an effective sign to keep women away from a place (such as a water-hole for bathing) that men want to keep for themselves. The strongest "proof" given locally of the inherent dangers of *imina* is recounted through the myth of the discovery of the mask by a woman. According to the myth, the woman, who had misused the mask to scare her husband, subsequently had problems conceiving, because, it is

said, "the masks were too powerful for her." In addition, the metaphysical danger of *imina* to women is mentioned frequently in *dama* songs, as the following example demonstrates: "The mask became powerful, powerful, burning hot, burning hot. . . . To the woman who touches it with her hand, to that woman there arrives misfortune."[67]

However, beyond such examples, actual occurrences of women being rendered mad by masks are less frequently encountered. I had initially wondered if the metaphysical danger of *imina* was heightened by men's talk and, therefore, was at odds with the reality of the mask such as it was to women. Yet confirmation of the inherent danger came at a chance encounter during the Amani *dama* in 2000 in which I had myself been initiated as *yasiginɛ*.[68] One afternoon, I had been dancing with the other *yasiginɛ* on a flat rooftop. When the dance ended, instead of following my more nimble-footed female colleagues down a dry stone wall, I took a short cut. Descending instead through a yard full of women and children who had been watching the proceedings from a distance, I was not prepared for their

66. This is very different from the example of Ebira masquerade in which the ancestral mask hides that which is too dangerous to see (Picton 1989:192).

67. "Le masque est devenu puissant, puissant, ardent, ardent . . . A la femme qui le touche de sa main, à cette femme il arrive malheur'" (Griaule 1938b:362).

68. My initiation as *yasiginɛ* (sister of the masks) was proposed by my host, the mask chief of Amani, to enable me to approach the masks in safety during the Amani *dama* of 2000.

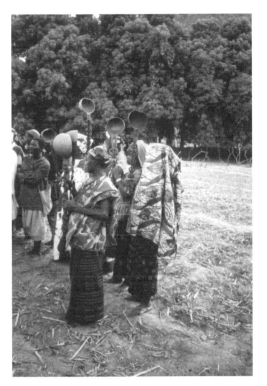

Figure 8. *Yasiginɛ* holding their *dugugi-yenu* ladles. Idieli, 1999. Photo by the author.

reaction to my appearance. As I made my way through the crowd, women parted fearfully in all directions, eyeing with visible fright the *dugugi-yenu* ladle of the *yasiginɛ* (fig. 8) that I carried before me, murmuring: "*imina . . . imina*" to alert others in their way. The following day, a male friend showed no surprise when I recounted this event and explained it as follows: "If women have given birth to many girls, they may hide to touch the *imina . . .* in order that they may conceive a boy . . . but if they come anywhere near the ladle of the *yasiginɛ* they will have serious problems bearing children, and if they are pregnant they may abort. . . . It will be much more serious" (Saye 2000). When I expressed surprise that I had not been told before of this occasional positive outcome of women coming into contact with *imina*, my friend said: "Of course! You cannot expect to learn everything about the masks all at once!"

This episode served to reinforce several points. It confirmed that *imina* are indeed imbued with an energy that women perceive as being dangerous. Yet as revealed here, energies of *imina* are not simply a threat to Dogon women but can be harnessed as a beneficial

force: the *ɲama* of the mask enabling a woman to conceive a son.[69] The differentiation of women's and children's energies from that of the masks is evidently crucial for Dogon people. Yet, the extent to which these energies are either threatened or enhanced by the *ɲama* of the mask remains to be fully understood.

The status of masks

When facts pertaining to the different masks presented here are considered together, a hierarchy begins to emerge through inference from both the dangers and secrecy surrounding masks. This hierarchy gradually became clear to me during fieldwork, and yet it was not until a chance encounter in the latter part of my research that I began to consider it more seriously. The incident in question concerned a brief discussion that occurred during the Amani *dama* in 2000 in the courtyard of the *imina kubaɲa*. A young man from the village had been commissioned to create a painted mud relief featuring *imina* on the wall of a house in the main public place where masked dances were to be held. Having prepared the wall, the man came to question the *kubaɲa* as to which masks were the most important and what should be the order of their appearance. The *kubaɲa* discussed the question with elders present and was emphatic in his reply: "The *aɲakay* is the *imina diyɛū* (principal *imina*), . . . the *walu* comes next. All the rest are *imina i ãrã* (imina I/me man) (Pujugo 2000).

Considered in isolation, this incident can be read as little more than the subjective response of a few old men. Yet it began to confirm for me a pattern of inferred hierarchic status, collected from *teŋe kã,* and *tɔrɔ sɔ* zones over some time. The manifestation of hierarchy primarily is very localized and subject to principles particular to each village. In an attempt to clarify commonalities, I have mapped my findings in the accompanying diagrams (figs. 9–11), which I shall now aim to explain more fully.[70]

69. In the same vein, Griaule noted that the attachment of a *dolaba* (cross-seat used in the *sigi* rite) to the trunk of a fruit tree constituted a prohibition considered extremely dangerous for women to violate. Yet, in spite of this supposed method of protection, sterile women would steal fruit deliberately from such a tree in order to become pregnant, "for it is one of the properties of the *dolaba* to put women in that condition" (Griaule 1938b:765).

70. Where it might be possible to reduce these to one diagram, in practice, they present a series of dichotomies, and I wanted to avoid the reductionist trap of presenting one scheme. The hierarchy does not, however, take account of the *dolaba* (sigi stool), the status of which I did not ascertain.

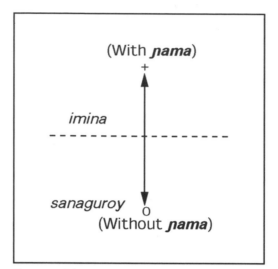

Figure 9. Diagram A.

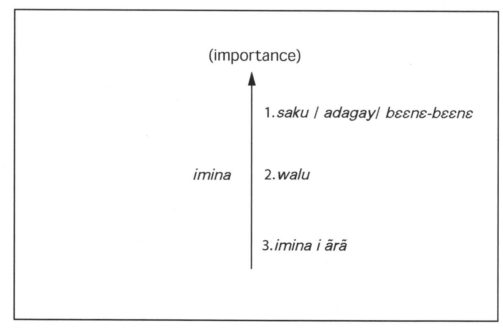

Figure 10. Diagram B.

In the lowest position on diagram A (fig. 9), I have placed the *sanaguroy*, deemed by virtue of the absence of *ɲama* to be without danger, and therefore comparatively benign. As stated previously, with the exception of the village of Idiely-Na, where the tradition was found to be more developed, the *sanaguroy* was generally not taken very seriously, viewed primarily as a mask *pour les enfants*. Consequently, the *imina* in which

ɲama is present is at the top of the scale, deemed locally as the "older brother" of *sanaguroy*.

Among *imina*, a futher hierarchy is implied (fig. 10, diagram B). The *adagay* (or *saku*) may be referred to as *imina diyɛũ* (principal/oldest mask). The superior status of the *adagay* as the earliest mask said to have been acquired by Dogon people accounts for its prominent role in the course of post-burial rituals. However, it is

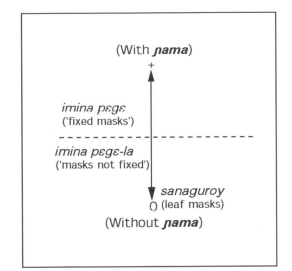

Figure 11. Diagram C.

also worth noting that historically, in the context of *imina* and their inherent dangers, the *adagay* has more reason to be feared than other mask types. First, in the past, *adagay* masks exerted a force in society as executioners. Paulme (1940:254) referred to the execution by a masked designate of a suspected witch who was condemned by a tribunal consisting of the council of elders and *olubaru*. In Pelou, there was also a verbalized history of this practice: Once the village council had condemned a criminal (male or female) to death, the *adagay* would carry out the death sentence (often in the bush).[71] In this instance, the mask was said to serve a protective purpose: "The ornaments of the masks, fibers and other, took the vital force of the person put to death and could not do harm to the masked man."[72]

Furthermore, the *bɛɛnɛ-bɛɛnɛ* (fig. 5), a variant of the *adagay*, chosen to lead the way in battle during hostilities between villages and to strike the first blow in all acts of aggression, can also account for this mask's historical renown. This is particularly the case in the

71. "When the masks were carrying out a death sentence pronounced by elders (against a criminal or against a woman that had violated an important rule), the designated men clothed themselves only in the white fiber skirt below the *jibe-na* (black fiber skirt), covering the head with the hood of the *azagɛy* mask" (Kervran and Tembely 1999:332, footnote 5).

72. "Les ornements des masques, fibers et autres prenaient la force vitale de la personne mise à mort, et celle-ci ne pouvait pas nuire aux hommes masqués" (Kervan, Kassogué, and Tembely 1989:109).

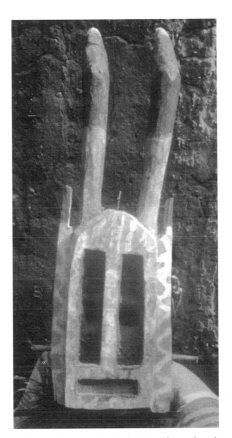

Figure 12. *walu* mask. Nombori, 1994. Photo by the author.

dono sɔ- and *teŋe kã*-speaking zones, where it is perceived as the most dangerous of masks. In these regions, the *bɛɛnɛ-bɛɛnɛ* and *adagay* masks are still said to roam in the bush at the time of a *dama* in search of the human offering necessary for sacrifice to the *dani*.[73] As a result, while warfare and executions remain a thing of the past, these masks are marked by the memory of their supposed past roles, with a reputation for being bloody. In consequence, the fear of both *adagay* and *bɛɛnɛ-bɛɛnɛ* remains very much in evidence.

After the *adagay*, the *walu* (buffalo mask, fig. 12), widely assumes the next position of importance. Like the *adagay*, the *walu* has an unpredictable character. It can break away from the rest of the line of masks entering or dancing, to chase and pursue spectators and passers-by that have dared to get too close, thereby

73. *dani* (*tɔrɔ sɔ*/*teŋe kã*), *dannu* (*tɔrɔ sɔ*/*dono sɔ*): a wooden altar in the form of a post, planted in the ground at the moment of the *dama*.

enacting a policing role. Stories about it frequently describe this unpredictable character of the mask and in several examples the *walu* is endowed with a level of supernatural energy. For example, one story told of a dangerous *walu* roaming on the Woro Woro plateau, the headpiece of which was covered with a mass of bees: "When the *walu* cried '*hun*' the bees swarmed and attacked anyone in its path" (A. Guindo 1999). Another story recalled the *dama* song, "*lajugɔ aŋa gwoyma suŋulɛ penaii yɛ*" ("There were how many masks? It was one thousand masks"). This was said to recount a moment in the past when a fearless *walu* at Gimini leapt off the cliff, killing all 1000 people in the crowd below. The *walu* survived and because of his power all the other mask fibers caught fire (Amadou Sagara 1998).

After *adagay* and *walu*, the remaining *imina* assume a lower position of importance. Referred to as *imina* i *ãrã* (*imina* I/me man), these masks serve to emphasize one's masculinity, to exhibit one's self and show off one's prowess as a man. Nevertheless, among *imina*, as we have already established, a relative hierarchic value between *imina pegati* (masks that have been entrusted to an altar) and their counterpart, *imina pɛgɛ-la*, runs in parallel (see fig. 11, diagram C), a fact that may challenge the above categorization according to mask type. For example, even a *walu* mask that is *pɛgɛ-la* will not generally be regarded as dangerous.

There are further levels of hierarchy pertaining to the material make-up of the mask headpiece, which are commonly observed in the context of ritual practice. For instance, in certain villages,[74] *lajugɔ kirɛ gu* (*imina* with horns),[75] may not be worn by a masked dancer if his wife is pregnant for fear of causing a miscarriage, in contrast to masks made from fiber, which are generally deemed as safe.[76] Kervran and Tembely noted in this regard: "It has been said that the *dannu* (*dani*) is the chief of the masks and that the masks that have a wooden head are nearer to him than the other masks."[77]

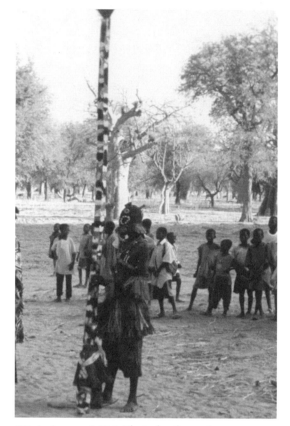

Figure 13. *imina na,* 1994. Photo by the author.

As mentioned previously, in most villages, entry among masks may require the wearing of certain mask types; once this has been achieved, the choice of mask worn is said to be left up to the individual. Yet, inevitably, peer pressure and established convention usually have a part to play in the mask chosen. A *jɔmɔ* (hare) mask, for example, will usually be deemed suitable for a fourteen-year-old boy that has not yet acquired the physical strength to dance with a larger wooden headpiece such as the *kanaga* or *sirige,* whereas a twenty-year-old man might be ridiculed for dancing a *jɔmɔ*. Furthermore, masks such as the *dɛgɛ* (black monkey), which have an obscene or comic performance, are not status-worthy in the way that a *kanaga* mask is. This may affect the individual's choice, as one dancer from Banani pointed out: "If I danced the *dɛgɛ* it would be embarrassing for me to go to Sangha. . . . Everyone would laugh at me for my behavior in this mask" (Sirou 1996).

As already mentioned, *imina* may also present a hierarchic status that is unique to certain villages, and in

74. It is not clear how widespread this prohibition is, although in addition to the *dono sɔ* zone, it was also upheld in the *teŋe kã* village of Idiely-Na.

75. Griaule referred repeatedly to categories of "wooden" and "fiber" masks, but my own research yielded no equivalent categories in the Dogon language. The *teŋe kã* reference to masks "with horns" was made by one informant only; I was not able to confirm how widely it was applied.

76. The exception to this has been found at Sangha-Ogol-Leye, where, as mentioned by Griaule (1938b:383), performers are prohibited from wearing red fibers if their wives are pregnant for fear of causing a miscarriage to occur.

77. "On dit que le *dannu* est le chef des masques et que ceux qui ont une tête de bois sont plus près de lui que les autres masques" (Kervran and Tembely 1999:281).

cases such as these, the performance of specific mask types may be restricted. Several examples of this have been related to me in which the hierarchy of *imina* directly relates to mask use. In the village of Tereli, the *yanga imina* mask, which commenced the *dama* activities in the dead of night, was regarded locally as being the most dangerous of masks.[78] In view of what was perceived as its innate danger, this mask could be worn only by an elder deemed to be nearing the end of his life, since it was felt that he would die within three years of performing it. By contrast, in Koundou-Ando a hierarchy pertaining to masks was reinforced by youths at a recent *yimu yaana* rite. While youths (many of whom had converted to Catholicism) willingly performed *imina*, there was a refusal to participate in the *saku* (*adagay*) mask, to the fury of the elders, one of whom ultimately carried a headpiece in his hand, at the head of the mask line, to represent *asa* (the original tradition). Here was a moment of change in which the ritual tradition had been adjusted accordingly.

Among masks, however, the *imina* that are not worn, the *imina-na* ("great mask," fig. 13)[79] and *dani* (fig. 14), are deemed to be the most dangerous and, by inference, stand at the top of the hierarchic scale. The status of these objects can first be gleaned from the secrecy with which they are treated and, in addition, from the inherent danger with which they are said to be imbued. Of all aspects of the mask society, this was an area where in my own experience it proved the most difficult to obtain information. This very fact served to emphasize for me the inherent value with which these ritual objects were still imbued, over and above all other masks to which I gained access.[80] While these ritual objects were previously placed within the mask shelter, having proved an all-too-frequent target of theft from roaming art thieves (and visiting ethnographic teams of the past), their whereabouts are no longer common knowledge and rarely disclosed. In some villages, the discussion of such objects is deemed appropriate only for the family of the *imina kubana*, for whom they are a direct concern.

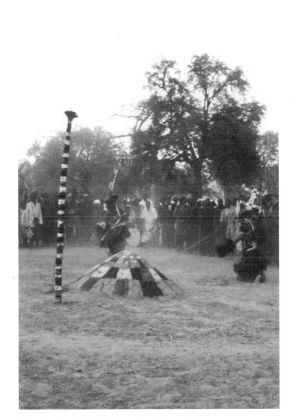

Figure 14. *dani,* 1998. Photo by the author.

As mentioned previously, the responsibility of such objects lies directly with the *imina kubana*, who is in a permanent state of *puru* and may come into contact with them without coming to harm. Other persons may be called in to assist with the preparation of these objects, such as repainting, carrying, or planting. Yet in coming into contact with the *imina na* and *dani*, these persons will be immediately rendered *puru* and will be required to remain apart and eat and drink separately from other men and villagers until sunset of that day. Should anyone come into contact with them accidentally, they will also be rendered *puru* and a sacrifice will have to be undertaken on their behalf to undo this contamination.

If the incident related previously about the *dugugi-yenu* ladle of the *yasigine* is to be taken into account, then this object would also appear to be of high, or at least of higher status than *imina* that are worn. In Amani, the *dugugi-yenu* carved for my own initiation as *yasigine* could, in principle, only be held by the *olubaru* at moments when I needed to put it down and was

78. The *yanga imina* mask did not have a headpiece, but was said to consist of white fibers that were not dyed, worn on the arms and around the waist as a skirt and a small *kɔrɔ* log bell that is tapped with a stick to warn anyone who has not yet hidden themselves indoors to do so.

79. A moveable altar resembling the *sirige* mask in form, carved at the moment of the *sigi*.

80. The wealth of information provided by Griaule about these objects does little to convey the secrecy with which they are regarded. This raises questions as to the method of his inquiry.

locked up overnight along with ladles belonging to the other *yasiginɛ* in the private hut of the *imina kubaŋa*.[81]

I have attempted to describe the hierarchic status of masks, principally in the *tɔrɔ sɔ* and *teŋe ka*-speaking zones, where masks are still present. It should also be said that there is a widely held perception today that the "dangers" of masks, though still present, are in some respects decreasing. While participants express a knowledge of prohibitions and precautions that must be taken concerning masks, they are no longer rigidly observed. Griaule noted that all cuttings of mask fibers that fell in preparation in the mask shelter would formerly be burned on the spot (1938b:355). Likewise, the *olubaru* was formerly said to be required to rid the public place of any fallen mask fibers at the end of a performance. Precautions such as these are no longer said to be taken. Furthermore, it is no longer always the case today that those who have come into contact with the *dani* altar will remain in seclusion. Nonetheless, a consensus is reached in certain villages regarding what is deemed acceptable and what precautions should be taken. In some villages, "real" masks will not even be shown to strangers, let alone sold. Elsewhere, villagers may consent. Equally, at a time when the demand by visiting tourists and dignitaries for masked performance is high, villages such as Koundou and Youga, which refuse to participate in these performances-on-demand, gain a reputation locally for taking their masks seriously. In villages where dances for tourists and visiting dignitaries frequently occur, they are met with regret and a longing by some for the "dangerous masks" of the past. Clearly, Dogon people are, like Griaule, capable of an all-too-human nostalgia for a "golden past" that, perhaps, never existed. Change has always occurred and clearly continues to be occurring. What seems less clear is the extent to which we can ultimately make reliable comparisons between different epochs and thereby assess the historical processes of these transformations.

The purpose of *imina* at post-burial rites

The importance of the masks dancing on the roof of the deceased at post-burial rites has been greatly emphasized in the literature. Of the *dama* Griaule wrote: "The essential act of this ceremony is the dancing of masked men on the terrace of the dead man's house."[82] Subsequent works appear to have taken for granted the essential function of the masks as a material support for the "spiritual forces" or "soul" released upon death. Marti wrote: "The general idea, valid for all the masks is to offer a material support for the spiritual forces liberated by death, failing which these could become dangerous."[83] Similarly, Pascal James Imperato cited Montserrat Palau Marti: "For the Dogon, masks are a material support for the spiritual forces (*nyama*) liberated by death" (Imperato 1978:16). Moreover, Doquet explained: "When the masks dance on the terrace of the deceased, they are there above all to charm the souls before attracting them out of the village."[84] Most recently, Bilot echoed Griaule, noting: "From the ritual point of view the departure of the soul is assured by a masked dance executed on the terrace of the deceased's house."[85] In contrast, Van Beek focused instead on the ritual entries of the mask from bush to village, which he described as "the crucial ritual element of the mask festival" (Van Beek 1991a:57).

In the course of my research, only one informant (a mask dancer and tourist guide) acknowledged that the dancing of masks on the roof of the deceased "put the soul to rest" (Sirou 1996). A second informant said that masks "chase away the *kinɛ*" and thus "purify the village" (Saye 2000). Another popular justification for the masks' appearance was more straightforward: masks provide a display of Dogon tradition; by dancing on the roofs of the deceased and in the *tay* (public place), they honor those who have died. Furthermore, it was denied that the masks mediated in the manner of mask altars. As my field assistant commented: "If you catch fire while you are masked, it is the fibers that catch fire first. . . . If you break your legs wearing the *tinge tange*, it is the stilts that cause you to fall. But the mask does not act as a mediating object in the manner of the *dani* or *ama* (altar)" (N. Guindo 2000d).

81. I was assigned a young mask initiate to assist in holding my ladle for the duration of the *dama* ceremonies in which I participated, because my need for an extra pair of hands was deemed to be greater than that of my *yasiginɛ* sisters, and because the *olubaru* in question was frequently indisposed.

82. "L'acte essentiel de cette cérémonie est la danse des hommes masqués sur la terrasse mortuaire" (Griaule 1938b:342).

83. "L'idée générale, valable pour tous les masques et d'offrir un support matériel aux forces spirituelles libérées par la mort, faute de quoi celles-ci pourraient devenir dangereuses" (Marti 1957:75).

84. "Lorsque les masques dansent sur la terrasse du mort, ils sont là avant tout pour charmer les âmes avant de les attirer hors du village" (Doquet 1997:139).

85. "[L]e départ de l'âme est assuré par une danse exécutée sur la terrasse de la maison mortuaire" (Griaule 1938b:344). "De point de vue rituel, le départ de l'âme étant assuré par une danse masquée exécutée sur la terasse de la maison mortuaire" (Bilot 2001:43).

It is significant that the main public appearances of *sanaguroy* masks in Idiely coincided with key rites that occurred in private at the *īrī kama* and *lɛwɛ* (*lɛbɛ*) altars.[86] Similarly, when considered alongside rituals occurring at the heart of the post-burial rites, *imina* are indeed on the periphery of rituals ensuring the departure of the *kikinu*. While masks provide the public focus of the event, at the heart of the public *dama* and *yimu yaanu* rites at which masks appear are rites that are enacted, often by a few elders, in private, either at dusk or once night has fallen. It can therefore be said that the public performance of *imina* and *sanaguroy* provide, alongside the simultaneous activities of men at these celebrations, the ceremonial framing for ritually more significant events. In the light of this observation, taken together with the changing context for masquerade performance today, where masks are perceived as being less "dangerous," it is perhaps not surprising that Muslims and Christians can comfortably attend and even participate in such mask performances. Muslims and Christians will often dance masks, because they want to show respect for close members of the family who have died, even if they do not actively participate in other rituals of the mask society, which, at the core of post-burial rituals, involve blood sacrifice and similar rites that are perceived as being problematic within Christian and Muslim contexts. As Van Beek noted: "[E]ven in the cliff villages with a majority of Muslims, such as Sangha, the masks still dance and the *dama* is still held" (Van Beek 1991a:72). In light of my revelation of this purpose of the mask, as part of the overt ceremonial framing rites at the core of village life (and death), it is perhaps even less surprising that masquerade has had the capacity for adaptation observed in the latter part of the twentieth century.

Conclusion

The aim of this article has been to demystify the Dogon mask and to clarify what such masks are to Dogon people, other than blocks of wood and bundles of fibers or leaves. Where existing literature has preferred to place an emphasis on the masks as *imina*, a comparison of *imina* and *sanaguroy* serves to establish the contrasting factors by which the ontological status of these masks are defined. The *imina*, as we have seen,

are physically dangerous; they also possess *ɲama*, which makes them fearsome. By contrast, in the *sanaguroy*, this energy is absent. The phenomenon of *ɲama* (associated with red, fire, and the optical effect of contrasting colors in mask performances) is located in both people and artifacts (some more than others). This factor explains in part the absence of *sanaguroy* from so much of the literature to date and sheds light on important aspects of Dogon masks, contradicting in particular the "throwaway value" assigned to *imina* previously. It also does much to explain local perception and values of *imina*, including the notion of "secrecy."

Performers of *imina* are predominantly men. Moreover, they are recognizable as particular men. A discourse in terms of secrecy serves to create some distance, but ultimately the mask itself is the locus of energy, and secrecy is not so significant. Perhaps most importantly, this article has revealed the function of the mask within the context of the *dama* and *agu* rites where it provides the elaborate public framing of events that occur with greater privacy at the core of the ritual, at mask and village altars.

Appendix I

nɛ yɔ yegerema banriyɛn ma bɛrɛ maa, ee
Alors ce préparer fait rougir fait avec (?) oui
Alors, aprés avoir confectionné et teint (en rouge)
So, after having prepared it and colored it red,

haya gɔwɔ duwa jɛɛri mɛ
donc crochet forgé ramené si
on fait, ensuite façonner le crochet appelé *'gɔwɔ'* auprés du forgeron,
one then has a gɔwɔ (a sort of hook) made by the smith,

ɛmɛ anran yaa diniya jɛɛri mɛ
poulet mâle femelle gardé apporté si
on apporte un pair de poulets qu'on
a pair of chickens are brought that are

yeya awaga kun pɛgɛ mɛ
allé awaga sur fixer si
sacrifice sur le awaga pour y fixer son masque
sacrificed on the awaga (altar) in order to the fix the mask upon it,

86. The *īrī kama* altar is principally for the protection of young shepherds. The *lɛwɛ* (*lɛbɛ*) are the founding altars of the village or group of villages and are tended to by the Hogon (*ɔgɔ-nɔ*) religious chief.

koŋi daga je ko lo, pɛgɛla u dagɛ mɛ
ainsi laisser est ce pas, fixer pas toi laissé si
c'est ainsi qu'on procède. Si jamais on le garde sans le fixer
it is thus that one proceeds. If ever one keeps it without fixing it

u ni mɔrɔ ro
toi à loisir pas
celà và nuire au propriétaire qui và l'utiliser
it will do harm to the owner who uses it.

haya, iye nɛ
Alors ce jour encore
Par ailleurs
Futhermore,

ɛjɛ yɔ gɔa daga u kanran
objet ce dansé laisser toi faire
lorsqu'on le dépose aprés les danses d'un "danwan"
when it is put down after the "danwan"

ɛjɛ yɔ kɔy kain
objet ce (bruit) fait
et que cet, objet se fende
this object will crack open,

kun u ni siin siin siin,
tete toi à (manières)
le propriétaire aura trés chaud,
the owner will become very hot,

mai mai kɔɔrɔ u kũ gararo
dur dur est pas toi tête passer pas
en fait, c'est difficilement qu'il s'en sortira
in fact it will be difficult for him to take it off,

haya, u baa urin nani dɔgɔ dawa ni?!
donc toi père enfants les à honte monter pas?!
si celà arrivera, les gens de ta famille n'auront-ils pas subi de honte?
if that happens, wouldn't the people of your family be subjected to shame?

Appendix II

kɛɛ wɔɔn nɛɛ kinɛ dui dui dui ko kɔ
premier certes alors esprit (battements) ce est
Au départ, alors mon coeur battait fortement,
The first time my heart was beating very loudly

kɔmiyan in kanra
attaché moi faire
lorsque j'eu à porter le masque,
when I had attached the mask

nɛɛ ɲaŋu taŋaju maa taŋaju maa maani
alors feu s'allumer est ou s'allumer est on penser ai
je craignais fortement que le masque ne prenne feu
I was really afraid that the mask would catch alight (catch fire).

ko ninaa goa yeya dɛgɛna suga
ce jour sorti allé soir déscendu
l'ayant porté toute la journée jusqu'au petit soir
having carried it the whole day until the early evening

yeya pagara in kanran sɛɛw kɔ
allé détacher moi faire bien est
lorsque je me devêtis, j'ai trouvé que c'est encore en bon état
when I undressed, I found that it was still there in good condition.

ŋɛɛ kinɛ ma gooro, abada!
Donc, espirit moi à sortir pas, jamais!
Désormais, je n'ai plus eu de craintes (ou de peurs).
From then on, I didn't have any fear.

in kanran anraan kɛnɛ yoe ma jugɛ
Moi aussi homme coeur entré? reconnus
Je reconnus, donc, que j'ai adhéré la société des "hommes"
I recognized that I had entered amongst the heart of men. (Ampindo Sagara, 2000a)

Appendix III

kɛɛ in ɔɛ jilei maa maani, nɛɛ
premier moi vu jilei comme penser a, alors
Lorsque j'en ai vu pour la premiere fois, je pensais que c'était un jilei, sinon
When I saw it for the first time I thought it was jilei (a spirit).

nai maa inɛ
personne est comme ignore
j'ignorais que c'était un être humain (qui s'était masqué)
I didn't know that it was a person.

nɛɛ satɔrɔ goa koŋi (nai) jugɛ
maintenant adolescence sorti ainsi (personnes est)
 connu
C'est lorsque j'ai grandi que je le su
It was when I was bigger that I knew this.

ko lo mɛ wɔɔn aa, liliyɛju koi
ce pas si certes ah, crains certes.
Au départ, j'en avais terriblement peur (car)
At the beginning I was very afraid because

yesoo mɛ gire dɛwɛju koi
venir est si yeux couvres certes
en les voyant venir (de loin), je me couvrai le visage
 avec mes mains
seeing them arrive (from afar), I covered my face with
 my hands.

ɛmɛ inɛ, jaga ko ni yoyooje se
Nous ignore, or ce dans entrer pour avons
Nous ne savions pas qu'un jour que nous y particperons
 aussi
We didn't know that one day we would take part also
 in this.

sagatɔrɔ goa
adolescence sorti
Lorsque nous grandîmes
When we got older

kiriya ko ni wuyɔw
sauté ce dans (manière)
nous nous y sommes jetés brusquement
we realized this abruptly.

nɛɛ nai jugiyɛ
A présent personne est connûmes
Par la suite, je reconnus que c'étaient des hommes (qui
 revêtaient les masques)
Subsequently I realized that it was men (that wore
 the masks). (Ampindo Sagara, 2000a)

BIBLIOGRAPHY

Abspoel, P.
 1988 *Chansons pour les masques dogons.* Institut
 d'Anthropologie d'Utrecht/Musée national de
 Bamako.

Bilot, A., G. Calame-Griaule, and F. Ndiaye
 2001 *Masques du pays dogons.* Adam Biro, Paris.

Calame-Griaule, G.
 1965 *Ethnologie et langage; La parole chez les Dogon.*
 Gallimard NRF, Paris.

Cissé, Y. T.
 1964 "Notes sur les sociétés de chasseurs malinké." *Journal*
 de Société des Africanistes 34 (2):175–226.

Colleyn, J-P.
 1982 "Le chiot court mais ne connaît pas les odeurs. Notes
 sur la société et les systèmes de pensée des Minyanka
 du Mali." *Africa* 52 (1):3–14.
 1988 *Les Chemins de Nya. Culte de possession au Mali.*
 Édition de l'École des Hautes Études en Sciences
 Sociales, Visual Anthropology Collection, Paris.
 2001 *Bamana the Art of Existence in Mali.* Museum for
 African Art, New York; Snoeck-Ducaju and Zoon,
 Gent; Museum Rietberg Zurich.

Dara, A.
 1998 Personal communication, May 7.

Dieterlen, G.
 1940 "La personalité chez les Dogons: autels individuals."
 L'Anthropologie [Paris: Institut d'Ethnologie] 22
 (3):829–831.
 1941 *Les âmes des Dogon.* Institut d'Ethnologie #20, Paris.
 1947 "Mechanisme de l'impureté chez les Dogon." *Journal*
 de Société des Africanistes 17:81–90.
 1950 "Les correspondances cosmo-biologiques chez les
 Soudanais." *Journal de Psychologie normale et*
 pathologique 43 (3):350–366.
 1973 "Images du corps et composantes de la personne
 chez les Dogon." *Actes du colloque international du*
 CNRS. La notion de personne en Afrique noire, pp.
 205–229. CNRS, Paris.
 1989 "Masks and Mythology among the Dogon." *African*
 Arts [Univ. of California] 22 (3):34–43.

Dolo, D.
 1996 Personal communication, February 12.

Doquet, A.
 1997 "Les masques dogons sous le regard de l'Autre: fixité
 et changement dans une société ethnographiée."
 Ph.D. diss., Univ. Bordeaux II.

de Ganay, S.
 1940 "Rôle protecteur de certaines peintures rupestres du Soudan français." *Journal de la Société des Africanistes* 10:87–98.

Griaule, M.
 1938a *Jeux Dogons.* Travaux et mémoires de l'Institut d'Ethnologie, no. 32, Paris.
 1938b *Masques Dogons.* Institut d'Ethnologie, no. 33, Paris.
 1940a "Remarques sur le mécanisme du sacrifice dogon (Soudan français)." *Journal de la Société des Africanistes* 10:127–130.
 1940b "Notes complémentaire sur les masques dogons." *Journal de la Société des Africanistes* 10:79–85.

Guindo, A.
 1999 Personal communication.

Guindo, M.
 1994 Personal communication, May 19.

Guindo, N.
 2000a Personal communication, April 29.
 2000b Personal communication, April 17.
 2000c Personal communication, May 1.
 2000d Personal communication, April 28.

Imperato, P. J.
 1978 *Dogon Cliff Dwellers: The Art of Mali's Mountain People.* An exhibition catalogue. Kahan Gallery, New York.

Jolly, E.
 1995 "La Bière de mil dans la société dogon." Ph.D. diss., Paris X Nanterre.

Kervran, M. P. B., D. P. Kassogué, and A. A.Tembely (Groupe de Recherche des Coutumes Dogon)
 1989 "La celebration de la levee de deuil (les rites du *dannyi* chez les Dogon de PElu)." Unpublished paper, Catholic Parish of Bandiagara.
 1991 "Les funérailles et le *yimu-kçmç* chez les Dogon du Kamma (dans les villages de PElu et Veje)." Unpublished paper, Catholic Parish of Bandiagara.

Kervran, M. P. B., and A. A. Tembely (Groupe de Recherche des Coutumes Dogon)
 1999 *La vie et la mort en pays dogon: Rites et celebration chez les donnon.* L'Imprimerie Joudier à Gueugnon, Saône-et Loire.

Labouret, H.
 1934 *Les Manding et leur langues.* Institut d'ethnologie, Paris.

Leloup, H.
 1994 *Dogon Statuary.* Amez, Strasbourg.

Le Moal, G.
 1973 "Quelques aperçus sur la notion de personne chez les Bobo." *La notion de personne en Afrique noire* 7:193–204.

Marti, M. P.
 1957 *Les Dogons.* Monographes éthnologique Africaines, Paris.

McNaughton, P.
 2001 "The 'Power Associations': Introduction," in *Bamana the Art of Existence in Mali,* ed. J-P. Colleyn, pp. 167–173. Museum for African Art, New York; Snoeck-Ducaju and Zoon, Gent; Museum Rietberg Zurich.

Oumou (first name, surname not recorded)
 2000 Personal communication, March 13.

Paulme, D.
 1988 *Organisation sociale des Dogon* (1940). Jean Michel Place, Paris.

Picton, J.
 1989 "What's in a Mask." *African Languages and Cultures* 3 (2):181–202.

Pujugo, O.
 2000 Personal communication, April 28.

Sagara, Amadou.
 1998 Personal communication, May 6.

Sagara, Ampindo.
 2000a Interview by the author, April 18. Tape recording.
 2000b Interview by the author, April 16. Tape recording.

Saye, A.
 2000 Personal communication, May 4.

Sirou, D.
 1996 Personal communication, February 26.
 1999 Personal communication, May 29.

Van Beek, W. E.
 1991a "Dogon Restudied (a Field Evaluation of the Work of Marcel Griaule)." *Current Anthropology* 32 (3):139–158.
 1991b "Enter the Bush: A Dogon mask festival." *Africa Explores Twentieth-Century Art,* ed. S. Vogel, pp. 56–73. Center for African Art, New York and Prestel, Munich.

The unfunctioning baby and other spectacular departures from the human in Yoruba visual culture

DAVID T. DORIS

We want to be pictures, not just to be in them, and so when I look at a picture I am also looking at myself, at a way that I might be.

—*James Elkins*[1]

What follows is a thought experiment, a fiction, willfully blind and necessarily incomplete. The premise is simple: I want to revisit some of the terms outlined in previous cultural studies of the Yoruba people of southwestern Nigeria and the Republic of Benin by examining objects that have rarely been discussed in those terms.[2] Yoruba culture is surely the most widely studied in Africa, and its expressive inventions have long rewarded close scrutiny from many disciplinary vantage points. It also has been the object of much diasporic celebration, with "Yoruba" framed as a kind of originary unity—a site of moral order, divine kingship, and perfect spiritual attainment—against the fragmentation and dispersal brought about by colonialism, racism, and continuing economic oppression on both sides of the Atlantic. In keeping with a certain tradition of Yoruba scholarship, I too am going to step outside historical analysis for a moment, bracketing and setting aside the politically charged manufacture of "Yoruba" as a monolithic ethnic identity (Kasfir 1984; Peel 2000; Bayart 2005). In a similarly anachronistic move, I will not bring into play the historical moment in which the research for this article unfolded: Nigeria in the late 1990s, a period of tumultuous, even disastrous, political, social, and economic shift.[3] Instead, taking Yoruba *personhood* as an ontological and social formation that continues to have significance for many people who identify themselves as Yoruba, I will focus on the hermeneutics of visuality in the construction of the "traditional Yoruba subject."

To support the problematic term "tradition," I look to the work of Olabiyi Yai (1994:113), who notes that *àsà*, its Yoruba translation, contains an essential ambiguity. It denotes, to be sure, an empowering repetition of

historical precedent, but at its linguistic and conceptual core, it entails also a moment of difference (*ìyàtó*) or departure from that precedent—*àsà* is built around the verb *sà* (to choose, to select, to discriminate). The implication is compelling: Individual acts of choice both constitute and transform the cultural field of "tradition"; further, the historical authority of that tradition is perpetually being invoked in the present to justify acts of transformative choice (Peel 1984).[4]

Objects have a place in this field, and some of those objects will be featured in this essay. For now I am not interested in defining such objects as either ennobling "art" or mere "artifact." Moreover, they are not "fetishes," they are not "idols," and they are not "magical" things—all terms we freely employ to disavow ourselves of the responsibility to understand other societies in their own terms (Taylor 1985). Rather, in this Yoruba-centric discussion, the objects at issue are *àwòrán*, images, defined in translation as "what we look at and remember." Within the dynamic field of "tradition," images play a significant suasive role: They remind viewers that there are socially and culturally established constraints upon individual difference and call those viewers to recognize and affirm those constraints. In that communicative process—a visual dialogue of call and response in which an individual is also implicated as an image to be regarded by others—Yoruba personhood and its negation are constructed.

The virtues of dead wood

I'll forgive you this once, but remember:
A boy who won't be good,
Might just as well be made of wood.
—*The Blue Fairy, Walt Disney's* Pinocchio *(1940)*

Nearly half a century ago, the scholar of African religions E. Bolaji Idowu (1995 [1962]:184–185) noted that there is in "a certain locality of Yorubaland" a method by which a baby's character, its "intrinsic moral fibre," is determined and revealed. Idowu never named

1. Elkins 1996:85.

2. For their generous and solid support during the preparation of this essay, I offer many large thanks to Rowland Abíódún, Sarah M. Adams, Glenn Adamson, Matthew Biro, Kevin Carr, Diane Mark-Walker, Stella Nair, Jacob Olúpóna, Francesco Pellizzi, Alex Potts, Elizabeth Sears, Raymond A. Silverman, and Robert Farris Thompson. This essay is dedicated, inevitably, to Melissa Doris.

3. Such issues will be addressed briefly in the appendix that follows this article.

4. This articulation of *àsà* resonates strongly with Pierre Bourdieu's conception of *habitus*, a term describing the matrix of collectively held codes of appropriate thought, feeling, and behavior that in any given society guide, govern, and structure a person from the very beginning of life. Habitus is a "durably installed generative principle of regulated improvisations" (1977:78), a flexible but limiting framework in which innovation can be expressed and recognized.

this locality, and the method, to my knowledge, is not mentioned in other texts on Yoruba culture. That said, it illustrates with almost proverbial clarity the ways in which vision and objects continue to play significant roles in the constitution of a person as a subject in Yoruba society. Here is Idowu's exposition of the performance, a ritual set in motion as an intervention, because a baby is crying, and apparently it will not stop:

When the baby is crying, another baby is danced before it, and a song follows:

Dáké o, Stop crying,
Omo niíb'omo. A (human) baby
 Is the one to console a (human) baby.

If the baby stops crying, it is the traditional belief that it would grow up with the virtues of a person.

If the baby does not stop crying, a kid (i.e., a young goat) is danced before it, with the song:

Dáké o, Stop crying,
Eran niíb'eran. An animal is the one to console an
 animal.

If the baby stops crying, it is the belief of that locality that it has the inner norm of an animal and would grow up to behave as such.

If the baby continues crying with the kid danced before it, a wooden doll is danced before it, with the song:

Dáké o, Stop crying,
Igi niíbe'gi. It is wood that consoles wood.

If the baby stops crying, it is believed that the baby would grow up with the "virtues" of dead wood! (ibid.)

What then is this baby? Why won't it stop crying? What—or who—is the motivating force behind the "selfish" disruption expressed as the baby's cry? The performance provides a method through which the human community can determine the nature of the baby as an expression of its inner relationship to pre-existent beings. In that determination, the community also can forecast the baby's future relationships. Such an assessment of past and future is possible because, in the performance of its disruptive behavior, the baby has become an *àwòrán,* an image that others interpret by means of other images.

The baby is "consoled" by one of three objects danced in sequence before its eyes: a human baby, a baby goat, and a wooden doll. The baby's relationship to the object placed before it is not grounded in its perception of a pleasing visual correspondence—if it were, we can assume the baby would simply cease

crying upon seeing its reflection in another baby. Rather, it is "consoled" by, and responds to, an otherwise invisible affinity of indwelling spirit (*èmí*) and character (*ìwà,* which Idowu calls an "inner norm"). The baby stops crying because it has recognized its own *ìwà* or *èmí* in another being.

In responding to one or another of the objects, the baby is not making a conscious *choice*—it is a baby, after all, and not a fully socialized, "complete" person. Rather, it is "behaving *ìwà*" (*ìhùwà*), in this case expressing subjective affinity in relation to a predetermined set of symbolic objects. That is, the baby's invisible *ìwà* is made visible in its behavior relative to those other objects—only through that behavior can other members of the community, there to witness the performance, come to know the child's *ìwà.*[5] The baby's inner experience, then, is simultaneously a public *spectacle* for others: Its behavior reveals to the community its hidden "virtues," and prefigures its future. Over the course of its lifetime, the child will be expected to manifest in his social behavior the "inner norm" of a human, an animal, or "dead wood."[6] While the problems arising from the child's association with the first two beings can be readily addressed by family and community through appropriate healing techniques, an association with the wooden doll presents more significant and even insoluble problems. How, after all, does one even begin to communicate with "dead wood"? And what does it mean for a person to be like "dead wood"?

The unfunctioning baby

To address these questions, let us look more closely at that little wooden doll, the most obviously image-like of the three objects set before the baby. Such dolls, called *omolangidi,* are children's playthings (fig. 1).

5. Idowu makes no mention of the other participants at the event, but it is likely that at least one of the child's parents, as well as one or several important elders and community leaders, would be on hand as witnesses. At the very least, another person is causing the three objects to dance, and yet another is holding the baby. Given the clear intent of the performance—to both placate the baby and determine the nature of its character (*ìwà*)—it is likely that a divination specialist (*babaláwo*) would preside.

6. Indeed, the child who responds positively to the goat might well be regarded as a reincarnation of an ancestor. In Yoruba tradition, notes Segun Gbadegesin (1998:164), "there is the belief in divine sanctions in the afterlife." In an afterlife that includes reincarnation, he continues, "any individual who has grossly misbehaved while on earth will be punished at death and the *èmí* of such a person may be made to inhabit the body of an animal to become a beast of burden in later life."

Figure 1. Name of makers unknown. *Omolangidi* figures. Collected in markets in Ibadan, Nigeria, January–February 1999. Wood, embossed with branding iron. Collection. David T. Doris.

Omolangidi are often roughly hewn from a single slab of wood, flat and rectangular, with a head indicated by a simple notched triangle surmounting the body. *Omolangidi* are among the first objects a newly apprenticed wood-sculptor will be charged with creating; they are rudimentary figures and require little skill to complete. In many instances, the finished sculpture is repeatedly branded with a hot iron, which leaves in its wake blackened, embossed patterns. In markets throughout Yorubaland, *omolangidi* are sold cheaply by *lékuléja* (literally, "have-rat-have-fish"), women who sell medicinal ingredients and accoutrements.

In addition to being toys, *omolangidi* also are representations of *abíkú,* "children who are born to die."[7] Such children reside partly in this world (*ayé*) and partly in the other (*òrun*). The child who is *abíkú,* despite its human appearance, is *just barely* human. The *abíkú* torments its parents by entering the world only to leave again after causing much suffering—once born, it dies, only to repeat the process several times. It is a selfish being who receives love and care from its parents, but provides them no reward in exchange for their troubles. *Abíkú* withdraw from the reciprocative human community into a private world of suffering. Young girls suspected of being *abíkú* are sometimes presented with *omolangidi,* which they wrap onto their backs as a mother ties her child. By analogy, the girl too will be "tied" to this world and to the human community.[8] If Yoruba cultural studies show us that the ideal person possesses *ìwàrere* or *ìwàpèlé* (a fine, pleasing, generous character), and possesses the valued quality of *ìlutí* (responsive "good hearing"),[9] then the

abíkú is the inversion of that ideal: It is vindictive, self-serving, and utterly unresponsive.

In effect, the *abíkú* is a *thief* who in its actions opposes Yoruba ideals of social reciprocation. This is made clear in a passage by Timothy Mobolade (1973:62):

> It is the intention of every *Abiku,* the Yorubas believe, to return affluent to its abode after having turned its parents into a wretched couple. The parents naturally would sacrifice anything to make certain the child stays with them; they might even sell almost all their property, becoming poverty-stricken in the process. The wealth which the parents lose in this way is believed to have gone into the coffers of the *Abiku.*

As a representation of *abíkú,* insisted the *babaláwo* (diviner and ritual specialist) Kóláwolé Oshìtólá (January 7, 1999), *omolangidi* is the image of an "unfunctioning baby," the child who "would grow up with the 'virtues' of a dead wood" (Idowu 1995[1962]:185). Indeed, *omolangidi* represents in the sketchiest of sculpted forms the very antithesis of personhood (*ènìyàn*). In a passage that has become canonical in the discussion of Yoruba aesthetics, *omolangidi* is likened to a person without character (*ìwà*), that is, to a person who is not a person at all:

> *Omo t'ó dára tíkò n'íwà*
> *Omo-langidi ni i*
> *Ìwà rere l'èsó ènìà*
> *B'óbìnrín dára bí Egbara*
> *Bíkò n'íwà*
> *Omo-langidi ni i*
> *B'ókùnrin, suwòn, suwòn*
> *Bí eja inú omi*
> *Bíkò n'íwà rere*
> *Omo-langidi ni I*[10]

> If a child is good-looking but has no character
> He might as well be a wooden doll.
> Good character is a person's guardian.[11]

7. On *abíkú,* see esp. Verger (1967:1448–1487). See also Ellis (1894:111–114), Johnson (1921:83-84, 137), and Mobolade (1973). On other sculptural forms associated with the cult of *abíkú,* see Merlo (1975). Regarding *abíkú* as a potent metaphor of contemporary Nigerian experience, see Okri (1991).

8. Letter to the editor from "Sina, artiste," *Post Express* (December 5, 1998); the letter concerned adolescent girls and the "spiritual implications" of imported teddy bears. In the poem "Omolangidi," Roli Hope Odeka (2000:11), an expatriate Nigerian living in Italy, recalls the doll of her childhood as a source of comfort and longing, restoring in memory her bonds to home and to family: "Squeezing you to my ribs / Fixed eyes facing the wall / Lay on my bed made of clay / Mothers faces on the wall . . . / My wooden doll Omolangidi / My wooden doll Omolangidi / You look real to me / Created from childhood fantasy / Mothers warmth flow through / I missed her presence / My wooden doll Omolangidi. . . ."

9. On *ìlutí,* see Abíódún (1994:72–73) who notes that this fundamental attribute of good character (*ìwà*) "refers to qualities such as obedience, teachableness, understanding and, above all, the ability to communicate."

10. Originally in A. Fajana (1966:66–128, n. 5). Quoted in Lawal (1996:28).

11. This translation, inspired by Lawal's (1996:28), is my own and departs from his. There, this line reads: "Good character is the *beauty* of a person." *Èsó,* however, is more accurately translated as "guardian," suggesting the protective capacity of good, beautiful character. Further, I have translated *dara* in lines 1 and 4 not as "beautiful" but as "good-looking" and "pretty," respectively. If beauty is constituted by character, as stated in the classic Yoruba proverb, *Ìwà l'ewà omo eniyan* ("character is the beauty of a person"), then the good-looking child, woman, and man are not necessarily beautiful at all. They're just nice to look at.

A woman can be as pretty as Egbara.[12]
If she has no character
She is no more than a wooden doll.
A man may be very handsome,
Like a fish in the water.
If he doesn't have good character,
He is just a wooden doll.

Orí: The person as representation

In Yoruba ontology, an individual human being is regarded as unique and unrepeatable. This understanding is revealed in the philosophical conception of ìwà as "essential nature," the character of the person in his existence (ìwà) as such. But as the above ritual performance suggests, it is only through its visible manifestations that ìwà is known, articulated in behaviors (ìhùwà) perceived by others in relation to conventionalized codes of understanding. Essential nature, then, is never a pure interiority, but is necessarily bound to social being.

Another Yoruba philosophical concept further complicates the notion of a stable, isolable selfhood: orí, the head as the embodiment of individual destiny. Orí is chosen before birth as one kneels in heaven (òrun) preparing to enter the world (ayé). Other accounts say that orí is presented to the person, rather than chosen—this is so, for example, in instances of reincarnation.[13] Orí is constituted in two parts: the spiritual inner head (orí inú) and the visible outer head (orí òde). So conceived, orí is the centerpiece of a person's life; it is at once the most intimate and energizing portion of one's own unique being and one's public face, enacting and so communicating what lies beneath its exterior. One's destiny (ìpín, or allotment) is not merely chosen or pre-given, but is actively made throughout the course of one's journey through life. Yoruba visual arts express the centrality of this two part complex not only in the proportional emphasis placed on sculptural representations of the head, but also in the sheer variety of art forms that depict the head as carrying worldly burdens[14] (fig. 2).

The uniqueness of orí also is made problematic by an understanding of the human being as an amalgamation of conventionalized physical, spiritual, and psychological attributes. Each birth, like the being that results from it, is a unique event, but similar births have happened before—and there are codes by which novelty can be understood within the frameworks provided by the past. To be born is to be cast *into* and *as* a set of characterizations that have always already been determined. When a child is born, for example, careful attention is paid to the circumstantial details of the birth. The physical condition of the child as he or she comes out of the womb is perceived as evidence, a set of signs that reveal the contours of the child's destiny. Perhaps the umbilical cord is wrapped around the child's neck or around the left leg or right arm, or perhaps the child is still enshrouded by the cowl of the placenta. These physical facts, appearing during a pivotal moment of transformation, of transportation between worlds, are read as signifiers that reveal truths about the child's unique selfhood. Similarly, if a child enters the world as a twin (ìbejì) or as a breach-birth (ìgè), these conditions, too, will play a role in determining the child's path through life, including how the child will be perceived and treated by others.

The newborn child's physical resemblance (jíjora) to a parent or an ancestor also is a powerful signifier of that child's orí as well as its character (ìwà). A father recognizes a new child as his own when the child is determined as resembling him—the mother, of course, needs no such proof that the child belongs to her.[15] But physical resemblance also bespeaks more profound concerns. In some cases, the human subject is regarded as a *repetition* of ancestors, a novel re-presentation of those who lived and died before, now "again-born" (atúnbí) into the world.[15] Such popular names as Bàbátúndé (Father-Again-Arrives) and Yétúndé (Mother-Again-Arrives) concretize in empowering language the indexical imprint (ojú) of the past on the bodies of the present. The individual who has been determined to be a reincarnation has already partially existed in the body, character, and passage through life of one who previously was born and died. It would be expected that

12. *Egbara* is a small rodent, noted for its sleek, glossy coat.

13. See Gbadegesin (1998:155). For accounts of the importance of orí in Yoruba culture, see Abíódún, (1987), Abimbola. (1973:79–85; 1976:113–149), Hallen (2000:51–54), Idowu (1995 [1962]:180–184), Lawal (1985; 2000), and Makinde (1985).

14. See, for example, Abíódún (1987) and Lawal (1985).

15. See Idowu (1995 [1962]:184): "A father insists on making sure that a child is his own and does not belong to another man by looking at the child carefully and establishing some points of lineage resemblance while at the same time thinking that the child is a newly created, newly predestined being."

16. Babatunde Lawal (1985:94) notes: "[P]hysical likeness of any sort is highly valued by the Yoruba. Not only does it confirm the legitimacy of a child, but it can be taken as evidence of the reincarnation of an ancestor. . . ."

those traits and that passage would be repeated—with a difference—during the child's life.

The Yoruba child is itself, and in its resemblance to others it also embodies and represents them.[17] The body and psyche of the individual are images through which the ancestors and the historical forces they represent continue to establish their authority within the world of the living. The engagement is reciprocal: In acknowledging and embodying those antecedent beings and forces, a person is better able to establish her own authority within the hierarchies of power that constitute the social world *now.* The Yoruba subject, then, is a complex construction, at once unique and conventionalized, possessed of an individual destiny and also inhabited by—and responsible to—the subjectivities of others past, future, and present. These notions are complementary rather than mutually exclusive; the subject always exists *in* and *as* a fundamental relationship with other subjects.[18] Yoruba subjecthood is constituted not only in the recognition that one exists within an intersubjective social field, but also in the uncanny sense that one's very subjecthood is structured *as* an intersubjective social field. In Yoruba culture, words and images consistently remind Yoruba people that this is the case.

A stick in the forest

In *Olódùmarè: God in Yoruba Belief,* the foundational text of Yoruba cultural studies in which the troublesome child realized his destiny in the trio of dancing babies, Idowu (1995 [1962]:173) asserted that a single phrase sums up Yoruba ideals of interpersonal ethical relations:

Bí a bá sé' gi n'igbo,
K'á f'òrò ro ara eni wò!

Whenever a person breaks a stick in the forest,
Let him consider what it would feel like if it were himself
(that was thus broken).

At first glance, such a phrase seems a graceful solicitation to compassionate behavior, and so it is—its call for ethics based on reciprocative self-interest is not a far cry from "Do unto others as you would have them do unto you" (Matthew 7:12).[19] But the Yoruba phrase is less a commandment than an invitation: It avoids direct address by shifting emphasis from interpersonal relations to the relations between person and thing, implying a metaphorical connection between the world of human interaction and that which—to most evidence of the senses—would qualify as "non-human." Both a subject and an object—a person and a stick—are posited in the phrase, but the phrase undermines the privilege associated with notions of unbounded human freedom. The subject, it is clear, is not wholly free to break whatever sticks she pleases. Rather, she is compelled to do some imaginative work, some considering. She is called into participation, invited to identify herself metaphorically *as an object,* and, in this way, to actively perceive the consequences of her own actions in a world where many things may be empowered to act *as subjects.* In the proverb cited by Idowu, the person, in effect, is held accountable before the stick. And that stick, it is clear, is much more than a stick. It also is a representation of the person who would break it.

But like so many Yoruba objects—spoken, carved, cast in bronze, drummed—what is not uttered or immediately perceived in the text is the thing that is most present. The phrase suggests that when one acts upon the world, one should consider also what it might be like *to be acted upon.* It is a subtle reminder that one is always located within an intersubjective network, a hierarchy of powers, and that some of these powers are always greater than oneself—so great, in fact, that they can break a person as easily as a person can break a stick. Idowu's proverb, like the stick it names, invokes through metaphor the presence of unseen powers, the constraining forces of moral law. The person who breaks that symbolic stick is reminded to regard herself as

17. As Karin Barber has amply demonstrated in her work on *oríkì* (oral praise-poetry), the Yoruba subject is not the wholly distinct individual highlighted in Western post-Enlightenment thought. *Oríkì* are names of appraisal considered to encapsulate essential attributes of the subject for whom they are called (*pé*). In *oríkì*, the subject is reconstituted at the level of language—rendered in the sensuous material of spoken utterance as a disjunctive stream of fragmentary, compressed images. Such potent words do not merely represent the person, they call aspects of the person into being. Barber's description of *oríkì* (1991:249–250) reveals also the composition of Yoruba personhood: "All oriki mark individuality, but all have a tendency to float, to be shared by more than one subject. An individual's 'own' oriki are a tissue of quotations, a collection of borrowings from diverse sources. This floating is not accidental but is a fundamental feature of the eclectic and incorporative mode of oriki. Individual subjects thus share with others the components that make up their innermost identity, and recognise fragments of it in other people wherever they go."

18. The work of Karin Barber (1981; 1991; 1994) is to date the most fully articulated expression of this complex interrelationship.

19. Indeed, it is likely that in claiming the centrality of this phrase to Yoruba ethical life, Idowu was appealing directly to the Christianity that was already central to his own life.

subject to those powers, to set herself in place within their hierarchy, and to affirm that emplacement.[20]

There is, indeed, another Yoruba proverb that addresses this process of utterance and recognition, of authoritative call and affirming response, as a function of *symbolic power*—a term I borrow from Pierre Bourdieu (1979; 1991), who proposes that the *production* of power is only part of the story—symbolic power "can be exercised only if it is recognized . . . defined in and through a given relation between those who exercise power and those who submit to it" (1991:170). Here is the Yoruba rendering of this concept:[21]

Àbò òrò là nso fómolúwàbí; bó bá dénú è a dodindi.

Half a statement is all one makes to a well-bred person; when it gets inside him it becomes whole (Owomoyela 1988.4).

Àwòrán: What we look at and remember

If a stick, set into a proverb, has the capacity to compel a person to recall that she exists as a subject within an intersubjective network, then what of other significant objects? Artworks, for example—do they have any sort of subject-*constituting* power? If they do, says art historian Whitney Davis, that power is necessarily derivative, secondary. That is, the power of an "artwork" first arises before that "artwork" even exists, in the history of the subjects who make and ascribe meaning and power to such things. "In this history," continues Davis (1994:570), "many artifacts and images, including other artworks, might have a place. . . ."

> An artwork then, is a reflection: though it might reflect a subject-constituting power to an audience, this is, in turn, a reflection of the earlier significances of artifacts or images in the historical experience of both its maker and its viewers (ibid).

In Yoruba, this idea is tacit in the conception not of the "artwork," but of the *image* itself. The term *àwòrán* is applied to drawings, paintings, photographs, TV shows, and sculptures alike. The word is roughly translated into English as "image," but its etymology suggests that in Yoruba culture the image also effects a pivotal cognitive function in the viewer. According to both Babatunde Lawal and C. O. Adepegba (who cites the *babaláwo* Ifáàtògùn of Ilora as his source), *àwòrán* is a shortened form of *à-wò-ránti*. Lawal (1996:98–99; 2001) translates the phrase as "what we look at and remember" or "a visual reminder"; Adepegba (1983:14) translates *àwòrán* as "something to look at and remember" or "a memorial image." He observes that the term *àwòrán* is "interchangeably used" with the term *ère* (sculpture), although the latter, he feels, is more appropriately applied to three-dimensional objects. Lawal, instead, uses *àwòrán* more broadly, bringing it to bear on the multidisciplinary, multisensory Gèlèdé performance as a "spectacle" (*ìran*).[22]

20. Barber (1981:724) observes that this emplacement within an intersubjective social frame is also enacted in relation to divinity: "[I]f the Yoruba see the òrìsà's power as being maintained and augmented by human attention, that is because they live in a kind of society where it is very clear that the *human* individual's power depends in the long run on the attention and acknowledgment of his fellow-men." Similarly, Thompson (1969:181) has remarked of the Yoruba master potter Àbátàn, "The expression of her individuality is set within a world where it is believed life depends upon an illusion of social harmony and continuity." It is compelling to compare the proverbial scenario of an encounter with a stick in the forest to one from another philosophical tradition. For Jean-Paul Sartre (1960:37), self-awareness also is activated in the cracking of metaphorical branches: "What I apprehend immediately when I hear the branches cracking behind me is not that there is someone there; it is that I am vulnerable; that I have a body which can be hurt; that I occupy a place and I cannot in any case escape from this space in which I am without defense—in short, I am seen." This is one of the founding allegories of the operation of *the gaze*; in it, the subject is constructed in a moment of disruption. In the audible break of the branches, the transparency of the subject's outward gaze also is broken, and turns inward. In such introspection, it is revealed that he too is—and probably always has been—a spectacle for another. In contrast to the Yoruba proverb's function as a tactful reminder of one's place as an agent within a network of subjects and power—a reminder accompanied in this case by a barely veiled threat—Sartre's scenario describes a harrowing moment of profound paranoia and helplessness. This paranoiac structuring of the modern subject has been an important and persistent theme in European and American cultural studies; see, for example, Foucault (1979); Jay (1993:415); Lacan (1981:95–97); Zizek (1992).

21. In Yoruba culture, proverbs are ubiquitous elements of such authoritative discourse. A proverb enables its user to speak with the voice of an entire people, as it were: Proverbs are usually introduced with "The Yoruba say," or "The elders say," deflecting attention away from the immediate position of the speaker to the voice of discourse itself. Further, to utter a proverb is to presume the listener is already in possession of the knowledge that will allow him or her to relate the proverb appropriately to the matter at hand. It implies the active,

responsive participation of the listener, who, as Owomoyela suggests (1988:4), is left "to flesh out all the details." The proverb, then, is a *break* in the smooth flow of discourse. In this break the listener recognizes, reassembles, and reaffirms already-determined links between metaphor and reality. On the relationship between spoken proverbs and visual images in Yoruba culture, see Abíódún (1987) and Doris (2001); this also will be the topic of a future article.

22. Henry and Margaret Drewal (1990:1–4) also discuss Gèlèdé performance as *ìran*. Their exegesis of the term suggests that *ìran* resides not in visible, exterior objects as such, but rather in *visualization*, an interior process of seeing often activated in relation to external stimuli, including such phenomena as mystical experience and narrative storytelling.

In contrast to twentieth-century European models of the spectacle as a fetishizing abandonment of the individual's relation to a lived history (Debord 1967), the Yoruba conception of spectacle (*ìran*), articulated also in the term *àwòrán,* posits a relationship between image and viewer that is inherently historical. This is an embodied relationship; the past is effectively brought into the present in the image because *by definition* the image stimulates memory (*ìrántí*).[23] The mnemonic function of the image is two-fold.[24] First, the power of an affective image is such that it is *memorable,* something the viewer will recall in the future and that, in many cases, models an idealized state of affairs that may come to be: It is *prospective.* Second, the image refers to and draws the viewer into an awareness of its historical origins—the past events, utterances, institutions, laws of practice, moments of ingenuity, other objects and indeed, people that brought the image into being: It is *retrospective.*

In this latter capacity, *àwòrán* also proposes that the viewer shares aspects of the history that is necessarily one of the referents signified—sharing, at the very least, the common social framework that allows the possibility of communication, the system of discursive practices that Pierre Bourdieu (1977) calls *habitus* and that the Yoruba call *àsà.* Without this common context, the image is to a large degree opaque, static, meaningless. *Within* this context, the image defines its viewer's relation to lived historical time: It is an element within the field of *habitus* or *àsà* that articulates its viewer's relationship to that field.[25] Whether the *àwòrán* in

Figure 2. Lawrence Ayòdélé, *Àrùgbá Òsun,* 1998, Ilé-Ifè, Nigeria. Wood, height 21¾". Collection: David T. Doris.

question is an intricately ornamented woodcarving that depicts the well-behaved supplicant of a deity (fig. 2) or an *ààlè,* an assemblage of wasted objects set in space to warn thieves of the consequences of their actions (fig. 3), it is expected to prompt meditation on the origins of authoritative or iterative power. Further, it compels the viewer to recognize and affirm his or her derivation from those origins—a derivation shared with both the creator of the *àwòrán* and the *àwòrán* itself. This recognition is as much an interior psychological process as it is an exterior communicative one.

In Yoruba culture, the conception of the image as *àwòrán* suggests that the viewing subject is shaped in participatory acts of cultural memory, the field of shared

23. In a major study of Central Pende masquerade, Zoe S. Strother (1998:101–102) critiques bell hooks's assertion that "[r]itual is a ceremonial act that carries with it meaning and significance beyond what appears, while spectacle functions primarily as entertaining dramatic display." This dichotomy, suggests Strother—citing Roland Barthes's work on the "ideal understanding of things" proffered in the spectacular performance of professional wrestling—"is a false one." In Yoruba culture, the conception of spectacle as *ìran* and image as *àwòrán* indicates clearly that there is *always* "meaning and significance beyond what appears."

24. Here I both acknowledge and depart from Lawal's (1996:99) proposal that *àwòrán* has "two levels of signification." See also Lawal's (2001) richly expanded discussion of the term *àwòrán* as brought to bear on canonical Yoruba artworks as visual representations of spiritual selfhood.

25. Indeed, as Henry and Margaret Drewal point out (1990:2), the term *ìran* also connotes "a generation . . . the members of a lineage (*ìdílé*) who are born into the world at approximately the same time." The spectacle and the image "we look at and remember" are thus inextricably linked with the conception of the person as belonging to a collectivity, to a synchronic community that locates itself as a transitory passage within the diachronic flow of historical time.

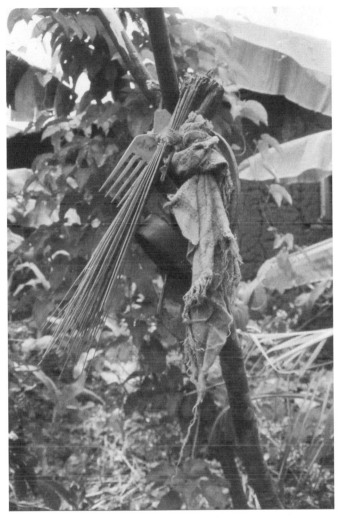

Figure 3. Babaláwo Adérèmí Fágbadé, Ààlè Ìsé ("Ààlè of Poverty"), July 24, 1998, Òkèìgbó, Òndó State, Nigeria. Old broom, worn-out shoe, cloth, comb (òòyà), fiber, wood. Photo: David T. Doris.

history and practice in which individual personhood is constituted not only as an interiority but also as an open-ended set of exteriorizing relationships with others. Such relationships involve the subject both with other persons and with the objects that are made to represent those persons. Canonical Yoruba sculpture, as is well known, typically represents ideal subjects in idealizing form—the specialized field of "Yoruba art history" is fairly founded on just this interpretive premise. The classic style of well-made Yoruba woodcarving (fig. 2) smooths individual likeness into a "cooled," generic humanity; the object "resembles the body" (jíjóra) of no one in particular, but, instead, monumentalizes and memorializes all who act rightly in

this world. Such images are, in effect, models of "good" personhood, proffering excellent rewards for those who choose to see themselves in their mirror: community, strength, health, wealth, fertility. They command self-identification with the ideals they render visible, articulating individual desire under the protective ægis of collectivity. As images "we look at and remember," such àwòrán perform an ideological function by calling a viewer to respond to the question they pose, silently but insistently, in significant, conventionalized form: *Iwo nko?*—And you?[26]

Ojú: The face, eyes, presence, and index of power

In the visual call posited by an àwòrán, the àwòrán also sees its viewer. "Each object has a presence," says visual culture historian James Elkins (1996:72), "a being and a face of its own—and if we take that seriously (not as a vague intuition but as a fact of vision), then the world is full of eyes." From a Yoruba perspective, this is not intuition, but rather a fundamental aspect of being, and pivotal to our understanding of how both persons and images are constituted within an intersubjective social frame. To demonstrate, let's translate Elkins' phrase—minus the parenthetical enclosure—into Yoruba:

Gbogbo nnkan lo ní ojú—lo ni íwà àti ojú—nítorí náa, ti àbá yìí wolé gbogbo ayé ní ó kún fún ojú.

Three of the terms mentioned in Elkins' statement— "face," "eyes," and "presence"—are all connoted in Yoruba by the same word, *ojú*. The word also may be translated as "index." This four-part confluence is significant. In Yoruba culture, a work of affecting *presence* (Armstrong 1971), an image that is the made index of its creator's intentional acts, possesses a *face* that can be seen and *eyes* that see. Indeed, the term *ojú* articulates a crossroads at which power and visuality meet.

To appreciate this important convergence, let us consider the Yoruba altar, the central site of traditional

26. In an essay that has become a staple in the field of cultural studies, Louis Althusser (1994:129) suggests that the affirmative reception of such conventionalized utterances (each a moment of ideological "hailing" or interpellation) is practically preordained: "It is indeed a peculiarity of ideology that it imposes (without appearing to do so, since these are 'obviousnesses') obviousnesses as obviousnesses, which we cannot *fail to recognize* and before which we have the inevitable and natural reaction of crying out (aloud or in the 'still, small voice of conscience'): 'That's obvious! That's right! That's true!'"

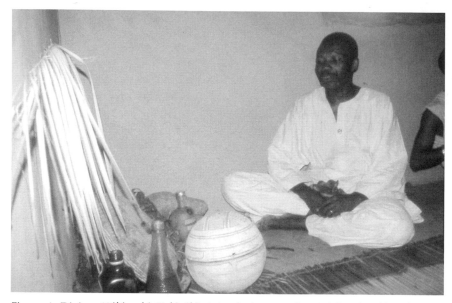

Figure 4. Diviner Kóláwolé Oshìtólá sitting before an altar (*ojúbo*) for Ifá and ancestors (*eegún*), November 2001. Challenge quarter of Ibadan, Nigeria. Photo: David T. Doris.

Yoruba religious practice. Here, persons and divinities (*òrìsà*) alike are constituted in acts of empowered, mutual seeing (fig. 4). In Yoruba, the altar is called *ojúbo,* a term Robert Farris Thompson (1993:149) has appropriately translated as "face of the gods." The word *ojúbo* is a contraction of *ojú ebo,* translated with equal accuracy as both "the face of sacrifice" and "the eyes of sacrifice." Implicit in the idea of an altar as *ojúbo* is the understanding that the site of sacrifice (*ebo*) is fundamentally an arena of reciprocative communication.[27] There is a Yoruba adage that speaks to this reciprocity:

Ojú ní òrò o wà.

Communication is in the eyes/face.[28]

When one makes a sacrificial offering before the visible face of power, the *òrìsà* and the communities of the living and the dead witness the behavior of the supplicant, the generous actions that embody social grace. As *babaláwo* Kóláwolé Oshìtólá noted in a proverb (January 11, 1999): "The ancestors know the person who tied the ram" (*Eégún, ó mò eni tí ó mú àgbò so*).

The verb *mò,* to know, is suggestive in this context. As Barry Hallen (2000:15) has maintained in a discussion of Yoruba epistemology:

Persons are said to "*mò*" (to "know") or to have "*ìmò*" ("knowledge") only of experience they have witnessed in a firsthand or personal manner. The example most frequently cited by discussants, virtually as a paradigm, is visual perception of a scene or an event as it is taking place.

The ancestors *know* the person who presented the ram in sacrifice because they have *seen* him do so.

27. Thompson (1993:147) depicts the altar, along with its visible components, as a brilliantly constructed teaching machine: "The altar is a school of being, designed to attract and deepen the powers of inspiration. By spatial and iconic means it instructs the devotee in the proper arts of *ìwà pèlé.* Dwarf doors force the postulant to bow deeply upon entrance to the inner shrine; altar icons mime proper act and gesture in proximity to the divine—kneeling, double presentation of the hands, dancing for the spirit with the head tie wrapped respectfully around the waist. These images are not passive pieces of shrine 'furniture,' then; they essentialize 'the work,' showing the proper way to stand and kneel before the gods." As "a school of being," then, the communicative "face" constituted in the altar plays a significant role in the education of "proper" subjects. Gilles Deleuze and Félix Guattari (1987:179) address the centralizing ideological power of such *facial* communication—a signifying power that includes, but also resides beyond, that of language.

28. Abíódún has translated this proverb on several occasions: "*Òrò*, the essence of communication, takes place in the eyes/face" (1994:72); "The face is important in communication" (1987:268). Thompson (1993:148) has translated the phrase to suggest the full range of its affective implications: "When two see eye to eye, face to face, that is communication and spiritual attainment."

Indeed, continued Oshìtólá, sacrifice is a form of labor in which the supplicant is rendered morally transparent to divinity, to community, and also to himself: "Sacrifice is self-judgment, which all can see afterward." Ìrù ebo, the labor of "carrying" sacrifice, is a conscious act of surrender—while it is surely an important avenue to self-advancement, it demands that one first conform to socially prescribed, community-oriented acts of giving. The ojúbo, then, is the site of labor, judgment, and reward, where power sees and is seen, and where one sees oneself as if one were being seen by powerful others. In this doubled exchange of mutual gazes—one exterior and one interior—both person and community come to be.[29] Efficacy resides in communication and in the intersubjectivity it presupposes. As babaláwo L. A. Oláyíwolá of Ìséyìn insisted (September 3, 1998), "It's all in the eyes" (Lójú ni nnkan wà).

A very appalling spectacle

Death, what a dishonor! To become suddenly an *object* . . .
—E. M. Cioran (1983:85)

I will now examine àwòrán that depart dramatically, even absolutely, from the familiar images of wood and brass and clay, all models of human excellence, that have been the celebrated stuff of Yoruba art history. Unlike most of those images, the objects at issue are not pretty things and address themselves to a matter that is similarly unpleasant: the constitution of "the thief" as a person who is no longer regarded as such in Yoruba society.[30] Like the proverbial stick in the forest, these objects remind one that there are limits to human autonomy and difference. Like the wooden doll that triggered the crying baby's response, they depict in form the person who is devoid of character (aláìnìwà). And like any of the àwòrán that constitute the canon of Yoruba "art" (including the performative space of the ojúbo itself), they prompt one to look and remember that, indeed, a person is a person *because* he sees and is seen by others; further, that a person recognizes and responds to the visual call of lawful power expressed in objects that embody ojú.

In ìrù ebo, the labor of sacrifice, a subject is constituted—he becomes a person, a human being—in an idealizing performance of mutual witness and generosity. In absolute contrast, acts of thievery occur in isolation and invisibility, beyond the gaze of others. However, as Moyo Okediji (1991:36) observes, when a thief is caught, he is violently drawn back into public view, transformed into a spectacle and absolutely devalued in that display:

A captured thief could be stripped naked and paraded through the streets. Displaying the offender in the nude is believed to have irreparably destroyed his esteem in the public. Whatever is publicly seen naked has lost its value and significance and has become cheapened or worthless.

Historically, thieves were dealt with harshly in Yoruba communities. Remarking on the efficiency of retributive justice in Abeokuta in 1861, Robert Campbell (1861:34) noted: "Punishment is always summary and certain; notwithstanding, nobody complains of injustice. The penalty for theft is extreme, being either decapitation or foreign slavery." While neither of those penalties is exacted today in southwestern Nigeria—there are, however, many others—Campbell's pairing suggests a dreadful ratio that is fundamental to them all: The transgressive body is excised from society as the head is removed from the body. The reciprocative relationship between the part and the whole is definitively, irrevocably cut—the thief is transformed within the social gaze from a subject into an absolute object. The convicted thief, "cheapened and worthless" in his

29. In an important argument on visuality in the constitution of agency in both subjects and objects, Alfred Gell (1998:116–121) locates the animating power of Hindu religious "idols" in the representation of eyes and in the resulting acts of mutual *seeing* that unfold between image and devotee. Here, in Gell's words, the idol's capacity to see and to bless the devotee "is a *nested component* of '[the devotee's] seeing herself seeing the idol.' The net result of the regression whereby devotee's and idol's perspectives become logically interdigitated with one another in this way is a kind of optical oscillation in which idol's and devotee's perspectives shift back and forth with such rapidity that interpersonal boundaries are effaced and 'union' is achieved." Within a Yoruba frame, too, the object's capacity to engage its viewer in a moment of mutual seeing is a "nested component" of the viewer's own self-reflection. This affecting power, however, does not require the depiction of eyes, nor does it result in the blessed union of devotee and divinity. Rather, the object, as the "indexical face" of "presence," has "eyes" that are ultimately abstract, dispersed through the whole of the object, and interiorized in the viewer as a moment of "looking and remembering."

30. Again, I am stepping away from situating these phenomena within historical contexts, choosing instead to focus on social and cultural *ideals,* both positive and negative, as a kind of hermeneutical exercise in dialogue with Yoruba cultural studies as an inclusive field of practice. Briefly, though: In Nigeria, criminal acts such as theft and armed robbery have risen exponentially over the past decade, a clear index of a national economy in deepening crisis. Within a nation long ruled by famously corrupt leaders, thievery especially has come to be widely regarded as normative and is even considered a salient characteristic of "Nigerian" identity. In this context, the "traditional" objects outlined below, still very much in use today, have taken on for their creators an *allegorical* significance that I am unable to address here. For details, see Doris (2001, 2006).

spectacular display, is described as "having no face" (*kò lójú*); that is, he is no longer a full and trusted participant in the dialogue that structures the human community. We see him, but he's not really there.

But let us return for a moment to decapitation. For centuries, at least, the heads of convicted thieves were nailed to trees in sites throughout what would come to be known as Yorubaland.[31] "The skulls are nailed to their trunks and large limbs," said Captain John Adams in 1786 (1970[1822]:26), "and present a very appalling spectacle." Sometimes bodies were hung there as well. For foreign visitors to the region, such trees were a source of real fascination and were documented with varying degrees of horror, amusement, and even familiarity—indeed, similar spectacles of institutional wrath also occurred in Europe.[32] If these demonstrations of power were for some foreign visitors "very appalling" in aspect, they also provided a moment of comfort—a touch of home, as it were—visible proof that the African landscape was not without its efficient, "civilized" laws. With the imposition of British colonial law in the region, such intimidating displays of chiefly power and social vengeance against transgressors were invariably outlawed.[33] But despite this suppression, the trees persisted for a time as powerful expressions of moral retribution in Yorubaland because, no doubt, they continued to be regarded by Yoruba people as effective *deterrents* to crime.[34] This sort of punitive spectacle,

after all, was not intended only to humiliate thieves, who were already dead by the time they were nailed in place.

If the punished and displayed head of the thief, the robber, the murderer, no longer has eyes to see, his face, in death, is very clearly seen. Further, that head has become the index (*ojú*) of the lawful forces it sought to transgress in life. Severed heads are no longer the houses of individual subjectivities, the loci of their owners' distinct, unrepeatable *orí*. Rather, in one irrevocable moment of severance, they have become *objects,* visual signs to be seen and deciphered by the living. In their display, said Stephen S. Farrow in 1926 (1996[1926]:73), "The fate of the criminal is published to the world, as a warning to evil-doers." A Yoruba proverb attests to the useful signifying function of such objectified beings:

Eni jìn sí kòtò kó ará ìyókù lógbón.

When one falls into a pit he becomes a warning [a lesson] to others. (Ajibola 1962[1947]:21, 56)

There is another proverb—in Yoruba, there is always another proverb—that offers a body metaphor to account for the practice of punitive spectacles as necessary warnings and proofs of power:

Bí a bá yo ipin lójú, ojú l'à á fi í hòn.

When a discharge is removed from the eye, it is the eye to which it must be shown (Ajibola 1962[1947]:16, 48).

This rich phrase suggests a theme fundamental to Yoruba conceptions of justice as a set of practices empowered not only to remove "discharge"—the formless index of pathological disruption—from the body of the community, but also to *render visible* (*farahòn*) those disruptions that previously could not be seen. The community at large, and the would-be transgressor in particular, is *made to see* the consequences of transgression—as Ajibola (ibid.:48) interprets the phrase: "A person's wrong-doing must be shown to him." Judiciary power is enacted in compelling images (*àwòrán*) that are at once retrospective and prospective. The thief, who has been forcibly discharged from the intersubjective network of community, is returned to the field of vision as an abstraction: an absence, a presence, a portent.

31. One such tree is illustrated in Farrow (1996[1926]: facing page 72).

32. On the long and widespread history of punishment as spectacle in Europe, see Foucault (1979), Linebaugh (1992), Merback (1999), and Spierenburn (1984). Regarding those spectacles within the frame of art history, see Edgerton (1985), Freedberg (1989:246–282), and Puppi (1991). For a more detailed discussion of such punitive spectacles in Yorubaland, including citations of many foreign visitors' observations, see Doris (2001).

33. "Lagos has learned to hide her horrors," said Richard Burton (1863:19) in an early report, "at the east end of the town [we no longer] find large trees covered with the heads of malefactors." Later in the document (ibid.:283–284), he alluded to the hypocrisy of this suppression in an account of a conversation with the Alake: "The Akpesi . . . observed that it might be the wish of the Englishmen not to behead criminals; that yesterday we had been looking at and 'writing' [i.e., drawing] the skulls, and so forth. . . . This was easily settled. Legal executions are not yet objected to by the civilized people of England. *C'est incroyable, mais c'est vrai.*"

34. The missionary S. G. Pinnock (1917:23) suggests that this mode of punishment was still practiced in southern Yorubaland through the second decade of the twentieth century: ". . . [W]e came to the outskirts of the town of Ijebu Ode. The first sight to greet us was a large open space, dotted here and there with trees, on which human skulls were nailed." By 1939, hints H. L. Price (1939:26), the trees

were no longer active, their studded trunks becoming fascinating relics: "There are trees in existence today with the actual nails still embedded in their trunks."

A corncob tied with a string

Behold, I come as a thief. Blessed is he that watcheth, and keepeth his garments, lest he walk naked, and they see his shame.

—Revelation 16:15

Now we will turn to other images, àwòrán that also depict "the thief" in abstract terms, and which are intended to dissuade men and women who are not yet thieves from actually becoming thieves. Ààlè are assemblages of often broken, ruined, or depleted objects usually set in place on farms, woodpiles, and displays of market goods to signify ownership, and to warn would-be thieves to reconsider their aggressively non-reciprocative intentions (figs. 3, 5, 6, 7). Empty snail shells, worn-out shoes, old brooms, ragged cloths, corncobs, rusted iron scraps—when such discarded objects are gathered and displayed in context as ààlè, they undergo a pivotal transformation. In their recontextualization they become àwòrán, visual reminders that encode the punishments awaiting a thief.[35] They anticipate a viewer who is culturally prepared to decode those meanings in context, reading intention, and consequence in the fragmented objects on display.[36] Here is one especially elegant example of

how even a single object becomes such as assemblage and is made to mean as an ààlè.

In December 1998, in the town of Iseyin, Jáwésolá Àwàlà, a medicinal specialist (onísègùn) and priest of the divinity Òsun, picked up a dry corncob from the ground, carefully tied it with a length of string, and suspended the perfectly balanced object in the air before me. "This is an ààlè," he said (fig. 5). "If we hang the corncob without adding any medicine (oògùn) to it," he continued, "we just hang it from a tree by a path, and it will be suspended like that. They will see it."

The implication is clear: there is efficacy even in seeing such an object. Àwàlà's simple act transformed the discarded corncob into a sign, an àwòrán. In Yoruba culture, a full ear of corn (àgbàdó) is well known as the very emblem of plenitude. Laden with uncountable kernels and covered with luxuriant layers of cornhusk, the ear of corn is likened to the body of the prosperous man or woman, blessed with many children and dressed in finest clothing. Such blessings, according to the divination orature of Ifá, don't just happen by chance; they come as the reward of appropriately good and humble behavior, such as that epitomized in the labor of sacrifice.[37]

In visible contrast to the full ear of corn, the corncob (sùkù àgbàdú) is bereft of its kernels and husk; it is a symbol of barrenness and nakedness. When displayed as an ààlè, it depicts the body and indeed the life of "the thief" via analogy (àfiwé) as a set of symptoms. Its kernels and husk are not merely absent, however; they were forcibly removed from its body. The corncob, then, is more than a synchronic symbol: It is an index (ojú) that testifies to the history of its own depletion at the hands of more powerful others. As an image "we look at and remember," a corncob displayed as ààlè threatens a would-be thief that he, too, can be similarly depleted. Further, in its careful balance from a single string, the corncob stands for (dúró fun) its creator's embodied powers of balanced judgment (ìwòntúnwònsì) and ability to render appropriate punishment.

As an àwòrán, an ààlè gives a palpable face (ojú) to the presence of authoritative, transformative power (àse)

35. Here is a list of some of the punishments proffered by ààlè that came up over the course of my research: suffering (ìpònjú, ìyà); poverty (isé); excessive financial recompense to property-owner; fruitless labor (asèèrí); madness (ìwèrè); "scattering" of one's life (yà jakujaku); wandering (ìkiri; ìsánlo); restlessness (wàdùwàdù); exile (ìlélùgbé); dying in the bush (ìra nínú igbó); uselessness (aláìwúlò; kò wúlò mó); crawling (ìrá); paralysis (ègbà); homelessness (ìsáìnílé); nakedness, clothlessness (ìhòòhò); dressing in rags (àkisà); filthiness (aláìmón); falling apart (túkà); spoiling (ìbájè); weakness (àìlè; àìlágbára); troubling by evil spirits (ebora, iwin); tying (dídì); barrenness (ègòn); death of children (ikú omo); giving birth to abíkù; hunchback, bending (ìkákò); swelling of body parts (ara wiwú); hunger (ebi); starvation (ìpalébi); emaciation (rirù); diarrhea (ìsunún); smallpox (sònpònná); epilepsy (wárápá); leprosy (ètè, àálè); fever (ibà); body rash, itching, burning (ara gbóná); blindness (ìfójú; literally, shattering the eyes); deafness (ìdití); stuttering (ìkóòlòlò); beating (ìlù); whipping (ìlagbà). Regarded in terms of spiritual import these are the intimate names of the ajogun, "the warriors against humanity" (Lawal 1996:22), allegorical figures that give shape to the diversity of negative human experience as embodiments of the most mundane, ubiquitous sufferings.

36. I have argued elsewhere (Doris 2001) that ààlè are a subspecies of a wider system of non-verbal communication called àrokò. In this centuries-old system, three-dimensional objects are used to transport messages from sender to receiver in situations where direct verbal communication is impossible or undesirable. The objects used in àrokò constitute a code determined within specific social groups and uttered within specific contexts. In their utterance and reception, àrokò presuppose communities of shared knowledge—the person who

receives an àrokò can interpret its meaning because he or she shares a history with its sender. Ààlè can be considered a type of "public àrokò"; in contrast to the àrokò learned, say, through initiation into a particular society or trade, the meanings of such objects are conventionalized, culturally common knowledge. Further, the ordinary objects used as ààlè are displayed publicly to transmit specific messages to a broad constituency, rather than to a specific person.

37. For an extensive iconographic discussion of corn and corncobs in Yoruba culture, see Doris (2001).

Figure 5. Chief Apènà Ajáwésolá Àwàlà. *Àálè* warning assemblage, December 5, 1998, Ìséyìn, Òyó State, Nigeria. Corncob, string. Photo: Lyle Peterzell, National Gallery of Art, Washington, D.C., August 2001.

in the Yoruba social landscape. For a would-be thief who enters an empty farm expecting to find himself alone there, an *àálè* is an irruption within the field of vision, meant to remind him that *he is not alone*. It marks the absence of the property owner as an *index* (*ojú*) and so confronts its viewer as an articulated *presence* (*ojú*). In its transformation from ordinary thing into *àálè*, the object is constituted such that it will function as the eyes (*ojú*) of its absent creator and, by extension, of the historical and mythic forces that are the generative stuff of Yoruba tradition. An *àálè* is always constructed in performative dialogue with these forces— even the wordless hanging of a corncob from a branch

in a farm or the placement of an empty snail shell atop a woodpile is already an implicit affirmation of traditional practice.[38] In this dialogue, both creator and created become personifications of the gaze of authoritative power, sanctioned to see and punish transgressive actors and acts in the landscape.

Faced with an *àálè* in an isolated field at a crucial, unstable boundary between town and bush where "civilization" is maintained only through a farmer's persistent labors, a would-be thief is made to *see*, to *remember*, and to *recognize* that her destiny as a social being hangs in tenuous balance. That *àálè* is intended to disrupt the isolated act of theft by engaging the would-be thief in a visual dialogue with an emblem of power that is itself constructed as a kind of empowered subject (figs. 6, 7).[39] In such a dialogue, seeing means also that one is being seen, and that one sees oneself being seen. In short, an *àálè* is a trigger of *conscience*, a concept that in Yoruba is constituted as *erí okàn*—translated as "You/They see the mind/heart/thoughts." There is a proverb:

> *Àwòdì òkè kò mò pé ara ilè nwò ó.*

> The eagle flying high in the sky does not know that those on the ground are looking at him (Delano 1979: 129–130).[40]

The metaphor is rephrased in another proverb:

> *Bi enia ba nsika, k'ó má rò pé Olórun kó rí oun.*

> When a person does evil, he should not forget that God sees him (Ajibola 1962:17,50).

Here the gaze of law is figured as the all-seeing authority of God and the sanctioned vision of "those who live on the ground"—those, that is, who live within the constraints of terrestrial law. Radically individuated

38. The snail shell (*ikarawun igbín*), like the corncob, is the inert remainder of a being widely regarded as a symbol of Yoruba cultural ideals. The snail (*igbín*) is an avatar of good character (*ìwàpele*): It moves slowly like an honored elder, it is cool even to the touch, and it generously leaves a libation of cooling liquid (*omi ero*) wherever it travels. The snail shell, used as *àálè*, inverts these ideals, and threatens that a thief will be similarly dry, empty, barren, or forcibly extracted from her home. The iconography of the snail and its shell are discussed at length, and in contemporary historical context, in Doris (2001).

39. In this way, an *àálè* functions as a kind of ideological police officer (cf. Althusser 1994:139 n.17): It "hails" its suspects (which could be anyone), compelling recognition both of the caller's authority and of one's own position as the subject of the call.

40. *Àwòdì* is the African Black Kite (*Milvus Migrans Parasitus*). Abraham (1958:80) also cites this proverb, with a slight difference: "*Àwòdì kò mòn pé ará ilèé n rí òun.*" His compact translation is compelling: "Nothing can remain unrevealed."

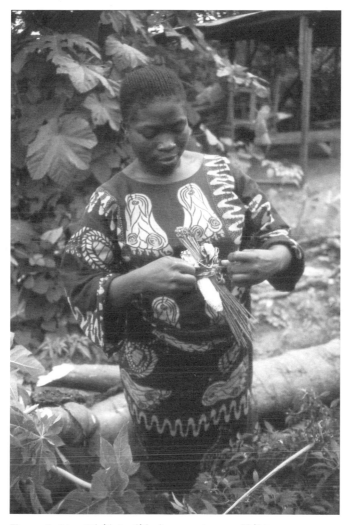

Figure 6. Mrs. Bíólá Awólówò preparing an *ààlè* to protect a pepper plant growing in the Old Buka market area at Obafemi Awolowo University in Ilé-Ifè, August 1996. Photo: David T. Doris.

Figure 7. Mrs. Bíólá Awólówò's *Ààlè* warning assemblage. August 1996, Old Buka, Obafemi Awolowo University, Ilé-Ifè. Òsun State Pepper, cloth, worn-out broom, corncob, earth, wood. Photo: David T. Doris.

desire, expressed as transgression ("flying high," "doing evil") is kept in check through acts of empowered seeing that are effectively installed in individual consciousness as conscience. Yoruba tradition (*àsà*), as noted above, contains within itself an essential and clearly defined moment of individual choice, the freedom to depart from the ways of the past to determine one's unique path through life. But the freedom of the individual is always enacted in dialogue with the flexible constraints of *àsà*. There are moral limits to such flexibility: Beyond them, intersubjective dialogue can no longer be maintained. In Yoruba society, historically, acts of theft

transgress these limits absolutely. Isolation is anathema. Acts performed in isolation—acts such as theft, which occur in secrecy, beyond the gaze and voices of others—are likewise.

An *ààlè* is a *vigilant thing* (*nnkan tó fè lójú*) that anchors subjects and their properties in social space and time by establishing a gaze of moral judgment. This gaze reveals the invisible actions of the thief, the "evil man"—the adult version of the "unfunctioning baby" who acts selfishly, in silence and solitude. The person who entirely dissociates from that social gaze—and in Yoruba ontology, such a person has either chosen or is

destined to do so—will be assessed as *èniyàn buréwà,* a person of bad character, and thus an "un-beautiful" person.[41] Indeed, as philosopher Segun Gbadegesin points out (1998:149), the person who "[falls] short of what it takes to be recognized" as a person will elicit from others the comment, *Kì í se èniyàn* (he or she is not a person). A person who has been recognized as a thief is no longer a person as such, and is no longer bound into the intersubjective network of social dialogue and invocative power. As descriptions (*àpèjúwe*) of such non-persons, *àalè* reveal to would-be thieves the attributes of suffering that all thieves are deemed to hold in common, articulating them in visible forms—often broken, discarded, fragmentary, or useless things—that metaphorically bespeak powerlessness, facelessness, namelessness, and, ultimately, separation.

For the person who would dare contradict such extraordinary power in socially inappropriate action—the person who would "put his hand in *àalè*" (*tówó bàalè*)—the broken-down objects displayed as *àalè* are harbingers of his or her own destiny, nothing less. Displayed as evidence of irrevocable transformation, a broken object used in *àalè* is inevitably compared by knowledgeable Yoruba men and women to the person—or, more accurately, the *non*-person—of the thief. For the person identified as a thief, the person who has been compelled to identify himself as a thief, there is no access to the transcendental means of power, the intersubjective, dialogical networks of authoritative discourse, the socially determined laws of human engagement. There is, instead, only a future of separation and social uselessness in which the thief is laid bare to the wrath of social justice and structured as an isolated subject, an outlaw. This, ultimately, is what it means to "grow up with the 'virtues' of dead wood" (Idowu 1995[1962]:85).

In the biography of the writer and thief Jean Genet, Jean-Paul Sartre (1963:68) speaks of the consequences of choosing a path of radical transgression:

He who chooses to be wrong and who knowingly persists in being so cannot rely on collective forces, on tradition, on truth or on *any* kind of being. For error is *nothing.* He exhausts himself in upholding a Nothingness in solitude. The unrecognized scientist or artist dreams of future approval. When he is dead, at least his memory will be revered. But the name of the man who wants to be wrong is writ on water. The memory of him will disappear from the world with his life. He falls out of history and out of the world.

The stakes here resonate powerfully with those elaborated in a Yoruba moral frame. There is, of course, a Yoruba proverb that addresses the issue: *Bí omodé ba n yo ilè dà, o n bùbùrù a máa yóo se.* The *babaláwo* Kóláwolé Oshìtólá (January 11, 1999) translated this proverb in two ways, the first in what he called "good English," the second in "Yoruba English":

If a child proves perfidious to his obligation in secret, he shall suffer the consequences in silence.

If a child is behaving against the Mother Earth, it will be in secret. Something punishing will happen in silence.[42]

The performance of social justice mirrors and completes the performance of the transgressive act. Punishment happens in silence, *as* silence: the thief is extracted from the dialogical realm of communicative humanity. "That is what leads to total destruction," Oshìtólá added:

When all the things they have done is totally vanity, totally rubbish. Then they fear ending up in vain. They fear ending up in rubbish. Hence, they end up like that. Nobody is going to come and plead for them. Because to whom will you plead? To the Mother Earth? To Olódùmáre? To *òrìsàs*? To individual *orí inú*? How can all these collective *isèsè* [help or] forgive an offender? When the offender himself has admitted guilty [to himself]. . . .

Within the gaze of a community founded on the continuities of history and tradition, whether that community is in Paris or Ilé-Ifè, such a person is no longer regarded as fully *being.* For Sartre, however, the thief is heroic in his defiance, a martyr to the cause of

41. I have outlined elsewhere (Doris 2001, 2005) that *àalè*—in *usefully* deploying useless objects to abstractly depict the "useless" (*kò wúlò*) non-person of the thief—constitute a Yoruba anti-aesthetic. If, as Robert Farris Thompson has rightly argued regarding Yoruba sculpture (1974b:33), "excessive abstraction" is "[r]elated to the notion of mimesis, on a negative grid of disapproval," then *àalè* stand in a singular position among Yoruba representations of the human. Across the board, *àalè* express the "signs of excess or disease, heat, self-expression, danger, and ugliness"—the symptoms of pathology that cannot be accommodated within the idealizing frame of a Yoruba aesthetic canon. There is no "equanimity of mind and body" here (Thompson 1974a:120). Instead, an *àalè* is the quintessence of the "bad or evil-looking art" that "disturbs the purity of idealized communication by introduction of particularity." It represents in form, as a portrait, *that one particular person* who will recognize himself in it at a moment of moral and ethical crisis—as a disturbance.

42. In translating *ilè* as "Mother Earth," Oshìtólá invokes the authority of the Ògbóni society of elders who claim the Earth as the secret source of their omnipotence. By referring to his translation as "Yoruba English," Oshìtólá hints at deeper levels of untranslatable discourse. See Delano (1979:131) and Ajibola (1962[1947]:17, 50) for alternate versions and translations of this proverb.

independent atomic subjectivity. This is not the case in a traditional Yoruba context where independence is inevitably articulated as responsive *inter*-dependence. Here, the memory of the thief is writ not on water, but rather is projected in a constellation of useless damaged goods. The ordinary objects on display as *ààlè* are dilapidated residues of the history of their uses, as the body of the thief will become the impoverished, battered index of the social powers set in motion to combat transgression. An *ààlè* image describes the contours of what it means to "end up in rubbish," to become—through one's own choice to act as a thief—a person who is no longer recognized *as a person as such:* with no recourse to the legacies of the past, with no foreseeable future, and without a legible face.

A final note

Since I first began writing this essay, I have been trying to determine, with little success, why it has made me feel so very uncomfortable. It started, again, as a thought experiment—a narrowly limiting study based on a much broader project set in southwestern Nigeria around the turn of the millennium. The question here has been: How do we understand the moral and social power inherent in Yoruba conceptions of the image as *àwòrán*, and can we do so by staying tightly focused on Yoruba explanatory terms? To a degree, I think such an understanding can be accomplished, and, indeed, it must be accomplished if we ever hope to move past our inevitably fetishizing notions of *what others do.* I hope at least to have sketched out here some possibilities for achieving a sort of limited *emic* understanding of some aspects of "Yoruba tradition" (*àsà ìbílè Yorùbá*).

But the argument is not merely a fiction, framing complex social realities in idealizing moral terms: It is a fairy tale, setting a stable "worldview" in an "ethnographic present" that Yoruba people might refer to as *igbá láílái*—the time of never. Was there ever, anywhere in this world, a moment when truly committed thieves were dissuaded from their work because of a warning sign? Perhaps not. But then, at least in southwestern Nigeria today, committed thieves are not the ones for whom such warnings are intended. Rather, they are addressed to men and women who, for one reason or another, may feel compelled to steal from their neighbors, but who have not yet committed themselves to the act. For such people, a deftly placed reminder is expected to suffice—something "to look at and remember." Such "traditional" images are powerful and convincing in part *because* they are traditional. In

the face of violent social change, they propose—in shards and tatters—an enduring world of moral order and social cohesion, a world in which good works are rewarded, and all crimes meet their just, confident punishments. That world does not exist now, of course, and it probably never did. But the desire for it never ceases to be.

Appendix: The potsherd pavement and the General's sunglasses

Let me tell you one thing. No article is being used for a certain thing that cannot be used for another purpose.
—Babaláwo *Kóláwolé Oshìtólá (September 24, 1998)*

Here is the story of how, on March 10, 1999, one of Africa's great archaeological treasures became an *ààlè*, an *àwòrán*—in this case, an allegorical emblem of corrupted leadership and the suffering it causes.

It had been three days since I last visited Gàníyù Awótúndé, and he seemed anxious to get past the greetings and on with the day ahead. I knew Awótúndé—a hunter, farmer, Ògbóni member, and herbalist priest of the *òrìsà* Òsanyìn—from my first visits to Nigeria in 1995 and 1996, but was unable to see him in 1998 because of the Ifè-Modákéké war. Awótúndé lived in the Ìyékéré quarter of Ilé-Ifè, one of the hottest and worst-ravaged war zones, just a few meters from Modákéké. When I finally returned to Ìyékéré in February 1999, most of its homes and shops had been leveled, and the quarter was all but abandoned. Awótúndé, who traced his origin to Èkìtì and so reckoned himself a non-partisan, chose to remain in Ìyékéré throughout.

He paid a price for his choice. One night, as a battle flamed on the streets of Ìyékéré, Awótúndé consulted his *òrìsà*, who warned him not to leave the house. He disregarded the warning, and was shot in the face. Awótúndé lost his right eye in the blast, and fragments of shrapnel still were lodged in his shoulder, his jaw, his temple. He taught me a new greeting as he held my fingers to his scars: "*A ti ja àjàbó láti rí oni,*" "We have survived to see today."

Awótúndé said he had a surprise for me, something of great interest for my study. In Ifè, not far from his house, was what he called an *ààlè àlílè*, or *ààlè ilè*—an ancient *ààlè* that had endured the assaults of time and which today could still be witnessed in the landscape.[43]

43. The term *ààlè ilè* can be translated, "the earth's *ààlè*," thus denoting great age. Such an association with the earth suggests vast

I was convinced, after nearly a year of research, that *ààlè* were almost always *ephemeral* objects, intended to be deployed within specific spaces and for limited amounts of time. I also was pretty sure that a roughly canonical set of objects was used to construct *ààlè*: brooms, snail shells, corncobs, old shoes, rags, peppers, and so on. Awótúndé demonstrated that I had been premature in coming to any such conclusions.

We left the house and walked in silence through Iyékéré and onto Òkégbàlà Street. Leaving the road, we walked the labyrinthine paths between closely congregated walls of several compounds. In a courtyard, Awótúndé halted next to a dry, leafless tree and said, "*A tí dé*"—we have arrived.

I looked around, baffled. There were no familiar objects dangling from the tree, and a quick look around the courtyard revealed nothing extraordinary: a few shuttered windows, a water-well, a load of freshly washed clothes hung out on a line to dry. And Awótúndé just stood there, smiling.

"*Kí n ló dé?*" I asked. What's up with this?

"*Wò*," said Awótúndé. Look. He pointed to the ground. There, raised just slightly above the hard red earth, was a one-meter square section of potsherd pavement, a sight familiar to anyone who has ever studied African art and archaeology (fig. 8). Comprised of fragments of broken ceramic pottery painstakingly set on edge, usually in a characteristic herringbone pattern, the Ifè pavement is by all accounts a remarkable architectural achievement. Sections of it are found today in many sites throughout Ifè, suggesting that much of the town was at one time artfully surfaced with ceramic and stone (Willett 1967:104). Dating back to 1000–1400 C.E. the pavement surely stands witness to the excellence and antiquity of a classical Yoruba civilization.

But Awótúndé had a different take on the matter.

"*Ààlè ilè ni*," he said. ("It is an ancient *ààlè*.")

Okay, I thought, I'm listening.

Assisted by his friend and fellow hunter, James Ojúadé, as well as by several other men and women who joined us over the course of an hour, Awótúndé proceeded to unravel the history of the pavement. I will supplement that history with information drawn from published sources:

Lúwòó Àyárè, also called Lúwòó Gbadiga, was the first and only woman ever to hold the office of the Óòni

Figure 8. Section of potsherd pavement, ca. 1000–1400 C.E. Ìyékéré quarter of Ilé-Ifè, March 10, 1999. Photo: David T. Doris.

of Ifè, traditionally the supreme leader of the Yoruba world. She was the eighteenth or nineteenth Óòni in that royal lineage (Akinjogbin 1992:104–105). Lúwòó was a powerful woman, as attested by one of her *oríkì* (names of appraisal), *Aròjiròjò*, "The one who has the blessing to command rain." Another *oríkì*, *Akosulogbele*, can be translated, "The one who has heaps of yams in dry season." Yams are not plentiful then, and so this *oríkì*, too, intimates Lúwòó's extraordinary powers to control nature's production.

"Lúwòó was a very cruel woman," said Awótúndé, citing another of her *oríkì*: *Agbésorosoro bo ojú o juju*, "The heartless one who will take a needle to poke

powers of witness and punishment. Olómólà (1991) notes that *àlílè* is an Èkìtì dialectical variant of *ààlè*, a fact consonant with Awótúndé's use of the term.

someone's open sores."[44] Ifè will never again place a woman in the position of Óòni, he said, on account of Lúwòó's wickedness.[45] "She was power-drunk," suggested a man in the group, and given to making demands on her subjects that challenged the boundaries of propriety and reason.

"She made the slaves work harder than necessary," said Awótúndé.

Under Lúwòó's command, agrees Obafemi Awolowo University archaeologist Adisa Ògúnfólákan (1990:89), "Slaves were not allowed to rest, they [had] to work most of the time, even to the core of the night." Such cruelty, he tells us, earned Lúwòó another, rather ironic, oríkì: Lúwòó Àyárè, Lúwòó Ejídé, Kò ni'ka nínú, O ni k'eru gun ope se Egunsi ("Lúwòó Àyárè, Lúwòó Ejídé, She is not wicked, she asked slaves to carry melon to the palm-tree to peel"). As Lúwòó's palm wine tappers waited in the treetops for the palm's nectar to fill their empty gourds, they were required to carry and peel a load of bààrà melons from which would be extracted egúsí seeds for Lúwòó's evening's stew.

Akinjogbin (1992:104) also documents this moment of "alleged cruelty" and tries to provide some positive spin, suggesting that Lúwòó "probably discouraged idleness" among the Ifè. But this is not how she was regarded by the people I met there. According to a woman among the small crowd in the courtyard, the palm wine tappers' extra labor was evidence that Lúwòó was fearful, paranoid (ó bèrù). Lúwòó had her servants prepare dinner among the treetops so that no one could witness the preparations—and also, one could surmise, so no one could dose her stew with poison.

The fabrication of the potsherd pavements can be "regarded as part and parcel of [Lúwòó's] cruelty," proposes Akinjogbin (ibid.). They were constructed during the dry season (Ògúnfólákan 1990:90), a period when there is no farmwork to be done, thus further depriving Lúwòó's slaves of hard-earned leisure. Lúwòó thus accrued yet another disagreeable oríkì: N'ílé, l'óko, ma ráyé sùn sílè ("At home [i.e., in town] in the farm, I have no time to rest").

The potsherd pavement remains today, suggested Awótúndé, as a testament to a leader's arrogance and fear. This powerful, privileged woman felt she should not be obliged to walk upon the same ground as other mortals. To this end, Lúwòó had her slaves work constantly to piece together a surface that would be hers alone, a kind of moving sidewalk that bloomed slowly, malignantly forth over the earth wherever the Óòni wished to place her feet. No one but she could step on the pavement, at risk of certain death.

"You see?" said Awótúnde, "It is ààlè."

I did not see. What to do with this information, I thought? Here, a trained medical practitioner, an ologbón (person of wisdom), was telling me with great conviction that a well-known monument belonged to what I felt was surely the wrong category. A pavement, as experienced everyday, cannot really be said to function as do the old shoes, rags, palm fronds, and even medicinal objects that are employed as ààlè. But then, this was no everyday pavement, and Awótúndé was insistent: Lúwòó created it as ààlè. Granted, it was possible that Awótúndé was just having a friendly laugh at my expense—not at all unlikely, given his own love for the occasional bit of mischief. A practical joke, then?

I don't think so. As Awótúndé and others in the casually assembled group articulated their experience of the potsherd pavement, Lúwòó had indeed created a kind of ààlè: a warning sign, a protective enclosure, a marker of inviolable personal space. But if the term "ààlè" was lost in the ensuing discussion, its very definition was expanded. The word was soon replaced by comments that set the pavement not only in the context of ancient Yoruba history, but also in the frame of late twentieth-century Nigeria. Several in the group likened Lúwòó to a contemporary figure held in equally low esteem—for them, Lúwòó and her legacy of suffering found a present-day analogue in the greatly feared and despised president of Nigeria, General Sani Abacha.

"She was Abacha Number One!" said Ojúadé, laughing.

"Abacha Obìnrin!" ("the female Abacha"), added Awótúndé, who could barely contain himself.

"Abacha Àtijó!" ("Abacha of a long time ago"), came a woman's voice, as others murmured in agreement.

Lovingly described by Dr. Tunji Brathwaite (1998:12) as a "despotic, thieving, megalomaniac and godless military impostor," Sani Abacha died on July 8, 1998, just ten months before this meeting. The sufferings he wrought on the citizens of Nigeria during his four-year presidency are too numerous to recount here—anyway, this is not the place to do so—but the infamy of Abacha's rule was still fresh in everyone's memory. Like Lúwòó Àyárè, Abacha was regarded as "power-drunk."

44. This oríki also is cited by Ògúnfólákan (1990:89).

45. Awótúndé's claim fits with Akinjogbin's report (1992:104): "It is said that as a result of her cruelty, the Ifè resolved never again to have a female Ooni."

Like Lúwòó, he was held to be unjust and unnecessarily cruel to his subjects. And like Lúwòó, the General's abuse of power had made him deeply, dangerously paranoid.

The Nigerian press dubbed Abacha "the Hermit of Aso Rock": Increasingly fearful of a coup that would end both his reign and his life, Abacha wielded power from within the guarded isolation of the presidential palace in Abuja. When he did appear in public, he usually wore dark or mirrored aviator sunglasses—a fact regularly noted in the Nigerian press. The opaque lenses covered much of the upper half of his face, and prevented one from seeing his eyes. Among people I knew in Ifè and Ìbàdàn, the sunglasses were the source of simultaneous amusement and dread. Abacha's affectation was regarded as a tough-guy pose, a quotation of the appearance of the "area boys," bandits who stalked the roads and densely populated districts of Lagos. Many area boys, in turn, borrowed their own style from Western gangster and war movies.

Sunglasses—particularly mirrored sunglasses—signify and enact a one-way movement of power, a disruption in the reciprocity of gazes: The gaze of power surveys, but cannot be returned. The discomfort caused by such an accoutrement is palpable—think of the classic cinematic image of the U.S. highway patrol officer, his mirror shades rendering him expressionless, frozen, monumental, and unquestionably powerful. Abacha's sunglasses constituted an unmistakable psychic barrier between himself and the people of Nigeria. In life, when Abacha presented himself *to be seen as a memorable picture,* a persona, he was hidden, isolated behind two opaque, protective screens. In death, when Abacha is *remembered,* those dark lenses form his most accurate portrait, the image by which he is finally, truly seen. Their surfaces disclose the extent of Abacha's hidden crimes and reflect the suffering he exacted on the people of Nigeria.

Similarly, Awótúndé and others in the group at Ifè did not treasure the fragment of Lúwòó's pavement as a thing of classical beauty and lasting, civilized grace— though certainly it is that. In its interpretation, the pavement was transformed from an unnoticed fragment of everyday life—into an òwe, a proverb, a site of memory.[46] Through it, Lúwòó was recalled to memory as a living force in a moment of conflict, made to serve

the present as a model of corrupt leadership: cruel, paranoiac, a source of human suffering. The memory of Lúwòó's self-isolation and the anguish of her subjects was crystallized in an image (àwòrán) of singularly profound disruption: the face of the earth (ojú ilè) covered by shattered, useless shards of pottery.

The lesson of the potsherds, like that of Abacha's sunglasses, is unambiguous. In a society that demands transparent social reciprocity as an engine of its identity, the ruler of a nation cannot establish an impermeable boundary between him- or herself and the community at large. In doing so, he or she becomes a spectacle of inhuman folly, a palpable image of involuted leadership, of justice become suffering, of generosity transformed into greed, megalomania, and theft.

The word àà/è can broadly be interpreted as "we must not" or "we are not permitted." In this reading of the term, a royal walkway and a pair of darkened sunglasses both can be considered as àà/è. Like a corncob, a snail shell, or indeed, a single broken fragment of ceramic pottery hung from a tree as a warning to thieves, they are allegorical emblems of *what must not be done.* Actively interpreted by men and women who clearly have not lost all their connections to a common past—or who, at least, are still able to recognize the signs of that common connection—the undisclosed fragments of daily life are transformed into metaphors of reciprocative social and cultural ideals shattered, broken, drained of their fullness, utterly inverted by excessive self-interest.

which continuities between the present and the past are always the function of fragmentary, subjective readings. Karin Barber (1994) looks to Nora's work in one of her expositions on Yoruba oríkì. Barber's analysis suggests that in Yoruba culture the production of the relation between past and present is *always* articulated as an oscillation between repetition and novelty, between memory and history, between the acknowledgment of a break and the longing for the restoration of continuity. As for the allegorical transformation of objects into "proverbs" in Yoruba culture, there is indeed a Yoruba proverb: *Ìjà ló dé l'órin d'òwe*—"In a time of conflict a song innocently sung becomes a proverb" (Abíódún 1987:47).

46. I borrow this last term from Pierre Nora (1989). *Lieux de mémoire* dwell in the "push and pull" between the "disappearance of a peasant culture" (7), founded on memory and repetition of a transparently available past, and the advent of a culture of history in

BIBLIOGRAPHY

Abímbóla, Wande
1973 "The Yoruba Concept of Human Personality," in *La Notion de Personne en Afrique Noire,* Colloques Internationaux du C.N.R.S, no. 544, pp. 73–89. Éditions du Centre National de la Recherche Scientifique, Paris.
1976 Ifá: *An Exposition of Ifá Literary Corpus.* Athelia Henrietta Press, New York.

Abíódún, Rowland
1987 "Verbal and Visual Metaphors: Mythical Allusions in Yoruba Ritualistic Art of Orí." *Word & Image* 3(3):252–270.
1994 "Understanding Yoruba Art and Aesthetics: The Concept of *Ase.*" *African Arts* 27(3):68–78, 102–103.

Abraham, R. C.
1958 *Dictionary of Modern Yoruba.* University of London Press, London.

Adams, Captain John
1970 *Sketches taken during ten voyages to Africa, between the years 1786 and 1800; including observations on the country between Cape Palmas and the River Congo; and cursory remarks on the physical and moral character of the inhabitants: with an appendix, containing an account of the European trade with the west coast of Africa.* Johnson Reprint Co., New York. [Originally published by Hurst, Robinson & Co., London and Constable & Co. in Edinburgh in 1822.]

Adepegba, C. O.
1983 "The Essence of the Image in the Religious Sculptures of the Yoruba of Nigeria." *Nigeria Magazine* 144:13–21.

Ajibola, J. O.
1962 *Owe Yoruba.* Oxford University Press, London and Ibadan. [Originally published in 1947.]

Akinjogbin, I. A.
1992 "The Growth of Ife from Oduduwa to 1800," in *Ife: The Cradle of a Race,* ed. I. A. Akinjogbin, pp. 96–121. Sunray Publications, Port Harcourt.

Althusser, Louis
1994 "Ideology and Ideological State Apparatuses (Notes Toward an Investigation)," in *Mapping Ideology,* ed. Slavoj Zizek, pp. 100–140. Verso, London and New York.

Armstrong, Robert P.
1971 *The Affecting Presence: An Essay in Humanistic Anthropology.* University of Illinois Press, Chicago.

Barber, Karin
1981 "How Man Makes God in West Africa: Yoruba Attitudes Toward the Òrìsà." *Africa* 51:724–745.
1991 *I Could Speak Until Tomorrow: Oríkì, Women and the Past in a Yoruba Town.* Edinburgh University Press, Edinburgh.
1994 "The Secretion of Oríkì in the Material World." *Passages: A Chronicle of the Humanities* 7:10–15.

Bayart, Jean-Francois
2005 *The Illusion of Cultural Identity.* University of Chicago Press, Chicago.

Bourdieu, Pierre
1977 *Outline of a Theory of Practice.* Cambridge University Press, Cambridge.
1979 "Symbolic Power," *Critique of Anthropology* 13/14:77–86.
1991 *Language & Symbolic Power,* trans. Gino Raymond and Matthew Adamson. Harvard University Press, Cambridge, Mass.

Brathwaite, Dr. Tunji
1998 "Transition has slipped into darkness: Being excerpts of a speech presented at Dr. Tunji Brathwaite's chambers on Thursday, December 17, 1998." *The Punch,* December 23:12.

Burton, Richard F.
1863 *Abeokuta and the Camaroons Mountains: An Exploration,* vol. 1. Tinsley Brothers, London.

Campbell, Robert
1861 *A Pilgrimage to My Motherland: An Account of a Journey Among the Egbas and the Yorubas of Central Africa, in 1859–60.* Thomas Hamilton, New York.

Cioran, E. M.
1983 *Drawn and Quartered,* trans. Richard Howard. Seaver Books, New York.

Davis, Whitney
1994 "The Subject in the Scene of Representation." *Art Bulletin* 76(4) December:570–575.

Debord, Guy
1967 *La Societé du Spectacle.* Buchet-Chastel, Paris.

Delano, Isaac O.
1979 *Òwe L'Esin Oro: Yoruba Proverbs—Their Meaning and Usage.* University Press Limited, Ibadan.

Deleuze, Gilles, and Felix Guattari
 1987 *A Thousand Plateaus: Capitalism and Schizophrenia*,
 trans. Brian Massumi. University of Minnesota Press,
 Minneapolis.

Doris, David T.
 2001 "Vigilant Things: The Strange Fates of Ordinary
 Objects in Southwestern Nigeria." Ph.D. diss., Yale
 University.
 2005 "Symptoms and Strangeness in Yoruba Anti-
 aesthetics." *African Arts* 38(4):24–31, 92.
 2006 "'Traditional Somethings': The Persistence of *Àà̀lè* in
 Nigeria." *The Southern Review* 42(1) Winter:95–125.

Drewal, Henry J., and Margaret T. Drewal
 1990 *Gelede: Art and Female Power Among the Yoruba.*
 University of Indiana Press, Bloomington.

Edgerton, Samuel Y. Jr.
 1985 *Pictures and Punishment: Art and Criminal
 Prosecution During the Florentine Renaissance.*
 Cornell University Press, Ithaca and London.

Elkins, James
 1996 *The Object Stares Back: On the Nature of Seeing.*
 Harcourt Brace, New York.

Ellis, Alfred Burdon
 1894 *The Yoruba-Speaking Peoples of the Slave Coast of
 West Africa: Their Religions, Manners, Customs,
 Laws, Language, etc.* Chapman and Hall, London.

Fajana, A.
 1966 "Some Aspects of Yoruba Traditional Education." *Odu:
 University of Ife Journal of African Studies* 3(1):
 66–128.

Farrow, Stephen S.
 1996 *Faith, Fancies & Fetish, or Yoruba Paganism.* Athelia
 Henrietta Press, Brooklyn. [Originally published by
 the Society for Promoting Christian Knowledge in
 1926.]

Foucault, Michel
 1979 *Discipline and Punish: The Birth of the Prison.* Trans,
 Alan Sheridan. Penguin Books, London.

Freedberg, David
 1989 *The Power of Images: Studies in the History and
 Theory of Response.* University of Chicago Press,
 Chicago.

Gbadegesin, Segun
 1998 "Enìyàn: The Yoruba Concept of a Person," in
 Philosophy from Africa: A Text with Readings, ed.
 P. H. Coetzee and A. P. J. Roux, pp. 149–168.
 International Thomson Publishers, Johannesburg.

Gell, Alfred
 1998 *Art and Agency: An Anthropological Theory.*
 Clarendon Press, Oxford.

Hallen, Barry
 2000 *The Good, the Bad and the Beautiful: Discourse
 About Values in Yoruba Culture.* Indiana University
 Press, Bloomington.

Idowu, E. Bolaji
 1962 *Olódùmarè: God in Yoruba Belief.* Longmans, Green
 & Co., London. [2nd edition: New York: Original
 Publications, 1995.]

Jay, Martin
 1993 *Downcast Eyes: The Denigration of Vision in
 Twentieth-Century French Thought.* University of
 California Press, Berkeley.

Johnson, Samuel
 1921 *The History of the Yorubas: From the Earliest Times to
 the Beginning of the British Protectorate.* Routledge
 and Kegan Paul, London. [Reprinted by CSS Press,
 Lagos, Nigeria, in 1998.]

Kasfir, Sidney Littlefield
 1984 "One Tribe, One Style? Paradigms in the
 Historiography of African Art." *History in Africa*
 11:163–193.

Lacan, Jacques
 1981 *The Four Fundamental Concepts of Psychoanalysis.*
 W. W. Norton & Co., New York.

Lawal, Babatunde
 1985 "Ori: The Significance of the Head in Yoruba
 Sculpture." *Journal of Anthropological Research*
 41(1):91–103.
 1996 *The Gèlèdé Spectacle: Art, Gender, and Social
 Harmony in an African Culture.* University of
 Washington Press, Seattle.
 2000 "ORILONISE: The Hermeneutics of the Head and
 Hairstyles among the Yoruba," in *Hair in African Art
 and Culture,* ed. Roy Sieber and Frank Herreman, pp.
 93–109. New York: Museum for African Art, New
 York; and Prestel, Munich, London, and New York.
 2001 "Àwòrán: Representing the Self and Its Metaphysical
 Other in Yoruba Art." *The Art Bulletin* 83(3):498–526.

Linebaugh, Peter
 1992 *The London Hanged: Crime and Civil Society in the Eighteenth Century.* Cambridge University Press, New York.

Makinde, M. Akin
 1985 "A Philosophical Analysis of the Yoruba Concepts of Ori and Human Destiny." *International Studies in Philosophy* 17(1):53–69.

Merback, Mitchell B.
 1999 *The Thief, the Cross and the Wheel: Pain and the Spectacle of Punishment in Medieval and Renaissance Europe.* University of Chicago Press, Chicago.

Merlo, Christian
 1975 "Statuettes of the Abiku Cult." *African Arts* 8(4) Summer:30 35, 84.

Mobolade, Timothy
 1973 "The Concept of Abiku." *African Arts* 7(1) Autumn:62–64.

Nora, Pierre
 1989 "Between Memory and History: *Les Lieux de Mémoire.*" *Representations* 26:7–25.

Odeka, Roli Hope
 2000 *Reviving Echo.* Minerva Press, London, 2000.

Ògúnfólákan, Adisa
 1990 "Luwo Potsherd Pavements in Ile-Ife," in *Nigeria: Thirty Years of Independence,* ed. Natalia B. Kochakova, pp. 87–93. Moscow Academy of Science, Institute of African Studies, Moscow.

Okediji, Moyo
 1991 "The Naked Truth: Nude Figures in Yoruba Art." *Journal of Black Studies* 22(1) September:30–44.

Okri, Ben
 1991 *The Famished Road.* Jonathan Cape, London.

Olómólà, Ìsòlà
 1991 "Alile: Traditional Security System Among the Yoruba." *Africana Marburgensia* 24(2):50–61.

Owomoyela, Oyekan
 1988 *A Kì í: Yorùbá Proscriptive and Prescriptive Proverbs.* University Press of America, Lanham, Md.

Peel, J. D. Y.
 1984 "Making History: The Past in the Ijesha Present." *Man* (New Series) 19:111–132.

 2000 *Religious Encounter and the Making of the Yoruba.* Indiana University Press, Bloomington.

Pinnock, S. G.
 1917 *The Romance of Missions in Nigeria.* Foreign Missionary Board, Southern Baptist Convention, Richmond, Virginia.

Price, H. L.
 1939 *Land Tenure in the Yoruba Provinces.* Government Printer, Lagos.

Puppi, Lionello
 1991 *Torment in Art: Pain, Violence and Martyrdom,* trans. Jeremy Scott. Rizzoli, New York.

Sartre, Jean-Paul
 1960 "The Other and His Look," in *To Freedom Condemned,* ed. Justin Treller. Philosophical Library, New York.
 1963 *Saint Genet: Actor & Martyr,* trans. Bernard Frechtman, Pantheon, New York.

Spierenburn, Pieter
 1984 *The Spectacle of Suffering: Executions and the Evolution of Repression.* Cambridge University Press, New York.

Strother, Zoe S.
 1998 *Inventing Masks: Agency and History in the Art of the Central Pende.* University of Chicago Press, Chicago and London.

Taylor, Charles
 1985 "Understanding and Ethnocentricity," in *Philosophy and the Human Sciences: Philosophical Papers,* vol. 2, pp. 116–133. Cambridge University Press, Cambridge.

Thompson, Robert Farris
 1969 "Abátan: A Master Potter of the Ègbádó Yorùbá," in *Tradition and Creativity in Tribal Art,* ed. Daniel P. Bieybuyck, pp. 120–182, plates 80–95. University of California Press, Berkeley and Los Angeles.
 1974a *African Art in Motion: Icon and Act.* University of California Press, Los Angeles.
 1974b "Yoruba Artistic Criticism." In *The Traditional Artist in African Societies,* ed. Warren L. d'Azevedo, pp. 18–61. Indiana University Press, Bloomington.
 1993 *Face of the Gods: Art and Altars of Africa and the African Americas.* The Museum for African Art, New York.

Verger, Pierre Fatumbi
 1967 "La societé egbé òrun des àbíkú, les enfants qui
 naissent pour mourir maintes fois." *Bulletin de
 l'IFAN,* serie B 30(4):1448–1487.

Willett, Frank
 1967 *Ife in the History of West African Sculpture.* McGraw-
 Hill, New York.

Yai, Olabiyi Babalola
 1994 "In praise of metonymy: The concepts of 'tradition'
 and 'creativity' in the transmission of Yoruba artistry
 over time and space," in *The Yoruba Artist: New
 Theoretical Perspectives on African Arts,* ed. Rowland
 Abíódún, Henry Drewal, and John Pemberton III,
 pp. 107–115. Smithsonian Institution Press,
 Washington, D.C.

Zizek, Slavoj
 1992 "In His Bold Gaze My Ruin is Writ Large," in
 *Everything You Always Wanted to Know About
 Hitchcock, but Were Afraid to Ask Lacan,* ed. Slavoj
 Zizek, pp. 211–272. Verso, London and New York.

The torchlight visit

Guiding the eye through late eighteenth- and early nineteenth-century antique sculpture galleries

CLAUDIA MATTOS

To admire this collection in its entire splendor one should have seen it by torchlight.
—*J. W. von Archenholz on the Pio-Clementine Museum*[1]

In the late eighteenth century, with the establishment of the first sculpture museums in Europe, a peculiar new practice emerged in the reception of sculpture, namely that of viewing statues by torchlight. From the 1780s on, we find descriptions of these visits to the two most important museums of antiquity in Rome, the Pio-Clementine Museum and the Capitoline Museum, in the diaries of travelers on the Grand Tour.[2] In 1787, for instance, Goethe commented on a visit he made to the Capitoline in the company of his friend Heinrich Meyer.[3] Similar descriptions can be found in the writings of Karl Philipp Moritz, Johann Gottfried Herder, Johann Wilhelm von Archenholz, Stendahl, Madame de Staël, and many others during their stay in Italy. Although the practice was popular for several decades, it fell into disuse after the mid-nineteenth century. Its brief lifespan suggests that it served a very specific function in this period, related to the history of the reception of sculpture in the late eighteenth and early nineteenth centuries, when sculpture was just beginning to assert its position as an autonomous form of art. In the present article I shall analyze the relation between the torchlight visit and the development of new modes of viewing art in the museum. I will also examine the role played by torchlight in the reorganization of the baroque exhibition space in galleries and museums dedicated to

sculpture, before a new museological model emerged in the nineteenth century, which favored individualized attention to each work of art.[4]

Since Oskar Bätschmann's influential article "Pygmalion als Betrachter" (Pygmalion as beholder),[5] historians have related the practice of night visits to museums in the late eighteenth century to the new aesthetic theories of Felix Mendelssohn, Edmund Burke, Denis Diderot, and others, which inspired a new generation of German theoreticians such as Herder, Goethe, and Moritz.[6] In his article, Bätschmann

1. "Um diese Sammlung in ihrem Ganze zu bewundern, muss man sie bei Fackeln besehen," Johann Wilhelm von Archenholz, *Rom und Neapel 1787* (Heidelberg: Manutus, 1990), p. 108.

2. The literature on the Grand Tour in Italy is extensive and has grown considerably in the last few years. For a good introduction to the subject in the eighteenth century, see the exhibition catalogue by Andrew Wilton and Ilaria Bignamini, *Grand Tour: The Lure of Italy in the Eighteenth Century* (London: Tate Gallery, 1996).

3. Goethe was in fact enthusiastic about the practice of torch viewing and planned to write an essay on the theme for the *Propyläen*, but unfortunately he never did. See Herbert von Einem and Hans Joachim Schimpf's notes to the text "Über Laocoön" in *Goethe Werke,* Erich Trunz, ed., Hamburger ed., vol. 12 (Munich: Beck Verlag, 1982), p. 600.

4. The period here in question corresponds to the birth of the museum as a public institution dedicated to the preservation of the material heritage of a country and to the construction of its national identity. By the beginning of the nineteenth century, in part as a consequence of the confiscation of works of art in Italy during the Napoleonic invasion, an international debate arose on the subject of patrimony, involving such important figures as Quatremère de Quincy, Giovanni Battista Visconti, and the sculptor Antonio Canova. This European debate was preceded by the critical work of Lafont de Saint-Yenne who, in the mid-eighteenth century, lobbied for the establishment of a public museum in France as a means of developing the *bon goût*, which meant the appreciation of history painting by the general public. The present discussion should be seen in relation to this wider discourse concerning the birth of the museum institution. On the history of the museum, see Edouard Pomier, "La naissance des musées," in Thomas Gaehtgens and Krzysztof Pomian, eds., *Le XVIIIe siècle* (Paris: Seuil, 1998), pp. 91–94, and also Daniel J. Grange and Dominique Poulot, *L'Esprit des lieux. Le patrimoine et la cité* (Grenoble: Presses Universitaires de Grenoble, 1997).

5. Oskar Bätschmann, "Pygmalion als Betrachter. Die Rezeption von Plastik und Malerei in der zweiten Hälfte des 18. Jahrhunderts," in Wolfgang Kemp, ed., *Der Betrachter ist im Bild. Kunstwissenschaft und Rezeptionsästhetik* (Berlin: Dietrich Reimer Verlag, 1992), pp. 237–278.

6. The present article does not address directly the aesthetic and philosophical implications of the practice, since it was already well explored by previous literature on the subject. In addition to Bätschmann's article cited above, the following texts are especially pertinent: Oskar Bätschmann, "Belebung durch Betrachtung: Pygmalion als Modell der Kunstrezeption," in Mathias Mayer and Gehard Neumann, eds., *Pygmalion Die Geschichte des Mythos in der abendländischen Kultur* (Freiburg im Breisgau: Rombach, 1997), pp. 325–370 and Michael Diers, "Nach-Lebende Bilder. Praxisformen klassizistischer Kunsttheorie," in Dieter Burdorf and Wolfgang Schweickard, eds., *Die Schöne Verwirrung der Phantasie. Antike Mythologie in Literatur und Kunst um 1800* (Tübingen: Francke Verlag,

associates the practice of night visits to museums with other forms of aesthetic delectation, such as *tableaux-vivants*,[7] Lady Hamilton's *attitudes*,[8] and similar performances, which sought to "bring the picture to life." He interprets these impersonations as practical counterparts of the newly emerging aesthetic theories that saw art primarily as an aspect of illusion (*Täuschung*) and emphasized the role of imagination (*Einbildungskraft*) in reception. In short, these theories saw the imagination as "completing" the work of art, turning it into something truly "alive" for the beholder.[9] This *topos* can be traced to the descriptions Pliny gives of Zeuxis's art in his *Natural History* (Book XXXV, 66) and recurs frequently in the historiography of art. Giorgio Vasari used this topos repeatedly in the descriptions he gave of works in *The Lives of the Artists*,[10] and the tradition survived throughout the centuries, becoming a standard part of academic theory. However, as Bätschmann shows, this *topos* gained renewed vitality in the eighteenth century through the innovative idea that the beholder had an important role to play in the construction of the work of art as such. To this end, the use of torchlight in the process of viewing statues as well as the theatrical effects of the *tableaux vivants* and the *attitudes* served as stimuli to the imagination. In fact, some reports concerning the observation of statues by torchlight talk about the experience of seeing them "coming to life." Herder, for example, wrote a brief

poem on the theme, in which he described the torch's flame as possessing such a vivifying power:

> O welchen Schatz des Holden und des Guten
> Hast Du, o Kunst, in manchen Stein gesenkt!
> Wie quillt's hervor, wenn mit den Flammengluten
> Den todten Stein die Lebensfackel tränkt![11]

The myth of Pygmalion, which describes the passion of a sculptor for his own statue, *Galatea*, and its transformation into a real woman through the intervention of Venus, served as a perfect metaphor for this new aesthetic practice, becoming a popular subject for artists of the period.[12] As the title of his article suggests, Bätschmann treats the torchlight visit through this perspective. He also makes little differentiation between genres, proposing a logical continuity between the ways of looking at paintings and statues at the time, despite contemporary concern with and reflection on the specificity of painting when compared to sculpture.[13] The implications for the history of sculpture and the forms of exhibiting them in the museum are our main concern here. This article focuses on the period when such nocturnal visits to museums became widespread. At the time, a reorientation in the traditional modes of display had taken place in order to better serve the new ideas about art in general and about sculpture (especially antique sculpture) in particular. I suggest torchlight played an important role in the transition between successive ways of organizing the exhibition space in collections of sculpture, and once the transition had been made, the practice rapidly fell into disuse.

Because this article traces the historical development of conventions of sculptural display from the late eighteenth to the early nineteenth centuries, it is necessary to mention the status of sculpture at the time. As we shall see in more detail, during the baroque

1998), pp. 175–185. Horst Bredekamp, "Antikensehnsucht und Maschinenglauben," in Herbert Beck and Peter Bol, eds., *Forschungen zur Villa Albani. Antike Kunst und die Epoche der Aufklärung* (Berlin: Mann, 1982), pp. 507–559.

7. The *tableau vivant* was a hybrid kind of art genre situated between painting and theater in which a historical painting was staged and its action developed by the actors to its final outcome. The genre became especially popular after the staging of Jacques-Louis David's *The Lictors Returning to Brutus the Bodies of his Sons* before the presentation of Voltaire's *Brutus* in 1791. Bätschmann (see note 6), p. 354.

8. Emma Hamilton, a young beauty married to the diplomat and antiquarian William Hamilton, became famous in all Europe for her performances, in which she would dress and take the pose of an antique statue (*Venus*, Niobe, etc.), then starting to move as if the statue was coming into life. These performances were seen and admired by many intellectuals and artists of the time, such as Goethe, Herder, Wilhelm Tischbein, and Angelika Kauffmann. On the subject, see Ulrike Ittershagen, "Lady Hamiltons Attitüde" (Ph.D. diss., Ruhr-Universität, Bochum, 1996) and August Langer, "Attitude und Tableau in der Goethezeit," in *Jahrbuch der deutschen Schillergesellschaft* 12 (1968):194–258.

9. Bätschmann (see note 5).

10. Giorgio Vasari, *The Lives of the Artists,* trans. George Bull, 3d ed. (London: Penguin Classics, 1987),vol. 1.

11. Herder, as quoted in Diers (see note 6), p. 183.

12. Mayer and Neumann (see note 6).

13. Discussions about the differences between artistic media can be traced back to the Renaissance, where it expressed itself most emphatically in the dispute [*paragone*] between painting and sculpture. Nonetheless, the debate on the specific qualities of each art took a new impulse with the appearance of theories of reception in the eighteenth century, especially after the publication of Lessing's *Laocoön* in 1766. In 1780, when delivering in the Royal Academy his tenth discourse dedicated to sculpture, Reynolds also remarked on the specific peculiarities of genres concerning painting and sculpture: "I wish now to make some remarks with particular relation to Sculpture; to consider wherein, or in what manner, its principles and those of Painting agree or differ." This remark points to the importance of the subject to the academic tradition. See Sir Joshua Reynolds, *Discourses,* ed. Pat Rogers (London: Penguin Classics, 1992), p. 232.

period, sculpture (more than painting) lost much of its autonomy as an art object that it had gained during the Renaissance: It was increasingly used for religious or representative ends. In the eighteenth century, sculpture regained (in more radical form) its autonomous status as pure aesthetic object largely under the influence of Winckelmann, who established a history of the styles of antique sculpture and opened the way to what we now call Neoclassicism. Thus, the autonomization of sculpture was preceded by the recognition of the artistic value of antique sculpture. It was only in the last decade of the eighteenth century with the emergence of Antonio Canova in the Roman art world that the same autonomy was accorded to modern sculpture.[14] In fact, the museums founded in the eighteenth century were still, in essence, museums of antique art. It was in these museums dedicated to classical antiquity, therefore, that new forms of viewing sculpture initially took place.[15]

Beholding antique sculpture in the baroque galleries

Though collections of antiquities can be traced back to the beginning of the Renaissance, in the sixteenth century their display underwent a structural change as they began to be incorporated into large decorative programs designed to reinforce the noble origins of principal Roman families.[16] One of the first examples of this new usage of antique art was the decoration of the Villa Giulia, built for Pope Julius III by Vignola and Bartolomeo Ammanati. Bartolomeo Ammanati himself declared that the building was conceived as a theater where, for the first time, antique statues were integrated into a wider program including paintings and other decorative objects, all arranged according to a single principle.[17] The adoption of this decorative principle by Francis I in his castle at Fontainebleau in 1540 contributed greatly to its success, and in subsequent decades the use of antique statues within ostentatious programs was applied to the residences of many important families in Italy and elsewhere in Europe. One of the most impressive examples was the decoration of the Farnese Palace in Rome, where freestanding sculptures, busts, and fresco paintings were combined to celebrate the marriage of Ranuccio Farnese with Margherita Aldobrandini under the mythological theme of celestial and earthly love.[18] Similar schemes were also used in the palaces of the Mattei family, the Medici, the Pamphili, and several others.

By the seventeenth century, this mode of "exhibiting" antique statues was an established tradition that invited a specific manner of viewing. The privileged visitor who entered these seventeenth-century palaces read the decoration as a whole, associating its different elements with one another. Such viewing did not encourage close examination of specific statues on display. In Liebenwein's words, "the statues revealed themselves to the beholder through a global view, centered in one or few fixed points of reference."[19] There was little space

14. It is, therefore, no coincidence that Canova's *Perseus* was chosen to occupy the place left by the *Apollo Belvedere*, when the latter was confiscated by Napoleon's troops and taken to Paris in 1796. On the episode, see Antonio Pinelli, "La sfida rispettosa di Antonio Canova. Genesi e peripezie del 'Perseo trionfante,'" in *Ricerche di Storia dell'Arte*, vols. 13–14 of *Il Neoclassicismo tra rivoluzione e restaurazione* (Roma: La Nuova Italia Scientifica, 1981), pp. 21–39 and Christopher Johns, *Antonio Canova and the Politics of Patronage in Revolutionary and Napoleonic Europe* (Berkeley, Los Angeles, London: University of California Press, 1998).

15. In the nineteenth century, when the practice of viewing statues by torchlight became fashionable in France, it began to be applied to visits to other museums also. A picture painted in 1848 by Auguste Vinchon, today in the Musée National in Versailles, shows, for instance, a night visit by Louis Philippe and his company to the Galérie de Pierre, in order to observe a statue of Joan of Arc by torchlight.

16. Before the sixteenth century, antique art was used to construct a *locus amoenus* for the study of antique literature. This was certainly the case of the first known collection of antiquities, established by Poggio Bacciolini in 1440, and very probably the intention of Julius II when, in 1506, he commissioned Bramante to build the Belvedere gardens, in which antique statues were placed between orange trees. For a brief history of art collections in Italy, see Wolfgang Liebenwein, "Die Villa Albani und die Geschichte der Kunstsammlung," in Beck and Bol (see note 6), pp. 462–506. Early antique collections of similar nature also existed in the palaces of noble Italian families of the time, such as the Medici in Florence who, according to Vasari, decorated their residence with antique art under Donatello's guidance: "Et egli [Donate] fu potissima cagione che a Cosimo de'Medici si destasse la voluntà dell' introdurre a Fiorenza la antichità, che sono et erano in casa Medici, le quali tutte da sua mano acconciò." Giorgio Vasari, *Le Vite* (Rome: Newton Compton, 1993), p. 358. ("And it was largely because of him [Donatello] that Cosimo de' Medici grew ambitious to introduce to Florence the antiquities which are still in the house of the Medici, all of which he restored with his own hand" [see note 10], p. 186.)

17. For Bartolomeo Ammanati's declaration, see Liebenwein (note 16). Ammanati was probably inspired by Michelangelo's unrealized plans for the decoration of the Villa Farnese (where the whole ensemble was submitted to the myth of Hercules) and his great "staging" of the equestrian statue of Marcus Aurelius at the Campidoglio.

18. For a detailed analysis of this decorative program, see Alfons Reckermann, *Amor Mutuus. Annibale Carraccis Galleria-Farnese-Fresken und das Bild-Denken der Renaissance* (Cologne and Vienna: Böhlau, 1991).

19. "Die Skulpturen erschließen sich dem Betrachter in einer Gesamtschau, die auf einem oder doch nur wenige feste Punkte bezogen ist." Liebenwein (see note 16), p. 471.

left for appreciation of individual works apart from the context of the decorative program.[20]

The integration of antique sculpture into large decorative schemes in the baroque period is particularly evident in the restoration practices of the time. Antique fragments were often restored to serve a certain symbolic purpose, alluding overtly to the name and deeds of their owners. Bernini's famous restoration in the Villa Borghese of an antique fragment of a horse as Marcus Curtius, the hero who threw himself into the chasm at the Forum to save the city of Rome, was an allusion to Cardinal Scipione Borghese's visit to the victims of the Tiber flood on the embankments in 1606. The restored sculpture was placed on the outside wall of the Villa, where it stood until at least 1776, as a statement of the patriotic courage and benevolence of the Borghese. Bernini restored the Ludovisi Mars in the same spirit, adding a little cupid at the feet of Mars, alluding to the powers of love over war.[21] An even more striking example of such usage of antique art is given by Algardi's 1630 "restoration"—more appropriately, "transformation"—of an antique torso of an emperor as a portrait of Carlo Barberini, the brother of Pope Urban VIII. As Jennifer Montagu notes, this procedure, not uncommon for the time, represented "an assimilation of the modern hero to his ancient prototype, an incorporation of the glory and valor of these Roman generals and emperors into their later descendants, quite as effectively, if rather more literally than those paintings glorifying contemporary rulers in the guise of an ancient hero or god."[22]

Another practice associated with the introduction of antique sculpture into wider, unified iconographical programs was the scraping and polishing of the surface of the statues in order to harmonize them with modern counterparts. Algardi undertook this practice in his restoring of antique sculptures with the approval of Giovanni Pietro Bellori.[23] Commenting on the practice

some centuries later, Jacob Burckhardt lamented that in such collections as those of the Farnese and the Medici, antique statues were "unfortunately . . . associated with a finishing and polishing of the whole in order to attempt to harmonize its parts with new elements."[24]

In seventeenth-century Italy, therefore, large sculptures were intended to be seen not as individual objects in their own right, but as part of larger display programs shown in great representative rooms or in the gardens of the luxurious palaces.[25] Of course, as Haskell and Penny point out, there were already some statues, such as the Laocoön, the Torso, and the Apollo, located in the Vatican collection, that were independently admired for their exceptional beauty and quality. However, after a period of a relatively easy access to the Belvedere—the period which certainly contributed greatly to its fame—the works were removed from exhibition in 1566 by the order of Pope Pius V and were not returned until the eighteenth century.[26] As a result, paradoxically, the artistic quality of these works was appreciated during the baroque period through prints and casts, and although the utility of their concetto as models for contemporary art was widely acknowledged, the sculptures themselves had little impact on the public's understanding of antique originals in the gallery context.

New requirements for viewing the antique: Winckelmann and the gallery in transformation

This state of affairs changed in the eighteenth century, but not as quickly as we usually think. From the turn of the century, there was an increasingly widespread interest in antiquity, expressed through the development of antiquarian studies, which slowly positioned antique statuary at the center of discussions about classical heritage. Such antiquarians as Comte de Caylus, Pierre Jean Mariette, and Jean-Jacques Barthélèmy made initial

20. There were, in fact, specific spaces in the Roman palaces where detailed observation of antique statues did occur. Sculptures were admired in conjunction with other kinds of antique objects, such as precious cameos and coins in private "art cabinets." These works were, however, mostly small statuettes, suited for close examination and manipulation by hand. Large-size sculptures did not have a place in such cabinets.

21. Orietta Rossi Pinelli, "Scultura antica e restauri storici," in Salvatore Sattis, ed., Memoria dell'antico nell'arte italiana, vol. 3 (Turin: Einaudi, 1986), especially pp. 221–226.

22. Jennifer Montagu, Roman Baroque Sculpture. The industry of art, 2nd ed. (New Haven and London: Yale University Press, 1992), p. 157.

23. Pinelli (see note 21), p. 224.

24. "leider . . . mit der Überarbeitung und Glättung des ganzen Werkes verbunden, welches man mit den neuen Zuthaten in Harmonie bringen wollte." Jacob Burckhardt, Cicerone, as quoted in Ulrike Kaspar Müller, "Das sogenannte Falsche am Echten. Antikenergänzungen im spaäen 18. Jahrhundert in Rom," (Ph.D. diss., Universität Bonn; 1988), p. 22.

25. The Villa Borghese seems to have been a partial exception here, since the display of the collection aimed to establish a competition [paragone] between antique and modern art as well as between painting and sculpture. However, to some extent, this was also a "program" that united the whole collection. Liebenwein (see note 16).

26. Francis Haskell and Nicholas Penny, Taste and the Antique, 5th ed. (New Haven and London: Yale University Press, 1998), p. 14.

attempts to organize antique art into chronological periods, while paying unprecedented attention to individual sculptures.[27] However, the definitive step towards a new approach to antique sculpture was made by Winckelmann who established the aesthetic categories of Greek art. He organized classical sculpture according to style, giving an account of its historical development from an initial primitivism to perfection and subsequent decadence.[28] He paralleled these aesthetic developments with a discussion of the highest moral and ethical values of classical antiquity. This analysis established descriptions [*Beschreibungen*] of surviving Greek statues, which Winckelmann instituted as his principal method of investigation, the privileged path of access to antique values, considered lost to modernity. In this way, Winckelmann transformed formal description of classical sculpture into instruments for the interpretation of the work.[29]

In describing his method, Winckelmann inaugurated a new type of gaze, which was not distracted and relational, as it had been before, but focused and inquisitive. Commenting on Winckelmann's role as *cicerone* in Rome, Adelheid Müller draws attention to this important shift: "With Winckelmann's appearance in the context of the eighteenth century travels, new patterns of ideal perception were established. In the foreground was set the sensorial experience of what is seen, which he had captured in his famous descriptions of the statues in the Belvedere."[30] In Winckelmann's

ideal gallery, therefore, Greek sculpture would not be blended in with other elements of comprehensive decorative program, but relate only to its own history, a history tied to the evolution of ethics and morality in antiquity, which were in turn related to the political and climatic conditions of classical Greece. A detailed investigation of each work would enable the beholder to establish its relative position in the greater historical development of classical art and determine its relative aesthetic and moral values.

I would like to emphasize that verbal descriptions of artworks (ecphrasis) were a central part of the historiography of art since antiquity. Ecphrasis was, in fact, the practical counterpart of the famous dictum of Horace—*ut pictura poesis*—which theorized an unproblematic translation between visual and literary media.[31] According to this tradition, the picture or statue (or a whole artistic program) was a stimulus for literary discourse. The discourse actually "erased" the formal qualities of the image in order to "bring to life" the represented scene before the eyes of the spectator.[32] The image worked pretty much as a memory aid, something to punctuate the discourse and recall its argument to the spectator.[33] This substitution of discourse for the image formed the basic logic of the installation of statues in the baroque galleries, where the discourse referenced the accomplishments and heritage of their owners.

27. For a discussion about the antiquary environment and their methods before Winckelmann, see Alex Potts, "Winckelmann's Interpretation of the History of Ancient Art in its Eighteenth Century Context" (Ph.D.diss., Warburg Institute, University of London, 1978).

28. Winckelmann describes four styles of Greek art: "primitive" [*primitiv*], "sublime" [*erhaben*], "beautiful" [*schön*], and "imitative" [*nachahmend*]. See Johann Joachim Winckelmann, *Geschichte der Kunst des Altertums* (Darmstadt: Wissenschaftliche Buchgesellschaft, 1993), p. 207. In *Flesh and the Ideal*, Alex Potts points to the important fact that Winckelmann described two equally "perfect" styles, the "sublime" and the "beautiful." For the first time in the historiography of art, the matter was not only to describe the evolution of art from a primitive state to its inevitable decadence—what Vasari had already attempted with the *Lives*—but to create criteria for judgment that would permit the articulation of a discourse about varying forms within the same chronological period. Alex Potts, *Flesh and the Ideal. Winckelmann and the Origin of Art History* (New Haven and London: Yale University Press, 1994), p. 75.

29. "The description of a statue must demonstrate the causes of its beauty . . ." ("Die Beschreibung einer Statue soll die Ursache der Schönheit derselben beweisen . . ."). Winckelmann (see note 28), p. 10.

30. "Mit dem Erscheinen Winckelmanns im Reisegeschehen des 18. Jahrhunderts waren neue ideelle Wahrnehmungsmaßstäbe gesetzt worden. . . . In den Vordergrund trat das sinnenhafte Erfahren des Gesehenen, das er in seinen vielgerühmten Beschreibungen der

Statuen vom Belvedere schriftlich gefaßt hatte." Adelheid Müller, "Winckelmann als Cicerone," in *Römische Antikensammlungen im 18. Jahrhundert*, exh. cat. (Stendal: Winckelmann Museum, 1998), p. 163.

31. The unproblematic translation between poetry and painting was not the original meaning of Horace's famous phrase, but came to be interpreted in this way within art critical tradition. In fact, the *ut pictura poesis* appears in the *Ars Poetica* (verse 361) as part of Horace's analysis of critical judgment. Horace used the comparison with painting to illustrate the different expectations that a critic should have when judging an epic discourse or a short text to be read with close scrutiny. In his view, the first type of discourse should be judged in its general effect, as we judge those paintings made to be viewed from a distance, while the second type should be judged in the same way as those paintings that need to be seen very close up. The comparison between rhetorical style and the visual arts was, in fact, commonplace in antiquity, finding a precedent already in Aristotle's *Rhetoric*. Horace, therefore, had no explicit intention of discussing the relationship between the natures of poetry and painting. On this subject, see Rensselaer W. Lee, *Ut Pictura Poesis. The Humanistic Theory of Painting* (New York: W. W. Norton, 1967). See also Wesley Trimpi, "Horace's Ut Pictura Poesis," *Journal of the Warburg and Courtauld Institutes*, 36 (1973):1–34.

32. A radical example of this use of the ecphrasis can be seen in Diderot's descriptions of pictures in the Salons, especially his description of a landscape by Joseph Vernet in the 1763 Salon.

33. See Francis Yates, *The Art of Memory* (Chicago: University of Chicago Press, 1984).

Although working inside the ecphrastic tradition, Winckelmann's descriptions are of a significantly different nature. He never entirely passes from the image to the literary discourse but stays *between* them, basing his interpretation on an accumulation of details, each of which might suggest an independent commentary, without ever wholly absorbing him. This procedure is clear in his famous description of the Belvedere Torso: "In the powerful contours of this body I see the invincible force of the conqueror of the mighty giants who rebelled against the gods and were laid low by him in the fields of Phlegrea; and at the same time the soft features of this outline, which make the edifice of the body light and pliable, place before me the swift turns of his fight with Achelous, who, despite all his various forms, could not escape the hero's hand. Every part of this body reveals, as in a painting, the entire hero in a particular deed; and here one sees the use for which deed every part has served, just as one sees the suitable purposes in the rational construction of a palace."[34] According to Winckelmann, therefore, one has to look attentively at every detail in order to grasp the intention of the artist in its entirety. The literary description of the hero's deeds is a gradual construction of his moral character through attention to meaningful formal details.[35] This new attitude privileged the understanding of sculptures as autonomous works of art by relating them exclusively to other classical sculptures and suppressing any attempts to integrate them with paintings or other decorative objects.

The display of antique statues as an integral part of the decorative programs of baroque art galleries did not support Winckelmann's innovative mode of viewing the sculpture as an independent work of art. Instead, the beholder was called upon to establish relations among sculptures, paintings, and other objects present in the gallery rooms, which were displayed in such a way as to form a coherent unity with a clear message. This traditional mode of displaying art was well established. Even the first museums of the eighteenth century, the Capitoline and Pio-Clementine museums in Rome, followed this method, in spite of the growing popularity of Winckelmann's innovative approach. In an essay on the Pio-Clementine, Hans Steuben wrote: "As a 'type' of collection, the gallery followed the Roman palaces that since the sixteenth century were garnished with sculpture galleries in accordance with the French model. . . . Winckelmann's developmental historical thinking could not assert itself in the face of this powerful tradition."[36]

A detailed study undertaken by Elisabeth Schröter equally shows that even the Villa Albani, built by Cardinal Alessandro Albani and inaugurated in 1765,[37] was decorated with a unified program in conformity with the baroque tradition: "The observation of antique statues in the gallery . . . showed, therefore, that they relate thematically and in their organization to the ideas presented in the upper levels in the fresco program. Taken individually, they developed, commented, and added to this program. The gallery decoration, thus, presents itself as a homogenous totality, in which no detail is casual or arbitrary."[38] There was, therefore, a disparity between the new ideas about antique sculpture

34. "Ich sehe in den mächtigen Umrissen dieses Leibes die unüberwundene Kraft der gewaltigen Riesen, die sich wider der Götter empöreten, und in den phlegräischen Feldern von ihm erleget wurden: und zugleicher Zeit stellen mir die sanften Züge dieser Umrisse, die das Gebäude des Leibes leicht und gelenksam machen, die geschwinden Wendungen desselben in dem Kampfe mit dem Achelous vor, der mit vielförmigen Verwandlungen seinen Händen nicht entgehen konnte. In jedem Theil dieses Körpers offenbaret sich, wie in einem Gemählde, der ganze Held in einer besondern That, und man sieht, so wie die richtigen Absichten, in dem vernünftigen Baue eines Pallastes, hier den Gebrauch, zu welcher That ein jedes Theil gedienet hat." Johann Joachim Winckelmann, "Beschreibung des Torso im Belvedere zu Rom," in Helmut Pfotenhauer and Norbert Miller, eds., *Früh-Klassizismus. Position und Oposition: Winckelmann, Mengs, Heinse* (Frankfurt: Deutsche Klassiker Verlag, 1995), p. 176. For an English translation, see J. J. Winckelmann, *Essays on the Philosophy and History of Art,* vol. 1, ed. Curtis Bowman (Bristol: Thoemmes Press, 2001), pp. xiv–xv.

35. On Winckelmann's ecphrasis, see Helmut Pfotenhauer, "Winckelmann und Heinse. Die Typen der Beschreibungskunst im 18. Jahrhundert oder die Geburt der neueren Kunstgeschichte," in Gottfried Boehm and Helmut Pfotenhauer, eds., *Beschreibungskunst— Kunstbeschreibung* (Munich: W. Fink, 1995), pp. 314–340.

36. "Als Sammiungstypus folgt die Galerie wieder den römischen Pälasten, die seit dem 16, Jahrhundert nach französischen Vorbild mit statuengeschmückten Galerien ausgestattet waren . . . Gegen diese mächtige Traditon hat sich der ehtwicklungsgeschichtliche Gedanke Winckelmanns nicht durchsetzen können." Hans Steuben, "Das Museo Pio-Clementino," in Herbert Beck et al., eds., *Römische Antikensammlungen im 18. Jahrhundert* (Berlin: Mann, 1981), pp. 154–155.

37. In 1765, Winckelmann was still part of Cardinal Albani's household, serving him as a librarian and a counsellor on antiquity issues.

38. "Die Betrachtung der Antiken in der Galerie . . . hat also gezeigt, daß sie sich in ihrer Thematik und Anordnung auf die Ideen des übergeordneten Freskenprogramms beziehen und diese im einzelnen auf einer anderen Bildebene fortführen, kommentieren, ergänzen. Die Ausstattung der Galerie stellt sich damit in allen ihren Teilen als ein inhaltlich homogenes Ganzes heraus, in dem kein Detail zufällig oder wahllos ist" Elisabeth Schröter, "Die Villa Albani als Imago Mundi," in Beck and Bol (see note 6), p. 281.

as discussed by Winckelmann and contemporary exhibition practice, which depended upon earlier conventions. These were the circumstances that led to the adoption of the old atelier custom of studying statues by torchlight in the museum and a novel form of viewing sculpture.

Although complex torchlight arrangements had been used previously in baroque galleries and palaces during banquets and religious festivities, they emphasized the spectacular dimension of the social event. It is reasonable to argue that much of the importance of light as a dramatic element in baroque sculpture and painting is directly related to these spectacles.[39] Even so, these settings were the backdrops for social events and the full decorative program was still the context for viewing. It is, therefore, necessary to look elsewhere for the origin of the use of torchlight in a reception context that isolated the artwork rather than blended it into a greater unity.

The search for new patterns of viewing: Observations on the origin of the torchlight visits

Long before its introduction in the late eighteenth century as a means of beholding statues in the gallery context,[40] torchlight was already used in the ateliers and academies of art as a technique for capturing the distribution of light and shade on the model. Since the Renaissance, an important body of iconographical material leading uninterruptedly from the Accademia of Baccio Bandinelli (1493–1560) to the end of the nineteenth century, testifies to the use of artificial light in the theory and practice of painting, specifically in

relation to discussions of techniques of distributing light and shade in pictures.[41]

The habit of executing small models to be illuminated by candlelight as a means of controlling the play of light and shadow on the figures to be painted was in fact already established in the sixteenth century. Vasari tells us that Michelangelo worked from such models and that Jacobo Sansovino produced a series of them for other painters of the period.[42] Carlo Ridolfi affirmed in his Le Meraviglie dell'Arte that Tintoretto used small wax models made by Danielle de Volterra from antique sarcophagi in the Medici collection.[43] As Kaufmann showed, in the seventeenth century the practical methods of guaranteeing a coherent distribution of light and shade in complex pictorial compositions acquired a mathematical formulation and were "assimilated into art theory alongside perspective" under the concept of sciography.[44] However, training of students in the academies continued to involve the study of light distribution on the sculptural model illuminated by torchlight. At the end of the eighteenth century, this traditional method for training the hand and the eye was still very much alive. In an article on "Light and Shade in French Classicism," J. J. L. Whiteley argued that drawing by torchlight actually experienced a revival in

39. Jennifer Montagu writes in this respect: "It has become a commonplace of art history to point out how the light effects of these ephemeral displays recur in the permanent art of baroque Rome." Montagu (see note 22), p. 178.

40. Horst Bredekamp opens his article "Antikensehnsucht und Maschinenglauben" with a reference to nocturnal torchlight visits to the galleries in the Villa Albani, without, however, mentioning his source (see note 6). Although it is tempting to think that these visits to the heart of the collection supervised by Winckelmann himself actually happened, unfortunately I have been unable to find any supportive documentary evidence, neither in Bredekamp's nor in Winckelmann's writings, nor in the documents and literature about the Villa Albani. Bredekamp also refers to an anecdote told by Cellini about the presentation of one of his statues by torchlight in the galleries of Francois I at Fontainebleau; however, as Whiteley comments, this episode was probably caused by a delay in the ceremony and Cellini apparently did not foresee the positive effects that such illumination would have on his work. J. J. L. Whiteley, "Light and Shade in French Neo-Classicism," The Burlington Magazine 117 (1975):768–773.

41. Most historians addressing the theme of artificial light in viewing art do not differentiate between this iconography and the one directly related to the viewing of statues under torchlight, even though they are different in nature. As we shall see, the use of torchlight in the academy relates more directly to the practice of painting, while the museum visits are above all associated with forms of viewing sculpture.

42. Giorgio Vasari, Le Vite, as cited in Thomas DaCosta Kaufmann, "The Perspective of Shadows: The History of the Shadow Projection," Journal of the Warburg and Courtauld Institutes, 38 (1975):258–287.

43. Carlo Ridolfi, Le Meraviglie dell'Arte (1648) as cited in Kaufmann (see note 42). According to his biographers Giovanni Pietro Bellori and Joachim von Sandrart, Nicolas Poussin built small sceneries for the purpose of studying the effects of light and shadow on the figures when illuminated by candlelight. See Anthony Blunt, Poussin (London: Pallas Athene, 1995), pp. 241–247 and Claire Pace, Félibien's Life of Poussin (London: A. Zwemmer, 1981).

44. According to Baxandall's definition, "Sciograpy, a sub-branch of linear perspective, is the representation in two dimensions of the calculated forms of (almost exclusively) projected shadows." Michael Baxandall, Shadows and Enlightenment (New Haven and London: Yale University Press, 1995), p. 84. In reality, the mathematical method initially introduced by Abraham Bosse in the French Academy never totally substituted for the practical methods of observation. Charles LeBrun did not trust Bosse's method, and after their disagreement became public in 1661, LeBrun finally managed to expel Bosse from the Academy. On academic methods of teaching and on the debate about perspective in the French Academy, see Carl Goldstein, Teaching Art. Academies and Schools from Vasari to Albers (Cambridge: Cambridge University Press, 1996).

the academies of the late eighteenth century, when artists started to show an outstanding interest in the contrast of light and shade in painting.[45] In these nocturnal drawing sessions, the hand was frequently trained on casts of the most famous statues of antiquity, as we can see in a painting by Johann Zoffany, which depicts a room at the Royal Academy filled with students drawing after the great masterpieces of antique sculpture by artificial light. According to Whiteley, ". . . the cast was studied by artificial light to give the student a mastery of chiaroscuro but it also ensured that pupils, before working from the life were capable of seeing the living model through the experience of antique sculpture so that sculptural figures and groups provided a repertory of form which recur throughout the period."[46]

Although the intended effect of torchlight in the museum was quite different from that sought in the academies and ateliers, one can imagine that the use of artificial lighting in nocturnal drawing sessions in the academies might have opened the way to its later use in the museum. A 1769 picture by Wright of Derby, *The Academy by Torchlight,* shows a group of young men clustered around a copy of the antique statue *Nymph with a Shell.* It suggests a possible link between the two distinct practices. In the foreground of the picture we see a nicely dressed gentleman drawing the statue attentively with black-and-white chalk on blue paper. Next to him is a boy with his portfolio, looking as if he has just finished his own work and is waiting for his friends to complete their task. Both figures clearly represent the relation between an artist and his model, which was well established in academic teaching. However, at the left side of the picture another gentleman stands with a different attitude. He is not working and has no paper or pencil but is simply gazing at the Nymph with dreamy eyes. Lost in his contemplation, he is pictured as a Pygmalion—an observer in love with his statue—an impression that is reinforced by the Nymph's position, which seems to "come to life" in response to his affection. Here, Wright of Derby places side by side the two different uses of torchlight in the period, thus indicating that at least he saw them as somehow related.

The transition between the use of torchlight in academic teaching and its use in the museum can be related, as we said, to Winckelmann. His novel attitudes regarding reception of works of art were disseminated not only through his writings, but also through his activities as *cicerone* in Rome. Serving as a guide to noble visitors in their passage through the city was part of Winckelmann's obligations as superintendent of antiquities in the Vatican, and his letters are full of references to this occupation.[47] Although the activity of *cicerone* was well established in Rome, Winckelmann's way of guiding his pupils through the Roman galleries was different. Instead of reciting information learned by heart on each piece of work, as was the usual practice among *ciceroni*,[48] he focussed on direct and personal involvement with the original works of art exposed in the galleries, expressing his particular aesthetic experience in an outburst of emotion. An eyewitness to a visit Winckelmann undertook with Johann Jacob Volkmann to the Vatican Museum gives us a good picture of what these enthusiastic commentaries sounded like to the unaware public: "The papal guards stood there with open mouths completely astonished and maybe thought that the malaria had disturbed his brains."[49]

45. "The late eighteenth century interest in the art of outline engraving has influenced definitions of neo-classic art in general as flat and linear. . . . However, the opposite phenomenon of depth, treated with an exaggerated attention to the contrast of light and shade, was not only characteristic of art in the same period, inspired also by classical sources, but was held by artists in higher esteem than the decorative emphasis on the two dimensional which was confined, in the main, to lesser genres." Whiteley (see note 40), p. 768.

46. Ibid., p. 771. Not only painters but also sculptors took part in nocturnal drawing sessions. Antonio Canova's travel diary, for instance, is full of references to his frequent attendance of the nocturnal drawing sessions offered by the academy at the Campidoglio. See Antonio Canova, *I Quaderni di Viaggio (1779–1780),* ed. Elena Bassi (Venice and Rome: Leo S. Olschki, 1959).

47. As superintendent of the antiquities in the Vatican, Winckelmann had three main obligations: supervise excavations; control the antiquary market, making sure that high-quality art works did not leave the city; and accompany noble visitors during their stay in Rome. Axel Rügler and Max Kunze, "Antikenhandel und Antikenrestaurierung in Rom," in Beck et al. (see note 36), pp. 98–99.

48. Johann Jakob Volkmann drew a good profile of the *ciceroni* working in Rome at the time: "Die mehrsten dieser Antiquarii sind Abbate, welche die Sache als ein Handwerk treiben. Ohne viel Wissenschaft und Geschmack zu besitzen, haben sie den Sclendrian gleichsam auswendig gelernt, . . . tauften die Statuen nach Belieben, und geben den Gemälden falsche Namen. . . . Die meisten Stücke sind bey ihnen ohne Wahl cose stupende, sie können aber den Liebhaber selten auf das wahre Schöne führen, und zu Bildung seines Geschmacks beytragen." (Most of these antiquaries are abbots who work in the field as manual workers. Without possessing science or taste, they learn their routine by heart . . . baptise the statues according to their will, and give false names to the pictures. Most of the pieces are called *cose stupende* with no discrimination, but they can very seldom conduct the art lover to true beauty and to the building of his taste. As cited in Müller [see note 30], p. 162.)

49. "Die Päpstlichen Aufseher immer mit offenem Munde ganz erstaunt da standen und vielleicht dachten, daß die malaria ihm das

Winckelmann's descriptions of works of art *in loco* were conceived as a way of restoring the work of art to its original state, or, more precisely, as a way to restore the Greek past to the present through imagination. In the description of the Apollo, we read: "I feel transported in spirit to Delos and to the Lycian fields, place honored by the presence of Apollo. Since my picture appears to gain life and movement like Pygmalion's beauty."[50] This pattern of reception, which involved a high emotional response to the works of art, became a model of aesthetic fulfillment for the next generation of art lovers and most probably for some of the artists trained in the academies. Yet Winckelmann himself considered that such response to art required special talent and was not accessible to a large public. It demanded an excessive power of imagination, which was only to be expected from erudite scholars. Commenting on the description of the absent head of the Torso, Winckelmann wrote: "I fear that it [the description] will serve very few people, since everything goes beyond our understanding and is considered so unreal."[51]

The magic effect of torchlight stimulated the imagination and helped to overcome the difficulties indicated by Winckelmann. With new expectations regarding the reception of antique art, students in the academy probably started to perceive the effects of torchlight in a novel way. In 1798, Carl August Böttinger wrote down in the journal *Prometheus* a description of a visit to the Dresden gallery of antiquities, where the effect of torchlight on the imagination was emphasized: "One can compare this illumination with Propetheus' torch. It is life-giving. . . . How lively it brings out all that is authentic!"[52] By the last two decades of the eighteenth century, torchlight visits to museums were already well established and had become a real fashion among "grand tourists," at least in Rome.

The torchlight visit

Unfortunately, evidence regarding night visits to museums in Rome in the eighteenth century is restricted to comments in diaries of the "grand tourists." No register of them can be found in the archives of the Capitoline or Pio-Clementine museums. But there is some mention of the practice in the archives of these museums about visits in the nineteenth century.[53] These descriptions can help us gain some insight into how the visits were conducted, although we have to reckon with some changes of attitude toward antiquity in the intervening period. Taking into account these late registers and descriptions, both earlier and contemporaneous, the first observation to be made is that significant class differences existed in the kind of public that visited each museum. While the Pio-Clementine's archive mentions many royal and noble visitors coming from all over Europe, the Capitoline's archive contains mostly lists of requests for night visits from Englishmen and other "grand tourists" of protestant origin (Goethe only visited the Capitoline by night).[54] Artists also had much easier access to the Capitoline than to the Vatican. Already at the time of the Capitoline's opening to the public in 1734, museum regulations explicitly stipulated that it should be open to "the curiosity of foreigners and dilettantes, and for the commodity of scholars [*studiosi*]."[55]

The torchlight visits at the Capitoline seem to have been more spontaneous or less ritualized than those that took place in the Vatican museums. While the

Gehirn verrückt hätte." As cited in Müller (see note 30), p. 158. Winckelmann took Volkmann to the Vatican Museum to show his compatriot the manuscripts of his descriptions of the Apollo and the Laocoön.

50. "Ich fühle mich weggerückt nach Delos und in die Lycischen Hayne, Orte, welche Apollo mit seiner Gegenwart beehrte: denn mein Bild scheint Leben und Bewegung zu bekommen, wie des Pygmalions Schönheit." Winckelmann, "Apollo Beschreibung," in Pfotenhauerand Miller (see note 34), p. 166.

51. Winckelmann, "Von der Restauration der Antiquen," as cited in Max Kunze and Stephanie-Gerrit Bruer, eds., *Von der Restauration der Antiquen. Eine unvollendete Schrift Winckelmanns* (Mainz: von Zabern, 1996), p. 105.

52. Carl August Böttiger, as cited in Diers (see note 6), p. 180.

53. These records begin only in the first decades of the nineteenth century, because during Napoleonic occupation, the institutions were adapting themselves to the model of French bureaucracy, which led to the establishment of more precise record-keeping of museums' activities. See Maria Antonietta De Angelis, "Il 'Braccio Nuovo' del Museo Chiaramonti un Prototipo di Museo tra Passato e Futuro," *Monumenti Musei e Gallerie Pontificie* 14 (1994):187–256. On the transformations brought about in the very concept of the museum during the period of the French Revolution, see Dominique Poulot, "Les finalité des musées du XVIIe siécle au XIX siécle" in her book *Quels musées, pour quelles fins aujourd'hui?* (Paris: La Documentation francaise, 1983), pp. 13–32.

54. The different status of the two museums is of relevance here. While the Vatican museums were developed throughout the centuries as the property of the church, the Capitoline Museum was seen, on the contrary, as the property of the city of Rome. Its symbolic location on the site of ancient Rome's political center was important, and since the fifteenth century various popes made donations of antique statues to the Capitol as symbolic gifts to the city and its Roman citizens. Haskell and Penny (see note 26), pp. 62–73.

55. Archivo della Presidenza del Museo Capitolino, Rome, Busta 21, titolo 1: Regolamiento e normative (1834–1854).

Capitoline Museum was opened as a museum of the city of Rome, the Vatican had always been subject to the Vatican hierarchy and not infrequently to the personal desires of the pope. In the Capitoline Museum, it was apparently the visitor himself who dictated what he wished to view. This was probably also the case in the eighteenth century. There were, of course, some restrictions to the form that the nocturnal visits to the Capitoline could take. We read, for instance, in an 1838 Motu Proprio concerning the regulations of the Capitoline Museum and signed by Pope Gregory XVI that groups of visitors to the museum at night should not exceed twelve people and that a Swiss Guard should accompany them.[56]

In the Vatican, on the contrary, torchlight visits were apparently regarded as part of the ceremonial routines with which the high clergy and the Pope entertained their important diplomatic visitors, and these visits tended to follow a well-defined protocol. As a consequence, the primary material on torchlight visits to the Vatican is much more detailed and vivid. Among the many registers of royal visitors, there are two interesting documents from the mid-nineteenth century that contain detailed descriptions of the actual proceedings on these occasions. The first document is a general description of protocol that should be followed during the torchlight visits, containing precise details of the ceremony, while the second document describes the actual torchlight visit that a Russian prince and his company took through the Vatican in 1852.[57]

According to the two descriptions, the visitors came into the Vatican through the Galleria Lapidario to start the tour at the entrance to the Braccio Nuovo. As they arrived, the entire corridor was to be illuminated with fixed torches, which were subsequently extinguished in order to start the contemplation of individual sculptures under the illumination of hand-held torches.[58] On the

occasion of the Russian prince's visit, the works seen were the following: "Silenus and Bacchus, the Antinous, the Pudicizia, the Ganimede, the Strigilatore, the Demostenes, a Venus coming out of her bath, the Nile, Minerva Medici, and Lucio Vero."[59] The group then came into the Chiaramonti Museum, where the same procedure took place: first the whole corridor was lit, and after the lights were put out, visitors proceeded with the observation of individual sculptures.[60] At the end of the Chiaramonti, the visitors moved over to the Pio-Clementine, which was the high point of the visit. The Pio-Clementine included the famous Belvedere courtyard, which contained the most valued pieces of antique sculpture. Once the visitors entered the museum, the first work to be viewed was the Belvedere Torso (in the round vestibule), followed by the Meleager. From there, visitors entered the octagonal courtyard, crossing it to see a cabinet with works by Antonio Canova. The inclusion of Canova's statues in the torchlight tour confirms his high reputation at the time as the only contemporary artist to rival antiquity. Discussions must then have turned to comparisons, such as that of his Perseus with the Apollo Belvedere.

The group then moved on to the Galleria degli Animali (Room of the Animals), where once again the whole gallery was lit to permit contemplation of the architecture and the perspective built towards the Salla delle Muse (Room of the Muses) which they subsequently entered. After the Room of the Muses, they went on to see famous busts, including Giove d'Atticoli, Comodo, Adrian, Nerva, and the Giunone Barberini, each illuminated individually with hand-held torches.

56. Ibid., busta 21, titolo 1: regulamento e normative (1834–1854).

57. Both documents are preserved at the Archivo Storico Musei Vaticani, busta 15, fasc. 1, under the titles: "Relazione di quanto si praticava nelle serate souvrane del Museo Vaticano" and "Disposizione per far vedere I Capi d'opera del Museo alle A.A.S.S. II. i gran Principe di Russia a lume di trocie." Unfortunately, the exact date of the first document is unknown, but it must date from the mid-nineteenth century, since it describes approximately the same itinerary traced in the documentation of the Russian prince's visit in 1852. I would like to thank Maria Antunietta De Angelis for calling my attention to these documents and for giving me access to them.

58. The selection of proper light was taken very seriously by artists in their studios and also in the context of night drawing sessions in the

academies. According to Andreas Blüm and Louise Lippincott, "the complex system of lamps, reflections, and shutters installed in the academy permitted specific controlled lighting on the subject. (Who selected the pose and lighting was often a subject of intense negotiation.)" Andreas Blühm and Louise Lippincott, Light! (Amsterdam: Van Gogh Museum, 2000), p. 114. This certainly developed a special sensibility for appreciating the effects of different light sources (oil lamp, torches, Argand lamps) on works of art. Such precise use of lighting was also an important part of the spectacle of the nocturnal museum visits.

59. "Disposizione per far vedere I Capi d'opera del Museo alle A.A.S.S. II. i gran Principe di Russia a lume di trocie" (see note 57). The Braccio Nuovo was opened to the public only after 1822, and some of the works housed there were still unknown in the eighteenth century.

60. The Pio-Clementine Museum was also built in the nineteenth century, under the tutelage of Antonio Canova, to house new archaeological findings. In this museum, the visitors observed three works: Draped Fragment, Bust of Young Augustus, and Tiberius.

While the visitors entertained themselves with these characters, the doors that gave access to the Salla della Croce Greca (Greek Cross Room) were opened, and the stairway was lit with fixed torches. Before walking down the stairs, the group saw the Discobolus, again by itself, and once the group reached the lower level, they moved on to admire the Antinus in the form of an Egyptian idol. After that, they walked into the Greek Cross Room, and passed once again through the Room of the Animals, where they saw the Augustus Vase illuminated from inside.

At this point a break was planned, and the group walked into the Galleria delle Statue (Gallery of Statues), where a table with refreshments was laid in a chamber lit by thirty fixed torches, making the museum seem as light as in the daytime (*illuminata a giorno*). Here the group paused, and when they had finished drinking, eating, and talking, the visit continued with hand-held torches, stopping in front of the Apollo Sauroctonus, then by the Greek philosophers Menandrus and Posólip, and finally before the Jupiter Verospi. They then visited the Mask Cabinet, the Ariadne, and then walked back toward the Belvedere courtyard, ending the visit with the spectacular views of the Laocoön and the Apollo illuminated by torchlight.

The precise planning and the large number of servants involved in the proceedings of the visit are impressive. In the more general description of the torchlight visits in the Vatican, we learn that every detail was established beforehand—for instance, which servants would stand at each of the galleries and with what designation. The whole itinerary must have created a dazzling impression. But beyond mere entertainment, it seems that there was also a desire to construct a kind of an "imaginary gallery" that would be imposed on the physical gallery space. The spectacle that resulted from lighting the torches and extinguishing them at different moments along the tour of the museum aimed at regulating not only what was going to be seen, but also the range of emotional responses to the works of art. An intense contact between the beholder and each of the statues was created by the concentration of light on individual works, which to some extent corresponds to the new response to antique statuary present in Winckelmann's texts.

Although the experience of night visits to the Capitoline Museum was probably much less spectacular and less theatrical, it must also have aimed for more intimate and emotional relation to the works exhibited there.

Toward the modern gallery

As we have already seen, renewed disposition toward viewing freestanding sculptures inherited from classical antiquity as autonomous works of art was in part hindered by the continuing convention of baroque display. The artifice of the torchlight visit responded, therefore, to a necessity of reorganizing the actual exhibition space in the museums of the time, neutralizing somewhat the still predominantly baroque ensembles, and enabling the viewer's detailed observation of individual works. Reporting Heinrich Meyer's observation on this practice, which evidently reflected his own way of thinking, Goethe noted in his diary: "Advantages of torchlight: each piece is isolated and can be observed separately from the rest, and the beholder's attention is directed only to this piece; then, in the powerfully active light, all the nuances of the work appear with more clarity. . . ."[61]

The power of torchlight in shaping the beholder's perception is, in fact, a leitmotif in the reports of travelers who experienced it. Karl Philipp Moritz said that under this peculiar light, "the most minute elevations became visible to the eye,"[62] while Lord Minto, a noble Scotsman who took part in a nocturnal visit to the Pio-Clementine Museum in 1821, later made the following observation:

I had always been a little skeptical with regard to the power of torchlight in bringing out the beauties of a fine statue, as it did not appear to me that the statues I had seen in lighted rooms at night gained very much. But in the Vatican, and with the concentrated light of one flambeau, the effect is quite marvelous. . . . The [Belvedere] Torso, which is the first we saw, is also that which gains the most by torchlight, as in addition to the beautiful display of form and muscle it acquires a fleshy appearance which gives it an air of life such as I never saw in any other work. That however which I should quote as the greatest proof of the effect of torchlight is the Laocoön. Seen by day, the unrivalled beauty of the composition and execution of this statue (the only unquestionable *chef d'oeuvre* of Greek sculpture that we know) affects everyone very powerfully. But it is at night

61. "Vorteile der Fackelbeleuchtung: Jedes Stück wird nur einzeln, abgeschlossen von allen übrigen betrachtet, und die Aufmerksamkeit des Betrachters bleibt lediglich auf dasselbe gerichtet; dann erscheinen in dem gewaltigen wirksamen Fackellicht alle Nuancen der Arbeit weit deutlicher. . . ." Johann Wolfgang von Goethe, "Italienische Reise" (1786–1787), in *Goethe Werke* vol. 11, (see note 3), p. 439.

62. "Die allerfeinsten Erhöhungen werden dem Augen sichtbar. . . ." Karl Philipp Moritz, *Reisen. Schriften zur Kunst und Mythologie*, vol. 2 (Frankfurt: Insel Verlag, 1993), p. 414.

only that we can really appreciate the grandeur, the variety and the expression of this miraculous work.[63]

A little further in his description, recalling the traditional comparison between ancients and moderns, he says of Canova's works in the Vatican:

> I was very curious to see how Canova's three statues would endure a test, which added much to the charms of the fine works about them. . . . Torchlight, which shows every touch, betrays the poverty of Canova's work, for in his statues in the Vatican a Greek artist would only have seen the sketch of a subject in which the great muscles were left to be softened down, and in which the whole of the lesser detail remained to be supplied. Having been much delighted with the great progress of modern sculpture in Rome, I was mortified to find how little the best living artists could bear the comparison with ordinary ancient sculpture, and how wide the interval by which they fall short of the models they profess to study.[64]

In this desire for a minute examination of ancient sculpture, we can recognize a disposition to follow the path opened by Winckelmann. Torchlight was to serve as an additional aid to capture and fix the beholder's eye, still accustomed to the baroque conventions of reception and display, and allow it to take part in a new form of aesthetic experience. Walking through the galleries, observing one work at a time, the beholder would slowly construct in his mind, as the images accumulated in his memory, an alternative museum, more in accord with the new discourse about art and with the public's taste. Although the torchlight museological experience seems today very distant from our own museum experience, it certainly lies much closer to our own conventions of display than those of the baroque period. In many respects, the visit by torchlight can be seen as the starting point of modern modes of seeing and exhibiting sculpture.

63. Lord Minto as cited in Ian Gordon Brown, "Canova, Thorvaldsen and the Ancients. A Scottish View of Sculpture in Rome, 1821–1822," in Hugh Honour, ed. *The Three Graces. Antonio Canova* (Edinburgh: National Gallery of Scotland, 1995), pp. 76–77.

64. Ibid., pp. 77–78. The passages quoted above also suggest that there was a widespread idea that torchlight could substitute for touch in the examination of surface details. This is clearly articulated in another passage of Lord Minto's narrative: "I have always maintained, with Torwalson, that in the finest ancient sculpture some of the shading was so delicate and minute as not to be detected by the eye and only to be perceived by passing the hand over it. He, on the contrary, always asserted that the most minute depression or elevation in the surface of the marble was easily detected by torchlight, and I am now satisfied that he is right." (Ibid., p. 76).

Countermagical combinations by Dosso Dossi

CHRISTOPHER S. WOOD

I.

The witch emerged as a subject in European art in the late fifteenth century, at the very moment when the sacred image was beginning to lose its automatic centrality within the careers of artists and the imaginations of patrons. The witch of painting, engraving, or woodcut figured a lost ground of powerful mimetic magic to which the modern cult image no longer seemed securely connected. The profane, disenchanted artwork offered a different kind of magic. The *Enchantress* painted by the Ferrarese court painter Dosso Dossi, datable to the second half of the 1510s, is the ideal test of this historical model (fig. 1).[1]

Dosso's colleague at the court of Duke Alfonso d'Este was the poet Ludovico Ariosto. In the *Orlando Furioso*, published in Ferrara in 1516, Ariosto reports that the deceptive arts of enchantment, the arts of his fictional witches Alcina and Melissa, are arts "to our age unknown," *arti . . . al nostro tempo ignote* (7.73).[2] Ariosto so numbers magic among the institutions and folkways of the chivalric past now receding with all swiftness into oblivion. Such a measuring of the gradient between the present and a lost world is virtually the signature device of epic poetry. The *Orlando Furioso* tells of love adventures in the framework of the Frankish emperor Charlemagne's contests against the Saracen kings of Spain and North Africa in the late eighth century, a pre-history of the Crusades. The poem's internal time is an illogical dreamtime suspended between two remotenesses, temporal antiquity and the cultural east, places of splendid fabrics and efficacious witches and sibyls. Yet in the verse quoted, Ariosto concedes that his own poem belongs to—would be read within—a temporality all too rational. The world external to the poem is the modern *saeculum* of printed books, classical philology, and growing doubts about the long-term success of the Crusades. Unlike the oral tradition that carried the Roland legend for three centuries until it was written down around 1100, Ariosto's poetry understands too well its own origins in mere authorship. His poem, disillusioned, knows itself to be a counterfeit.[3] Later Ariosto points out that magical, prophetic painting has become equally rare, an art "extinguished in our day" (33.5). Romanticism may have invented the idea of a secularized, disenchanted Renaissance. And yet secularization and disenchantment were already aspects of early sixteenth-century culture's self-understanding.

Once there was magic, Ariosto says, and now no longer. Another, metaphorical sort of magic, however, sexual enchantment, might not be entirely a thing of the past (8, 1):

> *Oh quante sono incantatrici, oh quanti*
> *incantator tra noi, che non si sanno!*
>
> How many enchantresses among us! oh,
> How many enchanters are there, though unknown!

Ariosto's tone is suspect. He speaks as if magic did once exist, but undercuts himself with jocularity, hinting that he believes no such thing. If so, then it is impossible to take seriously Ariosto's profession of regret. He might really be saying not that the debased modern form of magic is sexual enchantment, but that magic was *only ever* a way of describing the art of allure, indeed only ever a way of accounting for art in general, the various technologies of illusion and fictionalization. "Magic," his text allows, is just a way that some cultures have of designating such things.[4] Ariosto is offering sexual enchantment and art, it would seem, as rational explanations of magic that would level the gradient between enchanted past and disenchanted present. Instead of a lost past, he is offering an explained past.

I am grateful to Stephen Campbell, Joanna Cannon, Charles Dempsey, Beate Fricke, Jeffrey Hamburger, Kristina Herrmann-Fiore, Eberhard König, Thomas Lentes, Lea Mendelsohn, David Nirenberg, David Quint, Francesco Pellizzi, Tom Robisheaux, and Joneath Spicer for information, advice, and comments. The paper is in many places closely dependent on conversation and collaborative work with Alexander Nagel.

1. Rome, Galleria Borghese, oil on canvas, 176 x 174 cm.

2. Ludovico Ariosto, *Orlando Furioso*, ed. Stewart A. Baker and A. Bartlett Giamatti (Indianapolis and New York: Bobbs-Merrill, 1968), in the nineteenth-century translation of William Stewart Rose.

3. David Quint, *Origin and Originality in Renaissance Literature* (New Haven: Yale University Press, 1983), pp. x–xi, 3–6, 23–24, and generally ch. 1 on the predicament of a Renaissance literary culture trying to grasp how poetic intervention in a sequence of texts of merely human fabrication could be construed as "original."

4. Cf. the dictum of René Girard: "Magic is never more than a poor use of the dangerous properties of mimesis," *Things Hidden since the Foundation of the World* (Stanford: Stanford University Press, 1987), p. 14.

Figure 1. Dosso Dossi, *Enchantress,* ca. 1515–1520. Oil on canvas, 176 x 174 cm. Rome, Galleria Borghese. Photo: Scala/Art Resource, N.Y.

There are then two kinds of disenchantment, naïve and knowing. The first kind regrets what we have lost, while the second realizes that we never were enchanted. The poem makes both kinds available.

Not everyone in Ariosto's society was ready to accept the absolute pastness of the witches' arts. In these very years witchcraft was emerging out of a long shadowy existence in biblical and pagan texts and in popular imagination and re-materializing in courtrooms. In the fifteenth century, after centuries of skepticism and hesitation, the papacy formally accepted the argument that local incidence of witchcraft was to be treated as a form of heresy and so subject to clerical prosecution.[5] The Dominican inquisitorial handbook *Malleus maleficarum*, the "Hammer of Witches," published in 1486 and frequently reprinted, gathered and ratified lore and hearsay, so initiating a vicious cycle of inquiry, discovery, judgment, and yet better-informed inquiry.[6] Clerical and civic authorities sought to unmask and try the witches who hid behind ordinary social and familial roles. Witches had been persecuted and even prosecuted throughout the Middle Ages, but the fearsome chain of judgments began in earnest in the 1480s. The Inquisition purported to expose an invisible community of witches in league with demons and the devil in villages in Italy, France, Germany, Switzerland, Scotland, England, and eventually in Brazil and Massachusetts. By the end of the madness one hundred thousand or even two hundred thousand witches, three-quarters of them women, had been tried for the heresy of intercourse with the devil and for experimenting with magical rites and spells. Many thousands of witches, perhaps ten thousand, were executed.[7] Trials in Ariosto's northern Italy, and indeed all over Europe, were far more numerous in the second half of the sixteenth century, and no one in 1515 could have foreseen the extent of the catastrophe. Still, the trials and the debate about the reality of witchcraft were well under way already in the first decades of the

century.[8] If Ariosto was right that witchcraft was a thing of the past, then what were all the interrogations and treatises about?

It is almost as if the secularization of the fine arts, involving the institutionalization of artistic authorship and of the poetic work, entailed a drastic "looking away" from violence, power, error, reality. By taking up witchcraft as one of its glamorous themes, the autonomous artwork would seem to mock the trial-victims by transposing their mostly unseen bodies into fictional apparition, mimicking the accusations of the inquisitors by representing the witch as alluring. For unlike the harrowed body of the Christian martyr, the punishable body of the witch was unrepresentable. The first images of the witches were the woodcuts illustrating German printed books on witchcraft in the wake of the *Malleus*. In an example from Ulrich Molitor's *De lamiis*, a handbook that went through several Latin and German-language editions beginning in 1488, the women are feasting *al fresco*, roofless and masterless—the nightmare of husbands, for they are obviously plotting something (fig. 2).[9] Such an image is not an identification guide. It does not help anyone recognize the witch beneath the housewife's wimple. The woodcut indeed has no content other than the unreliability of the witch's outward appearance.

The witch showed her true face—she was given her face—in only two places, on the scaffold and in elite, collectible artworks. The violent extraction of the witch from social life, involving an enforced passage into a textual existence as doctrinal question and a subsequent incarnation as a judicial subject, coincided historically with her apparition in art. The two sets of phenomena were complementary. The works of art, poems and

5. On the series of medieval papal bulls dealing with witchcraft, see Henry Charles Lea, *Materials Toward a History of Witchcraft*, vol. 1 (Philadelphia: University of Pennsylvania Press, 1939), pp. 220–229.

6. Heinrich Krämer and Jakob Sprenger, *Malleus maleficarum*, trans. Montague Summers (London: Arrow, 1971). The actual impact of the handbook is disputed by some, however: see Margaret A. Sullivan's summary of the debate, "The Witches of Dürer and Hans Baldung Grien," *Renaissance Quarterly* 53 (2000):332–401, here 337.

7. For these estimates, which are conservative, see Brian P. Levack, "The Great Witch-Hunt," in Thomas A. Brady, Jr., et al. eds., *Handbook of European History 1400–1600*, vol. 2 (Leiden: Brill, 1995), pp. 607–640; generally a concise and reliable orientation to the topic.

8. For the reports of heresy and sorcery in Lombardy from 1486, see Montague Summers, *The Geography of Witchcraft* (London: Kegan Paul; New York: Knopf, 1927), pp. 537–538. See also Albano Biondo, "Streghe ed eretici nei domini estensi all'epoca dell'Ariosto," in *Il rinascimento nelle corti padane: Società e cultura* (Bari: De Donato, 1977), pp. 165–199, and the discussion of the evidence in Peter Burke, "Witchcraft and Magic in Renaissance Italy: Gianfrancesco Pico and his *Strix*," in Sydney Anglo, ed., *The Damned Art: Essays in the Literature of Witchcraft* (London: Routledge, 1977), pp. 32–52, esp. 44–48.

9. Charles Zika, "'Magie'—'Zauberei'—'Hexerei': Bildmedien und Kulturelle Wandel," in Bernhard Jussen and Craig Koslofsky, eds., *Kulturelle Reformation: Sinnformation im Umbruch 1400–1600* (Göttingen: Vandenhoeck & Rupprecht, 1999), pp. 317–382, is the most substantial discussion of these woodcuts. See also Zika, *Exorcising our Demons: Magic, Witchcraft and Visual Culture in Early Modern Europe* (Leiden: Brill, 2003), pp. 244–246, 258–259, and 282–283.

Figure 2. Ulrich Molitor, *De lamiis et phitonicis* (Cologne, 1489), fol. d1r. Woodcut, 12.2 x 7.4 cm. Photo: Christopher S. Wood.

It is the sort of beauty that painters offer, as Ariosto points out: "As best to feign the industrious painter knows" (*quanto me' finger san pittor industri*) (7.11). It was the artistry of painters like Titian or Dosso Dossi, their control over the blandishments of touch and color, that encouraged writers to adduce painting as a metaphor for what enchantresses do to men's reason.[10] In the third edition of the *Orlando Furioso* (1532), Ariosto again compared the art of the magician to the art of the painter, singling out for mention, alongside the luminaries of art ancient and modern, the two artists closest to him, the brothers Dosso and Battista Dossi (33.2).[11] The tautological circle was closed a few decades later when the Venetian critic Ludovico Dolce, in his treatise on painting, invoked Ariosto's description of the witch Alcina's appearance as an example that painters might emulate.[12] The enchantress, creature of pure surface, pure aspect, emblem of female mutability (6.50–52), the purest test of descriptive power, was serving simultaneously as the paradigm for pictorial versifying and for word-painting.

Ariosto's friend and colleague Dosso painted two pictures of enchantresses, one in the Galleria Borghese in Rome, magnificently clothed, and the other in the National Gallery of Art in Washington D.C., nude (figs. 1, 3).[13] Both date most likely from the second decade of

pictures, came at the core issues of the social witchcraft crisis but from the opposite direction, as if in protest against the Dominican inquisitors' exclusive and arbitrary focus, out of the entire range of possible modes of magic, on the reality of the witch's pact with the devil. Although the devil is completely absent from the poems and pictures, the thematics of illusion are central, just as they were in the contemporary treatises and trials.

Ariosto treats his evil witch Alcina, who transforms into animals, plants, and rocks the love-sick soldiers of the heathen prince Ruggiero, to a full-dress description by body parts in the Petrarchan manner (7.11–15). A few stanzas later he reveals that Alcina's appearance is a pure deception that masks her aged and repulsive body (7.70–74). Cosmetically produced beauty is the poem's figure *par excellence* for the powers of the enchantress.

10. Ariosto's verse was echoed by Lilio Gregorio Giraldi, a Ferrarese scholar and friend of Pico, in his treatise on witches; see Giancarlo Fiorenza, "Studies in Dosso Dossi's Pictorial Language: Painting and Humanist Culture in Ferrara under Duke Alfonso I d'Este" (Ph.D. diss., Johns Hopkins University, 2000), p. 270.

11. On this mention, and on Vasari's opinion that Ariosto had overpraised Dosso, see Patricia A. Emison, *Creating the "Divine" Artist: From Dante to Michelangelo* (Leiden and Boston: Brill, 2004), pp. 134, 144. The conceit of the painter as enchanting deceiver, significantly, breaks both with the older "Daedalian" tradition of the artist as manipulator of technology and with the idea of the artwork as a magically efficacious mimetic double of the real. On these traditions, see Ernst Kris and Otto Kurz, *Legend, Myth, and Magic in the Image of the Artist* (1934; reprint New Haven: Yale University Press, 1979), pp. 61–90.

12. Dolce's *'Aretino' and Venetian Art Theory of the Cinquecento*, ed. Mark W. Roskill (New York: College Art Association, 1968), pp. 130–135: "If painters want to find without effort a perfect example of feminine loveliness, they should read those stanzas in which Ariosto describes quite marvelously the beauties of the Enchantress Alcina." See the discussion of this passage in Rensselaer W. Lee, "*Ut pictura poesis:* The Humanistic Theory of Painting," *Art Bulletin* 22 (1940):197–269, here p. 198. The *locus classicus* is Gotthold Ephraim Lessing, *Laokoon* (1766), section XX, who invoked Ariosto's description of Alcina in order to warn poets not to try to paint.

13. For dating, provenance, and histories of interpretations of the two pictures see Felton Gibbons, *Dosso and Battista Dossi: Court Painters at Ferrara* (Princeton: Princeton University Press, 1968), nos.

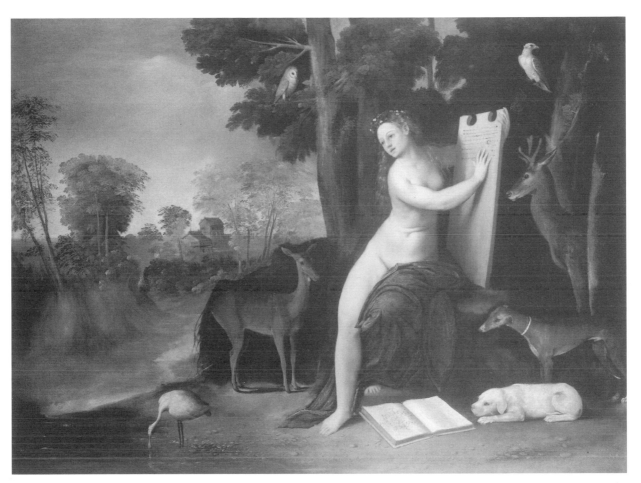

Figure 3. Dosso Dossi, *Circe and her Lovers in a Landscape,* ca. 1515–1520. Oil on canvas, 101 x 136 cm. National Gallery of Art, Washington, Samuel H. Kress Collection.

the century, around the time of the publication of the *Orlando Furioso*.[14] They both hold tablets bearing cryptic writing or diagrams and are accompanied by animals, apparently men they have transformed. The

earliest mention of the Rome picture, in an inventory of 1650, describes her simply as *maga,* female enchantress. Julius von Schlosser in 1900 first saw her as Ariosto's Melissa, the benevolent witch who undoes Alcina's spell, reversing the bad magic and converting Ruggiero's men back into human beings. The suit of armor on the ground suggested the chivalric context.

The Borghese *maga* wields a wand-like torch and her foot rests on a book of spells. She seems to have unmanned the soldier, separating him from his metallic shell, his social identity. She has in effect "exploded" the man into his bestial and spiritual selves: the animals below, principally the dog, the souls imprisoned in the tree above. She is a witch who has the power to separate soul from body. The curious doll-like figures hanging from the tree in the upper left, *homunculi* in fringed white skirts, with hands clasped in front as if in

59 and 80, also pp. 121–122; Fern Rusk Shapley, *Catalogue of the Italian Paintings* (Washington, D.C.: National Gallery of Art, 1979), no. 716; Mauro Lucco, "Due capolavori di Dosso Dossi: L'Apollo e la Melissa (già Maga Circe)," in Kristina Herrmann-Fiore, *Apollo e Dafne del Bernini nella Galleria Borghese* (Milan: Amilcare Pizzi, 1997), pp. 64–69; and the exhibition catalogue by Peter Humfrey and Mauro Lucco, *Dosso Dossi: Court Painter in Renaissance Ferrara* (New York: Metropolitan Museum of Art, 1998), nos. 3 and 12, pp. 89–92, 114–117 (both entries by Humfrey). Both pictures very likely came from the ducal circle in Ferrara if not the palace itself. The Borghese picture probably came to Rome with other Ferrarese pictures in 1598. It was first noted in 1650 in an inventory of the Villa Borghese.

14. Dosso was working in Ferrara from 1513.

prayer, are the disembodied souls of the soldiers, suspended as if in an embryonic state.[15] They are related to the small naked figures that sometimes stood in for souls in Christian iconography.[16] The dog, meanwhile, appears to retain some dim consciousness as he scrutinizes the empty cuirass.[17] Alcina does all this to her lovers in the poem. Later her spell is undone by Melissa's countermagic. The painting does not in fact make it clear which direction the charm is working in, that is, whether the *maga* has just unmanned the soldier or whether she is a good witch practicing a metamorphic countermagic, undoing a prior spell and so liberating the man from his canine prison. It is not clear, in other words, whether she is Alcina or Melissa or even if she is one of Ariosto's witches at all.

Witchcraft, to adapt the formula of Michael Taussig, was a "savage mirror" held up to mainstream society.[18]

In the narrative and the available role, witchcraft was a mimicking and ironizing of society's ways. The rural witch who summoned destructive hail with the jawbone of an animal mocked the rain ritual of the hopeful farmer.[19] The picnicking wives occupied the aristocratic topos of the love garden, familiar from tapestries, frescoes, and engravings. It is not clear exactly who was holding up the mimic mirror, whether it was the accused witches, an internally "colonized" population, or the society itself somehow placing the mirror in the victims' hands, a society at once requiring critique and working to dispel it. Witchcraft was a sacred war between the sexes, between an inside and an outside, waged at the heart of society.

By swerving into irresponsible freedom, the court poet and court painter would seem to have relinquished any capacity they might have had to register reality. Art appears to wash its hands of the real matter of witchcraft, founding itself as an institution on its prerogative of "looking away." And yet it can also be argued that such a painting as Dosso's extends the mimic work of witchcraft. The work turns back witchcraft's question, perhaps, with a question; meets witchcraft's mirror with a mirroring of its own. Dosso, like the narrative of the sabbath, the *gioco della donna*, ironizes the ethos of social love. Duplicitous, his paintings also turn on witchcraft and ironize society's critics, the witches themselves. Once there are two mirrors, there is no end of it. Art, ungrounded and in perpetual motion, suspends the question of the reality of the witch by provisonally occupying the same kind of "space between" that witchcraft had claimed for itself.[20]

Apart from the few German book illustrations, the surviving images of witches from this period were collectible works of art. The earliest was Albrecht Dürer's so-called *Four Witches*, his first dated engraving (1497), apparently a rendering of a coven of mature witches initiating a youthful bride (see fig. 10 below).[21] Dürer's

15. They are not representations of puppets or effigies of the sort sometimes used in sympathetic magic, nor are they people whom Alcina has transformed into plants, as some have argued. The skirts are a puzzle, however; they suggest a relation to the cult images of the New World, in particular the *zemi* of the Caribbean peoples, effigies made of wood or cloth. Columbus brought examples back to Europe. The *zemis* and the cult practices associated with them were described by the Milanese humanist Peter Martyr d'Anghiera. Peter Martyr's accounts of the discoveries circulated since the 1490s and were well known to every lettered person in early sixteenth-century Italy. No known *zemi* wears a skirt like these, nor are their hands clasped in this manner. Nevertheless, a possible association with the *zemi* cannot quite be ruled out. For the original descriptions of the *zemi* by the Catalan priest Ramón Pané and Peter Martyr's adaptation, see Fray Ramón Pané, *An Account of the Antiquities of the Indians,* ed. José Juan Arrom (Durham: Duke University Press, 1999), pp. 21, 35–37, 47, 51–52. For further descriptions by Peter Martyr, see *The Discovery of the New World in the Writings of Peter Martyr of Anghiera,* ed. Ernest Lunardi et al. (Rome: Istituto Poligrafico e Zecca dello Stato and Libreria dello Stato, 1992), pp. 92–95. On the *zemi* themselves, see Ricardo E. Alegria, "An Introduction to Taíno Culture and History," in *Taíno: Pre-Columbian Art and Culture from the Caribbean* (New York: Museo del Barrio, 1997), pp. 18 ff.

16. *Lexikon der Christlichen Ikonographie,* vol. 4 (Freiburg: Herder, 1972), s.v. "Seele." Nude figures in wax, sometimes with hands clasped in prayer, were suspended near altars as votive offerings; see, for example, the scene represented in the altarpiece at St. Wolfgang in Pipping, ca. 1480; Lenz Kriss-Rettenbeck, *Ex voto: Zeichen, Bild, und Abbild im christlichen Votivbrauchtum* (Zurich: Atlantis, 1972), plate 1 and p. 76.

17. Cf. the painting in Leipzig, Museum der Bildenden Künste (Lower Rhine, 1470s), never satisfactorily explained, representing the same triangle: the woman performs a magical ritual, a love charm, in the nude, in order, effectively, to reduce the man entering the door to the docile state of the dog curled at her feet. Dietulf Sander, ed., *Katalog der Gemälde* (Leipzig: Museum der Bildenden Künste, 1995), no. 509, ill. 479.

18. Michael Taussig, *Mimesis and Alterity* (London: Routledge, 1993), p. 78.

19. This act was illustrated in the early editions of Ulrich Molitor, *De lamiis*; see the publications of Charles Zika (see note 9).

20. Taussig (see note 18), pp. 78–79; and 86: "Mimesis sutures the real to the really made-up."

21. Interpretations are legion; see Rainer Schoch, Matthias Mende, and Anna Scherbaum, *Albrecht Dürer: Das druckgraphische Werk,* vol. 1, *Kupferstiche* (Munich: Prestel, 2001), no. 17. See the discussion of Dürer's witches in Linda C. Hults, *The Witch as Muse: Art, Gender, and Power in Early Modern Europe* (Philadephia: University of Pennsylvania Press, 2005), pp. 57–74. Hults's important study reveals the extent to which the misogynistic iconography of the witch served as a framework for male artistic self-fashioning. Still fundamental on the involvement of art with witchcraft is Eugenio Battisti, *L'Antirinascimento* (Milan: Feltrinelli, 1962), pp. 138–157.

Figure 4. Agostino Veneziano or Marcantonio Raimondi, "*Lo stregozzo*," ca. 1520. Engraving, 30.3 x 64.5 cm. Photo: Christopher S. Wood.

engraving of an ugly, distaff-wielding witch riding backwards on a goat dates from a few years later. The Italian engraving known as *Lo stregozzo,* a grotesque cavalcade, not easily deciphered, cites Dürer's rider (fig. 4).[22] The German artist Hans Baldung Grien, a pupil of Dürer, commented on the topos of the witches' sabbath in a series of works on paper. His chiaroscuro woodcut of 1510 both complied with and derided the folkloric-inquisitorial account of the nocturnal flights and gatherings (fig. 5).[23] A pair of fleshy nudes tend to the urn, the chalice, and the row of phallic sausages draped on a cooking-stick—the recipe for impotence. A crone holds an unsavory dish aloft. Two witches are already airborne, one of them balanced on Dürer's goat. Scattered on the ground are the apparatus of witchcraft as attested by the handbooks and the testimony they elicited: human and animal remains, a cat, a mirror, forked sticks for cooking and flying. The devil is absent. Baldung left several collectible drawings on colored paper of similar scenes.[24] In these drawings he develops the themes of masturbation and lesbianism, interpreting the witches' sabbath psychosexually as a lurid dream generated by the lower body.

Margaret Sullivan argues that the true context of Dürer's and Baldung's images was not the real-life persecutions and trials, but rather scholarly and humanistic interest in classical witch lore.[25] Patricia Emison makes exactly the opposite case, arguing that

22. The engraver is usually judged to be Agostino Veneziano or Marcantonio Raimondi; Patricia A. Emison, "Truth and *Bizzarria* in an Engraving of *Lo stregozzo*," *Art Bulletin* 81 (1999):623–636. Among other interesting arguments, Emison attributed the design to Battista or Dosso Dossi. Fiorenza (see note 10, p. 309) immediately disagreed. Emison's proposal is suggestive but not conclusive. For a recent defense of Konrad Oberhuber's attribution of the design to Girolamo Genga, see *Roma e lo stile classico di Raffaelle, 1515–1527* (Milan: Electa, 1999), no. 128, p. 192. Cf. also Hults (see note 21), pp. 39–46.

23. Matthias Mende, *Hans Baldung Grien: Das druckgraphische Werk* (Unterschneidheim: Uhl, 1978), no. 16. *Hans Baldung Grien: Prints and Drawings* (New Haven: Yale University Art Gallery, 1981), no. 18. See Zika, *Exorcising our Demons* (note 9), pp. 241–244, but see also pp. 271–272 where he revises part of his earlier reading of the image; and Hults (see note 21), pp. 15–26, 74–104.

24. The survival rate of works on paper is low; these must represent a small sample of a much larger body of witch-related work. On the series of Baldung drawings and their copies by other artists, see Carl Koch, *Die Zeichnungen Hans Baldung Griens* (Berlin: Deutscher Verein für Kunstwissenschaft, 1941) nos. 62–65, A16–A17, and pp. 30–31. See also Zika, *Exorcising our Demons* (note 9), pp. 260–262, 277, 283–292. Earlier than any of Baldung's witches is the drawing of a *Witches' Sabbath* by Albrecht Altdorfer (Paris, Louvre), dated 1506; see Franz Winzinger, *Albrecht Altdorfer: Zeichnungen* (Munich: Piper, 1952), no. 2. Baldung must have known it or an image like it by or after Altdorfer. Baldung made one painting of the subject, the so-called *Weather Witches* (1523) located in Frankfurt, Städelsches Kunstinstitut.

25. Sullivan (see note 6).

Figure 5. Hans Baldung Grien, *Witches' Sabbath,* 1510. Chiaroscuro woodcut, 38 x 26 cm. Photo: C. Jean. Louvre, Paris, France. Réunion des Musées Nationaux/Art Resource, N.Y.

dimensions embedded in vernacular lore. The form of his witches may strike modern beholders as unclassical, but this is our misconception. Baldung himself probably recognized no clear distinction between sources classical and vernacular, high and low.[27]

Baldung's images comment on the inquisitorial fascination with witch lore in the sense that they expose the textuality of the witchcraft phenomenon. They mirror the inquisitorial narratives back onto the society that invented them and unmask the entire witchcraft phenomenon as a massive fiction. These images move in Taussig's "space between"; they mimic and mock in both directions, first toward society, rhyming with the work of the witches and then immediately recoiling on and doubting the witches. The mimetic practice that such pictures parodically mimic is the inquisitorial persecution that in fact created witchcraft. For witchcraft was not a reality, but a narrative about women's lives and experiences that society compelled women to tell about themselves. The witchcraft narrative forced women by cruel persuasions to perform the identity "witch." The persecution produced the witch. Many women, it seems, chose voluntarily to perform that identity discursively, on a public stage, and so fling themselves self-destructively into the arms of justice, perhaps because it was one of the few discursive identities available to them. Retelling the witchcraft narrative was in many cases the only chance they had to tell anything at all. It allowed them to assume the role of the clear-seer, or the mystic, or the provocative antagonist, even for just a brief moment.[28]

The early sixteenth-century images of the witch appeared mostly in the small-scale and replicable media: woodcut, engraving, and bronze. These were artifacts that instantly signalled their independence from

the Italian engraving *Lo Stregozzo,* so obviously laden with classical erudition, in fact registers anxieties provoked by the recent trial in Mirandola. She sees the print as an attempt to envision the unseen horrors of the sabbath, even as a kind of "fabricated" evidence of the sabbath's reality.[26] Surely both are right. *Lo Stregozzo* was a shaping of text-based erudition to the description of the *corso* or sabbath as it was emerging in testimony and in print. Baldung's scenes, meanwhile, were ribald and ludic, but also in their own way scholarly. His milieu and clientele in Strasbourg were erudite and sophisticated. Baldung was excavating the pagan

27. The complexity of the "combinatorial" interplay between classical and "Germanic" or folkloric sources is brought out by Dieter Harmening, "Hexenbilder des späten Mittelalters—Kombinatorische Topik und ethnographischer Befund," in Peter Segl, ed., *Der Hexenhammer: Entstehung und Umfeld des Malleus maleficarum von 1487* (Cologne and Vienna: Böhlau, 1988), pp. 177–193. Sullivan, too, stresses the interaction between the traditions and the misleadingly "popular" tone of Baldung's images (see note 6, pp. 342–351, 363–364).

28. On the performative aspects of the testimonies, see the insightful analysis of Lyndal Roper, *Oedipus and the Devil: Witchcraft, Sexuality, and Religion in Early Modern Europe* (London and New York: Routledge, 1994), chs. 8–10. On the "sadistic, circular logic" that is both the condition for and the subject of Baldung's drawings, see Joseph Leo Koerner, *The Moment of Self Portraiture in German Renaissance Art* (Chicago: University of Chicago Press, 1993), pp. 323–357.

26. Emison (see note 22).

devotional or liturgical contexts. Dosso's Borghese picture was bolder in that it took over the scale and format of the sacred image, the altarpiece. Its immediate model was Raphael's *Madonna of the Meadows* in Vienna (ca. 1505), not only for the pose and the landscape setting but for the red and blue layers of clothing (reversed by Dosso) and the hair braided like a turban (fig. 6).[29] Before 1515, independent paintings on panel or canvas of that size and format, with non-religious subject matter, were scarce.[30] All these images, large and small, were distinguished from cult-based pictures by their *fictionality*. They make no reference to anything real.

Interest in fictionality was dialectically coupled with elite skepticism or impatience with the witchcraft phenomenon. The public for the artwork defined itself as the public capable of exercising independent, skeptical judgment about, for instance, the reality of witchcraft. To take a case from contemporary court culture: Queen Isabella of Castile was consulted about one of her nieces whose apparent sexual recalcitrance had been attributed to the influence of demons, perhaps summoned by a maleficent brother-in-law. Isabella, however, was skeptical, unwilling to resort to supernatural explanations for her niece's behavior. Such practices, she protested, "should not be asserted or believed among Catholics. It is a wrongheaded opinion of the common people [*vulgi*]." The Archbishop of Seville and inquisitor-general Diego de Deza tried to convince the queen that this sort of demonic possession was indeed possible and assured her that the doctors of the Church, Thomas Aquinas included, had said so. Still Isabella refused to bend. "I will certainly not believe," she said, "that a demon can exert any power over those conjoined in matrimony . . . for those things are more due to discord among humans than to interference by powerful demons."[31]

Refined and private artworks became zones of pragmatic, psychologically realist skepticism like Queen

Figure 6. Raphael, *Madonna and Child with St. John* (*Madonna of the Meadows*), 1505. Oil on panel, 113 x 87 cm. Kunsthistorisches Museum, Vienna. Photo: Erich Lessing/Art Resource, N.Y.

Isabella's. Realism about human nature was the natural psychological matrix of a receptivity to fictionality. Fictions only work because they are embedded within a community that share assumptions about the intelligibility of phenomena and the explicability of human behavior. Outside such a set of assumptions, the fictions would be mistaken for marvelous reports or simply for lies. In order for there to be fiction, the realist has to understand realism as a choice, an option; the realist has to have the sense of being surrounded by ordinary-thinking people incapable of lucid judgments about things. The gap between the elected realism and the simple belief-system of ordinary people becomes the space where fictions can be fashioned. The fiction *is* something like a lie, but it is a staged and protected lie.

Ariosto in the *Orlando Furioso* repeatedly comments in authorial asides on the improbablity of the very

29. Raphael's picture was painted for Taddeo Taddei, a merchant and collector. The picture was surely meant for the private residence and not a public or ritual setting and therefore belongs to a middle category between cult image and artwork.

30. Dosso's Washington *maga* may be dependent on one of them, Leonardo's *Leda and the Swan* (ca. 1506), as Peter Humfrey proposed; Humfrey and Lucco (see note 13), p. 90.

31. Josef Hansen, *Quellen und Untersuchungen zur Geschichte des Hexenwahns und der Hexenverfolgung im Mittelalter* (Bonn: Georgi, 1901), p. 262. The text is discussed by Walter Stephens, *Demon Lovers: Witchcraft, Sex, and the Crisis of Belief* (Chicago: University of Chicago Press, 2002), pp. 313–314 (Isabella's comments translated by Stephens).

events he is narrating, insisting on the reality and truthfulness precisely of the most fantastical elements of his story and so undermining the reliability of his own narrative.[32] By protesting too much, he concedes that enchantments and metamorphoses do not really happen in life. As if any reader thought they did! Ariosto pretends to tend to the truth-content of his poem long after anyone still imagined that poems might be in the business of truth-telling. Ariosto's pretense of reassuring his readers that he believes in the events described in his own poem establishes an Isabella-like realism about human motivation as the ground against which the fiction can unfold. Common sense is the fixed grid against which fiction, a controlled confusion, can move. All of this had long since been understood by readers of poetry. Ariosto's devices are a mere pantomime: For painting, by contrast, it would be a new game. Authorial irony is the main thing painting had to learn from poetry in these years.

Compare a sacred painting that dealt with witchcraft only a few years before Dosso's, the scenes from the life of St. Godelieve, painted in Bruges in the last quarter of the fifteenth century and now in the Metropolitan Museum of Art (fig. 7).[33] It is an altarpiece and therefore a painting prohibited from telling lies. St. Godelieve was a local martyr of the eleventh century. According to the legend, Godelieve's mother-in-law commissioned a maid to spy on her activities. In the middle ground of the scene illustrated here, the diminutive spy witnesses Godelieve's power to persuade crows to abandon the fields and instead enter a hut. In the foreground, the maid reports to the mother-in-law and husband. Godelieve is accused of possessing demonic powers and, in the next panel, will be strangled as a witch. The medieval witch was an anti-saint, a special woman embedded within society among normal people. The painting suggests that there is nothing on the surface that distinguishes between Christian saint and demonic witch. The painting warns that even a saint, perhaps especially a saint, is misrecognized. Such an image instantly identifies the political core of the problem,

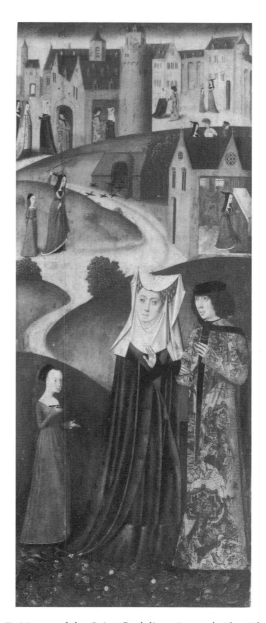

Figure 7. Master of the Saint Godelieve Legend, *The Life and Miracles of Saint Godieleve,* late fifteenth century. Detail of the right panel. Oil on wood, 125.1 x 43 cm. The Metropolitan Museum of Art, John Stewart Kennedy Fund, 1912 (12.79). Photograph, all rights reserved, The Metropolitan Museum of Art.

32. On the theory of literary autonomy encoded in the lunar episode of *Orlando Furioso,* see Quint (note 3), pp. 81–92. See also Daniel Javitch, "The Advertising of Fictionality in Orlando Furioso" and Elissa B. Weaver, "A Reading of the Interlaced Plot of the Orlando Furioso: The Three Cases of Love Madness," in Donald Beecher et al., eds, *Ariosto Today: Contemporary Perspectives* (Toronto: University of Toronto Press, 2003), pp. 106–125 and 126–153.

33. See *From Van Eyck to Bruegel* (New York: Metropolitan Museum of Art, 1998), no. 15. Figure 7 reproduces the right third of the central panel of the altarpiece.

which is that witchcraft itself is never seen. The nocturnal sabbaths, naked dancing, devouring of children, and so forth were never witnessed by outsiders. The Flemish painting reveals that the entire cultural project of singling out and exterminating

witches was built on spurious inference, guesswork, and extracted confessions.

Godelieve is mistaken for a witch, but not because she was falsely accused of wielding power over birds. The spy was truthful. The saint really did control the crows. The *vita* and the picture did not take the skeptical, rationalist option of deciding that Godelieve in the end never had anything to do with birds, and that the charges against her were entirely trumped up. They did not require such an option, for they had at their disposal a different supernatural explanation at hand, not witchcraft but saintly, divinely endowed powers. The panel's and the *vita*'s constitutional requirement to tell the truth compelled them to stick to supernatural explanations. The fictional poem and painting, by contrast, had the freedom to raise the skeptical possibility that no one ever had any supernatural powers.[34]

Unlike the Godelieve altarpiece, Dosso's canvases comment skeptically on the prosecution of witches by repeating and extending the work of the witch. At the same time, they comment skeptically on the witch by containing her within a work of artifice. The artwork at this point was already independent of both antagonists, prosecutor and witch. There is no more dramatic index of art's freedom than its refusal to take it seriously. In a formula of Gregory Bateson: "The playful nip denotes the bite, but it does not denote what would be denoted by the bite."[35]

At the elite courts, the question asked was precisely not: Are witches real? For this is like the question: is there a God? If it has to be asked, it is already too late.[36] Elite skepticism immediately fed back into the contemporary treatises on witchcraft, whose authors were often humanistically educated and court-based scholars. By asking the ontological question about witches, scholars were inadmissibly attempting to transfer a textual phenomenon into life. To ask the question was precisely to bring the chain of texts to a close, creating it now *as* the standard tradition of witch lore. Theologians had argued since Augustine that nocturnal sabbaths and metamorphoses were not

realities but figments of the erotic imagination provoked by the devil.[37] The modern prosecutors partially accepted this idea, making it both harder and easier for them to prosecute. Easier, because it removed the burden of producing evidence of the sabbaths; harder, because whereas the cause of a bestial transformation or a night flight had to be a demon, the cause of a mere illusion might be nothing more than the mind itself. The prosecutorial handbook *Malleus maleficarum,* for instance, tried to find a middle ground. The *Malleus* accepts the literal reality of the nocturnal sabbaths. In the section on transformations, however, the Dominican authors, following the opinions of Augustine and Aquinas, deny that witches can transform people into animals, explaining this instead as an illusion worked by demons.[38] Just behind the surface of the argumentation lurks the possibility that the sabbaths, too, are mere illusions; and the further possibility that such illusions, like dreams or fantasies of any sort, might have non-demonic or non-supernatural causes, threatening the whole prosecutorial enterprise. Such were the doubts that had stayed the hand of the Church for centuries: First, uncertainty about whether anyone really possessed the powers of the witch; second, uncertainty about whether belief in witches was an illusion caused by demons or generated by the mind; and therefore third, uncertainty about whether witchcraft amounted to heresy. Those who tried to argue for the reality of the sabbaths, no matter how thoughtful, were instantly caught in logical loops. Scholars found themselves adducing ancient texts, including poetic texts, to prove the reality of modern witchcraft. Both the *Malleus maleficarum* and Molitor's *De lamiis* had referred to the mythic and literary personage of Circe, the island enchantress who turned Odysseus's men into swine (*Odyssey* 10), equally familiar from Virgil (*Aeneid* 7) and Ovid (*Metamorphoses* 14). In his treatise *Strix,* Gianfrancesco Pico della Mirandola (1523; Italian ed., 1524) compared the modern witches, ten of whom had just been burned in Mirandola (Dosso's home town, incidentally), to their ancient predecessors.[39] It is an old

34. It should be noted, however, that the altarpiece, because it was narrating something that happened in the relatively distant past (four centuries earlier), did not strictly need to decide about the truth content of the *Vita*; it could just tell the story as it found it.

35. Gregory Bateson, "A Theory of Play and Fantasy" (1955), in Bateson, *Steps Toward an Ecology of Mind* (1972; Chicago: University of Chicago Press, 2000), pp. 177–193, here p. 180.

36. Northrop Frye, *The Great Code: The Bible and Literature* (New York: Harcourt Brace Jovanovich, 1983), p. 16: "[A]ny question beginning with 'is there' is, so to speak, already an ungodly question."

37. On the introduction of theories of the erotic imagination into demoniacal doctrine, see Ioan P. Couliano, *Eros and Magic in the Renaissance* (Chicago: University of Chicago Press, 1987), pp. 151–154.

38. *Malleus* (see note 6), part two, question 1, chapter 8.

39. Burke (note 8, pp. 37–38) points out that fictional texts by Ovid and Apuleius were adduced by scholars as evidence for the reality of witches. Apuleius was avidly read at the court of Ferrara in these years. See also the concise account of the interplay between the theological and humanistic accounts of modern witchcraft in Fiorenza

theological reflex, not different logically from using Christ's miracles to reinforce modern belief. In his biography of the lay holy woman Catherine of Raccongi, the same Pico legitimated the reports of her bodily transportations by referring to the ancient philosophers Pythagoras, Abaris, and Empedocles who had been borne aloft by demons. What happened to the philosophers, he argued, "nowadays happens to witches, who are carried to the game of Diana or Herodias, as we have discussed at length in *Strix*."[40] If demons can do such things, then surely angels can, too, and we should not doubt the living saint Catherine. The loops of unreason grew tighter when modern poetic texts were introduced as proofs. In the first decades of the seventeenth century, events in Torquato Tasso's *Gerusalemme liberata* were adduced by at least three demonologists either as reliable descriptions of witchcraft or as evidence of its reality.[41] There were both naïve and knowing versions of "humanism": on the one hand, literary authority introduced as an attempt to reground and justify; on the other, literary references introduced as semantic overdetermination, a loading up of the poem or picture with classical lore—Apuleius, Ovid, Theocritus—that was changing its meaning as fast as it was coming into philological focus.

Dosso Dossi returned the prosecutor's question: is she a witch? by creating a kind of picture which declined to answer the even more naïve question: which of Ariosto's witches is she? The picture in Rome may possibly illustrate the following passage (8.14–15) in which the soldiers of Ruggiero had been metamorphosized by Alcina and the beneficent witch Melissa storms the palace and undoes the bad magic, freeing the captives:

> *Non lascia alcuno a guardia del palagio:*
> *il che a Melissa che stava alla posta*
> *per liberar di quel regno malvagio*
> *la gente ch'in miseria v'era posta,*

> *diede commodità, diede grande agio*
> *di gir cercando ogni cosa a sua posta,*
> *imagini abbruciar, suggelli torre,*
> *e nodi e rombi e turbini disciorre.*

> *Indi pei campi accelerando i passi,*
> *gli antiqui amanti, ch'erano in gran torma*
> *conversi in fonti, in fere, in legni, in sassi,*
> *fe'ritornar ne la lor prima forma.*

Without a guard she left her palace there,
Which to Melissa, prompt her time to seize,
To loose her vassals that in misery were,
Afforded all convenience and full ease;
—To range, at leisure, through the palace fair,
And so examine all her witcheries;
To raze the seal, burn images, and loose
Or cancel hag-knot, rhomb, or magic noose.

Thence, through the fields, fast hurrying from that dome,
The former lovers changed, a mighty train,
Some into rock or tree, to fountain some,
Or beast, she made assume their shapes again.

The picture may more specifically refer to Melissa's conversion of the knight Astolfo, who had been transformed into a myrtle tree, so restoring him to his armor (8.17).[42] Neither passage is an exact fit. Again, the painting provides no information that would even help us decide which witch she is, Alcina or Melissa. She wears an expression neither malicious, benevolent, nor triumphant, but rather benign, neutral, sovereign, perhaps sybilline.[43] A seventeenth-century painting in Baltimore attributed to Agostino Tassi quotes Dosso but does not help identify the subject.[44] Certainly Dosso could have identified his witch unambiguously if he had

(note 10), pp. 264–270. See also Frédéric Max, "Les premières controverses sur la réalité du Sabbat dans Italie du XVI siècle," in Nicole Jacques-Chaquin and Maxime Preaud, *Le sabbat des sorciers en Europe (XVe–XVIIIe)* (Grenoble: Millon, 1993), pp. 55–62. Sullivan (note 6, pp. 347–348) also stresses the evidentiary use of ancient texts.

40. Quoted in Gabriella Zarri, "Living Saints: A Typology of Female Sanctity in the Early Sixteenth Century" (1980), in Daniel Bornstein and Roberto Rusconi, eds., *Women and Religion in Medieval and Renaissance Italy* (Chicago: University of Chicago Press, 1992), p. 245, n. 168.

41. Stuart Clark, "Tasso and the Literature of Witchcraft," in J. Salmons and W. Moretti, eds., *Renaissance in Ferrara and its European Horizon* (Cardiff: University of Wales Press and Ravenna: Mario Lapucci, 1984), pp. 3–21, esp. pp. 8–12.

42. See the review of opinions in Stefania Macioce, *L'Incantesimo di Circe: Temi di magia nella pittura da Dosso Dossi a Salvator Rosa* (Rome: Logart, n.d.), pp. 29–34.

43. The engraved sibyls by Baccio Baldini and Michelangelo's Sistine sibyls are among her models.

44. Baltimore, Walters Art Museum, inv. no. 37.1145. A sorceress in a landscape holds a torch to a brazier; there is armor, a dog, and other curious details, but the textual reference is no clearer than in Dosso. A child-like figure attached to the tree appears to be winged and wearing a pleated skirt, suggesting that Tassi had little idea what to make of Dosso's homunculi. See the entry by Federico Zeri, *Italian Paintings in the Walters Art Gallery*, vol. 2, no. 319 (Baltimore: Walters Art Gallery, 1976) [pp. 447–448] Patrizia Cavazzini, "Towards a Chronology of Agostino Tassi," *Burlington Magazine* 144 (2002):407, was the first to note the connection to Dosso. The brazier and torch resurface in the painting of the *Witch of Endor* (1526) by Jacob Cornelisz. van Oostsanen in the Rijksmuseum, Amsterdam; for a reproduction see Max J. Friedländer, *Early Netherlandish Painting*, vol. 12, no. 250 (Leiden: Sijthoff, 1967–), p. 115, plate 139.

wanted to.[45] The lack of information suggests that Dosso is deliberately converting the difficulty in recognizing witches into poetics. He refuses to close the word-image gap. In an earlier version of the composition, the *maga* appears to be looking at a soldier standing at the left with casually crossed legs, a figure now hidden by paint layers but revealed by X-radiography at the time of the recent exhibition.[46] The soldier, if Dosso had allowed him to remain, would have assisted, possibly clinched, the Ariostian reference. Giorgione did the same with his *Three Philosophers,* where the pentimenti—in this case, removal of explicit references to the Three Magi—rendered the picture more, not less, difficult to decipher.[47] The slight displacement from textual anchorage accomplished by the revision was the point of Dosso's picture, perhaps of Giorgione's as well. By demurring in the face of subject matter, declining to narrate or illustrate, Dosso sets his picture in motion in a more general stratum of meaning. Literature, unable to evade reference to subject matter so smoothly, has to signal such a move by other means. Painting is in effect learning how to exploit its wordlessness, its difficulty in making reference. It now voluntarily falls short of being "picture-writing."

A subject matter usually brings with it a set of themes and questions that ignite as soon as they are touched. To engage with the matter of the witch was to take over ready-made an entire problematic. The attractor around which ideas and debates about witchcraft clustered was the name Circe. Both Augustine's and Thomas Aquinas's discussions of the reality of metamorphoses had referred to Circe. The idea of Circe as the type of the deceitful temptress possibly in control of supernatural forces was perpetuated in vernacular literature, conspicuously in Boccaccio's *On Famous Women.* The principal function of this long debate that wound through texts poetic and theological as well as images was not to determine whether witches existed, but rather to test the powers of

fantasy and imagination against the possibility of the reality of supernatural transformations.[48]

Dosso's *maga* in the Villa Borghese was identified as Circe in an inventory of 1790 and was generally known by this title until Schlosser suggested the link to Ariosto. The Washington picture is still called *Circe.* Yet Circe does not quite fit either picture, for the iconography requires swine and a boat, Odysseus's boat.[49] Still, the pictures belong to the Circe tradition generously defined. "Circe" was a textual and iconographic framework for addressing the complex psychological problems of the delusion of the senses, imagination, sexual enchantment, and beauty. The sorceress was invoked in theological and literary texts as an all-purpose example. When Dosso actually paints a *maga,* applying *maga*-like treatment to the *maga* herself, he is allowing the means of the painter to "re-enter" the painting on the level of subject matter.[50]

In the early sixteenth century the Circe debate resurfaced in a different place in the public sphere, provoking poet and painter to define each other against each other. Painting began to do what it was always reputed to do: reproduce beauty while bracketing ontological questions. The equivalent is Ariosto's ludic foregrounding of those same questions. The end result is the same, but one might say that Dosso's method is cool and the poet's hot. The key distinction is that poetry seems compelled to introduce the thematics of surface versus essence, for example at *Orlando Furioso* (7.73) when Ruggiero sees through Alcina's charms. Painting does not have to describe such discernments; indeed, it has trouble doing so. Painting just gives you the

45. Fiorenza (see note 10), p. 259, makes this point.

46. Anna Coliva, "Dosso's Works in the Galleria Borghese: New Documentary, Iconographical, and Technical Information," in Humfrey and Lucco (see note 13), pp. 75–76, fig. 58; Coliva considers the hidden figure to be Astolfo.

47. On the original conception of the picture, see Salvatore Settis, *Giorgione's Tempest: Interpreting the Hidden Subject,* trans. Ellen Bianchini (Chicago: University of Chicago Press, 1990), pp. 20–29. Still valuable on the topic of ambiguity is Creighton Gilbert, "On Subject and Not-Subject in Italian Renaissance Pictures," *Art Bulletin* 34 (1952): 202–216.

48. Judith Yarnall, *Transformations of Circe: The History of an Enchantress* (Urbana and Chicago: University of Illinois Press, 1994), pp. 99–126; Gareth Roberts, "The Descendants of Circe: Witches and Renaissance Fictions," in Jonathan Barry and Marianne Hester, eds., *Witchcraft in Early Modern Europe* (Cambridge: Cambridge University Press, 1996), pp. 183–206; Charles Zika, "Images of Circe and Discourses of Witchcraft, 1480–1580," *Zeitenblicke* 1 (2002) (online journal, http://www.zeitenblicke.historicum.net/).

49. Admittedly, as some have pointed out, Circe is not in every case accompanied by swine; see Zika, note 48, adducing a 1518 edition of Ovid and Macioce (note 42), p. 30.

50. On "re-entry" as a structural feature of artworks, see Niklas Luhmann, *Art as a Social System* (Palo Alto: Stanford University Press, 2000), pp. 143, 301, and passim. C. S. Lewis argued that the sixteenth-century Italian epics demystified and mocked the popular romances of the Middle Ages but at the same time practiced their own aesthetic countermagic. "Even when you laugh at it, the old incantation works. Willy-nilly the fairies allure, the monsters alarm, the labyrinthine adventures draw you in." *The Allegory of Love: A Study in Medieval Tradition* (Oxford: Clarendon Press, 1938), p. 299.

surface.[51] Painting is learning how to perform operations that only painting can perform, rather than simply fulfilling poetry's expectation of it, namely that it deceive with beauty. Painting in this period is starting to make the case that its own true matrix is not poetry but other and prior pictures. By identifying the prehistory of modern painting as its matrix and then working within that matrix, painting begins to develop its own peculiar position on the problem of the gradient between past and present, the problem that Ariosto designated with the phrase *arti al nostro tempo ignote.*

Painting's intertextual recombination of its own prehistory is its local form of countermagic. In this way painting at once recognizes and begins to undo the force of history. The aim of this paper is to bring into coordination two traditions of reflection on enchantment, the theological-inquisitorial and the artistic-intertextual. Both traditions involved constant comparison of the past with the present, of once-powerful magic with its lesser modern forms, mere metaphors for magic.

II.

Vasari tells of the director of the hospital of Santa Maria Nuova who objected because the saints in a painting by Rosso Fiorentino resembled devils. Vasari's explanation for the patron's confusion is discouragingly literal: They looked like devils because "Rosso's custom in these oil sketches was to give certain faces an air of cruelty and despair, and then subsequently to soften their expressions and render them as they should be."[52] Painting in these decades was often skirting the frontier between good and evil. The "charge" of the picture, positive or negative, was easily misread by the unaware. Ariosto signalled the dangerous proximity of positive and negative by making both his witches, malevolent and benevolent, beautiful and finely dressed. It is this ambiguity that Dosso's Rome painting "illustrates."

The stakes of the game that painting was playing were higher, however. The borders of poetry were well established by Ariosto's time; he could confuse the distinction between good and evil in all safety,[53] whereas the secular painting, moving into a field traditionally occupied by altarpieces and devotional images, was fighting for its existence. The kind of picture about which the strongest truth claims were made, the non-fictional or referential picture, was very much still being made, indeed by the same artists who made the secular pictures. The implications of the painting's metamagical inquiry were only intensified by the institutional fact of the cabinet picture's recent disengagement from the cultic context.

This is a painting that is not a sacred image, but it resembles one. It defines itself in the first instance as "not a cult image." By simultaneously invoking and distancing itself from that prior image, such a painting, in effect, creates the cult image as a category; until then, the cult image was so ubiquitous as to be virtually invisible. It was an image imbedded within a ritually structured context. Such images often had other functions and were indeed often private and disconnected from formal ritual of any kind, but their primary identity derived from ritual context. The cult image claimed stable referential relations to the personages and events of sacred history or to eschatological doctrine. A non-cult image such as Dosso's is the sort of picture that does not have to specify what it refers to. It can just be "about" something; it can reflect from a detached standpoint, even on something potentially self-undermining such as the nature of deceptive appearances. A picture capable of commenting generally emerged in relief against a putative predecessor picture that could not do so. The cult image—not in reality, but from the point of view of Dosso's picture—had been naïve about appearances. The cult image had offered the image of the Madonna, for example, as a reliable guide to her essence. The image of the *maga* also offered a beautiful surface, but signalled, through its self-differentiation from the cult image, that appearance itself was unreliable. The fictional cabinet picture defined itself in terms of the cult image on the basis of differing referential claims. The cabinet picture's commentary on its notional

51. Cesare Gnudi, "L'Ariosto e le arti figurative," in *Signore cortese e umanissimo: Viaggio intorno a Ludovico Ariosto,* ed. Jadranka Bentini (Venice: Marsilio, 1994), pp. 13–47, here 35–37, said that whereas Ariosto transforms the true into a dream and back again, Dosso only goes in one direction.

52. Giorgio Vasari, *Le vite de' più eccellenti pittori scultori ed architettori,* ed. Gaetano Milanesi, vol. 5 (Florence: Sansoni, 1906), p.157; *Lives of the Artists,* trans. G. Bull, Vol. 2 (Harmondsworth: Penguin, 1987), p. 171. David Franklin, *Rosso in Italy* (New Haven: Yale University Press, 1994), p. 41, in turn reads Vasari's comment literally, as a critique of an ignorant patron who failed to realize that the angels were still unfinished.

53. When imported by sailors to the New World, poetry like Ariosto's had to start all over and hold its own against referential texts; see Barbara Fuchs, *Mimesis and Empire: The New World, Islam, and European Identities* (Cambridge: Cambridge University Press, 2001), pp. 13–34.

predecessor, the cult image, was part reverential and part skeptical.

Dosso deployed the Circe tradition, within an Ariostian framework, in order to re-stage an imagined predecessor state of art. He was testing the nature of his own mimetic powers by testing and monitoring versions of a prehistory of art, even a prehistory of Christian art. The enchantress's art figures within the painting as painting's own lost origin, a stronger form of mimetic figuration no longer available to painters. When the classical tradition describes witchcraft as a matter of cosmetic trickery, it is basically saying that the witch employs the same means as the artist. Dosso is testing this equation from the opposite direction. He wonders about whether some more powerful use of images might lie behind art. The painting tests art's role as the potential successor to witchcraft as producer of apparitions.

The new fictional image hardly dared venture out of the elite household, unless it flew on a piece of paper, a print, or a drawing. Such a work was comparing itself to the powerful, efficacious talismans that ancient cultures disposed of. It was comparing itself to indexical images, perhaps, of the sort that a witch or *maga* might manipulate. The efficacious cult image, the notional archaic ground of the secular cabinet picture, is not literally visible in the painting. The painting offers instead a displaced and transformed cult image. The cult image reappears in the guise of the cryptogram on the enchantress's tablet. The tablet is the artifact that matches up somehow with the order of the cosmos and she consults it for guidance. Conceptually it occupies the same space that the crucifix does in pictures of the devout St. Jerome in the wilderness. The cryptogram on the tablet in Dosso's Rome picture combines elements of what appear to be geometric figures with formless doodles or flourishes. The diagram is glossed by various script-like but meaningless marks.[54] The diagram and script on the tablet remember a primordial or cosmic writing, like the numbers and alphabet of *kabbala*, that precedes speech itself. Such writing preceded the hierarchization of cult image and mere artistic painting. The *maga* manipulates a non-representational, mimetic-magical language. The illegible words on the tablet and

on the ground, in the rim of the enclosing magic circle, are material tokens that simply *are* their referents. They are not formed by convention or governed by codes, as our writing is. In fact, the *maga* does not write or paint at all, but instead wields a kind of wand, a wax torch, in her left hand, the non-writing hand. She performs the writing much as a priest activates the Eucharist with a combination of words and gestures. Her own performance is partially carried out *as* writing, in the sense that after igniting the torch—or so one might read her gesture—she will brandish it aloft, replicating the formless pattern inscribed on the tablet, so in effect writing with smoke, inscribing an inscription on air that disappears as soon as it is written but has its effect nonetheless. That ephemeral smoke-writing is not alienated from speech as normal writing and painting are.[55]

The whole scene of art is present in this painting, art now as well as the lost prehistory of art that underwrites it. Dosso's enchantress is the image of the cosmic manipulator who has control of language at a deeper, pre-coded, pre-conventional level. She is a serene and successful version of Albrecht Dürer's *Melencolia I* (1514), an engraving which was obviously one of its models. Dürer's *Melancholy* also sits among her instruments, including a brazier and an incense burner. There is also a dog. She is despondent, for unlike the busy child next to her scribbling on a tablet, she has somehow lost the key to creativity.

On the wall above and behind Dürer's winged figure is a magic square, a tool for divination. Dosso's witch, meanwhile, sits in a magic circle, a protected precinct where her spells will have their effect and where words will leave the realm of the merely symbolic and instead become actions in the world.[56] In her circle she is invisible, just as are—notionally, it would seem—the nude nymphs in the Louvre *Fête Champêtre* by Giorgione or Titian. The three soldiers in fancy dress lounging in Dosso's landscape, already stock figures of northern Italian painting, are unaware of what is happening behind them.[57] The magic circle is an

54. Kristina Herrmann-Fiore, director of the Galleria Borghese, kindly made it possible for me to study the painting at close range. Attempts to make alchemical or geometrical sense of the tablet have not met with lasting success. The book open at the feet of the Washington *maga* is potentially more intelligible.

55. Cf. *Orlando Furioso* 6.38, "Alcina made the ready fish obey / By simple words and by mere magic lore" (*con semplici parole, e puri incanti*).

56. Cf. *Orlando Furioso* 3.21–22, where Melissa summons demons but protects Bradamante by enclosing her within a magic circle. Pico della Mirandola discussed the significance of the magic circle in his treatise *Strix*; see Burke (note 8), p. 37.

57. Felton Gibbons (see note 13, p. 200) argues that the *maga* must be Melissa if the soldiers are so relaxed.

architecture, a temple; the twisting vines on the tree suggest a sacred column; the circle permits her to be outdoors and indoors at once.

The magic circle around the witch is a figure for the picture frame. The frame was a virtual frontier differentiating a fictional from a real world, gathering all the strange forces and phenomena and collecting them inside the frame and leaving the rest of the world on the outside. By retreating inside a frame, art created the idea of its own opposite, a real practical world beyond the frame where things make sense. Art found a social function in the control and domestication of strangeness and unreason by differentiating constantly between fiction and reality. Art drew a distinction between real and fictional worlds and then copied that distinction back into itself as subject matter. That is exactly what happens here: The magic circle reproduces the picture frame *inside* the picture. In doing this, Dosso's canvas is not exceptional, but rather is only making visible the basic structure of every artwork in this period. The new picture frame, even when it does provide support, can never be mistaken for a *mere* structural support. The frame around the enchantress is perfectly square and so puts itself in analogy to the circle on the ground. Dosso's witch in her green laboratory is twice-framed.

The most important of the work's own notional origin points is most carefully disguised, namely the Christian image.[58] The sacred image is present only as a *disfigured intertext.* The true subject of the picture is the nature of that disguising through disfiguration. Witchcraft had become an occasion to reflect on latency, that is, on the doubled or layered structure of the artwork.[59] It is through disguising and disfiguration that the artwork, the newly institutionalized cabinet picture, worked its countermagic against the cult image: not a disenchantment, but a counterenchantment.[60]

Dosso's picture transforms a basic template or pattern of Christian painting, the *Madonna and Child in a*

Landscape. Dosso's witch takes the pose of a seated Virgin Mary in a landscape, perhaps in a *hortus conclusus.* She resembles the Virgin but is not her, in the same way that the magical writing on the ground resembles real writing but is not. Even the effigies in the tree reinforce the Marian thematics of the painting, for their hands are pressed together as if praying to the interceding Virgin for release.

If Dosso's witch is built on a Marian template, then by a principle of commutation the painting also allows the sorceress to flow back into the Virgin Mary and inhabit her. The painting excavates the witch-like layers latent within the Marian myth. The pagan thematics of the beautiful but deceptive surface were already negatively inscribed into the personage of the Virgin Mary, for Mary was the one woman whose beauty did *not* deceive. The picture works backwards and discloses the pagan and magical dimensions of the Christian figure.[61] The proposition is less outlandish if one considers the *Madonna and Child in a Landscape* by Dosso Dossi in Parma, commonly called the *Zingarella* or "Gypsy" on account of her orientalizing turban and the enchanted, fairy-tale atmosphere generated by the crumbling phosphorescent paint and the eery isolation of the figures in the landscape (fig. 8).[62] The Parma picture is the product of a transcoding; that is, an intersplicing of two unrelated codes: orthodox Marian and "romantic" or Giorgionesque.

But the excavation of the picture's intertexts has only just begun, for the picture is governed not only by the myth of the Virgin Mary, but even more particularly by the image of the Holy Family in the Landscape, the so-called Rest on the Flight to Egypt. The Ariostian subject comes to look increasingly like a decoy. Dosso's picture takes the Holy Family in the Landscape, disassembles it, breaks it down, and then reassembles it into a new picture. In doing this, Dosso extends the challenge thrown down by vernacular devotional literature to the Church's discursive monopoly on the

58. The elite beholders of the painting and readers of Ariosto's poem were not necessarily much worried about the epistemology and theology of witchcraft. They were naturally concerned about the Christian cult image, however, whose legitimacy was the most pressing possible public issue in these decades, not least in Ferrara, which was one of the centers of reformist or crypto-Protestant thought in Italy. That is to say, the sorts of discriminations that Dosso makes within his picture between one sort of magic and another may be functioning, just below the surface, as discriminations between one sort of religious image and another.

59. See Anselm Haverkamp, *Figura cryptica: Theorie der literarischen Latenz* (Frankfurt: Suhrkamp, 2002).

60. Cf. the concept, familiar to inquisitors, of the diabolical "countersacrament," Walter Stephens (see note 31), p. 198.

61. Cf. Renate Lachmann on the aesthetic "fission" of the individual, with implications far wider than her local subject, in *Memory and Literature: Intertextuality in Russian Modernism* (Minneapolis: University of Minnesota, 1997), p. 298: "The history of literature . . . can be read as a history of how dual beings have been split apart and tamed."

62. See Humfrey and Lucco (note 13), no. 7, pp. 110–113; Lucia Fornari Schianeti and Sylvia Ferino-Pagden, *Parmigianino e il manierismo europeo,* exhibition catalogue, Parma (Milan: Silvana, 2003), no. 1.12, pp. 161–162. The veil held over the Child derives from Raphael's *Madonna of Loreto* in Chantilly.

Figure 8. Dosso Dossi, *Madonna and Child* ("*La Zingarella*"), ca. 1513–1514. Oil on panel, 50 x 34 cm. Parma, Galleria Nazionale. Photo: Archivio Fotografico Soprintendenza PSAE di Parma e Piacenza.

Christian myth.[63] Vernacular retellings of the scriptural story expanded the spare narrative into a spatial dimension, giving the characters space to rest and unfold. Cultic painting followed by insinuating more and more subjects into the repertoire. The Rest on the Flight to Egypt was not an old subject but one that emerged only in the end of the fourteenth century and

flourished almost exclusively in northern Europe.[64] On the way to Egypt, traditionally, the little family rests like gypsies in a green spot; the Virgin Mary holds her child-god with Joseph in close attendance, or tending to

63. See the imaginative comments on this topic by Walter Seitter, *Distant Siegfried-Paraphrasen* (Berlin: Merve, 1993), p. 26 and passim.

64. Louis Réau, *Iconographie de l'art chrétien,* vol. 2 (Paris: Presses Universitaires Françaises, 1957), part 2, pp. 278–280; Gertrud Schiller, *Ikonographie der christlichen Kunst,* vol. 1 (Gütersloh: Mohn, 1966), pp. 132–133. Dosso's *Holy Family in a Landscape,* ca. 1516, in the Uffizi, was one of the earliest Italian versions; Humfrey and Lucco (see

household tasks. In the background, sometimes, a pagan idol topples from a column. Joseph, father to a child he has not fathered, is often a slightly ridiculous figure.[65] He is an older man who protects his young bride and her son but at the price of humiliation. The subject of the Holy Family discloses some of the paradoxes of Christianity, the religion where the abject and infantile is brought into such close proximity to the ideal and where ugliness and humiliation are so close to beauty. Dosso has simply taken the proleptic or foreshadowing structure of the traditional Christian image and pushed it further, literalized it, pulling apart the Holy Family and dispersing its components in a new picture. He has created an *anagram* of a Holy Family, just as if he had taken a word and recomposed its letters to form a new word. In this painting, faithful Joseph has become the dog, a mute, helpful, shaggy, grey presence who looks in wonder at the shining armor just as he had peered naively at the glittering gifts of the Magi who had travelled from the East to honor the birth of the Christ Child. Mary in this painting reasserts her original station outside of matrimony, the posture of permanent estrangement from the body of man that she had in fact maintained throughout her strange marriage to Joseph. In this she was witch-like, for fundamental to the folklore of the witch, and later the judicial description of the witch, was her alienation from marriage.[66]

In the thirteenth-century Austrian retelling of the story *Das Kindheit Jesu*, Joseph accuses Mary, when he is confronted with the fact of her pregnancy, of deception, trickery, and sexual mischief.[67] Mary and her deceitful handmaidens, for doubting Joseph, are untrustworthy sorceresses, complicit with supernatural forces.[68] In the

painting, Mary has abandoned her docile role and donned gaudy clothes. She reasserts the literal meaning of costume as an option, a way, a mere custom. She literally travesties the Madonna, who like other holy personages was identifiable in paintings mainly on the basis of costume and other accoutrements. The Rome enchantress is apparently the inverse of the nude figures in Dosso's Washington picture or the German prints and drawings. But in this respect these images are in fact equivalent: nude or splendidly bedecked, either way it is not Mary anymore. This is made clear by Dosso's *Venus and Cupid,* a recent attribution.[69] The picture is labelled by Cupid's wings and the obscure figure of Vulcan in the background, but in effect it is a nude *Madonna and Child in a Landscape*. The witch seduces through a treatment and ornamenting of her own body that runs directly against social convention, either through nudity—the inappropriate revelation of the body—or through fantastic costume and luxurious, superfluous materials. Her self-ornamentation turns the cosmos upside down, just as the soft woman masters the hard, armored soldier.[70] The "social" person always stays in costume. The witch's power over her male victims is symbolized by her ability to disrobe and desocialize him. The embroidered cloth draped on her lap is in fact an article of clothing, with a sleeve and a collar, but it is not her own robe. It belongs to the unfortunate soldier; perhaps it is the robe of silk and gold that the witch Alcina wove for Ruggiero with her own hands (7.53).[71]

This *maga* is equally a mimic inversion of, and a rival to, the three eastern kings who travelled to acknowledge the birth of the new king, magicians who voluntarily subordinated their magic to religion.[72]

note 13), no. 14. David Rosand remarks that Giorgione's *Tempesta* and other "pastoral" compositions "are almost secular variations on the Rest on the Flight into Egypt"; "Giorgione, Venice, and the Pastoral Vision," in Robert C. Cafritz, *Places of Delight: The Pastoral Landscape* (Washington, D.C.: Phillips Collection, 1988).

65. The resemblance of the traveling Holy Family to a family of gypsies was brought out by Martin Schongauer's engraving of a nameless wandering family projected onto the subject of the Flight to Egypt (1470s); see *Le Beau Martin: Gravures et dessins de Martin Schongauer* (Colmar: Musée d'Unterlinden, 1991), no. G4, pp. 254–255. On Joseph's marginalization, see Albrecht Koschorke, *Die Heilige Familie und ihre Folgen* (Frankfurt: Fischer, 2000), pp. 30–37.

66. Walter Stephens (see note 31), ch. 11.

67. Seitter (see note 63), pp. 26–56. Cf. Koschorke (see note 66, p. 20), pointing out that the name Gabriel means "my husband is God."

68. Koschorke (see note 65), p. 61. On the possible witch-like attributes of St. Anne in early sixteenth-century German culture, see Jean Wirth, "Ste Anne est une sorcière," *Bibliothèque d'humanisme et Renaissance* 40 (1978):449–480. Although Wirth proceeded from a

reading of a woodcut by Hans Baldung that Leo Steinberg later contested (*The Sexuality of Christ in Renaissance Art and in Modern Oblivion* [New York: Pantheon, 1983], pp. 6–8, 117), many of his suggestive theses hold up. Cf. Dosso's own *Holy Family* in the Royal Collection, with a weirdly horned and glowing Mary; Humfrey and Lucco (see note 13), no. 37, pp. 200–202.

69. Private collection. Humfrey and Lucco (see note 13), no. 29, pp. 179–180.

70. The proximity of armor to naked flesh is explored in the *Battle of Orlando and Rodomonte* at the Wadsworth Atheneum in Hartford, attributed by some to Dosso, by others to Battista Dossi; the only work by either brother unambiguously illustrating Ariosto. Humfrey and Lucco (see note 13), no. 50.

71. See Kristina Herrmann-Fiore's entries on the picture in *Il museo senza confini: Dipinti ferraresi del Rinascimento nelle raccolte romane* (Milan: Motta, 2002), no. 8, pp. 132–134; and *Un rinascimento singolare: La corte degli Este a Ferrara* (Milan: Silvana, 2003), no. 180, p. 257.

72. On the possibility of a "female Magus" and on the "femininity" of the Magi, see Richard Trexler, *The Journey of the Magi: Meanings in*

Dosso's Mary has recanted; the picture is her palinode. She desecrates the Christian chalice, vessel of the blood of Christ, by burning herbs in it. In her arms she holds not her child but a tablet. She has sent her child up to the tree, to join the others, completing the work of murder that the family had just escaped in Bethlehem and predicting the Crucifixion. Here Mary already sits below the Cross as she does in so many pictures of the Crucifixion or Lamentation. On her lap is not the body of her Son, but merely his seamless robe. Christ is the soldier she has disrobed and de-socialized. In a few moments the three soldiers in the background will gamble for it by throwing dice.

Cesare Gnudi wrote of the circle-based structure of this picture that brings it into alignment with the creations of Bramante and Raphael.[73] But it has come to look more like a parody of a harmonious man-cosmos relationship; or worse, it suggests that *only* the witch can enjoy such a relationship with nature.

The painting is an anagrammatic dispersal of a Rest on the Flight. But the painting also reveals that the conventional Rest on the Flight to Egypt was itself only ever an anagram of a Lamentation beneath the Cross. An anagram is the rearrangement of the letters of a word to form a new word. To make an anagram is to extract a word from a context of meaning and instead consider it as pure signifier. The rearranged letters make a new signifier. This rearrangement creates a new context. In the framework of the anagrammatic play, both versions of the word, both combinations, are equal. The words' reference to reality, their signifying function, is momentarily—though not irremediably—suspended.[74]

The commutativity between Christian subject matter and its exact opposite was increasingly a theme in these years. Vasari, in his anecdote about Rosso's diabolical angels (see above), attributed the switching to a beholder's philistinism. But such reversals were in fact cultivated by painting as it tried to keep pace with life and bring new domains of experience into the condition of representability. Pontormo's Carmignano *Visitation*

(ca. 1528) adapted Dürer's *Four Witches* engraving (figs. 9, 10). Bronzino's uncanny *Allegory with Venus and Cupid* in the National Gallery in London parodically overturned Raphael's *Holy Family of Francis I* in the Louvre.[75] Art kept trying combinations until magic met its match.

The proximity of holy and unholy was equally a theme of the discourse on witchcraft. The witch was the mocking mirror of the lay holy woman, the living saint who won adherents through spectacular self-denial, ecstasies, demonstrations of clairvoyance, or thaumaturgic powers.[76] In the era of the witch, the female lay saint fell instantly under suspicion. Biographies struggled to draw distinctions and refute accusations. Remarkably, the inquisitors and witch-scholars themselves were often closely involved with the holy women. Pico della Mirandola wrote a biography of a lay saint, Catherine of Racconigi, and his *Strix* dealt explicitly with the homology between witch and saint. The Mantuan inquisitor Domenico of Gargnano was in contact with several living saints.[77]

Dosso's refined anagrammatic play, a diabolical combinatory magic, relativized the powers of the witch whose very reality had never been decisively demonstrated. His painting took possession of the whole myth of witchcraft, the collective construction and the performance of the prosecutorial narrative, by reproducing that performance in a removed artistic sphere. Like the narrative put into the mouths of the victims, his picture disclosed the forces of disorder supposedly latent below a serene surface. In this way the picture brought out the fragility, conditionality, and performed quality of the Marian ideal of womanhood as it was retailed both by the traditional sacred image and the prosecutorial narrative. The painting equally relativized the magical efficacy of the Christian image, a power whose theological necessity and orthodoxy had never quite been established. It smoothed out the

History of a Christian Story (Princeton: Princeton University Press, 1997), pp. 107–118.

73. Gnudi (see note 51), p. 20.

74. See the essay by Paul de Man on Saussure's "hypograms" and their transformation in the poetics of Michael Riffaterre, exploring the tension between rigorously formalistic and more semantically replete—that is, approaching simple intertextuality—versions of anagrammatization; "Hypogram and Inscription," in de Man, *The Resistance to Theory* (Minneapolis: University of Minnesota Press, 1986), pp. 27–53.

75. Leatrice Mendelsohn, "L'Allegoria di Londra del Bronzino e la retorica di Carnevale," in Monika Cämmerer, ed., *Kunst des Cinquecento in der Toskana* (= *Italienische Forschungen, Kunsthistorisches Institut in Florenz*, vol. 17) (Munich: Bruckmann, 1992), pp.152–167, here p. 157. Others have noted the connection, but Mendelsohn stresses it and reads it as a carnivalesque or burlesque moment.

76. On this topic, see fundamentally Zarri (note 40), esp. pp. 244–248, and André Vauchez, *The Laity in the Middle Ages: Religious Beliefs and Devotional Practices* (Notre Dame and London: University of Notre Dame Press, 1993), esp. ch. 18.

77. Zarri (see note 40), pp. 244–245.

Figure 9. Jacopo Pontormo, *Visitation,* ca. 1528. Oil on panel, 202 x 156 cm. S. Michele, Carmignano. Photo: Scala/Art Resource, N.Y.

Figure 10. Albrecht Dürer, *Four Witches,* 1497. Engraving, 19 x 13 cm. Photo: Christopher S. Wood.

apparent gradient between the cult image and the fictional image. A modern, fictional painting such as Dosso's proposed a myth of a prior, more effective sort of picture whose powers derived from its ability to capture the true image of the divinity. It then refuted the very myth it had just offered by working a countermagic, a better magic, on the prior picture. The painting makes mimetic magic available again as a second-order phenomenon, by offering intertextual combinatorics as a mimicry of mimesis itself. By mimicking the mimetic image, the artwork took possession of it.[78] The painting does not really regret the loss of confidence in the efficacious cult image or the enchantress's talisman. Rather, it embeds the cult image or talisman inside itself,

sending the powerful message that the cult image is only ever available from a vantage point inside the fictional work of art. It shows how an image-magic might work if it had ever existed. That is not the usual account of the disenchantment process.

78. Cf. Taussig (see note 18), pp. 59–62.

The demotic Campidoglio

Ritual, social unrest, and a case of wizardry

CHARLES BURROUGHS

The magnificent reshaping of the Roman Campidoglio in the sixteenth and seventeenth centuries launched an enduring paradigm for princely architecture (fig. 1). The overall conception, embracing three palaces and the piazza between them, was the work of Michelangelo, who devised mighty pilasters to articulate the matching façades of facing lateral palaces, the Palazzo dei Conservatori and the Palazzo Nuovo. Rising through two stories, these pilasters are pioneer examples of the so called colossal (or giant) order, a motif that would become an architectural emblem of absolutist rule throughout Europe (fig. 2).[1] There is some irony in this, for both before and after its sixteenth-century renovation, the Palazzo dei Conservatori was the seat of Rome's municipal government, its "city hall." The transformation of at least the front of the building was envisaged ca. 1537, that is, in a period of enthusiasm for the revival of the venerable privileges and rights of the Roman municipal government;[2] the triumphalism of the project, then, was by no means inconsistent with its civic character.[3] However, the physical reconstruction of

the palace, including the erection of the façade, did not begin until 1563. This delay has provoked considerable scholarly debate about the date of the design, which influential recent commentators have associated with the building campaign rather than the initial planning.[4]

The implications are important. In formal terms, the result has been to emphasize the undoubted classicism of the palace architecture, which indeed evoked the lost temples of the Capitoline Hill as well as the plentiful surviving examples of architectural *romanitas* in the nearby Roman Forum (crucial hybrid and heterodox elements, by contrast, have gone largely unnoticed). In ideological terms, the deferral of the project by over two decades associates it firmly with papal agendas and policies, locating it within a milieu transformed by the Counter Reformation, that is, by far-reaching administrative and cultural changes either localized

1. Arnaldo Bruschi, "Michelangelo e l'invenzione dell'ordine gigante," *Storia Architettura* 4 (1979):7–28. In Rome itself, an especially important and influential (but toned down) version of the colossal order appears in the Palazzo Chigi Odescalchi, designed by Gian Lorenzo Bernini in clear homage to Michelangelo's design.

2. On October 23, 1537, the municipal council elected to fund the *magnificentia* of the Palazzo dei Conservatori with an annual subvention of 1000 *scudi*. A committee (*deputati super fabrica platea et palatii Conservatorum*) was appointed to see to the execution of the decision. The original members were Raimondo Capodiferro, Angelo del Bufalo, and Pietro dei Massimi, who were joined in the following month by the pope's close associate Latino Manetti (in his capacity as *maestro delle strade*, Manetti had recently served with Angelo del Bufalo). In a meeting of November 23, the committee chose Mario Maccarone *soprastante alla fabbrica della piazza e del palazzo*, implying the existence of a plan embracing both. See Pio Pecchiai, *Il Campidoglio nel Cinquecento sulla scorta dei documenti* (Rome: Ruffolo, 1950), pp. 36–38. On republican sentiment at this time, see below.

3. For the notion of "triumphalism" in relation to sixteenth-century Roman politics and visual culture, see Loren Partridge, "Triumphalism and the Sala Regia in the Vatican," in "*All the World's a Stage . . .*": *Art and Pageantry in the Renaissance and Baroque,* vol. 1, ed. Barbara Wisch and Susan S. Munshower, (University Park, Penn.: Penn State University Art History Department, 1990), pp. 22–81.

4. The literature on the Campidoglio is, of course, immense. The key proponent for dating the Palazzo dei Conservatori design, *in toto,* to 1563, is Andrew Morrogh. See his "The Palace of the Roman People: Michelangelo at the Palazzo dei Conservatori," *Römisches Jahrbuch für Kunstgeschichte* 29 (1994):129–185, especially pp. 178,183. Here, Morrogh clearly opposes, without citing it, my argument in Charles Burroughs, "Michelangelo at the Campidoglio: Artistic Identity, Patronage, and Manufacture," *Artibus et Historiae* 28 (1993):85-111. Morrogh's view is shared by Bruno Contardi, "Il progetto di Michelangelo," in *Il Palazzo dei Conservatori e il Palazzo Nuovo in Campidoglio: momenti della storia urbana di Roma,* ed. Maria Elisa Tittoni (Ospedaletto [Pisa]: Pacini, 1996), pp. 51–62, which emphasizes the lack of funding sources in the late 1530s and early 1540s but ignores the political context. The main arguments for an early date are marshaled by James S. Ackerman, *The Architecture of Michelangelo,* rev. ed. (Chicago: University of Chicago Press, 1986), pp. 136–153. In my view, a crucial circumstance in support of my argument is the echo of the Capitoline colossal order on the exterior of St. Peter's: The date of Michelangelo's design for this is not certain, though by 1547 there was a model in existence that presumably included an exterior solution. See the entry by Henry Millon and Craig H. Smyth in *The Renaissance from Brunelleschi to Michelangelo: The Representation of Architecture,* ed. Henry A. Millon and Vittorio Magnago Lampugnani (New York: Rizzoli, 1994), pp. 650–651 no. 373. Finally, in the 1550 edition of his biography of the artist, Vasari mentions "il disegno del Campidoglio"; see Giorgio Vasari, *La vita di Michelangelo nelle redazioni del 1550 e del 1568,* vol. 4, ed. Paola Barocchi (Milan: R. Ricciardi, 1962), p. 1483.

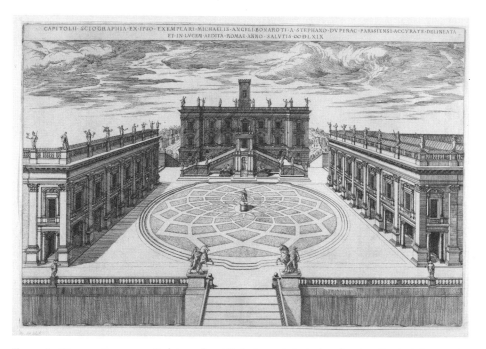

Figure 1. Etienne Duperac, Etching after Michelangelo's design for the Capitol Square in Rome, Italy, 1569. Graphische Sammlung Albertina, Vienna. Photo: Erich Lessing/Art Resource, N.Y.

in Rome or, if of broader scope, with important implications for the city. Attitudes and presumptions also changed, not least on the part of the aging Michelangelo, whose own political concerns of the 1530s had given way to an intense and exclusive piety long before construction began on the Palazzo dei Conservatori in 1563.[5] He died the following year, at the age of eighty-nine.[6]

In an earlier article on the façade architecture of the Palazzo dei Conservatori, I argued that certain subsidiary, but far from inconspicuous, elements constituted a key semantic as well as formal dimension of the design (fig. 3). Accepting a date in the later 1530s for at least the main features of Michelangelo's design for the façade, I maintained that these elements subtly injected a demotic and even "carnivalesque" note into the design, not only through a generalized grotesque character often found in Michelangelo's work, but also

5. I have discussed elsewhere Michelangelo's political alliances in the mid-1530s and his later adoption of a pietistic outlook; see my article "The *Last Judgment* of Michelangelo: Pictorial Space, Sacred Topography, and the Social World," *Artibus et Historiae* 32 (1996): 55–89. A key figure for Michelangelo after his final departure from Florence was the noted Florentine political theorist Donato Giannotti (1492–1573). Having served as secretary of the supreme council of the short-lived Florentine republic, Giannotti escaped to Rome in 1530 following the return of the Medici to power. In his major political work, *Della repubblica fiorentina* (written between 1531 and 1538), he reflected on the reasons for the collapse of Florentine republican government in the past and the prospects for its future success. See Giorgio Cadoni, "Ancora sulla *Republica Fiorentina* di Donato Giannotti: per una cronologia delle varianti d'autore," *Storia e Politica* 19 (1980):1–27; Alois Riklin, "Donato Giannotti: Ein verkannter Vordenker der Gewalten-Teilung aus der Zeit der Florentiner Renaissance," *Zeitschrift für Neuere Rechtsgeschichte* 14 (1992):129–

161. Michelangelo produced his only explicitly political work, the bust of Brutus (ca. 1538), during the period of his association with the Florentine exiles around Gianotti, see Vasari (note 4), vol. 5, p. 1792; Joachim Poeschke, *Die Skulptur der Renaissance in Italien,* vol. 2, *Michelangelo und seine Zeit* (Munich: Hirmer, 1992), p. 118. Michelangelo's spiritual (and artistic) development under the influence of Vittoria Colonna has been much discussed; see, for example, Claudia Gerken, "Die *Pietà* im Oeuvre Michelangelos: Meilensteine in der Entwicklung eines Motivs am Beispiel zweier Blätter aus der Graphischen Sammlung der Albertina," *Wiener Geschichtsblätter* 54 (1999):220–234. See also Emidio Campi, *Michelangelo e Vittoria Colonna: un dialogo artistico-teologico ispirato da Bernardino Ochino* (Turin: Claudiana, 1994).

6. Michelangelo was born in Florence in March 1475; he died in Rome in February 1564.

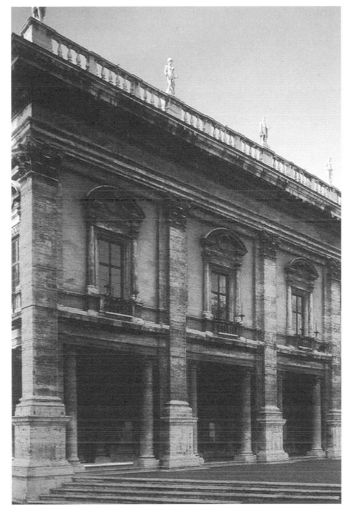

Figure 2. Palazzo dei Conservatori, Campidoglio, Rome. Façade detail. Photo: Charles Burroughs.

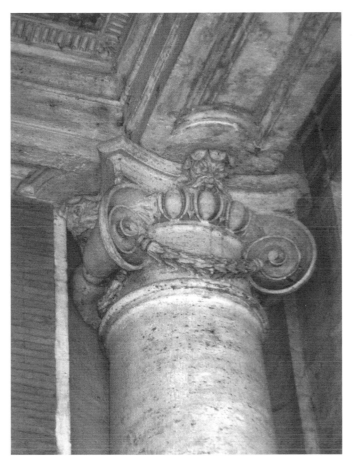

Figure 3. Palazzo dei Conservatori, Campidoglio, Rome. Portico detail: ionic capital with satyr mask. Photo: Charles Burroughs.

by alluding specifically to certain contemporary associations and functions of the site and the building itself.[7] Subsequently, it has become clear that the Campidoglio was itself a setting for certain festivities of carnival, in a way that is certainly suggestive for any attempt to elucidate the more unorthodox elements of Michelangelo's design for the façade of the palace as well as the contrast instituted within the overall composition between these and more orthodox elements. Whatever their significance for the shaping of

the physical environment, the celebrations of carnival on the Campidoglio were of great importance in the ritual calendar of Rome until their disappearance around the middle of the sixteenth century. The study of these rituals and of their significance, however, is hampered by the almost complete absence of references—not to speak of descriptions or representations—in contemporary sources, implying a clear bias in the historical record that, unfortunately, has been enshrined in most modern scholarship on the Renaissance city.

This is all the more remarkable as the Roman carnival itself has attracted the attention of historians and others. Much has been written, for instance, about the gory massacre of bulls that constituted the traditional culminating event of the carnival festivities, but which apparently, like the rituals performed on the

7. Burroughs (see note 4), pp. 85–111.

Campidoglio, fell victim to the Counter Reformation. The killing of the bulls was a great spectator event, attracting viewers from far afield; the rituals on the Campidoglio, in contrast, were intended for a relatively local audience that was nevertheless also markedly diverse, in view of the relatively broad-based participation of citizens of different social status. Though centered on the Capitoline Hill, the rituals were also distributed in neighborhoods throughout the city, instituting a topographical as well as social and symbolic link between the intense life of the streets and markets and the space of government high above it.

The markedly demotic aspect of the Capitoline rituals may lie behind the silence about them in the sources as in the scholarship. A further factor is the scarcity of diaries and similar documentation of everyday lives written by Roman citizens, as well as the ordinariness, in general, of the annual rituals themselves, familiar events to every Roman. In this article, I propose to explore a unique and far more richly documented and extraordinary incident: a case of wizardry that spurred a riot that briefly engulfed the Campidoglio itself, emptied its prisons, and marked communal memory of the site. The social world conjured by contemporary accounts of the events and the reactions to them (even as far away as Venice) is remarkably distant from the usual image of Renaissance Rome; at the same time, it is in many ways profoundly puzzling. A key consideration in any attempt at an explanation, I will argue, is the assured familiarity of the incident's protagonists and audiences with carnival festivities, especially those involving the Campidoglio. As many readers will recognize, my procedure is greatly indebted to the celebrated "thick description" pioneered by the anthropologist Clifford Geertz.[8]

The incident in question took place in the hot, plague-ridden August of 1522, several years before Michelangelo's involvement with the Campidoglio, though echoes of the incident surely lingered and affected attitudes for years to come. The situation was made worse by political and economic uncertainties following the death of Pope Leo X de' Medici, which ended a pontificate noted for lavish patronage. Leo's popularity in the city as well as in court circles was manifested by a vote of the city council to honor him

posthumously with the first papal statue ever set up on the Campidoglio, the site of municipal administrative bodies and a symbol of local aspirations to autonomy.[9] Within strict limits, the papal regime tolerated—and made use of—the municipal institutions, notably the governing council and the paired chief officials (*conservatori*) housed in the eponymous palace on the upper floor, above the premises of several trade guilds. The other main secular building on the Campidoglio, the Senator's palace, sheltered important law courts; it had carried the papal arms since at least the mid-fifteenth century.[10]

As an elected monarchy, the papacy regularly experienced succession crises. The period between the death of a pope and the coronation of his successor (*sede vacante*) offered a political vacuum that the normally vulnerable but comparatively permanent municipal authority was well-placed to fill and that emboldened citizens to frame demands for the recovery of a lost role in government.[11] Leo's death was followed by an especially long and difficult interregnum. At the time of his election, Leo's successor Hadrian VI was in Spain, and it took several months (from January to August 1522) for him to travel to Rome to accept the tiara.[12] Few in Rome looked forward to the arrival of the new pope, a severe Dutchman elected largely through Habsburg pressure. Meanwhile, plague, factional conflict, and random violence were raging in Rome, driving out many of its inhabitants; according to Baldesar Castiglione, the city resembled a plundered abbey (*una abatia spogliata*).[13] It was in this climate of

8. Clifford Geertz, "Thick Description: Toward an Interpretative Theory of Culture" and "Deep Play: Notes on the Balinese Cockfight," in his *The Interpretation of Cultures* (New York: Basic Books, 1973), pp. 3–20, 412–453 (for the latter article, see also http://webhome. idirect.com/~boweevil/BaliCockGeertz.html).

9. The statue was installed in 1523; see Maria dell'Era, "Storia e istituzioni 1471–1523," in *Il Campidoglio all'epoca di Raffaello*, ed. Giorgio Muratore (Milan: Electa, 1984), p. 15.

10. Charles Burroughs, *From Signs to Design: Environmental Process and Reform in Early Renaissance Rome* (Cambridge, Mass., and London: MIT Press, 1990), p. 27.

11. See, in general, Laurie Nussdorfer, "The Vacant See: Ritual and protest in early modern Rome," *Sixteenth Century Journal* 18 (1987):173–190. Following the death of Paul III, for example, the *conservatori* took the place of the Senator (normally a non-Roman professional jurist); Arturo Bassotti, *La magistratura capitolina dal secolo XIV al secolo XIX con speciale riferimento al Senatore di Roma* (Rome: Ugo Pinto, 1955), p. 31.

12. Hadrian was at Vitoria in the Basque country when he heard the news of his accession on January 24, 1522. He arrived in Rome at the end of August. See Ludwig von Pastor, *The History of the Popes from the Close of the Middle Ages*, vol. 9, ed. Frederick I. Antrobus (St. Louis: Herder, 1950), p. 44.

13. In Rome, there was "unparalleled confusion" in January, with considerable social unrest; the situation deteriorated even further when plague broke out. See Pastor (note 12), vol. 9, p. 51. For Castiglione's remark, see ibid., p. 66.

unrest that the famous "speaking statue" of Pasquino, often identified as Hercules, became a focus of political dissent.[14]

At such a time people naturally turned to supernatural remedies, some official (such as penitential processions),[15] others involving marginalized practices, including "sorcery." A certain Demetrios, identified in the sources as a Greek and as a wizard, presented himself to the local authorities with an offer to rid the city of pestilence.[16] The offer was accepted, and Demetrios set out to scour the city and adjoining areas in search of a well or source of water with at least potential healing power, eventually selecting a *fontana* located "three miles" from the Campidoglio. This detail is important, for it establishes the setting for the discovery by Demetrios of a wild black bull. Three miles from the Campidoglio puts the encounter well beyond the city walls in a notoriously rough, wild area that perhaps evoked for contemporaries the scenery of popular chivalric stories in which such a landscape, sometimes expressly associated with wild bulls, constitutes the antithesis of the idealized settled order of the city.[17] Demetrios used magical incantations to tame the bull, which he then led from its savage lair to the edge of the city. Here he relaxed the charm, allowing the bull to revert to its original wild state. He then handed over the bull to a group of local men, who struggled to control it but were nevertheless able to drag the bull through no fewer than five city gates.

The movement of the bull and his handlers from gate to gate required a perambulation of much, if not all, of the city itself.[18] It echoed—or parodied—the city's legendary foundation rite as transmitted by Plutarch and other sources: Under the sign of Taurus, Romulus hitched bulls to a plow to drive the sacred furrow marking and symbolizing the city's walls.[19] It is significant, therefore, that it was not the Greek who marched the bull around the city, but rather a group of local men. Subsequently, Demetrios renewed his spell and paraded the bull, once again docile, into the city. As the sources emphatically specify, he led it by a piece of string attached to its horns, a detail that emphatically demonstrates the wizard's power over an animal symbolizing, and potentially embodying, the force of nature.[20] At the same time, it was perhaps especially provocative to the authorities, for the thin string drew attention to the illicit character of Demetrios's control of the bull, in that the use of incantations to tame a wild animal was recognized and condemned as sorcery.[21]

14. Pastor (note 12), p. 66; Peter Partner, *Renaissance Rome 1500–1559: Portrait of a Society* (Berkeley: University of California Press, 1979), p. 202.

15. Among other measures, a grand procession of penitents marched through the city, carrying sacred images; see Luigi Fiorani, Giuseppe Mantovano, Pio Pecchiai, Antonio Martini, and Giovanni Orioli, *Riti, cerimonie, feste e vita di popolo nella Roma dei papi* (Rome: Cappelli, 1970), p. 170.

16. Henry C. Lea, *Materials Toward a History of Witchcraft*, vol. 1, ed. Arthur C. Howland, introd. George L. Burr (New York: T. Yoseloff, 1957), p. 407.

17. Jacques Le Goff, "Levi-Strauss in Brocéliande: a brief analysis of a courtly romance" in his book *The Medieval Imagination*, trans. Arthur Goldhammer (Chicago: University of Chicago Press, 1988), p. 120. The wildness of the countryside around Rome, and even its spread into the city, is a topos of early descriptions; see Charles L. Stinger, *The Renaissance in Rome*, rev. ed. (Bloomington: Indiana University Press, 1998), p. 15.

18. Marino Sanuto, *I diarii di Marino Sanuto*, vol. 33, ed. Rinaldo Fulin, et al. (Venice: Visentini, 1879–1903), p. 403. See appendix A.

19. On the foundation rite, see Joseph Rykwert, *The Idea of a Town: The Anthropology of Urban Form in Rome, Italy and the Ancient World* (Princeton, N.J.: Princeton University Press, 1976), p. 126 (the source is Plutarch's *Life of Romulus*). By the late sixteenth century, a link was established between the birthday of Rome, Romulus's bulls, and the *meta Romuli;* see Philip J. Jacks, "A sacred Meta for pilgrims in the Holy Year 1575," *Architectura* 19 (1989):150. The foundation legend was also associated with Hercules; a coin minted by Commodus shows the latter "in fancy dress" as Hercules, and the hero himself, as *conditor urbis,* driving a yoked bull and heifer in the foundation ritual on the reverse; ibid., p. 133, fig. 107. Rykwert, p. 92, also notes the reference in Tacitus (*Annales* 12.24) to a bronze bull in the Forum Boarium commemorating the first furrow, which was laid out so as to include the altar of Hercules, the famous *ara maxima.* There were allusions to bulls in the gates and gate-like structures of the city; in the opening chapter, "On gates," of his compendium of inscriptions in Rome (the *Epigrammata antique urbis* of 1521), Jacopo Mazzocchi, fol. 2r, asserts that the Porta San Lorenzo was called Taurina by the ancients. In his chapter "On aqueducts," fols. 11v/r, he illustrates an arch, flanked by Tuscan columns, with a bull's head as the keystone. On the *Epigrammata,* see in general Armando Petrucci, *Public Lettering: Script, Power, and Culture* (Chicago: University of Chicago Press, 1993), pp. 22ff. I have elsewhere discussed the inscriptions connected to the Hercules cult; see Charles Burroughs, "The building's face and the Herculean paradigm: agendas and agency in Roman Renaissance architecture," *RES* 23 (1993):23.

20. For the *chordula satis debilis* mentioned by Paolo Grillandi, see Lea (note 16), p. 407. There is a remarkable echo of the story of Androcles, who led the lion *tenui loro* through the streets of Rome past applauding crowds to the presence of the emperor (Aulus Gellius, *Noctes Atticae,* 5.14), as represented in a detailed drawing by Baldassare Peruzzi, with an amphitheater in the background, containing a fierce bull! Christoph Frommel, *Baldassare Peruzzi als Maler und Zeichner* (Vienna: A. Schroll, 1968), p. 161, no. 131, dates the sheet to late in Peruzzi's life (he died in 1535).

21. Curing cattle by words alone is an offense listed in the *Malleus maleficarum,* see Lea (note 16), p. 327. The taming of wild beasts by words is regarded as sorcery by Jean Bodin, see William Monter,

Once within the city, Demetrios paraded the bull through the streets, leading it to the river where it spat blood into the water. Eventually he brought it to St. Peter's square in an apparent allusion to a familiar ceremonial occasion, the entry of an important personage into the city, involving passage through a gate and a procession toward the Vatican.[22] As he walked, the wizard read from a book, which is not identified, and he carried a *fazuol*—apparently a kind of shawl—on his shoulders.[23] This strange spectacle attracted a large and admiring crowd but also the suspicious eye of the papal authorities. Before he could reach his eventual goal (the identity of which, of course, can never be known),[24] Demetrios was arrested by the papal authorities and imprisoned, presumably in the dungeons of the Senator's palace on the Campidoglio. There was some urgency for this action, as it was already well into August and the pope's arrival was expected shortly.[25] No doubt there was concern that the austere Hadrian, whose vision of a Christendom unified against schismatics and infidels had already been communicated, would enter a city at peace, free of the turbulence caused by the rivalry of the pro-French and imperialist factions or arising from more local and obscure causes.[26] When Hadrian eventually arrived in Rome, he too exploited the symbolic associations of animals: To universal astonishment, he entered the city on the back of a mule.[27]

The Campidoglio was certainly the site of Demetrios's trial for witchcraft. He was accused of charming the bull "with words"—a charge to which Demetrios boastfully admitted in court.[28] Two major sources are known to me. One is the famous diary, or rather compendium, of the Venetian Marin Sanuto, who wrote to the Venetian ambassador in Rome, Alvise Gradenigo, to secure details about a case that had come to his attention as an item in the regular dispatches from Rome to Venice. He includes the response, unfortunately undated, in his diary (see appendix A).[29] Most of the known details of the case are contained in the ambassador's very full account.

The other major source is a passage in an important but little-known treatise on witchcraft that includes accounts of numerous trials of witches in early

"Bodin on inflation and witchcraft," in *Action and Conviction in Early Modern Europe,* ed. Theodore K. Rabb and Jerrold E. Seigel (Princeton: Princeton University Press, 1969), p. 380, n. 31, citing Bodin's *De la démonomanie des sorciers* (Paris, 1580 and later editions).

22. Maria Antonietta Visceglia, *La città rituale: Roma e le sue cerimonie in età moderna* (Rome: Viella, 2002), p. 192. In general, important visitors entered the city by the Porta del Popolo on the Via Flaminia. Unfortunately, the sources do not specify the identity of the gates traversed by the bull. It is noteworthy that at Florence "le processioni che giravano intorno al centro della città continuarono a insistere per un lungo arco di tempo, con un incredibile precisione, sulla cerchia di mura romana, ignorando successive modifiche della topografia della città"; see Giovanni Ciappelli, *Carnevale e quaresima: comportamenti sociali e cultura a Firenze nel Rinascimento* (Rome: Edizioni di Storia e Letteratura, 1997), p. 277. Ciappelli relates this ritual "beating of the bounds" to ancient purification rituals; this is relevant to Demetrios's concern to rid the city of plague. Rome, of course, as opposed to Florence, was still confined within its ancient wall system.

23. The book and shawl seem highly redolent of Jewish ritual, though there seems no obvious reason for such a connection. It may be relevant that Jews played a conspicuous role in the Roman carnival, as also in the papal *possesso* (the coronation procession), see David Freedberg, "Cassiano on the Jewish races," in *The Paper Museum of Cassiano dal Pozzo,* vol. 2, ed. Jennifer Montague (Ivrea: Olivetti, 1992), pp. 41–56.

24. Bulls or oxen that appeared in public rituals generally did not survive; Demetrios's bull, with its associations with carnival, was surely on its way to be killed and eaten. In fact, there was also an odd association of the killing, eating, and subsequent reconstitution of an ox (which at least then appeared to come back to life) with witchcraft: For occurrences of such a notion in the early sixteenth century, see Maurizio Bertolotti, "The ox's bones and the ox's hide: a popular myth, part hagiography and part witchcraft," in *Microhistory and the Lost Peoples of Europe: Selections from* Quaderni storici, ed. Edward Muir and Guido Ruggiero (Baltimore and London: Johns Hopkins University Press, 1991), esp. pp. 42–44. Bull sacrifice, of course, also had ancient associations: thus Hercules sacrificed a bovine at the time of his foundation of the Roman religious cult, which predated the Romulan city. For knowledge in Rome of ancient sculptures believed to show Hercules sacrificing a bull, see Phyllis P. Bober and Ruth O. Rubinstein, *Renaissance Artists & Antique Sculpture: A Handbook of*

Sources (London: Harvey Miller; and Oxford: Oxford University Press, 1986), p. 85.

25. Pastor (see note 12), p. 66: The "papal vicar" (unnamed) intervened and cut short Demetrios's adventure.

26. As a faithful Catholic, Pastor (see note 12), pp. 49, 51) criticizes the conduct of the all-too-partisan cardinals.

27. Pastor (see note 12), p. 64. This happened on August 28, 1522.

28. Hadrian was known as a stern opponent of witchcraft; this was perhaps a factor in the decision to initiate judicial proceedings against Demetrios, see Pastor (note 12), p. 66, n. 2. During his short reign, Hadrian would issue a number of ordinances designed to curb the activity and influence of *magi.*

29. Sanuto (see note 18), pp. 401–403 (see appendix A; this is the basis of the account of Pastor [note 12, p. 66], who seems unaware of Grillandi). Sanuto includes a letter from the Venetian envoy in Rome, Alvise Gradenigo, who had responded to Sanuto's request for detailed information on a matter mentioned cursorily in a regular dispatch. Gradenigo gives Demetrios's name and says that the business with the bull, which he specifies was black, followed negotiations between the wizard and a committee of Roman patricians appointed to oversee measures to combat the plague. For Sanuto's interest in the unusual, see Andrea Martignoni, "'Era nato uno monstro, cossa horendissima': Monstres et teratologie à Venise dans les *diarii* de Marin Sanuto (1496–1533)," *Revue Historique* 306 (2004):49–80.

sixteenth-century Rome (appendix B). The author was the (or a) presiding magistrate at Demetrios's trial, the celebrated jurist and energetic persecutor of "witches," Paolo Grillandi da Castiglion Fiorentino.[30] Grillandi does not hide his chagrin that, during the night following the first day's proceedings, a socially diverse crowd of Romans—including, we are expressly told, "certain magnates"—attacked the Capitoline prison and released Demetrios.[31] The wizard fled to the country retreat of one of his major supporters, while Grillandi had to make do with burning his magic book. In his treatise, Grillandi extensively documents his energetic persecution of those practicing the magic arts, that is, typically, the use of love philters and spells on the part, predominantly, of female immigrants from peasant backgrounds in the nearby countryside. Needless to say, such activity would fit a familiar early modern pattern of the repression of demotic culture at the hands of an emerging professional elite. Nevertheless, the mixing of classes that so appalled Grillandi was symptomatic of an imbrication of "popular" and learned cultures that endured in Rome and its environs at least into the early

sixteenth century.[32] Indeed, Fabio Troncarelli has eloquently underlined the existence of "a kind of second Rome existing in the shadow of the world of officialdom and respectability but intertwined with it by obscure ties."[33] Needless to say, few studies of "Renaissance Rome" mention witch-hunting in the city and the beliefs that sustained it.[34]

The strange incident of the wizard and the bull raises a number of questions. In the first place, it is surely significant that the notoriously unwieldy and complex judicial apparatus of Rome was itself currently undergoing assessment, and that a key member of the commission was Mario Salamonio degli Alberteschi, a scion of an old Roman patrician who was later to achieve prominence as a protagonist of the revival of republican government.[35] The obviously controversial case of Demetrios perhaps intensified longstanding dissatisfaction with the administration of justice in the city, possibly pitting local interests against magistrates from elsewhere, such as Grillandi—or, to put it another way, opening a rift between the Palazzo dei Conservatori and the Senator's palace. This does not explain, however, the apparent impact of Demetrios's performance on its diverse audiences in ways that had little to do with Demetrios's stated goal, the cessation of plague.

The key is surely the bull and its particular role in the proceedings. There were clearly political undertones:

30. Paulus Grillandus, *Tractatus de hereticis: et sortilegijs omnifariam coitu eorumq[ue] penis.* The first extant edition is that of Giacomo Giunti, Lyons, 1536 (with a further edition in 1545); on Demetrios, see pp. 143–144 (appendix B). The passage is quoted in a translation by Lea (see note 16), p. 407, who states that the work was written in 1525 and was probably published before 1536. Grillandi also wrote on judicial process, if that's the appropriate word, in his *De qvaestionibvs, atque tortura . . .* (Venice: Francesco Ziletti, 1584 and 1586). Grillandi relates a number of cases of which he had direct experience, though he certainly knew and occasionally refers to Sylvester Prierias, *De strigimarum daemonumque mirandis.* This was first published in 1521 in Rome, according to Lea (see note 16) p. 412, and is closely based on the *Malleus maleficarum,* though Prierias also draws on his own experience of prosecutions for witchcraft in Rome, and mentions frequent burnings in that city. In view of the date of Prierias's treatise, it may have helped form attitudes toward Demetrios in the following year. The scholarly neglect of Grillandi and others like him in early sixteenth-century Rome is very striking and has led to such unfortunate pronouncements as that of James M. Saslow, *Pictures and Passions: A History of Homosexuality in the Visual Arts* (New York: Viking, 1999), p. 76: "The fifteenth century witnessed stark contrasts, with Renaissance humanism triumphing in Italy during the decade that the Germans published the first manual for persecution of witches in 1484."

31. It is interesting that in this point, Grillandi's account diverges sharply from that of Gradenigo, who says that the wizard was let go following an appeal made by the Romans to the papal authorities (see appendix A). Gradenigo makes no mention of violence. It is unlikely that Gradenigo was an eye-witness of the events on the Campidoglio, which the authorities may well have wanted to "spin" in a way that played down the degree of unrest.

32. For the general argument, see Giuseppe Bonomo, "Nuove ricerche sulla stregoneria," in *La strega, il teologo, lo scienziato,* ed. M. Cuccu and P. A. Rossi (Genoa: Edizoni Culturali Internazionali, 1986), p. 60. Bonomo emphasizes the prevalence of "superstitious" beliefs and practices in Rome, also among the educated elites, though neither he nor any other contributor to the volume refers to the activity or writings of Grillandi. The experience of Benvenuto Cellini is well known, though in general insufficiently contextualized; see Franco Cardini, "I diavoli al Colosseo," in *La città dei segreti: magia, astrologia e cultura esoterica a Roma (XV–XVIII),* ed. Fabio Troncarelli (Milan: Franco Angeli, 1983), pp. 43–54.

33. Troncarelli (see note 32), pp. 11–12 ("una sorta di seconda Roma . . . che vive all'ombra dell'ufficialità e della rispettabilità, intrecciando oscuri legami con essa").

34. For mention of the persecution of witches in Rome, see Pio Pecchiai, *Roma nel Cinquecento, Storia di Roma,* vol. 13 (Bologna: Cappelli, 1948), p. 398; Lea (note 16), p. 359; Rainer Decker, *Die Päpste und die Hexen: aus den geheimen Akten der Inquisition* (Darmstadt: Primus, 2003), p. 69.

35. Niccolò Del Re, *La Curia Capitolina e tre altri antichi organi giustiziari romani* (Rome: Fondazione Marco Besso, 1993), pp. 47–48. Del Re also notes that a commission of lawyers (led by Mario Salamonio degli Alberteschi) had since 1518 been working on a clarification of statutory legislation issued following the reform of the city's statutes in 1469. The commission's report was published in 1523. On Mario Salamonio's role in the defense of Roman civic privileges, see note 68 below.

Demetrios's feat was evidently regarded as a provocation by the authorities, especially Grillandi, who found themselves challenged to respond to the wizard's ability to galvanize anti-papal resentment in the city, at least in part by cleverly exploiting the symbolic associations of bulls. Some of these associations were centered on the Campidoglio at the point of convergence of the civic festal economy and the city's economic activity, in both of which cattle—bulls—were central. The wealth of the Roman citizen elite came in large part from a far-flung transhumance system. In the fall, cattle and other animals were driven down from distant mountains to grazing areas in the wild territory around the city, and even within, and many were slaughtered at the butchers' establishments scattered through the city.[36]

A closer and more overt link between this economic sector and the Campidoglio was instituted in 1536 when the important toll station (the *dogana di bestiame*) that controlled and taxed the movement of animals was moved to the Forum Romanum, close to the foot of the Campidoglio, following clearances carried out in preparation for the visit of Charles V that year.[37] In her book on the Campo Vaccino, the name by which the Forum was soon to be known, Marlise Hoff suggests economic as well as representational motives, noting that the demolitions opened out "a great communication artery between the countryside and the city center," allowing the country people easier access to the markets of Rome.[38] In particular, of course, the changes benefited those who drove animals into the city, which was heavily dependent on revenues from the trade in

meat and hides.[39] Accordingly, at the very moment when the project of embellishment of the Palazzo dei Conservatori began to take shape, the association of the Capitoline Hill with the transhumance system was given new spatial expression. And there were butchers' stalls nearby: When in the early 1530s Michelangelo himself settled in Rome, he chose to live far from the Florentine quarter (which was close to the Vatican and the bankers' district) but in a neighborhood close to the Campidoglio, the Macel de' Corvi, where, as the street's name suggests, his neighbors included workers in the meat trades.[40]

A place of butchery and of dark superstitions, in short, the Renaissance city, was different indeed from the haunt of enlightened humanists and artists conjured by so many scholars.[41] Indeed, the wild black bull

36. Burroughs, (see note 10), pp. 195–198.

37. Giuseppe Tomassetti, *La Campagna romana antica, medioevale e moderna,* ed. Luisa Chiumenti and Fernando Bilancia, vol. 1 (Rome: Banco di Roma, 1979), p. 119.

38. Marlise Hoff, *Rom: vom Forum Romanum zum Campo Vacchino. Studien zur Darstellung des Forum Romanum im 16 und 17 Jahrhundert* (Berlin, 1987), pp. 21–39. The *dogana* had been at the Torre dell'Inserra, demolished in 1536, which was in front of the Temple of Antoninus and Faustina. Now it was moved to the Torre della Campanara at the Column of Phocas, where a weekly cattle market was held. Hoff (p. 25) also suggests an economic motive on the part of those who owned or bought land in the area; in particular, she notes that a key piece of land was owned by the Capodiferro family, one of whom played a key role early in the Campidoglio remodeling project, as noted above. Nevertheless, Hoff still connects the clearing of the forum too closely with Paul's urbanistic program. Another nearby center of economic activity was the Piazza Montanara, "ai piedi del Campidoglio," where the laborers from the city and the countryside assembled to await recruitment, often for agricultural work; see Giorgio Rossi, *L'Agro di Roma tra '500 e 800: condizioni di vita e lavoro* (Rome: Edizioni di Storia e Letteratura, 1985), p. 147.

39. Klaus Güthlein, "Der 'Palazzo Nuovo' des Kapitols," *Römisches Jahrbuch für Kunstgeschichte* 22 (1985):94, notes that the *gabella della carne* was one of the main sources of revenue of the city government itself. Presumably, then, the buildings of the government were built, at least in part, out of proceeds from meat and skin. In 1526, a new tax imposed on the butchers occasioned open revolt with the butchers enjoying the support of the Spanish community in Rome, suggesting a geopolitical dimension of the affair; see Judith Hook, *The Sack of Rome, 1527* (London: Macmillan, 1972), p. 72. Pope Clement VII backed down and repealed the tax.

40. A *macello* is a butcher's shop or place for slaughtering animals. Michelangelo first lived in the Macel de' Corvi, to which he jokingly referred as the "macel dei poveri," from ca. 1513 to 1517. He returned in August 1532 and kept his major domicile there until his death in 1564. A neighbor, whose daughter was a maid in Michelangelo's house for a short time, was a *pizzicarolo*. See Anna-Maria Corbo, "Documenti romani su Michelangelo," *Commentari* 16 (1965):109. Until the early nineteenth-century construction of a public meat market near the Porta del Popolo, butchers worked and animals were slaughtered throughout the city, see Wheelock Whitney, *Géricault in Italy* (New Haven: Yale University Press, 1997), pp. 74–75.

41. It is striking that there is very little echo in the visual arts of the economic and festal practices discussed in this article. For an observant response, we must wait until the Romantic era and a foreign artist. In 1816–1817, Theodore Géricault lived in Rome, turning his attention, above all, to powerful scenes and incidents of daily life, from public executions to the horse races of the carnival. He also produced images of the driving and killing of cattle, mostly of contemporary inspiration though they include an ancient sacrifice scene. In a splendid drawing and subsequent print, depicting the *bouchers de Rome*, mounted drovers and their dogs struggle to control a surging group of massive bulls. See Whitney (note 40), pp. 71–88; and Lorenz Eitner, "Géricault's first lithograph: a hitherto unrecorded first state of the *Bouchers de Rome,*" *Apollo* 148/441 (1998):33–36. Whitney (note 40), pp. 75–76, describes Géricault's approach as "almost ethnographic," while also connecting his studies of elemental combat between men and beasts with the *giostra a corea* held in the Mausoleum of Augustus following the Feast of the Assumption, a late echo of medieval practices.

encountered by Demetrios may have been understood by contemporary witnesses as symbolizing or even embodying the malady that afflicted Rome, a harsh corrective to any ideal image of the city current among the intelligentsia. It would be inaccurate, however, to draw too absolute a line between the "wizard" and the city's protagonists of high culture. After all, as I will argue, his exploit in 1522 drew on knowledge of ancient legends of the birth of cities and of the crucial place of bulls in those stories; to be effective, moreover, Demetrios's performance presupposed some knowledge of such stories in his audience. Most conspicuously, when the bull was led specifically to and through several city gates ("five gates of the city"),[42] as if marking the perimeter of the city, this surely echoed the foundation ritual of the ancient city, as described in the ancient sources, which involved the use of a plow drawn by bulls to incise a furrow marking out the sacred boundary.[43] Accordingly, it is likely that Demetrios himself was a man of learning, who used the bull to communicate to the learned, as well as, no doubt, to those of little learning.

The echo of the Roman foundation legend is certainly inexact. A much closer similarity obtains between Demetrios's exploit and a story associated with the founding hero of Athens, Theseus.[44] The source is the Life of Theseus by Plutarch (who explicitly associates Theseus and Romulus in parallel Lives). In what was hardly an obscure text to an educated native speaker and reader of Greek, Plutarch recounts Theseus's encounter with the Cretan bull, a beast that is best known as Hercules's antagonist and victim in one of the hero's canonical labors. Rather than killing the bull, however, in Plutarch's account, Hercules lets it go, and it ravages the countryside around Marathon on the mainland. After definitively conquering the bull, Theseus parades it into Athens and sacrifices it to Athena, presumably at her altar on the Acropolis (the Athenian correlate of the Roman Capitol), though this is not specified in the text. With the sacrifice, of course, the parallel with Demetrios ends, because, as noted above, we do not know what the latter planned to do with his bull if his arrest had not prevented him. The likelihood is that the bull was to serve as a scapegoat, and that with its death the plague would also cease; certainly, scapegoating rituals had a long history in Rome, most notably as part of the Roman carnival.[45]

Whether or not Demetrios regarded the bull as a scapegoat, he was surely aware of the carnivalesque associations, for the citizens of Rome, of his obviously carefully considered maneuvers with the bull. It is impossible to exaggerate the importance of carnival in the social and political order as well the ritual calendar of municipal Rome. The nature and sequence of the events of carnival were minutely regulated in the city statutes, which specified two main groups of games (ludi) that extended over several days. The ludi d'Agone chiefly comprised a procession of floats that wound its way from the foot of the Campidoglio to the Piazza Navona (hence the name). Each rione (ward) of the city provided a float, suggesting an emphasis on the civic aspect of the event, though the ludi d'Agone were especially liable to be shaped to accommodate new cultural fashions and papal political agendas. The other major component of carnival was the ludi di Testaccio, so-called because the events of the final climactic day of carnival, usually a Sunday, took place at and around Monte Testaccio, a hill of ancient detritus in the far corner of the walled city. This was the site of a chaotic-sounding but carefully prescribed slaughter of several bulls and pigs, all driven down the hill (the pigs in carts) to the waiting knives of the crowd assembled below.[46]

42. Sanuto (note 18), p. 403. Sanuto's source specifies that it was not Demetrios but a group of Romans that led the bull around the city, and with great difficulty, since the wizard had relaxed his spell. It was apparently important that the refoundation of the city should be enacted by citizens, not by an exotic and eccentric stranger.

43. Rykwert (see note 19), p. 126 (the main source is Plutarch's Life of Romulus).

44. Plutarch, Life of Theseus, ch. 14 (http://www.perseus.tufts.edu/cgi-bin/ptext?lookup=Plut.+Thes.+14.1): "But Theseus, who was eager to go into action and to win over the local people, set out against the Marathonian bull, which was doing great damage in the Tetrapolis region. Once he had brought it under his control, he made a display of driving it alive through the city. Then he sacrificed it to Delphinian Apollo" (my translation). See also Marcel Detienne, The Writing of Orpheus: Greek Myth in Cultural Contact (Baltimore: Johns Hopkins University Press, 2003), p. 96.

45. Giuseppe Mantovano, "Il medioevo," in Fiorani et al. (see note 15), p. 115: In the thirteenth-century carnival, "in presenza del pontefice, rilevato con gran pompa al laterano dal prefetto e dai nobili, . . . si ucciderano un orso che simboleggiava il demonio, giumenti raffiguranti la superbia umana da debellare e un gallo segno di lussuria." To what extent some memory of this practice persisted into the sixteenth century is unknown to me.

46. Martine Boiteux, "Chasse aux taureaux et jeux romains de la Renaissance," in Les jeux à la Renaissance: actes du XXIIIe Colloque international d'études humanistes, Tours, juillet 1980, ed. Philippe Ariès and Jean Claude Margolin (Paris: Librairie Philosophique J. Vrin, 1981), p. 44; Fabrizio Cruciani, Il Teatro nel Rinascimento, Roma 1450–1550 (Roma: Bulzoni, 1983), pp. 537–567 (with texts of contemporary accounts of the spectacle); Visceglia (see note 22), p. 94. On the political connotations of the Testaccio games, see Mario Sanfilippo, Il carnevale di Roma (Milan: Motta, 1991), pp. 15 and 17,

The association of Testaccio as a killing ground was related to its normal economic function as an important meadow, permanently rented by the city and used for herds brought into the city in the fall through the transhumance system that dominated the local economy.[47] By the time of carnival, most of these animals had doubtless been killed and their meat and hides put to good use.

Until the later fifteenth century, the Testaccio games also included a horse race, or *palio,* which was run over the level ground near the hill. At the behest of Pope Paul II, however, in 1467, the carnival races were moved to the Via Lata (Via del Corso), apparently because of the topographical relationship between that street and the Palazzo San Marco (Venezia), which Paul had founded as a cardinal's residence and hugely expanded once he became pope.[48] The transfer of the violent races of carnival to the Via del Corso in the center of Rome belongs in the same process of appropriation as the elaboration of the *ludi d'Agone.* New centers of activity drew attention away from the games at distant Testaccio, which disappeared by the end of the sixteenth century, no doubt in large part because they fell victim to shifting religious and cultural standards, accompanied by the proliferation of private bullfights in the Spanish fashion.[49]

Insofar as it was not simply an orgy of blood, the Testaccio massacre derived significance from rituals, prescribed by statute, which preceded the games of Testaccio and reinforced the latter's official status as a municipal event. On carnival Saturday, the thirteen bulls destined to die the next day at Testaccio were presented with much pomp and circumstance to the civic authorities assembled on the Campidoglio.[50] Not yet victims (along with a number of squealing pigs) of a demeaning and gruesomely comic massacre, they were now festively adorned if certainly reluctant protagonists of a grand spectacle. From the tower of the Senator's palace, the great bell, known as the Patarino, tolled to gather the people at the hill; otherwise it pealed only during emergencies and executions (frequently a part of carnival) to summon citizens to council and to mark the election or death of a pope.[51] Echoing across the whole city, the sound of the bell expressed the enormous symbolic importance of carnival for *all* the citizens, especially (but not exclusively) the patrician elite. Each of the bulls represented one of the city's *rioni* and each was brought to the ceremony from its *rione,* where it

noting the involvement, required by statute, of the consuls of the merchant guild and the *bovattieri* and the conspicuous display of the banner of the Roman municipality. A contemporary patrician notes the involvement of the local elite: see Marco Antonio Altieri, *Li nuptiali,* ed. Enrico Narducci (1873; Rome: Roma nel Rinascimento, 1995), p. 110. On the setting, see Anna Vos, "Testaccio: change and continuity in urban space and rituals," in *Urban Rituals in Italy and the Netherlands: Historical Contrasts in the Use of Public Space, Architecture, and the Urban Environment,* ed. Heidi De Mare and Anna Vos (Assen: Van Gorcum, 1993), pp. 58-89, esp. pp. 79-82; Emilio Rodriguez-Almeida, *Il monte Testaccio: ambiente—storia—materiali* (Rome: Edizioni Quasar, 1984), pp. 121–124. The parading of bulls occurred elsewhere as a feature of carnival; for example, in France, see C. Demeulenaere-Donyère, "La promenade du boeuf gras à Paris," *Gaveroche* 7 (1982):25–27; Samuel Kinser, *Carnival American Style: Mardi Gras at New Orleans and Mobile* (Chicago: University of Chicago Press, 1990), pp. 154–155. The bulls, or at least oxen, were led by costumed "wild men," perhaps echoed in the satyr masques incorporated into the architectural ornament of the Palazzo dei Conservatori, see Burroughs (note 4), p. 94. However, I have found no reference to wild men in the Roman carnival.

47. Bartolomeo Rossetti, *I bulli di Roma* (Rome: Newton Compton, 1979), p. 143.

48. Sanfilippo (see note 46), pp. 19–20. The shift was made official in a revised edition of the city's statutes issued in 1469.

49. The eve of Assumption Day (St. Bartholomew's Day) was also marked by private bullfights, most notably those orchestrated by the Spanish community, see Boiteux (note 46), p. 49.

50. Carlo Pietrangeli, "I palazzi capitolini nel rinascimento," *Capitolium* 39 (1964):190; De Mare and Vos (see note 46), p. 80. There are also occasional references to a *caccia di tori* on the Campidoglio: Sanfilippo (see note 46, p. 17) states that such events became standard in the fifteenth century on the Saturday of carnival (it's not clear how this related to the presentation of bulls to the *caporioni*). See also Pecchiai (note 34), pp. 356–358. In 1483, a *caccia* at the Campidoglio degenerated into a riot —or perhaps only an intensification of an annual atmosphere of abandon—see Emmanuel Rodocanachi, *Une cour princière au Vatican pendant la Renaissance* (Paris: Hachette, 1925), p. 59. On the accession of Pope Julius III (1550), which coincided with carnival, a *caccia* with six bulls took place on the Campidoglio (see Sanfilippo [note 46], p. 27, Francesco Clementi, *Il Carnevale romano nelle cronache contemporanee dalle origini al secolo XVIII,* vol. 1 [Città di Castello: Unione Arti Grafiche, 1939], p. 243). In sharp contrast with events at Testaccio, this *caccia* was combined with the display, in the courtyard of the Palazzo dei Conservatori, of classicizing history paintings. This polite and learned setting of the still indispensable violence illustrates the effect on key civic ritual forms of the Roman patriciate's eagerness to represent itself as an Italian or even European aristocracy, rather than simply in relation to the local social world.

51. Pio Pecchiai, *Il Campidoglio nel Cinquecento sulla scorta dei documenti* (Rome: Ruffolo, 1950), p. 110; Carlo Pietrangeli, "I palazzi capitolini prima di Michelangelo," *Capitolium* 39 (1964), p. 5; Edward Muir, *Ritual in early modern Europe* (Cambridge and New York: Cambridge University Press, 1997), p. 261 (calling the bell the *patara*). The bell had originally been taken in 1200 as booty from the city of Viterbo, then a rival of the city of Rome. There were two municipal councils; the bell was used to summon eligible citizens to the relatively rare meetings of the larger "great council." As argued by Güthlein (see note 39, pp. 83–190), the Palazzo Nuovo was built to accommodate this larger deliberative body.

was paraded through the streets and around the perimeter, in part to wear it down and make it more manageable.[52] In the 1530s, Roman citizens no doubt regarded the presentation of bulls as a ceremony sanctioned by tradition, although the practice had come into being only around the middle of the fifteenth century, perhaps when the hill underwent its earlier major remodeling.[53] The ceremony would not survive the increasingly repressive cultural and political circumstances of the mid-sixteenth century.[54]

I have found no detailed descriptions or visual representations of the presentation of the bulls and few references to it.[55] Somewhat curiously, cacce di tori are recorded as occasionally occurring on the Campidoglio during carnival. If these were actual bullfights, presumably they occurred at the behest of the pope of the time and the bulls concerned were supplementary to those of Testaccio, such as those killed at privately organized and funded bullfights in the Spanish manner, which took place in the city during carnival. It is possible that the sources simply reflect a misunderstanding of the ceremony of presentation, which, indeed, was inherently no less dangerous than it was dramatic. In 1516, for example, a bull got loose and killed a couple of bystanders as it was being maneuvered through the streets. The bull was arrested, tried for murder, and executed on the Campo dei Fiori.[56] The ceremony on the Campidoglio, on the other hand, involved not one but thirteen frightened bulls, gathered in a relatively small space and doubtless bucking and kicking out at their handlers. To some observers this may, indeed, have seemed more of a chaotic caccia than a formal ceremony; on the other hand, as Peter Brown has noted, the presence of dangerous animals at festivals is an ancient and recurrent motif, even if it occurred in exaggerated form at Rome.[57] Indeed, a striking echo of this practice is documented in fourteenth-century Rome as a surprisingly carnivalesque element of the celebration of Cola di Rienzo's knighthood: At the banquet following the ceremony, a jester costumed as a bull entertained the diners.[58]

An element of parody is, of course, quite typical of carnival in different times and places, and to see a parodic overtone in the processions that marched each bull through its rione to the Campidoglio is not to minimize the ritual's importance to the participants. At least in the era of humanism, the cavalcade of bulls surely alluded in particular to ancient ceremonial practices, notably the Roman triumph, which informed many of the papal ceremonies of the early sixteenth century.[59] The ancient triumphal route led through the

52. Bullfighting had civic associations elsewhere: See, for example, Robert C. Davis, "The trouble with bulls: the cacce dei tori in early-modern Venice," Social History 29 (1996):275–290, esp. 285–287. As in Rome, the bulls or oxen were driven through the individual neighborhoods, though apparently without connection to the main civic bullfight at the Doge's palace. I am grateful to Thomas Cohen for this reference.

53. Pietrangeli, "I palazzi capitolini nel rinascimento" (see note 51), p. 190. For the remodeling of the Campidoglio under Nicholas V, see my book From Signs to Design (note 10), p. 27. The Palazzo dei Conservatori was built more or less from the ground at this time. The Campidoglio was already a station in the most important ritual event of the municipal year, the procession of the Assumption of the Virgin on August 15; see Burroughs (note 10), pp. 26–32, 144, 160–162.

54. According to Vos (see note 46, p. 80), the Testaccio games "fell into oblivion in the sixteenth century." See also Sanfilippo (note 46), p. 29.

55. For a brief fourteenth-century description, see Beatrice Premoli, Ludus carnelevarii: il carnevale a Roma dal secolo 12. al secolo 16 (Rome: G. Guidotti, 1981), p. 19; Philip J. Jacks, The Antiquarian and the Myth of Antiquity: The Origins of Rome in Renaissance Thought (Cambridge and New York: Cambridge University Press, 1993), p. 67. There may also be a reference to the presence of bulls in the streets during the Roman carnival of 1513 in a poem by Giovanni Jacopo Penni, a Florentine physician: see Cruciani (note 46), p. 373: "Del mese di gennaro a trenta giorni / La festa incominciò . . . / Sentia in ogni strada et omni foro / In caccia il bicornuto bravo toro." This may however refer to private bull fights, which became a feature of the Roman carnival at this time.

56. Boiteux (see note 46), p. 38. Two attendants (giostratori) were killed and many others wounded. On the not uncommon medieval practice of the trial and execution of animals, see Edward P. Evans, The Criminal Prosecution and Capital Punishment of Animals (1906; London: Faber, 1987) and Esther Cohen, "Law, folklore and animal lore," Past & Present 110 (1986):6–37. For execution of human "malefactors" as a standard part of carnival, especially in Rome, see Ciappelli (note 22), p. 258; Sanfilippo (note 46), p. 28.

57. Peter Brown, The Cult of the Saints: Its Rise and Function in Latin Christianity (Chicago: University of Chicago Press, 1981), pp. 113, 172, n. 39.

58. The jester was dressed in a bull's hide, with horns on his head. The ceremony had taken place at the Lateran, but the location of the banquet is not given; see Gustav Seibt, Anonimo romano: Geschichtsschreibung in Rom an der Schwelle zur Renaissance (Stuttgart: Klett, 1992), p. 159. Seibt places the jester among details given by the chronicler that have nothing to with the "Symbolbereich von Rienzos politischen Projekten"—this is surely incorrect. For the ceremony, see Amanda Collins, Greater than Emperor: Cola di Rienzo (ca. 1313–54) and the World of Fourteenth-Century Rome (Ann Arbor: University of Michigan Press, 2002), p. 48 and Ronald G. Musto, Apocalypse in Rome: Cola di Rienzo and the Politics of the New Age (Berkeley: University of California Press, 2003), p. 177. Neither mentions the banquet, in spite of Cola's well-documented use of public spectacle.

59. Stinger (see note 17), pp. 183–191; Partner (see note 14), p. 193.

Forum to its destination on the Capitoline Hill; in early sixteenth-century Rome, on the other hand, the major papal processions, such as the entry of the Emperor Charles V in 1536, avoided the hill.[60] The cavalcade of bulls, then, accessed territory that lay beyond the papal ceremonial ambit, except on special occasions, such as the festive celebration early in Leo X's pontificate, when the pope's nephews received Roman citizenship. This too was officially a municipal event.[61]

From around 1515 on, an image of an emperor in triumph formed part of the famous collection of statues and inscriptions that accumulated at the Campidoglio in the Renaissance. This image was one of a group of relief panels stripped from a triumphal arch; another, also at the Campidoglio, showed an emperor about to sacrifice a white bull (or at least ox) in front of the Capitoline Temple of Jupiter (fig. 4).[62] An especially prominent statue in the Capitoline collections was the bronze cult statue of Hercules (fig. 5) brought from the site of his temple in the ancient cattle market, along with inscriptions recording the civic cult of the hero.[63] Hercules is of particular interest because his canonical labors included the victory over a massive wild bull, a frequent subject in ancient art (as we have seen, this was the bull that features in the Theseus story). Moreover, his temple and altar in Rome marked the place where the hero sacrificed a bovine, following his destruction of the monstrous Cacus, and retrieved from him a stolen herd of cattle. Long before the foundation of the city of Rome, then, a cult of Hercules, instituted by the hero himself, became the foundational moment of ancient Roman religion, closely linked to an economy of cattle raising. Little wonder that in early

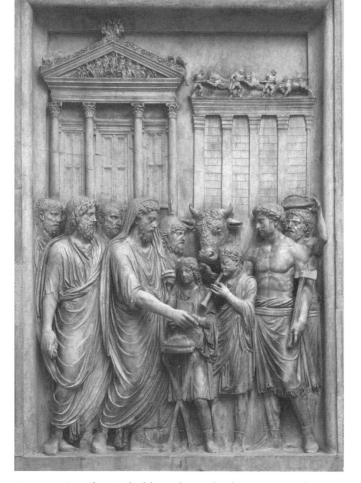

Figure 4. *Sacrifice*. Relief from the Arch of Marcus Aurelius, 176–180 C.E. Palazzo dei Conservatori, Rome. Photo: Nimatallah/Art Resource, N.Y.

sixteenth-century Rome, there was again a kind of civic cult of Hercules, both at the Campidoglio and in aristocratic households.[64]

60. On Charles's entry see Pecchiai, (note 2), pp. 35ff.; Maria Luisa Madonna, "L'ingresso di Carlo V a Roma," in Marcello Fagiolo, ed., *La Città effimera e l'universo artificiale del giardino: la Firenze dei Medici e l'Italia del '500* (Rome: Officina, 1980), pp. 63–67.

61. Cruciani (see note 46); Charles Stinger, "The Campidoglio as the locus of Renovatio Imperii in Renaissance Rome," in *Art and Politics in Late Medieval and Early Renaissance Italy 1250–1500*, ed. Charles M. Rosenberg, ed., (Notre Dame and London: Notre Dame University Press, 1990), pp. 135–156.

62. Bober and Rubinstein (see note 24), p. 223ff. This relief and two others from the same lost triumphal arch of Marcus Aurelius were given by Leo X to the Roman people in 1515 and placed in the courtyard of the Palazzo dei Conservatori.

63. It is noteworthy that the Hercules was not part of the famous donation of Pope Sixtus IV but was brought to the Campidoglio through the agency of the *conservatori* themselves; see Herbert Siebenhüner, *Das Kapitol in Rom: Idee und Gestalt* (Munich: Koesel, 1954), pp. 43, 45.

64. On the cult image of Hercules from the Forum Boarium, see the catalogue entry by Maria Elisa Tittoni in Muratore (note 9), no. 12, p. 40; Matthias Winner, "Der eherne Hercules Victor auf dem Kapitol," in *Hülle und Fülle: Festschrift für Tilmann Buddensieg*, ed. Andreas Beyer, V. M. Lampugnani, and G. Schweikhart (Alfter: VDG, 1993), pp. 629– 642. In his 1556 account of Roman statues displayed in Rome, Aldrovandi locates the Hercules in a major room (Tittoni identifies this as the present Sala dei Capitani) on the upper floor of the palace, on a round base formed of an altar dedicated to Hercules. Until 1578, indeed, when the statue received a different base, the statue's character as cult image was retained. The inscriptions were published

The association of the Capitoline hill with ancient bull cults was not only a matter of the transfer of charismatic objects like the statue of Hercules. In the early sixteenth century, the relief statue of a hero in the act of overcoming a powerful bull was found in a kind of cave beneath the piazza (fig. 6).[65] The subject was soon identified as "Hercules with the Cretan bull"; in fact, the cave was a subterranean Mithraeum, and the statue represents the bull sacrifice of Mithras, hero of a cult unfamiliar to sixteenth-century antiquarians.[66] The chthonic power of the statue perhaps explains why, very unusually, the statue remained in its original location until the cave collapsed sometime after 1550, when the statue became one of many mere museum pieces in and around the Capitoline palaces. Until then, the statue surely reinforced the association of Hercules with the hill, adding an extra level of meaning to ceremonies involving the exercise of power over vigorous and virile animals. The circumstances imply that the cave's collapse was not accidental.

In conclusion, there obviously is no direct connection between the case of Demetrios and Michelangelo's Capitoline designs of at least some fifteen years later.

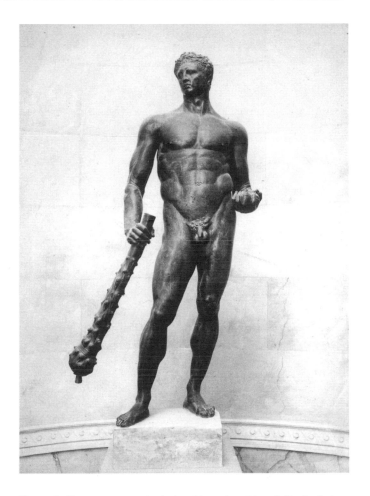

Figure 5. Bronze statue depicting Hercules. Musei Capitolini, Rome. Photo: Alinari/Art Resource, N.Y.

by Jacopo Mazzocchi in the *Epigrammata antique urbis,* a printed epigraphic collection of 1521 (see note 19 above). Mazzocchi was also the publisher of the annual booklet of verses dedicated to Pasquino, sometimes in the guise of Hercules; see Partner (note 14), p. 202. Long before he was associated with the Campidoglio, Michelangelo had worked on an image of Hercules and Cacus as a pendant to his *David.* This project is related to a sketch of Hercules and Antaeus on a sheet of drawings, including many of grotesque faces recalling the Conservatori capitals; see Michael Hirst, *Michelangelo and His Drawings* (New Haven and London: Yale University Press, 1988), p. 74.

65. Now in the Louvre: see Bober and Rubinstein (note 24), p. 85; Oskar Seyffert, *Dictionary of Classical Antiquities,* ed. Henry Nettleship and J. E. Sandys (London: W. Glaisher, 1894), p. 396; Leonard Barkan, *Unearthing the Past: Archaeology and Aesthetics in the Making of Renaissance Culture* (New Haven: Yale University Press, 1999), pp. 170–172. The relief was already known in the time of Cola di Rienzo. The description of the site is that of Flaminio Vacca, the son of an antiquities hunter, who saw it as a child (he was born in 1538). Barkan notes that the identification of the subject shifted in the course of the century, exemplifying a transition from public to private and heroic to erotic interpretations. He does not explore the political context or ideological implications of this shift. For Michelangelo's own interest in and association with the statue, see Irving Lavin, "David's sling and Michelangelo's bow," in *Der Künstler über sich in seinem Werk: internationales Symposium der Bibliotheca Hertziana, Rom, 1989,* ed. Matthias Winner (Weinheim: VCH, Acta Humaniora, 1992), pp. 166–167.

66. Bober and Rubinstein (see note 24), p. 85. Apart from Hercules's own sacrifice of bovines, the sacrifice of bulls to Hercules was a common practice in antiquity; Seyffert (see note 65), p. 400.

However, the Greek's trial and escape in 1522 on the Campidoglio occurred shortly before a significant repair campaign was carried out, including, by 1530, the construction in the courtyard of the Palazzo dei Conservatori of a new well-head, which carried an inscription in honor of Jupiter, the rain-bringing god, a pagan gesture celebrating the ancient associations of the site, where Jupiter's primary shrine had stood.[67] In 1534,

67. The well-head is mentioned and its pagan inscription recorded by the German traveler Johannes Fichard, who was in Rome in 1536; see Carlo Pietrangeli, "La fontana del Palazzo dei Conservatori," *Capitolium* 27 (1952):143. According to Pecchiai, *Il Campidoglio nel Cinquecento* (see note 2, pp. 15–17), the work of a builder identified unhelpfully only as Domenico is attested at the Campidoglio in 1521. In fact, in November 1521, he was threatening legal action to secure

Figure 6. Engraving from the relief of the *Sacrifice of Mithras* from Capitoline Hill, Musée du Louvre, often identified in the sixteenth century as *Hercules and the Cretan Bull*. Reproduced in Oskar Seyffert, *A Dictionary of Classical Antiquities: Mythology, Religion, Literature, and Art* (London: W. Glaisher, 1894), p. 396.

the election of Paul III was preceded by an especially tense interregnum, during which the patricians formulated uncompromising demands to be put before the new pope.[68] Paul's positive response to these

demands as well as his emphatic claim that he, too, was a native Roman clearly are evidence of an overtly conciliatory posture following his accession. At the time, only seven years had elapsed since the Sack of Rome of

payment for the "ampliamento del cortile." In a meeting of October 29, 1524, the city council decided to complete the work on the courtyard and the well (*cisterna*). In 1526, the council voted for the installation of a library in the palace. A new well-head was installed in 1588; see Anna Bedon, "La realizzazione del Campidoglio michelangiolesco all'epoca di Sisto V e la situazione urbana della zona capitolina," in *Il Campidoglio e Sisto V,* ed. Luigi Spezzaferro and Maria Elisa Tittoni (Rome: Edizioni Carte Segrete, 1991), p. 77. This is presumably also the date of the removal of the earlier "pagan" well-head, to which Sixtus may well have objected!

68. Clement died on September 24, 1534, and on October 6 Flaminio Tomarozzi made a fiery speech on the Campidoglio (in the church of S. Maria in Aracoeli), which led to the formulation of

demands to be made to the new pope; see Melissa M. Bullard, "Grain supply and urban unrest in Renaissance Rome: the crisis of 1534," in *Rome in the Renaissance: The City and the Myth,* ed. Paul Ramsey (Binghamton, N.Y.: MRTS, 1980), p. 284. See also Pecchiai (note 34), pp. 216–225; Clara Gennaro, "La 'Pax romana' del 1511," *Archivio della Società romana di Storia patria,* 3rd ser., 21 (1967):47. A key figure was the Roman political theorist and committed republican Mario Salamonio degli Alberteschi; see Pecchiai (note 34), p. 216; Gennaro (ibid.), p. 28, n. 37; Vincenzo De Caprio, "Roma," in *Letteratura italiana, storia e geografia, 2. L'età moderna,* ed. Alberto Asor Rosa et al. (Turin: Einaudi, 1988), p. 344. Mario Salamonio's magisterial work *De principatu* appeared in 1544, though it had been long in the making.

1527; the trauma caused by the rampages of foreign troops, allowed a free hand in the city for several days, was certainly far from overcome.

Following the Sack, the Roman carnival was discontinued for many years. After his accession, Paul acted quickly to accelerate the city's recovery. In 1536 he reinstituted the carnival as a means to restore morale as well as to project and celebrate his own authority and indulge his own enthusiasm for such spectacles.[69] Indeed, an image of the *ludi di Testaccio* appears in the richly illuminated Farnese Hours, completed in 1546,[70] a symptom of the pattern, evident throughout early modern Europe, of appropriation of carnival by the state. In Rome, this pattern was emphatically accelerated under Paul III.[71]

Also in the mid-1530s, Paul instituted and/or supported a range of architectural and urbanistic projects, including the reshaping of the Campidoglio. This began in 1537, officially as a municipal project,[72] for which Paul was certainly happy to take some credit, though he certainly did not fund it as generously as he might have: The contrast with the work on his own

family palace is instructive.[73] A key element was the transfer to the hill early in 1538 of the equestrian statue of the ancient emperor, Marcus Aurelius, as the principal ornament of the piazza which, along with the "palace" (i.e., that of the *conservatori*), the initial scheme was designed to enhance. Without fanfare Michelangelo himself took Roman citizenship in 1537; through his friend Tommaso de' Cavalieri, he entertained close links with members of the Roman patrician elite. It is not clear if the commission formed in 1537 to oversee work on the Campidoglio restoration had Michelangelo's scheme before them. Certainly, however, elements of this were already realized by 1550, suggesting that the main features of the façade of the Palazzo dei Conservatori were worked out in or soon after 1537. However, the late 1530s saw a series of terrible winters with appalling effects on conditions in the city, and in 1541 war broke out in the hinterland of Rome. The Campidoglio project was effectively shelved.

In 1535, Paul had commissioned Michelangelo's *Last Judgment* to restore the city's sanctity following the large-scale desecration as well as destruction of the Sack.[74] Like that great painting, Michelangelo's design for the Palazzo dei Conservatori combines contrasting elements: the classical and the unorthodox (and grotesque), the high and the demotic; and, in the case of the palace, the domain of reason and that of the processing of natural substances. It was, of course, Michelangelo's practice to design for eternity, but as Richard Trexler has demonstrated in his work on the Medici Chapel, he was attentive to issues of political as well as social status and representation.[75] In this case, indeed, he sought to celebrate a political culture with which, at the time, he was deeply in sympathy and even to convey a sense not only of the Roman elite's dream of autonomy, but also of the necessary and fruitful antitheses within any republican system.

69. For the date, see Clementi, (note 50), p. 209, who remarks on the revival of the "classiche feste carnevalesche."

70. William Voelkle and Ivan Golub, eds., *Das Farnese Stundenbuch mit Miniaturen von Giulio Clovio Croata* (New York and Graz, 2001), pp. 68, 72. This is one of five double-sided images in the manuscript, all associated with important texts. The image of Testaccio accompanies the liturgical reference to the death of Christ; this is perhaps connected with the use of the hill to represent Golgotha in sacred dramas during Easter week. Giulio's miniature is based on a print carrying the pope's arms along with the date 1534. The print therefore preceded by a year the reintroduction by Paul III of the celebration of carnival in 1535 (as noted below), and presumably coincided with and drew attention to the pope's no doubt very popular decision. Giulio himself designed liveries for the carnival of 1541; this may be the event celebrated here.

71. On the transformation of carnival, see Martine Boiteux, "Carnaval annexé. Essai de lecture d'une fête romaine," *Annales ESC* 32 (1977):356–380; on the ritual economy in general, see Boiteux, "Espace urbain, pratiques rituelles, parcours symboliques. Rome dans la seconde moitié du XVIe siècle," in *Rome: l'espace urbain et ses représentations,* ed. Francois Hinard and Manuel Royo (Paris: Presses de l'Université de Paris-Sorbonne, 1991), pp. 111–146. For the social inclusiveness of the bull fights of late medieval Rome (including those of carnival), which regularly involved aristocratic participants, see Mario Verdone, "Cacce e giostre taurine nelle città italiane," *Lares* 29 (1963):176–183. Some authors posit a distinction between aristocratic *ludi d'Agone* and popular/demotic *ludi di Testaccio;* see Ciappelli (note 22), p. 270. Such a distinction was certainly not absolute.

72. The city administration appointed an oversight commission of eminent patricians and a building contractor (Mario Maccarone, hired on November 26, 1537); see Pecchiai (note 2), p. 36.

73. Apart from construction at the Torre Farnese on the Capitoline Hill, extensive work was also done to create a secret garden at the Vatican; see Léon Dorez, *La cour du pape Paul III d'après les registres de la Trésorerie secrète,* vol. 1 (Paris: E. Leroux 1932), pp. 14ff.; James S. Ackerman, "The Belvedere as a classical villa," *Journal of the Warburg and Courtauld Institutes* 14 (1951):78.

74. Charles Burroughs, "The *Last Judgment* of Michelangelo. Pictorial Space, Sacred Topography, and the Social World," *Artibus et Historiae* 32 (1996):55–89.

75. Richard C. Trexler, "Two captains and three kings: new light on the Medici Chapel," *Studies in Medieval and Renaissance History* 4 (1981):91–177; "True light shining: obscuranticism in the study of Michelangelo's New Sacristy," *Artibus et Historiae* 42 (2000):101–118.

Appendix A

Marin Sanuto, *I Diarii di Marino Sanuto,* vol. 33 (March 1, 1522–February 28, 1523), cc. 401–422. Venice: Visentini, 1893.

c. 4. Sanuto calls his project "la mia historia de sucesi di Italia." He mentions the investigations he carries out to gather information and claims his history is worthy of public honor.

c. 401, August 1522.

Di Roma, fo letere di sier Alvixe Gradenigo orator nostro, di 27 et 29 dil passato. Come hanno aviso il Papa partirà questo Septembrio di Spagna per venir a Roma. Scrive esser capitato de lì un certo greco, qual richiese uno toro rabioso, che si conveniva tenir legato con assà corda ben stretta, et fato condur in piazza di San Piero, li disse certe parole in la orecchia et lo deslegò et ligò a sua posta con uno spageto a un corno, et fata certa oration al cielo, mena questa bestia al Tevere dove li fa butar di boca certo sangue, et poi stà mansueto. Si dice lo fa per incantamento, per modo che tutta Roma li coreva driedo ditto greco ; et li cardinali lo fece retenir dubitando de idolatria, unde el popolo con gran furia ge lo haveano richiesto, et erano in gran confusione per questo.

c. 402

Alvise Gradenigo's letter, presumably to Sanuto. Undated.

Magnifico missier.

Perchè Vostra Magnifientia vol saper quella cossa de l'incantamento de le peste, sapia Vostra M. che un certo Dimitri de la Morea, habitante a Corfù, andò dal signor Constantino, et disseli che lui sapeva far un incanto che cesaria la peste, et voleva per premio 20 ducati al mexe per se e sui eriedi et successori, et questo voleva comenzase la provixion da poi fato l'incanto, e cessata la peste; et se la cossa non havea, efeto [sic: this should read "havea efeto,"] voleva esser punito e condennato. Parse al signor Constantino de parlarne a certi gentilhomeni ronani, che erano deputati a le provexion sopra la peste, et al reverendissimo Camerlengo, et alcuni altri cardinali. Da poi fato il pato, ditto Demetrio andò per turra Roma cercando fontane, per fino che ne trovò una luntano cercha tre milia dal Campitolio, in

certo po/c.403/dere di Hotaviano de Paluzo; poi volse che se trovasse un bravissimo toro, che fosse tutto negro, el qual fu conduto a uno certo logo de le terra, dove stete fino a le 5 hore de la nocte. Et di lì andò dito Demetrio, et ancora avanti zorno el feze condur con gran difficoltà a ditta fontana, che eran più de 20 homeni che el conduzevano. Poi s'acostò dito Demetrio e disse certe parole, per le qual el bravissimo toro deventò piu human che un agnello. Ditto greco feze desparturar (?) dito toro e levarli tutte fune con le qual era legato, poi lui pigliò un spago et mesello a le corne del toro, et menavaselo driedo piu humano che un agnello. Fecelli bever de l'aqua de la funtana, poi de continuo lezeva certo libro, et tegneva lezando certo fazuol su le spale. Poi pigliò e taglioli le ponte de le corne fino sul vivo, che'l toro non se movè più che fuse stato de petra; et stato un poco, essendo zorno chiaro, feze da cao atacharli le fune a le corna, impasturarlo come era prima, et ordinò a quelli ch' l'aveano conduto che piliasseno le corde in mano. Et lui se li acostò, e dile certe parole, et sbufoli con certa aqua sul muxo. De subito el toro se resvegliò più bravo et feroze che mai, de sorte che con fadiga el poteno condur et farlo entrar e usir cinque porte de la terra. Questa cossa fu un Zobia. Lui ordenò che per tutta Roma non se dovesse amazar nesuno anemal de quatro piedi, oferendosi che, pasadi li 3 zorni, ne li qual lui avea far certe altre cose l'intravano per complemento de ditto incanto, lui se obligava che nisuno se amaleria più de peste, et li amalati che havesano de l'aqua de dita fontana, tutti varirian. Parse a l'avichario del Papa, che è el reverendissimo Jacobatii, che a lui non fu domandato licentia, e per far el debito de vero ecclesiastico, fece incarcerar dito Demetrio el Jovedi al tardi, et tenello prexone 4 zorni; et con gran difficoltà li deputati con el signor Constantino otenero gratia de liberar Demetri. Son stà bruxati li so' libri, et lui è andato fora de Roma ad un castello, dove è fuzito el signor Constantino per dubito del morbo.

Appendix B

Paulus Grillandus (Paolo Grillandi), *Tractatus de Her[e]ticis: et Sortilegijs omnifariam Coitu: eorumq[ue] penis. Ite[m] de Questionibus: & Tortura: ac de Relaxatio[n]e Carceratorum,* pp. 143–144 (book 2, fol. 47r). Lyons: Giunti, 1547 (New York Public Research Library, *KB 1547).

The passage on the Greek wizard occurs in a section on the use of charms and verbal spells in sorcery:

(Quandoqu. nullo veneni haustu vel mixture in corpore vel extra corp. adiecta: sed sola potentia carminis et verborum perficitur maleficium . . .)

Et ego alias vidi Rome quondam magnum excellentissimum grecum tempore Adriani VI antequam perveniret ad urbem in presenti [?]. ipse qui solis verbis compresserat vires cuiusdam ferocissimi tauri existentis in armento in loco sylvestri quem sic affixum ut ita dixerim et humiliatum apprehendit per cornua et chordula quadam satis debili arte tamen magica fabricata taurum ipsum ligatum quo voluit adduxit media nocte circiter quatuor aut quinque miliaribus: et hec notoria sunt que visa/ fol.48R/ fuerunt per ducentes et ultra vires [viros?] quem postea habui in carceribus capitolinis examinandum : et omnia ista et maiora quoque ingenue fatebatur verborum potentia efficere posse qui tamen postea evasit imperfecto examine favoribus populi Romani et quorundarum magnatum.

Figure 1. Étienne Dupérac, Basilica of Constantine, *I vestigi dell'antichità di Roma* (Rome, 1575), pl. 37. By permission of Avery Architectural and Fine Arts Library, Columbia University in the City of New York.

Anachronism and simulation in Renaissance architectural theory

ANNE-MARIE SANKOVITCH

The Italian Renaissance is famously believed to have achieved a true rebirth of antiquity, a phenomenon now so naturalized in world thought that we rarely inquire into the belief system that gave it credibility. We tend to subscribe rather blindly to the notion that the strange concept of *rinascita* was firmly sustained by a newly invented tripartite historical narrative of antiquity's glory, its destruction and abandonment (the "dark ages"), and thus, finally, its rebirth. But when we look closely at Renaissance discourse in architecture—more central to Renaissance thought than is currently imagined—we find that the historical imaginary of the Italian Renaissance was, in fact, structured differently. Namely, its deep structure was not narrational, nor did it depend on the presence or the absence of antiquity (that is, on a pivotal diachronic figuration of the "dark ages"). In architecture, the Renaissance historical imaginary fundamentally was not aligned with a tripartite narrative. Indeed, at its core it was not even temporal in the usual diachronic sense. Rather, its structure was spatial, dyadic, and paratactic, gathered into an uncanny transcultural, specular chiasm.

The completion of the historiographic model derived from Petrarch's invention of the dark ages has long been seen as critical to the Italian Renaissance society's self-definition as an age that achieved a true rebirth—a veritable *rinascita*—of classical antiquity. For the visual arts, including architecture, which is the focus of this study, the text that has seemed to articulate most effectively the Petrarchan dream and to function as a manifesto of an achieved and singular *rinascita* by Italian renaissance architects is Giorgio Vasari's *Lives of the Artists*. Indeed, the first edition of the *Lives* of 1550 does successfully tell a story of the death of ancient architecture in the medieval period and its rebirth in the Renaissance. In this edition, medieval buildings are primarily encountered in two nondescript a-narrative lists, two laconic inventories. This lack of individualized ecphratic substance—Vasari mentions these buildings only by name and does not textually figure them as palpable material monuments—allowed these structures to remain blank slates that could sustain the theoretical ideal of a dark age teeming with anticlassical buildings from which the *rinascita* could then emerge. Vasari declares his intention to write a story of the "perfection, and ruin, and restoration, or to put it better, *rinascita*" of the arts.[1] He wants a sequential history of clearly compartmentalized phases in which the period of death and ruin is structurally necessary for that of rebirth. In the 1550 *Lives*, this is all successfully accomplished as Vasari aligns his built examples with his metaphorical model of death and rebirth and with his historiographic model predicated on a tripartite chronology and period-style segregation.

As I have elaborated in a recent article in *Res*,[2] in the second edition of the *Lives*, which appeared in 1568, Vasari's lucid structure develops numerous cracks and flaws. The integrity of his Petrarchan narrative, and consequently of the *rinascita*, is severely damaged. In the second edition, Vasari examines architecture much more closely and adds a lengthy narrative of medieval architecture from the fifth to the thirteenth centuries. As a result of these changes, Vasari has trouble making the *buona maniera antica*, which he tells us is shared by both the ancients and the moderns—by *only* the ancients and the moderns—behave properly. In his new narrative of medieval architecture, the text is fractured between those passages devoted to plot and those devoted to textual figuration of buildings. An ongoing battle is played out between the story (its theoretical, critical, and historical imperatives) and its rebellious objects. In the case of the plot, Vasari is constantly implanting the text with statements about how clumsy, degenerate, and far removed from the ideals of antiquity this architecture is and how virtually no progress is made between the fifth and thirteenth centuries.

However, in the case of the specific buildings that Vasari chooses as illustrative examples—from those of fifth- and sixth-century Ravenna, such as San Vitale, to

This essay is a lightly edited version of a lecture delivered at Berkeley on November 18, 2003; the footnotes, restricted to citations, were filled in by Marvin Trachtenberg. It distills much of the argument of the manuscript for a book, provisionally titled *A Credible Renaissance*, virtually completed by Sankovitch at the time of her death in 2005. It is anticipated that this book will be published in the near future.

1. Giorgio Vasari, *Le Vite de' più eccellenti pittori, scultori e architettori nelle redazioni del 1550 e 1568*, ed. Rosanna Bettarini and Paola Barrochi, vol. 2 (Florence: Sansoni, 1966–87), p. 13: ". . . perfezzione e rovina e restaurazione e, per dir meglio, rinascita . . ."

2. Anne-Marie Sankovitch, "The myth of the 'myth of the medieval': Gothic architecture in Vasari's *rinascita* and Panofsky's Renaissance," *RES* 40 (2001):29–50.

those of eleventh- to thirteeth-century Tuscany, such as Pisa Duomo—almost all he sees and describes are classical spoils or newly manufactured columns, capitals, bases, architraves, cornices, and arches. That is, all he can see and describe are the formal stigmata of the *buona maniera antica* as it had been defined in the cinquecento. Moreover, several of these buildings are also said to resemble the ancient manner and many are described as beautiful or well proportioned. This is particularly true for late medieval buildings, which follow an upward trajectory that locates them at a considerable distance from architecture's miserable late-antique downfall.

Vasari tries to deny what he has seen by concluding his medieval narrative with the statement that "little or no . . . improvement can be seen to have been made over the course of so many years [that is, since the fifth century] by architecture, which remained within the same limits and continued to go on in that [crude and inept] manner."[3] But this desperate and clumsy textual intervention, which comes out of the blue and tries to jerk medieval architecture back onto the narrative track Vasari wants it to take, cannot erase the considerable evidence of antiquity's medieval afterlife that he has depicted. Vasari states that the *buona maniera* of all three arts adheres to a life cycle based on a natural biological pattern: "Like human bodies [the arts] have their birth, growth, aging, and death."[4] But when he tries to write art history's first detailed narrative of medieval architecture, classical architecture rejects the biotic imperatives of a healthy mortal life and instead enjoys an unwholesome, unnatural afterlife, morbidly surfacing throughout the period of its supposed death. In 1568, the whole of Vasari's historical theory, which includes his model of death and rebirth and his tripartite chronology of tightly sealed period-style compartments, fractures and dissolves. His Petrarchan theory of history—which within the self-enclosed imaginative realm of the *Lives* works well enough for the figurative arts—cannot be sustained by architecture, by the built things whose history the theory is supposed to elucidate.

In the article where I elaborated these and related points, I was primarily interested in the implications for modern art historical practice of what I had found in Vasari. I asked, for example, what does it mean when the art history we believe we have inherited from Vasari and have never really been able to shake off turns out not to be quite as we had imagined? Here, however, I

want to pursue other issues, related to the rebirth of ancient architecture in the collective historical and creative imagination of the Italian Renaissance. And the first issue I want to address is that the contradictions that undermine the 1568 *Lives* result not only from a conflict between a theory of history and the things of history, between narrative and ecphrasis. They also emerge from a conflict between the temporal and historical structures on which the ideological program—the myth—of *rinascita* depends and where it takes place. That is, the Petrarchan dream of a reborn antiquity in architecture and architectural discourse proved to be fundamentally incompatible with the realization in historical practice (such as the writing of the *Lives*) of the Petrarchan historiographic model. In the monodirectional and tripartite historiographic model, linear time—constantly if unevenly moving forward, rising and descending, endowed with momentum and the capacity for change—describes historical time and plots its objects. The structure of the space in which the Petrarchan dream was actually consummated in architectural theory and practice had, however, a different relationship to time and history. The best way to come to terms with this alternate schema is to begin with a consideration of the archaeological nature of the *rinascita* and follow the sequence of causes and effects, actions and reactions that it engendered.

As is well known, the *rinascita*'s fundamental archaeological character was manifest in the drive to retrieve, reconstruct, and reanimate that which had been lost, forgotten, damaged, and obscured. As the literary historian Thomas Greene has put it: "There is first the archaeological impulse downward into the earth, into the past, the unknown and recondite, and then the upward impulse to bring forth a corpse whole and newly restored, re-illuminated, made harmonious and quick."[5]

5. Thomas Greene, "Resurrecting Rome: The Double Task of the Humanist Imagination," in *Rome in the Renaissance: The City and the Myth*, ed. P. A. Ramsey (Binghamton, N.Y.: Center for Medieval and Renaissance Studies, 1983), p. 41; see also his book *The Light in Troy: Imitation and Discovery in Renaissance Poetry* (New Haven: Yale University Press, 1982), ch. 11. Greene's reading appears to inform or find parallels in, for example, Leonard Barkan, *Unearthing the Past: Archaeology and Aesthetics in the Making of Renaissance Culture* (New Haven and London: Yale University Press, 1999); Alina A. Payne, *The Architectural Treatise in the Italian Renaissance: Architectural Invention, Ornament, and Literary Culture* (Cambridge: Cambridge University Press, 1999); and, rather similarly, in Howard Burns, "Pirro Ligorio's Reconstruction of Ancient Rome: the Antiquae Urbis Imago of 1561," in *Pirro Ligorio Artist and Antiquarian*, ed. Robert Gaston (Milan: Silvana, 1988), pp. 19–92.

3. Vasari (see note 1), pp. 27–28.
4. Ibid., p. 31.

Greene proposes archaeology as a metaphor to explore the tension between the downward movement of imitation and the transformative upward motion of invention in the poetic imagination of the Renaissance. In architectural discourse, the archaeological impulse was, however, simultaneously real and figurative, scientific and imaginative. In Petrarch's famous letter to his friend Giovanni Colonna, the poet wrote: "Who can doubt that Rome would rise up again if she but began to know herself?"[6] Knowledge as identity, self-knowledge as self-presence are anticipated as the necessary conditions for a reborn Rome; and, beginning in the early quattrocento, Petrarch's purely literary and nonvisual recreation project became a physical, scientific, and, soon, visual enterprise as humanists, architects, and antiquarians measured, analyzed, studied, and surveyed the ruins; collated the information with literary and other sources, such as inscriptions and coins; and produced detailed verbal and then graphic reconstructions. A general trajectory of penetration and emergence can be charted from Flavio Biondo's *Roma instaurata* of 1444 where the ruins, previously perceived as anonymous, mute, and frightening *mirabilia,* are given presence and meaning though the basic act of identification; to their ecphratic reconstruction in Alberti's typological descriptions of 1450; and, finally, to their being granted visible substance in drawings, sketchbooks, architectural treatises, and maps.

As a result of these activities, the derelict, disfigured architecture of antiquity—principally that of Rome—seemed to be made imaginatively whole again as architects represented the ruined monuments as if they were new and the depredations wrought by the passage of time had never happened. Vasari wrote about Filippo Brunelleschi: "His studies were so thorough and intelligent that in his mind's eye he could see Rome as it had stood before it fell into ruins." While Brunelleschi's own thoughts on the matter are unknown, Vasari's statement accurately represents the efforts of many other Italian architects who believed themselves able to retrieve the original status of the ruins as undecayed and inviolate objects and drew this imagined perfection as if it were materially real. If Rome was a shambles of the overgrown, buried, and despoiled, as in Etienne Duperac's image of the Basilica of Constantine in the pages of the sketchbook and, above all, those of the treatise, individual monuments were re-membered and seemed to regain their long-lost condition of organic

Figure 2. Francesco di Giorgio Martini, Basilica of Constantine, *Trattato di architettura, ingegneria et arte militare,* Codice Saluzziano 148 (Siena, ca. 1482), f. 76. By permission of Biblioteca Reale, Turin.

wholeness, as in Francesco di Giorgio's reconstruction of the Basilica of Constantine (figs. 1 and 2).

In addition to the pleasures of making the monuments of antiquity transparent, alive, and knowable, the drive to disinter and make whole was also stoked by the desire to retrieve models and rules for contemporary architectural practice. In 1413, Guarino Guarini wrote about Niccolò Niccoli: "Who could help bursting with laughter when this man, in order to . . . expound the laws of architecture, bares his arms and probes ancient buildings."[7] He finds

6. Cited in T. E. Mommsen, "Petrarch's Conception of the 'Dark Ages'," *Speculum* 17 (1942):232.

7. Cited in Ernst H. Gombrich, "From the Revival of Letters to the Reform of the Arts: Niccolò Niccoli and Filippo Brunelleschi," (1967) reprinted in *The Essential Gombrich: Selected Writings on Art and Culture,* ed. Richard Woodfield (London: Phaidon, 1996), p. 424.

ludicrous both the activity of physically measuring and studying—rather than loftily contemplating—ancient ruins, as well as the notion that the rules of architectural practice could thereby be discovered. Yet, Niccolò's efforts, methods, and goals, shocking though they may have seemed to Gaurino, soon became normative. The ruins were not only structures to be virtually repaired, but also texts whose proper decipherment could make legible the *all'antica* method of building, and, even more, make virtually present and physically vital once again *all'antica* architecture itself, as at, for example, Andrea Palladio's Basilica in Vicenza. These were mutually reinforcing activities, and in each case invention was directed toward the creative problem of piecing together the detritus of the past into seamless and coherent, unified wholes.

Yet all the monuments thus created, ancient and modern, on paper and as built, were, inevitably, anachronistic. The reconstructions were always distortions, and the new projects were never really credible counterfeits of ancient structures. They could not recapture some single original instant in time but were marked by the anachronic condition of multiple temporality. This holds true not only for those ancient types most difficult to retrieve, such as the Etruscan temple, the Greek temple, and the Roman house, but even the recuperative best-case extremes are anachronic, as represented on the one hand by ancient monuments whose physical condition should have left little room for interpretive doubt, and, on the other, by modern buildings that seemed to most authentically reclaim the form of ancient prototypes. Thus, the Pantheon—that most intact and celebrated of ancient Roman buildings—was transformed, fixed, and supplemented as Baldassarre Peruzzi, Sebastiano Serlio, Antonio da Sangallo, Palladio, and others submitted it to a range of alterations: entrance steps were added, an exterior pediment removed, its *pilastrini* shifted or suppressed, the columns of its porch were moved and increased in number, antique statues were placed in its niches, fine exterior revetment was invented for it, or, as in a drawing by Francesco di Giorgio Martini, its interior space was dramatically reproportioned and a three-part elevation became a four-part one (fig. 3). Similarly fractured by temporal misalignments is the building so frequently praised by contemporaries as incarnating the dream of perfect recovery: Donato Bramante's Tempietto, which, for all of its seeming *all'antica* purity and veracity,

Figure 3. Francesco di Giorgio Martini, Basilica of Constantine, *Trattato di architettura, ingegneria et arte militare,* Codice Saluzziano 148 (Siena, ca. 1482), f. 80. By permission of Biblioteca Reale, Turin.

displays a considerable residue of cinquecento novelty, such as the domed tholos or the balusters that become anachronistic traces situating the building at the nexus of more than one chronological moment.

Simulations rather than duplicates of what was lost and longed for, the products of the *rinascita* may have been formally seamless, but they nevertheless reveal rifts in the historical project of total recall: Indeed, they reveal that this could not really have been the goal of the project after all. In this respect it is useful to invoke Manfredo Tafuri's reformulation of the imitation-versus-invention dialectic as imitation versus

simulation. "The '*rinascita*,'" he notes, "could only be simulated."[8] Tafuri did not develop this statement much further, but it can be taken to mean that imitation necessarily engages invention to simulate the full and spontaneous retrieval of what is in fact irretrievable. That is, what the Renaissance proposes as creative imitation was basically an act of creative simulation. Various hypotheses came to be offered as surrogates for the genuinely antique. These ranged from the openly imaginative where artifice is foregrounded, as in Francesco di Giorgio's Pantheon, to the apparently archaeologically dutiful, where anachronism seems successfully dissimulated, as in Bramante's Tempietto. That is, in some cases the gap between the ruin and the reconstruction or between the model and the made was discernable and part of the game; whereas in others it was more densely screened, so as to pretend that perfect identity had been achieved. Anachronism, the difference between antiquity and its modern simulations, was not a predetermined stable condition but could emerge anywhere on a continuum between the poles of artifice and dissimulation. Yet the signs of temporal distance were never entirely erased, and all efforts were identified as virtual rather than absolute retrievals.

This brings us closer to the heart of the matter. Italian architects and theorists saw the interval of difference between then and now, but they could not tolerate it for what it actually was. They could not recognize difference as a sign of distance, irrecuperability, non-identity, and change through time because these were the conditions not of revival—of a phoenix-like *rinascita*—but of survival—of the always mutating never-dead. In art historical discourse, "survival" and "revival" have typically been comprehended as distinguished by degrees of intent and agency, and as respectively describing the essential difference between unwitting medieval and self-aware Renaissance uses of antiquity. This was famously codified by Erwin Panofsky in his sequence of medieval renascences and one singular Renaissance. Survival and revival are better understood, however, as different conditions of ontological wholeness and of being in time. Survival indicates a difficult journey through time during which the survivor occasionally surfaces as hurt, contaminated, alienated, and altered. To survive is to be transformed via trauma, often by a series of accreted traumas, of dislocation and

being rendered uncanny to oneself, of cultural innovation and good intentions, or of historical contingency and expediency.

Revival describes a very different—and ultimately unreal, indeed, oneiric—experience. Time hardly enters into the picture at all. The condition of revival is immediate: It takes place now. History seems benevolent and cultural demands fortuitous. The revived object is allowed to see its past self narcissistically, as if in a mirror. Being displaced from its original home and excised from the horizon of conventions in which it first took shape is completely without consequence. Revival denies time because it denies change in time and points to the pure and intact recovery of something integral, uncontaminated, and whole that is unmarked by the molestations, whether benign or malignant, ignorant or deliberate, suffered by the survivor. Rather than difference because of time and history, there is identity between original and revival despite time and history. In other words, revival is a state that is always out of reach. To claim, as scholars often do, that survival and revival can be simultaneously present in any given work or period is to be blind to the fact that revival is a dream whose waking realization can only be a survival simulating revival and seeking, at least in humanist Italy, to dissimulate this distressing condition.

Recently, there has been a growing interest in reexamining Aby Warburg's concept of survival or *Nachleben*. The scholar who has provided the strongest reading of Warburg is the French art historian Georges Didi-Huberman, who writes: "The Renaissance is impure—survival would be the Warburgian manner of naming the temporal mode of this impurity."[9] Survival provides a reading of the image (like Warburg, Didi-Huberman is primarily interested in painting, not architecture) in terms of the multiple non-aligned temporalities that constitute it: "An image, each image, is the result of movements that are provisionally sedimented or crystallized within it. These movements traversing it through and through, each has a trajectory—historical, anthropological, psychological—launched from far away and continuing well beyond it. . . . To put it in plain language. . . the time of the image is not the time of history in general."[10] Didi-Huberman thus argues that Warburg's "survival" designates that the

8. Manfredo Tafuri, *Ricerca del rinascimento* (Turin: G. Einaudi, 1992), pp. 13–14.

9. Georges Didi-Huberman, *L'image survivante: Histoire de l'art et temps des fantômes selon Aby Warburg*, (Paris: Les Edition de Minuit, 2002), p. 82.

10. Ibid., p 39.

temporal condition of images is anachronistic and not chronological as historians from Vasari to Panofsky would have it. This interpretation can certainly be extended to architecture, where it allows us to appreciate that, for example, the anachronism of Bramante's Tempietto cannot be plotted only in terms of a simple ancient versus modern opposition, or categorized only in formal, morphological, or stylistic terms.

What Warburg and Didi-Huberman do not allow, however, is an understanding of how Italian Renaissance architects and theorists were able to persuade themselves that formally, morphologically, and stylistically they had achieved an authentic *rinascita*—truly a revival, beyond any survival—and that the specific classicism they created did in fact wholly recreate the timeless and true classicism of the ancients. Furthermore, Didi-Huberman sees the structure of survival as a dialectical one, involving both survival and revival. He declines to recognize that fundamentally *there are only different states of survival,* and it is precisely these different states that are embodied in any given work. That is, as much as a reappraisal of Warburg's "survival" is congruent with an understanding of architecture that I would agree with, it does not take into account the mechanisms of dissimulation that are critical to understanding the Italian Renaissance architectural imagination. For much of what was most creative about this imagination can be directly traced to the ceaseless inventiveness of its bravura experimentations—built and textual, graphic and rhetorical—with epistemic camouflage: the efforts to simulate a revival of antiquity and dissimulate the condition of survival.

To sustain the illusion of an achieved *rinascita,* Italian architects and theorists variously dissimulated the nature of the anachronistic interval that left its traces on all their creations. Instead of acknowledging the gap for what it was—a sign of irretrievability and non-identity, of instrumentalized and maimed survival, rather than pure and wholesome revival—the nature of the difference was concealed and cast as something else. Difference was often accepted and even flaunted as invention, license, originality, but its true origins and character were imaginatively dissembled. Dissimulative methods were devised, all of which dealt with the problems posed by anachronism and survival in formal terms. The new and public discourse on the rules of architecture, the preoccupation with identifying and classifying architectural errors even within antiquity itself, the conception of buildings in terms of Vitruvius's

corporeal analogies, the reading of modern buildings through ancient texts, and so on—all of these offered ways of conceiving or of making architectural form in such a way that the anachronistic disfigurements of survival were masked. Yet these dissimulative efforts were successful only because they took place in an imaginative space that effectively omitted rather than camouflaged history and the medieval. Conversely, this space was itself brought into being by these various dissimulative efforts whose drives, desires, and products articulated its ideal configuration.

Critical to comprehending the contours of this space is the twofold nature of the archeological project of *rinascita.* It is important to recognize that the restoration of antiquity (fig. 4) and the creation of new buildings in the ancient manner (fig. 5), while closely intertwined, in fact, represented two separate recovery efforts: two rebirths. They did so because they were responding to two separate though related deaths: the death of ancient buildings and the death of the knowledge of how to build. In the 1460s, Filarete poignantly mourns the former, as he lists now-lost buildings that are known to him only through their descriptions in ancient texts. At the same time, he relates the latter as a progressive disaster, beginning with the barbarian wars that brought desolation and poverty (which, in turn, led to the collapse of the will and the financial means to build well) and ending in the complete extinction of architectural knowledge. A century later, Vasari again stressed the dual nature of the loss, specifically identifying its two victims. He tells us not only how the invading barbarian tribes destroyed the city of Rome, laying it to waste and razing its architecture to the ground, but also that the wars had killed all the architects: The knowledge of the art of good building died with them. The ruination of the buildings was a loss to the "miserable city of Rome," which had thereby lost its majesty and its essence. The loss of knowledge—a loss Vasari tells us was "of far greater consequence"—was a loss to all future generations of architects (and all people generally), including those of the recent past and present who felt it most keenly. The two losses (or deaths) were thus vanquished by two rebirths, as two architectural cultures were restored to life and became the two inseparable parts of the *rinascita.*

In this twofold project of *rinascita,* both the moderns and the ancients were imagined as active participants. That is, agency and motivation, the desire to save and to be saved, was conferred upon antiquity by Italian Renaissance architects, as though they were in direct unmediated communication with each other. Often, the

ruins themselves are personified and seen as coextensive with their makers. They reveal and show, they bear witness. For Alberti, the ruins are professors who teach him, and, similarly, Manetti in his biography of Brunelleschi writes that in studying the ruins Brunelleschi was studying the ancient masters themselves. The antiquities seemed to effortlessly yield their past perfection to the searching eye of the learned architect. Palladio, for example, writes of the Basilica of Constantine, as he does of many monuments, that "its remains, ruined though they are, suggest such magnificence that one can imagine all too well what it was like when it was complete."[11] That Palladio's desire to know was equalled by the desire and capacity of antiquity to disclose seemed self-evident. The ruins also share the traits that the Renaissance believed were possessed by the ancients. Again, I can cite Palladio, who wrote, "the fragments of many ancient buildings . . . provide, even as stupendous ruins, clear and powerful proof of the *virtù* and greatness of the Romans."[12] And the ancients themselves are often imagined as seeing and judging the works of the present. In his praise of Giulio Romano, Pietro Aretino claimed that Vitruvius and Appelles would have greatly admired his works.

The active and direct engagement of the ancients in the project of *rinascita* is most explicitly spelled out, however, in Filarete's architectural treatise, which is a fictional account of the construction of the utopian city of Sforzinda. Filarete recounts that one day, while the foundations of a new building for Sforzinda are being excavated, a large stone box is discovered, and in this box is found a golden book, written centuries ago by a certain King Zogalia, who had once reigned over a disappeared city of Plusiapolis. In the Golden Book, Zogalia writes that he is composing his text for the future. He has foreseen the disasters that will befall his country, which will be invaded by barbarians, fall into ruin, and disappear. Thus, the Golden Book contains a series of detailed descriptions and engravings of the buildings of Plusiapolis, so that "posterity. . . can have some knowledge of us," and, as becomes clear, can itself benefit from this knowledge.[13] Among the buildings

Figure 4. Sebastiano Serlio, Theatre of Marcellus, *Tutte l'opere d'archittetura, et prospetiva, Terzo Libro* (Venice, 1619), 71r. By permission of Avery Architectural and Fine Arts Library, Columbia University in the City of New York.

for which Zogalia provides detailed measurements and images is the Temple of Plusiapolis of which he writes: "Because of its beauty I have engraved it in this our golden book, which we have left because . . . it will be a memorial to us."[14] The temple of Plusiapolis becomes the model for the cathedral of Sforzinda, and, in general, the buildings described by Zogalia (buildings whose architect's name is a specular anagram for Filarete's real name, Antonio Averlino) are used as models for the architecture of Sforzinda. Thus, at Sforzinda, the lost ancient architecture of Plusiapolis is reborn through the joint efforts of Zogalia with his architect *and* the lord of Sforzinda with his architect.

11. *Andrea Palladio: The Four Books on Architecture*, vol. 4, ed. and trans. R. Tavenor and R. Schofield (Cambridge and London: Cambridge University Press, 1997), p. 11.

12. Ibid., vol. 1, p. 3.

13. Filarete, *Treatise on architecture, being the treatise by Antonio di Piero Averlino, known as Filarete*, vol. 1, trans. J. R. Spencer (New Haven and London: Yale University Press, 1965), p. 183/105r.

14. Ibid., p.188/107v.

Figure 5. Sebastiano Serlio, Doric Façade, *Tutte l'opere d'archittetura, et prospetiva, Quarto Libro* (Venice, 1619), 151r. By permission of Avery Architectural and Fine Arts Library, Columbia University in the City of New York.

Filarete's story of the Golden Book can be read as an allegory of the desires and anxieties of Italian Renaissance architects. The Golden Book makes antiquity transparent, lucid, and completely knowable. Antiquity speaks directly and immediately to the present in the present, leaving no room for interpretive doubt or distortions. The vast span of historical time that stands between antiquity and the present disappears. Zogalia fully anticipates the needs and desires of the future builders of Sforzinda and also recognizes that his own desire to have his architectural culture be made perfectly whole and knowable again can and will be satisfied in the future. Filarete's allegory directly lays bare what is muted in the more scientific and dispassionate treatises of such authors as Alberti, Serlio, and Palladio. Much of what Filarete describes, in particular the participation of a desiring antiquity in its own rebirth, informs and vibrates throughout these treatises and the Italian

Renaissance architectural imagination in general, as it sought to effect a *rinascita*.

This brings me back to the issue of the nature of the space where the dream of *rinascita* was realized: That is, the space where revival was simulated, by which I mean the space where anachronism and survival are produced, while simultaneously being dissimulated. I would argue that comprehended as a temporal phenomenon, the archeological project of *rinascita* in its two rebirths and with its two sets of actors was imagined as two separate but simultaneous and intersecting gestures across time: from the present back to the past, as the degraded architecture of antiquity was rescued and restored (for example, in Palladio's reconstruction of the Basilica of Constantine from his *Quattro Libri* [fig. 6]); and also from the past to the present, as the architecture of antiquity became a model for contemporary architecture, which could thereby be

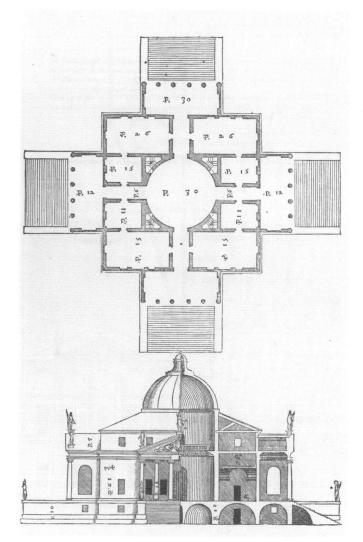

Figure 6. Andrea Palladio, Basilica of Constantine, *I quattro libri dell'architettura, Quarto Libro* (Venice, 1570), p. 13. By permission of Avery Architectural and Fine Arts Library, Columbia University in the City of New York.

Figure 7. Andrea Palladio, Villa Rotonda, *I quattro libri dell'architettura, Quarto Libro* (Venice, 1570), p. 19. By permission of Avery Architectural and Fine Arts Library, Columbia University in the City of New York.

delivered from the degraded condition it endured for so long (as was apparently achieved in Palladio's Villa Rotonda, seen also in an image from the *Quattro Libri* [fig. 7]). The *rinascita* only attains presence and authority because the two simulated revivals function synchronically at the intermediate conceptual place where the two sets of regenerative vectors, projected through time, meet.

The space and the mechanism of *rinascita* is thus chiasmic, generated by the dynamic crossing of the two recuperative drives that together produce and articulate a virtual, superhistorical space outside of linear, monodirectional historical time: A space where the two

simulated revivals are equally present. In this space at the center of the chiasm, where the revived architecture of the ancients and the new architecture of the Renaissance are brought face to face, temporal distance evanesces. Here the condition of anachronistic non-identity, which characterizes each simulated revival individually, disappears to be replaced not by identity but specular analogy. Each is defined as authentic by the degree of similarity it bears to the other. The dissimilarities between them are not negative traits, for they are seen to result not from temporal distance but

from *spatial distance* within the same imaginative field. Consequently anachronism, which is predicated on duration and chronology, becomes a term without meaning and a condition that no longer obtains. The center of the chiasmic *rinascita*, it should also be stressed, is not occupied by the medieval, but at best by its transformation into an indefinable ahistoricized fog exterior to the chiasm, existing outside the creative forcefield of the architectural imagination of *rinascita*. Thus the objects created there are amnesiac, ignorant of history, and free of the distortions of survival.

Serlio wrote about Bramante that he had "brought back to life . . . the fine architecture which, from the ancients to that time, had lain buried."[15] Palladio concurred, "Bramante was the first to bring to light that good and beautiful architecture which had been hidden from the time of the ancients till now."[16] At first glance, these statements present us with an apparent ambiguity: Did Bramante excavate and physically repair the long-buried architecture of antiquity? Or did he build new monuments based on the study of antiquity, which had revealed its forms and knowledge to him? Because we are familiar with Bramante's activities, we are inclined to answer that only the latter is meant. But understood as an imaginative exercise, so is the former. The statements are ambiguous only to the extent that we fail to recognize the twofold, simultaneous, and virtually specular nature of events within the chiasmic field. These statements also indicate an extreme proximity between restoration and imitation, which is not always the case. Because the distance between the two revivals in the chiasm is spatial rather than temporal, the measure of this distance is not fixed but fluid and thus is able to expand or contract. In the eyes of Serlio and Palladio, Bramante's Tempietto seemed to greatly narrow this spatial distance to the point of near obliteration. Yet because formal difference within the chiasmic *rinascita* is not a sign of irrecuperability and loss, the interval could be safely opened up (as in the Villa Rotunda). Also, far greater disparities between the two revivals could be absorbed into discourse as evidence of exceptional individual achievement within a common field (hence the frequency of the trope that the ancients have been rivaled and surpassed). This is what Alberti says about Brunelleschi's cupola, what Vasari says about virtually everything created by Michelangelo, and what

Raphael says about himself. Even the builders of the fictional city of Sforzinda declare their intention to exceed the architecture of Plusiapolis. Such claims are not merely sustained by an insecure rhetoric that seeks to mask an anxious reality, but rather attain credibility in the virtual reality of the chiasmic *rinascita* whose creations are, in Pietro Aretino's words, "anciently modern and modernly ancient."[17] In this simple turn of phrase, Aretino not only articulates the conditions of non-identity and difference, but also the specular analogy, resemblance, and proximity that define the products of the *rinascita* as a twinned, detemporalized, superhistorical phenomenon that unfolds in a space where the slippery term *all'antica* gains semantic traction.

If the Petrarchan historiographic model is sequential, linear, tripartite, and mono-directional and places its events in a motivated narrative chronology, the structure of the detemporalized space where the architectural *rinascita* could gain self-evident authority is, to the contrary, paratactic, chiasmic, bipartite, and specular. Its events and objects are not coordinated on a motivated temporal chain where each is assigned a fixed position, but emerge dyadically as independent entities in a shared creative and discursive field where the relationship between them is elastic. The *rinascita*, it might thus be said, has the uncanny structure and the mobile logic of a dream. This is not to say that it is inauthentic or false. The *rinascita* was real to the extent that we understand it to possess the genuine reality of a simulacrum. There exists no prior or exterior reality of any substance and presence that it veils or distorts. It is an authentic cultural phenomenon.

What the *rinascita* is not, however, is a phenomenon that can be narrated. It is a mistake to impose on Renaissance theoretical discourse about the production of *all'antica* architecture the narrative structure that was developed in the quattrocento from Petrarch's invention of the dark ages. The medieval was essential to the formation of the chiasmic *rinascita*, but only as an entity to be immediately evacuated. Its emergence as a defined span of historical time generated its own obliteration in the imaginative and symbolic domains. The rebirth of antiquity could only occur not after antiquity's death, but after the death of its death, the definitive consigning of the dark ages to darkness, which takes place in the

15. *Sebastiano Serlio on Architecture,* trans. Vaughan Hart and Peter Hicks (London and New Haven: Yale University Press, 1996), vol. 1, p. 127.

16. Ibid., p. 276.

17. Pietro Aretino, *Lettere sull'arte,* ed. E. Camesca (Milan: Edizioni del Milione, 1957), letter 142 ("anticamente moderni et modernamente antichi").

a-narrative space of the chiasm. It is here and not in the historiographic model, articulated by quattrocento humanists and transferred to art history by Vasari, that Petrarch's dream of a revitalized antiquity was most successfully realized, at least for architecture. The second edition of the *Lives* is thus compromised not only by the tensions between history and historical buildings, but more fundamentally by Vasari's overarching intent to narrate a comprehensive and sequential history of architecture, to construct a narrative link between antiquity and the present, to flesh out what in the previous edition had only been a theoretical abstraction and to thereby bring the dark ages into light, make it visible: All of which gave presence to a historical space that should not have any. The assumptions and imperatives of the tripartite motivated narrative were thus brought into inevitable conflict with those of the bipartite paratactic chiasm. This was the intractable flaw embedded in the very structure of Vasari's ambitious project.

But if the trans-historical narrative could not serve as an effective and necessary manifesto of the *rinascita,* another genre could: the architectural treatise, in particular the printed illustrated treatises of the cinquecento. It is for this reason that so much of the material I have used to explain and illustrate the chiasm has been drawn from treatises. I now want to turn to a more direct consideration of the Italian Renaissance treatise and the chiasmic *rinascita.* The many treatises that appeared in the quattrocento and cinquecento are typically seen as engaged only in contemporary debates about the rules of architectural practice and as offering pedagogical models, both contemporary and ancient, that illustrate these rules. Because they are treatises and not histories and thus are not concerned with duration, narrative, and descriptions of the temporal trajectories of the classical, they have not been understood as offering a theory of the Renaissance historical imagination. And they certainly are not understood as being the fundamental—in fact the only—place where the chiasmic *rinascita* in all its dimensions could be reified. Yet this is precisely what they did and what they were.

The dynamics of the chiasm and the relationship between its objects are identical to those found in the Italian Renaissance architectural treatise. This holds true already for the manuscript treatises of the quattrocento, even for Alberti's *De re aedificatoria* of 1450 that does not have illustrations. But it was the illustrated and printed cinquecento treatise, whose images took priority over text, that provided the ideal space to display and theorize the chiasmic *rinascita.* It is only in its pages that

the virtually restored architecture of antiquity and images of contemporary architecture could be brought together as part of the same project, thereby affirming each other's authenticity and, moreover, because of the nature of the printed image could do so with great epistemic credibility. To a certain extent, two illustrations from Palladio's *Quattro Libri* of 1570 make the point (figs. 6 and 7). That both the reconstructed ancient basilica and Palladio's own villa are anachronistic survivors, incapable of making authentically present antiquity's irretrievable condition of self-present plenitude, is rendered irrelevant, as they dyadically embody the state of specular analogy of the *rinascita.*

This printed graphic project of *rinascita* was first realized and its protocol of representational tactics first coalesced, however, in Serlio's treatise, the third book of which appeared in 1540 and was entitled *On Antiquities.* Prior to the appearance of Serlio's Book III, no ancient building had ever been published. Now Serlio printed not one but a whole group of ancient monuments in a single volume. The actual physical condition of the buildings represented by Serlio varied considerably and ranged from the relatively undamaged Pantheon to a Greek building of unspecified function of which Serlio had only a vague textual knowledge. In between these two extremes were such monuments as the arch of Septimius Severus, which (as in Heemskerk's and other views of the forum) was half-buried in the sixteenth century, yet was graphically disinterred and cleaned up by Serlio. Even more, buildings in a near total state of ruin, such as the mausolea on the Via Appia, which Serlio calls *tempiettos,* were seamlessly pieced back together (fig. 8).

Serlio's woodcuts did more than simply erase the varying effects of time and history that had rendered antiquity more or less accessible. They also effaced all traces of the buildings' diverse historical origins. The antiquities that he illustrates ranged from ancient classical Greece to Republican and late Imperial and Constantian Rome and thus varied greatly in their formal and morphological traits as well as in their scale, material, and relative lavishness. Yet the graphic conventions by which they were represented reduced them all to a common plane of stylized abstraction that annulled these differences. For example, the early second-century Hadrianic Pantheon and the mid-fourth century Santa Costanza (which Serlio calls the Temple of Bacchus), two buildings that were basically intact, are represented as versions of the same architectural mode (figs. 9 and 10). That the Pantheon was far more lavish, encrusted with multicolored rare marbles, and that its

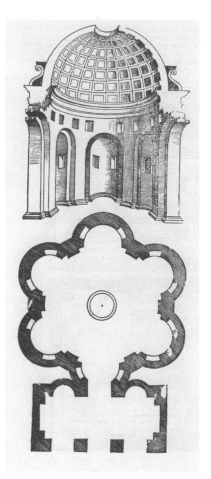

Figure 8. Sebastiano Serlio, Tempietto, *Tutte l'opere d'archittetura, et prospetiva, Terzo Libro* (Venice, 1619), 68r. By permission of Avery Architectural and Fine Arts Library, Columbia University in the City of New York.

individual forms are of far greater complexity and refinement than those of the Temple of Bacchus, is not signalled in Serlio's woodcuts. Thus the graphic conventions of his woodcuts dehistoricized antiquity and represented it as an idealized timeless whole where its diverse moments were collapsed into a single synchronic space.

Despite the fact that Serlio's Book III was entitled *On Antiquities,* he included in the dehistoricized, detemporalized synchronic space of the treatise a number of contemporary projects and buildings, such as Peruzzi's unrealized plan for Saint Peter's, Raphael's Villa Madama, Bramante's unrealized project for the dome of Saint Peter's, and, of course, his Tempietto. The presence of these and other sixteenth-century projects in Book III

is usually interpreted as evidence of the cinquecento's pride in its own accomplishments. Yet as true as this may be, it is important to recognize that here for the first time the two aspects of restored antiquity, its two simulated revivals, were brought face to face in a printed book and were, moreover, graphically figured in such a way that both were seen as participating in an identical architectural project that they dyadically reify. Whatever their actual condition in the world outside the book, whether intact, ruined, or unbuilt, known materially or textually, within the self-enclosed autonomous realm of the treatise they are all equally real and whole. The treatise is not coextensive with nor does it substitute for the experience of physical structures out there in the world. Instead the treatise is a self-focusing, self-reflecting, self-constituting world that creates an alternate and authentic reality. Thereby the imaginative space at the center of the chiasmic *rinascita* was rendered visibly real and genuine in Book III, whose pages created a superhistorical space outside of linear time where the restored—graphically reborn— architecture of the ancients and the newly imagined buildings of the moderns are each equally present.

Furthermore, if the space of *rinascita* is created by the fusion of two historical moments into a single common superhistorical terrain, as already indicated, its two groups of objects never similarly fuse or collapse into each other. They never formally merge into an inert synthetic monolith. The creative vitality of the *rinascita* resided in the differences between its two products, in their condition of non-identical specular analogy. Had he wanted, Serlio could have presented one of his reconstructions of a particularly badly damaged and barely standing antiquity as a near duplicate of a modern project. Yet he never did so. Instead, a series of formal motifs appear in his woodcuts as devices in which ancient and modern projects are graphically emphasized as similar but non-identical participants in the same architectural discourse. One such motif, which derives from triumphal arches, is that of paired columns framing a niche and an inset plaque. This can be found flanking either side of Bramante's Cortile del Be21levedere staircase, as in fact occurred in reality. But Serlio also adds the motif to many other structures, such as the temple at Tivoli (fig. 11) about which Serlio writes: "The temple shown . . . is very ruined. . . . At the front there are no traces of . . . niches . . . but I have shown it in this way . . . since it could certainly have been like this."[18] He also incorporates it in his wholly imaginative

18. *Sebastiano Serlio on Architecture* (see note 15), p. 126.

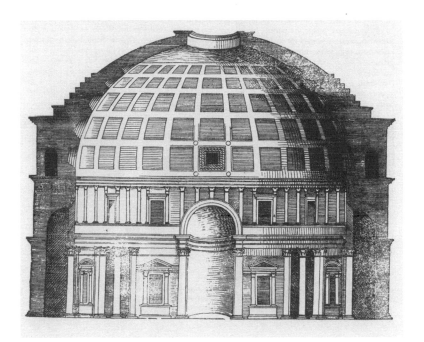

Figure 9. Sebastiano Serlio, Interior of Pantheon, *Tutte l'opere d'archittetura, et prospetiva, Terzo Libro* (Venice, 1619), 52r. By permission of Avery Architectural and Fine Arts Library, Columbia University in the City of New York.

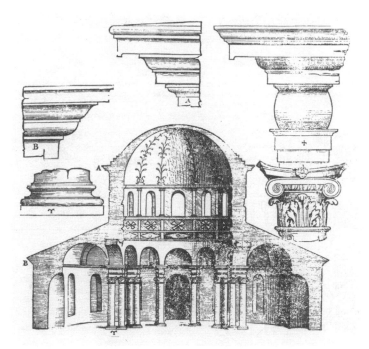

Figure 10. Sebastiano Serlio, Temple of Bacchus, *Tutte l'opere d'archittetura, et prospetiva, Terzo Libro* (Venice, 1619), 57v. By permission of Avery Architectural and Fine Arts Library, Columbia University in the City of New York.

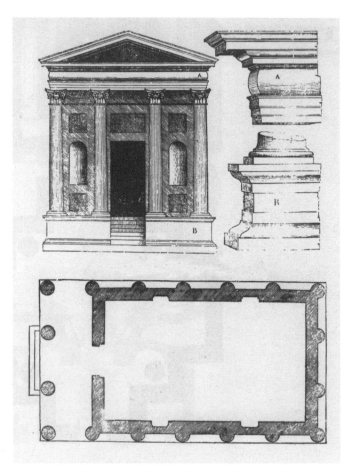

Figure 11. Sebastiano Serlio, Temple at Tivoli, *Tutte l'opere d'archittetura, et prospetiva, Terzo Libro* (Venice, 1619), 64r. By permission of Avery Architectural and Fine Arts Library, Columbia University in the City of New York.

reconstruction of a Greek building. In addition to these ruined or completely lost ancient buildings, he even appends the motif to perfectly intact contemporary monuments, such as Raphael's Villa Madama. Serlio admits: "The niches at the sides . . . do not exist."[19] He nevertheless refigures the façade to include them and thereby graphically indicates that the Villa Madama, the Greek building, and the Roman temple all emerge in the same creative space, where the formal links between them are paratactic rather than sequential.

The forms that most clearly establish the presence of a common terrain of architectural invention were, of course, the classical orders. The system of the five

19. Ibid., 238.

orders, as Christof Thoenes and Hubertus Günther have clearly and extensively demonstrated, was a modern invention. The very concept of an order, what properly constitutes it, the hierarchy and canon of the five orders from Tuscan to Composite, were all anachronistic and dehistoricizing inventions both abstracted from and imposed upon the vast chaotic complexity of ancient buildings and texts. The first place where the orders were codified and graphically presented as a comprehensive canon of standardized forms was in the image from Serlio's *On the Five Manners of Building* (fig. 12), Book IV of his series, which had appeared in 1537, three years before he published the book on antiquities. That Serlio published his system of the orders before his book on antiquities has never really been adequately explained. I would argue that the self-evident credibility of the theory embodied in the images of Book III, the self-evident veracity of the superhistorical dyadic *rinascita* depended upon establishing the presence and credibility of superhistorical formal links between antiquity and modernity. Disembodied formal ideals detached from actual physical structures, Serlio's orders were validated in Book IV as the self-evident stigmata of classical architecture, which they had not previously been. Furthermore, Books III and IV were soon published as one volume, and all its images, such as the reconstruction of the Theater of Marcellus from Book III (fig. 4) and Serlio's project for a palace façade from Book IV (fig. 5), were now joined, thereby extending and amplifying the space and the project of *rinascita*.

Serlio's treatise, like those which followed, is a highly effective manifesto of the cinquecento's pseudo-Petrarchan project. The Italian-printed, illustrated architectural treatise is, however, not merely the manifesto of the *rinascita,* declaring the parameters, nature, and intent of its program. It also is highly credible evidence—proof—that the *rinascita* had in fact been achieved. The dream of architectural rebirth is effortlessly made real in the images of the treatise which, moreover, could only have the epistemic authority it does because it is a printed book. The advantage of the treatise over Vasari's *Lives* is not only that its statements are primarily conveyed in images rather than words, but also that these images are printed. The sketchbooks and codexes of drawings that were created by Renaissance architects always betray the interpretive nature of their facture. The images in a printed book, however, seem severed from the messy and contingent creative process of making and consequently suggest that their information is self-

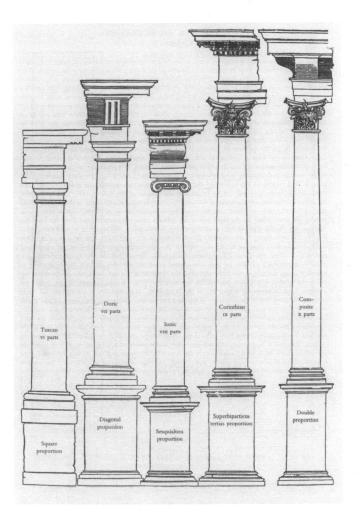

Figure 12. Sebastiano Serlio, Composite image of the orders, *Tutte l'opere d'archittetura, et prospetiva, Quarto Libro* (Venice, 1619), 127r. By permission of Avery Architectural and Fine Arts Library, Columbia University in the City of New York.

printed image is launched into the world cleanly detached from its origins in a specific interpretive context. The printed image in the sixteenth century had the kind of evidentiary status that the photograph did in the modern era. It was Serlio's great insight to be the first to recognize that the technology of printing and the printed, illustrated book could be used to authenticate and to incarnate the Italian Renaissance architectural project of *rinascita* in a way that a narrativized, chronological art history never could. At the same time, the tremendous success of Serlio's project, which had rendered the *rinascita* so real and credible, was the very event that led Vasari, a diligent student of Serlio's treatise, to believe that the *rinascita*'s reality could be written into history.

contained and self-evident. Mario Carpo has recently suggested that the technology of the printed image "guarantee[s] . . . that no middlemen will tamper with or disrupt the chain of transmission—from the maker to the user—of the image itself."[20] But I see it differently. Printing does not protect but rather suppresses the presence of a maker as it breaks the connection between an intending person and the image. The

20. Mario Carpo, "How do you imitate a building that you have never seen? Printed image, ancient models, and handmade drawings in Renaissance architectural theory," *Zeitschrift für Kunstgeschichte* 64 (2001):230ff.

Figure 1. Volumetric-sectional study for a focal point of sound: superimposed increments of a wave front acoustically reflected off the concave belly of a 20-ft. sound mirror.

An improbable dimension

RAVIV GANCHROW
Commentary by REMO GIUIDIERI

This text will focus on a particular moment in imaging technology developments where apprehension of an object shifts from the optic model of the telescope (mobilization of a viewing point through an extension of the eye into the landscape) to the radiant model of interferometry (where the viewing point is assigned the only stable position within a fluctuating field of interacting wave fronts).[1] The outcome is a shift in the relationship between sound, temporality, and perception that signals a reorientation of the site of experience.

Prior to the Second World War, Britain conducted research toward the development of a national acoustic defense system. The years between 1927 and 1930 yielded the design and construction of several large-scale "sound mirrors" mounted in strategic positions along the coastline of southern England. These listening structures consisted of sections of spheres, mostly made of cast concrete, ranging in size from 20-ft. vertical dishes to a 200-ft.-long curving wall, all of which were aimed at acoustic apprehension of incoming

hostile aircraft. This endeavor sits at the brink of the development of radar, at the point where the glass lens is about to diffuse into electromagnetic radiation. In this case of the sound mirrors, the transformation from optics to electromagnetic echo intersects in the acoustic domain, where oscillating matter still presents itself at a scale compatible with the body. In other words, the acoustic experience of sound occurs within the audible realm, maintaining an unmediated tuning with the sensorium.

I propose to cast the example of the sound mirrors as a critical threshold within the evolution of a specialized attentive practice. My intent is to highlight an alteration in the grasp of presence when a viewer becomes a listener and through it suggest the emergence of a skewed conception of space that is based on an oscillatory, temporal, and what might be broadly termed "tactile" understanding of perception. This notion replaces the linear geometry of Cartesian coordinates with a realm of concentric fluctuating patterns of interference, opening a parallel domain where what was seen before in terms of "remote" or "distant" resurfaces astonishingly close to the observer.

The present survey will isolate a short period of military history at the risk of obscuring the political underpinnings that led up to those particular events; it will also avoid drawing any suggestive links (although such links may exist) to other transformations taking shape at that time within the predominant European visual cultures. This is done in order to reveal a "mechanism" that despite its apparent isolation has subsequently resurfaced in a multitude of contemporary cultural, political, and medical applications. This position by no means suggests equating a form of surveillance with more contemplative forms of observation. The example here simply hopes to locate and evaluate a threshold condition within a specialized attentive practice where all the components are still relatively reduced and therefore remain accessible to descriptive analysis. The term "attentive" is used here to emphasize a concentrated condition of anticipation, where a subject is purposefully positioned toward an expected state of comprehension. It is also a term that stresses the process of perceiving without favoring a particular sense organ. The aim is to avoid attributing

I would like to thank Richard N. Scarth for sharing his expertise concerning the development of acoustic early warning systems in Britain, and Owen Layshon for his assistance in the complex coordination leading up to my visit to the sound mirrors. Additional thanks to Remo Guidieri for his critical elucidations, not only with respect to the current endeavor, but also for his seminars at the Cooper Union in New York, which I attended some time ago. I am particularly indebted to Roy Tzohar and Michaela Fruhwirth for their pointed feedback throughout the development of the various ideas presented here and to my family for their encouragement. This research was made possible with the support of The Netherlands Foundation for Visual Arts, Design, and Architecture.

All of the unattributed drawings and photographs accompanying this text are my own and stem from on-site surveys at Denge and Abbots Cliff. Photographs have been incorporated into the article primarily to give a sense of place and scale. However, it is with some uneasiness that I have decided to include the drawings relating to sound itself, particularly figure 1, because they are as crucial as they may be misleading.

1. The term "radiant" is applied here to describe phenomena such as heat. It should be thought of as an expanding cloud that diminishes in intensity the farther away it gets from the source of emission. In other words, one may think of radiance as a three-dimensional wave pattern, rather than clusters of straight-line rays. This should not be confused with ideas of luminosity or other forms of radiant energy that employ the analogy of straight line trajectories or spokes on a wheel, as these belong to optic analogies that stand in contradistinction to the ideas presented here.

greater preeminence to the ear over the eye within the ongoing prosthesis of the senses.[2]

The military's interest in locating the limits of visibility results in an ongoing process of innovation that eventually seeps down into common use. Once within the broader social consciousness, these devices take on denser, more oblique meanings whose range of implications is yet to be explored. In this respect, a "turning point" might be more difficult to locate as a distinct moment, once these techniques have been absorbed into the public domain. That said, this example is not meant merely as an historic reiteration, but also is intended to provide insight into the broader discussion of perception within the context of a modern disrupted experience.

Britain's sound mirrors

Britain's acoustic defense project was primarily focused on the development of sound mirrors. These structures were conceived to operate as long-range listening devices aimed at intercepting sounds of approaching aircraft outside of the visual range. The problem the project sought to overcome was that of amplification: By the time the sound of an aircraft had reached the coast, the propeller rumble had faded to such an extent that it could no longer be detected by the naked ear. The solution was to collect the incoming vibrations, refocus their energy, and by doing so amplify the sound back into the audible range. This was accomplished by applying reflective properties of curved surfaces to large-scale construction methods.[3] The early

1930s marked a peak of activity in sound mirror development. After the completion of six large-scale concrete mirrors, a proposal was drafted for an early warning network, with mirrors placed in consecutive increments every sixteen miles. The plan was to construct a "listening shield" extending from East Anglia in the north to Dorset in the south (figs. 2a and 2b).

The remaining cluster of mirrors to be seen today on the shingle coast of Denge presents the most advanced stage reached in the project. The site includes three mirrors: a 20-ft. and a 30-ft. spherical dish, and a 200-ft. strip mirror wall. The latter two mirrors were to be the prototypes for the acoustic coastal network that consequently was never realized. After the mirror was erected at Denge, only one other 200-ft. mirror was built at Maghtab, Malta, late in the mid-1930s. In fact, sound mirrors never developed beyond the experimental stage of design due to the discovery of a more powerful means of aircraft detection. In 1936, successful apprehension of a remote flying aircraft by means of Radio Detection Finding (RDF) sealed the fate of the project and effectively announced the birth of radar. The end of the acoustic defense story overlaps with the early days of radar when individuals working on the mirror research were relocated to posts in the radar endeavor. It is important to stress here a kinship between the two techniques. Both radar and sound mirrors employ principles of radiation and reflection. Both establish knowledge of a remote object by intercepting an incoming signal. The difference is that sound mirrors maintain coherence in relation to the physical body. They remain aligned with the human sensorium. Sound mirrors are for the most part purely mechanical instruments, employing only the inherent properties of airborne acoustic vibration, solid surfaces, and human aural capacities.[4] In contrast, radar relies on obtaining information from remote objects by means of registering the rebounding echoes emitted by a pulse of electromagnetic waves. Therefore, radar is already the point at which technology is extended beyond the spectral tuning of the senses, demanding an interface of decoding that translates the actual occurrence of an event via an electronic mediator. Only when the

2. Within the very mechanism of observation at work in the mirrors, there exists already an overlap of the acoustic and the optic, since the idea of a final "apprehending" of airplanes involves a geo-optic transcription. A series of charts accompanying test reports of the sound mirrors show meticulous plotting of the flight patterns inferred from the unfolding acoustic registration that is projected by means of draftsmanship onto a bird's-eye map of the Dover straits.

3. Two main types of listening dishes were developed: one deeper, with parabolic properties, and the other shallow, of spherical curvature. The parabolic type was direction-sensitive and therefore primarily developed for use in mobile-listening units; spherical mirrors were capable of detecting sounds traveling at oblique angles to the surface of curvature, deeming them appropriate for use as fixed-position sound locators. Almost all the structures built along the narrow stretch of eastern coastline were of the spherical type. The initial mirror designs were carved directly into the chalk cliffs at Joss Gap, Kent, and were already operational during the First World War. Experiments with various other methods of sound detection including listening wells and various disc configurations were also conducted at several locations along the eastern coast of the United Kingdom.

4. It is necessary to mention in this context that specialized "hot-wire" microphones were employed in the largest of the mirrors at Denge because of the relative insensitivity of the human ear to the low frequencies set to be detected. The microphones, consisting of a heated wire attached to an electrical resistance register mounted within the chamber of tuned Helmhlotz resonators, provided a cross-reference for the ear-witness reports of patrolling listeners.

Figure 2a. Map indicating the location and listening extents defined by a coastal network of 200-ft. sound mirrors (detail). The National Archive, ref. AIR 16/317, *Sound discs and mirrors development 1934 Feb.–1935 Nov.*

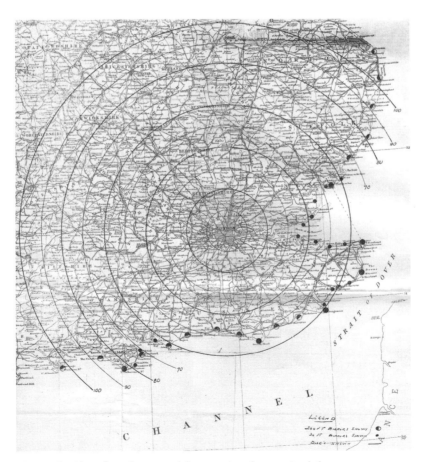

Figure 2b. Abandoned proposal for a national acoustic defense system designating a "listening wall" of coordinated 30-ft. and 200-ft. sound mirrors along the eastern coastline of Britain (detail). The National Archive, ref. AIR 16/317, *Sound discs and mirrors development 1934 Feb.–1935 Nov.*

electronic detector is attached to a register in the form of a dial, screen, loudspeaker, or plotter, does the signal emerge as a legible representation accessible to the senses. All the examples of radiant technologies after this brief historic interlude rely on one form or another of an electronic interface for the processing and depiction of transmitted signals.[5]

It is important to note that within the configuration of the mirrors, there is already a pronounced reorientation of the listener toward a surrounding that, once having taken hold, is not fundamentally altered through the introduction of electronic or digital interfacing methods. For this reason, the actual anatomy of acoustic mirrors is of interest here. This reorientation will be described as occurring on two levels: first and foremost, in the physical positioning of the body in relation to an anticipated sound event (a position which is inscribed tectonically into the design of the mirrors); and secondly, a resultant adjustment in the listener's grasp of the wider perceptual field. These two criteria were embedded within the various stages of the sound mirror designs and became more pronounced as the project evolved.

Reorientation

Early in mirror testing, a single listener was often positioned, perched on a small platform facing the curvature of the disc. This configuration can be clearly seen in the Abbots Cliff mirror completed in 1928 on the coast of Kent (fig. 3), as well as in the later construction of a vertical mirror at Denge. Both mirrors measure twenty feet in diameter and are among the smallest of the fixed-version sound locators. In these designs, a concrete tongue protrudes from the base of the dish to support a listener's platform. When in operation, the mirror is manned by a single observer positioned on the platform with his back to the nautical landscape. Rising from the center of the platform is a mast-like structure that supports a swinging trumpet arm. The trumpet-shaped collector channels the sounds via flexible tubing to a stethoscope located at the end of the tubing. The detection of airplanes was established by

a

b

Figure 3. (a) Drawing based on a photograph from 1928 of the 20-ft. sound mirror at Abbots Cliff, Kent coast. The mirror was designed to be operated by a single listener. Consulted document: The National Archive, ref. AVIA 7 / 2765. *Strip mirrors 1926–1940.* (b) Photograph of the concrete sound mirror at Abbots Cliff. In the present condition, the listening platform and swinging trumpet arm are no longer to be found at the site. Kent coast, 2005.

manually scanning the area in front of the dish with the pivoted arm. In this way, when the sound was located at its point of maximum intensity, the horizontal funnel arm, outstretched and pointing skyward, would indicate the angular bearing of the yet-to-be-seen source of the sound.

The departure from those paradigms that orient the eye under similar circumstances was clearly established in this early phase of the sound mirror project. With reference to telescopic modes of observation, two complementary optical principles may be denoted: the watchtower (pushing the limits of the horizon by increasing the elevation of the gaze) and the telescope

5. Electromagnetic spectrum technologies include radio, television, cellular-phone communication, radar, and global positioning systems. Examples of ultrasonic spectrum technique are sonar, echocardiography, and ultrasound. Specialized medical imaging techniques including Computer/Assisted Tomography (CAT scan), electron microscopy, thermography, and Magnetic Resonance Imaging (MRI), all employing principles of interferometry.

Figure 4. Two-hundred-foot mirror at Denge, 2005.

(extending the gaze into the landscape).[6] Both cases create a privileged form of ocular navigation.

But already in the early designs of sound locators the most basic rules that govern the scanning eye undergo a crucial reconfiguration. An attentiveness that was previously oriented toward extending visual gaze outward now finds its focus in the point of contact between an incoming signal and the listener's ear. Upon discovering an airplane, the position of the body is restricted to the same location as the occurrence of the sound. Instead of extending attention outward with a mobile gaze, the listener is oriented to finding a local phenomenal occurrence. In the sound mirror, this point is articulated within the mechanism of apprehension: the confrontation (between a listener and a sound) happens at a localized zone that is sought out by physically moving the ear (by way of a stethoscope) along a pivoted trajectory until the sound is discovered.[7]

As the funnel aligns with a corresponding acoustic event, the ear embraces the sound at a particular point, suspended, as it were, in mid-air in front of the concrete dish (fig. 3).[8]

Two simple acoustic principles guided the design of the 200-ft. mirror off the coast of Kent at Denge (fig. 4): the focal properties of curved surfaces and an assessment of the acoustic fingerprint deemed critical for airplane detection.[9] In other words, the concrete wall acted so as to enhance airborne sounds and was literally tuned to the size of the airplane's fundamental frequencies. Of particular interest for the design were the lower frequencies, that is to say, the rumble pitch of the

6. In the example of the telescope and the watchtower, an observer is situated in a privileged visual position in command of an expanse while maintaining a strictly frontal orientation to the objects of apprehension. Angle of view and magnification only serve to enhance the topographic comprehension of spatial relations. This frontal visual gaze remains focused on the physiognomic skin of things, finding its orientation in coordinate positions firmly anchored in the landscape.

7. "Apprehension" is used here to describe a quality of perception that is seen to emerge from a "seizing" or "capturing" of an encounter. The emphasis is to highlight perception as an *active* and *transformative* process.

8. The funnel fastened to the end of the pivoting arm in the sound mirror swings along a designated arc where, according to the acoustic principles of reflection, the sounds are to be amplified back into the audible realm.

9. The form of the 200-ft. mirror at Denge was based on conclusions drawn from experience with the mirrors that were 20 and 30 feet in diameter. The resulting strip mirror has a radius of curvature of 150 feet, a height of 26 feet, and a span of 200 feet. Its concave surface has a double curvature that is flanked at its base with an attached sloping forecourt. One document concerning the mirrors at Denge includes a chart indicating a series of aircraft models analyzed and calibrated for their specific acoustic fingerprint, denoted in terms of cycles per second. The attempt was to gauge the size of the vibrations produced by the propeller's friction with air, combined with the noise from the exhaust pipes of the aircraft engine. What is important to stress here is a thinking of an acoustic vibration in terms of the physical sizes of frequencies. *Long Distance Listening with Sound Mirrors,* Document AVIA12/132 (London, October 1932), p. 14.

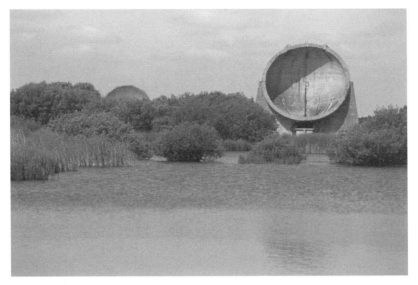

Figure 5. Thirty-foot hemispherical sound mirror, Denge, 2005.

aircraft. These pitches were thought to have superior transmission properties over great distances, since it was believed that atmospheric absorption dampened the high-frequency components of airborne vibrations. The lowest target frequencies chosen for the 200-ft. mirror design correspond to wavelengths of 15 to 18 feet in size, which roughly bridge 60–70 Hz.[10] Once the lower frequency limit was determined, the physical dimension of the wave was multiplied by a factor of ten in order to achieve the desired focal properties within the curved surface of the mirror (fig. 6).

Due to the sheer size of the wall at Denge, the swinging trumpet with attached stethoscope was replaced by a mobile patrol of listeners. The listeners were organized in teams participating in an orchestrated search for sounds. The forecourt was divided into triangular patrol sectors that corresponded to a certain range of azimuths, extending out over the open sea. On either side of the structure, large canvas curtains were erected, attempting to minimize lateral wind noise. In addition, patrollers were supplied with rubber shoes and nonabrasive clothing to cut down as much as possible on the local sounds produced while walking the zones. Each triangular sector was assigned to a single listener,

trained to seek out the invisible focal points of sound that were deemed to occur somewhere along a designated arc in the forecourt of the mirror. To locate an airplane meant to literally coincide with a location in which the focused acoustic activity was taking place (fig. 7).

The radiant model

Within this curious theater of appearance, the transition is completed from a model based on magnification and point of view to the model of radiation and interception. If the eye in a mode of telescopic vision ascertains a grasp of things by comprehending the distance between the body and a remote point of reference, then in the case of the mirrors, a grasp emerges by eliminating the distance between the observer and an occurrence. *In other words, an explicitly localized event produces knowledge of a remote and still-invisible object.* It is precisely in that moment that the peculiarities begin to emerge. When in operation, the mirror produces a double evocation—it reveals the airplane (as the object of apprehension) while at the

10. The estimate of critical frequencies varies in the military documents dating from the early 1930s. For example, one such document from 1932 cites a figure ranging from 30–100 Hz, whereas the frequency chart for R.A.F. single-engine aircraft indicates a 27.8–165 Hz range. Incidentally, in the case of the early single-engined aircrafts produced by the German Messerschmitt company

incorporated British-made Rolls Royce engines. The particular figures mentioned here are based on a quote by Dr. W. S. Tucker cited in Richard N. Scarth, *Echoes from the Sky—A story of acoustic defense* (Hyth Civic Society, Kent, 1999), p. 93. For a discussion of spectral decay in relation to atmospheric conditions, see "16.5 The 200 ft. Strip Mirror," *The Theory of Anti-Aircraft Sound Location and Detection,* Document WO/33/1360 (London, 1932), p. 249.

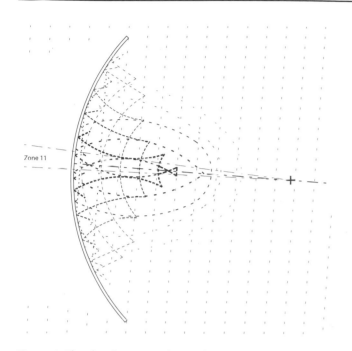

Figure 6. The development of a single incoming wave front superimposed in different stages of reflection off the 200-ft. mirror. Sectional diagram.

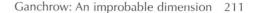
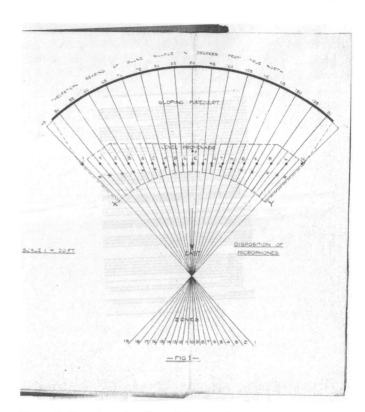

Figure 7. Drawing of a plan of the 200-ft. mirror at Denge, designating the division of incremental listening zones in the forecourt of the mirror. Each triangular sector, radiating off an azimuth converging point, charts a five-degree shift in the listener's horizontal orientation toward an anticipated sound. The National Archive, ref. AVIA 12/132, "A.D.E.E. Acoustical Report No. 77, October 1932," in *Long distance listening with sound mirrors: employment of servicemen 1932.*

same time it draws attention to the occurrence of sound in itself by placing it in a discrete location in space. When standing in the appropriate position in the mirror, the airplane emerges as simultaneously "here" and "out there." The apprehension of this sound involves a tactile interaction,[11] taking place on the surface of the body where the ear meets the sound and that then gets re-projected, cognizantly, back across the horizon to form the listener's knowledge of a yet-to-be-seen object. A radiant principle is at work here as an elastic property of sound extending in space and time to physically bridge the gap between observer and observed through an undulating current of connectivity. This radiant extension inherent to sound normally remains hidden beneath the instinctive capacity to localize the identified vibration back at its imagined source. When in operation, the

mirror emphasizes an acoustic event (an occurrence close at hand) rather than an instance of hearing (cognizant recognition). Here, the idea of sound in its raw, still pre-cognized state as "traveling matter" and not as "appearance"[12] is embedded within the structure of the mirror by considering frequencies in terms of substances and by translating vibrations into physical sizes (this is demonstrated in the scale of the mirrors whose enormous proportions are derived from the crest-to-crest distances of critical frequencies, imagined to be traveling at 1107 feet per second). The angle that

11. The term "tactile" refers to a connection with the sense of touch in order to emphasize the acoustic experience as arising from direct contact with an occurrence of sound. It is also used to evoke the sense of "affecting" or "slightly modifying" by way of an interaction. Within common English usage, tactility has been limited to the sense of touch alone, therefore strengthening the idea of a separation of an onlooker from the world. For the present discussion, I propose to broaden the term to mean a multi-sensorial idea of interaction.

12. My use of the word "appearance" is intended to evoke sensation as it takes hold within any region of the sensorium as a whole. The preference is for a broader definition than the ocular connotation.

emerges from a point of observation located within the focal zone of the sound mirror subverts the assertion of a geo-spatial realm of objects by superimposing it with the curious field of pulsating wave interaction.

Interestingly enough, this frame of thought can also be found in the internal documents distributed during the period of research. In an introduction to a 400-page dossier from 1932, the author explicitly instructs the reader to abandon the dictionary definition of sound as an auditory event:

> Sound may be defined as a vibratory motion of matter of the type to which the auditory organ of hearing responds. It has been defined as the effect produced upon the auditory nerve by a certain vibratory motion; but this is not a convenient definition for the purpose of this book, because it will be necessary to consider the propagation of sound without reference to its ultimate detection by the ear. . . . It is more convenient for the discussion of the physical properties of sounds to consider them as having an independent existence apart from the means by which they are recognized.[13]

Here the challenge is no longer to apprehend by means of magnification (by recognizing a distance that needs to be overcome), but rather is a matter of tuning, through a matching of characteristics.

To think "sound," as opposed to hearing it, evokes the knowledge of a fluid-fluctuating counterpart to seemingly empty space. It reveals a kind of concrete abstractness that coincides with the visible, yet remains opaque to the illuminating rays of vision. This territory of acoustic interaction presents a stark contrast to the morphology we associate with our surroundings. It consists of concentric expanding shells of compression and contraction, developing radially from multiple sources. Its geometry is that of complex curves and morphing ellipses that are modified through every collision with a solid body or any intersection with other propagating waves. As these shells collide, they may cancel each other, combine to form an even greater agitation, or simply pass through one another, unaffected and indifferent. What emerges is a continuous enfolded cloud of undulating interactions. Thereby, the very idea of "stasis" remains foreign within this realm. The sonic dimension occupies the same expanse within which the body is immersed, yet it does not obey the rules of gravity. Sound's evolution is symmetric and concentric when examined from a single emitting point, but when broadened to a wider field of interactions it results in a seemingly chaotic domain of extraordinary complexity.

Not surprisingly, the most pronounced geometry employed in the construction of the mirror takes the form of the radial sweep. A dossier published at the time of the research incorporates a plan view drawing of the mirror in which divisions in the sloping forecourt designate nineteen adjacent "zones," all radiating off an imaginary convergence point located seventy-five feet in front of the forecourt wall (fig. 7).[14] This intersection is not the focal point of converging wave fronts, but rather a crucial hinge in the design of the mirror. It serves as the origin of measure from which the various arcs and diagonal lines composing the geometry of the structure have been derived. The "vanishing point" depicted in the diagram of the mirror constitutes a coordinate reference from which the intended azimuth readings are to be inferred. However, this vanishing point has been pulled from the horizon and assigned a tangible position within the site, namely on axis and exactly seventy-five feet in front of the mirror (fig. 8).

Instead of fulfilling a task of magnification by extending toward an imagined horizon, the mirror begins to operate as a device of mediation, displacing the vanishing point to a pre-appearance idea of the world. This deviation from the rules governing optic projection, under these circumstances, derives from a redefinition of "horizon." The azimuth vanishing point depicted in figure 7 designates an un-affective pivot, forming a hinge between a device and an acoustic material. Within the physical context of sound itself, all sources are multiple, limits and thresholds lose their edges, diffusing into a continuum of exponential multiplicity. In the airwaves, *there is no horizon*; all activity is mutually dispersed. The sound mirror constructs a metaphoric point of convergence at the moment it anchors into the flux of sounds. It forms an intermediate projection between an expanse and the possibility of grasping. In stark contrast, the visual vanishing point operates as the cognitive pull through which various surfaces and objects get strung together in a stabilizing net of perceptions. The lines traced through

13. "The Principles of Sound and Sound Location and Detection," *The Theory of Anti-Aircraft Sound Location and Detection*, Document WO/33/1360 (London, 1932), p. 1.

14. Each zone covers a five-degree shift in horizontal orientation toward the anticipated signal and is marked in the drawing as a series of radial lines emanating from the imaginary point beyond the forecourt wall. These lines do not manifest in the 200-ft. mirror but rather describe the rate of accuracy in localization strategies that would be determined within the nearest five degrees of horizontal orientation. The azimuth convergence point is also the center of an imaginary 300-ft. sphere from which the strip mirror derives its indentation (figs. 7 and 8).

vision that ensure that parallel surfaces will never be experienced in their parallelism express the matrix of gravitational trajectories borne out of the meeting between cognition and an instance of vision. The very recognition of a visual vanishing point already indicates a re-presentation, a perceptive re-projection. It appears after parallax interpolation has had its way with the "things of the world." If the visual vanishing point and its emanating perspective can be seen as indicating a subjectively anchored point of view, then in contrast, the azimuth vanishing point does not require an observer as a referent. The 200-ft. mirror becomes its own orientation mechanism by demarcating a territory where the "distant" gets played out in a theater of local appearances. In these terms, the azimuth vanishing point of the 200-ft. mirror represents the synchronizing hinge between a particular fragment and the abstract expanse to which it relates. This idea is clearly expressed in a map indicating a proposal for a network of strip mirrors along the eastern coastline of Britain (figs. 2a and 2b). Figure 2a displays the estimated cumulative listening coverage of the entire network of mirrors by describing the geographic extents of the field opened up into the expanse of acoustic interaction. In architectural terms, the 200-ft. wall extends beyond its own tectonic form, plumbing a malleable space between the wall and a remote resonating object. The result is a structure that relates very precisely to an expanse that extends 84 degrees in width and is approximately 128 seconds long.

By positioning the physical body precisely within this device of appearances, an unmistakable sequencing of apprehension is exposed, as occurrence gives way to hearing. Even though the double evocation of a sound and its corresponding referent seems to occur simultaneously, the localized collision with acoustic matter can only be read as the *initial* condition. The result effectively highlights the delay inherent within the process of recognition by exposing the line strung between an event and an appearance. The evident dislocation in this condition is not in the relation formed between the body and a prosthetic device, but rather, in exposing the disjunctive relation between "stimulus" and "semblance" in the process of appearance itself. The airplane is indeed as much "here" as it is "out there." In terms of a tool, the mirror establishes a stage upon which the theater of perception gets played out in minute detail.

One of the paradoxes of the revealed acoustic expanse is that for the listener, the "view" never extends beyond the surface of tactile contact. This apparent

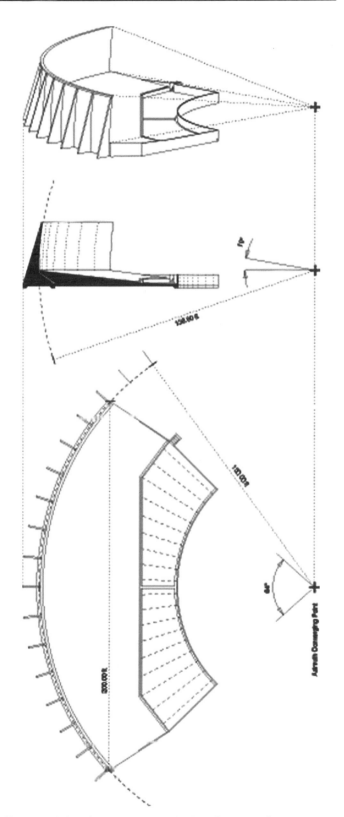

Figure 8. Azimuth converging point in relation to the tectonic configuration of the 200-ft. mirror.

flatness, linked with a view opened into the vista of sound, is a consequence of the saturated space of interactions to which it relates. The moment space becomes "full," it is immediately rendered opaque. In ocular terms it can only be viewed as a section, just as the interference pattern in water only reveals its form on the surface of a lake. Any window into this space inevitably fogs over, rendering the depth of this fluid flip side to appearance as fundamentally problematic when broached with optic metaphors. Nonetheless, depth—volumetric space—in this condition remains intact, enfolded within a peculiar interior-ness; a seemingly contradictory position where the imprint of volumetric relationships somehow unfold from within the surface articulations (of the vibration), from within the spacing of micro-agitations. At the moment of contact, as the notion of depth congeals, space begins to take shape, thereby separating itself from the fluid state of interactions. Space emerges from the haptic registration of discontinuities within a medium brushing up against the body.[15]

Radiant technologies

The story of acoustic defense sits moments before an immense proliferation in techniques of communication and visualization. In 1937, just two years after radar replaced the function of the sound mirrors, the first radio telescope (a parabolic-shaped antenna) was constructed to "observe" astronomical phenomena "seen" only in the radio-frequency sector of the electromagnetic spectrum. Already here, the radiant principle exceeds an aural phenomenon, as received signals are synthesized into graphic depictions. Since the 1950s, expanding telecommunication networks and corresponding developments in visualization methods have given rise to practical techniques by which the radiant model is brought to the foreground. Today's normative modes of communication (for example radio, satellite television, and cellular telephone networks) are, for the most part,

based on translations of mediums that ease back and forth between electromagnetic frequencies (hinging into fields inaccessible to the senses) and aural/visual intelligibility. The abundance of such methods is deemed transparent, judging by the extent to which we have grown accustomed to their pragmatic usefulness.

Similarly, the most pervasive methods employed in scientific visualization (in many accounts providing access to previously "unseen" facets of materiality) incorporate principles of transmission and reception by which various wave phenomena are employed to construct images of remote "realities."[16] What is important to stress here is an acceptance of a truthfulness, a "visualized realism" that relies not on a mimetic copy but rather on radically non-geometric modes of transcription. A preference for words such as "imaging" and "visualizing" seems to mirror this condition by suggesting pictorial methods that have ceased to mimic their subjects. When trying to define the extents of a contemporary "factual accuracy," the term would seem to answer to the characteristics of an aggregate—an amalgamation whose properties are part sonic and part optic. The translation from received or derived data into a pictorial format implies an acceptance of the *authority* of translative mediums dramatically different from the emulative capacities of the lens. The threshold that may have been more recently crossed is the pragmatic superimposition of the non-tangible onto the tangible through an applied knowledge of reception.

Radiant perception

The above-mentioned examples aim to highlight certain prevalent modalities lining social and visual communication in order to discern particular systems of restraints within which the perceiving subject may be said to operate. Admittedly, perception is assumed to possess a certain malleability where the technological is seen as one factor within a multitude of forces shaping a momentary context of perceptual conditioning. It is never the sense organ that is modified through history; instead it is the cognizant posture that is continually restructured in relation to established codes and habits.

15. My use here of the term "haptic" is not in the sense of "close proximity" as this would still assume (by posing a duality) the existence of an apprehension of "the far." Rather, I'm trying to highlight a condition that *only* operates through connectivity—where entities are linked. Any idea of "far" should be seen as an outcome of this initial tactile engagement. My emphasis here is on a radiant perspective by which perception is understood to be unfolding within a broader tactile field of interactions. This relationship assumes a doubly active position: the active potentiality of a stratum coupled with an active process of discovery and recovery from traversed surfaces.

16. Tomographic techniques, such as Magnetic Resonance Imaging, are able to construct a sectional image through solid bodies by way of interpreted resonant vibration of hydrogen atoms. What the imaging component of the device receives is the emitted signal from hydrogen molecules that get "decoded" by way of a Fourier transform and then are plotted onto a two-dimensional image.

Figure 9. View toward the Denge sound mirror site, near Dungeness, Kent, 2005.

Any attempt at mapping the influences shaping the current site of perception reveals a multitude of communication practices and representational methods within which the perceiving subject is enmeshed. I am proposing here an ambivalent approach that attempts to avoid the binary polarization of progress versus decline through an attentiveness to the glitches and transparencies arising from a technological confrontation. This view speculates that "ways of doing" are still partially accountable to "ways of seeing," though, needless to say, in an oblique manner that no longer holds tools to be self-evident derivatives of anything but themselves. In the example at hand, the plurality of adjusting circumstances may expose "ways of doing" that begin to clash with, and potentially amend, predominant ideas of perceiving—a complex intertwining that exceeds an analysis of a mutating visuality.

One limitation that arises from visual accounts of perception is the assumption that the ocular is somehow symmetric with the sensorium as a whole. The problem is that visibility relies on the same optic plane of appearances—be it microscopic, fragmented, or even as understood to occur dislodged from the perceiving body. It is, namely, the geometric realm of spatiality appearing through various lenses of deformation. I would like to suggest that there is something more peculiar than a "distortion" that begins to take shape through the radiant model. Distortion relies on an implicit space "as it should be," an implicated intact physiognomy of place from which to derive a current state of decline. Radiance is, for the most part, an inevitable blind spot in the semblance of visual appearance; by way of analogy, the ocular remains trapped in the optical illusion of a mirage by recognizing only a disfigured landscape and never grasping the emanating heat. Returning to the initial example, if the "flip" presented through the condition of the sound mirrors is a reorientation in the thinking of "grasping," it could be understood as a shift within a *mechanism of appearance* itself, and therefore does not necessarily remain restricted to an aural phenomenon.[17] What is at stake

17. The tactile position is more easily exposed in sound, as, for example, in the phenomenon of echo. In echo, the time elapsed between a repeated utterance indicates the path navigated by a sound traveling to touch a distant surface and return. The relative slowness of sound, approximately one million times slower than that of light, in this case draws attention to its own movements.

with the radiant position is a potential amendment to an epistemology of cognition that could uncover a more subtle and, it should be emphasized, preexisting level of experience that is subsequently replicated in the anatomy of widespread techniques.

If we were to extend the idea of tactility to a wider "haptic" field of interaction, then vision too takes on a different articulation. A haptic dimension in vision might be revealed by taking up the obsolete model of the camera obscura, and shifting the emphasis from the picture plane of projection to the puncture of the pinhole. In this respect, the pinhole or aperture presents the most radical proposition in the mystery of dimensions as the point at which the sky meets the ground in a vortex of interaction. Within the opening of an infinitesimally small hole separating the inside from the outside of the camera obscura, all of the exterior world is momentarily compressed into a tapestry of undulating light fields, thrust through the pinhole as a bundle of a yet-to-emerge landscape. This "moment-beforeness" from which all that will become familiar remains momentarily inaccessible, foreign, and indifferent to our notion of "thing-ness" is the very knot from which our visual field eventually unfolds. Any ideas of "near," "far," "shape," or "distance" in this position are still encrypted possibilities yet to be unlocked through a complex pattern of interactions. Such a condition inevitably draws attention to that which was always present yet remained hidden beneath a shroud of coherent "thing-ness."[18] It is under these terms that the perceived materializing of distances into depth-of-field emphasizes the unfolding of "experience" as an inborn assembly of comprehension where spatial clarity is deemed an elementary meaning-reflex, able to unite the vast knotting of multiple projections. To this end, the appearance of color upon which the creasing of perspective lines gets enfolded presents a reconciliation with micro-fluctuations: a reminder that even the most still and solitary glance at a seemingly stable surface is inextricably infused with an underlying temporality.

It then follows that the eye that was thought before to operate through a complex gauging of distances between points of view and a relatively stable geo-spatial expanse, now is itself in a constant state of apprehension from each registered moment to the next.

The outcome is an adjustment to the notion of "expanse." Space, previously conceived of as an *outcome* of the network of relations between dispersed objects within a visual field, is foreshadowed by the space of the *interval itself*—in other words, a registration of the micro-spacing between successive fluctuations that constitute an ongoing pulsation of appearances. Within this particular joint, the separation between near and far is eradicated, opening up a continuum where stasis and movement begin to fuse one into the other. The transition is toward a dynamic understanding of radiant form in which any differentiated shape inevitably emerges entangled within the grips of time.

The notion of the haptic field, in its explicit bond with time, provides the potential to reevaluate the constituents of dimensions and temporal relations. It suggests certain sensorial parallels within an individual's unfolding experience as emerging from an interaction occurring within a contact with materials that are oscillatory in nature. The apparent dissimilarity between properties of sound and light can suddenly be reconciled from within this vantage point as events that inherently possess a kinship through their precise spacing in time. When confronted with the knowledge of continuously adjusting relations, the fixing of the field of sensations into perceived distances, colors, and tones occurs as a secondary effect that somehow gets instinctively re-projected outward to appear as an external attribute. Consequently, the experience of expanse and form appears as a collapsed and reconstructed phantom of tactilely traversed intervals and durations. The very nature of appearance begins to emerge as an enigmatic ability of projective translation. Within every moment of apprehending, there seems to exist an undisclosed motor of creative construction at work. This position signals a profound attentiveness to *discontinuities,* the spacing between successive pressure zones in air, the micro-fluctuations between crests of electromagnetic waves and the distance separating one obstruction from the next on a gravitational surface; these all form the critical inconsistencies from which the realm of perceived spaces emerges.[19]

18. I would like to emphasize here the very rapid nature of the constructed experience, a condition that effortlessly delivers the assertive physiognomic qualities of things. What is relevant to the radiant point of view is an exposure of the *foundations* upon which the thing-ness of experience takes hold.

19. With respect to music and perception, I am stressing the fact that even the recognition of a single tone is already bound to an inescapable temporality. Here, I am focusing on a much smaller scale of intervallic fluctuation than that of a melody: for example, the relationship of a numeric frequency (the measure of fluctuations per second) to a perceived pitch. Tones, colors, and distances appear as curious forms shaped within perception—that vital spacing that lets 440 nm (of electromagnetic activity) emerge as "indigo," 440 cycles per second (of acoustic activity) to emerge as the note "A." Within

The haptic position and the implicit interference expanse emphasize the dense fog of activity within which the apprehending body is submerged. It presents a hinge where both occurrence and semblance are played off one another, on the one hand expressing a distinct interconnection and on the other a curious contradiction. "Grasping" is exposed here as a peculiar mending agent able to reconcile the seemingly opposed notions of motion and stasis. Thus, space appears less as a set of relations that results from a shifting point of view *through* time and more as an enigmatic collision *with* time. Under these terms, a grasp of surroundings seems instinctively to *emerge* from tracings left on the perceiver by the very nature of time itself, where the sediment of experience is accumulated from a contact with the emissive echo of things. Yet despite the implied intimacy, one of the strangest ideas to emerge from the haptic position is that it reveals direct experience as being located in a realm at least twice removed from the possibility of ever knowing the actual nature of things. Appearance as the semblance of activated potentialities knows its subject only by way of projections.

Implicit in the radiant model, as mentioned before, is a juxtaposing of appearance with its fluid flip side. Superimposing the sharp contours of geometric intelligibility with a realm of gradient fog results in a weakening of the authority previously vested in a presupposed physiognomic coherence. This superimposition opens a view that exceeds the apparent "naturalness" of appearance. Within the backdrop of those cultures that are deeply rooted in figurative representation, the chaotic oscillation of matter might appear as a virus invading the anthropomorphic body of meanings. In other words, the radiant model and its haptic view could be creating ripples through our culturally accepted assumptions of "form" by recasting the idea of "limits" and short-circuiting the dichotomy of stasis versus movement: a situation with potentially important implications for a cultural capacity to construct significant forms. In this respect, problems expressed in discussions of perception and modernization—the disembodied gaze, rifts and disruptions within the perceptual field, and the inconsistencies of space created through implementation of non-localized communication networks—may be

seen as stemming from a reluctance to abandon a model of space that still clings to the analogies of the lens, a position securely anchored within the certainty of axial geometry and coordinate relations. If there is a disjunction or rift to be discerned, it is not so much in the dislocation of perception from the perceiving body as it is in the predisposition we have vested in the thingness of the world. To this end, the current condition may highlight an inevitable clash between an emerging understanding of form and previously established modes of descriptive comprehension.

Commentary by Remo Guidieri

To a conspicuous extent, late modernity dating from the Great Transformation (or Great Butchery) converges toward a perceptual jumble of complementary fields, each *phenomenally* distinct, that experimentation would undertake in order to range and compile them. Such a process of amalgamation brings with it repercussions in techno-economical development and, fatally, in the way we live with them "domestically." *Mind* and the entire spectrum of messages brought by pathways for the most part incontrollable and efficient ("unconscious") are compelled, contradictorily, to recognize and grant admittance to the incongruous. Surrealism considered this realm if not familiar, then at least plausible, attesting to the domain of the phantasmagorical, revindicated as liberation in times still "utopianly humanist" (or optimistic if only by virtue of *ingenuousness*).[20]

What took place was the opposite of such "utopian humanism." Modernity, at all times on the brink of being "mature," while allowing nothing to become complete any longer, keeps rediscovering archaic modes of submission toward that which embodies plausibility and certitude and yet is deprived of the support of belief. We undergo a credulous primitivity that carries us into the condition of *voyeurs* of phantoms, more de Chirico-esque than pagan or monotheist. Ancient or merely

these parameters there is a potentially useful broadening of the definition of space as an emergent property tuned to various scales of discontinuity. An exploration of this view demands a more rigorous evaluation of the constituents of space that remains beyond the scope of the current investigation.

20. What's at stake in this case is the capacity of wonder, the state of grace proper to childhood. It is impossible to overstate the extent to which this source in itself is not aesthetic but pragmatic. The same thing goes for the commodity as for the archaic fetish: They are forms, but only insofar as they are means, utensils. A separate discourse could be made on Futurism's testimony of enthusiasm for technology, which Surrealism, with the exception of perhaps Bataille (a latecomer to Surrealism) seems to generally ignore. Apart from the political implications that had an outlet in Fascism (but not only there, *vide* Russia), Futurism evinces the transformations occurring in perception (above all visual) due to technical development. All of which is far from being simply anti-traditionalist as Marinetti's manifesto purported. The supreme example is Boccioni.

exhumed, *syncretic,* the in-saturated image amplifies the stage. We gather all sorts of presences dislodging them with instruments that relentlessly place them under scrutiny. The eclipse of the divine comes to project shadows upon the murky bottom. We gulp deep draughts from this font, despite the profound skepticism of our times: we are skeptical *and* credulous in a *socius* drenched through and through with presences.

This eidetic duplicity through which the archaic penetrates into the modern is much more remote and primordial than the fascist experimentation of the first half of the last century, which was linked ideologically through various leitmotifs to the era of the First World War. Their terrible collapse forever condemned the recourse to myth and had made Europe into an epilogue. Thrown into an archaic without myths, we are cut off from any form of epic. We are archaic in the midst of modernity. From the former, we derive our common gregariousness—the *"organique,"* but without any myths—from the latter, we inherit our lives that overflow with apparitions forged by technology. *Maitre d'oeuvre,* the avant-garde, or (as Raymond Aron called it) the "imperial republic," could well repeat after Prospero:

> Now my charms are all o'erthrown,
> And what strength I have's mine own,
> Which is most faint.[21]

Modernity is victim and artifice of peculiarly monstrous Montages bred under the aegis of thought that promotes the rhizomatic growth of mediation and, thus, of alienation.[22] An anamorphosis of the

pharmakon, at once remedy and poison, has gigantically expanded. The interminable taking advantage of this circumstance is probative, insofar as its effect accentuates what for some is de-naturalization and for others is a positive increment of the real: The self-prolonging of *development* whose vitality is attested by the cleaved overcome or on the verge of so being.

Spiraling stages

Their increment testifies to the *dynamis,* or rather, to the never-dwindling force that is, at least, tributary of the *techne* to which man has succumbed. Denaturalization endowed with the same principles of the "human nature of man": the occupying of historical time with those faculties necessary for remaining there. Since one is the flip side of the other, we can picture the process as a single enormous Moebius strip. With a simple twist, the bundle obtains two faces, each separate yet continuous: development and de-naturalization. It would be reductive to consider it a chiasm of insurmountable and collusive polarity on the order of *eros* and *thanatos.*

The process no longer corresponds, even metaphorically, neither with the ontological duality of progress and decline, nor with representations (whether current or modern) of history, presented in evolutionary or catastrophic terms. It is thus impossibility, which delineates the decline of the messianic in late modernity.[23] An unfolding knowing-no-end and sundering (thus also refuting) the ring of the eternal-return-of-the-same in terms that were presented under diverse guises by Junger and Heidegger (and later Löwith) during an era over a half-century ago when the already mature process was still restrained by the conservative break-pulling and the totalitarian experiments with the "hope principle" between the two wars.

This phase is concluded. The technique of modernity is a-theological (as well as a-teleological by reason of its being indefinite: Each initial attempt today is forward-oriented; the present in and of itself is nothing if not

21. William Shakespeare, *The Tempest,* epilogue, lines 1–3.

22. Understood in Hegelian terms, this basically says: "The sphere of spirit at this stage breaks up into two regions. The one is the actual world, that of self-estrangement, the other is that which spirit constructs for itself in the ether of pure consciousness raising itself above the first. This second world, being constructed in opposition and contrast to that estrangement, is just on that account not free from it; on the contrary, it is only the other form of that very estrangement, which consists precisely in having a conscious existence in two sorts of worlds, and embraces both. Hence it is not self-consciousness of Absolute Being in and for itself, not Religion, which is here dealt with: it is Belief, Faith, insofar as faith is a flight from the actual world, and thus is not a self-complete experience (*an und für sich*). Such flight from the realm of the present is, therefore, directly in its very nature a dual state of mind. Pure consciousness is the sphere into which spirit rises: but it is not only the element of faith, but of the notion as well. Consequently both appear on the scene together at the same time, and the former comes before us only in antithesis to the latter." G. W. F Hegel, *The Phenomenology of Mind,* trans. J. B. Baillie (London and New York, [1977]), p. 99.

23. "Nulla di storico puo' voler porsi da se stesso in relazione al messianico . . . Il regno di Dio non e' il telos della dynamis storica; esso non puo' essere posto come meta. Da un punto di vista storico, esso non e' la meta ma la fine L'ordine del profano dev'essere edificato guardando all'idea di felicita'. . . ." Letter from Walter Benjamin to E. Schoen, 1919, in *Sul concetto di storia* (Turin, 1977), p. 255 and passim. Messianic zeal is not progress, but an overtaking and a reversal (of order, of time). There is no idea of redemption in it. As if redemption and happiness were disjointed.

consumption, *jouissance,* or catastrophe). It opposes itself to ancient and pagan figures, taken in an anti-monotheistic chord by Nietzsche. The enormous energy of violent forms throughout the century shows the extent to which nihilism contains the anticipation of an overcoming of the very figure by which it is represented. New accoutrements—-and *telos*—-serve to declare the circle shattered. Such is *la passion du réel* of the century upon which the sun has so recently gone down, to use the formula of Alain Badiou, overlooking how much of the tautological such passion contains and has already more than adequately manifested.[24]

Mediation breaks down and overcomes dissidences, thetic as well as phenomenic: It invests the incompatibilities of the most banal experiences, gaining force in the modification of the human *ens* and its faculty for considering itself unique (finite) and multiple (infinite). The same holds true for perception of sound as well as that of sight, and not merely for those who observe the pan-esthetic in which to wallow willy-nilly while taking up the chorus of Gottfried Benn: "Looking around I see only sociology and the void."[25] Foreshadowing of such an orientation exists in the scenic, this is to say, ludic, sphere, which is also the realm of the equivocal (the true and false having only persuasive necessities: to implicate participants in a play whose place is that of the computed *Einfühlung* or *groupe en fusion,* ossified in a hall where a pseudo-rite is consumed).

These qualities are already spectacularly identified in the Wagnerian *Gesamtkunstwerk,* the working qualification of which has been, in its intentions and its results, overcome (even if, musically speaking, this overcoming remains ineffective as much as that of the metaphysic announced by Nietzsche). We remain on the brink, awaiting a watershed to be forded, rootless and on unsure footing. We fall back upon instincts more ethological than eidetic. It was to this idea that Heidegger referred, declaring the metaphysical word and conversion from categorical entity, revealing the process that causes its upheaval—the process, unsuitable to the restitution of that which, in the ontic sense, no longer exists. The detachment of entity, at this point almost entirely *artificialis* and "muffled" by artificiality regarding the category to which it would correspond, is no longer to be located at the noetic base of signs but in the fatal push to the enforced nomadism of language and of things.

In a similar historical instance, our perceptions could call forth an echo, amplifying an alchemical (and far from mystical) project-in-effectuation, exoteric by reason of its being flaunted on a scale both micro and macro, "a-gravitational" (if one wishes to lend an ear to how much Peter Sloterdijk pursues it with involuntarily Dalinesque philosophical countenance) in this frenetic time of Lenten spectacularity. There is no question of harmonizing these perceptions—they are already alive in various ways—but rather one of enlisting them in a project of exploitation where, between reciprocal collusions and contaminations, one is called to serve the other. Vast aberrant couplings are rendered "judged" to the extent to which they are usable: The result must *produce* new paradigms, new possibilities of initiative. The example Raviv Ganchrow provides is summarized already in the title, "The *Improbable* Dimension." An adjective prone to contradictory intentions and demonstrating the fertile ambiguity of grand doubts; a quest that disembogues in the imposing ascertainment of the unsurpassability and of the arbitrary nature of fundamentals,[26] which otherwise increase the number of rhizomatic possibilities of *trouvailles* having instead pragmatic and, *à la lettre,* unqualifiable pragmatic consequences. Enough can never be said regarding the extent to which the ultra-metaphysic already bears a name and prolegomena whose effects are those of the pataphysic.[27]

The unusual is but "functions." It experiences "concrete irreality" of the object conceived and produced not by human hands but by machines. But irreality is also *idée en conserve:* if not a thing, a presence.[28] Expanded projection jostles, deforms our factual relation with the entity (to the same extent as we

24. "Ce siècle a été hanté par sa propre horreur . . . et se pense comme commencement d'un âge nouveau . . . par un exaltation du réel [qui inclut] horreur et mort [et il assume le réel] comme présent. Qui a jamais fait quoi que ce soit au nom d'un futur indéterminé?" Alain Badiou, *Le siecle* (Paris, 2005), pp. 33; 35 36.

25. On a more ample and totalizing scale, it is a question for relativizing noetic fundamentals: space and time.

26. When doubt goes in pursuit of questions without pragmatic solutions, they are failed messianisms like the cargo-cults of Melanesia (my view also of Kafka).

27. "La pataphysique est la science de ce qui se surajoute à la metaphysique, soit en elle-même, soit hors d'elle-même, s'étendant aussi au-delà de celle-ci au-delà de la physique." Alfred Jarry, *Gestes et opinions du docteur Faustroll* [1911], book 2, ed. Noel Arnaud and Herni Bordillon (Paris: Gallimard, 1980). In the era of Jarry it was "speculation"; now it is effectuation.

28. Already in the case of music: a route of great antiquity exists? for "creating presences abstractly."

experienced plants and animals in the neolithic age). The source is not only remote but increasingly separate. Thus, the variations of robotics that make up for pragmatic human faculties capable of implicating themselves in causes that have rendered these faculties possible in the first place are oriented toward the invasion of real space in order to saturate it with tangible "schemes." Both the source and effect of this occurrence is ready-mades. The ready-mades forge a style, albeit the style of their circumstance. An *eidos* of pure virtuality, an "idea," recognizable merely as object-presence, "ou moins ambitieusement décrit . . . un univers que l'on peut voir et que peut-être l'on doit voir à la place du traditionnel étant de correlations d'exceptions aussi, quoique plus frequentes, en tout cas de faits accidentels qui, se réduisant à des exceptions peu traditionnelles n'ont même pas l'attrait de la singularité."[29] An *eidos* that would overcome factuality and imposed obstacles.

Thus, it also happens, in a space exemplarily defined (that is to say closed) for bodies in pictorial representation that with the avant-gardes of the last century were supposed to capture movement (which is to say duration), taking turns at the insuperable hub of space and time. From problematical objects the bodies represented became objects of paradox.[30] The internal and the external, the full and the empty are the basics here. The presence passes through reflexes. Sound does so as well. It does not flee projection. De Chirico set forth, prophetically, the oppressive character of these fundamentals or at least their *relativization*. To call them "dimensions" is metaphorical. They are *poles* of an inexhaustible symmetry.[31] The exposition of Ganchrow, in some way, demonstrates a third, attainable and highly fertile pole, in keeping with the formula "three is more than the succession of one and two." A sum $(1 + 2)$? That, too, but first and foremost, a leap:

This notion [of radiance] replaces the linear geometry of Cartesian coordinates with concentric, fluctuating patterns of interference; a parallel realm where what was seen before in terms of "remote" or "distant" resurfaces astonishingly close to the observer.

Radiance has to do with movement from which is distinguished near and far (rendered audible/non-audible) reflection in the instrument that mirrors it. "Beyond the limits of the visible" the realm of the virtual is entered. These realms must, however, have effect, or, in other words, usefulness. The (optical) illusion re-enters the history of mimesis in particular with conversion from volume to bi-dimensionality. In what manner are we then to understand the "concentric, fluctuating patterns of interference"?

Ganchrow writes: "A radiant perspective where the perception is understood to be unfolding within a broader tactile field of interactions: an active potentiality of a stratum coupled with an active process of discovery and recovery from traversed surfaces." It travels on the surface and operates by means of connections between presences, that is, volumes. The proximity rendered by the instrument does not explore the near and the distant.[32] A sort of zero-set in the gathering of measurable distance with the poles close-at-hand/far-off.

A passage from "the linear geometry of Cartesian coordinates" to an "oscillatory, temporal, and tactile view of perception" implies that Cartesian space consists in orthogonal disposition and in complexity.[33] But is such a distinction appropriate? The geometric configuration before and after Descartes excludes basing itself on the separation between the sense of sight and that of hearing. The essay speaks precisely about such fertile inbreeding. If not ideality (*idéalité*), then geometry projects as much as it subordinates itself to visual perception. This is true, even if in astronomy, before and after Newton, the non-perceptive included perception through a lens (which takes advantage of the glass-which-corrects). It is deduced with a medium that is neither visual nor auditory, but rather mathematical, that is, calculable.

29. It was the case when this "idea" was artifice of that, which belonged to *heroes*. Prior to this, it belonged to the effigy of the god: the ubiquitous god. It possessed specific ontic presence. (Jarry [see note 8], pp. 31–332.)

30. Long before ludic tendencies of Dada and Surrealism, in part represented in the project of the *Large Glass* that features "l'objet abstrait, invisible . . ." Duchamp thinks four-dimensionally: "[L]ieu de l'accouplement erotique [ou] vagin et penis perdent à l'instar d'une illusion anamorphique tout caractère distinctif." To this description, I would add what Marx called phantasmagoria, insisting on the phantom.

31. It would seem that only mania, divination, and death can eradicate them.

32. See note 15 in Alois Riegl's essay on *haptic perception,* which is a perception reconciled with surfaces.

33. See also Pascal's critique: "All mathematicians would then be intuitive if they had clear sight, for they do not reason incorrectly from principles known to them; and intuitive minds would be mathematical if they could turn their eyes to the principles of mathematics to which they are unused." Blaise Pascal, *Thoughts on mind and style,* trans. W. F. Trotter (1996).

Compatibility and incompatibility follow accordingly. Such aspects include the non-geometrical reception by means of sound in construction of the instruments herein described. From a source-origin there issue forth vibrations ("waves"). Prior, the role of source belonged to the eye. Prior, there were light and shadow; now, there are vibrations. Visual perception established itself esoterically from perspective. For architecture that precedes, whether ancient or gothic, cannot be considered ignorant of such theoretical or technical problems. It arises in the architectonic edification of volumes, in methods remaining as arcane as geometry (in the initiatic sense), geometry that exists in the ambit of the Pythagorean selective vision that privileges one eye rather than two. Such "incompetence" merits a comment on the holism of perspective representation in the Florentine matrix and reveals the place for whatsoever is thereby rendered representative: It is not to be accomplished, except at the price of omitting the duplicity of source. Concavity instead of linearity.

Visual perception is far more complex than this: It is "a vortex of pulsating radiance," writes Ganchrow. Retracing technological innovation in preamble to a reform of perception, Svetlana Alpers described another specularity *in nuce* as it arises with the undertaking of the lens in the times of Descartes. This seems to echo Roberto Longhi's comment on the figures of Titian "who leaves the breath of a moveable essay of a life in flux and in increase," that is, always before.[34] The Venetians were fully conscious of exploring precisely this light, dissolving fatally the Apollonian fable of Tuscan-Umbrian painting that reached its peak in all probability with Piero (the *sfumato* of Leonardo and the reiterated incompleteness of his works would indicate the gradual skepticism that contemporary exponents of mannerism in his time rekindled to the bitter end). Space as discontinued, intermittent, spouting from multiple sources: "magnetic fields." It would be welcome, as Ganchrow suggests, to take into consideration the expansion of multiple focality as the impulse behind the perceptual heterogeneity where all is reducible, but where also, except in pragmatic use, the phantoms are admitted as virtuality to be activated.

It is an enormous question. A question concerning the current situation, the "historical block" of modern perception can be posed as follows: melted or liquified? To what model does this question harken back? Does this choice present us with a victorious recourse to a rising fluidity? Does it unhinge confines by placing trust in the "radiant model" of reconstructing the issue perceived from field-to-field boundless universe? The question would be once again posed on the *bellicose-industrial* scale, tangibly resuming the meaning of *prelest'* of Pavel Florenski: the "blunder," that "error-fiction," that "vision emerging from the confines of the visible world and from the invisible world, the Master says, an absence of terrestrial reference" to which these "husks" would correspond; that *klippoth* of the Cabala; those voids that deceive by demonstrating themselves as fraudulent; the Latin *corpus astralis,* the insubstantial imprint left by death—*in fine*, the Suprematist objects that are no longer "art objects" but tracks.

The question can be posed as follows: visibility and/or legibility, or "comprehensibility." The way of perceiving or receiving (that is, to gather in what is perceived) is intended as "making sense." Geometrically, the sense is visual and immediately recognized as such. The figures are "natural." The magmatic has no basis in geometry. Every figure is a projection of another; shadows are not only included, but also become dominant.

"Radiance" (but to be also intended as "brightness") in some way possesses kinship with the "effulgence" of Rothko. A question of color is that of light, the spatial perception given by geometry (and, therefore, also by perspective) make it an original architectural procedure to the degree that color has a subaltern role in construction: lines, volumes are considered as homogeneous spaces possessing pre-emptive coherence.

In the non-geometrical space, the perceived mass is deduced by means of instruments, through elements that possess non-visual origins. Through these means we visualize the remote, the invisible. It is possible to derive from these visualizing methods a menacing invisible, captured by rendering the mirror a captor. The acoustic reflex copies visual presence. In such a way, the reflex regards bodies, masses in motion. Before the spectacular is rendered *mimetike* immobile, the following rule is imposed on a volume with or without the three dimensions: "[o]btenir en se servant d'une multiplicité de fragments a n dimensions une unité a n + 1 dimensions."[35]

New York, autumn 2005
(Translated from Italian by Alan Jones)

34. Roberto Longhi, *Viatico per cinque secoli di pittura veneziana* (Florence, 1952), p. 23.

35. Marcel Duchamp "mirroring" the first *Nu descendant l'escalier,* located in the Philadephia Museum of Art.

Figure 1. I buy houses (pre-Katrina street sign).

Learning from New Orleans

WES WALLACE

When I moved to New Orleans a year ago, I thought it would be a chance for me to change my life. Beset by insomnia, anxiety, recurrent fevers, itching, gastrointestinal problems—at the age of thirty-five, I often felt closer to sixty. I needed major renovation. I thought it would be a good idea to move far away from the Northeast, where I was mostly raised and have lived for the past twenty-five years. The image of New Orleans as a lazy, hedonistic city attracted me, as did its humid yet classy old buildings, from which mosses and vines and even small trees would sprout in places.

But as I got to living there, I realized that there was stress beneath the surface. People lived in darkened apartments, behind security grilles. They talked of termites, cockroaches, electrical outages, flooding. Many streets were knee-deep in water after a heavy rain. Crime was random and horrific. In my first few months, I remember the story of an eight-year-old child, murdered by his mother's boyfriend. The newspaper said a fight broke out between the two adults over who would smoke the last rock of crack. The mother told her son to run outside and call the police from a pay phone. The boyfriend then chased the child outside and killed him. A witness said that the man plunged a knife into the child's skull, lifting the boy off the street in his attempt to withdraw the weapon.

People living in New Orleans ignored the crime just as they ignored the danger of a direct hit by a hurricane. I learned to do the same, feeling that the stagy tone of the news media did not do justice to the slow and often sleepy reality of daily life. I also suspected that the sensational place of crime in the media and in people's conversation reflected an underlying racism—the neighborhoods reputed to be dangerous were always black neighborhoods.

Today, I believe this attitude was foolish. Out of wishful thinking—not wanting to be racist, not wanting to be negative, above all wanting always to believe that New Orleans was the magical antidote to the Northeast—I had simply ignored and filtered out much of what was going on around me.

This past summer was considered a particularly heavy one crime-wise. To speak only of the incidents that affected friends of mine: A woman was raped on a Sunday afternoon, in her office on the campus of Tulane University; a shopkeeper was shot to death in front of her husband, in their store on Magazine Street, a busy shopping district for boutiques and antique furniture; a man was shot to death after his car was hit from behind by another vehicle (the man got out to inspect the damage, whereupon the other driver shot him); a woman was murdered at home by her lesbian lover, one of several "love triangle" murders that occurred over the summer. And there were other stories: a tourist bludgeoned to death by "goths" in a hotel bathtub, territorial wars between street gangs, and more. These incidents spanned the gamut of race and social class.

In fact I now think that their prominence in people's conversation, far from being a sign of racism, came from a kind of mutant civic pride. Black and white, rich and poor loved to tell these stories, and if there were different motives each time, they all did converge in a strong desire to impress the listener.

Looking back at the city I knew after hurricane Katrina had temporarily erased it from the map, I did have to wonder if it was worth rebuilding. I was not surprised when Congressman Dennis Hastert raised that question—nor, I wager, were many New Orleanians.

But upon further reflection, having turned over the matter in my mind, I have concluded that New Orleans is worth rebuilding. The reason is not "to preserve the Jazz Heritage" or the Architectural Heritage, or any other such thing. The reason is that rebuilding New Orleans is like rebuilding America. Hell, it's like rebuilding the whole of Western civilization.

In the act of rebuilding, New Orleans could rise to its true and great potential: not only an antidote to the Northeast, but an example to the world.

New Orleans's own quasi-prophetic novelist Walker Percy claimed in one of his essays[1] that the best model for urban and spiritual renewal in America is not any New Age community or designer suburb, but in fact, the cracked and beleaguered New Orleans. I have meditated on this pronouncement. It used to feed into my pre-Katrina thinking, and confirm my sense of purpose. But I will admit that one thing puzzled me:

All photographs accompanying this article were taken by the author before Hurricane Katrina.

1. "New Orleans, Mon Amour," collected in *Signposts in a Strange Land* (1991).

Figure 2. Magnolia Supermarket, Jackson Avenue.

Percy presented as an important piece of evidence in support of his argument "the passable neighborhood restaurant." I couldn't help but think: Is that really it? Does the healing power of New Orleans boil down to a bunch of people eating crawfish and gumbo? And what to make of the custom whereby crawfish were consumed out of paper bags, and their uneaten heads tossed onto the sidewalk in trails that could be followed for days?

No: There has to be an existential dimension to it, something indirect but universal—something like a "way of seeing." What is it then about New Orleans, assuming the insight is true, that we really can learn from?

Figure 3. Discarded crawfish head, Magazine Street.

New Orleans before Katrina was, yes, by many standards a dirty city, a violent city. But it still seemed consistently and improbably beautiful. Perhaps especially for a transplanted Northerner, its landscape had a kind of newness. To the untrained eye, it's true, New Orleans was full of old things, broken-down things—it was distinctive in the American landscape precisely for being so un-new. And yet, there was something about rebuilding, starting anew, shedding the old, that was constitutively part of the New Orleans character. Anyone who has actually lived there can attest to this.

But this quality of mind is not something that can be demonstrated by argument. Its nature is such that focused attention dissolves it. And so to explain this, I see no other way forward than to digress.

When I arrived in New Orleans, I belonged to a class of young professionals and pre-professionals who were moving into the Lower Garden District, a neighborhood built in the mid-nineteenth century. There was a kind of myth about recent developments in our neighborhood—a story told from various angles by people in the area. Reduced to its essentials, the story went something like this:

> First there was the St. Thomas housing project—a place of crime and danger. The whole Lower Garden District, including the grand old houses, was a bad neighborhood. The housing project was filled with criminals, and the grand old houses were subdivided into low-rent apartments, mixed with crack houses and whorehouses.
>
> Then Wal-Mart came in. Wal-Mart, the biggest retail chain in the world—the largest private employer in the United States. Wal-Mart made a deal with the city to tear down the St. Thomas housing project and build a Wal-Mart there instead. They offered to "redevelop" the rest of the area. They even promised to include "low-income housing" in the new development.

Wal-Mart's plan was accepted by city authorities, and the housing project was torn down about ten years ago. According to a local resident: "It took forever to tear it down, too. That thing was built out of solid fuckin' brick, they knew how to build in those days. It wasn't built for blacks either, it was built for Irish construction workers!"

Nevertheless, before the Wal-Mart, poor blacks had been living in the neighborhood for about twenty years.

> They lived in the grand old houses. They consumed drugs, got into fights, killed one another. But then, after the projects were torn down, the blacks were displaced by whites who wanted to buy and restore the grand old houses, renovate them and raise the real estate value.

Figure 4. An old "shotgun" cottage is moved and carefully reconstructed.

The first wave of whites were marginal people with minimal cash reserves: "gays," "artists," "white trash." But after these people did their work, young and affluent people started to move in. "Everything is going condo," as my local informant expressed it.

"Where do the people come from who buy these condos?" I asked him.

"Who knows where they come from!" he replied hotly. "Most of them come from Houston probably: That's where the money is. There's no economy in this fuckin' town, unless you want to be a waiter or something."

But in the beginning, before the crack houses, there were the grand old houses. Why did the rich people move out of these houses, leaving them to the crack addicts? The answer is not hard to find. It was "white flight"—a social phenomenon so familiar that it has its own nickname.

And again, there is a kind of mythic story here:

> After public schools were desegregated in the 1960s, the white population fled to the suburbs, leaving the "inner city" to blacks. The inner city then fell into ruin as low-rent apartments and eventually crack houses and brothels were carved out of the stately town houses and department stores.

Is this story true? Or to put it another way: Is this the whole story? Here we have a myth, which essentially says: Black people don't know how to take care of a place. They wanted equality and look what they got: a slum. And the facts do seem to confirm this, so that even "liberals" are hard-pressed to say different.

But I want to suggest that there is another version of the story, or at least another dimension to it—a more existential dimension which I have been calling "the Involution." This concept first occurred to me in the form of a parable:

> Before the 1970s, the whole movement of the city was outward-going, and the pursuit of pleasure followed suit. The farther "out" you went, the more wild things were, the more you could kind of set up on your own without worrying about regulations. But then in the 1970s, this outward-going movement reached a limit. The proliferation of suburban retail environments, with mega-stores and large multi-lane roads with slow-moving traffic, gradually blocked unregulated movement and enforced a kind of passive surrender to, and encapsulation within, a system of limited and regulated pathways.
>
> This, in turn, brought an involution in basic ways of living and looking at the world. Exploration, colonization, development were no longer directed outward but rather inward, into impoverished but formerly elegant areas.

In this version of the story, even as white people were fleeing New Orleans, conditions were already being prepared for their return. And indeed, white people began to return in the 1990s, renovating the ruined

Figure 5. Ruin of Handelman's department store, Oretha Castle Haley Boulevard.

houses. Here New Orleans followed the pattern of many other American cities: a pattern known to developers as the "Soho model," since it proved so lucrative in New York's abandoned Soho warehouse district back in the 1980s.

The Soho model says that given a few taxation or zoning concessions by the city, ruined buildings will be reinhabited by artists and marginal people, leading to the emergence of charming independently owned stores and coffee-houses and the rejuvenation of a neighborhood. Eventually, wealthy people will be attracted to the area, spurring costly renovations and profitable rent and tax increases. (Along with, sadly, the disappearance of the charming independently owned stores.)

This economic model is the primary force behind the development of "historical districts." And New Orleans, before Katrina, was a city where historical districts had become central to the economy. The city billed itself as the "Birthplace of Jazz," and its annual Jazz and Heritage Festival attracted tens of thousands of tourists. But to Jazz had been added a whole slew of other heritage phenomena, from Greek Revival architecture to gumbo stew, Cajun/Zydeco music, voodoo, swamps, alligators, four-poster beds, wrought-iron balconies, etc.

In fact, the word "heritage" came up so frequently in New Orleans it could have just been abbreviated "Htg."

Evidently, Htg. was what tourists came to New Orleans to consume. They wanted a chance to see and experience something tested, authentic, traditional, interesting—however you may define it. Some came for music, others for food—others just for a walk in a city neighborhood.

> Where they came from, presumably, there was no music or food, there were no walkable city neighborhoods. In a sense they came from the desert—perhaps not in a measurable sense, but "spiritually."

And yet, in this treasure-house of the authentic, some people were not there to visit, but to live. I was among them, and I felt that I had a right to call the place home, with a pride and a casualness unavailable to those tourists who schlepped around the streets in guided packs.

> And yet we who lived in the restored, historical neighborhoods of New Orleans were like visitors to an empty house. The owners and builders of this house were gone. They had died perhaps, or evacuated the area—in any case we saw no trace of them. We lived in the rooms and streets they built, but we had no social contact with them, with their customs, or with their history.

Figure 6. An unrestored house in the Lower Garden District.

And yet the ghosts of the builders spoke to us, as we walked within their creation. Why else would we live in a historical district—I and so many others who paid the price to live there? It must be that we felt something around us, a mood or a spirit which emanated from the houses, and comforted us.

Sometimes, even, I inwardly addressed the ghosts of the builders. I imagined myself living among them.

How many people who lived in the historical districts imagined themselves living the mythic lives of the builders—living in the grand style, in the slowness and grandeur of those old houses—eating lunch, say, at the old kitchen table, under the comforting gaze of servant women?

But this mirage died out daily, dispersed by the reality of futons, piles of papers, tangles of wires, computer equipment. The bricked-in fireplace with its carved mantelpiece, the windows that won't open: It's a stage set—a cave. And the illusion is maintained by a supply infrastructure located at the periphery of the historical district, at the Wal-Mart, the Winn-Dixie, the Sav-A-Center, the Whole Foods store. (Not to speak of the giant retail chains out on the strip in Metairie: Bed Bath & Beyond, BestBuy, Target, Lowe's, and beside them the malls with their "food courts" and clothing chains—Old Navy, Gap, Eddie Bauer, Banana Republic, Abercrombie & Fitch, J. Crew)

In those places of social contact with other inhabitants of New Orleans, I saw that I lived among strangers. The people around me did not share my basic ontological commitments. I did not live in a community. My community, if I did have one, was not organized by geographical proximity, but by telecommunication. The Biblical injunction "love thy neighbor as thyself" had become fundamentally uninterpretable—even senseless.

And so, in this prized ruin where I lived, I had no desire to find out what other people were doing. I wanted to have the *option* to meet interesting people, go to interesting places, but in the end I found it much easier *not* to go to those places. I was drained and even dazed by some invisible neuro-endocrine shut-down.

I was shut down by my endocrine system as it chronically secreted stifling signals in response to an incomprehensible environment.

I saw the tattoos of aging rockers: a woman in her thirties with stout legs, of pioneer stock, with the word "Gramps" tattooed on her calf surrounded by an exploding bomb.

Why did these people, and why did I, converge there where the old wooden porches and iron railings abounded, where the old peeling tilted houses were giving way to renovated or even newly constructed "antiques"—a life of theater, a "look," a special little place where we could cultivate weird habits?

We went there to find authenticity, perhaps, but also a path of least resistance. We were tired of fighting, somehow, in whatever battles we had been fighting. And this made us easy prey to the gods of fatigue, laziness, ruination. We bought into quick fixes, our minds beguiled by a dream of grandeur that was already, in its very inception, a dream of decay.

Who can deny that there is something liberating about a place that is dramatically falling apart?

And maybe the healing power of New Orleans came down to this: that the magnitude of its problems forced people to reason obliquely. In the face of crime, racism, toxicity, corruption, heat, vermin, and periodic

evacuations, why not just have a little fun? Why not admit that you're screwed and relish the ugliness?

Idealism is a great danger, actually—a great contributor to human misery. When you want an ideal, you want the right clothes, the right car, the right place: you become someone who is not living, but only working toward an ideal.

And here in the land of crawfish heads, destitute banana trees, crumbling old mansions, barracks-like housing projects, here you can finally learn to cast away ideals. You can learn to laugh: to laugh in an existential way, a laughter not really emitted but *accessed* by you.

* * *

A middle-aged man wearing large black Buddy Holly eyeglasses rides by on a bicycle, bellowing loudly to the empty street. His voice functions like a horn but also like a kind of soundtrack to himself.

* * *

In Audubon Park, ducks waddling to the tune of old jazz (a trombone and guitar duo), their sleek boat-like bodies moving egg-like between their paddle feet. The squirrels run near the ducks but do not seem to notice them. They live in separate "streams," their flow patterns do not interfere, they coexist within the city of New Orleans but do not commingle.

* * *

As I watch the ducks swimming along a moat that separates the golf course from the tiny ribbon of grass—the only public land that remains in this so-called public park—I come upon an old man in a mesh baseball hat and checkered shirt: seemingly a "cracker," an old white man of deep wrinkles and distant stare. I remark to him that the ducks don't seem to be bothered much by the joggers. He replies: "They're just mindin' their own business."

* * *

I wake up one day to find a giant cockroach floating dead in my kitchen sink. I stare at it with fear and then with laughter: It seems to be challenging me, questioning the foundations of my world.

* * *

While driving, I listen to a song by the late New Orleans entertainer, Professor Longhair. The carelessness

of his delivery is at first disconcerting, but eventually sensible, logical, inevitable.

* * *

I am on my way out of a chain store pharmacy. I pass an elderly black woman wearing oversized rectangular sunglasses (the kind that fit around normal prescription glasses). She is standing in the entranceway to the store, between the two sets of automatic doors, and she looks as though she has been standing there for quite some time. As I pass between the automatic doors, I hear her say: "I got high blood pressure."

I notice that another black woman of indiscriminate age is standing opposite her, on the other side of the rubber mat, and this second woman replies: "Mm-hmm."

* * *

Is there a red thread here? Can I pick up a few pieces and take them on to the next place?

October 2005

Trends in New Orleans psychogeography

A major hurricane in an urban area like New Orleans brings with it a lot of attention, especially to our understanding of how cities work. As New Orleans is rebuilt, the slow forces that normally guide the evolution of an urban environment will be dramatically amplified and focused into a short period of time. But I expect that the rebuilding will follow some basic trends that were already in place prior to hurricane Katrina.

The most obvious trend was a kind of renovation frenzy. Throughout the city, old houses that had fallen into disrepair were in high demand. Everywhere, you saw the familiar logo of "Tyvek" house wrap and heard the screech of buzz saws and sanders. Property prices were rising quickly, creating a heady sense of opportunity among those with the knowledge and resources to buy and restore historic homes. Abandoned industrial warehouses were being gutted and remodeled as high-end loft-style apartments, with their nineteenth-century exteriors still intact. Modest early twentieth-century houses could be spruced up and resold as "Creole cottages." Even the smaller "shotgun" cottages were known to double in value immediately after renovation. There was no doubt that this was the time to buy up property, especially property with historic interest, regardless of the neighborhood. Some people even said that the peak moment for good deals had already passed.

A second trend was the construction of new buildings designed to be virtually indistinguishable from nineteenth-century houses. Particularly noteworthy in this respect was the redevelopment of the St. Thomas housing project in the Lower Garden District. The old brick housing project was bulldozed and replaced by a Wal-Mart and rows of brand-new Greek Revival homes and "camelbacks" with gas lamps hanging from the balconies. The project had initially been billed as a "mixed-income development," but well before the hurricane, the results had also been mixed: The residents of the defunct housing project were relocated to the west bank of the Mississippi; meanwhile, their old neighborhood boasted a large Paris Parker day spa and vast Florida-style apartment complexes with high-rise parking structures, which did little to inspire hopes for social integration or urban reform.

The remodeling of Anne Rice's old estate on Napoleon Avenue was emblematic of these two trends.

This property had been built as a boarding school and later became the St. Elizabeth's orphanage for girls, run by the Daughters of Charity. The style of the building, described by Rice as "Second Empire," featured white columns against a red brick façade with winged angels at the entrance steps, stained-glass windows, and a functioning chapel. After Anne Rice bought the property in the early 1990s, she used it as a grand residence and a place for entertaining guests. When she put the building and grounds up for sale in 2003, they were acquired by developers who planned to turn the main building into luxury condominiums. In June 2005, a large sign outside still read: "Only one left at St. Elizabeth's." By July, all the units were sold. The backyard of the old orphanage was also being redeveloped into expensive "town houses." The newly added row of houses was designed to look like the slave quarters of the main house, but garages on the ground floor of each unit gave it an ambiguous appearance: a "carriage house" look in the neo-historic style of an imaginary slave quarters.

Another noticeable trend was the functionalization of public space. There was literally no place to rest in metropolitan New Orleans. Walking around the French Quarter on a hot afternoon, you found yourself forced onwards and eventually out of the Quarter altogether. The Garden District and Uptown, though superficially presenting the prospect of leafy repose, were almost entirely governed by the principle of private property. You would end up circling around and retreating yet again. There were no public benches on the streets; the coffee houses catered to manic pre-professional students as dens of exam-cramming and wireless Internet use. Access to nature was limited to Audubon Park, but even here the trees and winding paths had gradually been replaced by "exercise zones." Everyone had to be active and every space had a designated activity, from golf to chest curls. Granted, there were ribbons of grass on the edges of the golf course and a parallelogram of grass beside the Mississippi River where you were free to rest. However, the accessibility of these places was usually disrupted by a competing din of boom boxes, SUV radios, private crawfish parties, and Ultimate Frisbee pick-up games. This was a far cry from Frederick Law Olmsted's vision of his park as "a specimen of God's handiwork."

However, despite all this, the functionalized redevelopment of New Orleans was incomplete. One might even cynically say that the "crime rate" attested to a stubborn sign of life, or at least a failure to completely "theme-park" the city. Interspersed among the areas of renovation, there were "high-crime" (mostly black) neighborhoods where families continued to live side by side. On any hot evening the steps and stoops of these streets would be filled with people of every description: babies, children, mothers, teenagers standing in groups, old men drinking beer, people calling loudly to each other across the street. Sometimes music would be playing from a stereo system, and during festivals people would dance in the street at little block parties.

Probably, such neighborhoods continued to exist only because of the reduced mobility of their black citizens—literally immobilized by lack of access to transportation and higher education. Such neighborhoods were often plagued by violence and drugs, and one might argue that they were hardly ideal models for the future of a city. But there were moments that proved otherwise. This is not to romanticize poverty but at least to suggest that in a city under rapid renovation, there were neighborhoods where people still knew each other and had some joy in living close to each other. The challenge for rebuilding New Orleans will be to keep this kind of freedom and joy in the open street, even in a booming real estate market.

The "Kulturbolschewiken" II

Fluxus, Khrushchev, and the "concretist society"

CUAUHTÉMOC MEDINA

Fluxus and LEF?

Given the lack of detailed research on the art historical and theoretical development of the ideas of the Fluxus group, much has been made of George Maciunas's alleged identification with the anti-artistic projects of the early Soviet avant-garde. Prominent in most of those debates is a paragraph from his letters to Tomas Schmit where Maciunas refers to LEF and Mayakovsky as the ideological forerunners of Fluxus:

> Fluxus objectives are social (not aesthetic). They are connected to the group of the LEF group of 1929 [sic] in Soviet Union (ideologically) and concern itself with: Gradual elimination of fine arts . . . This is motivated by desire to stop the waste of material and human resources (like yourself) and divert it to socially constructive ends. Such as applied arts would be (industrial design, journalism, architecture, engineering, graphic-topographic arts, printing, etc.).[1]

There are few places in Maciunas's scarce texts that seem as unequivocal as this one, but it would be hard to explain his attack by the abstractedness of modern art and his wish to redirect artistic efforts to the development of the productive forces of the industrial era as a rendition of the 1920s Russian Productivism.

Rather, as we will see, Maciunas's agenda can in many ways be seen as a reversal of the actual Productivist project. On the one hand, Maciunas's knowledge of the Soviet avant-garde was not only superficial (as with most Western artists until the early 1960s) but also was clearly reduced to a very peculiar interpretation of the debates of the 1920s. On the other hand, I will try to prove that Maciunas's economicism is better understood as an offshoot of a completely different context: the ideological arguments arising from the economic challenges the Soviet Union was facing in the late 1950s and early 1960s.

Russian Productivism and the critique of modern production

How accurate is Maciunas's rendering of Russian Productivism? No doubt, Russian Constructivism, in its several branches and phases, represents one of the most radical attempts to breach the antinomy of art and production.[2] The 1917 coup and the Bolsheviks' decision to improvise a policy of technological and economic modernization of Russia when their expectations of a sudden revolution across Europe failed to materialize was interpreted by the Russian Futurist, post-cubist, and abstract art circles as the opening of a new social era in which the preeminence of the values of "expediency" and "utility" left no room for the remaining contemplative and religious bases of bourgeois artistic practice. The paucity of aesthetic speculation in Marxism before the Soviet revolution allowed the avant-garde to entertain the possibility of combining the recent achievements of abstract art and Futurist poetry, mixed with Aleksandr Bogdanov's organization theories and Lenin's devotion to material development. Contemporary scholarship has done much

This is the second part of the article published by *RES* 48 (autumn 2005, pp. 179–192) that examined the history of the Fluxus project of abolishing art as it was conceived by its so-called leader, the Lithuanian-American George Maciunas. Beyond reviewing the conflicts around the "terrorist" actions of Maciunas and Henry Flynt in 1963–1964 and the importance that the pursuit of forms of "pure amusement" had in their anti-artistic projects, the article described how Maciunas had hopes that art could be abolished in the Eastern bloc "by decree." In the second and last part of this text, I will examine the political and art historical assumptions behind that project. These two articles are derived from the Ph.D. dissertation I wrote for the University of Essex under the direction of Dawn Ades. I would like to thank the various archives and people who helped me in the process of conducting this research.

1. George Maciunas, letter to Tomas Schmit, January 1964, in *Fluxus etc./Addenda II. The Gilbert and Lila Silverman Collection*, ed. Jon Hendricks (Pasadena: Baxter Art Gallery, California Institute of Technology, 1983), p. 166.

2. See Hal Foster, "Some Uses and Abuses of Russian Constructivism," in *Art into Life: Russian Constructivism, 1914–1932*, ed. Richard Andrews and Milena Kalinovska (New York: Rizzoli and Seattle: University of Washington, The Henry Art Gallery, 1992), pp. 241–244.

to distinguish the variety of models under which the integration of art into the productive forces of Soviet Russia was formulated in the early revolutionary days: from Naum Gabo and Antoine Pevsner's calls for a new technological real space and time where their "constructive" language meant to express aesthetically the functional organization of socialist development without actually participating in the industrial structure, to Velimir Khlevnikov's and Vladimir Tatlin's visionary projects of an alternative non-rationalistic and "organic" approach to material culture.[3]

Although Productivism tends to be identified with the works and ideas of the artists of the so-called "Working Group of Constructivists"—Aleksandr Rodchenko, Varvara Stepanova, Aleksei Gan, Konstantin Medunetsky, and Vladimir and Georgii Stenberg—Boris Arvatov had a point in thinking that only the theoreticians, such as Gan, Nikolai Tarabukin, Osip Brik, and himself were Productivists in the strict sense of the word.[4] It was among the theorists related to the Futurist and Formalist circles that pursuit of "the new" was interpreted as a death warrant against autonomous and speculative values of all former artistic creation. More than an expression of an original hatred against art, Russian Productivism can be seen as the attempt to rescue something out of art's unavoidable destitution, an attitude that seemed to follow logically from Marxism's disdain for any form of aesthetic agency. Such was the frame of mind in which writers such as Brik launched by 1918 and 1919 the first Productivist arguments in Soviet Russia: not only denouncing art as a bourgeois activity, but also desperately searching for a place for artistic practice in the newly born society.

> A shoemaker makes shoes, a carpenter—tables. And what does an artist do? He does not do anything; he "creates." Unclear and suspicious. . . . If the artists do not want to share the fate of the parasitic elements, they must show their right to existence. . . . They [must] do a fully definable, socially useful work.[5]

The Productivists' response to this predicament was to take the revolution as the opportunity to overcome the alienated condition of art in modernity. Given that "aesthetic activity" was incompatible with "the functions

of intellectual and material production,"[6] they concentrated their efforts on substituting the former artist with a new social character, that of the "artist-constructor" or the "artist-engineer." Such an agent would bring together the revolutionary impulse of the Soviet society (tectonics) and the direct knowledge of the organic possibilities of the available materials (*faktura*) into a new kind of discipline directly occupied with the rational organization of communist life (construction).

Of course, there were discordant views on how exactly this new conjunction of intuition, technical knowledge, and creativity would occur. Tarabukin remained skeptical about the possibility that artists without specialized technical knowledge could truly be able to become anything better than mere aesthetes. Other theoreticians, such as Arvatov, proposed a new form of integration of aesthetics into the productive machine that was also intended to transform the social character of the modern productive process. Even if Arvatov argued that "technology [had] swallowed art," this incorporation would need to imply the actual overcoming of the "'historically conditioned' division between artistic technique and general social technology."[7] This emphasis on redeeming the alienated character of modern industrial production was crucial in those discourses. Even among its most "Taylorist" representatives, Productivist theorists tended to assume that the art's willingness to abandon its alienated stance would involve the elevation of the industrial system into a state of artistic perfection. Productivist theory involved a resolute critique of the limited and inhuman principles of modern engineering:

> [C]ontemporary engineering, although "technically completely revolutionary", was "completely conservative in its aesthetics." . . . This new task could not be executed by the old type of applied artist nor by the old type of engineer. It could only be done by a new social type [of] . . . "engineer-constructors, equipped with the whole apparatus of technical knowledge, scientific methods for the organization of work and with a productivist attitude to form."[8]

3. Christina Lodder, *Russian Constructivism* (New Haven and London: Yale University Press, 1983), pp. 34–42, 205–223.

4. Ibid., p. 108. For a review of the different positions around Productivism in Russia in the 1920s, see pp. 73–108.

5. O. M. Brik, "Khudozhnik i kommuna," *Izobrazitel'noe iskusstvo,* no. 1, 1919, p. 25, cited in Halina Stephan, *"LEF" and the Left Front of the Arts* (München: Verlag Otto Sagner, 1981), p. 63.

6. Alexandr Rodchenko and Varvara Stepanova, "Programme of the First Working Group of Constructivists" (1922), in *Art in Theory 1900–1990. An Anthology of Changing Ideas,* ed. Charles Harrison and Paul Wood (Oxford: Cambridge University Press and USA: Blackwell Publishers, 1992), p. 318.

7. Boris Arvatov, *Iskusstvo v proizvodstvo* (Moscow, 1926), p. 96, as quoted in Lodder (see note 3), p. 106, note 185.

8. Lodder (see note 3), pp. 106–107.

Far from advising the former artists to turn to applied arts and discard the notion of aesthetic creativity per se, as Maciunas would intend forty years later,[9] the "war on art" launched by Russian Productivism always involved a parallel effort to effect a *transference* of a series of characteristics of aesthetic creation into creative approaches to industrial design and production. In Brik's words, "artistic production" was to bring about "a consciously creative relationship to the production process." Small surprise that it involved a social critique of the alienated character of the labor process:

> We want the worker to cease being a mechanical executor of some type of plan unfamiliar to him. He must become a conscious and active participant in the creative process of producing an object.[10]

And those who conformed their aesthetic output to the aesthetics of the machine, such as Rodchenko, always kept in mind the goal of employing beauty as a form of "universal" social reconciliation. That is, they demonstrated the intention of using the rhetoric of taste to validate the industrial product and its social environment:

> All hail to the Communist expression of material building! . . . The end has come to pure and applied [art]. A time of social expediency has begun. An object of only utilitarian significance will be introduced in a form acceptable to all.[11]

A Stalinist history of the avant-garde

We should conclude that no matter how close Maciunas felt his anti-art proclamations were to early Russian Productivism, the specific contribution of the Constructivists in relation to the quest of a conciliation between aesthetics and work remained beyond his understanding: the intention of infusing modern production with the principles and powers of previous *purely aesthetic products*. He was not so much trying to save the artist from his or her demise, but rather trying to accelerate it. His symbolic commitment to socialism referred to its conditions in the second half of the

century and not to its utopian mirages of the 1920s. But the claims he made concerning LEF's program, and particularly the historical inaccuracies they included, can be traced to specific topics of the scarce sources available at the outset of the 1960s.

In fact, his letters to Schmit of 1964 kept on making the same curious chronological mistake: He dated Mayakovsky and LEF's anti-artistic project in "1929." Later on he tried to correct himself and referred explicitly to "V. Mayakovsky New LEF (1928) as the precursor of Fluxus anti-art and Henry Flynt's 'BREND.'"[12] Certainly, from 1927 and 1928, *Novyi LEF* championed the adoption of Nikolai Chuzhak's "literature of fact" (*literatura fakta*) and the promotion of documentary genres of photography and film exemplified by Dziga Vertov's *Cinema of Truth* (*Kino-Pravda*). *Novyi LEF* marked the group's departure from their initial Futurist-Constructivist program. This might also be interpreted as an attempt of last resort (privately disapproved by Mayakovsky) to redefine the avant-garde's anti-illusionist aesthetic in ways that could be amicable to the late 1920s Soviet regime.[13] However, it would be naïve to believe that Maciunas had a clear picture of those historical differences. His need to push LEF toward the end of the 1920s more likely derived from his hope of relating LEF's anti-art with the economic and political changes that are normally perceived as responsible for the decline of the Russian avant-garde.

Among Maciunas's papers in the Silverman collection, there is a historical diagram of the socialist revolution in Russia, from the October revolution of 1917 to Sergei Kirov's murder in 1934. The scope of this research is not innocent: The diagram reads as a rather apologetic history of the rise of Stalinism.[14] Its main purpose, very much in the line of Maciunas's historical project from his student days, was to coordinate the

9. One of the most important fields of Productivist theory was the critique of the notion of "applied art." In fact, historians such as Lodder have rightly pointed out that the late 1920s confinement of Constructivism to propaganda, photomontage, and graphic design was the result of the decline of the movement and not a logical derivation of its principles (ibid., p. 204).

10. O. M. Brik, "On the Order of the Day," quoted in ibid., p. 102.

11. Alexei Gan, *Constructivsm* (1922), quoted in ibid., p. 319.

12. George Maciunas, "Expanded Arts Diagram" (ca. end of 1966), in *Film Culture*. Special issue, no. 43 (winter 1966): 7.

13. Stephan (see note 5), pp. 55–56.

14. George Maciunas, "Diagram on the Soviet Revolution" (unpublished manuscript). The Gilbert and Lila Silverman Collection, Detroit and New York, curator Jon Hendricks (from now on: *Silverman*). From the style of the document and of Maciunas's handwriting, one can safely assume the diagram was done in the early 1960s. It does not fit with the description Leokajda Maciunas provides in her memoirs of a diagram on Russian history that Yurgis composed in the early 1950s. I think there are reasons to believe this chart was composed by Maciunas during his culture-Bolshevik years and guided him in the attempt to model Fluxus on the basis of the history of the Soviet regime.

different stages of economic and social policy with the major developments of "Poetry and Prose" under Stalinist Russia.

The implicit narrative of the chart (clearly composed on the basis of official accounts of culture in the USSR) can be roughly transcribed as follows: After the predominance of the "Symbolist school" during the 1910s, the revolution had brought literature to serve the "cause of the state" despite the "great confusion" of the early Soviet times. But while the Proletkult artists of the early 1920s failed in their attempt to develop literary and artistic genres akin to the tastes of the proletariat, the "Futurist school" and Mayakovsky (its most "colorful propagandist") proposed the complete abandonment of the "outmoded traditions of the past." Such a proposal was still pending when the New Economic Policy of 1921 inaugurated a certain tolerance toward the arts. The Communist Party had to constrain itself to a simple show of support toward those "fellow-traveler" writers such as Mayakovsky, who dared to criticize the bureaucracy. However, the laxness that the NEP (New Economic Policy) imposed in aesthetic matters came to an end with the First Five-Year Plan of 1928–1929 when literature entered a new phase that Maciunas described as the era of "Social command." The revolution needed the "full cooperation of art" in terms of "constructive criticism," because it demanded artists to glorify the achievements of the revolution.

This would suggest that Maciunas's special interest in the 1928–1929 period of the avant-garde in Russia has to be interpreted as part of his approval of the moment in the late 1920s and early 1930s when the Soviet state reasserted its control of culture. In other words, he imagined that the move of artists toward industry and anti-art projects was part of the complete social planning involved in the issuing of the First Five-Year Plan.

In fact, Maciunas knew well that Stalinism had caused great distress among the Soviet population due to the forcible collectivization in the countryside, the reorganization of the army, and the purges Stalin enacted on the Soviet leadership. With extreme cynicism, Maciunas related those developments to the rise of Socialist Realism. But far from condemning Stalinist social and political violence, Maciunas seems to have approved of the way the state used realist art to ameliorate the disillusionment provoked by totalitarianism. He described Socialist Realist "forced humor" as a policy aimed to prevent the social unrest arising from Stalin's policies. It is not by chance that up to the 1970s, his historical diagrams of the origins of Fluxus included "Socialist Realism/Didactic Art" among

the positive contributions of anti-art.[15] It follows that when Maciunas reflected that Fluxus needed to metamorphose into "vaudeville, amusement, satire, etc., rather than a vulgar shock" to infiltrate the socialist republics, he was guided by the assumption that socialism in the postwar years also needed a positive kind of artistic practice aimed to demonstrate that life under socialism, no matter how displeasing, was superior to any kind of fantasy. Thus, in the early 1960s he came to conceive the official Socialist Realist policy of the Soviets as a form of anti-artistic political control:

> Socialist Realism
> Artist must be optimistic, constructive, accept life as beautiful. It is the artist that is wrong, not life.[16]

Fluxus commitment to humor was permeated by this strange rationalization of the official Soviet artistic dogma. Even though Maciunas was not a crypto-Zhdanovist, because he rejected the extreme stylization of Socialist Realism, he attributed to it a higher social function: helping Stalin to impose the forceful collectivization and industrialization of the Soviet Union.

Similarly unique was Maciunas's understanding of LEF's history. Under close inspection, it appears as a peculiar synthesis of many 1920s and 1930s leftist theories, which he dutifully introduced into a composite portrait of Vladimir Mayakovsky.

> VLADIMIR MAYAKOVSKY
> LEF (LEFT FRONT) . . .
> Painters advised to design posters, newspapers.
> Sculptors to design machinery, pots, etc.
> Directors to organize folk festivals
> Poets to write for newspapers, poster texts
> DISSOLVING ART INTO LIFE!
> KEMENSKY [sic]
> BURLYUK[17]

That Mayakovsky appears as an overpowering character in Maciunas's charts is not surprising at all: From the moment Stalin mischievously decreed in 1935 that indifference towards Mayakovsky's memory and works were "a crime," the poet became the only Soviet member of the avant-garde worth discussing in good

15. George Maciunas, "Diagram of Historical Development of Fluxus and other 4 Dimensional, Aural, Optic, Olfactory, Epithelial and Tactile Art forms" (ca. 1974), in *Fluxus Codex*, ed. Jon Hendricks (New York: The Gilbert and Lila Silverman Fluxus Collection in association with Harry N. Abrams, Inc. Publishers, 1988), p. 329.

16. Maciunas (see note 14).

17. Maciunas (see note 15), p. 329.

leftist circles.[18] More significant is the fact that, nonetheless, Maciunas felt it important to inscribe in his charts the rather more obscure references to David Burliuk and Vassilii Kamensky.

The "thaw" and anti-art: Ehrenburg's account of Futurism

Maciunas and Henry Flynt were among the first postwar artists who took the Soviet avant-garde as an essential point of reference. It was an ill-digested, but amazingly timely reception: Nineteen sixty-two was the "year one" of the resurrection of the Russian avant-garde, particularly due to the publication of Camilla Gray's seminal study, *The Great Experiment: Russian Art 1863–1922*. That same summer, Jonas Mekas published the very first direct translations of Vertov's writings into English in *Film Culture*.[19] As a result of those and other sources, in a quick succession of letters between January and February 1963, Flynt and Maciunas came to the conclusion that the Soviet debate on the death of art was far more significant than Dada's:

> [B]ourgeois "Western" art dead by 1920 result of dadaism & Soviet a-g. . . . Stalin faced problem of decadent art. Art only used in educational sense. Now should bypass art altogether. Go directly to H[enry] F[lynt] superior concept of pure recreation. Education to be continued by non-fiction & realism . . .
>
> Mayakovsky—anti art statement—much superior to W. European dada.
>
> Most advanced thinker anywhere. —does not imitate West like other "avant-gardists" . . .
>
> Communist didactic art is still art & better replaced by non-artistic forms of propaganda.
>
> Must get LEF magazine. —make selection of manifestos of M[ayakovsky]'s "war" against art . . .
>
> Dziga Vertov is one of us—I was right—[Flynt] found more material on him.[20]

Although Flynt recommended that Maciunas read Gray's book,[21] and although the slogans "art into life" that the Fluxus leader quoted in the 1970s came from Gray's account of Tatlin and Rodchenko's ideas,[22] it would be wrong to trace his reading of LEF to that book alone. In fact, by 1962 Maciunas was much more impressed by the fragmentary anecdotes on the Ego-Futurists leaked by the only writer who, through a remarkable combination of luck, foxiness, and at times slightly heroic opportunism, was able to survive all the cultural battles of Soviet history—Ilya Ehrenburg. Just a few weeks after Maciunas issued his *Manifesto*, Flynt recorded their intellectual debt to the author of *Julio Jurenito*. On February 28, in his lecture-manifesto "From Culture to Veramusement," Flynt argued that his new doctrine "was anticipated by little known ideas of Mayakovsky, Dziga Vertov, and their group, as related in Ilya Ehrenburg's memoirs and elsewhere."[23]

Besides his outstanding achievements in the Constructivist/Surrealist crossroads of the 1920s, Ehrenburg's heyday was the brief period to which he

18. Letter from Stalin to Nikolai Ezhov, head of the secret police, quoted in Anna Lawton, ed., *Russian Futurism through Its Manifestoes, 1912–1928* (Ithaca and London: Cornell University Press, 1988) pp. 47–48, fn. 133. Something similar had occurred in 1922 when Lenin decided out of convoluted practical reasons to praise Mayakovsky's poem "Lost in Conference": While *LEF* was edited by Brik, it was politically convenient to maintain Mayakovsky as the official editor of the magazine. (On this issue and LEF's critical history, see Stephan [note 5], pp. 33–38, p. 191ff. and her article "The Rediscovery of the Left Front of the Arts in the 1960s and 1970s," *Canadian-American Slavic Studies* 13, no. 3 [Fall 1979]:332–349).

19. P. Adams Sitney, ed., *Film Culture. An Anthology*. (London: Secker & Warburg, 1971), pp. 353-375.

20. George Maciunas, card file on Henry Flynt, Sohm Archive, Staatsgalerie Stuttgart.

21. Maciunas mentions Gray among the books Flynt was using at the time in his own private notes. The reader might find it interesting to see this reading list, which ranges from history books to a classical monograph on Mexican mural painting:

"Henry Flynt—Sources
The Modern Theater, Vol. VI. Double day, Anchor Books, 1960
The Great Experiment in Russian Art 1863–1922. Camilla Gray, H. Abrams
Bedbug and Selected Poetry by Mayakowsky. Meridian, New York, 1960
An Illustrated History of Russia by Joel Carmichael, Reynal & Co. New York, 1960
International Socialist Review, N.Y. 1962 Winter
Evergeen Review, Vol. 6. No. 25 (more Soviet Science fiction) Collier Boks [*sic*]
The Mexican Muralists. Alma Reed. Crown Publ, New York, 1960
Soviet Literature (Soviet publ) nothing to do with communism"
(Sohm Archive [note 20], card file on Henry Flynt).

22. A comparison of the context of Gray's discussion and Maciunas's summary is useful to confirm the transformation of the Productivist project that Maciunas worked out: "On the other side, Tatlin and the ardently Communist Rodchenko insisted that the artist must become a technician; that he must learn to use the tools and materials of modern production in order to offer his energies directly for the benefit of the Proletariat. The artist-engineer must build harmony in life itself, transforming work into art, and art into work. 'Art into life!' was his slogan, and that of all the future Constructivists" (Camilla Gray, *The Great Experiment: Russian Art 1863–1922* [London: Thames and Hudson, 1962], p. 244).

23. Press release for "From Culture to Veramusent" (March–April 1963), in *Henry Flynt: Fragments & Reconstructions from a Destroyed Oeuvre, 1959–1963*, an exhibition at Backworks (New York), April 27-June 12, 1982, document 20E.

lent a name: the "thaw" of Soviet politics under Nikita Khrushchev's premiership. He was not only the only member of the cultural elite who was allowed to openly resist Socialist Realism's dictates under Stalin's rule. During the 1950s, Ehrenburg fought intensely to rehabilitate modern art and literature in his country. He exhibited Picasso in the mid-1950s, promoted tolerance to Kafka's and Joyce's work among Soviet literary circles, and took good care to rescue the books of banned authors, such as Isaac Babel, Boris Pasternak, and Maria Tsvetaeva. Ehrenburg also helped to stage the first and very influential exhibitions on the early Soviet avant-garde: Natalia Goncharova's and Robert Falk's, among others. Ehrenburg was instrumental in provoking the momentary relaxation of the regime toward the *intelligentsia*, a move that provoked resentment among the Stalinist bureaucracy and conservative artists.[24] Maciunas and Flynt got caught in the hall of mirrors of this turbulent era and Ehrenburg's personality. The Fluxus chairman's views on Mayakovsky's war against art, from his letters to Schmit to the diagrams in the 1970s, were nothing but a verbatim transcription of Ehrenburg's recollections on the matter:

> Mayakovsky . . . wanted to destroy poetry by poems. LEF published a death sentence on the arts: on "so-called poets," "so-called painters," "so-called producers." Instead of working on easel paintings, artists were advised to turn their attention to the aesthetics of machinery, textiles and household articles; theatrical producers were enjoined to organize popular festivals and demonstrations and to bid farewell to the footlights; poets to abandon the lyric and write for the newspapers, invent captions for posters and copy for advertisements.[25]

Ehrenburg's memoirs were strategically devised to confound the censors and push for cultural openness. Purportedly ridiculing the extremism of the 1920s,

Ehrenburg gave his readers a glimpse of a cultural era far richer than their times. The standard Soviet reader was sophisticated enough to interpret such Aesopian strategies of writing, but more naive Western audiences, such as Flynt and Maciunas, risked getting lost in those subtleties. So, instead of being compelled, as Ehrenburg probably wished, to support a liberalization of culture in the Eastern bloc, Maciunas felt attracted to the deliberately hilarious anecdotes with which Ehrenburg accompanied his account of the Russian Futurists' enmity towards art.[26] The sole reason behind his devotion for the two Ego-Futurist Russian poets he mentions in his charts, Burliuk and Kamensky, was a tale told by Ehrenburg about the day Mayakovsky and the two of them covered the walls of Moscow with a decree, supposedly issued by Lenin, that abolished all the old artistic institutions of the czarist era:

> Every morning the townspeople carefully studied the decrees still wet and crinkled, pasted on the walls, trying to find out what was allowed, what forbidden. Once I saw a crowd round a sheet entitled "Decree No. 1 on the Democratization of the Arts." Someone read aloud: "henceforth, together with the destruction of the Tsarist regime, the keeping of art in those lumber rooms and store sheds of human genius—viz. places, galleries, salons, libraries and theatres—is hereby abolished." An old woman squawked: "Dear O Lord, they're taking away our store sheds now!" The bespectacled man reading the "decree" explained: "It doesn't say anything about sheds, but they'll close down the libraries all right, and the theatres too, of course." The text was composed by Futurists, and the signatures of Mayakovsky, Kamensky and Burlyuk appeared at the bottom. The names meant nothing to the man in the street, but everyone knew the magic word "decree."[27]

It is clear that Maciunas found inspiration in this anecdote when he devised his master plan of eliminating art by decree under socialism. Here, as in other moments of the history of Maciunas's career, a specific art historical view overdetermines his theory and practice. We need to examine the final question: Why was it precisely at the beginning of 1963 that Maciunas thought it was possible to convince the Soviet

24. On these events, see the remarkable assessment of his life by Joshua Rubenstein, *Tangled Loyalties. The Life and Times of Ilya Ehrenburg* (London and New York: I. B. Tauris Publishers, 1996), esp. pp. 278–354.

25. Ilya Ehrenburg, *First Years of Revolution 1918–21*, vol. 2, *Of Men, Years-Life* (London: Macgibbon & Kee, 1962), pp. 42–43. In fact, Maciunas's problems with the chronology of LEF might also come simply from the strange structure of Ehrenburg's narrative. Some lines after the passage I quoted, Ehrenburg reflected that Mayakovsky's "rejection of art" grew less harsh with the years, to the point that by "the end of 1928 New LEF stated that Mayakovsky had publicly proclaimed: 'I am granting an amnesty to Rembrandt.'" In a footnote, the autobiography includes the exact chronology Maciunas used in his 1974 historical chart: "LEF: The organization and journal 'Left Front' 1923–25. New LEF 1927. REF: Revolutionary Front of the arts, 1929."

26. His description of the Poet's Café of 1917–1918 must have delighted Maciunas and actually reminded him of Fluxus. To use Ehrenburg's words, this was a place where no one "talked about art, no one argued, no one suffered," and where David Burliuk "heavily powdered and holding a lorgnette" declaimed nonsensical provocations—"I am fond of pregnant men . . ."—to all those "bourgeois who hadn't had their throats cut yet," ibid., pp. 38–39.

27. Ibid., p. 55.

leadership to sign up a legislative measure prohibiting art all through the socialist republics? How could he conceive that such policy would actually contribute to the victory of socialism in the Cold War era? The answers are encrypted in the missing correspondence between Maciunas and Flynt and involves a story of Molieresque dimensions.

Khrushchev and anti-art

Thanks to Maciunas's quasi-telegraphic summary of his correspondence, we know that the epistolary dialogue between the two "cultural Bolsheviks" went more or less as follows. Early in January 1963, Maciunas told Flynt that "East Europe [was] more ready than West" for Fluxus. His explanation was decisive: He thought there was "[g]ood economic justification to eliminate art" in the Eastern Bloc, and that the "destruction of piano" in Wiesbaden had been "allied to such demonstr[ation]." Henry Flynt was not that convinced:

Tempted to abandon attempts to convert present generation. Attack on Chruschev [sic] unworthy (on abstr[act] art). Agrees money should be stopped if used by artists painting abstr[act art]. ([B]ecause abstr[act] art is useless) ground of attack all wrong. Condemned on grounds of bourgeois philistine traditionalism. Nothing socialist about attack. No comparison made with socialist education, portrayal of revolution, work, etc. . . .
Traditional feudal-bourgeois art as worthless as modern art (still lives etc.)
. . . Burden them with defense of their trad[itional]-feudal-bourgeois art.
Desires closer communication with me on Fluxus matters.[28]

Let's try to reconstruct the argument. Flynt was not sure that the current generation of Soviet leaders (most of them, including Khrushchev, old Stalinists) could truly be converted into their anti-artistic crusade. However, he agreed with Maciunas that abstract art was economically unsuitable for socialism, like all the "feudal-bourgeois" modes of art practice, including Socialist Realism, because they had no use-value. Quite rightly, Flynt was trying to tell Maciunas that Khrushchev's hostility toward abstract art was merely a defense of traditional realist aesthetics: The Soviet leader was not ready to eliminate art, he simply expected artists to devote themselves to the "portrayal" of the workers and the revolution.

All of these objections imply that the reasons behind Maciunas's calculations hinged almost absolutely on the critique of modern art that Premier Nikita Khrushchev had voiced at the Second Exhibition of Modern Art at the Manezh Gallery in Moscow in December 1962. By 1962, Khrushchev's policy of de-Stalinization had brought unprecedented levels of artistic freedom to the USSR. The "thaw" gained momentum in October 1962 when Khrushchev tried to mobilize in his favor the liberal impulses of young Soviet artists and writers. *Pravda* published "Stalin's Heirs," a poem by Yevgeny Yevtushenko that warned the citizens to be on alert, "so that Stalin may not rise again and, with Stalin, the past."[29]

It is possible that Khrushchev himself had commissioned the poem to use it against his political enemies, preparing a purge of the remaining Stalinists in power by means of a sudden politicization of literature.[30] That same November, *Novyi mir* published *One Day in the Life of Ivan Denisovich* by Alexandr Solzhenitsin, which for the first time put flesh and bones on the atrocities of the Siberian labor camps denounced at the Twentieth Congress of the Communist Party. However, Khrushchev's plans were thwarted by the aftermath of the Cuban missile crisis. His deal with Kennedy to avert nuclear war—to dismantle the missile bases in Cuba in exchange for a similar move by NATO in Turkey—heavily undermined his prestige in the Kremlin, for it was seen as a retreat and a national humiliation. These tensions, which could not be openly expressed politically, were naturally cultural battles.

While the country suffered from a new economic crisis, which even threatened to bring social unrest, the conservatives staged a counteroffensive in the party, denouncing the emergence of "revisionist" and "formalist" trends in art. Either because he felt the need to appease his political enemies or because of his own distaste for the vagaries of abstraction, on December 1, 1962, Khrushchev walked by surprise to the Manezh Gallery in Moscow and waded into the abstract paintings being shown at the Second Exhibition of Modern Art. It is possible that the right wing had set him a publicity trap: In front of the journalists from the international press, he confronted the artists at the opening, dismissing their paintings as those of a child

28. Maciunas, card file on Henry Flynt, early January 1963, Sohm Archive (see note 20).

29. Johnson, Priscilla, and Leopold Labed, eds., *Khrushchev and the Arts. The Politics of Soviet Culture, 1962–1964* (Cambridge, Mass.: The M.I.T. Press, 1965), pp. 93–95.

30. Carl A. Linden, *Khrushchev and the Soviet Leadership 1957–1964* (Baltimore and London: The John Hopkins University Press, 1966), pp. 147–148.

who "had done his business on the canvas when his mother was away and then spread it around with his hands."[31] Right on the spot, Khrushchev vowed to impose a stricter control on aesthetic matters. The contents of that famous outburst will be quite familiar to the reader:

> As long as I am president of the Council of Ministers, we are going to support a genuine art. We aren't going to give a kopeck for pictures painted by jackasses . . .
>
> No, we don't need pictures like this. As long as the people support us and have confidence in us we will carry out our own policy in art. And if pictures like these appear, it means that we are not doing our work properly . . .
>
> The Dutch masters painted differently. You can look at their pictures through a magnifying glass and still admire them. But your paintings just give a person constipation . . .
>
> You are stealing from society. You are a parasite. We have to organize our society so that it will be clear who is useful and who is useless. What right do you have to live in an apartment built for genuine people, one made of real materials? . . .
>
> Gentlemen, we are declaring war on you.[32]

Crowds of Moscovites rushed to see the exhibition, because Khrushchev's assault had proven the best kind of publicity; the Communist Party meetings and newspapers were full of attacks against any hint of modernization, while Yevtushenko and Ehrenburg quite courageously discussed with Khrushchev their hopes to rescue the trend toward liberalization. Although in March 1963 Khrushchev dictated that for the Soviet state "abstractionism and formalism" were "forms of capitalist ideology," and, as a consequence, that "peaceful coexistence in the field of ideology" was out of the question, because it would be a "betrayal of the cause of the workers and peasants,"[33] the issue remained unsettled until Khrushchev was removed from office by Leonid Brezhnev in October 1964.

Evidently, no independent observer at the time could have understood the underground forces that had launched Khrushchev's "war" against abstract art. Maciunas derived from them the most outlandish hopes. It was just on February 21, 1963, that he wrote to Flynt that "[i]n [the] East [it was] best to convert [the] leadership—[and] then [have] art eliminated by

decree."[34] He must have rejoiced in Khrushchev's vocabulary: the idea that artists were social parasites producing childish dribbles, and even the bad joke of the premier about the "constipation" provoked by modern painting.

As a consequence, Maciunas wrote a letter to the Soviet cultural authorities seeking their collaboration to organize the "3 to 4 month long 'exhibit-tour' throughout the USSR," which was to be the centerpiece of Fluxus' "world-wide concretist art and music festival." Maciunas argued that Fluxus in its entirety, both its concerts and its magazine, had been devised to demonstrate the coherence between "concretism" and the USSR. On one hand, Fluxus wanted to recruit the most "revolutionary and concretist artists in the USSR" to join the movement. On the other hand, Maciunas wanted to establish his headquarters "within the USSR," so as to make it easier for party officials to provide "political leadership to the FLUXUS movement." Maciunas told the Soviet authorities that Fluxus would start "coordinating our efforts with the socio-political aims of your party leadership." Paraphrasing the *Manifesto* of 1963, he was adamant that the Soviet Union was, in itself, a "concretist society":

> [P]ublishing a periodical in bilingual editions . . . would be able to express in most articulate terms: (1) our desire for purging the sickness of the bourgeois world, (2) our desire for continuous moving forward of artists, music and philosophy towards concretism-realism and (3) our desire for reapproachment [*sic*] and unity between concretist artists of the world and the concretist society which exists in USSR. All these objectives are best summarized in the very meaning of flux and fluxus.[35]

The "anti-style" of Socialist efficiency

In claiming the Soviet Union as a "concretist society," Maciunas must have surely thought of the purely utilitarian characteristics of the Soviet industrial regime, which appeared to him as a realization of his anti-stylistic notion of the material object. Only in a society without market, and busy extirpating cultural traditions,

31. Ibid., p. 159.

32. I base my account of the Soviet polemic on modern art on Johnson and Labed, *Khrushchev and the Arts* (see note 29). Khrushchev's attacks on the abstract artists of the Manezh Gallery are quoted on pp. 101–105.

33. "Khrushchev speaks again," in *Pravda,* March 10, 1963; published in English as "Khrushchev on culture," ibid., pp. 169–170.

34. George Maciunas, summary of correspondence with Henry Flynt. Card file in Sohm Archive (see note 20).

35. George Maciunas, draft for a letter or circular to Soviet cultural authorities (ca. early 1963), in Sohm Archive (see note 20). Owen Smith mistakenly presented this letter as the one addressed to Khrushchev (see Owen Smith, "George Maciunas and a History of Fluxus or, the Art Movement that Never Existed." Ph.D. diss., University of Washington, 1991, pp. 138–139).

were material objects truly to be appreciated for their bare qualities, without any inefficient concession to non-utilitarian values. As a consequence, Maciunas felt it necessary to criticize Soviet design when it had not developed in that direction:

> "Applied Arts"—Henry Flynt wrote summarizing Maciunas's ideas— . . . are nothing but fields of design engineering which are particularly *retarded* by Artistic, national, and stylistic traditions (as well as by the profit economy) . . .
>
> To increase labor productivity in the "applied arts", public ownership is necessary, particularly to escape the forced consumption, the deliberately wasteful stylism required by the capitalist economy . . . But the experience of the Soviet Union shows that these economic prerequisites do not ensure efficient design . . . Economic prerequisites and engineering advances have to be *taken advantage of:* the efficient design has to be chosen over the stylized design.[36]

On the basis of this assumption that the anti-style was economically and ideologically more suitable for the Soviet project, Maciunas sent another letter to Khrushchev, "the Chairman of the Presidium," seeking his "revolutionary political orientation."[37] Alas, the text of this document is lost. We have to content ourselves with Jackson MacLow's account of its contents. But its main claim was clearly that anti-art's "realism" was akin to the "realist" nature of the Soviet economy.

> Maciunas' principal idea . . . was that there was no need for art. . . . Making artworks . . . was essentially a useless occupation. If people could learn to take the "art attitude" toward all everyday phenomena, artists could stop making artworks and become economically "productive" workers . . .
>
> These ideas relate to George's political notions. In the early 60s, at least, when I often talked and corresponded with him, he was a peculiar kind of Marxist-Leninist—even in his own way a "Russianist": At the AG, he once showed me a very long letter he'd just sent to Premier Khrushchev in which he urged the Soviet ruler to encourage "realistic art" (Such as G[eorge] Brecht's, La Monte's, and to some extent mine) as being more consonant with "a realistic economic system" such as that of the Soviet Union than the old fashioned "socialist-realist" art then in favor.[38]

MacLow's suggestion that Maciunas's letter to Khrushchev was written sometime in 1961 might be a significant fact. When Maciunas claimed that "we should commence coordinating our efforts with the socio-political aims of your party leadership,"[39] he might not have been simply paying ideological respect to the Politburo. Between July and October 1961, a new program for the Soviet Communist Party was under discussion, and nominally, at least, the party was welcoming contributions and criticism from Soviet citizens and communists around the world. It is in the light of this turn in the rhetoric of the Soviet regime that Maciunas's economicism becomes transparent.

With the new communist world plan, Khrushchev expected to gain a place as a revolutionary theoretician. If today it is practically forgotten, the adoption of that new party program during the Twenty-Second Congress of the Communist Party of the Soviet Union was quite a momentous occasion. It was the first time that the Bolsheviks' fundamental directives had been reformed since Lenin rewrote the Social Democrats' credo in 1919. Khrushchev's new revolutionary theory consisted in stating that the fate of communism was not going to be decided through the success of revolutionary violence but by the mighty power of the Socialist economy. According to Khrushchev, the USSR was going to outdo the United States in a race for economic development. Capitalism would need to admit the superiority of "Socialist construction," flourishing under the truce provided by the doctrine of "peaceful coexistence." The document was the highest point of optimism in the communist bloc. Khrushchev practically promised that the transition from socialism to communism was going to take place in the Soviet Union by 1980:

> In the current decade (1961–70) the Soviet Union, in creating the material and technical basis of Communism, will surpass the strongest and richest capitalist country, the U.S.A., in production per head of population. . . . In the next decade (1971–80) the material and technical basis of Communism will be created, there will be an abundance of material and cultural benefits for the whole population. Soviet society will come close to a stage where it can introduce the principle of distribution according to needs, and there will be a gradual transition to one form of ownership—public ownership.[40]

36. Henry Flynt [and George Maciunas], *Communists Must Give Revolutionary Leadership in Culture* (New York: Worldview Publishers, 1966), p. 6. Reprinted in Fluxus etc. (see note 1), p. 38.

37. George Maciunas, draft for a letter or circular to Soviet cultural authorities (ca. early 1963), in Sohm Archive (see note 20).

38. Jackson MacLow, "Wie George Maciunas . . . ," in *Wiesbaden Fluxus 1982* (Wiesbaden, Kassel, Berlin: Harlekin Art Berliner Künstlerprogramm des DAAD, 1982[?]), p. 122.

39. George Maciunas, draft for a letter or circular to Soviet cultural authorities (ca. early 1963), in Sohm Archive (see note 20).

40. "Draft for the Program of the Communist Party," *Pravda,* July 30, 1961, translated and republished in *Keesing's Contemporary Archives: Weekly Diary of Important World Events with Index*

Nowadays is too easy to laugh at those predictions of a coming Soviet economic boom. But in early 1960s, after the Sputnik and Yuri Gagarin had orbited the earth, many observers and politicians in the West came to believe that actually the Soviet Union was about to dump capitalism in the dustbin of history. When Kennedy came to power, Harold Macmillan, the British Prime Minister, wrote him a letter warning him that unless capitalism would expand quickly, its "Communism will triumph . . . by seeming to be a better way of bringing people material comforts."[41] At the end of the day, Khrushchev's rhetoric just helped to further the economic effort of his enemies. Combining a huge state intervention in the economy; generous investment in science, technology, and education; and the "mixed economy" of increased military expenses and accelerated consumerism, the United States buried Socialism under a heavy artillery of cars, TV sets, computer games, and bacon.

Khrushchev's failure, as Frederic Jameson says with some nostalgia, determined that his generation would become the last one to believe in "the possibility of a renewal of Marxism, let alone Socialism."[42] It was also the last time an artistic avant-garde took the Soviet experiment seriously. Maciunas's stubborn Productivism is explained once we read Khrushchev's economic projections. According to the premier, by 1980 the Soviet Union was to increase its industrial output by 500 percent, its labor productivity was to exceed that of the United States by roughly 100 percent; its grain crops were to double and meat supply would rise about four-fold in the same period. For the first time since the revolution, the Soviet leadership felt like promising its citizens that their living standards were soon going to be higher than those of the rest of the world, and that their working week would shrink to just thirty-four hours. Paradise was just around the corner in the guise of an Eden of labor and organization:

> Communism is a highly organized society of free, socially conscious working people . . . in which labour for the good of society will become the prime and vital requirement for everyone, a necessity recognized by one and all, and the ability of each person will be employed to the greatest benefit of people.[43]

The pursuit of equality (1965)

This rhetoric was Maciunas's school of communism and not the classics of Marxism: It involved a view that was more a matter of management and work ethic than a discourse on agitation, pleasure, or rebellion.[44] Seemingly, these principles ruled his understanding of the task of Fluxus at least until 1965. In fact, Maciunas's attacks on art and idleness (as they were first formulated in his tract *Neo-Dada in Music, Theater, Poetry, Art* [1962] and the *Fluxus Manifesto* of 1963)[45] departed from the assumption that once autonomous art disappeared from earth, so would the idle classes. By the same token, Maciunas came to believe that only by means of the elimination of artistic practice would true social equality be achievable under socialism. This conviction rules Maciunas and Flynt's most important essay on socialist aesthetics, a pamphlet titled *Communist Must Give Revolutionary Leadership in Culture* that they both edited in 1965.

Even from its title, this text, signed by Flynt but most probably coauthored by the two *Kulturbolsheviken*, was an appeal to the communist leadership to embrace a policy aimed to extinguish art "by stages" in those countries already under the dictatorship of the proletariat.[46] As Flynt once put it, the document was written "as a proposed policy for the Soviet Union"— "the most important world institution inspired by Marxism."[47] By then, the two friends seemed to have

Continually Kept Up-to-Date, vol. XIII (Bristol: Kessing's Publications Ltd., 1961–1962) p. 18468.

41. Quoted in Martin Walker, *The Cold War and the Making of the Modern World* (London: Fourht State, 1993), pp. 137–138.

42. Frederic Jameson, *Postmodernism or the Cultural Logic of Late Capitalism* (London-New York: Verso, 1991), p. 274.

43. "Draft for the Program" (see note 40), p. 18470.

44. Maciunas's awareness of the Twenty-Second Congress of the CPSU is proven by the intensity with which he debated the Albanian question with Higgins in their correspondence of early 1962. It was during the Congress that Khrushchev condemned (very much to the Chinese leader's displeasure) Hoxa's regime for its fidelity to the personality cult. Hoxa, as is well known, defied the denunciation of Stalin's policies that Khrushchev made in the famous Twentieth Congress. Furthermore, as we will see later, he devoted himself to making a contribution to the field of socialist housing architecture, the only field where Khrushchev's program was ready to admit that the Soviet economy had structural problems.

45. George Maciunas, "Neo-Dada in Music, Theater, Poetry, Art" (June 1962), in Elizabeth Armstrong et. al., *In the Spirit of Fluxus* (Minneapolis: Walker Art Center, 1993), p. 156, and George Maciunas, letter to Tomas Schmit, "Fluxus Manifesto" (ca. June or early July, 1963), in *Fluxus etc.* (see note 1), p. 161.

46. Henry Flynt, "George Maciunas und meine Zusammenarbeit mit ihm," in René Block, ed., *1962 Wiesbaden Fluxus 1982* (Wiesbaden, Kassel, Berlin: Harlekin Art. Berliner Künstlerprogramm des DAAD, 1983), pp. 105–106.

47. Henry Flynt, "Mutations of the Avant-garde," in Achille Bonito Oliva, et al., *Ubi Fluxus ibi motus 1990–1962* (Milano: Nuove edizione Gabriele Mazzota, 1990), p. 116; Henry Flynt, "George Maciunas und meine Zusammenarbeit mit ihm"(see note 44), p. 109.

abandoned the naïve assumption that art could be exterminated from one day to the next by means of a government decree. Just as with religion, they now saw the eradication of art as a matter of a cunning and progressive enlightenment of the ignorant masses:

> For clarity, somewhere, sometime, the best possibilitity in culture for the present period has to be defined. As an analogy, with respect to religion Communists have to state somewhere, sometime that we are atheists, that the best possibility is the liquidation of religious institutions.
>
> But it is not possible to *implement at once* the best possibility before there is a social basis for it. . . . [A] Communist government cannot have all churches demolished the day it seizes power . . . [It] must implement its atheism by guaranteeing "freedom" of religion; at the same time closing down the faith healing and religious charity rackets, . . . secularizing the schools . . . and creating social conditions which tend against escapism among the masses.[48]

In *Communists Must Give Revolutionary Leadership in Culture,* Maciunas and Flynt defined three goals of a true Marxist agenda in culture. They were a recapitulation of some of the major themes of Maciunas's thought: to emphasize the cognitive dimension of "anti-art" contemporary genres; the need of a "common front of culture"; and, finally, a defense of the abolition of art in terms of its contribution to the material development of the Soviet Union:

> A. To increase the productivity of labor (for Marxists, a fundamental progressive historical tendency).
>
> B. To promote equality and solidarity of the workers, and to tend against the formation of a labor aristocracy, the stratification of the workers by nationality, and the formation of bureaucracies in the proletarian dictatorships.
>
> C. To satisfy the workers' desire, during a flood tide of class struggle, to come to grips with reality and to be done with escapism in culture.[49]

By 1965, the impact of Vertov's aesthetic of truth on Flynt and Maciunas had been so great that they proposed to liquidate the bourgeois genres of theater, fiction, visual arts, and narrative cinema to replace them with documentary genres, such as photography, "the socialist journalist book," and the documentary film. Documentary art now embodied a post-abstract aesthetic that would replace the luxurious "non-documentational Art Objects" produced by artists working to "glorify the bourgeoisie by symbolizing methods." For, in fact, what most worried Flynt and Maciunas about art was the way it embodied the dynamics of social emulation and the agency of prestige in the capitalist society. Their opposition to art linked the theme of its unproductive nature with the importance of leisure in the definition of social hierarchy.

Fundamental to their view was the idea that the identification of aristocratic and bourgeois aesthetics was too swift. Flynt and Maciunas argued that "serious culture" was a "method pioneered by the aristocracies . . . to consolidate and enhance the exploiters' position" by differentiating them from their inferiors. That function had not changed at all under capitalism where art kept on buttressing the prestige of what even a "bourgeois critic" such as Harold Rosenberg had called the "artistocracy" of business and finances. But Flynt and Maciunas were more worried about the effects of art among the workers, because the ideological superiority attributed to European bourgeois culture divided "the workers into white and black," dispelling any possibility of class solidarity between the workers around the world. More importantly, perhaps, was that the two friends accused the persistence of sophisticated artistic culture for the failure of real socialism, insofar as it was responsible for "the formation of bureaucracies in the proletarian dictatorships." That literally millions of people tried to get a ticket for the presentation of La Scala Opera of Milan in the 1964–1965 musical season in Moscow was compelling evidence of the way in which serious art was undermining the socialist regimes by seducing its citizens into aristocratic dreams of social ascendance. The two friends tried to convince the Soviet leaders of that, taking advantage of the recent downfall of Khrushchev from the top of the Kremlin's power:

> The first-night audience included almost every member of the Soviet élite from Yuri Gagarin to Ulanova. Premier Khruschev attended the second *Turandot* . . . Now the craving of those two million people for tickets, to see (and be seen at) an aristocratic frivolity like *Turandot* . . . is a craving to climb into the managerial elite. Yes, this culture finds its most appropriate, natural, and indispensable place in the aggressive consolidation of the bureaucracy. It is also significant that the top Soviet performing Artists . . . live in an ease second only to that of the top Government leaders. Sooner or later, the interpretation of patrician Art requires patrician performers.[50]

48. Henry Flynt [and George Maciunas], *Communists Must Give Revolutionary Leadership in Culture 1965* (New York: World View Publishers, 1966), reprinted in *Fluxus etc.* (see note 1), p. 39.

49. Ibid.

50. Ibid.

However radical this position might sound, the implications of Maciunas's Productivism become menacing once they are put in relation to the actual social situation of the socialist regimes. For there is good reason to claim that, in fact, there was a very real correspondence between Maciunas's "concretist" social project, and the nature of the regime. Neither Khrushchev, nor any of the "post-Stalinist" rulers, changed the basic assumptions of Stalinist development or the conditions that led, in the first place, to the return to authoritarian control to enforce production under the Soviet rule. Khrushchev or his ideologues argued (secretly quoting Saint Paul!) that labor ought to be in the center of "Communist morality" when they drafted the 1961 party program: "Conscientious labor for the good of society—'he who does not work, neither shall he eat.'"[51]

Under the Soviet empire, the communist dream degenerated into a disciplinarian doctrine, which simply reaffirmed the old bind between production and coercion, work and sacrifice. It is in this context that we should assess the implications of Maciunas's "Fluxus way of life." Had he truly found a way to convince the workers of the "beauty" of labor and to enforce happiness and humor despite the bare survival level of socialist everyday existence, Maciunas would have truly been adored by the East European leaders. He would have solved their biggest predicament—how to raise exploitation and at the same time keep the lowest possible levels of consumption. Maciunas's economic outlook shares the socialist "accumulation rationale" that the Central Committee of the East German Socialist Unity Party (SED) articulated so well in its resolution of May 14, 1953, to raise the production quotas 10 percent in a matter of a fortnight :

> [T]o lay the foundation for the Construction of Socialism, necessitates the strengthening of socialist industry . . . The fulfillment of this tasks depends, above all, on an uninterrupted rise in productivity and a constant reduction of production costs.
>
> The conditions can only be fulfilled by the introduction of a strict economy regime and the application of all available accumulated profits to the development of socialism.[52]

This economic dictate was a sure recipe for revolution; in fact, it provoked the 1950s popular explosions in Eastern Europe that, save for the intervention of the Red Army, could have toppled the rulers of the "democratic republics." In East Germany, the party's command to raise production quotas, combined with the food shortages caused by the exodus of farmers to the West that followed the policy of collectivization, caused the famous uprising of June 17, 1953. The bricklayers and carpenters building the housing project of the *Stalinhalle* in East Berlin, the "first Socialist street" of the reconstructed German capital, staged a spontaneous massive demonstration, demanding "butter, not guns" and calling for a general strike to reduce the production demands of the authorities.[53] In two days, the movement spread to approximately 300,000 workers in 270 towns across Germany, nearly provoking the downfall of Ulbricht's regime.[54]

We may conclude that it was not by chance that Maciunas's Productivism at one point confided its success in an authoritarian decree coming from the ruling elite of the Socialist Republics. One thing was to propose the end of art in the 1920s to introduce intuitive creativity at the core of the industrial process and quite another to propose its elimination as an attempt to make the workers understand that their alienated labor was the only possible horizon of their activity. While Constructivism in the 1920s tried to introduce the concept of freedom into "the constructive," Maciunas's adoption of the logic of "Socialist construction" sided with the absolute subordination of the particular to the economic brutality of an authoritarian view of the general good. In the end, his "Fluxus way of life" was an expression of the brutality of the "economic rule" the Soviet elite imposed on its society on the basis of convincing its citizens and the international communist movement that they had the monopoly on society's survival.[55] Maciunas arrived at a similar conclusion about Stalinism: in the absence of a market for exchange and in the absence of symbolic values, the economy

51. Rules of the Communist Party of the Soviet Union adopted by the Twenty-Second Congress of the CPSU on October 31, 1961. Cf. 2 Thess. 3:10.

52. Quoted in Arnulf Baring, *Uprising in East Germany: June 17, 1953*, trans. Gerald Onn (Ithaca and London: Cornell University Press, 1972), p. 117.

53. For an account of the uprising, see Stephan Brant, *The East German Rising. 17th June 1953*, trans. Charles Wheeler (London: Thames and Hudson, 1955).

54. Baring (see note 52), p. 71.

55. See also Guy Debord, *The Society of the Spectacle*, trans. Donald Nicholson-Smith (New York: Zone Books, 1994), pp. 41–42, thesis 64.

could only be sustained through terror. This is, in fact, what he wrote to Dick Higgins during the times he was busy organizing the first Fluxus festivals:

> I will disagree here . . . with American love of consistency as exemplified by Rockefeller's Study in Power. I think [it?] is totally inconsistent & unrealistic to expect others to be benefited by philanthropies (voluntary) of creative portions of society, because this does not take into consideration the many cases of selfishness among creative portions.
>
> Here I will also disagree with you that Democracy is for anybody to contribute what he can. I think it is to contribute what he pleases that's big difference. To extract all possible contributions from all, requires strong totalitarianism. I think democracies have shown that neither does the idea of philanthropism [sic] work nor voluntary contribution of all portions of society. I feel people are inherently lazy, they will crave for leisure to do nothing. Maybe the 2 legs make us similar to hens who can sit on a bar for days doing absolutely nothing—just like us.[56]

In supposing that the Soviet Union was most suitable to become an artless "concretist society," Maciunas enacted an aesthetic conflict analogous to the clash between the capitalist and the Socialist Realist projects in the 1950s and 1960s. Similarly, the failure of the notion of "the concrete" to drive artistic practice in the early 1960s can be read as the failure of a version of economic rationality. For it is arguable that the Soviet productive defeat was essentially political: It was unable to build a social model that would have drawn a similar psychological and economic motivation to that which capitalism found in the "work and spend" system of the consumerist society. Similarly, Maciunas's anti-art ought to be read as a failed attempt to contain the new texture of everydayness of late capitalism as it emerged during the 1960s. The assumption that the Socialist economies were expressions of materialist rationality implied a proximity between the object relations under the restricted economy of the East and the bare truth value of the "concretist" object. Anti-art, in that sense, involved resistance toward consumerism only in terms of its hope of helping to tackle capitalism by believing, rather naively, that it could prevent the market from using the aesthetics of the product as a means to increase consumption and, therefore, to ensure economic growth.

56. George Maciunas, letter to Dick Higgins (ca. spring 1962), David Mayor and the Fluxshow Archive, 815.2.1.1.24, Tate Gallery, London.

Figure 1. Paul Chan, *1st Light,* 2005. Digital animation projection on floor, dimensions variable.

Unforgiving art, unforgivable nations

ROBERT HULLOT-KENTOR

Rarely is political engagement viewed in terms of forgiveness.

—*"Considering Forgiveness" conference statement*

The title of this evening's discussion, "Unforgiving Art, Unforgivable Nations," took shape, half to its author's own surprise, while adapting a group of ideas about art and politics to the central question of the ongoing discussions this year here at the Vera List Center for Art and Politics, on "Considering Forgiveness."[1] The conference statement makes the observation: "Rarely is political engagement viewed in terms of forgiveness." Why is this rare? Why hasn't political engagement more often sought to comprehend its struggles in terms of forgiveness? It is an interesting question. By itself this would be plenty to think about in a half hour. But there is still more to consider this evening because the question is to be expanded to include speculation on what place art might have in a possible politics of forgiveness. In particular, this paper has been asked to address how Adorno's *Aesthetic Theory* would conceive of some possible relations between political engagement, forgiveness, and art. The complexity of this group of questions is then again substantially magnified by the urgency of the political moment that we occupy, which explains the considerable audience that is assembled here tonight.

Plainly, there is a great deal to consider this evening. And however counterintuitive, the most direct way to get at the whole of it is to realize that the title, chosen on the spur of the moment, needs to be replaced, though with the caveat that it not be changed in the slightest. This is a metamorphosis that prefers a change in consciousness to one of typography, but plainly supposes that the latter can contribute to the former. Hegel helps pursue this needed transformation with a clue from the *Philosophy of Right,* which is so germane to this discussion that he might have had us in mind in its formulation. In a way, I'm sure he did, since his observation pertains not only to this evening's discussion but to a whole nation where the average bumper sticker now reads something like "Pray for Peace" or "God

Bless America," and where the president believes himself factually sacred. Hegel notes in the *Philosophy of Right* that individuals in modern society easily suppose that they are in a condition of *sinfulness* when their actual circumstance is that of *alienation.*[2] Hegel was adamant—and Adorno would have entirely agreed with him—that in the possible and constant defeat of modern history, what is needed is not atonement or propitiation for sinfulness but more negation, that is, *more thinking* that refuses to accept its object for what it claims to be. And Adorno would also have again agreed with Hegel that this refusal would necessarily proceed immanently, as a process in which the object is so bound by its own words that by them alone it would be compelled to take the measure of itself, find itself inadequate to its own claims, and willingly shed its own persevering illusion. Only in its own words would it find the compelling resource to rebut them.

To follow up, then, on Hegel's recommendation and bring a degree of negation to the title—"Unforgiving Art, Unforgivable Nations"—to hold it to its word, we first need to consider the general political context in which this title exists; the situation, that is, that has shaped this title and to which it wants to respond. This won't take long. Summarizing the situation can be done with unfortunate and abrupt concision. For there is no doubt that this situation is almost intolerably on the minds of everyone here. As briefly as possible, then, the winter of 2006 is a moment of history coming true, with a vengeance:

> It is a mighty people that He has planted on this soil; a people sprung from the most masterful blood of history; a people perpetually revitalized by the virile, man-producing working-folk of all the earth; a people imperial by virtue of their power, by right of their institutions, by authority of their Heaven-directed purposes—the propagandists and not the misers of liberty.[3]

If listening in on "The March of the Flag," a much celebrated exhortation to the legislature of God's chosen people in 1896 to act decisively in asserting its righteous

1. This paper was presented at the Vera List Center for Art and Politics at The New School on January 26, 2006, in friendly collaboration with Paul Chan, a politically engaged New York City video artist. His much-discussed and highly regarded work was the point of reference throughout this talk.

2. See Mark Lilla, "Hegel and the Political Theology of Reconciliation," in *The Review of Metaphysics* 54 (June 2001), p. 898.

3. Albert J. Beveridge, "The March of the Flag" (1898), in *An American Primer,* ed. Daniel Boorstin (New York: Meridean, 1966), p. 645.

claim to dominion over the Philippines, the uninterrupted continuity of the national exaltation in its tactic is familiar, except in slight detail. What now perhaps leaves any assembly—such as this one this evening—slack-jawed in disbelief with itself is that that March of the Flag nowhere admitted that it intended to be the power to dominate the majority itself of a "people imperial by virtue of their power." The United States has evidently solved the ancient problem of how a democracy might temper and moderate the weight of the many against the few, for the majority has now become the instrument of a minority. This is a captured nation. At this moment, however unpopular and distrusted it may be, the government's offices and agencies are certainly prepared to take advantage of any next misfortune that might befall this country to solidify its grip on the nation. In this circumstance, if, under the current administration, this country is again drastically attacked, there is some chance that the United States will emerge from the event as the next catastrophically insane nation in human history. For the foreseeable future, escaping the very worst will be tremendous good fortune. This is a secret to no one in this room.

That is the circumstance, and it is no less the circumstance of the title of this discussion. And if a moment ago what was privately on everyone's mind is now openly and self-evidently on everyone's mind, it might be expected that, turning our attention to the title of this evening's discussion—"Unforgiving Art, Unforgivable Nations"—this title would immediately capture the momentum of the public recognition of the current situation. In the self-consciousness of what everyone in this room in one way or another is thinking, the title should begin to say something like: "What else can art be, given what the United States has now shown itself to be?" Or: "This is what art must be, if that is what the United States has become!" But, instead, where self-evidence should capture self-evidence and momentum combine with momentum, a title that wants to fulminate, to censure, and to denounce takes a deep breath that then immediately sputters out. Red in the face, if its words are able to conjure up anything at all, they cause a personified nation to step forward to respond, dryly: "Sticks and stones, sticks and stones—buster—break my heart, why don't you."

Hegel, in his warning to a potentially recurrently defeated modern society, helps understand why this title so inappositely and generally fails its moment. It fails by its archaism. After all, art, as long as it has been art, has never had the power to forgive: It has never had the

power to forgive nations, to forgive its own historical moment, its own maker, or its beholders. Without the power to grant forgiveness—without even the *desire* to grant forgiveness—neither has art ever had the ability *to withhold* forgiveness. This is why in our title art threatens and confronts no one at all, and illuminates so little, by refusing to forgive, for it never had that forgiveness to offer in the first place.

And, likewise, nation-states—ever since they emerged as nation-states—have neither been objects of forgiveness, nor have they themselves been capable of that power. We can, of course, talk about the possible forgiveness of nations—and have—but even when groups of wealthy nations go about "forgiving debts of the developing world," we know perfectly well that something else is occurring, just as we know—when we drive by a Coca-Cola bottle "redemption" center—that this is not redemption as the old books once wrote about it. This is why it would be skin off of no nation-state's nose—not even the nation of God's chosen democracy—if it somehow learned that tonight, of all nights, it was being denied forgiveness.

It should be noticed that, even after the few words so far this evening, the title of this discussion has already benefited from a degree of negation. It already touches the historical hour more importantly than it did at first, and with a needed sobriety. Listen to it again now and see if it hasn't changed a bit: "Unforgiving Art, Unforgivable Nations." That's true: Art is unforgiving, nations are unforgivable. Neither art nor nation is fundamentally capable of, or subject to, forgiveness. Notice also that the degree of negation that the title has experienced has rubbed off on the central statement of the series we are participating in, "Considering Forgiveness." Listen to the line again and see if it hasn't changed as well: "Rarely"—the statement reads—"is political engagement viewed in terms of forgiveness." Rarely, for sure. As a social structure, forgiveness in the deepest sense is of another age, prior to the discovery and the partial institutionalization of an emancipated political society that has the capacity and obligation to form its own laws, immanently, and to determine itself autonomously. The revolutions that founded political society made archaic the world in which the idea of forgiveness was utterly familiar and compelling. The emergence of political society—the experience of the immanence of human law itself, the sense that there is nowhere else to look for a source of law and institution other than in ourselves—involved the universalization of the exchange relationship, an absolutely encompassing

quid pro quo. The idea of forgiveness supposes, by contrast, a giving that goes beyond getting, and—by necessity—a transcendent source of that giving that insists on laws of another origin than our own.

Even briefly to approximate in imagination what that other age searched for in the blessedness of forgiveness requires considerable effort and doctrinal latitude. We can only expand on those vestiges of the idea of forgiveness that we, of course, continue to carry with us. Forgiveness is the idea that—whatever the culpability, whatever the duty or obligation that had gone unfulfilled, whatever trespass or wound had been inflicted—this wound would be made none at all. The misdeed itself would be less than inconsequential: It would have never existed. Forgiveness would be felt in perceiving that the only existence that the offense ever had was as a remnant in oneself, allowing one to better comprehend the breadth and depth of forgiveness and as a last trace of the dissolving terrifying threat of the retribution one had feared. Obviously, all that could dispense forgiveness of this most emphatic kind would itself necessarily be utterly beyond any trespass, hurt, or damage. What divine forgiveness would provide, in whose perspective evil itself would have no positive existence, would be boundless. This would be the most intoxicating speculation for a world that sought forgiveness on its knees, its head bowed.

What *we* live with is both better and worse than that. The age that dreamt of forgiveness, that conceived it and desperately sought it, could not produce it—whatever the claims, prayers, and visions of that age. St. Augustine, after a life-time of devotion, died in tears for the sin of the bit of fruit he stole as a child. Our age, by contrast, could have all the fruit anyone might care to eat, beyond guilt of any kind, and could, potentially, wipe away if not all the tears, then many of them. This is the idea of a society beyond scarcity; it is what the concept of forgiveness became in the emergence of an autonomous political society. But the enveloping totality of the exchange relationship in which the country's manufacturing capacity developed has now consumed this idea of being beyond necessity and with it the intention of freeing itself from what has long been its self-imposed scarcity. As the exchange relationship has become all-encompassing, it has made it impossible to conceive of anything that goes beyond the tit for tat, the giving that is always a getting, the pushing that is in fact shoving, in which equivalences are constantly traded while one person in the exchange is always being cheated. Now that the totality of the exchange

relationship has also succeeded at bartering off the whole of nature—and with it perhaps obliterating the image of abundance and cornucopia, the boughs heavy in the waiting harvest from which the utopian idea of a world beyond scarcity has drawn ever since Hesiod—the idea of a society beyond scarcity may soon be as hard to fathom as is, in this moment, the ancient idea of forgiveness itself. Last summer, as we all know, was unprecedentedly hot and this winter the thermometer keeps pushing at fifty and then at sixty.

For where this discussion has taken us so far, we now most of all want to consider what opposition is possible to the dominance of the exchange relation. We've understood that the idea of forgiveness is a source of our wanting to conceive this opposition to the exchange relation. Forgiveness, transmuted by the demand for human, political autonomy, became the idea of a possible society beyond scarcity. In art, forgiveness—that giving regardless of getting and beyond injury—was transmuted by the same demand for autonomy of the artwork's freedom to itself. This freedom of autonomous art to itself is its capacity to form *in itself* what is *other* than itself—something that, so far as I know, the Sunday-school divinities generally don't experiment with. If the relief that we feel, as a potential in any artwork, is a direct inheritance of the experience of forgiveness, in art this experience implies the additional relief that, to have it, to pursue it, we are not being asked to bend at the knees. We are not looking to be absolved; what we want of art—under the aegis of a desiderated human autonomy—is to have the truth, what art potentially forms in its freedom to itself as the capacity to transform meaning into import. This is the most profound opposition conceivable to the dominance of the exchange relation. In this situation, truth, the tensest possible truth, is the only form in which anything to do with forgiveness is now tolerable. In this critical capacity, art and politics converge with absolute urgency. It is an urgency to find some way through a world that has become a solid smoke screen. It turns out, however, that politics that heroically demands to subordinate art directly as a tool in political struggle is only another way of insisting that nothing may dare to exist that is not paying its rent with the rest of us. It is a heroic mask under which the impulse of resentment becomes especially portable; the same impulse that, in other situations, across shiny counters all over town, keeps insisting on counting out the change, even the valueless pennies, with rigid vigilance. In this fashion,

political art—whatever the slogans claim—betrays the impulse of human autonomy in which the modern concept of politics originated.

If this conclusion must in ways disappoint many of those in this room to whom a title seemed to promise horns locked between artist and nation in outrage and fury, the title, for what it has turned out to mean, may nevertheless come as a relief. Bad art is not art in the slightest, since art is not a normative category to start with: If examples of art are located, art has not been found. Correlatively, the political situation—for whatever else it is—is one endlessly demanding education, not art. In this recognition, there is no reason at all to be precious about using colored chalk on a sidewalk to demonstrate the relative tax rate on rich and poor, no reason to be reluctant about using drum and trombone to beat and blare for attention in front of a courthouse, or to set up cameras to video the trucks of strikebreakers as they careen toward the picket line. The problem is to figure out how to storm the proverbial Bastille, not the museums, whose doors that unproverbial earlier storming once succeeded at throwing open to the public. And if there is something else worthwhile in the conclusions to tonight's brief discussion, it may be that politics that has become curious about why it does not subordinate itself to the longing for forgiveness, and, while it is at it, has started to wonder why not take art with it, risks—perhaps eagerly in the intensifying primitiveness of our situation—becoming a politics set in the service of religion, a society's pragmatic theory of the efficacy of sacrifice, the overwhelming structure and direction of contemporary America. By comparison with the possible achieved comprehension of our situation today—even some achieved degree of self-comprehension—blessed forgiveness under winter skies that are touching at sixty degrees would be a thin substitute. Every complexity of Adorno's *Aesthetic Theory* devolves from its central thesis that art transforms history into truth: In variants, this idea has been thought since antiquity. Check first with Aristotle, then consult Tacitus and Cicero, and follow it along to Stendhal and Flaubert. For Adorno, as for us, the problem remains how to formulate this ancient insight in the moment when it has flickered out under the combined autonomy of art, on one hand (where the level of abstraction made the relation of art to history inscrutable) and, on the other hand, the omnipresent incursion of commercial entertainment. In the terms developed this evening, if art is to find any reality, it must become a struggle against what once gave it freedom to itself, its semblance. In

this paradox, whatever distinction there may be between shaping the truth and destroying the truth tends toward the inscrutable. This describes some substantial part of new work that now fills museums. For the moment, anyway, it is perhaps the only form in which a humanity that still dares to seek its own autonomy and thus ultimately something other than that autonomy—in which autonomy would be fulfilled—may try to come to its wits about its own self-destructiveness.

Amulets

FREDERIC WILL

1

For me the real thing is a freestanding closet in the Hotel Atlantique in Gabès. That closet is the first thing I ever looked at as though it was there. The operative word is *there*. By it I mean substantively over against me. The closet, though freestanding closet isn't enough to say of it, was not borrowing its life from me, though I was the one perceiving it, nor was it at the moment standing there indifferent to my perception of it. In my absence would the closet still have been there? I don't know. I can't know. I can guess, from my experience of other things, like my car, that remain there when I am away from them and that are still there when I go back to them, that the closet would have been there even if I had not perceived it. This kind of guess seems based on strong but not infallible pieces of evidence. I prefer the argument they shore up to the notion of a world toward which no pointer is given by habitual experience. I prefer to think the freestanding closet remains there, when I am not there, to the view that the closet is not there when I am not there. I prefer, I say. We live with the accounts of reality we are most comfortable with and that seem to percolate through our life. And as for the over against me part of the freestanding closet, let me say that the object is or was strong and insistent on itself. It was a vehicle of details. There were shelves, a clothes compartment with hangers, brown varnished feet. All these details were over against me. In other words, there were many modes of perceivable data, from colors to shapes to the class words for the different nouns—like *hangers* or *feet*—the recital of which is part of the kind of inventory I would give of my experience of that kind of object there, that freestanding closet. Despite the conceptual cognitive operations— impression, perception, cognition—which made the object an object of knowledge to me, I remained convinced that the object itself, which I believe is really over against me, was revealed to me through these operations. This, too, is simply a theory I have about the verifiability intended by the knowing process. Once again, no absolutely compelling evidence forces me to adopt the position I take, that the cognitive process reliably gives its objects. Once again, it is a question of the lifelong experience I have of objects, that what I perceive them to be proves itself to have been valid, because when I go to handle those objects, they are there to use as I perceived them to be. Even the prospect of a handling seems a promise of the stability of the object. In light of all of which it might seem worth asking: why *this particular closet* takes priority for me? as an instance of my discovering the objectivity of objects. Here I have to be autobiographical. I was in the right mood. That means that my abilities both to cognize and to penetrate to the thing through my cognition were for a moment fully available to me. Any critique of perception would have to follow the given particular perception. I avoid giving either a mystical or a mysterious tone to this observation. Moods are cognitive settings. Sometimes they promote a fresh awareness. I was on that afternoon in Tunisia a beneficiary of an awareness of the object. Furthermore, I write this down as though my writing was integrally implicit in my perception of the closet. I don't write this down as though I wanted writing to be an extra activity, taking place about the perceiving the closet. I write this down wanting my writing to be also the perceiving of the object, an ongoing process. You see, I think writing is a continuation of the things you write about.

2

Amulets (like freestanding closets) are objects that are there, and everything I said about the closet (plus more) applies to amulets. They may be of stone, of precious metals, or even of cloth. In other words, they are material constructions, like the closet. But the question can be raised whether there is not an essential difference between amulets and closets. In order to be what its definition suggests of it, the amulet would need to be full of some power, in addition to being there. (The freestanding closet need not have any "power" in order to fulfill its definition.) For the amulet to be itself, it should exercise power as well as be there. This power should flow from our inherent connectedness to the amulet, a connectedness that frees the amulet's power. (We may feel a connectedness to the closet, too, but because it has distinctive relations to us, not because it lives from an inherent power.) The essential thing is that the small amulet token should be full of your inherent connectedness to it. Now we need to ask about that

power of the amulet whether *we give that power to the amulet.*[1] (The reason we raise this question is because while the amulet, like the closet, is there, must be there, as a material thing, the amulet claims it has in it a superadded power, the origin of which seems begging to be known. Is that power inherent? Did we put it there in the knowing or thinking process? The question demands attention.) Quite obviously, "now we need to ask" and before that our easy talk of "power" inherent to an amulet, as though we were in a realm of mysteries and powers, all this prefatory chatter looks suspiciously like a gateway to unearned mystical insight. I mean no such thing, but I can't see how to prove that I mean that little, until we finish. So hang on please. Bracket what I'm saying, if you like. So back to the question of whether we "give the amulet its power." If we "believe in" the power of fetishes—some of us do, some of us do not— we know that when we touch the privileged stone or creation of cloth, when we feel the *kombologia* against our fingers in the pocket of our pants, we feel the object's power go through us, reassure us, strengthen us, as though it was coming from outside us. Is it that we simply give that power to the object in our pocket? Provisionally, let me try this. We do not exactly give its power to the amulet by feeling connected to its inner power. The amulet contains its power in the same way the freestanding closet contains its objectivity. (The amulet also contains objectivity, along with its power.) We let the amulet disclose its power, by touching it. That's the key formulation. We let the amulet disclose, etc. That is, we provide the amulet the chance to be what it is. This is also the idea of my book *Founding the Lasting,* which is all about enabling the other to be its full otherness, ultimately about enabling God, an idea congenial to me, but brought home to me first through

Kazantzakis's *Saviors of God,* as well as through Heidegger and Hoelderlin in their modes of ascribing authentic Being to art, which creates the Temple at Sunium, so praised by Heidegger in "On the Origin of the Work of Art."[2] This idea of enabling is also given a potent twist in those African religious cults in which the praise and respect of the believer creates and sustains the believer's god.[3] And yet this comparison of the object status of the closet with the inherent power of the amulet, which is both an object and perfused with power, is bound to raise questions. Many might say that the amulet contains no power in itself, but that it must be simply viewed as an object of perception, a material object—period. These people would say that objective status and having power are in all cases totally different, and that the amulet has—if any—only a kind of "mythical" power we attribute to it. They would concede, perhaps, the objective status of what we are calling an amulet, but they would dispute the ascription of objective status to the power of the amulet. But would they be *right* to dispute the claim that there is a power in the amulet over and above its object status? Would they be justified in thinking that the power of the amulet is not there, in the amulet, unless we think it into the amulet? This is our whole issue. We are writing about amulets because we want a notion that stands for objects of perception that presume to be inherently powerful as well as neutral objects of perception. This issue lies ahead, and we will look at different kinds of worldviews and philosophies that adopt positions on whether in fact the amulet could be viewed as a power as well as a thereness. We will "look at these perspectives," which will include the perspective of the animist, as well as some western philosophizing. "Look at" is the operative expression here. This essay is not about winning an argument. In a way, this essay is a private journal devoted to following the profile of thought about a world system instinctively different from the "scientific" worldview that shaped me, leaving me for a long time with only "imagination" as an escape hatch into the supra sensible; that is, with no sense that

1. An affirmative response seems required by the cultural logic of our time. In anthropological circles, this "yes" was already sanctified, for questions of "magical thinking," by Sir James George Frazer in *The Golden Bough* (1922). Anxious to detach primitive people's thought from its object, as in magical thinking, Frazer gave no quarter to the opposition—if such there is today, outside of a handful of anthropologists and indigenes working inside certain more or less pre-technological countries, like Niger or Nigeria. Subsequent anthropological thought has generally reinforced the verdict: Magic has no effect on its objects; the thrust of magical action toward an effect is dismissed by the argument that any power you ascribe to (put in) the amulet (say) is dependent totally on you. The intricate problems raised by an effort to counter this argument plays through my book *Founding the Lasting* (Detroit: Wayne State University Press, 1992).

2. Martin Heidegger, "The Origin of the Work of Art" (1936); Nikos Kazantzakis, *The Saviors of God,* trans. Kimon Friar (New York: Simon and Schuster, 1960).

3. For an instance of the same dynamic from African religion, see Karin Barba's discussion of the Orisa cult in Yoruba religion: "How Man Makes God in West Africa: Yoruba Attitudes toward the Orisa," in *Perspectives on Africa,* ed. Roy Richard Grinker and Christopher B. Steiner (Cambridge, Mass.: Blackwell, l997), pp. 392–411.

Four Kombologia, from Wikipedia®, Wikimedia Foundation, Inc.

thought might collaborate with imagination in addressing spiritual phenomena such as the inherent power of the amulet.

3

The notion of a power is that of an innate force capable of acting on x. Dynamite has power. So does a tank of gas, and—or does it?—an amulet. But can we perceive a stick of dynamite as power, or is its power something we have to perceive through action? Similarly with an amulet. We seem able to perceive its power only in the degree that we can perceive that power in action. (I refer to an action that comes from within the amulet, not to the action an amulet would exercise if someone stuck it in your eye.) Animist cultures have always ascribed such inherent power in action to the objects in nature: trees, brooks, storm clouds, rivers, creations in the act of being sacrificed; and even, in the case of totemic beliefs, to artifacts like manufactured cloths or aircraft. In fact, this kind of ascription probably lies near the base of religious belief. The Greek gods, for instance, were expressions of the power in motion of Sky, Sun, Wind, Ocean; they were what Louis Ménard, in *Du Polythéisme Hellénique* (1865), calls "*lois vivantes.*" The god of the Prophets is a force of Nature's power in action: "He hath compassed the waters with bounds, until the day and night come to an end / The pillars of heaven tremble and are astonished at his reproof . . . / He divideth the sea with his power, and by his understanding he smiteth through the proud . . ." (Job 26:10–12). What is Dyaus Pater himself, the Sanskrit Ur-God, but the power of the sky and the thunder in it? Physicists and chemists are not totally different from animists or religious prophets in this matter of reading force into nature, for they too ascribe powers as well as thereness to the constituents of nature: gasses, acids, carbon compounds. These physical conglomerates are not *visible* as power, but their effects can put their power before any eyes, as we all know from chemistry class in which we are able to see the process of toasting . . . the white starch of bread converted into dextrin, a yellowish-brown substance, which by stages turned into charcoal. It would be hard to imagine a worldview that

excluded such an attribution of potential powers to the things of nature—or the creations of man—unless it were a philosophical idealism, which questions any power beyond that of the mind and therefore sees the power nexus of the world as at most a dance across the screen of the mind. But we cannot that quickly characterize the issue of the ascription of power to the amulet by encasing it with the general multitude of power-containing objects—pieces of bread, airplane parts, raging rivers—in the world. The problem with our amulet is that many would question the particular form our ascription takes. As a physical object, these many would say, the amulet—of cloth, or stone, or precious metal—has only the powers peculiar to other "inanimate" forces in nature. The amulet has no power beyond that of any piece of cloth, or stone, or precious metal. There is not any field of action or consequence, springing from the existence of the amulet, to testify to its inherent power. What we would need to argue to support a dissenting opinion would be this: There is a plausible account of a "personal" (or animate) power in things as distinct from a physical power. This animate power would express itself in "physical consequences" but would nonetheless not be reducible to the mechanical cause-and-effect sequence by which nature deploys itself. It is *this* notion of the "animate" that we need first to clarify and then to work from. In order to clarify *this* notion of the animate we need to start with a working definition. Let's take a lead from etymology and say that the animate means that which takes its inherent character from the model of the human personality: from that which has an *anima* or soul. And what are the traits of human personality? It is conscious and aware, is self-conscious, is empathetic, and is capable of reason: in short, is flexible. The bottom line in this aggregation of traits is that the human being is a unique center of awareness and intellective presence. Can we believe that an inorganic object, such as our amulet, could possess these traits? Could it only possess those traits under the one condition, that we—human beings—transfer these traits to the amulet? Let's circumscribe that point from a different angle. Let's bring imagination into our arsenal of perceptual powers. The freestanding closet was absolutely there, but we know that only because our perception verified that the closet was over there against us. It was our perception that shored up the verifiable out-thereness of the freestanding closet. The same would hold in the way, through imagination, we awaken to our awareness the power inherent in the amulet. We perceive the amulet head on, as it is, through imagination. We imagine it, thus both knowing

and giving it power. The word *both* is crucial here. But what kind of imaginative transfer of power would that be? Wouldn't we then have to say that the transfer was *solely* imaginative, a consequence of imagination endowing an object with our own nature and not in the process highlighting the nature of the thing known? And wouldn't that description of the transfer of power, even if the transfer took place, imply that the amulet simply owned a borrowed imagining power? Wouldn't that borrowed power, though actual and "authentic," be at the same time on loan? These questions mustn't be shoved aside. Dealing with them is essential to our effort to clarify the notion of the animate. We are on the path to seeing whether a case can be made for animism. And to begin to answer these questions means to grapple with the meaning of the imagination itself.

4

Imagination: I employ this word in its most robust sense, as what Coleridge calls "the living power and prime agent of all human perception, and as a repetition in the finite mind of the eternal act of creation in the infinite I AM." To this he adds that through the use of Imagination, the power to "shape into one" (*Einbildungskraft* as Coleridge's German contemporaries like Schelling were formulating it), we put ourselves into the objective world around us and make wholes out of the outer world and inner self as we fashion them into fresh unities.[4] Coleridge was especially interested in the case of the "poet," a kind of exemplary human leading us in our quest to make the knowable world ours and to render from within it all its glory. By his imaginative faculty the actor we call the "poet" achieves his work of making organic wholes out of the reconstituted "outer world." How does the poet do this? Shakespeare takes his diverse experiences of war, human behavior, cultural difference, the euphonies of human sound, passes them through the filter of a theatrical tradition, then recasts them in the powerful smelting oven of his own mind. From this magma he creates *Henry V.* Would we say that what Shakespeare creates is solely in *his* mind? No. For one thing, we know that what he creates is also in

4. After much futzing around with imagination concepts anchored in the Latin *imago,* thus tied to literal mirroring of one sort or another, the Western tradition finally gave birth in the Romantic period to a transformative notion, which restored the poet, in theory, to the glory which Western cultures had in fact accorded him. The passage is from Samuel Taylor Coleridge, *Biographia Literaria,* vol. 1, chap. XIII (Oxford, 1939), p. 202.

other people's minds, for it is in yours and mine today. But what if we change our emphasis and ask whether what he creates is solely in his *mind*? Once again, *no*. Shakespeare's mind is furnished with the things of the world, so it is from its beginning part of the world, so that what Shakespeare creates is the world itself; he redeploys what the world is. But our *no* means more than that. There is a further sense in which what Shakespeare creates is not solely in his *mind*. *Henry V* contains within it objects, actual histories, actual conflicts. Shakespeare's art may contain those objects as simulacra of themselves, models or versions of things, but it is still those objects that are being contained. That he gives those "objects" new existence of their own we cannot yet say, and would need to, to come to grips with our amulet issue. Saying that would involve the issue of whether Shakespeare releases a new power from the created world's bric-a-brac. But at the moment, we are only trying to put the traits of imagination on the table and to establish that a work of imagination—think of Michelangelo's Sistine Chapel ceiling with its vast allegorical scenes embodied in fresco—contains forms or versions of real things, trumpets, flowing gowned figures, muscular prophets. We are only talking art at the moment, though we are crowding the edges of ontology. We are close to art at the point where it transforms and re-empowers the outer world. And as we crowd those edges, as we push the creations of imagination farther out into the space where they might be thought "objectively real," we are getting closer to the issues our amulet case made us begin with: issues revolving around the question of not only the reality but also the nuclear power of a precious talisman, and, of course, in the wider sense, of the objective reality of all the heart's favorite resting places outside the body. Into what extraself sites can imagination not transplant power, which becomes the animate power of the object it inhabits—the text, the sacred stone, the treasured stuffed animal? The familiar loved face?

5

I have made a sally into clarifying how imagination may take us to an objective world outside ourselves in which we find sites of animation: texts, sacred objects, banners and talismans, battles and history—raw materials of freshly established power. We may therefore have gone some distance toward shoring up the idea that the amulet (for instance) can contain within it the traits of personhood, animation, inherent vitality. The personhood or vitality of a thing? Is that possible

language? Have we not somewhere here to stop the argument's slide, toward imputing personality to objects? I mean, are we not soon to be agreeing that any object might be studied out as a site for implanting sacred powers? Are we after all talking about pantheism in which life energies are distributed equally across the universe and the zone of human consciousness bleeds out into every corner of the created world? Are we talking about ego running wild through the creation? I don't think so. I believe we can calm these worries that derive from ordinary language use, and that we can control their seemingly runaway implications. Let me tell a tale, to make more convincing the kind of experience I bring to the argument opening out here. We are, after all, in a discourse where personal experience cannot be disregarded, and where privileged observers or observation points have rights. (As in being in the right mood to see the objective condition of a freestanding closet.) A convincing narrative is the least we should expect of any candidate for the clarification of animistic power!

6

Ross was one of the two best friends of my early preschool and grade-school years. We were classmates until junior high and still share a fund of precious memories. One night, I went to his house to spend the night. It was a freezing Illinois night, ice on the trees, ice on the grass. Even with traditional coal-burning central heating, a hot fire churning in the basement, the house was cold. I was trying to find a warm spot in Ross' extra bed when I felt a powerful compassion for Ross' family car, which was parked in the driveway. I felt it should be covered, that it would otherwise suffer too much from direct contact with the icy night. Every pore in my body was pained by the feeling of the freezing pores in the body of the car. In a nervous and distressed state I went downstairs into the Bells' living room, where Ross's father, a humanistic geologist, was reading the paper. I told him what was worrying me. What he in fact thought about the attitude I was describing to him, I still have no idea. What he did was simple and reassuring. He took a huge camping blanket from the basement, and went with me out to the car. Then he spread the blanket over the car. He said nothing more about the matter. We returned to the house, and I went up to bed. I felt restored to myself and at ease. I felt I had done what needed to be done. I still feel that way in the presence of what seem to be out-of-balance arrangements of forces in the given world. I want to express this

preoccupation carefully, to ward off any suspicion that I am mentally unbalanced. I am a robust seventy-six-year-old with a gusto for life and enough *savoir vivre* to have worked, fathered, and created a couple of families. It is simply, I think, that whatever it is that leads some people to think of man as fallen leads me to sharp sensitivity to selected misalignments in nature. I often want to rectify the designs I see in nature, the position of a stone, the relation of one plant to another in a row. I rarely act on these impulses. Some speak of such impulses as phobic. But I am not sure that these impulses are not cognitive. They exist and are heard. It is as though there were always something out there to fix, and as though that something to fix was calling to me. Perhaps, you have to be in the mood to hear that call. "Let them who have ears, hear."

7

I started with the freestanding closet, because I wanted to sketch the first draft of a "realistic" epistemology in which I could portray the knowing and perceiving process as commensurate with the independent reality of objects of knowledge. Rather than argue that complicated "realism" issue into the ground—and entangle myself irrelevantly in the central epistemic issue of modern philosophy—I then moved the subject-object issue onto the terrain of putatively "animate" external objects. An amulet, a West African gris-gris seemed a suitable example, because it was a classical material object to which one has often attributed lifelike powers—like the Ka'aba, a saint's relics, or a World Series baseball captured in the stands by a fan. I started inspecting the ascription of objective status to the animate external generator of affects, like the amulet. Imagination entered at that point, a faculty to which we could attribute the power to bring external wholes into new syntheses of life. From there we made our way to Ross's house on a winter night. We met a freezing auto. What clearer example, personal and unscientific though it is, could there be for the voice of animation calling from the depths of the material world? The position we have thus brought ourselves to, making a case for a persisting sentient ambient universe, attributing to sites in that universe the multifaceted unity we call animation, is fully embedded in intimate examples. However, nothing about those examples guarantees to them more than a poetic relevance, as arguments for a philosophical position. Is this kind of relevance enough? Is it of cognitive value at all? The way chosen here, to this point, is to privilege in the

perceived object—car, amulet, "reference" of a great literary text—its seeming resistance, personal presence, instructive capacity, its flexibility—all conscious traits; and, while privileging, to insinuate a case for the power and vital status of the objects of our emotional intelligence. I have not been advancing a philosophy, but only examining perspectives from which it might be possible to view the claims of animism. In examining these perspectives I am trying to account for my own experiences in the past five years in Nigeria and Côte d'Ivoire. Those experiences exposed me to many intelligent people's convictions that witchcraft, sorcery, and fetish culture were part of a bundle of skills, not necessarily benign or useful skills, which could be routinely employed to effect change in the human or physical world. Piqued by this conviction, which ran counter to my expectations about the world, I wanted to evaluate my friends' assertions more closely. What I have written above is nothing more than an effort to pursue this evaluation. As I say, I have not been even trying out a philosophy. I know, however, that there are many organized systems of thought, "philosophies," which would have provided dramatic alternatives to my way of trying out a basically animist description of the world and knowing; and all those alternatives, those philosophies, would be sure to win more high-culture adherents than the one I am drafting as possible in this essay. Consider the critique that would rise from an "organized system," like that of Descartes, and go for only what seems (under the aspect of that perspective) certain. Certain would it be for Descartes to say of the amulet in my pocket that I am conscious, or have a consciousness of, the object in my pocket. Beyond that, what would be appropriate to say? The following would be from Descartes' pen: "soit que nous veillions, soit que nous dormions, nous ne nous devons jamais laisser persuader qu'à l'évidence de notre raison, et non point de notre imagination ni de nos sens."[5] No matter how wide we stretch Descartes' notion of "raison," it is not going to fit the scheme of knowing powers I require to make congenial the idea of inherent powers released from sacred sites in nature. The Cartesian will move only cautiously in ascribing to the amulet a spatio-temporal location. He will be very careful in ascription of thereness even to the freestanding closet, to point out that there is a wide gap between my act of conscious perception and the postulated thing in nature that I

5. René Descartes, *Discours de la Méthode; Quatrième Partie* (1637).

perceive. That's Descartes, who laid the foundation for the "formal" western tradition in epistemology. If I am a Husserlian, I will give the analysis of nature, even spatio-temporal material nature, a shorter rope than did Descartes. I quote briefly to document further the distance between certain kinds of philosophy of consciousness and the perspective I am putting out to dry in this essay. Husserl writes: "In front of me, in the dim light, lies this white paper. I see it, touch it. This perceptual seeing and touching of the paper as the full concrete experience of the paper that lies here as given in truth precisely with this relative lack of clearness, with this imperfect definition, appearing to me from this particular angle—is a *cogitatio*, a conscious experience. The paper itself with its objective qualities, its extension in space, its objective position in regard to that spatial thing I call my body, is not *cogitatio*, but *cogitatum*, not perceptual experience, but something perceived."[6] I will, as Husserlian, question whether the consciousness I have of the amulet is anything other than a *consciousness of*. The *cogitatio* is not like the *cogitatum*. I will raise a serious doubt about the analyzability of objects of consciousness, a doubt which will include the freestanding closet as well as the amulet. I will be very far from a worldview in which I can ascribe imaginative life to an amulet. Even more than the Cartesian, then, I will have taken recourse to a philosophical position from which the outer world is put at a problematical distance from mind. The realism I declared from the "right mood" in my first section will seem a dully pre-critical postulation. But even against the backdrop of a "scientific philosophy," some updated version of a Rudolf Carnap positivism, I will quickly find another way to dismiss the "animist" perspective we are circling around in this essay. I can conflate the amulet with the freestanding closet as two physical objects of perception, each of which I can surround conceptually, but neither of which has any internal resonance, one might say "any insides." Both objects of the logical positivist account are flat corpora. There are emotional and empathetic factors in knowing, but knowing what is true, the fact of the matter, involves shearing off any non-quantitative elements during the knowing process. Postulations about the inherent powers of sacred objects, no matter how complexly we dress them, are sure to fall under Carnap's severe rule as expressing no fact and "made with the vain intention of expressing accompanying object representation in the form of

statements, as if they were factual representations."[7] These various accounts—the Cartesian, the Husserlian, the Carnapian—of the relation between the conscious self and the "objective world," not to mention any allegedly personality-imbued other, are parts of other worldviews than the one I am trying on here. They are so dramatically parts of other worldviews that I have introduced them here for shock value and as part of a personal enterprise to see on what shores of thought history has deposited me and my life. Mainstream philosophy is hardly comfortable in today's sophisticated climate with even the bald realism I proclaimed in my first section, not to mention the empathetic logics of the animist view of things. (I know that somewhere out there is the air of an old-fashioned realism in Jacques Maritain's *The Degrees of Knowledge* [1959], or in George Moore's famous lecture "Proof of an External World," given to the British Academy in 1939. There are realists here and there, even in the Western University. Yet, even in those quarters, I feel I would have to win territory inch by inch for the position I am suggesting we look at here.) Nor is it possible to sever those mainstream accounts from the whole perspective they are embedded in—from the whole, basically anti-realist, thrusts of the thought of Descartes or Husserl. Nor is it plausible to view those complex and culture-formative philosophies as if they were simple choices of truth by the great men who authored them. *Weltanschauungen* don't come into being in that way, as the products of detached inquiry, but rather as personal elaborations of experience, shored up with the congenial and great circumambient thought of the time. It is not feasible to "choose" among these varied competing Western accounts of the other knowledge we are talking of here, just as it is not feasible to view the animist's embedded thought process as the product of a choice. The worldview we choose to affirm, whether Carnap's or Descartes' or Ogotemelli's, will be as fundamental, and some would say as unappealable, as any choices among a variety of competing worldviews. We can modify the stance we live from in our minds, and, indeed, maturity will consist of imposing certain modifications, as we grow, on what we have devised for ourselves as a thought system, but the changes we make even in our developed body of personal thought will never be simply versions of the correct over the incorrect. This fact of mind will be peculiarly true of the lived choice of an access theme as it arises from the bosom of a culture

6. Edmund Husserl, *Ideas* (1931), chap. 4, sec. 35.

7. Rudolf Carnap, *Pseudoproblems in Philosophy* (1927), sec. 9.

devoted to animism. So far is the animist, generally, from a conscious insight into his convictions, that for many interpreters of the pre-technological world it has seemed handy to discuss "animism" not as a failed way of knowing, but as a social practice of use to communities. This sociological interpretation—which must join the great mainstream philosophies, though as a different kind of device for demythologizing animism—will be the offspring of the vast social-scientific literature deriving from nineteenth-century colonialism, the Scramble for Africa, and the new scholarship industries that grew with the classificatory passions dear to the control passions of nineteenth-century Europe. This social-scientific interpretation will not be self-consciously philosophical in the sense of Descartes and Carnap, asking into the metaphysical premises of the knowing act. In fact, the social scientist will proudly carry his lack of transparency into the battlefield of knowledge. Social-scientific inquiry will be an empirical analysis of ethnographic data, designed in order to reach the highest level of general explanation justified by the teeming facts. Robertson Smith, Emile Durkheim, Sir James Frazer, Levi-Strauss, Clifford Geertz, Victor Turner—some of the many names emblazoned on the shield of social anthropology—these thinkers will all make their voices heard here and claim their rights over against both harder philosophy and the imagination-engendered claims of the animist.[8] Though all these men helped lay the foundations of current anthropological thinking, Geertz (in "Religion as a Cultural System") and Turner (in *The Forest of Symbols*), have pressed especially hard to characterize the kind of "animism" under discussion here. In his discussions of witchcraft and symbolism among the Ndembu of Zambia, Turner illuminates a universe pervaded with spirit forces in which objects are forever alive as implements of powerful change, baleful effect, and profound personal influence. Geertz sees animism as part of the symbolic system by which religion struggles to reconcile us to the difficulty of our existence. The functioning symbols of animism, the bright centers of special meaning scattered over the known world, are not fetishized "to deny the undeniable—that there are unexplained events, that life hurts, or that rain falls upon the just—but to deny that

there are inexplicable events, that life is unendurable, and that justice is a mirage."[9] In summary, these anthropologists account for animism as a byproduct of social need and see primitive religion as battening on the profits of magic. In short, the argument of these men is that animism doesn't reflect a valid (or invalid) employment of the knowing process but rather a useful and needs-satisfying employment. We should be able to see this kind of social contribution from within animist thought in a few examples to follow shortly. The compelling perspective of Turner and Geertz must be added to the worldviews with which we can imagine interpreting the omnipresence of animist thinking among pre-technological people. We find here a sociological explanation of animism, one quite different from a philosophical account and one that would circumscribe the knowing account systematic thought activates, or the account used as the default position in this essay—that animism itself is a kind of knowing of and handling of the world. These cultural anthropologists lived by "making sense" of animism as a form of cultural survival.

8

To choose a worldview is not exactly possible; rather we establish ourselves *inside* a worldview. And from being established there, in this view that has grown up around and through us, we proceed to rationalize the outlines of that view, which then once again reinforce our adherence to the view in question. This is the vicious circle applicable to "having a philosophy." That circle, while seemingly loose and benign, is in fact tight, a pressure to unilateral vision. Many of us feel constricted by having to have a worldview. We may well wish for more flexibility, more mental wiggle room, than is provided by any worldview at all. Is it possible to break out of this worldview circle by committing oneself to an incremental philosophy, which basically undermines the worldview idea? That is, why can we not say: I am always at the beginning of establishing a philosophy of life? I am always in the interrogative mode toward Husserl or Kant or Carnap or Victor Turner or . . . the very ideas of the world as it is seen from within animism? Can I not say that I am in the moment opening out a philosophy of mine by concepts and

8. I think in terms of Robertson Smith, *The Religion of the Semites* (1889); Emile Durkheim, *Les Formes Elémentaires de la Vie Religieuse* (1912); Sir James Frazer, *The Golden Bough* (1922); Claude Levi-Strauss, *Anthropologie Structurale* (1958); Clifford Geertz, "Religion as a Cultural System" (1966) in his *The Interpretation of Cultures* (New York: Basic Books, 1973); Victor Turner, *The Forest of Symbols* (1967).

9. Geertz (see note 8), p. 108. Geertz is concerned with the power of ritual myth to dull some of the pain of existence. A recent book by Paul Stoller, *Stranger in the Village of the Sick: A Memoir of Cancer, Sorcery, and Healing* (Boston: Beacon, 2004), goes much further into the power of sorcerous animism to heal.

intuitions, right now and at all times? Can't I just insist on being always in the state of just starting out to create a philosophy? Can't I claim all this even in the face of the scholar's dogged insistence that an articulate philosophy lies nestled in my stammering? There is a fresh poetry in this series of questions. The trick of thought behind this poetry, however, is delusive if attractive. The idea that I am in the moment and just starting out to conceptualize is premised on the concept of the anticipation of priority. In other words, to think that I can beat the priority of my worldview to my construction of a philosophy, that I can anticipate by always being in-process, is to ignore the priority, to even my-being-in-process, of a philosophy asserting that even my belief in an implicit personal incremental philosophy is justifiable. Philosophy does indeed bury its undertakers. But does that then leave us high and dry with the worldview we're born into? Are we to be allowed no criteria for preferring one philosophy to another? If my philosophy of life is the inescapable baggage of my way of being in the world, then how can I evaluate my philosophy or that of any other person? How can I ever *change* my philosophy? Of course, we know that de facto modification of philosophy is possible, and that it is good, but are we discussing what is really a change, and not just a modification of what we already believed? (Were Augustine or Nietzsche or Maritain really so different at the end from what they were at the beginning?) Or is one philosophy of life as good as another, perhaps only an epiphenomenon of what I really am, so that change is not necessary? I cannot believe that and still generate this inquiry-full amulet text, unless—an important unless—I take it that one's world-philosophy is more like a poem based on one's life than like a tractate anchored in observation and logical deduction. If I go for that account, I can generate this modest text without claiming that it represents a superior account of the way things are. I can adopt the philosophy of sidestepping the claims of philosophies that they are mutually exclusive. I can enter the realm of the philosophy that claims to be a poem. Does that realm include Lucretius, Heraclitus, Dante? Are we willing to include Homer in our list of the great philosophers and if no, why not?

9

We have brought in the option of the poetic nature of truth, the truth discerned through imagination, in order to widen our sense of the ways we can find out the reality of the world outside us. In this way we have let in a potential ally of the perception that the world outside us is *"peuplé d'esprits."* (We have brought in an ally, but not a reliable ally, for imagination has its own exacting criteria of discrimination and blows in its own wind.) We have not only hired the first horse available, a worldview congenial to the idea of imaginative projection and to the discovery of real personality in objects of the world. In fact, imagination is the last of several horses we have looked at. We speak here of only one of the available horses on offer—having already surveyed the horses of scientific positivism, Husserlian analyses of consciousness, or sociological relativism. The last horse we look at is called the horse of the discovery power of the imagination. It is not the anticipated winner of the next Kentucky Derby, nor is it the horse ridden by the professoriat in Western universities. But it's the pre-industrial world's generally preferred steed, and given world demographics in which the Third World comes out first, this "poetry" steed deserves more than passing attention.

We are not at liberty on the basis of a personal involvement with a particular horse—even the poetry horse—to invent a world. We have to be flexible, though, in dealing with the given real world, mysterious though it may seem to many Western assumptions for which the simple assertions that *natura non facit saltum*, that intelligible sequence rules in nature, that all can be measured, are enough. We must account for the non-empirical in a way that ascribes to some presence of the unexpected or unpredictable the degree of thisness we attributed to the freestanding closet at the beginning. I introduce in brief summary, as pieces of evidence from the world in which that horse rides, the following character sketches made in Nigeria by this author in the summer of 1999. It will be evident that *natura non facit saltum* does not cut it here, and that in each example animistic powers are being predicated onto "objects in nature." In the first instance, those "objects in nature" are raging water and the body of a sacrificial victim, each of which is known as a power.

1. L. seemed the last person. A cultured Yoruba software programmer, traditionally immersed in Kant, Hegel, and the seventeenth-century Western revolution of science and pragmatic values, he uncomplicatedly explained to me the following scene from his personal past: In a small Yoruba village at dusk he anxiously awaits the passing of a troupe of egbes, ritually violent men who uphold their community values in crises. At the first appearance of this band on the Main Street—burly giants with feathers in their teeth—all doors quickly close, lest these holy marauders in search of appropriate sacrifice spot the observer. The group continues

on, sabers flashing in the half light, interludes of dance embroidering their progress. At the far end of the village, they come on the already chosen victim who will serve their pressing needs and who awaits, stitched to a tree with withes, both terrified and honored by the role he is being forced to play. The strapping and handsome twenty-year-old is released from his prison, held from behind by two giant *egbes,* and in silence sliced through the sternum, until in two clean halves, perfumed by chants of exorcism, he slips like a garment onto the rainforest soil. Holding his devoted corpse, the chanting men proceed to the nearby river, whose banks are about to overflow, disastrously inundating the village and its crops. As the body slides into the brown waves, the river gradually calms, declines from its seething into a gentler flow, and within an hour has returned into its banks, sparing the village and the food on which the people depend for their lives.

A classic instance of propitiation matched with sympathetic magic. Both the body of the sacrificial victim and the force of the water assume personal, and ultimately reconciling, traits. Are we facing a poem or alternative pre-modern science?

2. J., a mechanical expert and mill owner, takes his place gloomily on our comfortable sofa, pours himself a courvoisier, and starts answering my questions about market life in southern Nigeria. He has the mind of a master economist, managing endless details of local market days, price fluctuations, and data on harvesting procedures. Gloomy, yes, but still the contemporary man who, on his own, set up and ran a remunerative palm kernel processing plant in the riverine area south of Ughelli. Later I ask a friend why J. is clinically depressed. It seems his wife has cast a spell on him, sequestering crucial objects of his clothing and damning him through them. He has fallen ill, his business is in shambles, and he drinks in the morning.

For all that, however, he is able to satisfy my curiosity about the strange fatality which haunts his native village. Many generations ago, a beautiful young woman from the village was wooed and bedded by the water spirit that lives in the great river that flows through the village. As a price for his godly love, the spirit demanded one night a week with her and with any female descendants she had for the "rest of time." The result is that, though the beautiful woman's beautiful descendants continue to live in the village, no young man is happy to marry into the lineage, knowing that he must share his wife once a week. The inciting curse goes on, haunting the village to this day.

Two accounts this time, the first a tribute to the omnipresent (in southern Nigeria) belief in the power of witchcraft. In this case, "concealed objects of clothing" are infused with powers. Those objects become the focus and vehicle of the sorcerer's malign intentions. They "acquire" inherently destructive powers by a

projection that "finds what is in them and releases it." In the second instance, we have another example of the animate powers of water, which can either be enraged or calmed (as in story number one) or can exercise a remorseless power over humans. It is to be observed that in two of these instances the animist power in question is malign. That is par for the pre-industrial course, and has led in one kind of sociology to a particular view of animism that in part it expresses the wish of down-classed people to gain power over their oppressors. "Good" witchcraft is rare, though witchcraft in the service of survival—as in the first example—is well-documented.

3. D. and Y., sophisticated Urhobos in the brokerage business, recount the day of the big party. It is a christening. Guests have been invited from all over Delta State, and the lawn has been scythed and decorated. Early in the morning of the big day, the women of the family have begun to stir the large pots of boiling water for *eba* (cassava porridge), for fish sauces, and for *ukodu* (plantain soup with fish). One thing is crucial, that the front of rain, which is sweeping across the State, should not wreck the party. Therefore, a small boy is sent for, one known for his "magic," and upon arrival the lad is invited to "exercise his powers" and activate his rain-inhibiting medicine. His incantations and exorcisms bring the rain front to a halt just before the margins of the hosts' party lawn. The rain abates for the necessary period of time.

Sympathetic magic again. The rain is calmed or driven away as the water had been affected in episode one. Another familiar and stock example of belief in the interconnected spiritual vibrations joining human mind with external nature. Consider, as an instance of the modest means sufficient to bear these vibes, the kind of power bundle from which the "magician" could release those powers needed for drying the rain front. Livingstone, in "Conversations on Rain-making" (1858) gives the following as ingredients of a power bundle designed to promote rain: "a variety of preparations, such as charcoal made of burned bats, inspissated renal deposit of the mountain cony . . . the internal parts of different animals—as jackals' livers, baboons' and lions' hearts, and hairy calculi from the bowels of old cows—serpents' skins and vertebrae, and every kind of tuber, bulb, root and plant to be found in the country."[10] We may well be thinking at this point that the animistic impulse is sufficiently strong that it can

10. David Livingstone, "Conversations on Rain-making," in *Missionary Travels and Researches in South Africa* (1858), cited in *Perspectives on Africa* (see note 3), p. 300.

enable any chosen sector of material reality to release animate power.

The truth claim of these three anecdotal testimonies cannot be tested; that claim comes from far down in the socio-cultural mind that is transacting with its reality through these stories. But it will not do to dismiss these tales out of hand, as part either of benighted pre-science or of Geertz's consolatory/explanatory social fabric in which pre-technological man makes the world of suffering endurable. We must first consider the kind of imaginative reality the world can be in which these stories are established. The worldview in which these tales are embedded is precisely the one we have been drawing attention to in expanding a realistic epistemology as far as it could go, out into the productivity of the imagination. We are on that plane of consideration we occupied in flying the idea that the great poets might be the great scientists. We are not playing games with the notion of truth in providing for a truth claim in stories: We are talking about another truth, but still an authentic cognizing truth, which can be reached on the horseback of poetry.

For these three documented tales to be plausible, the world they take place in would have to have several characteristics. In it, mind would have to be able to influence nature (make the rain fall or not fall; make a raging river recede; degrade another person's life by spells). The world/nature would in turn need to be such that it can be influenced by mind and become the site of potent transformation through offering up parts of itself for sacred uses. The result of such an interaction, triggered by prayer, spell, or ritual action, would have to exercise concrete effects, like those of what Frazer in *The Golden Bough* calls sympathetic or contagious magic. Given a world such as that, the tales mentioned above would fit the expectations of good sense, would not be startling—what could startle a Western evangelist drawn to speaking in tongues, laying on of hands, or for that matter a devout Catholic, bent over the transformed host? The worldview horse we hired above would easily convey us through territory we might in our severe Baconian moods incline to think magical, but which (if so) may be simply magic in that developmental stage where it is proto-science, as alchemy once was, and where magic is not far even from contemporary science—both of them experimentally grounded interactions with the material weave of the universe [11]

10.

I confront the above propositions head-on, for I face them across the kitchen table, married as I am to a Nigerian for whom the above anecdotes of reality are of no particular interest and do not require special explanation. I am looking, therefore, at an epistemology which (for her) is realistic in the sense I gave that term at the beginning—in looking at the thereness of a closet—and which passes seamlessly, without embedded critique, to the assumption that personal or animate powers inhere effectively in nature. That Nigerian world vision is one of the narratives possible to us in reconstituting the universe in thought and imagination and thus is one of the universes possible to imagination in its work of establishing a character for the outer world.

But of course a loud voice rises from this side of the kitchen table, inside an aging scion of academic life in the secular universities of the American Midwest. It is a voice crying out against the madness of the perspective of the amulet/gris-gris (or of animism in general) as embedded in the three narratives just offered (or as embedded in the lovely woman seated across from me). I need to address that secular voice, calm it down, and force it to tell me quietly its version of the way things are. Which horse does *it* ride?

When you get right down to it, the story is not as simple as it seemed; indeed the worldview of experimental science tends to run so deep in Mr. Educated Westerner that he can hardly bring it up to the light for inspection. When he tries, he comes up with something like this: "I am the voice of the seventeenth century in Europe, and I am a voice of experimentation, direct observation, and the application of a mathematic measure to what is a cause-and-effect-regulated, and spatio-temporally-displayed universe. I represent a philosophically sophisticated view of the knowing process—that is, I don't take the presentations of my sense world at face value—and I refine into my worldview the complexities of knowing—as in quantum theory—without questioning the knowability of the whole.[12] I do not, as inheritor of Bacon, Gassendi,

11. Bronislaw Malinowski in *Magic, Science, and Religion* (1925) is clear in sorting out the interplay of magic and science in Trobriand Islander culture and in discussing the place religion then plays in the dynamic of that culture.

12. Laymen like me are aware that the theory of quantum mechanics erects robust hurdles to our confidence in the knowability of the cosmic whole. Max Planck's account of the "issue of causality" is an accessible argument: He insists on the complex conditions that surround any measurement designed to verify the "absolute predictability" that establishes cause-and-effect in nature. We need go no further to qualify the enthusiastic belief in observable causality,

d'Holbach, or the Enlightenment, pronounce on the "spiritual realm." I may pronounce on it elsewhere in my mind's life, but not in the process of my scientific knowing. As it turns out, I am unfriendly to what I cannot weigh or measure. Neither the apparitions at Fatima nor the alleged incursions of the Devil are part of my cast of characters—and if you find me front row center in the Episcopal Church this Sunday, it will be because I have set aside a place for the Big Man, which is not assailable by what I learn in my lab.

The hold of this multi-faceted scientific Western view is pervasive. Backed up by the experimental method, activated to dynamite ancient worldview assumptions and seemingly confirmed by dazzling achievements in *techne* (achievements that have totally overthrown our human infrastructure, though often without regard to safety, sanity, or wisdom), the "scientific view" insists on its exclusive qualifications for addressing the nature of the universe. It has effectually banished from its purviews the kinds of universe account which encased the perceptions of our three Nigerian tales. Yet Western science—especially in its theoretical physics—relies on models and metaphors that no pragmatism can prove out. Time and again abstract research models, which may have an ultimate practical application, are undertaken in the blue sky of higher mathematics. Has the huge operational achievement of a perspective that puts us in cars, on the moon, and under the electric light, thereby proven the validity of its philosophical underpinnings? Or might there be a disconnect between the philosophy and the application of higher science, as though high abstraction was a kind of coughing-warning to practice—a warm-up to the real discovery promise—Benjamin Franklin or Thomas Edison?

I raise the issue and leave it. This essay is not about winning an argument, but about enlarging my own epistemic palette. We began with the creation of a realist epistemology, which then melded into a critique of the imagination and a case for the ascription of powers to sites in nature. That these sites were "personal" in nature, like forces (in an amulet, in a river, in rain clouds), made it seem appropriate to invoke the imagination as a producer of such sites, which both

depend on the productive mind for their existence and, once established, fully exist. These sites, that is, are on this account as fully "the real thing" as is the freestanding closet. If there is *any* truth in the idea that truth is the poem each of us (or each culture) writes from the start of its or his life, then from inside of that poetic assumption we will have trouble finding a specific standpoint from which to seek out our truth. Perhaps, we will not get much further in this search for a unitary concept of truth than to say that we know what a lie is, and that we neither like it nor have use for it. We don't like the lie because it doesn't work and because it does bad things to us. We all agree to that. But speaking of what we all agree on, I suppose, I need to conclude that I don't think the Nigerian lens onto malleable nature, spirit intrusions, and the power of sorcery is a particularly useful aspect of social equipment. True, as one kind of true, some aspects of this mindset may be. And may have been in the past, when magic was at its work of mating with early science in the construction of social evolution. Nonetheless, as one kind of search for truth, animism may ultimately have priced itself out of the market by delaying more effectual strategies for dealing with man's relation to nature. That doesn't mean "animism" has no place in our account of the ways humans know their world. It does not mean that a little boy cannot stop the rain. (After all, *Black Elk* started the rain at the end of *Black Elk Speaks*).[13] But it leaves us in no doubt why animism has not generated great societies, raised fine buildings into the sky, or even turned on a TV set.

13. Black Elk, *Black Elk Speaks* (1932).

which, though ripe in the achievements of great seventeenth-century physicists, was based on a "realistic" rather than on a more accurate "statistical" measuring system. Behind Planck, but on the level of philosophy, lay David Hume's renowned questionings of the foundations of cause-and-effect thinking. See Max Planck's "The Concept of Causality in Physics," in his *Scientific Autobiography*, trans. Frank Gaynor (New York: Philosophical Library, 1949), pp. 121–150.

List of authors

CHARLES BURROUGHS is Professor of Art History at Case Western Reserve University.

OSWALDO CHINCHILLA MAZARIEGOS is curator of the Popol Vuh Museum, Francisco Marroquín University, and Professor at the School of History, University of San Carlos, Guatemala.

DAVID T. DORIS is Assistant Professor in the Department of the History of Art and the Center for Afroamerican and African Studies at the University of Michigan.

BARBARA W. FASH is director of the Corpus of Maya Hieroglyphic Inscription Program, Peabody Museum, Harvard University.

WILLIAM L. FASH is William and Muriel Seabury Howells Director, Peabody Museum of Archaeology and Ethnology and Charles P. Bowditch Professor of Central American and Mexican Archaeology and Ethnology, Harvard University.

LAURA FILLOY NADAL is Senior Conservator, Museo Nacional de Antropología, INAH, México.

RAVIV GANCHROW teaches in the graduate program of architecture at Delft University of Technology and at the Institute of Sonology, the Royal Conservatory, The Hague.

REMO GUIDIERI is Professor of Anthropology at the Université de Paris X, Nanterre.

PILAR HERNÁNDEZ is Associate Conservator, Coordinación Nacional de Restauración del Patrimonio Cultural, INAH, México.

ROBERT HULLOT-KENTOR is Professor of English, Foreign Languages, and Literature at Long Island University, Brooklyn, New York.

DAVID Y. KIM is a Ph.D. candidate in the Department of History of Art and Architecture, Harvard University.

LEONARDO LÓPEZ LUJÁN is Senior Professor and Researcher, Museo del Templo Mayor, INAH, México.

CLAUDIA MATTOS is Professor of the History of Art at the Art Institute of the Campinas State University (Unicamp), Brazil.

CUAUHTÉMOC MEDINA is Researcher at the Instituto de Investigaciones Estéticas, UNAM, México, and Associate Curator, Latin American Art collections, at the Tate Gallery, United Kingdom.

POLLY RICHARDS is an independent scholar based in London.

ALESSANDRA RUSSO is Collaborative Researcher at the Instituto de Investigaciones Estéticas, UNAM, México, and doctoral candidate at the École des Hautes Études en Sciences Sociales, Paris.

ANNE-MARIE SANKOVITCH was a Research Associate in the Theory and History of Architecture at the Institute of Fine Arts, New York University.

WES WALLACE and AOIFE NAUGHTON edit the online publication of the *Psychogeographic Guide to the City of New Orleans*.

FREDERIC WILL is Visiting Professor of Greek, Deep Springs College.

CHRISTOPHER WOOD is Professor of the History of Art at Yale University.

Res 51 Spring 2007

Anthropology and aesthetics

Contents of upcoming issue

Books received, July 2005–May 2006

Alÿs, Francis, ed. *The Modern Procession*. New York: Public Art Fund, 2004.

Bacci, Michele. *Lo spazio dell'anima: Vita di una chiesa medievale*. Roma: Editore Laterza, 2005.

Bancroft, Frederic, ed. *Constable's Skies. With poems by David Shapiro*. New York: Salander-O'Reilly Galleries, 2004.

Bonhomme, Julien. *Le miroir et le crâne: Parcours initiatique du Bwete Misoko (Gabon)*. Paris: CNRS Editions, 2006.

Carpender, Edmund. *Two Essays: Chief and Creed*. North Andover, Mass.: Persimmon Press, 2005.

Chambrin, Romain. *Sacra & Paraphernalia: formes du Sepik, Mélanésie Occidentale*. Series in *Anthropologie des formes non occidentales*. Editions Carnets-Livres, 2005.

Cooper, Harry, and Megan R. Luke. *Frank Stella 1958*. New Haven and London: Yale University Press and Cambridge, Mass.: Harvard University Art Museums, 2006.

Cy Twombly and Jean-Michel Basquiat: Paintings and Works on Paper. Text by Francesco Pellizzi. Los Angeles: Michael Kohn Gallery, 2004.

Dehouve, Danièle. *Essai sur la royauté sacrée en République mexicaine*. CNRS Anthropologie. Paris: CNRS Editions, 2006.

D'Elia, Una Roman. *The Poetics of Titian's Religious Paintings*. New York: Cambridge University Press, 2005.

Fimani, Filippo. *Forme informi: Studi di Poetiche del visuale*. Geneva: il melangolo, 2006.

Herring, Adam. *Art and Writing in the Maya Cities, A.D. 600–800: A Poetics of Line*. New York: Cambridge University Press, 2005.

Greene, Rachel. *Internet Art. Thames and Hudson World of Art Series*. London: Thames and Hudson, Ltd., 2004.

Katharina Grosse, Richard Serra, Bernard Frize. The Parkett Series with Contemporary Artists, No. 74. Zurich and New York: Parkett, 2005.

Kristiansen, Kristian, and Thomas B. Larsson. *The Rise of Bronze Age Society*. New York: Cambridge University Press, 2005.

Lidova, Natalia. *Drama and Ritual of Early Hinduism*. Foreword by Kaial Vatsyayan. Performing Arts Series, volume 4. Delhi: Motilal Banarsidass Publishers Private Limited, 1994.

Mann, Charles C. *1491: New Revelations of the Americas before Columbus*. New York: Alfred A. Knopf, 2005.

Mardsen, Magnus. *Living Islam: Muslim Religious Experience in Pakistan's North-West Frontier*. Cambridge: Cambridge University Press, 2005.

McIntosh, Roderick J. *Ancient Middle Niger: Urbanism and the Self-Organizing Landscape*. New York and London: Cambridge University Press, 2005.

Mexican Report: Contemporary Art from Mexico. Exhibition Catalogue. San Antonio, Texas: Blue Contemporary Art Center and Insituto de México en San Antonio, Tex., 2004.

Milazzo, Richard. *Saint Clair Cemin: Sculptor from Cruz Alta*. New York: Brent Sikkema Editions, 2005.

Morphy, Howard, and Morgan Perkins, eds. *The Anthropology of Art: A Reader*. Series in Blackwell Anthologies in Social and Cultural Anthropology. Oxford and Malden, Massachusetts: Blackwell Publishing, 2006.

Ottenberg, Simon, and David A. Binkley, eds., *African Children's Masquerades: Playful Performers*. New Brunswick, New Jersey: Transaction Publishers, 2005.

Parkett no. 75 (January 2006) with Kai Althoff, Glenn Brown, Dana Schutz. Zürich: Parkett-Verlag.

Pasztory, Esther. *Thinking with Things: Toward a New Vision of Art*. Austin: University of Texas Press, 2005.

Racy, A. J. *Making Music in the Arab World*. New York and London: Cambridge University Press, 2003.

Retratos: Two Thousand Years of Latin American Portraits. Elizabeth P. Benson et al. New York: Museo del Barrio, New York and San Antonio Museum of Art, 2004.

Rice, Prudence M. *Pottery Analysis: A Sourcebook*. Paperback edition. Chicago and London: The University of Chicago Press, 2005.

Schneider, Arnd, and Christopher Wright. *Contemporary Art and Anthropology*. Oxford and New York: Berg, 2006.

Siracusano, Gabriela. *El poder de los colores: De lo material a lo simbólico en las prácticas culturales andinas. Siglos XVI–XVIII*. Buenos Aires: Fondo de Cultura Económica de Argentina, S. A., 2005.

Smith, C. J. *The Roman Clan: The Gens from Ancient Ideology to Modern Anthropology*. Cambridge: Cambridge University Press, 2006.

Sofaer, Joanna R. *The Body as Material Culture: A Theoretical Osteoarchaeology*. Topics in Contemporary Archaeology. Cambridge and New York: Cambridge University Press, 2006.

Thomson de Grummond, Nancy, and Erika Simon, eds. *The Religion of the Etruscans*. Austin: University of Texas Press, 2006.

Tibbles, Anthony, ed. *Transatlantic Slavery: Against Human Dignity*. Liverpool: National Museums of Liverpool and Liverpool University Press, 2005.

Zorach, Rebecca. *Blood, Milk, Ink, Gold: Abundance and Excess in the French Renaissance*. Chicago and London: The University of Chicago Press, 2005.

 res *anthropology and aesthetics*

Back issues are available from Peabody Museum Publications
11 Divinity Avenue, Cambridge, MA 02138
phone: 617-496-9922, fax: 617-495-7535
Order on line at www.res-journal.org

RECENT BACK ISSUES

medieval Narbonne • **RITA ASTUTI** Invisible objects: mortuary rituals among the Veso of western Madagascar • **WYATT MacGAFFEY** African objects and the idea of fetish • **BARBARA DUDEN** The fetus as an object of our time **$20**

RES 26 Autumn 1994
JOSEPH RYKWERT On the palmette • **MARIO PROSPERI** The masks of Menander • **VICTOR I. STOICHITA** Image and apparition: Spanish painting of the Golden Age and New World popular devotion • **ANDREW BUTTERFIELD** Social structure and typology of funerary monuments in Early Renaissance Florence • **DAVID BINDHAM** Am I not a man and a brother?: British art and slavery in the eighteenth century • **HELEN WESTON** Representing the right to represent: the *Portrait of Citizen Belley, ex-representative of the colonies* by A.-L. Girodet • **ELISHA P. RENNE** Things that threaten: a symbolic analysis of Bunu Yoruba masquerades • **JAMES ELKINS** The question of the body in Mesoamerican art • **ROBERTO CALASSO** *La Folie qui vient des Nymphes* **$20**

RES 27 Spring 1995
INDRA KAGIS McEWEN Housing fame: in the Tuscan villa of Pliny the Younger • **MARILYN E. HELDMAN** Legens of Lālibalā: the development of an Ethiopian pilgrimage site • **JEAN MICHAEL MASSING** Hans Burgkmair's depiction of native Africans • **ANDREA CARLINO** "Knowe thyself": anatomical figures in early modern Europe • **SERGE MAMINO** Reimagining the Grande Galleria of Carlo Emanuele I of Savoy • **DAVID R. SMITH** Inversion, revolution, and the carnivalesque in Rembrandt's *Civilis* • **ANNA LO GIUDICE** *Nage/danse, corps/écriture: de l'insularité valéryenne* • **MICHAEL W. MEISTER** Sweetmeats of corpses? Art history and ethnohistory • **PAMELA M. LEE** The aesthetics of value, the fetish of method: a case study at the Peabody Museum **$20**

RES 28 Autumn 1995
FRANCESCO PELLIZZI Songs of the material • **WILLIAM PIETZ** The spirit of civilization: blood sacrifice and monetary debt • **GIANNI VATTIMO** Postmodernity and new monumentality • **IVAN ILLICH** Guarding the eye in the age of show • **BEAT WYSS** *The Last Judgment* as artistic process: *The Flaying of Marsyas* in the Sistine Chapel • **PAULA CARABELL** *Finito* and *non-finito* in Titian's last paintings • **EMILY UMBERGER** Velázquez and naturalism II: interpreting *Las Meninas* • **DANIEL ARASSE** Entre dévotion et hérésie: la tablette de saint Bernardin ou le secret d'un prédicateur • **REMO GUIDIERI** Res • **ANNIE SUQUET** Archaic thought and ritual in the work of Joseph Beuys • **KIRK VARNEDOE with FRANCESCO CLEMENTE, BRICE MARDEN, and RICHARD SERRA** Cy Twombly: an artist's artist • **OCTAVIO PAZ** The Cy Twombly Gallery at the Menil Collection: a conversation

RES 29/30 Spring/Autumn 1996 *The pre-Columbian*
FRANCESCO PELLIZZI The pre-Columbian • **CLEMENCY CHASE COGGINS** Creation religion and the numbers at Teotihuacan and Izapa • **KARL TAUBE** The Olmec maize god: the face of corn in formative Mesoamerica • **BRIAN STROSS** The Mesoamerican cosmic portal: an early Zapotec example • **MARGARET YOUNG-SANCHEZ** An Aztec gold warrior figurine

(from the Cleveland Museum) • **WILLIAM and BARBARA FASH** Building a world-view: visual communication in Classic Maya architecture • **DAVID STUART** Kings of stone: a consideration of stelae in ancient Maya ritual and representation • **CLAUDE-FRANÇOIS BAUDEZ** Arquitectura y escenografía en Palenque: un ritual de entronización • **ARTHUR SCHLAK** Venus, Mercury, and the sun: GI, GII, and GIII of the Palenque Triad • **EVON Z. VOGT and VICTORIA R. BRICKER** The Zinacanteco Fiesta of San Sebastian: an essay in ethnographic interpretation • **ALAN L. KOLATA** Mimesis and monumentalism in native Andean cities • **GARY URTON** The body of meaning in Chavin art • **MAARTEN VAN DE GUCHTE** Sculpture and the concept of the double among the Inca kings • **VALERIE FRASER** The artistry of Guaman Poma • **MARY W. HELMS** Color and creativity: interpretation of themes and design styles on a Panamanian Conte bowl • **JEFFREY QUILTER** Continuity and disjunction in pre-Columbian art and culture • **ESTHER PASZTORY** Aesthetics and pre-Columbian art • **BARBARA MUNDY and DANA LEIBSOHN** Of copies, casts, and codices: Mexico on display in 1892 **$60**

RES 31 Spring 1997 *The abject*
JOSEPH LEO KOERNER The abject of art history • **JEFFREY F. HAMBURGER** "To make women weep": ugly art as "feminine" and the origins of modern aesthetics • **JULIET FLEMING** The Renaissance tattoo • **JOAN R. BRANHAM** Blood in flux, sanctity at issue • **SARAH BRETT-SMITH** The mouth of the Komo • **WILLIAM PIETZ** Death of the deodand: accursed objects and the money value of human life • **JOSEPH RYKWERT** The constitution of Bohemia • **VICTOR I. STOICHITA** Johann Caspar Lavater's *Essays on Physiognomy* and the hermeneutics of shadow • **NICHOLAS GRINDLE** "Our own imperfect knowledge": Petrus Camper and the search for an "ideal form" • **CHRISTINE ROSS** Redefinitions of abjection in contemporary performances of the female body • **MEYER SCHAPIRO** A critique: Pevsner on modernity (1938), translated by David Craven • **MEYER SCHAPIRO and LILLIAN MILGRAM SCHAPIRO with DAVID CRAVEN** A series of interviews (July 15, 1992– January 22, 1995) **$30**

RES 32 Autumn 1997 *Tradition—translation—treason*
FRANCESCO PELLIZZI Editorial • **SUSAN SONTAG** Being translated • **ROBERT FARRIS THOMPSON** Translating the world into generousness: remarks on Haitian vèvè • **ESTHER PASZTORY** Treason: comments to Robert Farris Thompson • **MIKHAIL IAMPOLSKI** Translating images . . . • **SERGE GAVRONSKY** On harmony: a theory of translation • **VINCENT CRAPANZANO** Translation: truth or metaphor • **SAINT CLAIR CEMIN** A comment on language, object, and translation • **GIANNI VATTIMO** Translation and interpretation • **ARTHUR DANTO** Translation and betrayal • **WILLIAM PIETZ** The future of treason: political boundaries in the information age • **JOHN HEJDUK** Sentences on the house and other sentences I and II • **DAVID SHAPIRO** Poetry and architecture: mistranslation and collaboration • **PAULA CARABELL** Image and identity in the unfinished works of Michelangelo • **KATHERINE HACKER** Dressing the Lord Jagannātha in silk: cloth, clothes, and status • **REMO GUIDIERI** Baits and traps • **BARBARA MONK FELDMAN** Music and the picture plane: Poussin's *Pyramus and Thisbe* and Morton Feldman's *For Philip Guston* **$30**

Res 33 Spring 1998 *Pre-Columbian states of being*
JEFFREY QUILTER Presentation • FRANK SALOMON How the Huacas were • CATHERINE J. ALLEN When utensils revolt: mind, matter, and modes of being in the pre-Columbian Andes • RICHARD L. BURGER and LUCY SALAZAR-BURGER A sacred effigy from Mina Perdida and the unseen ceremonies of the Peruvian Formative • MARY MILLER and MARCO SAMAYOA Where maize would grow: jade, chacmools, and the Maize God • STEPHEN HOUSTON and DAVID STUART The ancient Maya self: personhood and portraiture in the Classic period • ADAM HERRING Sculptural representations and self-reference in a carved Maya panel from the region of Tabasco, Mexico • ELIZABETH NEWSOME The ontology of being and spiritual power in the stone monument cults of the lowland Maya • JOHN MONAGHAN Definitions of person and the construction of difference in Mesoamerica • ROSEMARY JOYCE Performing the body in pre-Hispanic Central America • SUSAN TOBY EVANS Sexual politics in the Aztec palace: public, private, and profane • JOHN POHL Themes of drunkeness, violence, and factionalism in Tlaxcalan altar paintings • JILL LESLIE MCKEEVER FURST The *Nahualli* of Christ: the Trinity and the nature of the soul in ancient Mexico • NICHOLAS J. SAUNDERS Stealers of light, traders in brilliance: Amerindian metaphysics in the mirror of conquest **$30**

Res 34 Autumn 1998 *Architecture*
JOSEPH RYKWERT No gratification without configuration • LEONARD BARKAN The classical undead: Renaissance and antiquity face to face • ALINA A. PAYNE Creativity and bricolage in architectural literature of the Renaissance • CHARLES BURROUGHS Grammar and expression in early Renaissance architecture: Brunelleschi and Alberti • JOSEPH RYKWERT Translation and/or representation • DAVID FREEDBERG The limits of translation • VAUGHAN HART Decorum and the five Orders of Architecture: Sebastiano Serlio's military city • REBECCA WILLIAMSON The Clocktower Controversy • BARBARA KENDA On the Renaissance art of well-being: Pneuma in Villa Eolia • RICHARD WESLEY The idea of a house • PATRICK GEORGE Counting curvature: the numerical roots of North Indian temple architecture and Frank Gehry's "digital curvatures" • LOUIS RENOU The Vedic house, edited and with a preface by Michael W. Meister • CHARLES CORREA Hornby trains, Chinese gardens, and architecture • ELIZABETH ALICE HONIG Making sense of things: on the motives of Dutch still life • JÜRGEN WASIM FREMBGEN Saints in modern devotional poster-portraits: Meanings and uses of popular religious folk art in Pakistan • FIONA MAGOWAN Singing the light: sense and sensation in Yolgnu performance • DANIELLE VAN DE VELDE Existe-t-il des noms propres de temps? **$30**

RES 35 Spring 1999 *Intercultural China*
JONATHAN HAY Toward a theory of the intercultural • ALAIN THOTE Intercultural relations as seen from Chinese pictorial bronzes of the fifth century B.C.E. • LOTHAR VON FALKENHAUSEN Inconsequential incomprehensions: some instances of Chinese writing in alien contexts • EUGENE Y. WANG What do trigrams have to do with Buddhas? The Northern Liang stupas as a hybrid spatial model • ANGELA F. HOWARD The Eight Brilliant Kings of Wisdom of southwest China • CHRISTINE M. E.

GUTH • Mapping sectarian identity: Onjōji's statue of Shinra Myōjin • PRISCILLA SOUCEK Ceramic production as exemplar of Yuan–Ilkhanid relations • PETER CHARLES STURMAN Confronting dynastic change: painting after Mongol reunification of North and South China • DOROTHY BERINSTEIN Hunts, processions, and telescopes: a painting of an imperial hunt by Lang Shining (Giuseppe Castiglione) • LUCIA TRIPODES Painting and diplomacy at the Qianlong court: a commemorative picture by Wang Zhicheng (Jean-Denis Attiret) • JONATHAN HAY Culture, ethnicity, and empire in the work of two eighteenth-century "Eccentric" artists • LESLIE JONES Sanyu: Chinese painter of Montparnasse • JOHN HAY Questions of influence in Chinese art history **$30**

RES 36 Autumn 1999 *Factura*
JOSEPH LEO KOERNER *Factura* • BRUNO LATOUR Factures/fractures: from the concept of network to the concept of attachment • MARIA GOUGH *Faktura:* the making of the Russian avant-garde • GERHARD WOLF • The origins of painting • FRIEDRICH TEJA BACH Albrecht Dürer: figures of the marginal • PHILIP SOHM *Maniera* and the absent hand: avoiding the etymology of style • REBECCA ZORACH Everything swims with excess: gold and its fashioning in sixteenth-century France • BENJAMIN BINSTOCK Rembrandt's paint • PAULA CARABELL Framing and fiction in the work of Paolo Veronese: a study in the structure and meaning of the image *di sotto in su* • T. A. ANSTEY Fictive harmonies: music and the Tempio Malatestiano • DARIO GAMBONI "Fabrication of accidents": *factura* and chance in nineteenth-century art • MATTHEW SIMMS Cézanne's unfinish • PAMELA LEE How money looks: Man Ray's *Perpetual Motif* and the economy of time • HARRY COOPER Surface as psyche: a progress report **$30**

RES 37 Spring 2000
REMO GUIDIERI The soul of the Rhizome • ROBERT LINSLEY Mirror travel in the Yucatan: Robert Smithson, Michael Fried and the new critical drama • FEDERICO NAVARRETE The path from Aztlan to Mexico: on visual narration in Mesoamerican codices • ZOE S. STROTHER From performative utterance to performative object: Pende theories of speech, blood sacrifice, and power objects • WILLIAM HART *Kololewengoi* and the myth of the Big Thing • BERNARD FORMOSO A terraced world for an armored body: the symbolism of women costumes among the Yi of Yuanyang • OLAF H. SMEDAL Sociality on display: the aesthetics of Ngadha Houses • WILLIAM H. DAVENPORT Hornbill carvings of the Iban of Sarawak, Malaysia • KATHERINE F. HACKER Traveling objects: brass images, artisans, and audiences • PIKA GHOSH The story of a storyteller's scroll • PREMA SRINIVASAN *Ahara-niyama:* the Srivaisnava dietary regimen **$30**

RES 38 Autumn 2000
BORIS GROYS On the new • HENRY MAGUIRE Profane icons: the significance of animal violence in Byzantine art • BISSERA V. PENTCHEVA Rhetorical images of the Virgin: the icon of the "usual miracle" at the Blachernai • NICOLETTA ISAR The vision and its "exceedingly blessed beholder": of desire and participation in the icon • GRAZIELLA FEDERICI VESCOVINI A new origin of perspective • CHRISTOPHER HEUER Perspective as process in Vermeer • ALBA GUADALUPE MASTACHE and

DAFTARI Beyond Islamic roots—beyond Modernism • **JAMAL J. ELIAS** On wings of diesel: Spiritual space and religious imagination in Pakistani truck decoration • **REBECCA M. BROWN** Abject to object: Colonialism preserved through the imagery of Muharram $30

RES 44 Autumn 2003
FRANCESCO PELLIZZI Anthropology and primitivism • **ADRIENNE KAEPPLER** Sculptures of barkcloth and wood from Rapa Nui: Symbolic continuities and Polynesian affinities • **MARC ROCHETTE** On the meaning of *burekalou,* a.k.a "model spirit house" from Fiji • **DAVIDE STIMILLI** Daimon and nemesis • **FILIPPO FIMIANI** Portrait of the artist as an old dog: Of Rilke, Cézanne, and the animalisation of painting • **ILYA BERNSTEIN** Image scrimmage • **CARLO DE RITA** Who's afraid of Prometheus' challenge? The postmodern aesthetization of subjectivity's political agency and the artificial • **FRANCESCO PAOLO ADORNO** Astuteness and limits of penitence • **ANDRE SCRIMA** La phénoménologie du miracle, edited and with a preface by Vlad Alexandrescu • **MARY DOUGLAS** The gender of the trout • **HAL FOSTER** Medusa and the real • **ROBERT HULLOT-KENTOR** Right listening and a new type of human being $30

RES 45 Spring 2004
ROBERT HULLOT-KENTOR Adorno without quotation • **MICHAEL OPPITZ** Ritual objects of the Qiang shamans • **REBECCA STONE-MILLER** Human-animal imagery, shamanic visions, and ancient American aesthetics • **KARL A. TAUBE** Flower Mountain: Concepts of life, beauty, and paradise among the Classic Maya • **JULIA GUERNSEY KAPPELMAN** Demystifying the late preclassic Izapan-style stela-altar "cult" • **ANTHONY F. AVENI, SUSAN MILBRATH, CARLOS PERAZA LOPE** Chichén Itzá's legacy in the astronomically oriented architecture of Mayapán • **FEDERICO NAVARRETE** The hidden codes of the Codex Azcatitlan • **RENATO GONZÁLEZ MELLO** Manuel Gamio, Diego Rivera, and the politics of Mexican anthropology • **SUZANNE PRESTON BLIER** The art of assemblage: Aesthetic expression and social experience in Danhomè • **CLEMENTE MARCONI** Kosmos: The imagery of the archaic Greek temple • **BISSERA PENTCHEVA** Visual textuality: The *Logos* as pregnant body and building • **CHARLES BURROUGHS** Greening Brunelleschi: Botticelli at Santo Spirito • **ANGELA VANHAELEN** Local sites, foreign sights: A sailor's sketchbook of human and animal curiosities in early modern Amsterdam • **CUAUHTÉMOC MEDINA** Architecture and efficiency: George Maciunas and the economy of art $30

RES 46 Autumn 2004 Polemical objects
PHILIP ARMSTRONG, STEPHEN MELVILLE, and ERIKA NAGINSKI Ad Rem • **WHITNEY DAVIS** Visuality and pictoriality • **ALEXANDER NAGEL** Fashion and the now-time of Renaissance art • **TOMOO MATSUBARA** Battle, controversy, and two polemical images by Sodoma • **JOSEPH KOERNER** Impossible objects: Bosch's realism • **STEPHEN J. CAMPBELL** Counter Reformation polemic and Mannerist counter-aesthetics: Bronzino's *Martyrdom of St. Lawrence* in San Lorenzo • **VICTOR STOICHITA** Beautiful Helen and her

double in the *Galeria* by Cavalier Marino • **ERIKA NAGINSKI** Julien's *Poussin,* or the limits of sculpture • **CHRISTOPHER WOOD** Riegl's *Mache* • **PHILIP ARMSTRONG** Rodchenko's monochromes and the perfection of painting • **STEPHEN MELVILLE** Richard Serra: Taking the measure of the impossible • **HOWARD SINGERMAN** Sherrie Levine: On painting • **ROSALIND E. KRAUSS** "Specific" objects • **MEL BOCHNER** Ten predicaments • **EDWARD D. POWERS** Bodies at rest—or, the object of surrealism • **KENT MINTURN** Dubuffet, Lévi-Strauss, and the idea of art brut • **JEAN DUBUFFET** In honor of savage values $30

Res 47 Spring 2005
REMO GUIDIERI Socrates' death • **CHRISTINE STEVENSON** Antimasque, pageant: Restoration and Bethlem at Moorfields • CHRISTINE POGGI Picturing madness in 1905: Giacomo Balla's *La pazza* and the cycle *I vivienti* • **FILIPPO FIMIANI** Quoting Eros: Visual culture, irony, and anachronism in Thomas Mann • **LORI BOORNAZIAN DIEL** Women and political power: The inclusion and exclusion of noblewomen in Aztec pictorial histories • **OSWALDO CHINCHILLA–MAZARIEGOS** Cosmos and warfare on a Classic Maya vase • **BESS REED and BENJAMIN HUFBAUER** Ancestors and commemoration in Igbo *Odo* masquerades • **ROMAIN CHAMBRIN** Style and the standardization in some arts of the Sepik **SUZANNE KÜCHLER** The modality of time-maps: Quilting in the Pacific from another point of view • **JOHN LAYARD** Slit drums on Atchin • **HOWARD MORPHY** Style and meaning: Abelam art through Yolngu eyes • **DONALD COSENTINO** Vodou in the age of mechanical reproduction • **BARBARA DUDEN** Heterosomatics: Remarks of a historian of women's bodies • **MATTHEW RAMPLEY** The ethnographic sublime $30

Res 48 Autumn 2005 Permanent/Impermanent
FINBARR BARRY FLOOD and ZOÉ STROTHER Between creation and destruction • **SARAH ADAMS** People have three eyes: Ephemeral art and the archive in southeastern Nigeria • **KRISTINA VAN DYKE** Beyond monument lies empire: Mapping Songhay space in tenth- to sixteenth century West Africa • **JOHN PEFFER** Censorship and iconoclasm—unsettling monuments • **ERIC REINDERS** Recycling icons and bodies and Chinese anti-Buddhist persecutions • **BRYAN R. JUST** Modifications of ancient Maya sculpture • **RABUN TAYLOR** Roman oscilla: An assessment • **GERVASE ROSSER** Turning tale into vision: Time and image in the *Divina Commedia* • **MARVIN TRACHTENBERG** Building outside time in Alberti's *De re aedificatoria* • **MEREDITH COHEN** Restoration as re-creation at the Sainte-Chapelle • **TAHA AL-DOURI** The constitution of pleasure: François-Joseph Belanger and the Chateau de Bagatelle • **MAURO CARBONE** Composing Vinteuil: Proust's unheard music • **DANIEL BERTRAND MONK** Diskotel 1967: Israel and the Western Wall in the aftermath of the Six Day War • **CUAUHTÉMOC MEDINA** The "Kulturbolschewiken" I: Fluxis, the abolition of art, the Soviet Unioon, and "pure amusement" • **DAVID STIMILLI** Aby Warburg in America again $30

NEW BOOKS FROM THE

PEABODY MUSEUM PRESS BOOKS ARE DISTRIBUTED BY HARVARD
UNIVERSITY PRESS.
TO ORDER:
Toll-free in USA: 1-800-405-1619
USA FAX: 1-800-406-9145
INTERNATIONAL PHONE: 401-531-2800
INTERNATIONAL FAX: 401-531-2801
E-MAIL ORDERS: orders@triliteral.org
E-MAIL INQUIRIES: customercare@triliteral.org
WEB SITE: www.hup.harvard.edu

THE PEABODY MUSEUM COLLECTIONS SERIES
Rubie Watson, *Series Editor*

FEEDING THE ANCESTORS
Tlingit Carved Horn Spoons
Anne-Marie Victor-Howe
Foreword by Rosita Worl
Photographs by Hillel S. Burger

Feeding the Ancestors presents an exquisite group of
traditional feast spoons from the Pacific Northwest that
resides in the collections of Harvard's Peabody Museum of
Archaeology and Ethnology. Carved from the horns of
mountain goats and Dall sheep, and incorporating
elements of abalone shell and metal, most of the spoons
were collected in Alaska in the late nineteenth century and
were made and used by members of the Tlingit tribe. Hillel
Burger's beautiful color photographs reveal every nuance of
the carvers' extraordinary artistry. *Feeding the Ancestors* is
the first scholarly study of traditional Tlingit spoons and a
valuable contribution to our knowledge of Pacific
Northwest Coast peoples and their art.

Paper with flaps, ISBN 0-87365-403-X $21.95

A NOBLE PURSUIT
**The Duchess of Mecklenburg Collection from
Iron Age Slovenia**
Gloria Polizzotti Greis
Paper with flaps, ISBN 0-87365-404-8 $21.95

COLLECTING THE WEAVER'S ART
The William Claflin Collection of Southwestern Textiles
Laurie D. Webster
Paper with flaps, ISBN 0-87365-400-5 $21.95

PAINTED BY A DISTANT HAND
Mimbres Pottery from the American Southwest
Steven A. LeBlanc
Paper with flaps, ISBN 0-87365-402-1 $21.95

GIFTS OF THE GREAT RIVER
Arkansas Effigy Pottery from the Edwin Curtiss Collection
John H. House
Paper with flaps, ISBN 0-87365-401-3 $21.95

PEABODY MUSEUM CLASSICS

KIVA MURAL DECORATIONS AT AWATOVI AND KAWAIKA-A
**With a Survey of Other Wall Paintings in the Pueblo
Southwest**
Watson Smith

First published in 1952, this volume reports on the
remarkable painted murals found in underground
ceremonial chambers at the ancient Pueblo site of Awatovi
on the Hopi Reservation in Arizona and other Puebloan
sites. This stunning facsimile edition includes color
reproductions of the original serigraphs, which convey the
aesthetic power and symbolic imagery of the sacred wall-
painting tradition of the aboriginal Southwest.

Papers of the Peabody Museum 37 (Facsimile Edition)
Cloth, ISBN 0-87365-126-X $75.00

THE SWARTS RUIN
A Typical Mimbres Site in Southwestern New Mexico
H. S. and C. B. Cosgrove

This classic volume is the report of Burt and Hattie
Cosgrove's excavation seasons of 1924 to 1927 at the
Swarts Ruin in southern New Mexico, where they
recovered an extraordinary assemblage of Classic Mimbres
(ca. A.D. 1000–1150) ceramics. Hattie Cosgrove's
meticulous line drawings of over 700 individual pots are an
invaluable design catalogue, and this clothbound edition of
the original 1932 publication is an essential addition to any
collection of Native American art scholarship.

Papers of the Peabody Museum 15 (Facsimile Edition)
Cloth, ISBN 0-87365-054-9 $55.00

PEABODY MUSEUM PRESS

CORPUS OF MAYA HIEROGLYPHIC INSCRIPTIONS

Volume 9, Part 2
TONINA
Ian Graham

This is the fourth of five *Corpus* volumes on the Classic Maya monuments of Tonina, which lies east of the town of Ocosingo in Chiapas, Mexico. In 109 line drawings and 138 halftones, the volume describes and illustrates 36 sequentially numbered sculptures that represent most of the remaining unpublished and largely intact sculptures at the site.

Paper, ISBN 0-87365-773-X $50.00

Volume 9, Part 1
PIEDRAS NEGRAS
David Stuart and Ian Graham

This first of five anticipated volumes on the renowned monuments of Piedras Negras, Guatemala, describes the overall site and recounts the history of exploration at this important center of Classic Maya civilization. It includes photographs and detailed line drawings of 12 of the inscribed and sculpted monuments.

Paper, ISBN 0-87365-822-1 $50.00

AMERICAN SCHOOL OF PREHISTORIC RESEARCH

HOLON
A Lower Paleolithic Site in Israel
Michael Chazan and Liora Kolska Horwitz

Excavations at the open-air site of Holon, Israel, have provided a unique perspective on hominin behavior, technology, and subsistence strategies in the Middle East at the end of the Lower Paleolithic. This volume, the first integrated publication on a Lower Paleolithic site in the region, brings together geology, dating, archaeology, paleontology, taphonomy, and other studies by a team of leading international researchers. The results address fundamental questions of human evolution and the nature of cultural change.

Available in April 2007
American School of Prehistoric Research Bulletin 51
Paper, ISBN 0-87365-555-9 $75.00

THE FAUNAS OF HAYONIM CAVE, ISRAEL
A 200,000-Year Record of Paleolithic Diet, Demography, and Society
Mary C. Stiner

Stiner's pathbreaking analysis of changes in human ecology from the early Mousterian period through the end of Paleolithic cultures in the Levant employs a comparative approach to understanding early human behavioral and environmental change, based on a detailed study of 14 bone assemblages, associated artifacts, and well-preserved hearths from Hayonim Cave and Meged Rockshelter in Israel's Galilee. Anthropological in outlook, the analysis also integrates chemistry, foraging and population ecology, vertebrate paleontology, and biogeography.

American School of Prehistoric Research Bulletin 48
Paper, ISBN 0-87365-552-4 $75.00

AVAILABLE DIRECTLY FROM THE PEABODY MUSEUM PRESS

ARTS OF DIPLOMACY
Lewis and Clark's Indian Collection
Castle McLaughlin
Photographs by Hillel S. Burger
Foreword by James P. Ronda

Arts of Diplomacy challenges conventional wisdom about the Lewis and Clark expedition, revealing it as a complex process of diplomacy, mutual discovery, and exchange with Native American peoples. McLaughlin and colleagues analyze the Peabody Museum's "Lewis and Clark collection," a set of magnificent 18th- and early 19th-century objects long thought to be the only surviving ethnographic items acquired by the expedition, and trace their histories from public and private collections back to Native makers and users. With contributions by Native American artists and scholars, the book is a model for how museum collections can be used to tell their own vivid stories.

"This groundbreaking art book is a dazzling addition to Lewis and Clark libraries [and] an important testament to the vibrant Indian cultures flourishing in the territory when the expedition passed through."

—*Seattle Post-Intelligencer*

Published with the University of Washington Press
Cloth, ISBN 0-295-98360-4 $75.00
Paper, ISBN 0-295-98361-2 $40.00

TO ORDER FROM THE PEABODY MUSEUM PRESS
PHONE: 1-617-495-4255
FAX: 1-617-495-7535
E-MAIL: peapub@fas.harvard.edu
WEB SITE: www.peabody.harvard.edu/publications/

Res

Anthropology and aesthetics

Res is a journal of anthropology and comparative aesthetics dedicated to the study of the object, in particular cult and belief objects and objects of art. The journal brings together, in an anthropological perspective, contributions by philosophers, art historians, archaeologists, critics, linguists, architects, artists, and others. Its field of inquiry is open to all cultures, regions, and historical periods.

Res also seeks to make available textual and iconographic documents of importance for the history and theory of the arts.

Res is distributed by Harvard University Press. For orders and price information, and for information about placing a Standing Order for future issues, call Customer Service toll free, USA & Canada, 800-405-1619; all others, 401-531-2800. Fax: USA & Canada, 800-406-9145; all others, 401-531-2801. E-mail: customer.care@triliteral.org.

Res is a co-publication of the Peabody Museum of Archaeology and Ethnology and the Harvard University Art Museums.

Editorial correspondence should be sent to Francesco Pellizzi, *Res,* Editorial Office, 12 East 74th Street, New York, NY 10021, phone: 212-737-6109, fax: 212-861-7874, 212-744-3540, e-mail: pellizzi@fas.harvard.edu.

Information about back, current, and upcoming issues of *Res,* an author's guide, ordering information, and other features are available on the *Res* web site (www.res-journal.org) and the Harvard University Press web site (www.hup.harvard.edu).

Permission reprint requests for volumes 1–18 and 29/30 and on should be directed to the Peabody Museum of Archaeology and Ethnology, Publications Department, 11 Divinity Avenue, Cambridge, MA 02138, phone: 617-495-3938, fax: 617-495-7535; permission and reprint requests for volumes 19/20–28 only should be directed to the Getty Research Institute for the History of Art and the Humanities, Publications, 1200 Getty Center Drive, Suite 1100, Los Angeles, CA 90049-1688, phone: 310-440-7452, fax: 310-440-7778.